Also by Paul Fisher

House of Wits: An Intimate Portrait of the James Family

Artful Itineraries: European Art and American Careers in High Culture, 1865–1920

The
GRAND
AFFAIR

Paul Fisher

The
GRAND
AFFAIR

John Singer
Sargent
in His World

Farrar, Straus and Giroux
New York

Farrar, Straus and Giroux
120 Broadway, New York 10271

Illustration credits can be found on pages 475–479.

Library of Congress Cataloging-in-Publication Data
Names: Fisher, Paul, 1960– author.
Title: The grand affair : John Singer Sargent in his world / Paul Fisher.
Description: First edition. | New York : Farrar, Straus and Giroux, 2022. |
 Includes bibliographical references and index.
Identifiers: LCCN 2022023648 | ISBN 9780374165970 (hardcover)
Subjects: LCSH: Sargent, John Singer, 1856–1925. | Painters—United States—
 Biography.
Classification: LCC ND237.S3 F57 2022 | DDC 759.13 [B]—dc23/eng/20220712
LC record available at https://lccn.loc.gov/2022023648

Designed by Janet Evans-Scanlon

Our books may be purchased in bulk for promotional, educational,
or business use. Please contact your local bookseller or the Macmillan
Corporate and Premium Sales Department at 1-800-221-7945,
extension 5442, or by email at MacmillanSpecialMarkets@macmillan.com.

www.fsgbooks.com
www.twitter.com/fsgbooks • www.facebook.com/fsgbooks

10 9 8 7 6 5 4 3 2 1

Frontispiece: Artists' party with John Singer Sargent and others (detail), c. 1890.
Otto Bacher papers, 1873–1938. Archives of American Art, Smithsonian Institution.

To Tim and Sibella,
who showed me what an art world is

Contents

CONTENTS

The
GRAND
AFFAIR

Prologue:
The Prince of the Glass Palace

The three young artists hatched their plan, out of the blue, at an overpacked café in the Left-Bank quarter of Montparnasse. In the torrid mid-July, in the too-warm wool suits of the early 1880s, they all hankered to escape the hot pavements of Paris and its rowdy Bastille Day crowds. Their ringleader, the rising star American painter John Singer Sargent, had just hit on the perfect solution. Why not catch one of Baron Rothschild's fast overnight trains to Holland, the land of Johannes Vermeer, Rembrandt van Rijn, and Frans Hals?

Twenty-seven-year-old Sargent, though lanky, dark-bearded, and rather solemn—a card-carrying workaholic—enjoyed a good lark. At the prospect, his sedate surface broke. He flashed a little of the impudence that most people saw chiefly in his stylish, unconventional paintings.

Sargent's friends well understood that his still-water mysteries ran deeper than most people knew. He was deeply passionate about painting. Though an edgily modern artist, he didn't underestimate "Old Masters," as the nineteenth century understood them; he didn't consider them passé, stiff, or pedantic. He'd been infatuated, for a while now, with the splendors of Frans Hals. He adored that impudent seventeenth-century portraitist of swaggering, rich-costumed burghers, an artist no one else in Paris seemed to appreciate quite enough. And he'd also made a private religion of the seventeenth-century Spanish firebrand Diego Velázquez. Past artistic revolutionaries offered Sargent intriguing keys to painterly secrets as well as a vivid and emancipatory life. He was equally inspired by the bold new Parisian portraiture of the 1880s, of which he was already, at his young age, a leading light.

His friends, drawn to his enigmatic qualities—and yet kept at bay by

them—sensed that this sudden trip qualified as personally important to him. It channeled one of his sudden, heartfelt desires.

The diminutive, combustible Paul César Helleu especially delighted in Sargent's mysteries. He was often to be found smoking a cigarette and lounging in Sargent's studio. A slender, animated Breton of twenty-four, Helleu was immediately game to go.

The third conspirator, Albert de Belleroche, hung back a little more. This half-aristocratic, rather elfin Anglo-Belgian, just turning twenty, had only recently come to Paris to study art. He was just finding his feet in the painterly world. But he'd gone to quite a bit of trouble to pursue Sargent's friendship—was intrigued by the older man's color-soaked canvases and surging reputation. He also appreciated Sargent's "habitual good humour" and his willingness to undertake activities full of "surprises and *imprévu*"— the unexpectedness, now, of this spur-of-the-moment trip.

As the three friends gathered at the great glass portals of the Gare du Nord, nesting their carpetbags together, they paused beside a huge Roman arch of Lutetian limestone—*calcaire grossier*, the Parisians called it, "coarse limestone." But this limestone, from the nearby Oise Valley, actually appeared as smooth as butter and creamy in color, facing many of the public buildings in Paris and lending that great, electric-lit, modern metropolis its luminous, subtly consistent palette of pale gray, pale gold.

Almost everything in Sargent's Paris glowed with such visual style. Sargent was immersed in the latest Parisian trends, and his painter comrades were more than willing to follow where he led.

—✦—

Even among friends, Sargent could be shy, formal, socially awkward—fond of sitting back and obscuring himself in the fog of his endless cigarettes. Yet his little railway junket with his artist chums revealed another Sargent. His companions sparked a species of elation, not to mention at-ease intimacy, that liberated a more spontaneous and less filtered version of the young painter. At the palatial station, on the express train, Sargent flared into enthusiasms, jokes, and confidences. He waxed joyous and daring. He called Helleu "Leu-leu" and Belleroche "Baby Milbank"—a reference to the surname the young painter was using at the time, as well as to his younger age. The young artists buzzed with inside jokes, shoptalk, and art-insider fandom.

As the train rocked northward, the young men found it hard to sleep. Their overnight in the high-end sleepers called Wagon-Lits, inspired by

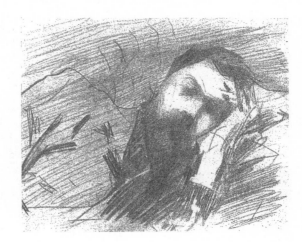

Belleroche's sketch of
Sargent, 1882 or 1883

Pullman cars in the United States, granted them all a whiff of luxury and adventure—even if their cramped, fold-down berths provided a rather coffin-like discomfort. And that's perhaps why, as the last hot light failed across the bleak and stubbly plains of northern France, Albert de Belleroche packed out a pencil and a hand-size notebook and risked a sketch of his drowsing friend.

What Belleroche captured, though not obviously striking, spoke volumes. It revealed an off guard, informal Sargent with his left hand pillowed under head, his shoulder bunched up in his jacket, his fingers curled against his forehead. What's more, though Sargent's short beard and mustache remained shadowy, Belleroche rendered his face as handsome and luminous as an angel's. Belleroche's rather dreamy image, in fact, revealed an intimate and private vision of Sargent that Belleroche wouldn't share with others till decades later, after Sargent's death. For this sketch illuminated a side of the two men's life, threaded with private meanings, that few people suspected.

What's more, Belleroche's sketch was actually just the tip of an immense iceberg. In fact, Sargent's own renderings of Belleroche were ten times as plentiful. Back at his studio in the boulevard Berthier, Sargent had reeled off many sketches and half-finished canvases of his younger friend. These included moody, lyrical views in charcoal and oils, capturing the young man's delicate features and Cupid's-bow lips. Such mementos littered the shelves, tables, and easels of the studio.

In a mania for sketching his friend, Sargent even considered producing a grand exhibition portrait, with the young man styled as a sort of Velázquez

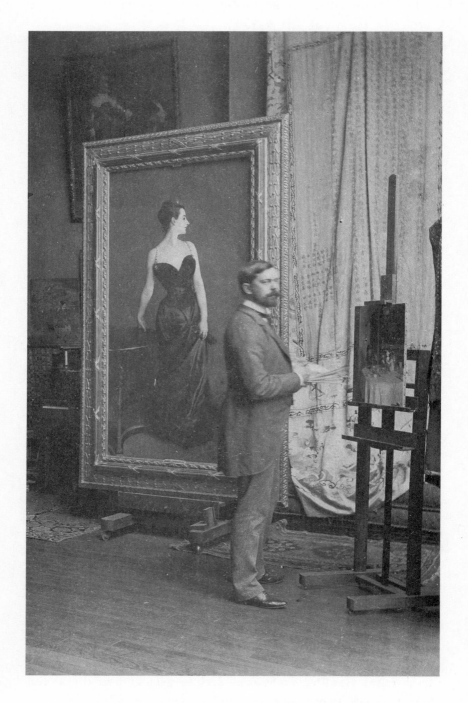

Sargent with *Madame X* in his Paris studio, c. 1884

prince, draped languorously over an enormous sword. "With the exception of Madame Gautreau," Belleroche later admitted, referring to Sargent's infamous *Madame X*, "I do not believe that Sargent ever had so many sittings as for this portrait." Yet Sargent would eventually abandon this princely set piece. Or rather he would alter it, rendering it smaller, more emotive, and more personal.

He'd also keep his images of Belleroche quietly in the semiprivacy of his studio. He would never exhibit them in the grand, sunlit halls of the Salon.

-+-

*Sargent's recent and sudden celebrity had first taken wing in another limestone-*faced glass greenhouse, some three miles from the Gare du Nord—the so-called Palais de l'Industrie in the Champs-Élysées. That great iron-and-glass-vaulted hall, built originally for Louis Napoléon's 1855 Exposition Universelle, hosted the world's most prestigious exhibition of paintings, the annual Paris Salon. Sargent had exhibited at the Salon every year since 1877. Merely to have works accepted counted as an honor. But Sargent hadn't just squeezed his canvases into the corners of this massive, world-class exhibition. He'd stolen the spotlight, the limelight, and just about all of the daylight. He'd already won two Salon medals, the maximum number allowed for an artist's whole lifetime.

Yet in the crush of the Salons, not just two but many of Sargent's paintings had dazzled critics and enthralled Salon-going crowds. Shrewdly, Sargent had chosen to portray conspicuously handsome and stylish Paris women: Marie Buloz Pailleron, the daughter of the editor of the *Revue des deux mondes*, sporting a tea gown in her half-wild garden at Chambéry; Amalia Subercaseaux, the young wife of a Chilean diplomat, sitting, fresh and charmingly dressed, at her piano. In his fascinating *Daughters of Edward Darley Boit*, he'd intriguingly captured four little American expatriate girls in pinafores, lost in the gloomy grandeur of their eighth-arrondissement apartment, hinting at the labyrinthine psychological complications of their high-end lifestyles.

Attuned to color and spectacle, Sargent had also dashed off lively portraits and figure studies of exquisitely beautiful and "exotic" women: a rosy Capri peasant, shawl-wrapped Venetian bead-stringers, and a white-robed Moroccan hovering over an incense brazier—this last an orientalist concoction he'd entitled *Fumée d'ambre gris*. And a year or two after this railway getaway, Sargent would produce his prodigious succès de scandale,

Madame X, which would crown his reputation as a portraitist of the em-
boldened, newly liberated women of the Belle Époque.

And yet all this dazzling work concealed another oeuvre.

-*+-

For all its huge, exhibitionistic greenhouses, the Victorian world was anything but
transparent. True, the art worlds of the Belle Époque provided Sargent with
a vast glass palace, part hall of mirrors, part forcing house, in which the
painter managed to seed and nurture his brilliant hothouse flowers. Yet for
all the rather edgy subjects that Sargent could paint—and he was enrap-
tured with the whole teeming visual world around him, its unexpectedness
and idiosyncrasy—there were plenty of things he couldn't, that threatened
to shatter the glass edifice of his reputation.

Reputations were especially fragile during an era when gender trans-
gressions raised furors, and same-sex liaisons were ridiculed in France and
brutally criminalized almost everywhere else. Under such surveillance, in
so grandiose and brittle a world, it is hardly surprising that Sargent, who
would pursue many friendships that pushed the acceptable boundaries of
the era, cultivated and enforced a strong distinction between his public and
private work. Even in relatively permissive Paris, Sargent was obliged to
present an expurgated self and a restricted painterly canon.

It wasn't just Albert de Belleroche who signaled Sargent's complex in-
volvements with other men. Throughout his long life, Sargent would con-
sort with fellow artists such as Paul Helleu, Edwin Austin Abbey, Frank
Millet, and Peter Harrison, as well as male models such as Anton Kamp,
Thomas McKeller, and Nicola d'Inverno—this last a man Sargent would
keep in his household for a quarter of a century. Such alliances dominated
the painter's life, for all of his important personal and professional connec-
tions with women. But to outsiders the possible significance of such male
companions remained largely obscure, taken at face value, until a different
category of Sargent's private artistic production came to light.

Significantly, Sargent didn't sketch Albert de Belleroche nude—not
that anyone can document, anyway. But throughout his career Sargent por-
trayed many other naked men. As Sargent's friend Abbey discovered sev-
eral years later in 1890, Sargent had in fact produced "stacks of sketches
of nude people." Though life-study nudes were a prominent feature of ac-
ademic painting, Abbey found himself a little unnerved by the revelation
of his friend's enthusiasm for nudes. Even from "cursory observations,"

Abbey found them "a bit earthy." It isn't known if the specific sketches Abbey observed have survived. But they belonged to an extensive private body of work that would take even longer to emerge, and that would eventually render Sargent an entirely new kind of conundrum.

Sargent's nudes, along with many of his sketches of Belleroche, didn't come to light, to scholarly and public attention, until the 1980s, when they raised thorny questions about Sargent's life and career, stirring up much scholarly and public debate about his identity. Yet the labels that have been attached to Sargent over the past several decades—some convincing, some less convincing: "homosexual," "gay," "queer," "asexual," or even "closet heterosexual"—have plucked Sargent from his own times and context. Such labels have tended to curb rather than liberate the painter's opulent complexities, which transcend simplistic categories and remain fused with his lived experiences. For here his private passions took on even larger implications.

Before the discovery of Sargent's private opus, in fact, many art historians regarded Sargent as an old-fashioned, high-cultural painter, antithetical to any form of compelling relevance. By the end of his life, thanks to a run of ultrafashionable portraits and some rather stodgy library decorations painted in Boston, the artist was pigeonholed by many as a glitzy society painter or a fustian muralist.

Yet the rediscovery of Sargent's fraught private life began a radical reconsideration of the painter and his work that has only gained momentum in the early twenty-first century. We can now see that Sargent's social and aesthetic relevance—both to his time and ours—draws strength not only from his same-sex interests and his fascination with gender nonconformity but also from his engagement with ethnicity, race, and emerging globalism—by his representation of an ever-more-complex modernity and an ever-more-diverse and multicultural world. In spite of his sometimes colonialist or orientalist formulations, Sargent's unique transnational perspective heralded the beginnings of an expanding polyglot global culture.

At home or abroad, it wasn't just Sargent's relations with men that we can now understand as productively rich. Sargent's distinctively unconventional liaisons with women too also profoundly shaped his work and its long-term relevance. In forging his career, in making a name for himself in Paris and then around the world, Sargent's most typical artistic formula, like that of some leading Impressionists, took advantage of bold, theatrical, iconoclastic women. If Édouard Manet painted cocottes and courtesans, if Edgar Degas sought out grisettes and ballet dancers, Sargent was increasingly obsessed

with divas. The term "diva," derived from the Italian for "goddess" or "fine lady," came into use in the 1880s to describe the bold female singers, dancers, and actresses of the Belle Époque who increasingly dominated both the high and low stages of Europe and America. And Sargent used these divas to fly high, himself. All his life, Sargent was powerfully drawn to dynamic, rule-breaking women. His choice of such exuberant models tapped into one of the biggest revolutions of his age, the creation of assertive, modern, and self-determining women.

What Henry James described as the "'uncanny' spectacle" of Sargent's talent was based on his glittering portrayals of such women, also on his penchant for tapping into the scandals they created. He did that with *Madame X*, his outrageous portrait of the society starlet Amélie Gautreau. But that, again, was only the tip of a complicated and ramifying iceberg. Sargent treated all his female models, courtesans and society ladies and suffragists, with a nervous personal fascination as well as a cool professional detachment.

For all the brilliance of Sargent's painterly eye, it mattered which specific friends, sitters, and patrons Sargent chose, cultivated, and pursued. It mattered how his passionate brand of outlawry shaped and infused both his private works and his better-known paintings. It mattered that he immersed himself in non-Western places like Egypt and Turkey, that he embraced Jewish cosmopolitanism, and that he consorted with working-class models of diverse ethnicities and races like Rosina Ferrara in Capri, Nicola d'Inverno in London, and finally Thomas McKeller in Boston.

For Sargent, travel was a crucial mode of encountering these multifaceted and potentially emancipating worlds. He perfected the art of travel (and sometimes tourism) as much as anything else. On the road, away from the strictures of home, he could enact versions of liberation that his society didn't otherwise permit. Whether his peripatetic cosmopolitanism was "queer" or simply free-spirited, it proved one of the most important mediums of his iconoclasm, as in the spontaneous outing he took to Holland with his two artist friends. Other junkets produced private fascinations as well as publicly acclaimed masterpieces.

In Paris as well as in London, Boston, and New York, Sargent's contraband private life strongly affected his public one. Painting during the rise of clinical psychiatry, Sargent was enmeshed in the psychological complexities of his sitters as well as spurred by his own inner demons. In particular, the restless, rebellious art worlds in which Sargent circulated—from his edgy

training in a bohemian Paris on down—allowed him to articulate more personal intricacies than the Victorian world otherwise permitted.

Among Paris decadents and bohemians, among English aesthetes and queers, among American mavericks, among Spanish vagabonds, among Venetian street people, Sargent could give rein to an idiosyncratic genius hardly allowed to show itself in the more conventional Victorian world. He adopted and adapted international art-world settings to create facsimiles of liberation and self-expression—both in his private works and, in sometimes fascinating and intriguing ways, his public ones.

Between 1874 and 1925 especially, Sargent ventured a quirky brand of personal liberty among his friends and fellow artists as well as in his studio worlds of models and patrons and in his paintings and drawings themselves. His semiprivate art-life—his sketchbooks and private pieces—allows us a vision of a fuller and richer, a more unpredictable and border-crossing Sargent.

In some ways Sargent remained a prisoner of his privileges; in others, he was able to transcend his narrow, elite milieu. Though a few critics have continued to see Sargent as a slick, elite, or meretricious artist, most twenty-first-century experts and audiences have been entranced by a brilliance in his best paintings whose exquisite painterly technique and provocative social content still strikes us as rare, elusive, and intriguing. Now that a more extensive opus has come to light, a more open and contextual exploration of Sargent's life, of his complicated historical world, can help us fathom that brilliance. It can also help reclaim a more adventurous and surprising version of him.

Sargent belongs to everyone, and everyone sees something different in *Madame X*, *The Daughters of Edward Darley Boit*, or his nude portrait of Thomas E. McKeller. But what many people have loved about Sargent is his perpetual freshness and free spirit.

Sargent's quirky spontaneity sprang from many sources—his family background, his early travels, his self-education, his infatuation with firebrand painters, his relentless transnational perspective, his unique Paris training. But his distinctive gift also grew from those half-hidden worlds in which he was able to find joy and inspiration, and the half-obscured passions that fueled his extraordinary love affair with the visual world. Sargent's works teem with all the many and multifarious relationships of his life—his imperious patrons, his iconoclastic friends, his enterprising models—with all their rich and shadowy complexity.

Whatever else Sargent's paradoxes have suggested, the painter's distinctive taste, imagination, and life experience enabled him to envision his many models, sitters, and patrons from a rare vantage point, rendering him a painter of dazzling human complexity. And it is just this complexity that grants this painter, this wayward stepchild of the Belle Époque, his most compelling contemporary relevance.

1

Mrs. Sargent's Party

During the winter of 1868–69, a woman with the grand-sounding if socially unfamiliar name of Mrs. Fitzwilliam Sargent, of Philadelphia, hosted dinners at a small, many-windowed house atop the Spanish Steps in Rome. The mistress of the house hadn't in fact seen Philadelphia for more than fourteen years. Pleasant, imperious, plump, and just over forty, she readily confessed that she liked Rome better than her own native city, liked living next door to the white, two-towered church of Trinità dei Monti, with is views out over the ancient city of Rome. She also admitted to being a watercolorist. Her love for art as well as the Eternal City had prompted her boldness in inviting some of the leading American painters and sculptors in Rome to her house.

Arriving for Mrs. Sargent's party in horse cabs and the rakish hired carriages known as *vetture di rimessa*, this parade of theatrical goatees, capes, and walking sticks might have intimidated a lesser woman. But Mrs. Sargent, openhearted if not exactly worldly, remained undaunted. As family friend Vernon Lee understood her, she was ambitious but almost childishly immune to snobbery, "bubbling with sympathies and the need for sympathy," full of "unquenchable youthfulness and *joie de vivre*." She loved the grand and curious in art—anything colorful, really, attracted her—in her household furnishings no less than her illustrious guests. Her artistic drawing room featured a pair of conspicuous if strangely contrasting marble busts: George Washington, the father of his country, and the Egyptian goddess Isis, the mother of hers.

In many ways, these two sculptures neatly embodied Mary Newbold Singer Sargent's paradoxes. She was a loyal American who still did everything in her power to cling to Europe. She was also a devoted wife and

mother of three children who hadn't, according to nineteenth-century imperatives of domestic virtue and wifely sacrifice, confined herself to some neat Philadelphia row house for her family's sake.

On the contrary, Mary Sargent used her small private income to channel what a later friend would call a "locomotive disposition." As Vernon Lee understood the matter, Mary Sargent's wanderlust was "born of innumerable stay-at-home generations; and this unimpaired zest for travel is but the accumulated thwarted longing of all those sedentary lives." The progressive journalist Ida Minerva Tarbell, confronting the dynamic and transgressive phenomenon of women's travel in the era, would understand women like Mary Sargent, this locomotive of her family's mobility, as engaged in a giddy and sometimes guilty "break for freedom" and a "revolt against security."

Mary Sargent's husband, Fitzwilliam, a tall, stiff, narrow-backed, rather haunted-looking man, had offered stability. At the beginning of the Sargents' marriage in 1850, he'd worked as a doctor at the Wills Hospital in Philadelphia, a promising young surgeon. He'd even published, in 1848, a definitive work on wound-dressing, entitled *On Bandaging, and Other Operations of Minor Surgery*. But his textbook had never seen a sequel. Dr. Sargent had relinquished his hospital position a dozen years before, in 1856, in order to escort his wife around Europe, for her health.

Now he mingled with modish Europeanized types, artists and bohemians, of whom he (politely) disapproved. In his many devout, long-suffering letters to the United States, he aired his disinclination for "the humbug variety of Americans" who aped European ways. At such a party he had little to do but watch the plates of food circulate and make conversation with his wife's guests about the healthy or unhealthy "air" of assorted European climates. About this present residence in Rome, his main remark was that the streets struck him as dirtier than before. Though a bright and learned man, Dr. Sargent was more interested in attending the American chapel, in stout Protestant defiance of the papal government of the city, than in mixing with sculptors.

The invited artists filtered into the house, discovering that Mrs. Sargent's small drawing room commanded a striking view, out over the city toward St. Peter's. That far-off dome glowing in Rome's handsome winter light stamped the occasion with a certain elegance. Yet that dome also belonged to the world's first mass tourism since the ancient Romans; it was an image strikingly familiar because it was reproduced in postcards, stereoscope pho-

tos, or such crude or sentimental images as might be daubed on lampshades, as souvenirs, by the lady's children.

The crimson-and-gold lampshades of the house, though, didn't belong to the family. As career expatriates, the Sargents owned little but such clothes and personal effects as they could cram into trunks, portmanteaus, and carpetbags. George Washington could have belonged to them, as Victorians more willingly lugged fragile, oversized, or heavy objects than modern travelers do. But, as the children's friend Vernon Lee later observed, such "gods or sibyls or stray martyrdoms" were often included with furnished lodgings in Rome.

These opportunistic rentals capitalized on the burgeoning middle-class American tourist market. A few years before, in 1866, fifty thousand Americans had steamed across the Atlantic, as the Sargents had done in an earlier year. Many itinerant Americans sooner or later discovered Rome—often rapturously—confident that the American Republic, with its own Capitol Hill and just-finished cast-iron Capitol dome, was Rome's successor. During the fashionable winter season, the Sargents could read listed in Roman newspapers a thousand names of visiting Americans. And those were only the prominent ones, notables who wished to trumpet their arrival to fellow Bostonians, New Yorkers, or Philadelphians.

Mary and Fitzwilliam didn't listen for such fanfares. They hardly belonged to any social register, though Dr. Sargent was relieved to find "a good many of our old acquaintance still here, who seem glad to see us again." He and his lively wife mixed primarily with other half-rich Americans (life in Europe in the nineteenth century cost half as much as in the United States) traveling in pursuit of their health. Such was Mary Sargent's official excuse for their quixotically changing residences.

Yet the family thrived on exile, finding it much less gloomy than Dr. Sargent, in his stoical disappointment, tended to describe it in his letters. They didn't live in "a household that quivered on the brink of doom," as one biographer would later describe it. Thanks to Mary, the family pursued pleasure, day after day, quite robustly—even if it was hard to tell if they were patients seeing the sights or just health-obsessed tourists. Here in Rome the Sargents behaved like sightseers, vigorously visiting churches, museums, and ruins, the children digging at bits of half-buried antique porphyry and cipollino with the tips of their umbrellas.

The young Sargents, especially thirteen-year-old John and twelve-year-old Emily, prided themselves on being veteran travelers. They'd spent time

in dozens of European towns and cities. But their current intimacy with the broken immensity of Rome, conducted day after day for a whole winter—for many winters, actually—struck them as more like home than tourism.

John and Emily knew their rooms at 17 Trinità dei Monti from other stays. "Rome seems quite like home to us after having passed so many winters in it," as their father remarked. What's more, Mary didn't hold with the tourist fashion of ordering her family's dinners from cookshops, delivered in metal boxes balanced on top of a porter's head. She "kept a white-capped *chef*," as Vernon Lee would remember, "and gave dinner-parties with ices." Even so, her dinners weren't large, for the family's income wasn't. Giving this party was a bold maneuver, an extravagance. Mary did so from deeper motivations, otherwise contained in her paint box and her children's nursery.

Mary knew she wouldn't have been able to throw such a party in Philadelphia. Her former home city claimed the oldest art academy in America, the Pennsylvania Academy of Fine Arts, founded in 1805 by the self-made patriot-naturalist-painter Charles Wilson Peale. By 1869, years after Mary had left it, Philadelphia had discovered an enthusiasm for art that would eventually yield such distinctive American painters as Cecilia Beaux and Thomas Eakins.

Still, Mary believed that Rome as a haunt for artists threw Philadelphia into the shade. To her romantic sensibility, stimulated by ruins and gardens and decayed grandeur, this imperial and papal city hinted at a higher form of art, built on both classical and Renaissance, pagan and Christian foundations. Especially from her family's high belvedere of Trinità dei Monti, the city beguiled her and her children with long smoky views over an ancient city of red roofs and as-yet-unexcavated ruins.

Mary had also learned, more practically, that Rome hosted a vibrant international artistic community that was centered, as her family themselves now were, on the Spanish Steps. At the top of the Pincian Hill, guarded by the stone lions of the Medici family, stood the tall, white, two-towered palace that the Sargents knew well. Since 1803 the Villa Medici had housed the French Academy, originally founded by Louis XIV in 1666, an engine of archaeological and artistic study for French painters and sculptors lucky enough to win the prestigious *Prix de Rome*.

Hardly prize-winning types, Mrs. Sargent's children and their playmates had been caught in the Medici gardens burning holes in laurel leaves with a magnifying glass, and ejected by a French porter who called them "*enfants mal élevés*," badly brought up children.

At the bottom of the hill ran the Via Margutta, an artist's warren of artists' garrets, studios, and ateliers that Mary and her children had also rather clandestinely explored. There and elsewhere Mary and her children had encountered artists, American, English, German, French, Danish—expatriates from rich northern countries like the Sargents themselves—during their daily circulation in Rome.

Linking the great oval fountain of the Piazza di Spagna below with the blanched classical façade of Santa Trinità dei Monti above, the Spanish Steps mounted the steep, almost cliff-like slope in sweeping, operatic flights. The Sargents knew these stairs and terraces well and saw that they provided the perfect balustraded stage for sun-browned locals offering themselves for hire to artists. The candidates wore picturesque peasant attire: sheep-fleece vests and bound leggings for men, headdresses and embroidered aprons for the women. Some of them even looked promisingly corporeal beneath their costumes, in case they were needed to serve as inspirations for Hercules, Venus, or Eve.

✈

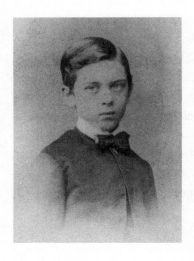

Sargent as a boy of eight, 1864

Mrs. Sargent's slim thirteen-year-old son, mounting these steps among the burly, busty, and costumed, had been pronounced a "skippery boy" by dour English observers. Others saw simply "a slender American-looking lad." Those who knew him better, such as his playmate Vernon Lee—then still known by her birth name of Violet Paget—understood him much better. To her, John was "grave and docile," a solemn, shy, blue-eyed lad. His brown hair was parted severely on one side, and he dressed in a "pepper-and-salt Eton jacket."

In his "quiet, grave way," as Lee remembered, John Sargent was intensely interested in Rome. His prominent pale-blue eyes seemed to absorb everything he saw. He'd also soaked in histories, encyclopedias of antiquities, and guidebooks (*Murray's*, published since 1836, was perennially popular). He'd

especially liked a scholarly if melodramatic account of imperial Roman life by Wilhelm Adolf Becker called *Gallus* (1848). John loved reading, and he adored the very air of Rome.

In metabolizing that heady, sometimes disturbing atmosphere, he'd acquired a "remarkably quick and correct eye," according to his mother. He had a gift for translating the rich chaos into orderly, accurate images. He was already an experienced plein air sketcher who had reason to pay attention to these loitering applicants on the Spanish Steps. As he sized them up, he was already testing out what would become a long and complicated relation with artists' models. Whatever his "boyish priggishness" made of this spectacle, he found in this farmers' market of picturesque types his first hints of the enticing interactions of the art world, in which privileged foreign artists like his mother's friends found uses for a whole demimonde of lower-class Italian models. They were there, on the Spanish Steps, waiting for him.

For Mary's artist acquaintances, paradoxically, such desperate or enterprising people often supplied the physical patterns for heroes, nobles, gods, and angels. Historical and mythological figures were in vogue. In the 1860s Rome was especially known in the United States for its tribe of American sculptors—on those rare occasions, that is, when these obscure expatriate Italophiles made any impression at all on the busy Republic.

Yet these sculptors had recently received a popular boost from Nathaniel Hawthorne's romance *The Marble Faun* (1860), a handsome volume that Mary Sargent had enthusiastically shared with her children. In this novel, sculptors, painters, and models threw themselves into tangled romantic complications, full of the nobility of their vocations and the mystical allure of their snowy marble works. The otherworldly glow of Hawthorn's tribute to the Roman art world, in fact, had enraptured Mrs. Sargent with a vision of the passionate, exalted beings who inhabited it.

*Mary's distinguished guests certainly looked the part. They arrived with swag-*ger, anecdotes, and properly accented Italian. Yet they also betrayed some more hidden and illicit aspects of the Rome art world that had fascinated Hawthorne against his will. The guest-sculptors were a colorful and somewhat disreputable lot. What's more, they gave young John his first model for what artists were and did. They strutted in with versions of liberty, license, and sophistication that granted the boy his first real glimpse of a heady and sexually transgressive world of art.

William Wetmore Story, with his goatee, pince-nez, high forehead, and Salem, Massachusetts, drawl, arrived at the Sargent's house from his apartments in the storied Palazzo Barberini, now the epicenter of the American art community. In 1868 Story had finished carving his monumental, bare-breasted *Libyan Sibyl*. But he was better known for a regal and sumptuous *Cleopatra* (exhibiting one naked breast), which had dazzled the crowds at the London Universal Exposition of 1863. From their collective reading of Hawthorne's novel, the Sargents knew the fictional version of the Egyptian queen that had featured in the book as "fierce, voluptuous, passionate, tender, wicked, terrible, and full of poisonous and rapturous enchantment."

Another neoclassical sculptor, Randolph Rogers, who in his studio wore a bohemian dressing gown and beret, showed visitors "every stage of wet-sheeted clay, pock-marked plaster, half-hewn or thoroughly sand-papered marble." He'd also famously rendered female breasts, notably in his *Nydia, the Blind Flower Girl of Pompeii* (1853–54), striking gold in the process. Melodramatic storytelling and tasteful seminudity went down well with Victorian audiences and collectors, and it was a recipe that young John would soon find particularly intoxicating.

Like her male colleagues, Harriet Hosmer had also recently sculpted a celebrated female classical figure: Zenobia, rebel queen of Palmyra (1857–59). Even more recently, though, Hosmer had sculpted her own marble fauns—the faun featuring as the mystical centerpiece of Hawthorne's tale—which manifested an icy fluidity and a somewhat gender-neutral sensuality. Her work also revealed the degree to which seemingly sober Victorian classical statuary, sanctioned by art, channeled complicated sexual energies, in what one recent critic has called the "erotics of purity." That paradox animated everyone at Mrs. Sargent's party, including the adolescents waiting for dinner leftovers. It certainly gripped John.

Mary took especial notice of Hattie Hosmer, her most risqué guest. Diminutive, vigorous, obsessed with outdoor exercise, Miss Hosmer dressed rather like a man. The irrepressible sculptor sported short, curly, sharply parted hair and wore a cravat and jacket that might have unnerved Mary's Philadelphia, where few people had witnessed the iconoclastic cross-dressing of figures like the radical French novelist George Sand. But Hosmer was well-known and at least partly understood in Rome. She'd taken refuge here in 1852, and openly consorted with a young widow, Louisa, Lady Ashburton, who would become her long-term companion.

Inviting the disreputable Hosmer counted as a bold maneuver for Mary

and revealed much about her cosmopolitan outlook. Perhaps she shared the opinion of Elizabeth Barrett Browning, who regarded the sculptor as a woman who "emancipate[d] the eccentric life of a perfectly 'emancipated female' from all shadow of blame by the purity of hers." Hosmer's "purity," however, hinged on how people understood her role as a self-professed "faithful worshipper of Celibacy." Even so, Mary had made a bold move. And it wasn't, by any stretch of the imagination, her first.

-+-

Mary Sargent had arrived at her party atop the Pincian Hill by an intrepid and, some thought, a rather devious route. In the 1850s in Philadelphia, she'd often dreamed of Rome, whose glories she'd first tasted as a schoolgirl. Even as a young married woman, she'd continued to ply at her sketchbooks. With Fitzwilliam, to be sure, she commanded a comfortable home—she was after all a doctor's wife as well as the mother of one small daughter.

But it was the greater sprawl of Philadelphia—that vast brick labyrinth, thickly populated with almost half a million natives and immigrants, startlingly polluted, and torrid in the summer—that would in fact furnish Mary with an opportunity, although it would come through a devastating personal tragedy. The Sargents' infant daughter Mary contracted an illness that even her doctor father couldn't accurately identify, much less cure. In July 1853, just two months after her second birthday, the little girl died.

Mary and Fitzwilliam understood that childhood mortality was widespread in their America. It would improve only slowly in coming decades with hard-won, incremental scientific advances in immunology and childhood medicine. But during the Sargents' young marriage at midcentury, modes of coping with death were changing before their eyes. In the harsher world of previous generations, stoical religion had helped parents accept such devastating losses—a perspective embodied in the grim Protestant culture of New England towns like Fitzwilliam's hometown of Gloucester, where the thin slate headstones of seventeenth- and early eighteenth-century baldly stated birth and death dates and bore images of winged skulls. (In Mary's Philadelphia, the dominant Quaker denomination favored minimalist grave markers or none at all, reflecting the Quaker belief that the dead, like the living, were all equal in God's eyes.) Yet, paralleling the changing and softening atmosphere of American families, austere traditional burial customs were now transforming, for the Sargents, into something gentler and more melancholy. Nondenominational rural cemeteries, inspired by

more sentimental and romantic visions of death, had begun to emerge in both Fitzwilliam's native Massachusetts (Mount Auburn Cemetery, Cambridge, 1831) and in Mary's Philadelphia (Laurel Hill, 1836). Fitzwilliam gently mourned the "void left in our family circles" by a child's death.

In spite of more allowed sentiments, both parents were devastated by the loss of their child. Mary, however, chose another Victorian method of coping with her bereavement. To people today, a trip to Europe seems a peculiar way of recovering from a family tragedy, even if we acknowledge the therapeutic value of a change of scene. But Mary's doctors—steeped in preepidemiological nineteenth-century medicine—understood disease as intimately related to climatic factors, to cold and heat and especially different kinds of "air." They also classed as physical, as diseases of the "nerves," much that we would consider psychological.

Mary knew that, in genteel Philadelphia—as in Boston, New York, and the rest of the polite world—traveling for health, to different climates, usually also to consult European doctors and try different spas and sanatoria, provided one of the few unquestionable justifications of foreign travel, especially for women. Julia Ward Howe, a Bostonian writer and reformer who like the Sargents haunted Rome in the 1860s, acknowledged "health" as a primary and irrefutable justification for travel, and one that "admit[ted] no argument": "The sick have a right . . . to go where they can be bettered; a duty, perhaps, to go where their waning years and wasting activities admits of multiplication." And though Mary wasn't exactly waning and certainly still young—just twenty-seven in 1854 when she lost her daughter—her bereavement genuinely damaged her health and spirits. For a cure, the logic of the time strongly endorsed European travel.

Whether or not Fitzwilliam medically concurred, the Sargents threw all their resources into the project. On September 13, 1854, Mary, her mother, and her husband boarded the upholstered American luxury steamer *Arctic* in Manhattan. It was a momentous departure, at the busy, coal-smelling docks on the Hudson River. Though she couldn't have known it as she crossed the gangplank, Mary wouldn't return to the United States for more than two decades.

Mary's cure-tour began in the acknowledged center of expertise, Paris. Here, her irrepressible energy saved her from the claustral, self-limiting role embraced by many female "invalids" of her time, even if that same determination stirred up other complications for herself and her family. Mary remained brisk and energetic. She called her husband "Fitz." Dr. Sargent

didn't tend to echo her playful form of address: he signed his rather solemn letters home with "FWS" or "FW Sargent." Mary herself seldom wrote letters, partly because the most important person in her own family, her mother, already traveled with the family and slept in the next room. When she did manage letters, though, they gushed with warmth and teemed with rapturous, underscored words. "Altho' my words are not skillfully chosen," Mary later apologized, "[I] express all the love and sympathy I feel."

Continental travel perfectly suited Mary by combining health considerations with novel and pleasant settings such as Pau, Biarritz, and Nice. In an era when doctors doubled as travel agents, Mary's purported illness threw all of Europe at her feet.

Yet Mary wanted much more than a cure. With her indefatigable love of culture, by October or November of 1855, she shepherded Fitz to Florence. There they took up residence at the Casa Arretini, a tall house on the Lungarno degli Acciaiuoli, on the right bank of the green-brown river, a short distance from the triple-arched, shop-burdened Ponte Vecchio.

Such a rental planted Mary and her family in the center of tourist Florence. In the 1850s the famed Renaissance city-state was already a magnet for English, German, and American visitors, and they came in droves. The Sargents' lodgings, though, granted Mary personal and privileged access to a resplendent red-and-gold city whose Renaissance art associations and traditions, filtered through nineteenth-century sensibilities, increasingly defined Anglo-American taste and cachet. Mary could now freely indulge her half-illicit fascinations. These included art, history, music, architecture, and other refined tastes that her more pragmatic and skeptical husband almost entirely lacked. Fitzwilliam would later boast that, though he'd gone a few times to the opera during his decades-long foreign residence, he'd "never been to a Theatre in Europe." Mary, though, carried a whole theater in herself. And she presided over a family who would increasingly become her own troupe of traveling players.

Florence was the storied, imaginative, touristic setting in which, on January 12, 1856, Mary gave birth to the Sargents' first son, John Singer. The baby's live-in grandmother, in the spirit of her daughter's artistic exile, nicknamed him "Fra Giovanni." Indeed, quickly handed to an Italian wet nurse and otherwise surrounded by the noisy, teeming world of Florence, the child would soon be as fluent in Italian as in English. He'd also grow up in the thick of historical associations and inside coteries of writers, artists, and travelers that Mary had already begun to cultivate. The little boy, with

his slightly prominent blue eyes, immediately faced an intriguing and colorful world, and with what seemed to be a startlingly long attention span.

◄+

The Sargents' seasonal passages between the Alps and the Mediterranean owed less to touristic than to sanitary motives, at least in Fitz's view. If he'd ceased to practice medicine, he still kept abreast of theory and devoted his knowledge to family health.

The Sargents' second daughter, Emily, was born during this first long winter residence in Rome, in January 1857, almost exactly a year after her brother had come into the world, and in what the Sargents considered the healthiest possible circumstances. Rome suffered from miasmas (and malaria) in the summer, but in winter its air grew clear as crystal. Everyone said so, all the top-hatted or bonneted American half acquaintances the Sargents met in the Corso or in the Piazza di Spagna. Still, Mary found she had her hands full, even with the usual Italian wet nurses and her long-suffering mother to help out. Fitzwilliam, too, had plenty to cope with. Now, reluctantly, he finally submitted his resignation to the Wills Hospital, acknowledging with a stiff acquiescent shrug that he and his expanding family weren't going to return to Philadelphia anytime soon.

Even with two young children, Mary wasn't daunted even if she wasn't quite cured. She still read guidebooks while rocking her infants to sleep. Mary's mother, however, was now ailing, and in spite of a convalescence with the family on the shore of the blue, volcanic crater lake of Nemi, she died in Rome in November 1859. Her daughter was devastated: the two women had long been close companions. At the same time, the elder Mary's death also granted her daughter a new lease on life, or at least on European travel.

In fastening onto the Continent, its spas, grand hotels, and art museums, Mary counted on her inheritance. She'd long been in possession of a $10,000 bequest from her indulgent, long-deceased father, once a successful tanner and hide merchant in Philadelphia. After her mother's death, property and investments worth $45,000 also came under Mary's control. By this time the family's foreign residence, four years long, had become their unquestioned status quo. Though never exactly wealthy, the family enjoyed an independent income—or rather Mary did. Though Fitzwilliam derived only a rather bittersweet and dutiful pleasure from travel, Mary thrived on the freedoms of an expatriate.

Legally in the 1850s, of course, Mary's family money entirely belonged to her husband, not to her. But Dr. Sargent was too polite and acquiescent to insist. And so Mary's capital helped her remain unusually independent during a time when many of her women compatriots were starved for options. Women's choices remained few even inside their designated "separate sphere" of domestic life, let alone in the wider men's world that lay outside and beyond it. "Separate spheres," that Victorian principle of segregation, enforced a harsh apartheid. So, for a middle-class wife like Mary, travel meant a kind of liberty that was otherwise all too hard to find in a welter of childbearing and nurseries. Mary adored her children, but she also loved her freedom. That's what Mary meant when she said, as kindred spirit Vernon Lee remembered, that "the happiest moment in life was in a hotel 'bus."

Mary's inheritance proved just enough to sustain the Sargents' ever-expanding genteel migrations. The family shifted between hotels and rented lodgings. They moved among the spas, watering places, and tourist towns in France, Germany, Switzerland, Italy, and Austria. They traveled in search of health or at least to avoid disease. In a series of temporary measures that soon evolved into a lifestyle, the family wintered in Mediterranean climates to avoid bronchitis and rheumatism, then summered in the mountains, usually in Switzerland with its famously healthy "air," to escape malaria and cholera. Though even Mary wasn't indestructible, Fitzwilliam often wearied of "this nomadic sort of life," of having repeatedly to "pack up our duds and be off to some mild region" in which they hoped their illness-prone family could thrive.

Such moves, even when based on the erroneous Victorian "miasma" theory, were no more than prudent. Cholera was virulently pandemic in Europe between 1852 and 1860. But this disease, untreatable in the 1850s and much feared, wasn't the only danger to children. "Children are a source of great and constant care and anxiety," as Dr. Sargent gloomily phrased the matter. In 1860, with the family once again settled in Rome, four-year-old Emily suffered a back injury: her nurse had dropped her, family tradition later hinted. Afraid for their daughter's life, the parents confined her to bed all day. Mary and Fitz even strapped her down to prevent her moving, contriving a special sprung platform to cushion the jolts of travel in carriages. Here as in many other cases the Sargents' trust in Victorian medicine actually aggravated the problem. As a result, Emily would be hunched and half-lame for the rest of her life.

Another daughter, Mary Winthrop Sargent, born at Nice in 1861, faced an even worse outcome, contracting a wasting lung disease when still under four, with her nine-year-old brother John looking helplessly on. "Poor little Minnie is getting thinner every day. She does not care for anything anymore," John wrote his Cuban American friend Ben del Castillo. "Emily and I bought her some beautiful Easter eggs but she would not look at them. She never talks nor smiles now." Minnie died in April 1865 at Pau, a couple of months after her fourth birthday. It was another great blow to the beleaguered parents, who had, after all, done everything in their power, as the nineteenth century understood it, to keep their children safe.

On the occasion of Mrs. Sargent's party in Rome during the winter of 1868–69, the Sargent children in the care of the Italian nurse numbered three: ablebodied John, long-suffering Emily, and their baby boy, just over a year old, Fitzwilliam Winthrop, about whom his parents were increasingly worried. At this infant's birth, Dr. Sargent had written home, with a twist of dark humor, that "the sooner he goes to heaven the better." That remark helped him cope with his own deep anxieties. But the summer after Mrs. Sargent's Roman party, though the family had prophylactically moved to Bad Kissingen in Bavaria, this child would also die from an unidentified childhood illness. "When I first began to practice medicine," Dr. Sargent lamented that same year, "I had a much more hopeful idea of its powers than I have now."

The Sargents' European expatriation has sometimes been portrayed as frivolous, with Mary's desire for travel especially represented as quixotic and self-indulgent. But did the Sargents really suffer from what one biographer has called a "sham domestic life"? On the contrary, their lives hinged on an embroiled if unusually mobile domesticity. Both Fitz and Mary Sargent loved babies, *their* babies. And Europe with its relative medical sophistication counted as a responsible choice as the era understood it, even without the many other advantages that Mary found there.

Altogether in Europe Mary delivered five children, three of whom survived into adulthood. The last of them, another daughter, Violet, fourteen years younger than John, was finally born in Florence in February 1870. Violet, at least, could at this stage of medical development be vaccinated, which enabled her to be healthy, to "smile and 'coo,'" as her father observed.

Mary could well have lost children in the United States. She'd already

done so, in fact. But she was determined to combine motherhood with a cultivated, pleasurable life abroad. And her choices, whether selfish or courageous, carried profound implications for her son.

In the course of the evening, the sculptors received unexpected entertainment from their cheerful and animated hostess. She brought out a leather-bound album. She opened it to sketches, in watercolor, in pencil, of various Roman monuments, scenes, and statues. In so doing, the "dear, eloquent, rubicund, exuberant, Mrs. Sargent," as Vernon Lee called her, made a point of showing off the sketches of her teenage son, John. She also introduced the cautious lad to these invited worthies.

These proceedings, though, as Vernon Lee remembered, were "not without wistful glances." These looks might have been directed at the famous sculptors, who abruptly understood the price of their fruit ices, and who may or may not have encouraged the mother's hopes.

But Mary Sargent mostly aimed such glances at her husband. Dr. Sargent's own gaze was "averted," as Lee remembered it, or else accompanied by "some curt glance or word expressing his estimation of the small boy's futile talent." Fitzwilliam Sargent disapproved of "the doubtful world of marble fauns."

2

The Fig Leaf

Fitz, though quiet—though introspective and rather religious, unlike his more impulsive and secular wife—remained a force to be reckoned with. Yet in Rome and elsewhere on the family peregrinations, Fitzwilliam Sargent discovered that his young son was already resisting his worldview. The small boy had managed that through a devious, stealthy, yet seemingly innocent means. He asserted himself, that is, through his spirited drawings.

Young John's first sketches had arrived in Gloucester, Massachusetts, by transatlantic steamer mail. Fitz spelled his son's name "Johnny"; his wife spelled it "Johnnie." Between 1860 and 1865, both of them dispatched drawings to the grandparents that John had never met, Winthrop Sargent IV and Emily Haskell Sargent. Four of Sargent's earliest efforts are currently on display in a quiet upstairs room at the Sargent House Museum in Gloucester, Massachusetts—a house historically associated with Fitzwilliam Sargent's rooted and ramifying New England merchant family, prosperous in the China trade until shipping disasters during Fitzwilliam's childhood bankrupted the family.

The Sargents had built their fortune on international adventure, as their descendant John Singer Sargent himself would later do in quite a different way. But they had always wanted more than simply to make money. Fitzwilliam's great-aunt Judith Sargent Murray, who also inhabited this erect, small, porticoed house on a rise overlooking Gloucester Harbor, was a precocious early feminist writer who courageously published a pamphlet entitled "On the Equality of the Sexes" in 1790, two years before the British writer Mary Wollstonecraft came out with her *A Vindication of the Rights of Woman*.

Talent, drive, and iconoclasm ran in the Sargent family. Fitzwilliam made his own career, overcoming the grim circumstances of the family's

bankruptcy. Stripped of fortune, he'd won admission to the University of Pennsylvania and made himself a doctor, a profession hitherto unknown among the Sargents. Having struggled and succeeded, he was in a position to chafe at his present idleness and worry about his son's irregular education— homeschooling, rashes of tutoring, or temporary academies in the midst of what seemed to him a carnival of European travel. The boy was, his father had remarked, resistant to simple division ("it tries his little soul wonderfully") and generally unacademic ("tolerably advanced in ignorance"). As John loved sailing ships, his father took him to see American frigates in Riviera harbors and perhaps contemplated turning him into a naval officer.

Yet the boy was seemingly more whimsical than the United States Navy might require, and less acquiescent to his father's desires. He did sketch ships enthusiastically, but he harbored more fanciful interests, too. One of John's drawings to his grandparents portrayed zoological-garden monkeys, another rose vines—observantly, carefully, and handsomely articulated. But two of the sketches, depicting the boy's father, stand out as even more telling and perhaps provocative. They are the future portraitist's earliest known portraits.

John Singer Sargent's first surviving portrait, made at Nice in December 1860, when he was almost five years old, shows a scrawled figure in profile writing at a blocky desk. The figure, leaning forward from a rather curvy armchair, has bulk and height as if seen from below, a scribble of hair, and a vivid frowning mouth bristling with teeth like a shark's. The little boy's portrayal struck his forty-year-old father as an "impertinence"—rendered without permission while the contemplative, angular, mustached New Englander was sitting writing a letter home. Even so, Fitzwilliam enclosed it in his letter. He didn't entirely lack a sense of humor, for the drawing was indeed impertinent.

Here was one of the first of the boy's many renderings from odd perspectives—in this case the floor at his father's feet, on ceramic tiles that embodied the faded resort luxuries of Nice. It was the first of a string of difficult, intimate portrayals done from a point of view few others could share. In the mild, bright Mediterranean winter, the Sargent family's hired rooms in Nice—a favorite and perennial winter refuge for them—smelled of the camphor and peppercorns that kept clothes in steamer trunks fresh and safe from moths. But their rented Riviera villa, the Maison Virello, also provided azure views fringed with potted palms and winter-blooming shrubs, pepper trees with dry indigo blossoms that for Vernon Lee encap-

sulated the genteel aridity of Nice. Such was Sargent's first portrait studio: middle-class lodgings; the compelling but tricky Sargent family milieu, centered on his particularly tricky father.

The second drawing, which dates from five years later, again depicts a ponderous, daunting paternal figure. In it, a neatly shaded cartoon of a large male figure with drooping hair bends over a small boy, holding the child's head in some sort of medical grip. An empty chair stands by, an interested dog, and the boy's little round, black hat dangles at his side as the examination—for that's what it seems to be—proceeds. The little boy isn't obviously the nine-year-old John; in the drawing, he's just a character.

But the manipulated boy is the central figure of this cartoon—so clearly a "cartoon" in the modern sense of the word, as pioneered by the British humor magazine *Punch*, then at the height of its early popularity, when it proliferated not only in England but also on expatriate reading tables all over the Mediterranean. ("There were illustrated books and papers lying about," as Vernon Lee observed of the Sargent household.) *Punch* lampooned, among other things, the vanities, pomposities, and foibles of Victorian domestic life. The doctor-father in the drawing, in a similar style, comes off as a lumbering, somewhat threatening figure, capable of taking little boys to task—a figure at once comic, pathetic, and interfering. But something like resentment may also underlie this drawing. In his adult life Sargent couldn't abide doctors and rarely consulted one.

Both of these childhood portrayals of Fitzwilliam Sargent are livelier and more complex than the young John Sargent's flat, seemingly straightforward mentions of his father in his childhood letters. John wrote most of these to Ben del Castillo, a friend with whom he also played in the fragrant meridional gardens of Nice. In rendering Dr. Sargent as solemn and even intimidating, Sargent's childhood drawings endorse the recollections of Vernon Lee. She remembered Fitzwilliam Sargent as "delicate, taciturn, austere," a "puritan, reserved, and rather sternly dissatisfied" figure. Such a personality also emerges from his rather plodding, literal, stoically resigned letters. These early drawings also show a bent for caricature that would subtly, furtively manifest itself in Sargent's future portraits, giving many of them an intangible edge of irony and social critique.

<div align="center">⤛⤜</div>

John's mother adopted a radically different attitude toward his artwork. At Christmas 1868, at the top of the Spanish Steps in Rome, John's sister Emily

gave him a small black sketchbook. She inscribed it to him, to "John S. Sargent," in her neat, laborious handwriting, "from his affectionate sister Emily." Yet, though the gift came from John's playmate and confidante, the gift revealed Mary's fine Italian hand. She'd thoroughly underwritten this gift.

"Johnnie is growing to be such a nice boy," Mary had written his Sargent grandmother, "and is growing old enough to enjoy and appreciate the beauties of nature and art, which are so lavishly on display in these old lands. He sketches quite nicely," she added, "and has a remarkably quick and correct eye. If we could afford to give him really good lessons, he would soon be quite a little artist. Thus far he has never had any instruction, but artists say that his touch is remarkable." She'd extorted that much, at least, from her Roman artist friends.

In October of 1868, when the family alighted in Florence, Mary had arranged for her twelve-year-old son to spend his free afternoons in the Bargello with his sketchbook, copying sculptures. (The museum cost one franc but was free on Sundays, and the expedition was about as near to education as John got, with haphazard, occasional tutors augmenting his parents' homeschooling.) The Bargello, a dizzyingly tall, thick-walled, fortresslike institution, formerly a prison, had just been rehabilitated, in 1865, as a national museum whose collection was "still in course of formation," according to Baedeker. The nascent museum offered "several admirable works, such as Renaissance bronzes formerly in the Uffizi." Especially Donatello's bronze *David* impressed John. That lithe masterwork from the 1440s, freshly given pride of place in the Bargello, would haunt his imagination and influence his future studio production.

Such an on-site education wasn't everyone's idea of school, but it was Mary's. Fitz worried more about the rest of his son's education—occasionally even planting him in a private school—noting, during one brief enrollment in 1870, that his teenage son was reading Horace and "working his way through Geometry, and Algebra." But art-focused Mary exercised an immense influence on her son, and not just because she introduced him to the fascinating "world of marble fauns," a world in which art counted as the whole purpose of life. But so far she's been given little credit for her impact on John Singer Sargent's artistic taste, method, or point of view.

Like other genteel American women, Mary had been brought up to be a custodian of refined culture. In her young womanhood in Philadelphia, she'd shown unusual motivation and application in learning to draw, paint, and play the piano. Mary's well-to-do Newbold ancestors had art in their

veins (owned paintings), and Mary took art more seriously than women were then permitted to do. Women's "accomplishments," cultivated through private tutors or in the new and flourishing "female academies" of the 1840s, aimed at domesticity, piety, morality, and the marriage market. Activities like painting, drawing, needlework, music, and modern languages such as French and Italian contributed to the so-called "Cult of True Womanhood." Yet it was Mary's childhood exposure to Italy that had left her with some higher aspirations: "As a girl [Mary] had travelled in Italy," Sargent's later biographer Evan Charteris would notice. "The magic of the country never ceased to exercise its spell."

Did Mary herself ever consider training as a painter? She came of age in one of the few nineteenth-century cities that at all countenanced professional women artists. Unusually progressive for its time, the Pennsylvania Academy of Fine Arts allowed aspiring women to sketch in the sculpture gallery as early as 1844 (when Mary was twenty-two—she may well have sketched there herself), taking the controversial step of allowing women to sit in on classes in anatomy and drawing from antique casts by 1860. Between 1868 and 1874, the Academy admitted women into life classes, where they drew and painted nearly nude models of both sexes. All of these moves were radical and highly controversial. The nineteenth century considered women's exposure to naked bodies dangerous; middle-class young women were molded to remain innocent and virtuous, as ignorant as possible of sex.

Accordingly, for most of the Victorian era, a professional woman artist was a potentially "disruptive sexual figure": "Of all the arts in the nineteenth century," one recent art historian has written, "only acting had such transgressive connotations for women as did painting and sculpting." Harriet Hosmer provided one living example of such a transgressive persona, no matter how her "purity" had struck Elizabeth Barrett Browning.

Mary lacked the instincts to become an overt iconoclast of Hosmer's type. But she'd traveled to Europe not only to escape domestic restrictions, as Hosmer had done, but also to accumulate artistic experiences for herself and her children. And her intensity, not to mention her perennial relentlessness, would have sweeping, life-shaping consequences.

—+—

For his first images in color, John borrowed his mother's paint box, and she seems very freely to have loaned it. Whether at Rome, Sorrento, Naples, Venice, Florence, Lake Como, Lake Maggiore, Pontresina, Lucerne, St. Moritz,

Zermatt, Mürren, Innsbruck, Munich, Leipzig, Carlsbad, Berlin, Paris, Pau, Biarritz, Nice, Madrid, Valencia, Cordoba, Seville, or Cádiz—the list is dizzying—there was hardly a landscape, monument, or curiosity that Mary Sargent didn't enthusiastically sketch or paint. A shutterbug without a camera, she was eager to capture all the delightful landscapes and curiosities around them. And she hauled her children with her as soon as they were old enough to hold a pencil or brush.

A vigorous if not methodical worker, Mary lived by one overarching rule. At least one sketch must be finished during every outing, no matter how it turned out. Vernon Lee remembered Mary as "painting, painting away, always an open paint-box in front of her, through the whole forty years I knew her, her whole jocund personality splashed, as it were, with the indigo of seas and the carmine of sunsets." Mary's drive and enthusiasm transformed the family travels into a gigantic free-form, plein air art school.

Over the course of her life, Mary herself must have filled many sketchbooks. But only two of her albums, now in the collections of New York's Metropolitan Museum, have survived. These drawings and paintings date from a trip she took in old age (intrepid in itself) to Greece and the Middle East in 1904. In the appraisal of at least one art historian, these works indicate that Mary had very little artistic talent: "The crude drawing style, incorrect perspective, and inept use of watercolor technique evident in these sketchbooks reveal her to have been a rank amateur."

Sargent's two sisters, who'd obviously seen a good deal of their mother's painting (Emily herself would become an amateur watercolorist of her mother's stamp), told Vernon Lee that John had inherited his raw talent not from Mary but from his father and the Sargent side of the family. One Sargent biographer also noted that Fitzwilliam had included carefully drafted drawings in his textbook on wound-dressing. He produced designs whose technique, "models of precision and clarity," parallel his son's careful execution and attention to detail. At the very least, Sargent inherited from his father what Lee described as a "deep-seated character" and "strength" that "smelted and tempered [his] talent into genius."

In one art historian's opinion, Sargent's artistic skill as an adolescent already "far exceeded his mother's meager accomplishments." Even if this is true, though, it doesn't follow that Mary "could not have served long as his teacher." Her influence would prove crucial and lasting. Even if she was a haphazard, amateur artist, she was an instinctive, innovative, and indefatigable traveler in her pursuit of European art. As a mentor of art educa-

tion and travel, Mary made an even more vital impact. Mary supplied her son with museums, galleries, ateliers, ruins, historical sites, and picturesque landscapes all over Europe. And it was from such excursions that John was already forging his passion for art.

<div align="center">—◄—</div>

Almost every day in Rome, as she'd done elsewhere in their travels, Mary assembled touring parties. These consisted of her husband (though Fitz was optional), her two oldest children, and sometimes young Violet Paget, who loved these excursions and the warm, stimulating woman who sponsored them. Paget—along with Ben del Castillo, almost the only friend John had outside of his family—contracted a lifelong adoration for the woman she described as "the enchanting, indomitable, incomparable Mrs. S."

Violet Paget remembered "months of strealing [*sic*] after [Mary Sargent] in and out of churches, palaces, and ruins, in company with Emily and John." Mary was a born cicerone and hatcher of excursions. She also excelled in colorfully retelling such adventures in her little house on Trinità dei Monti, where the children listened intently while polishing marble fragments and painting lampshades. She entranced Violet with stories of outings on which the girl hadn't been able to go: "I heard of rides in the Campagna, where you met brigands . . . I heard of excursions—my family never made excursions—to Albano and Frascati, and Horace's Sabine Farm—enchanting name!" For Paget, Mary distilled a romantic traveler's sensibility that transfigured the entire landscape around them. Mary made every possible destination pregnant with possibilities: "And beyond this Rome . . . appeared dim outlines of other parts of the world, with magic Alhambras and Temples of Paestum and Alpine forests; a Europe occupying other dimensions than that network of railways blobbed with hotels and custom-houses."

Such imaginative "other dimensions" of travel spurred John's earliest artistic training. Inspiration came at him from all sides, as daily experience and not an exceptional one. For Mary as for her son in subsequent years, travel offered many paths to personal meaning. It qualified, itself, as an art form.

With her enraptured visions of European museums, landscapes, and historical sites, Mary found that tourism offered many perks. After all, she and her family could organize the otherwise bewildering complexity of European cities—not to mention their own existence there—into sightseeing excursions and sketching projects. Such a method of tackling a cha-

otic, kaleidoscopic Europe likewise seduced her son. He sketched day in
and day out, as if his life depended on it. And it did. As Mary had earlier
appraised this development, he was "growing to appreciate the beauties of
nature and art which are so lavishly displayed in these old lands." With his
"quick and correct eye," Mary thought he showed promise though he had
"never had any instruction." Yet the "lavishly displayed" art of Italy, avail-
able through *Murray's* or *Baedeker's*, was proving a profound art school.

To be sure, Mary channeled an "insatiable love of travel." But was she
an artist of travel, or just a tourist? Women at the time were considered
lesser, more shallow observers. But in her *The Sentimental Traveller: Notes
on Places* (1908), Lee embraced Mary as a tourist—or rather as an improved
hybrid of tourist and traveler. Here Mary stood out as a passionate but
canny figure with the dynamism of a Madame de Staël—Germaine de Staël,
the Swiss woman of letters, political critic, and romantic traveler. For Lee,
Mary belonged to "a generation of the wondrous priestesses of the Genius
Loci" (Spirit of Place) who personified "the sacred fury of travel." Mary
even qualified as the "the high priestess of them all," "the most favoured
and inspired votary of the Spirit of Localities," and the "most genially im-
perious, this most wittily courteous, this most wisely fantastic of Wandering
Ladies."

Here Lee hardly made modest claims. Mary was her favorite steppar-
ent, the emotionally appealing mother she'd never had. But Lee was dead
accurate about the delights of travel for Mary and for many English and
American women of her generation. Though women had always traveled
more than the Victorian stay-at-home ideal suggested, Mary and others
boarded steamships and trains in defiance of the limitations of homes and
neighborhoods in their home countries, striking out with contagious delight
into the larger world. As one historian has described the phenomenon, "Mis-
sionaries and novelists, archaeologists and journalists, nurses and teachers,
reformers and society matrons, musicians and artists, wives, widows, and
single women, the curious, the young, and the old—all streamed into the
British Isles and Europe and fanned out around the globe."

An active and eager tourist even as an "invalid," Mary pushed her way
onto the gangplanks and into railway queues. She boldly chose travel even if
she wasn't an overt feminist, iconoclast, or bohemian. Touring Europe, as a
life vocation, was just respectable enough to channel such longings without
transforming Mary into an outright rebel or an outcast. Mary mastered a
balancing act that her son would inherit and imitate.

Quiet but observant, John was witnessing a woman who was able to slip out, and stay out, of her assigned sphere. From his dauntless mother, John Sargent was already learning to explore, to transgress, and, mutely, to defy conventions.

<center>-◄-</center>

*Meanwhile, John's own prodigal mind was already, and rather startlingly, begin-*ning to emerge. The sketchbook he'd received from Emily as a Christmas present soon filled up with ruins in watercolor, sailboats, caricatures, and a sketch of two men boxing. But he largely focused on drawings of classical statuary in the Vatican Museum: *Antinous*, *Hercules*, and *Perseus*. An Italian sketchbook from the spring of 1869, when the family traveled south to Naples to avoid the miasmas of Rome, included many drawings of classical statues and mosaics from various museums.

As one scholar of the sketchbooks has phrased it, teenage John was now showing a "serious interest in antiquities." As young John himself described it, he was always on the lookout for "some beautiful statues" to sketch. And his interest focused strongly on male figures.

In page after page of the sketchbooks that his mother or sister Emily had given him, the lad drew heroes and gods. What's more, the whole family

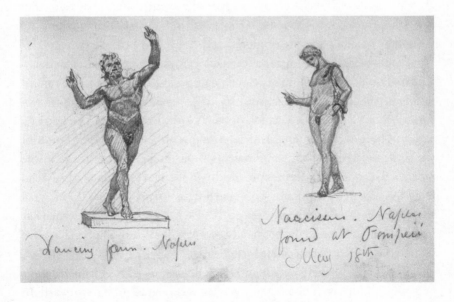

A dancing faun and Narcissus in Sargent's sketchbook, 1869

noticed and admired them. Mary and Fitz were used to encountering naked male torsos, as they leafed through the accumulating folios of their son's pencil sketches and watercolors. "Mamma and Pappa," as John called them, completely approved of their son's classical mania.

<div align="center">⤛⤜</div>

John's large number of male nudes was, on one hand, straightforward and easy to explain. Vernon Lee observed that the young Sargent liked to draw what he saw in front of him, that "to him paints were not for the telling of stories"— not for making up things out of his head. As it happened, the Italian museums that the Sargents visited with their Baedekers were simply stuffed with such classical works and their Renaissance imitations. Roman life in general was a parade of naked statues. Fitzwilliam noted how, during a cold snap in the city in January 1869, the children delighted in the "long icicles" that draped "the figures of Tritons, Dolphins, and other allegorical-mythological conceptions which constitute the sculpturesque part of the fountains."

What's more, the sketching and copying of classical statuary "after the antique" furnished an important part of nineteenth-century art-academy training, as the family knew well. Conventionally, after students copied drawings and engravings and before they attempted to sketch live models, they drew statues. Drawing "from the antique" constituted a vital stage of art training. It was such an obvious part of the curriculum that European and American art schools amassed rooms full of Greco-Roman plaster casts when they couldn't procure originals.

Much tradition stood behind art schools' fixation on classical statuary. The traditional emphasis on male nudes, according to one historian, banked on the aesthetic and moral superiority of the male body. Male nudes underpinned a Victorian idealization of men's knowledge, power, and artistic ability: "Indeed, the antique had so strong a hold on the imagination of the academic artists that even drawings from the live model made in the nineteenth century can seem more ideal—in the sense of imaginary—than real." As cultured expatriates who mixed with artists, Mary and Fitz were steeped in these decorous conventions. And Mary especially encouraged her son's sketching of such conventionally accepted statues, most of which were rendered even more respectable by fig leaves.

Yet this small detail in many of John's drawings—the fig leaf—hints at how much, in his childhood world, nudity wasn't at all straightforward. In the late nineteenth century, this small object, in fact, had become growingly

controversial and articulated a furious contemporary debate, almost a culture war, about the aesthetic value and morality of naked human bodies. That this debate simmered and sometimes raged in young Sargent's idyllic youth shows up even in these early sketches. Some of John's nudes, notably those from the Vatican Museum, clearly show a fig leaf in place. Others, sketches from the Capitoline and the Naples museums, revealed the penis. John copied what he found in front of him, and this dichotomy reflects the status, at various museums John visited, of this form of censorship.

The Vatican Museum, John knew, rigidly insisted on fig leaves—usually imposed, cemented-on ones. As a well-read adolescent, he may even have known that the Council of Trent (1545–63) had begun the official Catholic condemnation of nudity in art. Pope Paul IV attacked the representation of the human body in a papal bull in 1557 and was the first pontiff to mandate the use of fig leaves in painting and on sculptures. Subsequently, seventeenth-century Pope Innocent X reinforced this rule, and eighteenth-century Pope Clement XIII commissioned mass-produced fig leaves for the Vatican galleries. Pope Pius IX (1846–78), reigning during the Sargents' winter residences in Rome—the pope who Mary and her children glimpsed firsthand in winter 1868 and found "gray-headed" and "feeble," wearing an "amiable and benignant look"—instigated a renewed purge of offending art and ordered even more statues to be castrated with a chisel and then fitted with mortared-on fig leaves. Pius wanted to avoid arousing forbidden and unnatural passions among residents of the Vatican or visitors to it. "His character is said to be very pure," Dr. Sargent remarked. At the same time, retrograde papal intransigence amused Fitzwilliam, striking him, in a somewhat dubious twist of Abraham Lincoln's words, as "'the Pope's Bull against a Comet.'"

For the many censors of the era, the fig leaf embodied a moralistic or pietistic condemnation of artistic nudity. The era's religious conservatives scouted artistic liberties and erotic desires, and such censorship had a long history that was not limited only to papal disapproval or Catholic dogma. Similar prohibitions had erupted in Europe throughout the history of Christianity and, after the Reformation, also dictated public morality in Protestant countries as well. Yet censorship of nude art was never entirely consistent or universal. In the world where the Sargents circulated, not all Italian cities or art galleries imposed fig leaves. Indeed, prior to its unification in 1871 Italy was a mosaic of different states and administrations, some of them hostile to the papacy.

During the family's many monthslong stays in Florence, during the cooler months of 1869, 1870–71, 1872–73, and 1873–74, teenage John would have passed by the Palazzo Vecchio almost every day. He would regularly have encountered Michelangelo's *David*—one source, perhaps, of his later obsession with this artist. Michelangelo's glorious nude statue, seventeen feet tall, stood in this most public of places from 1504 to 1873—after which it was sheltered, lovingly, in the Accademia Gallery. Michelangelo's statue illustrated Florence's long defiance of Rome in this and other respects—a sort of David standing up against the papal Goliath. In its first few decades in the sixteenth century, it's true, the heroic marble had worn a leafy copper garland around its hips as the result of a vigorous dispute that had pitted Michelangelo, somewhat surprisingly, against a disapproving Leonardo da Vinci.

A new censorship battle regarding the *David* had erupted in 1857 when the Grand Duke of Tuscany bestowed a copy of the gigantic nude statue on Queen Victoria. The queen, duly shocked, required the South Kensington Museum, now the Victoria and Albert Museum, to commission a huge fig leaf to attach for Her Majesty's visits as well as for official photographs. In spite of the Victorian reputation for prudery, however, this fig leaf, unlike the cemented-on versions in the Vatican, was detachable. British art students continued to sketch this statue in its bare state, without complaint.

Fig leaves in the late nineteenth-century United States, however, enjoyed legal reinforcement. The Comstock Laws of 1873 strictly and exhaustively prohibited the circulation, as the statute read, of "every obscene, lewd, lascivious, filthy or vile article, matter, thing, device or substance." Yet even in the United States art was often seen as a special and privileged exception to censorship. When in 1887 the crusading Anthony Comstock tried to prosecute Roland Knoedler, a high-profile and reputable New York art dealer, for selling photographic reproductions of French paintings featuring female nudes, "virtually every New York city newspaper expressed outrage at this act of censorship."

Comstock backed off. Still, American art galleries and museums, sensitive to a pietistic public who like Comstock often objected to any form of nudity, continued feverishly to apply fig leaves. Boston's Museum of Fine Arts did so from its opening in 1876—when it enlisted a Harvard professor of surgery, Henry Jacob Bigelow, to complete a cover-up that would last, in some cases, till the 1950s and 1960s. The museum even blacked out the

phalloi of satyrs on Greek vases and did not reveal them till, around 1960, classical curator Cornelius Vermeule reversed the policy.

If some in the American art world defended the artistic liberty of nudity, others, such as one anonymous writer in the Chicago arts magazine *Brush and Pencil* in 1905, reinforced the more widespread American condemnation of nudes: "The plain truth is," this writer argued, in a characteristic "Plea for the Fig-Leaf," "that such art, after it is finished, is only fit for a dunghill, wither, in all probability, it ultimately goes. One may ask why artists persist in painting such questionable canvasses."

Even when rigorously applied, however, the fig leaf didn't merely signal Victorian prudery. Peculiarly, the fig leaf actually emphasized what it purported to hide. After all, it substituted something that was roughly the same shape. Perversely, the nineteenth-century censorship with which Sargent grew up more or less backfired, in itself. Instead of eliminating sexual curiosity, the fig leaf heightened it.

Though Sargent as a teenager knew little about vice crusaders, he would have felt their chilling effect even in Italy. And he would actually affront public morality repeatedly in his future. In fact, he'd later make his artistic reputation by scandal, by pushing and transgressing the boundaries of what others deemed permissible in art.

–←–

*Half-pagan Rome was a cornucopia, an endless pageant, of male nudes. But, fig-*leafed or not, John's early nude sketches involved him in some unusual and heady adventures. His nude drawings were complicated by the particular method by which he captured them. As Vernon Lee remembered their museum visits in Rome, the adolescents ranged through the "icy miles of Vatican galleries" on their own, with "scamperings, barely restrained by responsible elders." Without an art teacher or even necessarily a parent intervening, Sargent enjoyed a fairly free and independent choice of what to copy.

When Lee also recorded that John executed "hurried forbidden sketches of statues selected for easy portrayal," she literally referred to the rules governing Italian museums in the late 1860s. At the Vatican, visitors who wanted to sketch any artwork had to procure a *permesso* from the papal *maggiordomo*—a ritual that mandated a consular or ambassadorial letter of reference as well as a visit to this dignitary's office in the Vatican and a wait of days or weeks. A teenage boy like John Sargent had no such options. But

as an intelligent, motivated lad with a good deal of his mother's boldness, he could recruit quickness, stealth, and anonymity—circumstances that also explain why some of his sketches appear rather brief and minimal.

Yet Sargent's early nudes clearly amounted to "hurried forbidden sketches" in another sense. Such furtive, unsupervised drawings worried many of the family's friends and relatives, being the worst incarnation of a common fear among the era's social purity crusaders about children's and adolescents' increasing freedoms. According to antivice crusaders like Comstock, such liberties resulted not simply from permissive or negligent parents but also from Victorian adolescents' augmented private time and space—personal bedrooms rather than nurseries or common sleeping spaces growing ever more common among middle-class families. Comstock assailed adolescents' increased autonomy and privacy, worried especially about the "secret vice" of masturbation.

The kind of sexual and nonsexual exploration that Sargent's sketchbooks embodied—which seems healthy and natural to many people today— appeared highly pernicious to many of Sargent's contemporaries if not to his broad-minded parents. Sargent's youthful sketchbooks dramatize a kind of secrecy in plain sight, being both entirely "innocent" and yet freighted with sexual possibilities that, especially given Sargent's later predilection for drawing male nudes, hint that Sargent forged an early link between art and forbidden sexuality.

But this link had a curious further component—an outdoorsy mania that, on the surface, appeared extraordinarily conventional and wholesome.

3

Mountain Men

From the white, red-roofed, flower-box-pretty Swiss town of Thun, the massive and impressive Alps reared off to the south, across the glassy lake of the same name. In June 1870, when the Sargents arrived from Italy, these formidable peaks still lay half-entombed in snow, even on the threshold of summer. The sheer, storm-racked rock faces, some of them fourteen thousand feet high, dominated the town's lakeward streets, exciting the fourteen-year-old who, suddenly, saw fresh possibilities in them.

With no boys his own age to go adventuring with, John was left with the only other Sargent male, his father. And his father had a new mania to share. Fitz was bent on exploring passes, glaciers, and vertiginous mountain overlooks. The crags of the Bernese Oberland formed a "stupendous mountain wall whose battlements overhang in mid-air," as the British intellectual and mountaineer Leslie Stephen ecstatically described them: "No earthly object I have seen approaches [them] in grandeur." The Finsteraarhorn, the Aletschhorn, the Jungfrau—imposing crags with their ancient German names—loomed large in John's imagination as well in the inn windows of Thun.

Along with Mont Blanc and the Matterhorn, these mountains offered Fitz and John not only an unspoiled wilderness but also a high-altitude proving ground for Victorian men (and male artists), the purest manifestation of what, since the eighteenth century, European thinkers like Edmund Burke had described as the "sublime." In contrast to the more serene and feminine concept of beauty—often embodied in the easy, lyrical *dolce far niente* (it's sweet to do nothing) of the Sargents' Italy—Burke's aesthetic category of the sublime rendered art an exercise in courage, assertion, and mastery. The "sublime" and punishing challenge of the Alps evoked fear but also offered

a salutary, stimulating, and transformative experience to artists, travelers, and mountaineers alike.

Both Sargent males had freshly been seized by such enthusiasm. It had strangely bonded them. In anticipation, John eagerly sketched the peaks from Thun—the sheer tower of the Stockhorn, the brooding ridge (shaded in dark pencil) of the Jungfrau. The fourteen-year-old found mountains stimulating subject matter. John was beginning to fancy himself as a landscape painter—and, what was more earthshaking, he was beginning to win over his flinty father to that possibility. Part of John's excitement came from the prospect of mountain adventures. But even more from the notion that he please or impress his father, that he could win him over, that he could prove himself.

For starters, Dr. Sargent had finally acquiesced to his wife's long-cherished plan to provide John some artistic training. As Fitz summed up the issue a couple of months later, reflecting on this time with his son in the Alps, "My boy John seems to have a strong desire to be an Artist by profession, a painter, and he shows so much evidence of talent in that direction, and takes so much pleasure in cultivating it, that we have concluded to gratify him and keep that plan in view in his studies." To "keep that plan in view" was hardly a full endorsement, but Fitz was beginning to relent. In fact, he was about to contribute a whole new ingredient to John's training.

At the family's hostelry, father and son spent three weeks conspiratorially "incubating," as Fitzwilliam described it, their invasion plan for the peaks. A Swiss mountain excursion required steeling nerves. It also required gathering resources. The pair had to size up the mountains and passes, wait for the season to warm from June to July, scour guidebooks, spread out maps, and assemble the obligatory equipment. It was a male-bonding orgy. Their gear included an alpenstock for each of them—a long stave of ancient origin for dealing with glaciers. Its traditional sharp tip had recently been replaced by a chopping blade, so that this once-primitive staff had transformed into an ice ax that could cope with many high-altitude contingencies and emergencies.

John's enthusiasm showed in a lively sketch he'd made in Switzerland the summer before. In it, he depicted two male climbers on an Alpine overlook, the lead climber, in knee breeches and patterned stockings, leaning on an alpenstock and extravagantly hailing the view with his doffed feathered hat. Such a posed, stylized illustration wasn't typical of John's rather true-to-life instincts. But it neatly encapsulated his growing obsession with Alpine costumes, adventures, and fun.

Sargent's Alpine mountain climbers, 1869

Some Alpine excursionists, in fact, readily donned such festive local dress, dear to the picturesque Victorian imagination. Fitzwilliam Sargent was too dignified to dress like that. But, ever obsessed with his family's health, he'd always looked forward to what he called their "summer campaigns" in the Alps. He reveled in mountain rambles with his son walking "as brisk as a bee." He relished that John had grown taller and stronger. Now the two of them could test themselves and hazard a trek into the peaks.

Fitz didn't know that he and John were throwing themselves in what would later be described as the golden age of Alpinism. But they read in the newspapers about intrepid parties of climbers, most of them British, ascending one legendary peak after another. Even a cultivated bookworm like the British critic Leslie Stephen—hardly more athletic than Dr. Sargent—joined the first ascents of nine Alpine peaks in the 1850s and 1860s including the Blüemlisalphorn and the Schreckhorn.

Yet for both Sargent males, the attraction of the Swiss Alps, stocked with glaciers, freshets, cliffs, and rugged beauty, wasn't chiefly mountaineering—much as that prospect stirred many Victorian men as well as intrepid women such as Amelia B. Edwards, who explored the nearby Dolomites in the early 1870s, or Lucy Walker, who joined her brother on the first ascent of the Balmhorn in 1864. No, it was something more elusive than that. Fitz wasn't contemplating any Alpine firsts, the scaling of any improbable or dangerous peaks. Instead, he was focusing on a health-building, bond-deepening hiking trip with his son. For, thanks to more than a century of visits by pan-European artists and poets, the Alps had become the ne plus ultra of majestic, unspoiled nature.

Yet by the time of the Sargents' visit in 1870, the various Alpine quarters of France, Austria, Italy, and especially Switzerland had transformed from a wilderness into Leslie Stephen's "playground of Europe"—a scenic mountain region increasingly accessible to romanticized mass tourism and to increasing numbers of women and children, to chalet-hotels and (in the coming decades) precipitous, climbing railways to carry crowds to mountaintops.

Fitzwilliam's own restlessness in Switzerland hinted that Mary Sargent wasn't the only parent who instilled touristic compulsions in young John. In the case of the Alps, Fitz paralleled his wife's romantic wanderlust. This father-son walk demonstrated that he too could furnish his son with a particular traveler's liberation as well as a masculine compulsion for escape, exploration, and adventure.

-+-

Before the end of June, father and son set off together up the deep, wooded dale of the Kander, a picturesque stream threading through Alpine farms wedged between the peaks of the rugged Albristhorn on the west and the massive Jungfrau on the east. The pair's first night's hotel in the village of Kandersteg differed little from the family accommodations in Thun. But, as the weather had so far been clear, legendary crags loomed all around under the blaze of stars.

They could feel, then, that they'd broken away from dull lowland life and were poised for highland adventure. The Sargents' morning walk saw them ascending the Gasterntal gorge, a narrow gateway of rock between massive, sheer cliff walls. The air was cold, and tiny pines tilted from the heights. Yet even with the challenge of the 7,500-foot Gemmi Pass ahead, John stopped on the path to sketch this chasm as well as the rustic village below. However much he'd learned about alpenstocks, he cared more for the graphite, watercolors, and sketchbooks in his rucksack, and for the vivid images he could make with them. John spent as much time with his sketchbooks as other boys did with their friends, their studies, or their sports.

John had caught on to a vogue for Alpine art that had prompted international artists such as Albert Bierstadt, Alexandre Calame, and J. M. W. Turner to invade the Alps in order to muse, sketch, and produce stirring exhibition pieces. John's favorite, John Ruskin, had done much to promote the Alps as a prime site for manly Victorian art-making, not only for his admiration of Turner's paintings of the St. Gotthard Pass and the Dent d'Oche but also for his personal obsession with the Matterhorn. Ruskin saw this mountain as having an "effect . . . upon the imagination . . . so great, that even the gravest philosophers cannot resist it." A nonclimbing member of the Alpine Club himself, Ruskin penned panegyrics to mountains that he included in his multivolume *Modern Painters* (1843–60), in which he declared that mountains epitomized "the beginning and end of all natural scenery."

As John was already learning, painting any natural landscape wasn't easy. Ruskin had made that much clear in his *Elements of Drawing* (1857), a de rigueur volume on art training, appropriately designed for art students over "the age of twelve or fourteen." In his chapter "Sketching from Nature," Ruskin insisted that young students concentrate on sketching, or rather shading—for Ruskin didn't believe in drawing outlines—"rounded

and simple masses, like stones, or complicated arrangements of form, like those of leaves; provided only these masses or complexities will stay quiet for you to copy."

Yet fourteen-year-old John had gone far beyond still lifes of leaves and pebbles. He was already rendering whole landscapes and was experienced and ambitious enough to feel the importance of the grander subject material unfolding around him. He was already tapping into Ruskin's "effect . . . on the imagination" even more than Ruskin's discipline. Though he'd been using a pocket-size sketchbook that summer, he now inaugurated his larger book, later labeled by his mother with the title *Splendid Mountain Watercolours*.

Splendor definitely beguiled him, even more than it attracted his father. Already this tour was sparking somewhat different delights in the two of them. On the trail, Dr. Sargent remained matter-of-fact. In his letters to his friend George Bemis he was unflinchingly sober, literal, and no-nonsense— giving away little sense of his immediate experience. In his parallel letters to Ben del Castillo, written from inn bedrooms and sharing his father's lamp- light, the young painter adopted a similar voice, practical and straightfor- ward, with only occasional mild sallies of charm, humor, or affection.

John's sketches, though, struck an entirely different note. In his visual record, he adopted a lush expression more like poetry than prose. Yes, the craggy, forbidding landscapes through which they passed summoned a me- ticulous treatment, reflecting his father's rather scientific, exacting view. But already John was beginning to infuse these sketches with his dreams and moods. These surpassed his simple nudes in emotional content, but he also brought to bear the lyrical sensations of a boy who'd been brought up on the torrid, high-colored beauties of Italy. Now, though, this athletic trek was also beginning to stimulate John's tastes in a new direction.

After climbing through the gorge in bright, fine weather, father and son spent the night at an inn perched high in the mountains near the Gemmi Pass. They woke to a snowstorm that had begun before dawn and that had already whitened and obliterated the trail ahead. Storms in the Alps could prove deadly. But Fitzwilliam only recorded, in his understated way, that they crossed high, rugged country "to Loëch in a mixture of snow & rain." At Loèche-les-Bains (Leukerbad), the snow relented so that John could take advantage of the storm's aftereffects and sketch the tall timber houses of the village and the whitened mountain walls behind. "This was the only bad

weather we had," Dr. Sargent remarked. The number and quality of his son's subsequent sketches testified to the good weather for sketching the two found from that point on, as well as John's pleasure and persistence in drawing both rustic village scenes and stirring high-altitude panoramas. That pleasure made him exert himself, hour after hour.

In conscious or inadvertent parallel to Ruskin's dicta, Fitz imposed exactitude, diligence, and restraint. "*Accuracy*," Ruskin concluded, was "the first and last thing" parents should encourage. Fitzwilliam was a gentle teacher but a persistent and principled one; his reserve made him likely to follow Ruskin's advice and hold back from praising his son's work for "being clever." Ruskin recommended that parents should approve their children's work "only for what costs in self-denial, namely attention and hard work." John's proud and expressive mother seldom adopted such restraints.

Scaling peaks was one way to "conquer" them; committing them to paper was another. Both projects were audacious as well as meticulous, and John's moody, adventurous sketches incorporated their own forms of mountaineering's drama and struggle. This excursion was prompting John's most dramatic and ambitious sketches to date.

A few days after the Matterhorn, father and son scaled the 9,600-foot Eggishorn near Fiesch, in the canton of Valais, to reach the celebrated view from its summit. Gazing across miles of empty air, John carefully rendered the monstrous Aletsch Glacier and the line of cloud-scraping crags above it. A similar blend of accuracy and lyricism illuminated the rendering John made of the magnificent Rhône Glacier on July 13. Yet for John, as he and his father descended through the Grimsel Pass and the deep Aar valley, such elation wasn't just touristic and fleeting. It struck deep; he spent considerable time rendering this majestic glacier in his sketchbook. His powers of concentration, already formidable, were deepening.

This volume of landscapes memorialized an excursion John would never forget, rendering not only stormy Alpine scenes but also a grand, joyful, and slightly tempestuous portrait of his father and the time they'd spent together. In this same sketchbook, John included a literal portrait of Fitz. He portrayed his father as mild, bookish, and asleep, round spectacles perched on his face. Still, John had absorbed and articulated something much more dramatic—not a sleeping parent, but his father's frank taste for Alpine adventure. Through that, he'd also discovered a predilection for wild landscapes, outdoor adventure, and masculine companionship that would stick

with him for the rest of his life and that would determine much of his future production. No matter where he went, John would carry Alps inside him.

◂┿▸

Back at Interlaken—a well-appointed tourist hub straddling a scrap of land between two lakes plied by sightseeing steamers—the Sargent women awaited their mountaineers. Most fine days, Mary and her daughters entertained themselves in the gardens of the ornate and fanciful Kursaal, built in 1859. They didn't roam much farther, for, in spite of her touristic energy, Mary hated to walk far. In any case she had her energetic, assertive infant daughter Violet to tend. On his return, John picked up his pencil to capture his mother sitting on a bench—perhaps in those very Kursaal gardens— Mary sporting an elaborate frilled gown and bonnet, plying at a piece of needlework. John labeled the drawing: "*Regardez moi ça*" (Look at that)—a glimpse of the quiet family humor that united them.

John found his thirteen-year-old sister Emily struggling with her health. Worried, too, Fitzwilliam and Mary opted to spend August back in the high country, "on Emily's account, as she is so much benefited by high air in warm weather," as her father remarked. They all bumped by carriage on the rutted roads back up into the Oberland. They chose the hamlet of Mürren, an ancient settlement devoted to the herding of sheep and cattle in high pastures during the summer. As the English writer John Addington Symonds had described Mürren a few years before, the village combined weathered wooden architecture and "primitive" accommodations with influxes of English and American day-trippers and tourists.

As usual with the Sargents, considerations of health meshed with their touristic itinerary. But now both Mary and Fitzwilliam were also eager to promote John's artistic endeavor. At Mürren, they knew, the family could board cheaply and breathe healthful air. John could continue his Alpine sketchbooks: around them rose the Jungfrau, the Eiger, and other snow-sheathed mountains "as thick as blackberries," as Fitzwilliam put it, "from which avalanches roll and thunder daily." Here Fitz and John could embark on day hikes up pine-flanked streams, to waterfalls and great rocky overlooks. In addition to its scenic surroundings, Mürren furnished John a lavish outdoor art school. It afforded him the opportunity to draw rustic timber outbuildings, rail fences, long grass dotted with wildflowers, and Alpine peasants sporting picturesque embroidery and headgear.

In Mürren, in fact, John embarked on some of his earliest formal art in-

struction. Previously, in Rome during the winter of 1868–69, he may have spent mornings copying watercolors in the studio of a German landscape painter, Charles Feodor Welsch. According to Sargent's first biographer, Welsch "took an interest in the boy and noted his aptitude for drawing," inviting him to "come and work in his studio."

But in Mürren in 1870, the Sargents' residence coincided with that of Joseph Farquharson, an affable if laconic Scottish landscape painter. At twenty-four, Farquharson was a full ten years older than Sargent. Though the two later became friends as well as fellow members of the Royal Academy, Farquharson during the summer of 1870 counted more as an older artist who readily appreciated John's artistic abilities and aspirations. According to Charteris, Farquharson was "impressed by the boy's talent" and so offered to instruct him.

The family's slim resources and constant moves had always rendered any kind of education difficult. In Mürren living cost less, so drawing lessons were easier to afford, if the Sargents actually even paid for John's casual lessons. The pace of an Alpine art resort was slow. John's surviving sketches radiate charm and pleasure—as they so often did—rather than the rigors of technical or academic training that had long been favored in France or in American art schools like those in Mary Sargent's Philadelphia.

Clearly, Farquharson impacted the teenager. He later made a name for himself through paintings that combined snowbound Scottish landscapes, sheep, and sunsets. He tended to prefer small-scale rural rusticity to the species of wide-angle, moody mountain landscapes that John had painted during his recent hike. Farquharson instructed John in some of his distinctive plein air techniques. Also, though, he concentrated his pupil's attention on human details, on the type of nostalgic, picturesque, rural figures and settings that he loved to include in almost every one of his own canvases. Significantly, according to Charteris, Farquharson "gave [John] his first lessons in drawing a head."

John had already drawn and painted quite a few human heads and figures. Copies of statues, portraits of family members, sketches of Tyrolean peasants in previous summers, and cartoons of fellow travelers peppered his sketchbooks. But John's albums from this summer featured some drawings specifically of heads, including two carefully executed portraits, one in two stages of a beautiful, curly haired Mürren boy named Gottlieb Feutz.

A page including sensitive sketches of hands and a head may also belong to Sargent's "lessons." The hands, which are slender (and all left hands)

may well be Sargent's own. But a bearded head may belong to Farquharson himself, as the mustache, nose, and eyes closely resemble Farquharson's 1882 self-portrait. At Mürren, perhaps at Farquharson's instigation, John also undertook some rustic genre scenes featuring children and old people, a number of detailed, painstaking, and quite finished depictions of Mürren locals or fellow tourists in Switzerland (Frau von Allmen, Fraulein Sterchi, Theodore B. Bronson Jr.) which, especially with the names of the sitters penciled in, qualify as early Sargent portraits. Already, drawings were John's way of meeting people or relating to them. Without a pencil or brush, he was all nerves.

Human figures, though, had attracted John since his first infant drawings—the precocious, scrawled portraits of his father that his parents had sent to his grandparents in Gloucester, Massachusetts. Whatever instruction Farquharson gave the lad in Mürren, John was already quite experienced in handling human figures even if he was almost exclusively self-taught. He'd eagerly filled his sketchbooks with informal, seemingly spontaneous portraits, cartoons, and figure studies—often but not exclusively of family members, and often tinged with humor and irony. And he would soon discover fresh material on which to exercise his energy and wit. Another intriguing Alpine companion was now rising up.

—✦—

Charles Feodor Welsch, also known as Karl Theodor in the polyglot world in which he thrived, was forty-three in the summer of 1871, when he proposed taking fifteen-year-old John on an extended Alpine sketching excursion, the two of them on their own.

Though the Sargents had probably encountered Welsch through their art connections in Rome and Florence—and possibly already sent John to take lessons from him—Dr. Sargent chiefly knew him as a "Germanico-American Artist of reputation." But little is known about Welsch today, so it's hard to know what kind of influence he imposed on his pupil.

Born at Wesel on the flat northern stretches of the Rhine, the son and brother of painters, Welsch had studied in Düsseldorf as a teenager and then forged on to Brussels, the Hague, and Paris, where he'd apprenticed with the Barbizon painter Félix Ziem and the Swiss landscape painter Alexandre Calame. He was no doubt a polyglot, as he'd also lived and worked in the United States in the 1860s, where he'd trained the American landscape painter John Douglas Woodward as a teenage student in Cincinnati. Later

in life he'd travel to the Middle East in order to capture "exotic" scenes—a mode of orientalist fantasy that very much prefigured Sargent's own career. (It would also be in the Middle East, decades later, that Sargent would reunite with his other teacher in Switzerland, Farquharson.) But, to say the least, Welsch was already a seasoned traveler and a man steeped in the master-student relations that ruled art-world education.

By May 1871, teenage John had been studying hard all winter, if mostly on his own, and his father praised his "progress and general behavior." Fitz thus endorsed the idea of a long walk in the Tyrol, where John and his teacher would "sketch together, fish, &c." "It is an excellent opportunity for the boy," Fitz told John's grandfather, "who is very fond of drawing, and who seems to be more desirous of an Artist's life than any other avocation, and we intend to let him follow his bent."

Yet John's father remained uneasy about his son. Dr. Sargent stipulated that he would "keep near him so as to be able to get at him at any time in case of need. He is a very good boy, so far as I know, and as compared with other boys." As so often happened, Fitzwilliam's endorsement of John came with nervous reservations not quite voiced. Why was his well-behaved son a "very good boy, so far as I know"? Certainly, John's father had some qualms about sending the lad off with this well-traveled foreign artist.

In late July, a year after the grand Oberland trek, John hiked with his father through the steep-walled Ötztal valley, near Innsbruck. The "very pleasant six days walk" with "[his] son John" gratified Fitzwilliam, but it was only a warm-up. After that, John joined Welsch for a longer exploration— the names *J.S. Sargent/F.C. Welsch* were inscribed in the sketchbook that John would fill right up. In early August, he wrote, as his father reported, that he and his teacher were "amusing themselves trout-fishing when the weather does not permit of their painting." He'd caught "eight fine trout," he told his father, but a cat had made off with two of the trophy-size fish. Already, John loved trout streams—a subject he'd enjoy capturing in watercolors, even much later in life.

Welsch, primarily a landscape artist and illustrator, also appreciated the raw beauty of the peaks. Appropriately for the instruction Sargent received, many of the drawings from this sketchbook documented touristic views of craggy Tyrolean Alps. Yet new human figures abounded in John's Welsch sketchbook, too, suggesting that the pair encountered many fellow adventurers. As the English writer John Addington Symonds observed, "Alpine inns are favourable places for hatching acquaintance and gaining insight into

character." Stealthily, John took advantage of this polyglot hubbub to study the shapes, attributes, and personalities—physical and psychological—of human figures.

Though in many of his sketchbooks the teenage Sargent showed interest in women's hair and headdresses, many of the figure studies in this new volume were male: boaters, loungers, a handsome tough in a cap labeled Peter Paul Gotrein, and several drawings of a bearded man or men in Alpine walking gear, with alpenstock and pipe, that may well give us a glimpse of Welsch, of whom no other images are known to exist. In his own landscapes Welsch sometimes included human figures, so John's Tyrolean figure studies probably counted as additional lessons. But they also marked John's expanding visual and emotional interest in his fellow human beings. Personal encounters became artistic encounters, and vice versa.

John's holiday in the Alps, with their vistas and picturesque characters, tended toward a different kind of exploration. John's Welsch sketchbook not only drilled John in drawing techniques and painting methods but also exposed him to the heady artistic liberties of the open road—in this case, once again, the jaunty feathered caps and vertiginous switchbacks of the high Alps. Life on his own, or almost on his own, fascinated him with strangers with whom he could link up and whom he could wittily portray. Also, such a free-form excursion disposed John for an artist's carefree, itinerant life that he was coming to prefer to any other.

John's father, though, felt less relaxed about his son's future. While John finished his "painting tour" with Welsch, his father was staying in the blue-roofed Tyrolean village of Mayrhofen in Zillertal, wedged between grass peaks and stone peaks, undergoing a cure of "powders" for his chronic dizziness.

Between his treatments at the spa and his visits to *poste restante* to collect letters from his son, Dr. Sargent mulled the family's next move. He hankered to transplant them all to Dresden for the upcoming winter of 1871. "I wish to put my boy at school, if I can get him into one of the public schools," he reasoned to his brother. "I say *public* schools, because I think they are better than the private schools." He hoped a state-run Saxon school, having a smaller concentration of English and Americans than the haphazard private academies the Sargents had previously tried, would also help teach his son German—a useful scientific language—even if the lad could already speak more florid languages like Italian and French.

Both of John's parents, with their sometimes-contrasting goals, fre-

quently brooded over their son's education, or lack thereof. Now, once again, they were casting about for better schools than those available in the blithe garden enclaves of Nice where they'd so often wintered. London was too expensive and Paris too chaotic in the aftermath of the Prussian invasion of 1870. So Dr. Sargent asserted himself and masterminded a plan to winter in Dresden, in the so-called Florence of the North. But it would take, in fact, more than one Florence to get John Sargent even half-educated.

4

The School of Michelangelo

Florence, Italy, styled itself as an art center—or rather its extensive foreign colony did. Visiting artists tapped into a neo-Renaissance enthusiasm that glorified beautiful human bodies, at least as enshrined in paintings and statues. When the Sargents arrived in October 1873, for the umpteenth time, in a city that had so often served as their winter base, they once again unpacked their scuffed, overloaded steamer trunks. But their brand-new lodgings in the city also offered some additional delights—in autumn, stubble; by early spring, blossom and fresh grass. The Via Magenta ran parallel to the walls of Florence and abutted the open, hill-bounded Tuscan countryside just to the west. For all that, the Sargents' house stood near enough the center of Florence for Mary to invite the English and American artists, teachers, and scholars who wintered in the red-roofed city to teas and soirées.

Florence came as a relief to everyone. Fitzwilliam's Dresden winter, two years before, had proved a failure. Ever hopeful, the family had erected their fold-up household at 2 Wiener Strasse, just south of the formal, extensive parklands of the Baroque Grosser Garten. But Fitz had found Dresden a "dusky-looking town," with the coal-smelling air of London even if it didn't share its rather yellow atmosphere. Fifteen-year-old Emily had fallen seriously ill—to the point that she'd produced an earnest, handwritten will. And sixteen-year-old John, at loose ends and unable to matriculate right away at the Gymnasium of the Holy Cross, found himself reluctant to study algebra or Latin.

Through that winter in Saxony, with its harsh and mild spells, John quietly continued his sketchbook self-education. His favorite haunts—tepidly heated by tiled stoves—took him to the Dresden Museum and the Museum of Antiquities in the Grosser Garten. Otherwise, John's two surviving sketch-

books labeled "Dresden" primarily featured studies of street figures, animal drawings (John loved to sketch goats and cows), and town scenes documenting the family's junkets, when spring came at last and Emily's health permitted, across Germany and Bohemia.

These sketchbooks documented John's broad, attentive, highly eclectic openness to the ordinary sights he encountered every day. Yet it's possible that two nude figure studies in the lad's Welsch sketchbook were also done that winter, and from Dresden statuary. Whatever their source, these particular sketches exhibit a fresh and quirky liberation from the literal renditions and named masterworks of drawings "from the antique" that John had earlier pursued. These new nude figures virtually came to life, as though they'd been captured from live models. Taut, physical, and dynamic—delineated in a few bold lines—they didn't even hint at fig leaves or the lack thereof. John's own sensibilities were already transforming the "antique" into something immediate, dynamic, and intriguing.

John indeed hankered to strike out on his own, having inherited his mother's independent streak. At Carlsbad in May 1872, he abstained from drinking the "Saline-Alcaline [sic] waters," though his father quaffed three, his mother four, and his sister Emily two glasses of this bitter mineral water every day. He also forged through pine-and-beech woods with his newly invigorated mother and the family's German nurse, while his father led a "little Donkey cart by a circuitous route" that carried the invalid Emily and the exuberant toddler Violet. Though John himself fell ill in Bavaria and Switzerland that summer, he "was not so unwell," his father reported, "as to be prevented from walking off voluntarily every afternoon to make a sketch of something that pleased him, often at a distance of a couple of hours' walk." John's quiet high spirits simply couldn't be repressed, and he longed now to roam on his own.

That next summer, too, John continued his liberating highland explorations. In late August 1873, the adolescent struck out into the mountains by himself, intending to meet a friend at an Alpine hut. By 9:30 that night, though, he hadn't returned. Mary, alarmed, began to "fancy all sorts of horrors." Fitzwilliam telegraphed the father of the young man whom John was supposed to meet near the summit of the Bernina Pass. "This gentleman replied that his son and my son had left the inn for Pontresina in the evening," as Dr. Sargent later told the story. "This relieved our uneasiness, for his companion is several years older and a thorough mountaineer."

At 10:30, the pair finally arrived. Thankfully, they hadn't met the fate

of a seventy-one-year-old Englishman who'd been staying in Pontresina, who'd vanished in the mountains, leaving a chest full of money in his rooms. "Whether he fell into a crevasse of the glacier, or into the torrent, or was murdered by some roving Italian herdsman . . . no one knows," Fitzwilliam told his brother Tom. Such were the hazards even of the Sargents' chosen summering spot, idyllic as it was.

Yet, even if cautious by nature, John hadn't apprehended any danger. He'd been too exhilarated by the glorious mountain hike with his new friend to worry about such trivialities. He longed for such frank, luminous companionship.

-+-

Other companions provided John with more cerebral adventures that showed the growth of a restless, rather iconoclastic sensibility. A month after his scrape in the Tyrolean Alps, in September 1873, John reencountered his old friend Violet Paget during a short stayover in Bologna.

If the future lesbian aesthete Vernon Lee had grown into a "half-baked polyglot scribbler of sixteen," as she later remembered it, John at seventeen qualified as "a tall, slack, growing youth with as yet no sign of his later spick-and-span man-of-the-world appearance." He wore a "grey plaid shawl" to protect his "stooping shoulders" and to preserve himself from drafts. But his physical fastidiousness combined with decided and even rather daring opinions.

When Violet tried to interest her old friend in Mozart, he balked. That cheerful classical composer lacked "the exotic, far-fetched quality which always attracted John Sargent in music, literature, and, for many years, persons," she later remarked. He already displayed what the future Vernon Lee considered "that imaginative quality of his mind" that strongly differed from her own "priggish historical sensibilities." She noted that the "words 'strange, weird, fantastic' were already on his lips—and that adjective *curious*, pronounced with a long and somehow aspirated *u*, accompanied by a particular expression half of wonder and half of self-irony. That word *curious* was to me, at least, his dominant word for many years."

In the view of a budding fellow artist, John was now openly airing predilections his family couldn't quite appreciate or fathom. Already he was laying claim to a self-defined, exquisite, artistic world, where he would be allowed to fling aside his inveterate shyness. Part of that efflorescence, in Bologna, was spurred by the intellectual equal he'd reclaimed as his friend.

And part of that was his family's plan, flawed as it was, to provide him with a real art school at last.

<div align="center">⤙⤖</div>

In Florence, though, by April 1874, the Accademia delle Belle Arti wasn't living up to anyone's hopes. For one thing, John, now eighteen, was confined on a sofa, one foot propped up. Though he'd now grown more solid than he'd been in his slim early adolescence, when he'd delighted ladies as "a big-eyed, sentimental, charming boy, playing the mandolin very pleasantly," he was still like his mother, florid, dark-haired, amiable, and lively in his looks and laughs. The "brisk and decided" gait that had launched him on walks with his father and with various male friends, however, had now been hobbled.

It was his own fault, he confessed in a good-humored letter to his cousin Mrs. Elizabeth Austin. He'd inflicted his immobility, his inability "to use [his] right foot," on himself. Two weeks before, he'd severely sprained his ankle on the stairs of the academy. He'd been "leaping down stairs," Fitzwilliam added, "contrary to my oft-repeated warning and advice." Dr. Sargent applied a starched bandage, shaking his head sadly.

Even before this accident, the Sargents had been chafing at the artistic limitations of the city, John especially. The Accademia, John Sargent's first actual art school, hadn't proved very educational over the preceding winter of 1873–74. The family, increasingly focused on John's budding career, had in fact itched to return to Rome, with its familiar if rather rattletrap advantages. "This boy of ours is on our minds," Fitzwilliam had written a friend, "he has been improving a good deal this winter in his drawing, but we think that if [he] were under better direction than we can get for him here, he would do much better."

John was less equivocal: he believed his Florentine art school, even before his accident, had held him back, had qualified, in fact, as a complete catastrophe. "This unhappy Accademia . . . is the most unsatisfactory institution imaginable," he confided in Mrs. Austin, "human ingenuity has never contrived anything so unsatisfactory." Shortly after he'd enrolled late in the previous autumn, the Accademia had shut down for months while the professors had wrangled over a curriculum overhaul. Even when the school opened up again in March, the "students of the cast"—John's level, the group tasked with copying classical nudes—found themselves, as John put it, "without a Master, while the former Professor vacillated and still vacillates between resigning and continuing his instructions."

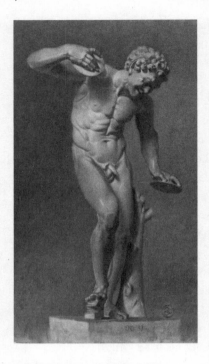

Sargent's drawing of the Uffizi
Dancing Faun

The Accademia especially didn't suit John because his sensibility was developing in its own directions, as he'd recently demonstrated to Vernon Lee. He yearned for a place where he could find full expression.

Of the sketches John made that year in Florence, under adverse conditions, one especially stood out. *The Dancing Faun, After the Antique*, a finished, almost photographic piece in black chalk and charcoal, especially showed off the young artist's virtuosity.

John's longstanding obsession with fauns, first inspired by Hawthorne's *Marble Faun* in his Roman childhood, had now found its full expression. Five years earlier, he'd sketched Hawthorne's inspiration, the so-called Faun of Praxiteles in the Capitoline Museum in Rome. He'd also captured another Dancing Faun, an exquisite bronze statue and survival of Pompeii, in Naples.

The sculpture that John rendered for the Accademia was more properly a satyr, a Hellenistic marble that had been painstakingly restored by Michelangelo and housed since the sixteenth century in the Tribuna, the great octagonal gallery of the Uffizi. A late nineteenth-century guide to the museum misattributed the statue to Praxiteles due to its perceived "extraordinary artistic value": it was also seen to be "executed with a remarkable knowledge of anatomy; every part of the body bears the features proper to the satyrs, and a kind of convulsive briskness seems to agitate each muscle." That description exactly fits Sargent's own meticulous, detailed rendering of the satyr's body in an energetic, impassioned, and contorted pose. The "features proper to satyrs" included a phallus that, in the defiant Florentine style, hadn't been fig-leafed over and also boldly featured in John's drawing.

That John chose the satyr for his Accademia thesis, as it were, hints at his predilections while enrolled in this largely unsupervised school. The Uffizi

and Florence in general teemed with other sculptures, and John made some sketches of them as well as some painstaking copies of classical paintings. Though still rather haphazard in his tastes, he was increasingly finding his favorites. That spring, he wrote Mrs. Austin that over the course of his family's many if rather brief visits to Venice he'd learned "to admire Tintoretto immensely and to consider him perhaps second only to Michael Angelo [*sic*] and Titian, whose beauties it was his aim to unite."

But John hadn't chosen to copy Titian's most famous female nude, the *Venus of Urbino*, which was also housed at the Uffizi. Italy was in fact well stocked with female nudes (mostly Renaissance paintings as opposed to classical statues), but virtually none of these images had found their way into John's sketchbooks—one rare exception being John's quick sketch of Michelangelo's rather muscular *Night* in the Medici Chapel at San Lorenzo in Florence. Otherwise, he not infrequently represented women. But mostly he rendered his mother, his sisters, genteel fellow tourists, and peasant women in picturesque regional costumes.

John's choice of the Uffizi satyr, in fact, counted as a bold one. It channeled an off-center version of masculinity. In contrast to more heroic, classical, and tranquil male nudes, which insisted on the restrained artistic ideals beloved of nineteenth-century art academicians as well as conventional male power, a satyr channeled a wild, quirky version of passion and physicality. In the Uffizi satyr, with his developed physique, this sexuality read as distinctly male in contrast to Hawthorne's more androgynous or even feminine marble faun. Seemingly both the faun and satyr deeply appealed to John.

Sargent's rendition—his careful shading giving dimensionality to the faun's muscular body—came off as illicit not only in its shed clothes and missing fig leaf but also in its defiance of the restrained classical ideals of the Uffizi, not to mention the Florentine Anglo-American colony. John's faun stood out boldly. It broadcast disruptive energy, clanging cymbals, and a defiant grimace.

-◂–

At home with his sprained ankle, meanwhile, John had "a very handsome Nea-politan model to draw and paint," he told Mrs. Austin, "who plays on the Zampogna [a double chantered pipe] and tamburino and dances tarantellas for us when he is tired of sitting." The tarantella was a traditional southern Italian dance that in its solo form most often mimicked the convulsive death

throes caused by a tarantula bite. Still with this dancing in mind, John added
that he hoped Mrs. Austin's artist daughter could "compel . . . her model to
dance when he is tired"—tired of posing, that is. John was no doubt courte-
ous to his model. He understood the model might want to move about after
sitting or standing still. But he also knew that he or his cousin could "com-
pel" a model to dance. He already fathomed the power disparity between
him and his hireling, which, though commonplace in European studios,
would increasingly become a heady dynamic for him.

In the Sargents' rented Florentine house, though, power was proving a
complicated matter. On one hand, Sargent's rustic Italian model success-
fully tapped into a lively if specialized market, and he profited from it. Such
unemployed migrants brought to aspiring artists the advantage of pictur-
esqueness and increasingly, as French realism in the 1870s created a vogue
for peasant and rural life, of earthy "authenticity," and that provided jobs
and livelihoods for some. On the other hand, such occasional and casual
aspirants abounded in cities like Florence and Rome, and they got little
enough for their trouble. They were cheap enough for the just-solvent Sar-
gents to sponsor command performances for their son.

Here the young artist tasted a spectacle performed just for his benefit,
a private enactment staged for him to watch and capture. He'd restage this
command performance in any number of future drawings and paintings.

John's Neapolitan model was only a stopgap, of course, and visitors to the house
brought ample suggestions for John's next step. He himself was ready for
something more and, when his mentors made suggestions, he eagerly lapped
them up.

One of the most august artists in the Sargents' circle, the sixty-five-year-
old Anglo-Scottish landscape painter Charles Heath Wilson, arrived at the
Sargents' doorstep weighed down with art-school credentials. He'd taught
at King's College London and at the Glasgow School of Design for decades.
He'd worked as a watercolorist and an illustrator, but he'd moved to Flor-
ence chiefly to finish a biographical and critical monograph, to be published
in 1876, entitled *Life and Works of Michelangelo Buonarroti*. And his fascina-
tion proved a good match for his protégé.

Though it's unclear how much instruction Heath Wilson gave the young
Sargent, the two shared a deep-seated admiration for Michelangelo as well
as an appreciation of the vital role male nudes had played in that artist's

career. In his book, Wilson praised Michelangelo's early figures for their resemblance to "Greek statues of Athletes," with "the full fullness of muscular development show[ing] how completely whilst yet so young, he had escaped from the meagerness in representing the nude hitherto so common." Michelangelo's early nudes, Wilson insisted, were "full of energy and movement; and show a power of representing the human form, which might well excite the hopes of his friends for his future."

Perhaps Wilson felt that John's satyr demonstrated similar promise. He may even have helped John choose or develop this subject, as this statue was a favorite of Michelangelo's and in fact had been restored by him. At any rate, Heath Wilson was interested enough in the lad's artistic future to recommend London the next place for John to study art. London immediately appealed to John. But Wilson's suggestion, partly thanks to the prohibitive expense of the world's metropolis, was soon overruled by others.

The fifty-seven-year-old Massachusetts painter Edwin White, who'd studied in Paris, Düsseldorf, and Rome, aired more Continental prejudices. These dovetailed with the Sargents' own. White's patches of success, though, had occurred mostly in the United States, at the National Academy of Design in New York. Once having sported curly, enfant terrible hair, White, long-faced and graying, now soberly devoted himself to teaching. He'd recently sent his promising students Frank Fowler and Walter Launt Palmer to Paris, in spite of his own disappointments in that city.

White now recommended Paris for John, who probably spoke on his advisor's authority when he described to his cousin the "unique artistic training" available there: "We hear that the French artists[,] undoubtedly the best now-a-days, are willing to take pupils in their studios." Still, John fretted that he wasn't "sufficiently advanced to enter a studio" and needed another year in a preparatory academy.

John Sargent's seemingly erratic preparation, though, along with his native ability, lent him a crucial edge. In his boldness and unconventionality, John more resembled Michelangelo than he himself understood.

What would happen next would transform the young Sargent from an inspired prospective into a world-class contender. As soon as John's ankle was better, the Sargents filled and fastened their steamer trunks. They said goodbye to their friends and boarded a train for Paris.

5

"Rather Too Sinister a Charm"

The Sargents hadn't come to Paris to see maimed trees. Streets and parks familiar to them from previous visits had been stripped of much of their greenery. Hacked to stumps or blackened by fire, these remnants marred an otherwise brilliant May full of fresh hopes and plans. All over the city as the Sargents hunted for a place to live "comfortably and cheaply," as Fitz stipulated, they encountered the shells of burnt-out buildings.

In the heart of the city, the Tuileries Palace, founded by Catherine de' Medici in 1559, had been reduced to a "gigantic heap of smouldering ruins," as Karl Baedeker's guidebook warned, after a period of turmoil beginning with the Prussian invasion of 1870 and continuing with the workers' revolt of the Paris Commune. "The ruins are not accessible to the public," the guidebook added, "but they may be well surveyed from the garden on the W. side." John and Emily had played in these very gardens, in the shadow of the now-lost palace, only seven years before, in June 1867. It had been one of the children's favorite spots in Paris.

The Sargents, trying *not* to witness such damage, shared the guidebook's outrage at the "fiendish proceedings of the Communists." Reminders of the recent social turmoil proved hard to avoid. Paris had lost not only the Tuileries but also at the Hôtel de Ville, now a vast gaunt stone skeleton already familiar to the Sargents from illustrated newspapers. (Fitzwilliam especially had rather fearfully kept track of the "war . . . going on between France and Germany," and its aftermath.) But the gutted Hôtel de Ville proved more vivid in person, blighting the Seine embankment just below the Île de la Cité. Three years before the family's arrival, this Renaissance masterwork had been stuffed with "heaps of combustibles steeped in petroleum" and "barrels of gunpowder" and burned to rubble during the final standoff

between the Parisian Communards and the nationalist Versailles army in May 1871.

By the Sargents' arrival in May 1874, the dust from the recent violent insurrections no longer floured the pavements and façades. But rubble was still to be found, cordoned off, all over the city. They could still find plump strawberries for sale, "abundant and large," that had "escaped injury," as Fitz put it. But the city had horribly changed. As Baedeker tallied the damage, "no fewer than twenty-two important public buildings and monuments were wholly or partly destroyed, and a similar fate overtook seven railway stations, the four principal public parks and gardens, and hundreds of dwelling-houses and other buildings." The Prussian troops whose invasion had set off the cataclysm that had swept away Louis Napoléon's Second Empire and given birth to the French Third Republic had departed only the year before. The city was still under martial law, ruled by the edicts of Marshal Patrice de MacMahon and his committee.

Such massive change felt personal as well as political. When the Sargents at last found lodgings in the rue Abbatrice near the Champs-Élysées, they also inherited a house servant that Dr. Sargent tarred as a "hard customer." She recounted with enjoyment the burning of the Tuileries and Hôtel de Ville. Fitzwilliam and Mary soon had to sack a domestic to whom they were afraid to entrust four-year-old Violet, as Fitzwilliam feared she would "sell or otherwise dispose of our flesh and blood." Violet was especially a concern, as she was the "biggest toad in [the] family puddle." In the Champs-Élysées, however, the Sargents enjoyed the spectacle of "thousands of carriages and tens of thousands of foot-passengers and riders on horseback." Fitzwilliam called to mind the quote he attributed to Oliver Wendell Holmes Sr., that "'good Americans when they die go to Paris.'" But he imagined that, if the dead could return, they'd "congregate about the Champs Élysées."

The Communards, though, had already disposed of quite a bit the Sargents cared about. Though painters like the revolutionary realist Gustave Courbet had sided with the beleaguered masses, the insurrection had sometimes targeted the elite art world, as an extension of other egregious privileges, at one point cramming the Louvre itself with incendiaries. (Courbet defended the museum from his revolutionary comrades, at the same time proposing a more democratic vision of art.) The library wing of the Louvre, it's true, had been gutted by the fire that had spread from the Tuileries— not by special malice—even if the progovernment Versailles troops had managed to douse the flames before they reached the picture galleries and

the superb collection of tens of thousands of artworks ranging from ancient archaeological relics to recent Salon masterpieces.

The revolutionaries, though, had mostly overlooked the nearby École des Beaux-Arts, on the opposite bank of the Seine, across the Pont des Arts, the nine-arched Napoleonic iron bridge. This institution, in its own way as venerable as the Louvre, sheltered behind iron gates and twin gateposts surmounted by busts of the artistic polymath Pierre Puget and the ground-breaking landscape painter Nicolas Poussin. Its main building or *palais* rose in a honey-colored Renaissance-revival façade in a grand courtyard. This art academy, indeed, had seemed unassailable since it had been founded by Louis XIV in 1648 "for the teaching of painting, sculpture, engraving, gem-cutting, and architecture." If its work had been disrupted by recent events, its rigorous classical training resumed in the 1870s, Baedeker noted, with a staff of fifty professors and "upwards of 500 pupils of different nationalities."

American pupils had so far been mostly architectural students, notably Richard Morris Hunt, the first American to attend the École in the 1840s. It was a measure of the magisterial reach and influence of this institution, especially in architecture, that in the 1870s and coming decades its graduates would radically reshape the face of American cities such as New York and Boston with the so-called Beaux Arts style, reduplicating the suave glories of Paris on the rock-ribbed coast of the northeastern United States.

As for Sargent himself, he'd previously tasted the far-reaching disci-pline of the École when as a child he had been expelled for disorderly con-duct from the gardens of the École's Villa Medici in Rome. But now, as a gifted eighteen-year-old with little of the discipline or formal training that the École favored, he hoped against hope to win a place in the world's most prestigious art academy.

Yet even if the École des Beaux-Arts hadn't sustained a Communard assault, its classical taste and academic methods, patronized by the French state under every government since Louis XIV, including the previous Emperor Na-poléon III, were now pitting it against revolutionaries of many kinds. A decade before, in 1863, the architectural medievalist Eugène Viollet-le-Duc had been tapped to bring about reform and inspire originality. His love for the French Gothic had inspired him to restore many of France's churches and cathedrals but also to set his neo-Gothic taste against the École's clas-

sical traditions. His inaugural lecture in the grand hemicycle of the École had sparked a counterrevolutionary uproar of "shouts and howls," soon followed by a "shower of apples, wads of paper, small coins, and eggs." Viollet-le-Duc had eventually resigned.

But, also in 1863, an even more serious challenge to the École's authority had emerged from a group of inventive young artists including Édouard Manet and Gustave Courbet. Manet painted not classicized historical epics but rather the "modern" life of the new promiscuous Parisian boulevards. Courbet, one of the founders of the independent Fédération des Artistes, was, according to Baedeker's bourgeois viewpoint, a "prominent political agitator" and "the chief modern votary of the coarsest realism." But even as a Communard, Courbet wanted not to destroy the arts but to liberate them from state control. He and his innovative allies, having rejected the institution's tastes, methods, and monopolistic privileges, found their works shut out from the vast and prestigious annual exhibition juried by the École, the Salon. But in 1863, the rejected ones, the Refusés, were determined to fight back.

The Salon of 1863 took place in a building Sargent would come to know well and would be pivotal in his life. This glass-roofed, eclectic-style exhibition space had been built for the Paris Exhibition Universelle of 1855. It had then been designated the Palais de l'Industrie but was increasingly known as the Élysée Palace (though not to be confused with the identically named residence of the French president after 1871). Mostly the Sargents associated it with magnificent state-sponsored exhibitions every spring. Yet in 1863 the Salon had complacently displayed "*une médiocrité implacable*" (an implacable mediocrity) according to Gustave Flaubert's friend, the critic Maxime Du Camp.

Most of the really original artists, with grudging support from the then-emperor, had set up a competing exhibition, the Salon des Refusés (an exhibition of the "refused ones") in a remote wing of the palace. The Refusés showcased unconventional and controversial art, most scandalously Édouard Manet's *Le Déjeuner sur l'herbe* (*The Luncheon on the Grass*), in which a naked woman picnicking with clothed men affronted the École's classical standards by rendering an ideal nude as a vividly contemporary prostitute. One free-spirited American expatriate, James McNeill Whistler, had also sided with the insurgents. He'd exhibited an exquisite and provocative portrait of his Irish mistress Joanna Hiffernan, *Symphony in White, No. 1: The White Girl*,

rejected by the Royal Academy, but eagerly included in this first Salon des Refusés.

As it happened, the Sargents' arrival in Paris almost exactly coincided with a fresh Salon des Refusés in April 1874. This exhibition exposed to public ridicule a new group of artists who'd also rejected the École—the Société Anonyme Coopérative painters Renoir, Pissarro, Morisot, Degas, Sisley, Boudin, and Cézanne, later known as Impressionists. Yet the Sargent family skirted this exposition at 35 boulevard des Capucines, as conveniently close as it was to their lodgings. Faced with a city teeming with new ideas, both artistic and social, even the more adventurous Mary Sargent opted for the known and approved.

Dr. Sargent, sensitive to the city's avant-garde reputation, disliked the risqué milieu his contemporaries often associated with Paris—what he referred to as "gaiety, vice, and debauchery." He wanted to believe that the city in fact offered a "solid substratum of honesty and probity and economy and virtue, of intelligent, honest hard-work, and of indefatigable search for truth in morals and happiness and domestic virtues"—a moral atmosphere that sounded more like an idealized vision of Fitzwilliam's native Massachusetts than Paris.

Fitz and his family duly patronized the more respectable and traditional Salon that had opened as usual on May 1 at the Élysée Palace. After all, the Sargents hadn't come to Paris to countenance lewd or even cutting-edge art. Instead they wanted to find, through the paintings of the Salon and the leading lights behind them, a well-established and respectable teacher for John, a patron whose atelier the eighteen-year-old could join.

Flanked by his parents at the Salon, John scrutinized the paintings of possible candidates. For now, at least, he shared much of his father's rectitude. Fitzwilliam, insofar as he endorsed art at all, wielded a sensibility more professional and less whimsical than his son's. He favored established and approved painters with solid careers. "Some of the French painters have Studios in which young men are received and trained," Fitz had explained to his American relatives, "and we think that if we can get the boy into one of them he will do well."

One acclaimed centerpiece of the Salon was an overelaborate, theatrical *John the Baptist* by Alexandre Cabanel. Another was Jean-Léon Gérôme's *L'Eminence grise*, a huge, dramatic historical painting celebrating the life

and machinations of Cardinal Richelieu's ally François Le Clerc. Both artists, pillars of the École, illustrated its entrenched artistic philosophy, its lionization of historical and religious painting to the exclusion of what it saw as lesser forms. But John found he didn't like these Salon masterworks. Gérôme's, he confided to his Florence mentor Heath Wilson, were "so smoothly painted, and with such softened edges and such a downy appearance as to look as if they were painted on ivory or china." In spite of his father, John was ready for something bolder.

Like Paris itself, as a future friend would put it, John was "eager for sensations." He soon fell in love with a pair of striking, rather unconventional portraits—even though the École considered portraiture a lower, debased, and mercenary form painting. One of these depicted a pink little girl dwarfed by a huge piebald greyhound. The other presented a majestic woman seated, as on a throne, "gleaming with the luster of black satin and dazzling jewels, bringing forward with intense relief the ivory tone of the skin and emphasizing its delicate carnations." This was the regal Second Empire society hostess Comtesse Mélanie de Pourtalès. Like many other young artists, John preferred this portrait's "intense expression of life" to the "sugared mediocrities" of the rest of the Salon. This portrait "created a sensation" with the Salon crowds and also with the prospective art student.

At the same time and paradoxically, John's natural caution also played a role in his choice of a potential teacher. The painter of this arresting piece, he'd heard through his Florentine grapevine, took "more interest in each of his pupils and that his atelier is less crowded and contains more gentlemanly scholars than is the case with the others." John's rather stiff term "gentlemanly" would echo through his ramifying career. As stiffly, he also considered this man, without knowing much about him, as "one of the greatest French artists."

On the contrary, though, this young firebrand of a painter more strongly resembled the insurrectionary Refusés than a Beaux-Arts academician. He'd in fact muscled his way into the Salon by force of will, public appeal, and charismatic bravado. His work was, as one of his students later acknowledged, "hotly disputed by the critics, and generally condemned without stint by the painters of the Institute"—the Institute of France, the grand academic pantheon who oversaw the École and otherwise policed French culture. The painter's name was Charles Auguste Émile Durand. But he'd impudently styled himself Carolus-Duran, transforming his common-sounding surname into a florid Latinism.

-+-

Intense-eyed, with a head of dark curls, a tweaked-up mustache, and a smart spade-shaped beard, Carolus-Duran was a reputed connoisseur of female beauty who sported a "tall and athletic frame" that, the newspapers remarked, "ought to be draped in a Spanish mantle." He cut a dashing if slightly Lucifer-like figure in the Paris art world of the 1870s, giving free rein to what one of his students called his "impressionable, artistic temperament" (see Fig. 3).

Thirty-six years old in 1874, Carolus-Duran had made his name as one of the younger and more iconoclastic of the fashionable Paris painters of the day. He'd been born in humble circumstances in Lille. He boasted a scrap of Spanish ancestry that he cited as one source of his deep fascination with the seventeenth-century Spanish painter Diego Velázquez—"harboring the fire and intense enthusiasm of the race of Velasquez [*sic*]," as one student mythologized him in an era when ethnicity implied cartoonish stereotypes. Carolus hadn't trained at the Paris École. Rather, earlier in his career, he'd chosen to emulate the radical socialist realism of Courbet. But his big breakthrough had come through a different provocation.

For the Salon of 1869, Carolus-Duran entered an elegant black-and-sepia monochrome in the Velázquez style, a portrait of his wife Pauline Croizette, *La Dame au gant* (*The Lady with a Glove*). In it, a crumpled white glove thrown down invoked Titian's *Man with a Glove* in the Louvre, thus declaring Carolus-Duran's outlawed love of the Venetian art, which the École scorned as debased and florid. Carolus-Duran's languid and erotic dropped glove also enticed Salon audiences with its subtle sexual suggestion. And his particular form of high-style, tasteful provocation increasingly fitted him for aristocratic and society portraits, including the sumptuous portrait of Mélanie de Pourtalès that had bowled over the young Sargent.

To attract patrons, Carolus-Duran held Thursday at-homes at his studio on the Left Bank, just off the rue Notre-Dame des Champs. "Titled people and celebrities of all nations," one student remembered, "rolled through the modest iron paling at either end of the Passage Stanislas and crossed the unpretentious threshold." Yet, on the inside, this showcase of fashionable art was anything but unpretentious. An obsequious valet guided visitors through an embroidered silk partition into a dramatic, high-ceilinged salon "finely lighted" by a massive skylight. The studio, hung with red draperies and paved with Oriental carpets, marshaled a luxurious, highly

arranged profusion of marble busts, statuettes, swords, guitars, antique cabinets, divans, Indian idols, and Japanese bibelots, its centerpiece being a great easel flanked by "several palettes covered with a rainbow of tones." A Worth dressing gown tossed over the back of a chair—a creation of Charles Frederick Worth, the English-born Paris designer and pioneer of haute couture—evoked the unclothed female model whose risqué frisson marked the tastes of cutting-edge Parisian art.

All of these lavish props suggested to buyers a "painter à la mode." Yet, like other successful men in the Paris art world, Carolus kept both a showy personal studio and a more practical teaching studio or atelier des élèves. The latter, a few streets away at 81 boulevard Montparnasse, offered much more homely facilities. It lay in an "out-of-the-way place," one student remembered, "surrounded by many market-gardens and long stretches of convent walls, which gave the neighborhood a rather desolate appearance."

It was to this plainer studio—a one-story building furnished with no more than easels, stools, a platform for a model, and a heating stove to warm the students as well as the shabby models of the 1870s who had no exposure to Worth gowns—that Dr. Sargent brought his son on May 26. John came with almost no resume of formal study. But he carried with him the copious and splendid portfolio he'd doggedly worked on and assembled in the Alps and Italy and that he and his parents now hoped would vouch for his ability.

The moment of truth had now come. As fellow atelier student Will H. Low remembered, John brought a "great roll of canvases and papers" that he "almost bashfully" unfurled before the eyes of Carolus-Duran and his onlooking pupils. These included "sketches and studies in various mediums," Low remembered, "the work of many years," all of them extraordinary. The sheer variety and genius of these sketches brought "amazement to the class."

The master, though, appeared unimpressed. Carolus closely studied John's sketches, scrutinizing them one by one in a way that many of his students found disconcerting. ("His observations were brief and his commendations exceedingly rare," his students remembered.) "You desire to enter the atelier as a pupil of mine?" Duran said after his customary intimidating delay, through which he kept students on tenterhooks. Then at last he said, breaking his deadpan expression, "I shall be very glad to have you do so." He'd in fact been astonished and deeply impressed.

Within days, John embarked on his training—suddenly transmuted from a touristic amateur to a Parisian art-apprentice. It was an honor to be

accepted so quickly through the *patron*'s high estimation of his work, even if
Carolus-Duran's atelier was neither as large nor as prestigious as Cabanel's
or Gérôme's, having, according to his father, "fifteen or twenty pupils, most
of them English or American." Then again, Carolus banned hazing, a ritual
common elsewhere, in which, John had heard, a "newcomer is treated in the
most brutal way . . . obliged to sing them a song, to do all their errands for
soup and soap for the brushes, and sometimes they actually strip him and
paint him blue all over, or shave one side of his head." "You may imagine
that I would not relish such jokes," he added. For, in his protective family,
he'd never had to endure rough-and-tumble school experiences.

At the age of eighteen, John remained gentle and dignified, at least
on his calm surface. He was also what he later considered to be "maudlin
sentimental"—a quality he'd soon outgrow, at least partly, as "Paris was
not the place for that kind of thing." As at most other such Paris studios,
the *patron* did not charge for his lessons but the students collectively paid to
keep up the premises—in Sargent's case, his father reckoned, it was about
twenty francs or four dollars a month. What's more, most of the students
were American or English. With the exception of what John described as
"two nasty little fat Frenchmen," the students all qualified as "gentlemanly,
nice fellows."

A live model appeared on Mondays, inaugurating the week's instruction.
He or she didn't always disrobe, for heads and costumes also were popular
in Paris studios. Often the models wore "picturesque" clothing, arriving
clad in peasant or regional dress, rather than stripping down for anatomical
studies. The students got a say in what they painted, as it was a published
rule of the studio that the choice of models (and their accoutrements) was
subject to a vote of the pupils beforehand.

Carolus-Duran himself dropped in on the atelier twice a week, on Tues-
days and Fridays. Though the studio was less traditional and hierarchal
than others in Paris, the *patron*'s review followed a strict formal ritual rich
in French scholastic discipline. The students rose from their stools; they
stood beside their easels as, one by one, he approached them, saying little
but sometimes snatching the student's pencil or brush to scrawl in improve-
ments. Quite soon in his training, John felt the influence of Carolus-Duran's
habit of "carefully and thoroughly" criticizing every student's work. "He
generally paints a newcomer's first study, as a lesson," Sargent reported to
Heath Wilson, "and as my first head had rather too sinister a charm sug-

gesting immoderate use of ivory black, he entirely repainted the face, and in about five minutes made a fine thing out of it." Yet a certain amount of "sinister charm"—in John's own suggestive phrase—was already characteristic of the master and was waiting latent in the student. Carolus's training veered sharply away from the precepts of the École.

Contrary to academic art methods, the master didn't hold with extensive drawing but rather stressed form and color. Ruskin's *Elements of Drawing*, that handbook favored by cultured Anglophones, had long privileged masses and shadings over lines. But Carolus's idiosyncratic method, based on the process of painting rather than drawing, differed considerably: he believed not in masses but planes. As one student remembered the approach, "the face must be laid directly on the unprepared canvas with a broad brush. These few surfaces—three or four in the forehead, as many in the nose, and so forth—must be studied in shape and place," especially in regard to variations of light. No "conventional bounding of eyes and features with lines" was allowed, and students made each tone in gradation, working up from medium tones or *demi-teints*, to highlights.

"*Cherchez le demi-teinte*," (Look for the halftone), the *patron* would repeat, "*mettez quelques accents, et puis les lumières*" (apply some accents and then the highlights). As Sargent himself later summed up this method, "You must *classify* the values. If you begin with the middle-tone and work up from it toward the darks—so that you deal last with your highest lights and darkest darks—you avoid false accents. That's what Carolus taught me."

These techniques weren't all that John was beginning to pick up from his teacher, however. Carolus-Duran's love and imitation of Diego Velázquez would grow into a shared passion, much more than an abstract or historical predilection. As a sixteenth-century Spanish court painter, Velázquez had been an iconoclast who'd wedded dramatic chiaroscuro with a penchant for gritty, real-life details and provocative poses. Such bold techniques, even in his court portraits, had rendered him a distinctive and idiosyncratic master during an era dominated by more conventional and history-encrusted schools of Baroque painting in Italy.

Still, after his death in 1660, Velázquez had been largely forgotten outside of Spain. But in the mid-nineteenth century, realist and Impressionist rebels in France had rediscovered him and ecstatically proclaimed him as a forerunner of their provocative, gritty modernity. Édouard Manet had dubbed Velázquez the "painter of painters. He has astonished me, he has ravished

me." James McNeill Whistler had also extravagantly if testily lionized him. Velázquez, in short, had become a watchword for the most pugnacious elements of the avant-garde.

Carolus-Duran was as besotted with the inspired painterly radical as anyone in Paris. The ever-volatile teacher would often cry out to the "shade of Velasquez [*sic*]": when painting, he'd "retreat a few steps from the canvas and then once more advance with his brush balanced in his hand as though it were a rapier." Sargent later exhibited a parallel idiosyncrasy, as his friends noted: he had a "habit of stepping backwards after almost every stroke of the brush on the canvas, and the track of his paces so worn on the carpet that it suggested a sheep-run through the heather," his biographer Charteris remembered. "He, too, when in difficulties, had a sort of battle cry of 'Dæmons, dæmons,' with which he would dash at his canvas."

-<+-

John's main goal in joining Duran's studio, though, was to gain admission to the École. After his first spring in the studio (and a summer spent on the Normandy coast with his family), John entered the throes of examinations in autumn 1874, for the first time in his life.

He now struggled with the most comprehensive overhaul in the art world. The *concours des places* involved rigorous tests in perspective, anatomy, and design. The examination culminated in a twelve-hour session in which applicants, as John related to Ben del Castillo, "must make a finished drawing of the human form divine"—in this case, a male nude in the classical mode. Such was the École's definition of divinity. John worried ("Heaven only knows if I shall get through; also Heaven alone could bring such a miracle to pass"), and not without cause.

On October 27, 1874, the examination results came down, as from Olympus. Only two members of Carolus-Duran's atelier had been accepted: J. Alden Weir, ranked thirty-first out of seventy, and John Sargent, ranked thirty-seventh. That Weir scored slightly higher—Weir had been in Paris longer and had studied with Gérôme—didn't disguise the fact that Sargent, who'd appeared out of thin air only months before, was the atelier's star pupil and Carolus-Duran's favorite.

Young Sargent's talent, in fact, already rivaled the master's. "We all watched his growth and wondered whether Carolus were teaching him or he were stimulating Carolus," John's fellow student from Léon Bonnat's atelier, Edwin H. Blashfield, recalled. Weir himself acknowledged that Sar-

gent was "one of the most talented fellows I have ever come across; his drawings are like the old masters, and his color is equally fine." Sargent impressed his fellow students while—genial, modest, and hard-working—he largely avoided generating envy or enmity among his compatriots.

"Such men wake one up," Weir remarked, "and as his principles are equal to his talents, I hope to have his friendship." Sargent's friendship, though—especially in the hothouse world of Parisian art students—would prove hard to win.

6

The *Rapins*

Most Americans couldn't get nearer the École des Beaux-Arts than peering through its wrought iron gates. But John now had the run of the most exalted temple of French art, basking in all its princely privileges, exploring all its secret inner workings. Matriculation at the École entitled him to two afternoon sessions in that sanctum of the rue Bonaparte. He studied with Adolphe Yvon, who'd made his reputation by painting Napoleonic battle pictures and also an official portrait of the recently deposed emperor. In some respects, for all its glories, the École's strict methods irked John, an eighteen-year-old with almost no formal education; in others, its rigid discipline exactly suited his industrious habits and high ideals.

For nude studies, the École employed only male models. Female models were deemed "too distracting for the students and insufficiently elevating to embody the serious and propriety sought in history painting," as one art historian has observed, women being more associated with the private and domestic artists' studios. But the appearance of male models in the classrooms and theaters of the École introduced complications in the very male-centered, conservative ethos of the École. This was true even if, as one historian has documented, the *beau idéal* of such *académies* had been gradually revised over the course of the century to allow less ideal or more individuated, down-to-earth types.

Sometime during his first two years at the École from 1874 to 1876, Sargent captured a telling glimpse of the École's life-drawing sessions. In his charcoal drawing, light fell from a high window on a nude model, only faintly recognizable as a man, in front of a class. The figure was lit in this chiaroscuro, but the students remained dark, blurred, almost sinister shapes, plying at their contrastingly bright papers or canvases. This study erased

the kinds of details that Sargent often had meticulously rendered in his earlier drawings of nude statuary in Italy. Superficially it looked like a reinforcement of the *beau idéal*, the abstracted and distanced perspective that academic art took of the male body. Yet the rather bold, dark, and dramatic quality of this drawing—a rare view *outside* of Sargent's usual perspective as one of the seated students—highlighted both the drama and psychological turbulence of the drawing of nude models and the complex emotions such exposure prompted.

During this highly formative stage in his career, Sargent sat in on sessions very much like the one depicted in François Sallé's *The Anatomy Class at the École des Beaux-Arts* (1888). In this painting, a bearded professor, clasping a model's arm in pedagogical demonstration, exposes to the gaze of the seated art students a handsome, muscular, mustached man naked to the waist, whose unclasped trousers suggest a process of undressing and introduce almost more eroticism—in the distinctly titillating manner of Madame Carolus-Duran's shed glove—than a nude model might do. As one contemporary review noted, this painting portrayed an obliging "*beau morceau de nu*" (fine piece of nude)—rather than the *beau idéal*, the dreamy, idealized nude that had reigned in earlier academic exercise. The conservative milieu of the École tried to strengthen men's bonds, bolster men's collective goals, and otherwise buttress the grand French patriarchal tradition. At the same time, the male nude during this period was becoming, in one art historian's phrase, a "troubled commodity."

In other parts of the world in the 1870s, the pedagogical use of male models didn't necessarily follow the École's traditions even during the acme of its influence. The Philadelphia painter Thomas Eakins, who'd studied at Gérôme's studio and at the École between 1866 and 1870, employed male models for quite different purposes. While an art student in Paris, Eakins wrote his father that a naked woman "is the most beautiful thing there is—except a naked man." He began teaching at the Pennsylvania Academy of Fine Arts in 1873, becoming Director of Instruction there in 1876. Inspired partly by Walt Whitman's celebration of natural eroticism, Eakins boldly employed both male and female models in his life classes. Stirring controversy especially in the land of the Comstock Laws, Eakins was eventually dismissed from his position in 1886 for removing a male model's loincloth in front of a women's class.

Yet from 1876 to 1886, in his role as teacher, Eakins and his students frequently used uninhibited nude photography in their art training. Such

earthy expressions of camaraderie, physical fitness, nature, and eroticism militated against the detached, stiff, and male-boosting *beau idéal* of academic tradition. Eakins's philosophy was most famously embodied in 1883 in his lyrical homoerotic painting, *The Swimming Hole.* The canvas was a complicated homage to Whitman, ordinary American life, and Plato's academy, providing a striking composition of six naked male figures, four youthful and two older, including a (mostly submerged) portrayal of Eakins himself.

One of Sargent's most intriguing sketches from this period, *In the Studio*, now lost except for a photograph of it taken in 1928, shows a fully clothed young man viewed from behind, sitting in an alcove and facing a naked model partly obscured, the two of them apparently in close conversation. This faceless, frock-coated student could have been any of Sargent's studio contemporaries. But, lanky and formally dressed, the figure suggested Sargent himself or at least his own point of view as an art student. The sketch evoked an unusual close-range intimacy between artist and model, more usually depicted as safely distant, conventional, and formal. Certainly, Sargent's own relation to male studio models threaded a twisting path, to judge from other sketches and paintings that have survived from the 1870s. These studies veer from the mundane into the lyrical and even frankly erotic.

Even in his depiction of the more quotidian aspects of studio modeling, in fact, Sargent pulsed with the wit and irony that would infuse his best work. Sargent's *A Male Model Standing Before a Stove*, from the late 1870s, beautifully renders the studio atmosphere of an unnamed model standing naked except for a posing pouch and slippers (see Fig. 2). (The posing pouch may be a later addition, as models wore these only when women were present.) The model's full-length, frontal pose in a glare of yellowish light appears exposed and awkward, with his spread legs and outthrust belly, his ribs and knees prominent, and his mustached face rather indistinct. Sargent emphasized the awkwardness of these features. He chose browns, yellows, and sepia tones as if to reinforce the quotidian and pragmatic aspects of the studio. The model clasped his hands behind his back as if to warm them. With the stove, too, Sargent recalled the cold, discomfort, and ennui of studio posing—often, no doubt, anything but erotic. What's more, this Italian-looking model may well have been an inexpensive studio hire. He was possibly one of the huge influx of Italian immigrants who inundated Paris beginning in the Second Empire, the École des Beaux-Arts having begun to

employ them as early as the 1850s. Such models conveniently united, as one historian has expressed it, the "sometimes conflicting concerns" of "classicism, primitivism, and authenticity."

Yet Sargent's reaction to Italian male models stood out. Almost always, he saw these figures through vivid color, lyrical movement, and brooding moodiness. Another painting from the same general period, perhaps portraying the same unnamed man in the same laurel wreath, renders the model very differently and provocatively. *Man Wearing Laurels* captures a handsome young man from the chest up, the naked bust-length portrait's laurels suggesting, as the art historian Trevor Fairbrother has described it, "a classical attribute for a man in perfect physical prime" (see Fig. 1). The Greco-Roman references—laurel leaves and reverie—hint at the *beau idéal*. But in this case the figure is so idiosyncratic, intense, and intimate as to counteract the detachment cultivated by the École. In fact, the exquisitely rendered details of the face—rich dark hair, tilted head, square chin, lips reflecting gleams of light under the mustache fashionable at the time and evidently intriguing to Sargent, deep-set eyes mysteriously veiled under the strong brows—creates a sultry and palpably erotic image. The sitter's rather aggressive expression also adds a dash of sensuality. As Sargent's friend Lucia Fairchild later remembered his remark, "cruelty, he was sometimes inclined to say, was necessary to handsomeness."

What's more, Sargent's image resembled a whole range of Victorian homoerotic art that had already emerged and that would continue to develop in many different art-world settings, not only in Eakins's Art Students' League of Philadelphia but also among aesthetes in France and Britain. In England, the so-called Pre-Raphaelite Brotherhood—not initially very homoerotic—featured painters such as John Everett Millais and Dante Gabriel Rossetti, who craved a return to the saturated colors and passionate, moody details of Quattrocento Italian art (art before the painter Raphael emerged on the scene in the sixteenth century, leading to a more mannered approach to art). Though this movement was decades-old by the time John Sargent arrived in Paris—more coeval, in fact, with his parents' generation—the Pre-Raphaelites' Old Master–inspired aesthetic revolt had continued to inspire younger artists such as the designer and poet William Morris and the stained-glass artist Edward Burne-Jones, who'd paved the way for the highly intense, colorful, and decorated sensibilities of late nineteenth-century aesthetes that were now beginning to emerge across the

Channel. In his early career, in fact, John maintained what his first biographer described as a "strong sympathy for the Pre-Raphaelite painters," even if this fascination didn't exactly show up as painterly influence in his Parisian-modern style.

As an American in a European orbit, John had grown up imbibing the art-lionizing, art-for-art's-sake sensibilities of John Ruskin, a great booster of at least some members of this school. For his part, John adored the Pre-Raphaelites for being "passionate in their art." He'd long been seduced by the very sumptuous, romantic, and provocative intensities that would fire the minds of many daring and over-the-top fin-de-siècle aesthetes, among them queer figures like Aubrey Beardsley and Oscar Wilde, who were nearer Sargent's age if not yet emerging on the artistic scene.

The thirtysomething British painter Simeon Solomon, working in the traditions of the Pre-Raphaelites, had already authored images whose dreamy eroticism somewhat resembled that of Sargent's art-school studies of young men. Yet Sargent's *Man Wearing Laurels*, in fact, appeared at least as erotically charged as Solomon's *Bacchus* (1867), another depiction of a beautiful laurel-crowned young man. (Solomon, sixteen years older than Sargent, had already been arrested in London in 1873 and then again in Paris in 1874 for homosexual activity.)

Yet whatever emotional and erotic sensibility Sargent was developing under the cover of his art training didn't express itself in the distinctly American form of Thomas Eakins's Philadelphia camaraderie. Nor did it take the characteristically English form of Walter Pater's Oxford aestheticism. (Pater's famous *Renaissance* came out in 1873, laying the foundation for a whole generation of exquisite Wildean aesthetes.) Unsurprisingly, Sargent's burgeoning explorations followed, rather, the peculiar codes of 1870s Paris bohemianism.

A bout of mild, sunny March weather in 1875 stirred up the young men of the studio, rendering John Sargent and his companions, as the nineteen-year-old put it, "wild to go out into the country and sketch." Plein air drawing or painting supplemented studio teaching; most of the young artists sought out picturesque rural retreats during the summers, and Sargent had spent the previous summer on the coast of Normandy and would spend the coming one in Brittany. But such excursions also helped provide psychological relief for spring impulses.

On this occasion, though, youthful hormones found a different outlet. As Sargent confided to his friend Ben, he and the students with whom he'd now spent many months training "cleared the studio of easels and canvasses" and "illuminated it with Venetian or coloured paper lanterns." They seized on the occasion of Mi-Carême (Mid-Lent), an ancient and distinctive French holiday. Mi-Carême resembled the Mardi-Gras celebrations that preceded Lent but, as Sargent observed, "quite surpass[ed] anything I have ever seen in the Italian carnival." The whole quarter was "out all night in the wildest festivity," John noted, and the students joined in with an extemporized ball in the studio. A hired piano poured out dance music—some of it probably provided by the musically adept Sargent himself.

Characteristically, Sargent didn't reveal if any women joined this extemporaneous party, although Carolus-Duran—unusually for a Parisian master of the day—kept a parallel women's art studio not far away. Though the École didn't admit women until 1897, the rival Académie Julian did so from 1868. Such female students were, by popular newspaper accounts, hardly retiring or diffident. They might eagerly have joined a spontaneous party. Also, on this particular holiday associated with Parisian laundry-workers, the streets teemed with young women. In parts of the city, one Paris journal reported, crowds thronged the streets, and parade floats of the *blanchisseuses* (laundresses) processed *"bien ornés"* (well decorated) with flowers that showcased these local clothes-washing beauties.

As evening came on and balls opened up, masks and costumes abounded in streets overflowing with revelers. As for the Left Bank, this somewhat disreputable student quarter boasted a café life that provided regular crowds of available women—notably *grisettes*, bold and flirtatious working-class women—as well as *cocottes*, *cocodettes*, *lorettes*, *grenouillères*, *grandes horizontales*, and prostitutes of various types. It is hard to imagine Sargent's American-dominated and "gentlemanly" fellow students inviting in disreputable women, so plentiful in 1870s Paris. But seasoned expatriates often quietly took advantage of local customs. Whoever else joined the students in their celebration, their dancing, songs, and heavy drinking went on till four in the morning. It qualified, Sargent's friend James Carroll Beckwith reported, as *"le plus bohème"* (the most bohemian) party he'd ever experienced.

Such carousing epitomized the popular understanding of Paris art-student life, and the Latin Quarter or Montmartre hosted a welter of cafés and restaurants, studios and ateliers, garrets and lodgings, dance halls and

all-night balls. This world was comically and pruriently canvassed in Parisian newspapers and magazines, through cartoons, lampoons, and eyewitness reports. Such popular myths also flourished in literary accounts such as Théophile Gautier's "Feuillets d'album d'un jeune artiste" ("Pages from the Album of a Young Artist," 1845), which traced the racy life of a Paris *rapin* or art student.

Even more powerfully, Henri Murger's *Scènes de la vie de bohème* (*The Bohemians of the Latin Quarter*, 1851) romanticized and legitimized a youthful art-world lifestyle ever afterward known as "bohemian." In the preface to his book, Murger launched a spirited defense of bohemianism as indispensable to art and literature. But his literary sketches, centered on amorous intrigues between artists and Latin Quarter women, traded on their erotic appeal; Murger's 1849 play version of his book, cowritten with Théodore Barrière, sparked a sensation at the Théâtre des Variétés. In 1896 an opera libretto based on his work would take world opera houses by storm. Giacomo Puccini's massively popular *La Bohème* unforgettably re-created Murger's seamstress and quintessential *grisette* heroine Mimi Pinson.

Enwreathed in popular success, Murger insisted (contradictorily) that artistic bohemia was both a human universal, prominent in European history since classical Greece and Renaissance Italy, but also that it *"n'existe et n'est possible qu'à Paris"* ("neither exists nor can exist anywhere but in Paris").

Young John Sargent, to be sure, strongly absorbed the Parisian version of this myth. One of his favorite books was Honoré de Balzac's *Un prince de la Bohème* (*A Prince of Bohemia*, 1840). He'd clearly imbibed such widespread popular understandings of bohemianism when he described the Mi-Carême studio dance as "a very good example of a Quartier Latin ball." "'The devil of a spree,'" he also called it—a spree being generally an alcoholic binge but sometimes implying sensual or erotic indulgence.

Fitzwilliam Sargent also knew about Latin Quarter excesses. That was what he'd meant by the "gaiety, vice, and debauchery" that he'd refused to acknowledge in his son's Paris. And in a sense Fitzwilliam was right about the Sargents' Paris *not* being that. John reveled in his Mi-Carême ball not because he lived the debauched life but because this springtime lark struck him as so unusual. "I enjoyed our spree enormously," he confided to his friend—who, incidentally, would himself soon join in Latin Quarter life. "I hope not too much; probably because it was such a new thing for me," John added. In 1875, Sargent's usual routine was structured, disciplined, and rooted in work and family.

Tellingly, John furnished his daily experience with women. But his women weren't *grisettes* but mostly Anglophone *ladies*, genteel family friends and of course his mother and sisters, to whom, as his first biographer put it, he was bound by a "romantic devotion."

In July 1876, when John was twenty, John, his mother, and his sister Emily ventured on a summer trip across the Atlantic together. They landed at Philadelphia in time for a staggering heat wave. The younger Sargents had never experienced anything like it.

Neither John nor Emily had set foot in the United States before, as much as they'd always identified themselves all over Europe as "Americans." Though shocked by the climate, they were otherwise intrigued by the offerings of a country they knew only from books, letters, parents, and expatriate companions. They met cousins, aunts, and uncles in person for the first time.

Assiduously attending the Philadelphia Centennial Exhibition in spite of the heat, John immersed himself in the event. Here he was "entirely taken up" with examples of Chinese and especially Japanese art, a growing fad in both Europe and the United States. Otherwise, he idled and sketched in Newport, enjoying hazy maritime scenes. He also traveled up the Hudson into Canada, impressed and not impressed by its vaunted resemblance to the Rhine with which he'd grown up. He took a stab at painting Niagara Falls, an obligatory set piece for American painters of the era. He also made a junket to Chicago with an artist friend from Paris who hasn't been identified.

The Sargent party devoted only three months to touring their native country. For Sargent, this first visit was just another summer excursion away from the heat and compression of Paris—and to which he took his Continental sensibilities. But this rather understated, throwaway visit was merely a prologue to a country that would in fact rule his future, and his future artistic production, more than he imagined. Sensibilities acquired in Paris would later play out for Sargent in the New World. As Oscar Wilde would later joke, in America "a good model is so great a rarity that most of the artists are reduced to painting Niagara and millionaires." But both obstreperous millionaires and provocative models lay in Sargent's American future.

The American interlude had allowed one kind of lark—if mostly involving family. Sargent's Paris life took a different shape but followed the same dynamic.

When in Paris, John was most often domestically ensconced and sheltered from "*l'existence debraillée des rapins*" (the loose life of art students). Unlike many other young painters in training, John began by living with his parents and sisters in various respectable lodgings near the Champs-Élysées, the heart of the American colony, and then took lodgings in that same milieu when his family, who hadn't changed their vagabond habits, wandered off elsewhere. When later, as an art student, he was finally boarding on his own, he avoided living—as a matter of pride and also family diplomacy—in riskier parts of Paris.

When his family was in town, John began many days, in fact, by sharing breakfast with his sister Emily. Serious and bright, now in her late teens, she wore her chestnut-colored hair up, or so John depicted her in a portrait a few years later. Emily furnished him cheer, talk, and firm grounding. When she couldn't sit across from him in person, she wrote him letters, or remembered him in her prayers, such as they were. After a childhood of illnesses, Emily was already versed in the Victorian women's role of an invalid and shut-in. She too harbored artistic aspirations and like her mother and brother painted watercolors when she could. But she'd never be allowed to study even at one of the few ateliers who accepted young women. Mary's voluble artistic unconventionality, it seemed, didn't extend to cultivating such liberties in a daughter understood to be ill and vulnerable.

Emily sometimes envied her brother's opportunities even if his exacting and obsessive work schedule didn't always strike her as desirable. John staggered with weariness some evenings. He now worked almost all the time. He attended regular sessions at the atelier and École on various mornings, afternoons, and evenings—some of them quite arduous, just as his exams had struck him as "unreasonably long difficult and terrible." As a youth who'd absorbed little formal schooling and knew few fetters outside of family life, John could easily have found his regimen onerous. But he loved his work and was delighted to sketch and paint for hours on end. He was, as Charteris insisted, "absorbed in his work to a point of fanaticism"—a description that would fit Sargent over most of his professional life.

In spite of or because of the rich, racy milieu of Paris, John most often poured his impulses, such as they were, into his art. That was his family-sanctioned venue for sensual as well as aesthetic impressions. This dynamic, too, was destined to have a future. Now, as through much of the rest of his life, Sargent was obsessed with forms of respectability. ("'Respectable' is

one of his highest terms of praise," his younger friend Lucia Miller would later observe.) Yet already he also felt an inner goad to transgress his own ideal. To work on his colorful, passionate paintings was to feel that spur almost every day. And Sargent's displacement of passions into art was rapidly becoming his signature dynamic. Increasingly, his life would show a contrast between a diffident, conventional-seeming painter and canvases whose magnificence and daring took people's breath away.

Work-obsessed, conspicuously talented, and wrapped up in his peculiar and close family whether or not they were immediately on the scene, Sargent looked like an atypical and rarified Parisian art student—and not at all a bohemian. Though he plunged into the Latin Quarter every day, he was insulated not only from the pleasures and disappointments of bohemian life but also from young manhood more generally.

Sargent's first biographer, Charteris, described Sargent the young art student as "a little shy and awkward in manner, reserved (as he remained throughout his life) in conversation, but charming, fresh, unsophisticated and even idealistic in his outlook on the world, engagingly modest and diffident." He was someone for whom bohemian Paris "formed no part of his . . . career." Stanley Olson understood the matter more psychologically, and darkly, insisting that the omnipresence of John's family provided him a false and protected emotional space that left no room for the emotional offerings of Paris: "All the menacing sensations of youth—doubt, fear vulnerability— were banished by their airless formation round him. He was safe, submerged in family life . . . John never looked outside his family to satisfy his emotional needs." According to Olson, John's sophistication, maturity, and talent rendered him separate and weirdly inhuman, and his "maturity and talent dazzled onlookers," fellow students like Alden Weir and Edwin Blashfield, "into silence," with the result of inspiring "awe, not intimacy." Such an account, however, oversimplifies the friendships Sargent was now beginning to forge.

For John wanted friends, had a mania for making friends, even if he went about it differently than his fellow students. To be sure, the serious, lanky young man hardly fit the stereotypical profile of a carefree art student. He didn't aspire to be the kind of artist who, as he later expressed it to Vernon Lee, "is screamed about by the Bohèmes over their beer at cafés." Every morning, he dressed with gentlemanly care in a bow tie, waistcoat, and frock coat, and not, as his younger friend and fellow artist Paul Helleu remembered the aesthetic type, in "the baggy corduroy trousers tight at the

ankle, the slouch hats or tam o'shanters, and the coloured sashes associated with the Latin Quarter."

Yet the Second Empire version of a *rapin*—as one writer remembered it, "his flowing locks[,] wide-brimmed hat, or voluminous Tam o' shanter, his collar and cravate à la Alfred de Musset, and the rest of his costume à la no one else in the world but his own interesting and picturesque self "— was already an historical cliché. In Sargent's Paris, in the French Third Republic, new forms of dandyism were increasingly emerging in *l'art pour l'art* aesthetic circles. They offered styles of transgression that Sargent— though rarely a flashy and self-advertising dresser in the later style of Oscar Wilde—would find magnetic and compelling.

What's more, the unconventional instincts that Sargent mostly lacked in dress were already cropping up in his tastes and mannerisms. Vernon Lee had earlier observed in Bologna that an "exotic, far-fetched quality . . . always attracted John Sargent in music, literature, and for many years, in persons." His "imaginative quality of mind" revealed itself in colorations of his speech, especially in his use of words like "strange," "weird," "fantastic," and, of course, "curious."

Continuing to see him occasionally during his student days in Paris, Lee confirmed how this sensibility had blossomed and ramified, still best encapsulated, for her, in his favorite word. This "dominant adjective in John's appreciations," Lee wrote elsewhere, was "pronounced with a sort of lingering undefinable aspirate which gave it[,] well, a *Curious* meaning of its own, summing up that instinct for the esoteric, the more-than-meets-the-eye." And such rarefied, exotic curiosity was already cropping up in Sargent's work.

Even later in life, Sargent could be boyish, enthusiastic, and whimsical in his speech: as his younger friend Lucia Fairchild observed, his "favorite expression . . . was 'La la!' and he was very gay all the time," reeling off "gay, fantastic things." In his art-student conversation, though, John wasn't a natural polemical rebel like his British fellow pupil at Carolus-Duran's *atelier* R. A. M. Stevenson. This cousin of Sargent's later friend Robert Louis Stevenson made conversation that was, according to Charteris, "iconoclastic and revolutionary, 'glancing like a meteor and making light in darkness.'" Such an art-world subversive made Carolus himself uneasy. Stevenson quite shocked teenage John. "Really my impression was that of having all my boyish ideals of art smashed (and good riddance)," he wrote in 1916, "and

being horrified by his free thought and independence—of course later on I saw the truth of what he used to say."

Though Sargent hardly understood himself as a rebel or bohemian, even his homelife in Paris was actually laying the ground for a future of "free thought and independence" beyond even Stevenson's tart example. John charmed his compatriots with his talent and "curious" sensibility—and infused his sketches and paintings with charm and devilry—partly because he remained steeped in his mother's rapturous, innocent pursuit of the arts.

While in Paris, Mary continued to cultivate her enthusiasms, visiting galleries and throwing her signature parties on a shoestring. She now invited and included John's new art-student friends. Alden Weir found the Sargents "the most highly educated and agreeable people I have ever met," with the plump, ruddy Mrs. Sargent particularly delightful as a hostess and animated conversationalist. A young Finnish painter named Albert Gustaf Edelfelt described Mary as artistically lively and witty, rather a bohemian in spirit herself: "I have never met such a woman who can discuss painting like a professional," he effused. In spite of his father's stiffness and his mother's seeming inability to appreciate the Salon des Réfusés, John's parents were artistic and unconventional enough to have outfitted their son for his own stealthy version of Left-Bank life.

Initially, the Sargents had found several rented accommodations near the Champs-Élysées, on the Right Bank, in a grand, sunny district favored by American expatriates that no doubt appeared to embody Fitzwilliam Sargent's sense of order, elegance, and propriety. Then during the winter of 1875–76, the family retreated to St. Enogat in Brittany, as accommodations there were cheaper than in Paris and the winters milder. Mary invited her son and a "couple of his friends, young American students of painting in Paris" to festivities at the little Breton house rendered "gay for them with holly and mistletoe," and laden with "mince-pie, plum-pudding, and turkey." When John returned to the family nest, Mary tucked John under one arm and Emily under the other: "My (fat!) arms," she lamented.

Otherwise, John continued to live on, in smaller quarters, in the same area of the Right Bank of which his parents approved. But in the 1870s this very quarter of Paris was actually fast becoming one of the most sexually subversive districts of the city, if in an underground and perilous mode that John, with his workaholic high ideals, probably found fully as unthinkable as the "criminal" element with which it was then associated.

The vibrant and increasingly visible queer life in Paris also coincided with art bohemianism. Nightlife cropped up everywhere in bohemian districts like Montparnasse, on the Left Bank, and Montmartre, on the Right, the former district being the one Sargent knew best and where he spent his days if not his evenings and nights. There, the same or next-door cafés, arcades, and boulevards served as venues for *grisettes* and prostitutes alongside "inverts," as sexologists had begun to call them.

Though homosexuality had been decriminalized in France since the Penal Code of 1791, continued police persecution, especially under the repressive government of Marshal Patrice de MacMahon from 1873 to 1879, during Sargent's unfolding residence in Paris, lumped homosexuality with crime and social disorder, in a city whose memories of the barricades of the Commune remained raw. Sensationalized press accounts emphasized the harsh consequences of homosexual behavior for respectable men. In 1876, for example, a young aristocratic lawyer, the Comte de Germiny, was arrested for public indecency with an eighteen-year-old jeweler in a urinal on the Champs-Élysées. This *pissoir* or *vaspasienne* (as they were called in Paris in the 1870s) lay right in John Sargent's daily path.

Ironically, the cosmopolitan quarter the Sargents had chosen for its respectable American colony—and where John continued to board even when his family headed off—figured prominently in police reports and newspaper scandal sheets. That was yet another dimension of the "gaiety, vice, and debauchery" that Fitzwilliam Sargent refused to acknowledge in Paris. However much twenty-year-old Sargent knew about this underworld, it would have appeared much more dangerous and shameful even than the world of *grisettes* and alcohol-drenched all-night *bals*.

Yet the young artist's lack of interest in woman-obsessed bohemia hints less at his rock-solid respectability than at his allegiance to a different, less visible form of bohemian life. The protected and sanctioned camaraderie of the studio offered a far less threatening space for Sargent to taste more open-ended companionship.

7

Little Billee

The summer after the Mi-Carême ball, in 1875, a year and a half into John Sargent's Paris art study, the young man took a studio with his friend and fellow student James Carroll Beckwith at 73 rue Notre-Dame-des-Champs. For this workspace deep in the Left Bank, a few streets away from Carolus-Duran's atelier, the two young artists shouldered a fee of a thousand francs, about two hundred dollars, for a winter of companionable workspace. John's parents stomached the outlay, even on their tight budget. That studio sealed their commitment to his career. The property also granted John his first independent workspace away from home.

Sargent had already haunted Beckwith's previous studio in the nearby rue des Saints-Pères. A mutually pleasurable companionship and a slightly fraught friendship had grown out of these autumn days of painting together in close proximity. "My talented young friend Sargent has been working in my studio lately," Beckwith wrote in his diary in October 1874, "and his work makes me shake myself." Beckwith, who'd begun his art training at the Chicago Academy of Design in 1868 and whose businessman father had been ruined by the Chicago fire of 1871, had also studied in New York. But he'd been ineluctably drawn to the glittering sophistication of Paris. His enrollment in 1873 at Carolus-Duran's studio struck him as inaugurating a life-changing transformation. It was the place, he later remarked, where his "real Art life began."

For Beckwith, superior art training helped put the capital *A* in Art. In 1873, Paris, the world's art capital, overflowed with celebrity painters and their infatuated students. Beckwith chose Paris for these masters as well as the company of talented young upstarts such as John Sargent. He especially craved the heady life of a private art studio. For Beckwith, who sported a

bold narrow goatee, a bright cravat, and a cape thrown off one shoulder, studio life involved a fashion statement (dandies jostled with scruffs on the Left Bank) as well as a deep plunge into the perceived Elysium of "Art." Lively studio arrangements, ad hoc or deliberate, proliferated in Paris. They shaped both its fabled artistic production and its complex "bohemian" atmosphere that was even more legendary.

Henri Murger's iconic account of bohemia, in fact, hadn't begun with *grisettes*. He'd opened his novel with the fateful meeting of a peculiar "brotherhood" (*cénacle*), who came together to forge brotherly bonds. An *"association fraternelle"* crucially defined Murger's bohemia. Compelling bonds prompted Murger's young male bohemians to gather in a studio, haunt it for hours, and sleep over after companionable drunken evenings. Even among young artists ostensibly obsessed with *cocottes*, male friendships proved at least as important as romps with women—even if they remained almost invisible in an era when male romantic friendship was "innocent" and largely uninterrogated. Yet bohemian life wasn't possible without this male companionship, enacted both in secret and in plain sight.

Strong, emotionally charged male bonds forged in shared Parisian studios also figured prominently in the best-known English-language novel later to mythologize bohemian art-world life, George du Maurier's *Trilby* (1894–95). Du Maurier, a half-French *Punch* cartoonist and writer who'd studied art in Paris with Charles Gleyre in 1856, adeptly captured the lyrical youthful chumminess of English-speaking art students in Paris. His young-buck British *rapins*, Taffy and the Laird, each sport fulsome Victorian whiskers as well as strong young physiques. They admire Trilby O'Ferrall, the novel's heroine, a half-Irish laundress and studio model. Indeed, Trilby, who as a fictional character created a sensation in the 1890s in her own right, giving her name to a fashionable hat, herself transgresses gender and sexual conventions. She first appears in the novel wearing a medley of soldier's clothing, her femininity betrayed only by a shapely foot. "She would have made a singularly handsome boy," du Maurier comments; "and one felt instinctively that it was a real pity she wasn't a boy, she would have made such a jolly one."

Du Maurier's bluff and athletic art students, who bunk together in a studio, also share it with a third and younger artist with whom they are fully as fascinated. Little Billee is small, delicate, with regular features and gentle manners. Taffy and the Laird "love" Little Billee intensely "for his lively and caressing ways" and find themselves "as fond of the boy as they could

be." Yet the novel celebrates the wholesomeness and normality of its char-
acters, repudiating any taint of homosexuality—this newly coined concept
constituting more of a threat in the 1890s, when this novel was published,
than in the less conscious 1850s, which it describes. Du Maurier did his level
best to recast bohemia's homosexual connotations. In his next novel, *The
Martian* (1896), written after the Wilde trials had made *Trilby* look even
more homoerotic, he blasted the sexually ambiguous aesthetes of the 1890s
as "unpleasant little anthropoids with the sexless little muse and the dirty
little Eros." He railed about "little misshapen troglodytes with foul minds
and perverted passions."

In *Trilby*, though, the young artists' fascination with Little Billee is so
profound that when the "charming Little Billee" quits Paris, all hell breaks
loose. The lads' boxing and fencing suffer, Taffy's muscles sag, and the two
young men sink into "such depths of demoralization" that eventually they
give up their studio and leave Paris. Taffy obsessively corresponds with
Little Billee, and finally the two athletic art students make a pilgrimage
back to London to see him. For them, art school in Paris had all hinged on
these two unconventional studio connections: "They realized . . . how keen
and penetrating and unintermittent had been the charm of those two cen-
tral figures—Trilby and Little Billee—and how hard it was to live without
them, after such intimacy as had been theirs."

Little Billee is worth noting because the studio emotions and bonds he
dramatized—fleshed out by the liberties of fiction—uncannily resemble
those that in 1875 and 1876 Sargent was exploring as a Parisian art student.
Du Maurier's friends suspected he'd based Little Billee on the painter and
illustrator Edward Walker, but the novelist actually used many facets of his
own appearance, career, and history to fill out the character of this slender,
handsome, and ambiguous artist. No one thought Little Billee was based on
Sargent, whom du Maurier hardly knew. But in 1903 Sargent's future friend
Henry James would create a character called Little Bilham, referencing du
Maurier's delicate young artist, on whom he would bestow certain elements
of Sargent's history and personality.

The parallels, in any case, are striking. Like Sargent (and also like du
Maurier in his own short Paris career), Little Billee lives with his family,
a mother and sister (though Sargent was increasingly living on his own,
even if he saw his family often). Being uninterested in *grisettes*, Little Billee
maintains an "almost girlish purity of mind." His studio mates also admire
him for "a quickness, a keenness, a delicacy of perception in matters of form

and color, a mysterious facility of execution, a sense of all that was sweet and beautiful in nature"—much as Sargent's young companions fell under the spell of his artistic genius and good manners.

Little Billee is the darling and favorite of the studio, as Sargent was, the object of some intense and complicated devotion. Yet such admiration and "love" passed as normal among these art-student bohemians precisely because, as one historian has pointed out, studio life was an exceptional "temporal space" allowed to young bohemians who would later achieve bourgeois marriages and conventional careers. Parisian bohemia amounted to an extension of conventional middle-class life rather than an alternative to it.

Yet Little Billee, though he eventually falls in love with a "sweet Alice," vividly illustrates the unconventional privileges accorded to artists at multiple stages. Even after returning to London from Paris, he plays the dandy, hobnobs with effete aristocrats, intimately befriends ambiguous and charismatic foreign artists, and even finds "much to interest him" in the "manly British pluck" of workingmen with whom he rubs shoulders while slumming. All these activities prefigure Sargent's own future. Also, like Little Billee, Sargent would ironically prove considerably more bohemian *after* his student stage than during it, annexing art-world liberties less as an ephemeral stage than as a lifelong adventure.

At twenty, at twenty-one, Sargent dodged the womanizing pursuits of bohemian life. Yet he readily engaged in the male bonding that, though sometimes connected to the homosexual Paris subculture of the time—bohemian cafés and clubs featured a strong homosexual element—was deemed harmless or even laudable in the Sargents' bourgeois circles, as it in fact sometimes was. In Paris in 1875 and 1876, Sargent may or may not have slept over at the rue Notre-Dame-des-Champs. But he spent long hours there.

The young artists' range of activities crop up in some lively sketches that he and his friend Beckwith made during the mid-1870s, glimpses of informal studio camaraderie long buried in Beckwith's personal papers but recently brought to light. Such scenes looked "respectable" in comparison to Murger's depiction of heavy drinking, *bals*, and adventures with young women, in which a *grisette*'s pink petticoat serves as one young artist's dressing gown. For, on the contrary, suited in dapper, formal clothing in Beckwith's sketches, John epitomized the high culture he admired—some of it gentlemanly, some of it fitting the "exotic, far-fetched" taste Vernon Lee observed in him.

In one of Beckwith's sketches, John hunches over an upright piano in the studio. (Playing the piano was always part of Sargent's emotional repertoire in the studio, as Vernon Lee noted a decade later during sittings when John was "talking the whole time & strumming the piano between whiles.") Leaning forward in a chair in two different sketches, John fingers Edwin Blashfield's violin. Lounging back in an armchair, he reads Shakespeare as part of what Beckwith labels a "reading club," legs comfortably yet firmly crossed.

In a number of sketches, Beckwith portrays Sargent at work, holding a palette, no doubt sometimes in Carolus-Duran's studio, sometimes in their shared space. In one case the young man's long legs, "intertwined" below him, capture, as one art historian has phrased it, "Sargent's personal panache with great intuitive insight."

The sketches appreciatively depict ultrarespectable artistic activities but always through the casual, intimate, appreciative poses that show how the young men infused their companionship with warmth and intimacy. Such mutual appreciation was always complex and sometimes not quite reciprocal. Although Beckwith deeply admired his friend, his detailed studies of Sargent's features emphasize the young man's rugged, bony profile, prominent

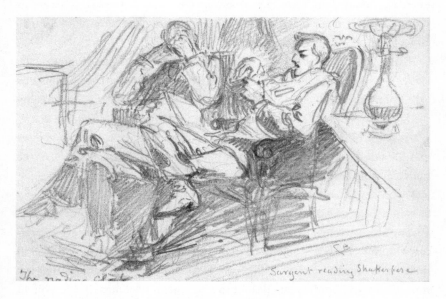

James Carroll Beckwith, *The Reading Club*, c. 1875

Two Half-Length Sketches of a Youth, c. 1878

eyes, and small chin. They appear almost ugly in comparison to Sargent's more ethereal, idealistic renderings of Beckwith, who shines with a Little Billee–like sweetness and beauty.

Sargent and Beckwith also shared, among other tastes, a fondness for sketching a young Italian model called Spinelli. Beckwith described him as "the handsomest Italian in Paris." Beckwith recruited Spinelli as the model for his 1878 painting *The Falconer*, a moody period piece in which the young man's body, fully suited in Renaissance velvet and lace, mostly vanished from consideration. Contrastingly, Sargent made two half-length sketches of the nude youth in poses reminiscent of one of his longtime favorite works, long ago discovered at the Bargello, Donatello's bronze *David*. In these studio sketches, the young model's torso became the intense focus of the artist's gaze.

Fairbrother notes that Sargent posed Spinelli in two instances that "allowed him to draw a nipple in profile." Sargent would repeat that detail in male nudes for the rest of his life, an aesthetic or erotic fixation that belonged to what Fairbrother describes as Sargent's "admiration for olive- or brown-skinned, dark-haired people of Mediterranean origin" and their "exotic allure."

Yet Sargent developed this fascination in tandem with Beckwith or at least in the same studio environment. These images, whose eroticism forcibly strikes modern audiences, blended with the respectable modes and styles of the time, in this case the work of Donatello, which rendered any eroticism acceptable and even admirable. Through the liberties of art, Sargent's particular interests were rendered almost as invisible. But they were not indistinguishable from those of studio companions like Beckwith, who followed more conventional paths. Beckwith, who left Paris in 1878, preferred female nudes. He married a decade later in 1887.

<p style="text-align:center">⤙⤚</p>

After Beckwith's departure from Paris, Sargent looked around for other friends to fill his studio time. Serendipitously, he'd already met another art student, with whom he had been forging an even stronger bond. Paul César Helleu, a diminutive, bearded Breton, was just eighteen, four years younger than Sargent. Handsome, bony, charismatic, and not without talent, he'd already been accepted into Jean-Léon Gérôme's atelier. Sargent initially impressed Helleu with his almost-native command of French. But it was an incident in Helleu's cramped studio in the rue de la Grande Chaumière that would weld the two painters together for life.

Despairing about his prospects as a painter, Helleu was on the verge of quitting art. He was about to rip up a little pastel he'd just shaded. Sargent stepped in to stop him. He insisted that the work was "Charming, charming. The best thing you've ever done, *mon petit* Helleu." Helleu, enchanted by Sargent's appreciation, brandished the pastel as a gift: "He would be proud if Sargent would accept it." But Sargent refused to take it. Producing a thousand-franc note—the same amount he'd paid for a winter's shared studio rent a couple of years before—he insisted on buying it from his friend. "I should never enjoy this pastel if I hadn't paid you a fair and honest price for it," Sargent said, earnestly.

It dawned on Helleu only afterward that Sargent's carrying this large-denomination note wasn't an accident. Rather it was a premeditated act of generosity and kindness. Helleu noted that Sargent often modestly and unobtrusively boosted his "less fortunate competitors." For Helleu, this act qualified as "the turning point of his career." Very soon the two young men were hunching together for breakfast at a favorite local café, joined sometimes by art bohemians Helleu knew: the scruffy sculptor Auguste Rodin and the pale, plump, dandyish writer Paul Bourget. In this company, Sargent showed

himself to be "vigorous, robust, full of humour and of theories minted in the practice of his art." He ate heartily and "warmed the company with his laughter."

Sargent soon called Helleu "Leuleu." The two young men were seen everywhere around the Left Bank, joined at the hip. Sargent persuaded Helleu to sit for him—and he was to paint Helleu many times, often informally (see Fig. 4). Sargent was attracted to his friend's devil-may-care charm and to his "wiry and physical angularity," as Richard Ormond and Elaine Kilmurray have noted. Sargent was particularly obsessed with his friend's "bony male knees." In turn, Helleu thrived on the attention and appreciation. Later he too married. He also produced a plethora of female nudes, in contrast to Sargent's many male ones. But Helleu carried a letter from Sargent with him the rest of his life as a keepsake of their intimacy, and he and Sargent remained loyal and lifelong friends. Even more materially for Sargent's future, Helleu boldly circulated on the fringes of queer Paris and would in fact introduce Sargent to some of its most prominent figures.

As Sargent's studies progressed and deepened in 1876 and 1877, his version of art-student companionship flowed in many channels. He and his artist friends' reciprocal painting of informal sketches and portraits continued over years of mutual work. In 1876, Sargent painted a portrait of his fellow art student Frank O'Meara, whom he remembered as "irresistible" from painting excursions together to Fontainebleau. Artists modeled for one another for free. But their mutual depiction also provided an avenue for playfulness, intimacy, and mutual appraisal. In Sargent's case, too, these informal likenesses accrued additional importance. For by the later 1870s he was beginning to contemplate, partly in order to earn a living for himself and his family, a career in portraiture.

-<+-

For his first entry to the Salon of 1877, Sargent executed a portrait of family friend Fanny Watts. Two years younger than John, Fanny belonged to a genteel New York dynasty who'd come to Europe to save money. She circulated in the same educated but cash-strapped circles as the Sargents. At St-Enogat in Brittany, Sargent made a sketch of her dark hair, dark eyes, and rather long face. His parents, with whatever accuracy, worried that John might start a romance with her; Mary was reputed to advise her son against any such scheme. The young woman, however, served as Sargent's first foray into art if not into romance. Dr. Sargent deemed his son's portrait a

"very creditable performance" and predicted, correctly, that the jury of the exhibition would accept it.

In launching a career as a portraitist, Sargent was choosing both a safe and a risky business. Quite apart from the financial aspects, painting paying sitters was rife with potential conflicts and complications. Even at twenty-one, Sargent well understood that any portrait was a complex negotiation among a painter, a sitter, and (sometimes) a patron—not to mention buyers or audiences. Thus, he would instinctively seek out images that capitalized on such heightened interpersonal transactions, each canvas amounting to a flirtation, a tense collaboration, or a headbutting conflict. Such interactions produced lively portraits. Yet such turbulence was a bumpy way of earning a living, as Sargent would soon come to know.

Of course, the art establishment of the Belle Époque didn't usually understand artists' relations with sitters, whether aristocratic nabobs or life models off the street, as collaborations. They certainly didn't see women's involvement in portraits as any form of empowerment or participation, even for patrician women who fished banknotes from their reticules to commission the works. With penniless models—whom Sargent would continue to paint, for his own pleasure, for advertisement, or for sale to collectors—the situation was even more unequal. Painters, critics, and audiences alike regarded studio models as objects and not subjects, as mere faces and bodies. Anything they contributed belonged to the artist and his imagination.

Portraits, though, would prove a rich medium for Sargent not only artistically but also socially, linking him to both nabobs and ne'er-do-wells. By choosing this most personal, private, and individual of painting genres, Sargent was committing himself to a lifetime of one-on-one relationships, commercial or passionate, that would overlap with his personal friendships and love interests. Already, in fact, he was making a career out of painting not only what he knew, but *whom*, and whom he wished to know better. Though often quite commercial transactions, created by commissions from strangers, portraits as often stood in for friendships—deepened friendships, or undermined friendships—the whole elusive emotional business captured in layers of paint and pentimento.

—◆—

That same year as Sargent's Salon debut, Carolus-Duran received a commission to provide a ceiling decoration for the Palais du Luxembourg. So, during Sargent's fourth year in the studio, Carolus enlisted him and a few other

students as understudies. Thus Sargent and Beckwith secured public if anonymous cameos by painting each other's likenesses. Sargent was now sporting a beard, partly to disguise and fill out his slightly receding chin. His image, though, merged into a crowded historical composition commemorating Marie de Médici.

As part of this rather incestuous studio project, Carolus-Duran painted Sargent as well, according to Emily Sargent. John also added Carolus's image, recognizable from its diabolical mustache, into the composition. This impish likeness so intrigued the master that "he told John he would sit for his portrait." At this point, the artists' playful renderings of each other were growing much more serious and significant, a matter of their careers as well as the complicated interactions of the studio. To paint the master as opposed to a fellow student, and to paint a formal portrait of this well-known public figure for exhibition in Paris, was for Sargent an intoxicating project, if also a fraught one.

Sargent knew that master-student bonds often grew even more intense and fraught than those between acolytes. The admiration and rivalry that had simmered between him and his teacher for years were apt to boil over this new portrait. That he was Carolus-Duran's conspicuously favored protégé—the only student from Carolus's studio to achieve a rating of second in the *concours*, in 1877—gave Sargent a privileged and glamorous footing.

Yet it was a problematic one, according to Blashfield, who thought that Sargent "was the envy of the whole studio and perhaps a bit the envy of Carolus, himself." The teacher "had, however, to admire generously" his star student. Sargent had long enjoyed a conspicuously close relation with Carolus. "The friendship existing between this young artist and his instructor . . . is of somewhat unusual intimacy," a writer reported in *Art Amateur* in 1880, detailing how Duran took Sargent with him on visits home to Lille. In that city, he "love[d] to have his young American disciple in company, introducing him to his relatives and making him a participant in his honors." On a studio group excursion to the South of France, when two pupils had to return to Paris because of illness, the master even "took one of their vacant beds in my room," as Sargent confided to his old friend Ben.

The bold, engaging portrait that Sargent painted of Duran paid tribute to his teacher and to their intense four-year relation (see Fig. 3). It also marked the first major portrait Sargent attempted—major because of its well-known, almost notorious subject, and also because of its inventive treatment of Carolus.

Sargent depicted his teacher seated against a dark background, leaning slightly forward in a pale-brown jacket and dark cravat, with the crimson ribbon of his Légion d'Honneur peeping from in his lapel buttonhole. Carolus wore an intense, weighty expression on his handsome, bearded face, with its upturned mustache. The bold composition also showcased Sargent's own abilities and his arrival as a painter in his own right. He inscribed it "*à mon cher maître M. Carolus Duran son élève affectioné.*" The portrait attracted a rush of favorable attention at the Salon of 1879 and won Sargent a precocious honorable mention. Carolus, though, seems to have rather taken the credit for his student's achievement, remarking, "*Oui mais Papa était là*" (Yes, but Papa was there).

One contemporary critic found that Duran's fashionable clothing, with his lacy cuffs, gave "a somewhat effeminate effect to 'dear Master Carolus.'" Other observers at the exhibition found Sargent's portrait "*épatant*" (shocking or amazing), according to John's fellow expatriate Charles Du Bois. With its pugnacious references to the style of Velázquez, with its intense gaze and theatrical pose, it certainly amplified Duran's iconoclastic intensity, so defiant of academic strictures. For the École, portraiture—and especially lush, sensational, somewhat edgy portraits—rated as lesser, more opportunistic paintings than other, more elevated genres such as historical or mythological painting. Even landscapes nudged out portraits as honorable productions. Such a system appraised Sargent's Carolus as a "minor" piece impatient to arouse major attention.

Fewer observers noted John Sargent's other contribution to the Salon in 1879, a painting of a young costumed peasant woman festooned over an olive tree, entitled *Dans les Oliviers*. Though Sargent didn't include the name of the sitter—and what did Paris care for the names of its penniless models?—this figure study also qualified as a portrait. John had painted it when off on his own, far from his family and from Carolus's Left-Bank studio. And it depicted a stunningly beautiful young woman of Arab appearance.

8

Rosina's Spell

In August 1878, in the isolation of his hotel on the island of Capri, John Sargent pined for the companionship of the Latin Quarter. Now, at this distance, that group of young men struck him as momentous. Having just taken an erratic, listing steamer across the bay, he'd escaped a teeming city of Naples, where also the mosquitoes, fleas, and bedbugs had tormented him. He was bound for a beautiful, rocky, two-peaked island that caught the breezes. Though he'd first visited the island in 1869 on one of his family's rambles, he was now returning by himself and with a fierce determination to paint something extraordinary—and also, it seemed, to taste independent experiences outside of the Sargent family milieu.

Capri promised Sargent new and provocative liberties. By preference, John left his family only to join other artists on their excursions, a habit he'd begun years before in the Tyrol with his early teacher Charles Welsch. In the summer of 1878, some Latin Quarter "fellows" had gone on a walking tour. But John, fastidious or standoffish, hadn't joined them. Now he regretted that, craving news of them all and welcoming a letter from his friend Beckwith, currently in New York. Beckwith, by the way, was the very artist chum who'd recommended Capri as a splendid place to paint. John was now homesick for the friends who'd made such recommendations. As he told Ben, "I am inclined to think that companionship a great object."

Pining for the Left Bank motivated John to re-create a facsimile on Capri. Sargent soon linked up with a stranger, drawing on his family's talent for making on-the-road connections. Shortly, he was once again sharing a studio with a young fellow painter. Twenty-eight-year-old Frank Hyde, an Englishman with a bushy walrus mustache, met Sargent halfway by also knowing

Paris—not from the studios but from the battle lines of the Franco-Prussian War, during which he'd worked as a war artist. Hyde painted in a literal, linear illustrator's style, though on Capri he also indulged in the colorful aesthetic instincts characteristic of the young, brash 1870s art world. Seemingly he could cope with what he called "brilliant Prix de Rome men," an ambitious category to which Sargent rather belonged, even without actually having won that prize.

In one sense, the easygoing Hyde had come to Capri simply as a tourist. Capri attracted increasing numbers of sightseers in the late nineteenth century with its sea-grottoes, particularly the Grotta Azzurra, rediscovered during a swim in 1826 by another artistic pair, the German writer August Kopisch and his painter friend Ernst Fries.

Still, the sirens of art had also lured Hyde to Capri. The island's antiquities, picturesquely steep villages, and pliable and good-looking inhabitants also attracted all manner of artists. Living was cheap, and Hyde had managed to create a splendid studio for himself in the abandoned seventeenth-century monastery of Santa Teresa, formerly occupied by Franciscan nuns, with its large central courtyard, huge Gothic doorways, and, on the second floor, three cheerful, sunlit rooms. On this steep, rocky, and crowded island, this impromptu studio furnished a serene atmosphere of light, whitewash, and open possibilities. These also appealed to Sargent. He soon painted both exterior and interior staircases, lending these architectural details and spaces a vibrant life of their own—some of the earliest examples of such revealing marginal and off-center architectural views in Sargent's work. Left to himself, Sargent *was* off-center.

The main hotel on the island, the Albergo Pagano, being full, Sargent found himself sharing quarters with his new friend in "one of the charmingly picturesque houses of the *contadini* [peasants]," Hyde later recollected. Every morning they had breakfast

> under a vine-covered pergola, where we could pick the grapes as we wanted them. The table, covered with a clean white cloth of coarse homespun, and laden with Capri delicacies, was flecked with patches of sunlight that filtered in through the leaves above; the sweet scent of orange-blossom filled the air, and now and again a tantalising aroma would reach us of the delicious coffee being roasted by the pretty waiting-girl in the garden below.

John Singer Sargent, c. 1880

Artists on the island, many of them English and French, gathered at Scoppa's Café or trawled, Hyde reported, "the tobacco shops, hidden away under the Moorish arches round the corner of the Piazza." For Hyde, the steps of the local market, where large flat baskets of fruits, vegetables, and fish were colorfully spread out, provided an ideal rendezvous for artists who "discussed affairs of State, heard the latest scandal and arranged those impromptu picnics and dinners which were among the island's greatest charms."

"Scandal" and picnics on Capri would soon include other artists whom Sargent was getting to know on this sunny, sociable little island. The Albergo Pagano, where Sargent finally claimed a room on September 14, proved a den of free-spirited art excursionists. Many of them were young, French, and, like Sargent, hankering for picturesque views to raise their spirits and boost their careers. We can glimpse the ephemera of their interactions because these artists recorded their playful wit and camaraderie right on the plaster walls of the hotel, as the proprietor allowed them to embellish almost every available space with decorations, drawings, cartoons, and painted images. Many of these impromptu jokes and little masterpieces have since been lost,

but a few drawings now preserved at the Biblioteca del Centro Caprense in Capri testify to the bohemian-style male companionship that enlivened this energetic group.

The twenty-eight-year-old French painter Théobald Chartran drew cartoons of pairs of handsome bearded young artists painting together on hillsides, sharing inside jokes about painterly motifs and broken paintbrushes. Another sketch shows a party riding donkeys up the steep mountain staircase to the town of Anacapri. Two more cartoons depict Sargent himself, characteristically playing the piano, alone or in a group of lounging artists, a lanky figure with big feet and a cowlick who is clearly at home in this lively group of chums.

Such fun and raillery didn't just blossom from high spirits and free time. It also signaled important personal and professional connection-making, something for which Sargent was developing a talent as well as a hankering. He'd become friendly enough with two of the guests at the Pagano, Charles-Edmond Daux and Armand-Eugène Bach, that he'd later travel with them to paint in Spain and Morocco. In the Pagano drawings, Frank Hyde depicted the handsome, suave Daux as a Renaissance figure with a ruff collar and a dashing peaked mustache and two-pronged beard. In the upper right-hand corner of this drawing, a dripping heart under a skull and crossbones suggests some amorous hazard in Daux, perhaps that he was a *roué* or womanizer, and certainly that he was powerfully charismatic.

In an equally momentous if even more mysterious connection, Sargent also encountered on Capri the French painter Auguste-Alexandre Hirsch, with whom he'd later share a studio in Paris from 1879 to 1883 and who'd become, according to Ormond and Kilmurray, a "close personal friend" even if "the record is silent both about their personal relationship and their influence on one another as artists." In 1914, after Hirsch's death, his widow sold a collection of twelve Sargent pictures that had belonged to Hirsch— including several works that the younger Sargent had possibly painted at Capri, including one of the most moodily erotic of Sargent's early studies of a male model.

Whatever "scandals" Hyde heard at the market or the artists circulated at the Pagano, Capri swarmed with erotic intrigues. It enjoyed a reputation for decadence that dated back to the Roman emperor Tiberius, whose island villa had reputedly hosted orgies involving both girls and boys. Sargent knew this history: as a lad of thirteen, he'd told his friend Ben about the "Salto di Tiberio, where Tiberius used to throw his victims into the sea."

The German historian Ferdinand Gregorovius, whose book on Capri was published near the time of Sargent's visit, asserted that Tiberius had kept a young male lover, Hypatos, whom, "under the influence of his demon," he "sacrificed to the sun" in one of the grottoes, as the Emperor Hadrian had later (metaphorically) sacrificed his favorite, "the beautiful Antinous," to the Nile.

Partly because of such legends, but even more because of the poverty, willingness, or enterprise of the local inhabitants, Capri attracted sexual tourists. As early as the seventeenth century, the island was known for the beauty of its women and men, both of whom, according to one early French visitor, "gladly do good turns." As the Duchesse de La Vallière, the mistress of Louis XIV, had once quipped, homosexuality was common in Spain among monks, in France among great nobles, and in Italy among everyone. By the nineteenth century, in fact, homosexuality was understood to be so common in Italy—caused, some thought, by a torrid climate—that it was sometimes termed "the Italian vice." And Capri was particularly sweltering in this respect. The German poet August von Platen-Hallermünde wrote poems to Capresi fishermen in the 1820s. Especially beginning in the late nineteenth century, Capri attracted high-profile queer foreign visitors and residents, including such figures as Hans Christian Andersen, Oscar Wilde, Axel Munthe, Somerset Maugham, and Romaine Brooks.

Sargent's visit, to be sure, antedated the most notorious period of Capri's homoerotic heyday that began with Italy's legalization of homosexuality through the Zanardelli Code of 1889. In later decades, Capri's reputation grew considerably, broadcast by many high-profile figures and cases. These included the homosexual scandal and suicide of the German industrialist Friedrich Krupp in 1902, the flamboyant public lifestyle of the French writer Jacques d'Adelswärd-Fersen and his lover Nicolo Cesarini at the Villa Lysis in the early twentieth century, and shelves of memoirs and novels exposing the shocking lifestyles of Capri beginning with d'Adelswärd-Fersen's *Et le feu s'éteignit sur la mer* (1910), Norman Douglas's *South Wind* (1917), and Compton Mackenzie's *Vestal Fire* (1927). Yet, even in 1878, Capri had already established strong homoerotic associations.

Sargent couldn't have been ignorant of Capri's reputation. True, the island was also more generally in vogue among English and French artists in the 1870s. Sargent's friends and acquaintances there tended ostensibly to be, like Frank Hyde and many of Sargent's companions at the Pagano, lovers of women. Still, many of these figures were attracted to the island

by its perceived sexual liberties. Some artists married local women. Some, like Charles-Edmond Daux, the dashing young French painter who had appeared with a toxic heart in Hyde's cartoon, celebrated exotic female figures and erotic nudes in their work, whether or not they carried on sexual intrigues. It wasn't without reason that Frank Hyde would later write that on Capri, "Great Pan is not dead. He lives, he lives for those who can still hear his whispered music."

For Sargent, that whispered music included male models, including one of his most sultry portraits of Italian men, *Young Man in Reverie*, an oil study that shows its subject leaning against a whitewashed wall, flanked by white-and-blue porcelain. Sargent defined this mustached, dark-haired young man by contrast, in bold, dark colors, the man's eyes half-closed, his dark clothing (nineteenth-century and not classical) hitched down to expose a naked chest and bare arm ending in a hand tensed on his hip.

Hyde may well have seen this painting. Yet when Sargent asked Hyde and other artists to find a model for him—especially one who would characteristically embody Capri—Sargent's friends all had one person in mind: Rosina.

Rosina Ferrara, a seventeen-year-old peasant girl, came from the primitive and as yet unspoiled village of Anacapri, up a vertiginous rock staircase at the top of Monte Solaro. She'd been first discovered a couple of years before by a visiting French painter. Once launched as a model (and sometimes a mistress), she would make an astonishingly successful career for herself, being painted by any number of English, French, and American artists on Capri, including Hyde and the American painter George Randolph Barse, whom she'd eventually marry in 1891. Lithe, brown-skinned, strong-featured, with raven-black hair, Rosina represented an exotic "type" in the highly racialized language of nineteenth-century ethnicity.

Hyde understood Anacapri girls as exhibiting "the Oriental colouring and Saracenic features . . . handed down from the time when that old Moorish pirate, Barbarossa, made his raids upon the island and carried off the women." Almost every foreign visitor to Capri described the local girls in this same way, Gregorovius noting that their "features often show signs of the mingling of different races," giving their faces "something of an Oriental character." Typically, Gregorovius understood such exotic beauty as both racially "other" and sexually compelling, as "wild" and "strange." Not

coincidentally, such problematic exoticism also strongly emerged in a re-
view of Charles Sprague Pearce's portrait of Rosina in the Salon of 1882,
which described Pearce's model as "tawney-skinned, panther-eyed, elf-like
Rosina, wildest and lithest of all the savage creatures on the savage island
of Capri."

Paradoxically, such "savage" young women were also seen as innocent—
as "simple" and "primitive" in Hyde's typical terms; as naïve, charming,
natural, and "unperverted" in Gregorovius's. These paradoxes of unruli-
ness and purity stemmed from the contradictions of nineteenth-century
ethnic stereotypes. In short, these women projected conflicts of Victorian
male heterosexual desire: "They made excellent wives," Hyde remarked.
They also reflected the inconsistencies of the French vogue for painting
peasants. As a characteristic genre of the time, peasant paintings (especially
those of peasant women) sought to capture both the unsophisticated sim-
plicity and earthy sensuality of such homegrown exotics. Such countrified
locals provided imagined antidotes to the more jaded urban life of cities
like Paris. The painterly cult of peasants even furnished its own southern
Italian incarnation. This specific vogue stemmed in part from Alphonse
de Lamartine's *Graziella* (1852), a wildly popular novel about a young
Frenchman who fell in love with a fisherman's granddaughter. Sargent, with
his thorough knowledge of French literature, had probably read this high-
colored, melodramatic work.

In any case, the young painter understood the art value in Paris of Capri
peasant-girls. He'd painted picturesque peasant women and children gath-
ering oysters on a Breton beach for the Salon of 1878. He now longed to
replicate this success with a Capri subject. It's no accident that he submitted
a painting of Rosina in profile, twined about an olive tree, *Dans les Oliviers*
(*In the Olive Grove*), to the 1879 Salon, along with his virtuoso portrait of
Carolus-Duran.

Hyde understood that Sargent was fascinated with Rosina, but such a de-
scription actually understates the young painter's obsession. Sargent painted
Rosina numerous times, in academic profile, stringing onions, dancing the
tarantella on a rooftop (see Fig. 5). Hyde reported seeing stacks of such
studies heaped up on the floor of Sargent's bedroom, even on the bed, in the
Grand Marina. Sargent's mania to paint Rosina stood out even in a milieu
where many artists had painted her repeatedly, testing her vaunted patience
and tractability as a model.

That Sargent acted from some romantic interest in Rosina, feigned or genuine—as his family had perceived in the case of his previous model Fanny Watts—isn't impossible. Also, John found himself in a situation that strikingly resembled Parisian bohemia, harboring a fascination for colorful and outré young women. Sargent hadn't really frequented that bohemia. But he was beginning to create certain idiosyncratic imitations or approximations of it, casting Mediterranean women as his evocative central figures. He also reduplicated his own earlier role in this bohemia, as he inscribed many of his sketches of Rosina to his fellow artists on Capri, using this rather outré figure to bond with his male compatriots.

Aesthetically at least, Sargent was strongly attracted to Rosina, as his multiple sketches attest. Yet his portrayals of this young Capriote, though charming and compelling, show few signs of erotic interest. Hyde painted Rosina reclining on a leopard skin, in classical draperies falling off her shoulders, her head propped up on one hand, her face intense and alluring—her expression reminiscent, in fact, of the sultry Italian men Sargent painted since the mid-1870s. By contrast, Sargent posed Rosina in full Caprese dress, in a long-sleeved white blouse and long pink skirt, often in profile, in positions that emphasize the young woman's grace, confidence, and self-possession.

Though romanticized, dreamily sentimentalized, and perhaps a little vampy, Sargent's Rosina subtly evaded both the sexual objectification and ethnic stereotyping of the time, so common to the cult of picturesque peasants. The art historian Kilmurray has accurately described this seemingly natural but carefully constructed Rosina as "self-contained, distant, and detached from the spectator, lost in reverie, a mysterious creature to whose secrets we are not granted access." But why would Sargent labor long and hard to create such masterful "independent creatures—sultry, sensual, and self-possessed," that differ from the sentimental conventions of the era, creations that often appeal to today's audiences?

John Sargent had grown up in close proximity to powerful, complex, ambitious, and self-possessed women—his mother and her venturesome expatriate friends. But Rosina stood out as a very different kind of woman. She didn't resemble his mother or his sister Emily, of whom he had painted a sensitive, attentive portrait in 1877, during the era when they'd often breakfasted together. Rosina's differences defied the genteel Anglo-American women Sargent knew best—they contrasted with the staid, respectable,

inhibited painter himself. Yet his vision of the young woman stimulated him as nothing else did. Was Rosina, that demure-looking femme fatale, transgressive and independent in a way that he couldn't be himself?

Rosina troubled Sargent enough to initiate a habit, a preoccupation, an obsession. He was beginning to direct his energies to magnetic and iconoclastic female figures. He was taking his first steps, in fact, on a path that would lead him to a painterly adulation of exotic, theatrical women—the women who'd later be termed divas in London and Paris.

Rosina wasn't a performer per se—unless to be an outrageously popular model was to qualify as such. Yet in his painting entitled *Rosina*, Sargent would paint the young woman in a dramatic, sideways dancer's stance. In *View of Capri*, he would show Rosina surveying the scene of the island, hands on hips, as if she owned everything she surveyed (see Fig. 5). And in his *Capri Girl on a Rooftop*, he'd portray Rosina with lifted arms, dancing the tarantella. That peasant dance was already resonant from the male Neapolitan model Sargent had sketched back in Florence four years before. Now, though, repurposed in female form, that peasant dancer would become a much more enduring figure for him. Rosina was his first concerted devil-may-care female exotic.

On an island full of handsome and sometimes willing fishermen, Sargent's aesthetic choice—certainly his public choice—was Rosina rather than her male cousins. Such an option wasn't accidental. Perhaps deceptively, Sargent's fascinations paralleled those of his fellow artists at the Pagano who displayed more overt or pronounced heterosexual interests. But—unaccompanied by clear erotic inflections—his interests swerved into a different path. Especially in his exhibition paintings—and Rosina was clearly destined for the Salon—he mostly kept to female objects.

Meanwhile, the elusive possibility, the theatrical or fantastic hope that animated Sargent's canvases, also led to other telling manifestations on Capri. Assuming his mother's inveterate role of host, Sargent threw at least one evening party during his residence on the island. With his Pagano friends, he "imported a breath of the Latin Quarter" to the Grand Marina, as Charteris reports. He hired an orchestra of tambourines and guitars as well as number of tarantella dancers to entertain his fellow artists on the island, including his French artist friends and his studio sidekick Frank Hyde. The audience of male artists wasn't immaterial, though it tended to disappear from most accounts of Sargent's time on Capri.

Frank Hyde, for one, was quite smitten by the spectacle and recollected

even decades later "with what delight we watched the effect of the graceful figures, silhouetted against the fading twilight, and, for a background, Vesuvius with its dark purple mantle and crown of fire." Sargent, perhaps smoking a cigarette, looked on, detached, enigmatic, full of the potential of his gift.

9

Travels in the Dark

Sargent had learned to smoke back in Paris, and there he'd grown his trim copper-brown beard, that badge of his freshly attained manhood. But now, in summer 1879, he'd cast off from Carolus-Duran's studio—though he'd hardly managed, yet, to escape his teacher's shadow. At his Right-Bank lodgings or his Left-Bank studio, the twenty-three-year-old painter found himself restless, wanting to be doing, wanting to be anywhere but the stuffy, overheated city. He was itching to reclaim the itinerant pan-European life on which he'd been raised.

Now that his friend Beckwith had returned to New York, Sargent divided his rather ramshackle studio at 73-bis, rue Nôtre-Dame-des-Champs with his new forty-six-year-old French-born Jewish friend from Capri, Auguste-Alexandre Hirsch. The two artists shared one large room that overlooked a sliver of garden. Here both men lost themselves in imaginings of far places—Sargent with such romantic sun-drenched scenes as filled his Capri pictures. Once upon a time, Hirsch had painted erotic classical genre pieces, streaked with pinks and greens and sporting crooked branches and half-naked figures. One of his best-known paintings from a decade before, *Calliope Teaching Orpheus*, featured a harp-wielding muse, her gown slipping from her plump shoulder, instructing a handsome and ephebic youth, crowned with blossom, naked above the silken crimson drapery in his lap. More recently, though, Hirsch had turned to orientalist pieces of the type he'd recently been pursuing on Capri, with lyrical peasant-women, which types he'd also painted in North Africa.

At best of times, neither Sargent nor his older friend was very tidy. Their mutual studio resembled the workshop that it was—canvases heaped against the walls, drifts of drawings encumbering the floor. A harmonium

and a guitar offered relief or distraction from obsessive labor at their easels. Sargent worked long hours at Montparnasse but slept a couple of miles away at the Hôtel des États-Unis, on the Right Bank of the Seine. Baedeker described his hotel as "second-class," but it stood near the Opéra in a white-façaded, respectable quarter of Paris that was, as the hotel's name suggested, preferred by Americans. Sargent's family, though, had recently headed off to the French Alps for the clearer air of various "cures," and the young painter was once again on his own and rather at loose ends, inclined to smoke, brood, or strum on the studio guitar.

John's restlessness of that summer showed up, brilliantly, in a portrait he painted of the celebrated poet-playwright Édouard Pailleron. Startlingly, the pink-faced and whiskered Pailleron appeared in what his daughter would later describe as *"en veston de travail et chemise de soie ouvert"* (in a work jacket and an open silk shirt). That much was an *"infraction aux règles"* (a violation of the rules), as she termed it. Boldly, Sargent didn't portray Pailleron in formal clothing, as the strictures of genteel portraiture dictated. Yet this rather bohemian piece proved even more provocative in its pose, with Pailleron half slouching in his stance, a dog-eared manuscript in one hand, his other hand planted on his hip—a detail that Sargent emphasized in his composition with streaks of luminous pale-pink paint glowing against a pitch-dark background.

This swagger owed to Velázquez, of course, and to that historical painter's style of provocation. It also fit a feisty playwright who, two years later, would stage a smash-hit play called *Le Monde où l'on s'ennuie* (1881), sometimes translated as *The Art of Being Bored*. Pailleron's crowd-pleaser was destined for a long stage-run at the Comédie-Française. His spoof of aristocrats and dandies also played well in London; and when, a decade later, Oscar Wilde's *The Importance of Being Earnest* premiered, a critic compared it, favorably, to Pailleron's amusing romp. Though Pailleron wasn't quite a proto-Wildean figure, Sargent instinctively chose a theatrical, insolent gesture to define him.

What's more, Sargent had used a similar gesture in his earlier portrait of Carolus—the master's left hand planted on his thigh, with a cocked elbow. That counted as one of the unconventional elements that a critic had seen as creating "a somewhat effeminate effect." Whether or not he was aware of it, Sargent was beginning to choose gestures and poses that his era read as insolent or outrageous, as violations of gender or even sexual norms. For even, or especially, when drawn from historical portraiture, a hand planted

on the hip was not a neutral or random posture. As historians have documented, it was a loaded gesture with a complicated history in European visual culture, drawing on long traditions in both aristocratic portrait painting and as well as illustrations, caricatures, and cartoons that treated dandies, tramps, vamps, and divas in Sargent's contemporary world.

In posing his sitters with an arm akimbo, Sargent made a risky move. But it was just this bold portrayal of Carolus that had attracted Pailleron, though a family man and later an elected member of the Académie Française, and spurred him to commission a portrait. Sargent's successful high-style provocation with Carolus had in fact engaged audiences rather than repelling them. Such outré painted gestures had raised the young painter's profile. Sargent's brazen, unconventional image of a local black-sheep celebrity had even earned him an honorable mention at the conservative Salon, an auspicious honor for a fledgling painter.

What's more, in spite of Sargent's subtle and fashionable transgressions in this piece, his decorous father too had been proud of the portrait, the prize, and, in a more restrained way, his son. He'd retailed to his brother Tom back in Massachusetts the many remarks he'd overheard about the painting's "excellence." Ever practical, though, Fitzwilliam believed that "the proof of the pudding is in the eating." Success for his would-be painter son must be measured in commissions.

Though Paris painters could and did paint works without preexisting commissions—hoping to sell them later, sometimes to a stable of admirers whose tastes they knew—portraitists especially worked through concrete orders, lodged by the sitters themselves, their families, or their friends. Portraiture was a strangely personal yet relentlessly commercial business. Even better-known painters, such as Whistler, had a hard time attracting commissions. Whistler's irascible and disputatious personality and his disinclination to flatter his sitters also put off potential clients. Here Sargent, with his mild and seemingly more pliant personality, stole the advantage. But still, commissions remained elusive. For the Salon in particular, Sargent sometimes painted uncommissioned portraits: these were meant as samples and advertisements to attract steadier paying work.

Of his son's official commissions, Dr. Sargent counted six. That the orders came from French patrons astonished everybody. With his good manners and almost-perfect French, with his budding Salon-fueled reputation for risk-taking, John Sargent had already broken into a market that other

American artists found impenetrable. In a city known for its brutal exclusivity, he'd made himself the toast of the town.

At just twenty-three, Sargent was already muscling onto the Paris scene. And at his studio, he was plotting something even more eye-catching for the next Salon, ten months off. That much wasn't vanity; he knew he had to gain an edge and stand out from the crowd if he wanted to win patrons in a glutted market. Already, he was angling for more than workmanlike portraiture, the solid career his father had envisioned. He still harbored his mother's hankering for even more colorful, heady, and intoxicating futures. He yearned for something more, even if he didn't know as yet exactly what.

If his pictorial pursuits remained as yet largely mysterious to him, Sargent still felt his family's hankering for travel and its associated freedoms. That August, he caught a train from the Gare de Lyon to Aix-les-Bains. That white spa town stood under a rocky, wooded ridge on the shore of azure, elongated, mountain-fringed Lac du Bourget in the Savoy. There, John rejoined his mother and sister Emily, who'd alighted for a two-month cure; his father and nine-year-old sister, Violet, had traveled on to Saint-Gervais-les-Bains, a mountain hamlet and beauty spot (nowadays a ski resort), where brisk mountain air promised an astringent tonic as well as a handsome backdrop. But John hadn't come to cure himself or even to sightsee. He'd come to execute a crucial new portrait nearby at Ronjoux, near Chambéry. As Emily wrote to Vernon Lee, John was applying himself to a "lady's portrait every propitious afternoon."

His sitter—though he'd paint her standing, in his first full-length portrait—was the well-connected Marie Pailleron, the daughter of François Buloz, the owner and editor of the influential monthly journal *Revue des deux mondes*. She was also the wife of Édouard Pailleron, whom Sargent had just painted. It's unclear how the artist met the Paillerons in the first place. The family, though, regarded Sargent as a rising star, and Marie had loved the saucy portrait he'd recently painted of her husband.

In Chambéry, and with Édouard's wife, though, Sargent intended to outdo himself. He posed Marie swishing the skirt of her jet-black afternoon gown in the midst of her sunny garden at Ronjoux. The urbane gown and its rustic backdrop didn't match, but the odd contrast captured Marie's complexities of sophistication and charisma, to which Sargent quickly warmed while staying as her guest, heading out for mountain walks, netting specimens for his butterfly collection, and generally charming his hosts.

Charm, to be sure, came across strongly in Sargent's unconventional portrait. In 1880, critics would find the piece "*éclatant*" (glittering). But the *éclat* of the piece sprang not only from Sargent's virtuoso painterly technique—the free, blurry brushstrokes that captured Marie's garden, her gown, and the fuzzy bow of white tulle under her chin—but also from Sargent's easy, playful rapport with his sitter.

In a year's time, in 1881, Sargent would paint an even more arresting masterpiece, a dark, complex portrait of the Pailleron children, sixteen-year-old Édouard and eleven-year-old Marie-Louise. For this piece, Sargent would summon an almost hypnotic unconventionality. He'd create a fraught, moody view of children who seemed brooding, uneasy, and grittily real-life in their clothing and expressions, far from the blurred, floral sentimental ideals that had tended to dominate Victorian images of children. Sargent himself, raised on Victorian sweetness-and-light domesticity, had once shared such a view. But now he was pioneering something darker and edgier.

<div align="center">⤙⤚</div>

Sargent, though, suffered from chronic wanderlust. He soon left both his family and the Paillerons behind. He struck south. By early September 1879, he'd crossed the dry, pine-scented crags of the Pyrenees into Spain, that country that had long fascinated him and that he'd visited only once, as an adolescent, a decade before. In Madrid by mid-October, he was copying paintings of Diego Velázquez, his artistic hero, in the grand skylighted vaults of the Prado. For the next couple of months, he relaxed into the luxury of wandering and absorbing the quirky, "primitive" sights and sounds of the Iberian Peninsula. In lingering, fascinated travels, often on horseback, he boarded at posadas and haunted Spanish cabarets and music venues in Seville—for he loved Spanish music, and he contemplated paintings that would incorporate the kind of Spanish dancers he found breathtaking to watch.

Though his steps are hard to trace, his sketches from this time document his fascination not only with chain-smoking or flailing gitana dancers but also with one slim male Spanish performer whose sharp pose, hands on hips, Sargent captured in spontaneous graphite. The éclat of another he captured in ink, in his *Spanish Male Dancer Before Nine Seated Figures*; this was a spirited work that would prefigure his later masterpiece *El Jaleo*, in which he would substitute a female dancer, and may well have been his first inspiration for it.

In the late autumn, Sargent also visited Ronda and Granada, where he

Spanish Male Dancer Before Nine Seated Figures, 1879

once again sketched the intricate geometric architectural details of the Alhambra, as he'd done as a boy. In late December, he pressed even farther south, crossing the windy Straits of Gibraltar to Morocco—hazarding a new country that the Sargents themselves had never managed to reach. Alexandre Hirsch had encountered Morocco in 1870 and had painted the local women in the port city of Tétouan. Perhaps the older man's recommendation had influenced Sargent to cross the blue, sail-flecked straits into Africa.

On his journey, Sargent also linked up with two artists he'd met on Capri. One was the handsome and high-spirited Charles-Edmond Daux. The other was Armand-Eugène Bach, about whom almost nothing is known except that he was Daux's fellow pupil in the Paris studio of the French academic painter Alexandre Cabanel. As for Daux, his surviving works include several sensual female nudes, for example his *Woman Playing with Doves* (1880), painted about the time of his excursion with Sargent. Once the party arrived in Morocco, Sargent shared a house in Tangier with this charming reputed womanizer.

Travel—and hence traveling companions—continued to engross Sargent, partly thanks to his own family's mobile domestic history. Bonding with these two painters was at least one aim of Sargent's trip beyond the boundaries of Europe. Surviving documentation reveals that in Morocco,

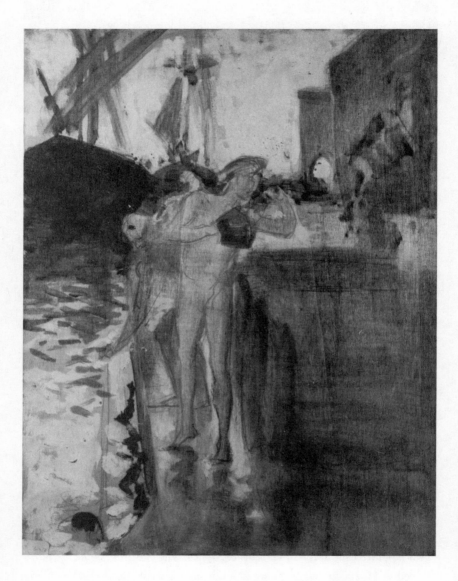

Sargent, *Two Nude Bathers Standing on a Wharf*, 1879–80

far from chasing women himself, Sargent noticed men during this two-month winter stay, for example the "half naked Arabs" who attended this trio's expeditions into the mountains and deserts. "The Arabs [are] often magnificent," Sargent wrote Ben del Castillo in January 1880.

One extant work possibly from Sargent's stay in Tangier—a town that would become fully as notorious as Capri for male homosexual tourism in the coming decades—is an oil sketch of two naked men on a quay. It is executed in sepia tones, with shadowy images of ships and Moorish arches in the background, one of the figures clearly lacking any fig leaf.

Strangely, though, this piece appeared less overtly erotic than some of Sargent's other male figures from the same period. The man's full nakedness was suggested rather than graphically represented, and, in this case, Sargent didn't zero in on the intense expression he portrayed in so many Italian models. Rather he depicted innocent undress—of a kind, incidentally, focused on bathers, that preoccupied his contemporaries Walt Whitman and Thomas Eakins. Sargent's image came off as dreamy and playful, created for private purposes. Clearly, the young painter understood the degree to which nudes of this type—ordinary Arabs being inadmissible for the École's *beau idéal*—didn't make for viable exhibition pieces. Even faint, aestheticized homoeroticism might raise eyebrows and compromise his career.

With his sights on the upcoming Salon later that spring, he worked instead on a much more admissible Moroccan piece. He wagered that an exoticized woman, especially a suitably costumed one, would entrance Salon audiences. He hoped to catch the audience's attention with an orientalized genre piece he entitled *Fumée d'ambre gris* (see Fig. 6). On his canvas, he depicted a graceful Moroccan spreading her outer robes to absorb a rare scent from an incense brazier, in a graceful and theatrical gesture. A friendly critic would later describe this figure as a "stately Mahometan," engaged in a "mysterious domestic or religious rite." The critic also noted that Sargent's painterly rendering of this elusive woman capitalized on the "radiant effect of white upon white, of similar but discriminated tones."

To be sure, Sargent executed a tonal study in the painterly high-fashion of the early 1880s. But he also capitalized on the orientalism then in vogue in Paris thanks to France's North African involvements: its colony in Algeria since 1830 and its growing commercial interests in Morocco. The future friend and critic would feel that Sargent's elegant figure in *Fumée d'ambre gris* "transports and torments us." But the magnificent painting memorial-

ized only a stylized kind of torment. Imperialist "torments" traded on huge privilege.

Back in Paris that May, Sargent exhibited both *Fumée* and his portrait of Marie Pailleron, aiming for a Salon *coup* with this pair of rather bold, contrasting canvases of women. But, with the latter piece especially, he was less enraptured by the sitter than put on his professional mettle. He remarked to Vernon Lee that his picture amounted to little more than an exercise in formal virtuosity: "The only interest of the thing," he bluntly admitted, "was the color."

<div align="center">⊶</div>

To Sargent's delight, the Chilean diplomat Ramón Subercaseaux and his pretty, socially ambitious twenty-year-old wife, Amalia Errázuriz, appreciated Sargent's use of color. Seeing *Fumée d'ambre gris* on display at the Salon piqued their interest. They pursued Sargent through their overlapping Paris circles and commissioned this exquisite new artistic discovery to paint Amalia's portrait.

For his part, twenty-four-year-old Sargent well knew the value of stylish, well-connected women as patrons and sitters. Increasingly, such women could reliably rivet the attention of the Salon, as Sargent instinctively understood. But when sittings with Amalia began in spring 1880, he adopted a different approach from that which he'd used with his mysterious North African. In this case, he rendered his sitter as an alert, bold woman sitting at a piano in a luxurious room near the fashionable Bois de Boulogne. Here the delicate, daring beauty of the portrait grew not out of distance, as with Sargent's "stately Mahometan," but rather out of intimacy.

Over several sittings, Sargent and the Subercaseauxs grew much more friendly. (Sargent painted a highly sensitive portrait of the diplomat, too, as a gift to his wife.) Ramón Subercaseaux also painted pictures, and the couple were self-conscious cosmopolitans who matched Sargent's predilections—so much so that painter and patrons later traveled together to Venice. Mme Subercaseaux's portrait, in fact, highlighted the trio's identification and understanding. In an elegant composition full of beautiful objects (a black ebonized chair, a Delft-blue jardinière), Sargent skirted the habits that art historians would later describe as the heterosexual "male gaze," common among the painters of the era. He didn't fix on this woman as an erotic or sentimental object. Rather he created a self-confident figure

who confronted, almost challenged, the audience with her steady dark eyes. Her pretty face wore a subtly wry expression, as if she didn't take her own beauty very seriously.

Significantly, Sargent seated Amalia Subercaseaux at her own piano. Her hand just dragging off the piano keys suggested that she was an artist herself, and perhaps a serious or passionate one. Sargent understood her not merely as a fresh-looking, attractive woman arrayed in a striking black-and-white afternoon gown, merely as a luxury object to be owned and displayed. In fact, Amalia Subercaseaux shared Sargent's love of music, and artist and sitter plunged into animated conversations about Louis Moreau Gottschalk, a composer inspired by Louisiana Creole music. They also canvassed the entrancing musical traditions of Spain and South America, their conversations fueled by Sargent's recent back-alley experiences in Spain.

For her part, Amalia found Sargent "a very attractive gentleman" even if his studio in the rue Notre-Dames-des-Champs, still shared with Alexandre Hirsch, which she visited, shocked her as "very poor and bohemian," with its disorder, grime, caked paint, and piled oil sketches. Though John actually slept at his Right-Bank hotel, his studio was a bachelor lair, or rather the lair of two bachelors, clearly devoid of any woman's touch. (Vernon Lee later found that Sargent had nothing to offer visitors to his studio except "siphon" or soda water.)

Yet the kind of natural rapport Sargent developed with the Subercaseauxs generated a compelling up-to-date portrait that he would later display at the Salon of 1881 and that would help him bolster his growing reputation. With such portraits, he was establishing a distinct style, a recognizable personality on canvas. Salon audiences (as the young artist cannily understood) responded to such intimate, incisive visions of women. These high-profile pieces also served as advertisements to potential patrons, especially female ones, many of whom increasingly responded well, as Marie Pailleron had done, to Sargent's unconventional and stylish portrayals of them. Sargent would win his second Salon medal for this piece. He confided to Ben del Castillo that he felt a "great swell" for the achievement.

◄┼

Ralph Wormeley Curtis, a swell himself, also appreciated Sargent's use of color. He was likewise a painter, or so he aspired to be. A twenty-seven-year-old scion of a rich Anglo-Bostonian family, he'd once studied in Paris—more

as a dilettante than a serious painter. A couple of years before, in 1879, he'd returned to Europe in order to enjoy an insouciant half artist's life. Haunting the Salons, he'd seen and liked some of Sargent's work, and in the summer of 1881, he decided to look up the rising-star artist on the Left Bank.

Curtis managed to catch Sargent, in fact, during one of the now-rare intervals when the restless young man had actually alighted in the city and was working in his Montparnasse studio. To do so, Curtis appealed to his Harvard classmate Francis Brooks Chadwick to introduce him. But he might have had an excuse for an introduction himself: his great-great-grandfather and Sargent's great-great-grandfather were siblings, so that Ralph Curtis soon styled himself, in his chummy Ivy League manner, as the painter's "cousin."

The three young men mingled quite readily—they shared painterly fascinations—and Sargent hatched a junket for them in mid-August. He masterminded an art tour of the Low Countries, including Amsterdam, Rotterdam, and the Hague. But his special destination was the old linen-and-silk town Haarlem in the Netherlands. This vigorous, vertical, brick-gabled town offered hardly any artistic atmosphere—unlike colorful, lyrical Paris—except for a couple of galleries that appeared self-conscious and out of place in that spruce market town, and the Frans Hals Museum, founded in 1862 in the brick cloisters of a former monastery. It was for Hals, the lively seventeenth-century portraitist of wealthy burghers, that Sargent had contracted a special enthusiasm. He loved Hals's loose brushwork, theatrical poses, and impudent treatment of patrons' faces. And his enthusiasm for the Dutch master quickly infected his companions.

Thirty-year-old Brooks Chadwick was, like Curtis, a Bostonian who'd been thoroughly converted to painting in Paris. He'd studied at the Académie Julian and with the academic painters Jules Lefebvre (who taught legions of Americans) and Gustave Boulanger (who'd obsessively churned out images of Pompeii), two former Prix de Rome men who had become decorated late in life rather than brilliant. Chadwick himself painted portraits and town scenes in a rather conventional style and tended to gravitate to Grez-sur-Loing, in the countryside northeast of Paris, rather than indulge in the bohemian hothouse of the city.

The portrait Sargent painted of him that year would actually be more inspired than anything Chadwick himself would ever paint—showing the young man as a handsome, narrow-faced redhead with a handlebar mustache and a brown-eyed squint. Sargent inscribed the painting "to my friend

Chadwick . . . Haarlem. / 1880," but it's unclear if Sargent painted the piece on this holiday or if he produced it as an offering of friendship and a memento of their shared junket. Chadwick, in any case, made only this brief cameo appearance in Sargent's life. After that he buried himself in picturesque Grez (beloved by a long string of foreign artists) and married a Swedish painter named Emma Löwstädt there in 1882.

Ralph Curtis, two years older than Sargent, added a satirical wit to the artistic travel party. But he remained a conventional dandy, accustomed to living in style rather than laboring as an artist. When they all stopped at the shore town of Scheveningen in the Netherlands, Sargent painted a portrait of Curtis as a small, dapper man with a receding hairline and a small, tweaked mustache, reclining insouciantly (fully clothed, with a hat and cane) on a beach. Sargent found Curtis's company congenial. He recognized his new friend as an amiable idler and a just-competent, workmanlike painter. Yet as a confidant the young man seemed more promising. He'd in fact have more of a future as Sargent's friend than either Chadwick or the Rhode Islander George Hickock, another painter the group eventually included in some legs of its boys' outing, and of whom Sargent also produced a handsome portrait, as if wanting to fix in his mind all his companions of that summer.

Back in Aix-les-Bains, Emily Sargent heard from her brother about the "two very nice friends" with whom he was traveling. In the Netherlands, he'd "enjoyed the pictures immensely," Emily reported to Vernon Lee. Her brother had found that nothing equaled viewing the works of Rubens, Rembrandt, and Hals in their native countries. But this trip to Haarlem wouldn't be Sargent's only or even his most significant homage to Dutch painting. He'd feel the magic of this late-summer junket enough to repeat it with subsequent artist friends of whom his portraits would prove even more compelling.

For the time being, though, the hard-traveling Sargent had other destinations in mind. He was going back to Aix-les-Bains to join Emily and the rest of his family. They all had something of a touristic family reunion in mind.

-+-

*The stairs down from arches of the railway station at Venice offered the five mem-*bers of the Sargent family their first glimpse of the Grand Canal in years. Of course, it wasn't at all their first visit, for they'd been coming to the city

together for more than a decade. But now they'd reunited, as a family, and with the intention of staying together for several months.

To Sargent, the reflection of a bright mid-September sun on the dark water boded well. He had new painterly schemes in mind. Gondolas piloted by one or two gondoliers awaited them at the bottom of the steps, as well as "omnibus-boats" ("not recommended," Baedeker cautioned) rumbling at the stone embankment. Steam launches, anyway, accepted only lighter articles, as the guidebook informed them. Even so the Sargents' trunks were soon dispatched to the other end of the S-shaped Grand Canal, so that they could travel the length of it by less encumbered means.

To facilitate John's plans, the Sargents boarded in style at a brand-new hotel, the Bauer-Grünwald, just opened in an historical palazzo by enterprising Austrians—no wonder the place was, as Baedeker said, "patronized by Germans." Otherwise known as the Grand Hotel d'Italie, the palazzo was just steps from the Piazza San Marco. Ogee-arched windows in its pink-and-white south façade took in a grand view including the many-domed church of Santa Maria della Salute and the grand classical façade and spired campanile of San Giorgio Maggiore, as well as swarms of gondolas and larger steam and sail vessels teeming in the sheltered waters of the lagoon. But, on this visit, twenty-four-year-old Sargent wasn't interested in painting any grand, Canaletto-style vistas.

During that autumn and winter, Sargent was instead testing out new subjects and themes in his paintings, fixing the spring Salon back in Paris firmly in his sights. Rather brashly, he began to paint genre scenes and figure studies of gritty Venetian street life as well interiors featuring humble bead-stringers—quotidian subjects, redolent of painterly realism, for which he enlisted working-class guides and intermediaries, often the very gondoliers who helped him and his family negotiate the water-laced city.

Though lodging en famille at the Teutonic Hotel d'Italie and often sketching from a gondola with his sister Emily, John set up painterly shop at the Palazzo Rezzonico on the far side of the Accademia Bridge. It was to this spacious, dilapidated studio that Sargent gathered Venetian women—perhaps with the help of ever-willing gondoliers—to paint a moody group genre scene later entitled *Venetian Women in the Palazzo Rezzonico*. This evocative figure study showed eight scattered, desultory figures in local dress, positioned in a cavernous whitewashed room dimly lighted by distant windows, expertly painted in a fashionably limited palette of gray tones. The painting captured a mood, a spirit, on which Sargent was bent.

But the Ca' Rezzonico was hardly as derelict, abject, and strewn with mendicant figures as Sargent portrayed it in his swift, free, and confident brushwork. According to Charteris, this old aristocratic residence on the canal had become instead a "barrack for artists, with some of the amenities of a palace and the gaiety of the Latin Quarter." As a matter of fact, these young men had come to this alluring artists' playground for a variety of personal and professional reasons. Many of them were energetically seeking, as Sargent was, fresh and compelling perspectives on a city that by the late nineteenth century had been ransacked for every conceivable image and artistic use—postcards, stereoscope photographs, and illustrated newspapers as well as in high-art paintings. Such images were aimed at an enthusiastic, Venice-mad public of mass tourists as well as cultivated or jaded travelers like those of Sargent's set.

Like Sargent, painters flocked to Venice for its distinctive communal art-life as well as its career opportunities. Harper Pennington, two years later Sargent's studio-mate in Venice, also first arrived in Venice in 1880. He detrained with some ragtag art-student pals from Paris and immediately fell in love with the life of *dolce far niente*. As he later recollected, he breakfasted late and cheaply on "coffee, rolls, and butter on old republic silver." Pennington, a Maryland patrician who'd studied in Paris with Jean-Léon Gérôme as well as Carolus-Duran, found himself completely dazzled by the colorful pageant of Venice. He found that his Paris-trained "palette appeared to be set with varied shades of mud. At first no pigments seemed bright and gay enough for Venice." Yet when the young artist encountered the more experienced forty-six-year-old Whistler, the magisterial, pugnacious American soon convinced Pennington and his friends of the "stupidity of [their] garish efforts."

Whistler, who rapidly became Pennington's idol, envisioned Venice not only in different painterly tones but through entirely different subject matter. He saw not the city's great vistas, palaces, and churches but its tawdry and derelict underside. He'd found, he claimed, "a Venice in Venice that others seem never to have perceived." Not everyone understood such an approach to the Serene Republic. One Boston museum official who mixed with Sargent and his friends in 1882 couldn't fathom this new vogue for "unpicturesque subjects, absence of color, absence of sunlight." He added testily that it seemed hardly worthwhile for Americans to come all the way to Venice to find squalor. But "palaces in rags," partly through Whistler's influence, had become the new vogue for representing Venice. Pennington,

though, thought little of "the inevitable study of bead-stringers"—the subject matter that was about to become Sargent's best-known version of this trend.

Sargent would stay on in Venice till February or March of 1881. Though his residence in the city overlapped with Whistler's, the two painters didn't meet. Nor did Sargent derive the inspiration for his working-class genre scenes from Whistler's high-profile series of etchings—not directly. After all, Sargent had already painted the realist or romanticized "low life" of peasants in Brittany and Capri. The grittiness of Venice simply offered him a fresh twist. In this respect, Venetian low life readily appealed to artists like Sargent who considered themselves "modern" in a decadent Parisian cast. For such artists, Venice was the quintessential Baudelairean city, and Sargent sometimes adopted the elements of the role of the flâneur, a discerning Baudelairean street idler. As one historian has written, "There were no slums more slummy than the Venetian back canals, with their leprous buildings and odour of decay; while in the great Venetian palaces there was an unparalleled example of human contrivance at odds with nature."

In beginning to haunt Venice's poorer quarters, Sargent was looking for fresh images to startle the Salon. He needed to do so to attract and maintain attention. He was even flirting with scandal, both from personal restlessness and in order to remain fresh and relevant in the Paris art scene.

Some of the Venice subject matter that he was beginning to discover and paint, however—especially a couple of pieces that to some onlookers would suggest prostitution—would prove *too* decadent for the Salon, as Sargent himself already understood. Was he beginning to outgrow the Salon? For even the less obviously provocative pictures Sargent was concocting in Venice, as Richard Ormond has observed, were capturing "moods that are strained, disturbed, sinister, and erotic." And erotic elements in particular distinguished Sargent's images from Whistler's and hinted at additional elements at work in Sargent's backstreets.

<div align="center">-+-</div>

Paris's backstreets, too, were increasingly haunting the young Sargent, or rather he was haunting them. In Paris, he wasn't exactly transforming into a card-carrying Baudelairean flâneur, out at all hours, frequenting dubious cafés or cabarets. But in 1881, Vernon Lee, renewing her friendship with Sargent, found her childhood playmate transformed from an aspirational art lover into a risk-taking twenty-five-year-old artist who was a "great maker of

theories"—and most tellingly, a disciple of "art for art's sake"—that credo of Belle Époque aestheticism.

A great reader if not much of a theorizer, Sargent had already encountered and embraced Charles Baudelaire, Walter Pater, and other hyper-aesthetic writers, even if—except for his freer discussions with his old friend, or with his Paris painter cronies—he tended to keep his strengthening opinions to himself. Lee also noted her friend was now "quite emancipated from all religious ideas"—not that the Sargents had ever been pious, exactly, except for fits of private devotion in Dr. Sargent and Emily. At least some of these transformations owed to John's new friends in Paris.

One new companion, whom Sargent probably met through his painter buddy Paul Helleu, especially raised eyebrows among Sargent's family and his American acquaintances. The aristocratic poet-aesthete Robert de Montesquiou-Fézensac was now joining Sargent and Helleu for evenings out in Montparnasse.

Whippet-thin, waspish, and impeccably dressed, with a spiky small mustache and beard of jet black, Montesquiou aspired to a starring role on the crowded stage of Paris society and was becoming better known for his star turns at parties than for his recherché, lackluster poetry. Later, in the 1890s, both Giovanni Boldini and James McNeill Whistler would paint striking portraits of an about-town Montesquiou, attired in formal evening dress and brandishing his silver-handled walking stick. In 1921–22, Marcel Proust would immortalize Count Robert as the Baron de Charlus in the fourth volume of À la Recherche, entitled Sodome et Gomorrhe—a vast and detailed exposé of high and low underworlds in turn-of-the-century Paris.

Sargent was at least ambivalently attracted to the young aristocrat's brazen nonconformity and orientalist enthusiasm. Though Sargent's restlessness and quixotic painting plans often took him away from Paris—he was forever dashing off to London, Venice, and the South of France—Paris still exerted a heavy influence on him and his emerging work. When he was in the city, laboring in the studio with Hirsch, frequenting cafés with Helleu, or headed to artistic dinner parties, he often encountered or accompanied Montesquiou.

Even in the early 1880s the Comte was already ubiquitous—notorious for his quips, his costumes, and his over-the-top decor at his apartment on the Quai d'Orsay. In 1884, the French writer Joris-Karl Huysmans would fictionalize the Count as the reclusive, perverse aesthete Jean des Esseintes in his novel À rebours (Against the Grain). That book both celebrated and

criticized the extreme dandyism and aestheticism associated with "deca-dence," of which Montesquiou was the self-proclaimed prince.

In 1885, Sargent would write a letter of introduction for Montesquiou in which he would describe him as "the unique extra-human Montesquoiu"—Sargent's term "unique" treating the Comte's flamboyance with tongs. At times, Sargent hardly knew what to make of his new friend. Yet he found himself visiting cafés, concert halls, and theaters with Montesquiou and a growing group of fearless, flamboyant Parisians. Other hangers-on included the writer Paul Bourget (who, though he later married, experi-enced a brief, intense passion for Montesquiou) and the portraitist Jacques-Émile Blanche. As one art historian has asserted, Montesquoiu and his group "exerted a powerful influence on Sargent and his art" in the 1880s. Though Sargent and Montesquiou were almost exactly opposite in social presentation—Montesquiou being flashy and self-advertising while Sar-gent remained understated, hardworking, and self-effacing—the two men shared many fascinations.

As Sargent now saw firsthand, Montesquiou indignantly denied any ac-cusations of homosexuality, as it was coming to be called in the 1880s. Yet he was exhibitionistic, flashy, and after 1885 furnished with a ubiquitous South American "secretary" in his lover Gabriel Yturri. (In his later three-volume memoir, Montesquiou devoted only a few brief paragraphs to "*mon cher Yturri*," his companion of twenty years, whom he described as living a couple of doors down.)

Really, Sargent's café companion was a living puzzle—and he worked hard to be regarded as such. Though homosexuality wasn't illegal in France (it was criminal in Britain and the United States), same-sex eroticism was still widely condemned even in Paris. Homosexuality was particularly risky given its heightened profile as a just-defined and all-too-prominent category of "illness" in medical pseudoscience. In Paris it was sometimes known as the *vice allemande* because of the prominent German sexologists who were now engrossed in studying it and cataloguing it, such as Richard von Krafft-Ebing, whose encyclopedic *Psychopathia Sexualis* appeared with great fan-fare in 1886.

Montesquiou's pose of disavowal illuminated the extent to which, even in relatively tolerant Paris, even in friendly and sophisticated salons or on ur-bane boulevards, queer desires and lifestyles had to be coded, disguised, and hidden. Montesquiou's chosen cover, later savagely lampooned by Proust, was to scorn men, especially men who attracted him, and surround himself

with women to the point of appearing a ruthless womanizer. As his biog-
rapher Philippe Jullian has phrased these tactics, women for Montesquiou
assumed "a far greater role in the life of this man who did not like them,
than in that of any Don Juan. He was to be surrounded and sometimes even
submerged with women."

Jullian gives a glimpse of how Parisian men avoided Montesquiou be-
cause he didn't pursue the French masculine pastimes of hunting and pol-
itics. In contrast, dowagers, society women, and art-minded women doted
on him, promoted him, and defended him: "But he has so much taste! It
was he who advised me to have a dress made like my grandmother's in the
Vigée-Lebrun portrait . . . He presented me with a Japanese vase overflow-
ing with chrysanthemums . . . And what originality!"

Montesquiou squired stunning and bejeweled women, mistresses of
powerful Parisian men, to the Salon and on rides in the Bois de Boulogne.
And what's more, his affective and aesthetic obsessions with women were
shared by many of his café companions—and, though in a somewhat dif-
ferent form, by Sargent himself. For Sargent remained highly sensitive to
censure as well as genuinely interested in charismatic, venturesome Parisian
women. Also, he witnessed firsthand the uncomfortable consequences even
of Montesquiou's small degree of openness.

Montesquiou made a great show of his devotion to the impulsive and
emotive actress Sarah Bernhardt, whose other admirers included Oscar
Wilde and Louis II of Bavaria. In a calmer way, Sargent made friends with
Judith Gautier, a sculpturesque poet and novelist crowned in a mass of dark
curls, daughter of the French writer Théophile Gautier and the Italian dancer
Carlotta Grisi and, for several years, a mistress of Richard Wagner. Sargent
painted a number of delightful, intimate oil portraits of Judith Gautier in the
1880s. Some of these lyrical, free-spirited, luminous pieces showed the influ-
ence of Sargent's new acquaintance Claude Monet. Cultivated women like
Gautier, who shared orientalist obsessions with Montesquiou (who liked to
consider himself the "ambassador" of Japanese art), often encouraged and
protected unconventional artists. Salon hostesses, actresses, dowagers, and
women novelists—the great dazzling panorama of Belle Époque Paris—
often provided raw inspiration, as well as much-needed shelter.

--+--

Montesquiou knew everybody, and he soon introduced Sargent to one of the most
fascinating if notorious men in Paris. Samuel Jean Pozzi offered Sargent an

even more magnetic and irresistible dinner companion than Paul Helleu's other racy friends. Thirty-five years old, good-looking, trimly bearded, and caressingly charismatic, Pozzi was a bosom friend of Montesquiou's. A gynecologist, Pozzi had earned the reputation of a Don Juan who was rumored to have indulged in many affairs, including a liaison with Sarah Bernhardt—in his case a physical one. (No one suspected Montesquiou's intimate involvement with Bernhardt to amount to a sexual affair, even though he was once induced—to his distaste—to roll around among cushions with her.)

Physically, Pozzi embodied Sargent's preferred Mediterranean type, having some Italian ancestry and coming from Bergerac in the South of France. In fact, he strangely resembled many of the other handsome, Italian-looking young men Sargent had painted privately during the 1870s. Not surprisingly, Sargent found Pozzi irresistible to put into paint; the charismatic, almost mesmeric *roué* provided heady material for Sargent's increasingly bold and transgressive instincts. With his "handsome, still youthful head," as another friend put it, Pozzi could easily assume the kind of ethereal, sensual expression that Sargent had previously captured on his handsome young Italian models. At least Pozzi could inspire Sargent to re-create it.

What's more, Pozzi lent himself to such a provocative portrayal because he qualified as what we might now describe as gay-friendly if not simply pansexual. Though we know little about his interactions with Sargent, at cafés or at the house where Sargent painted him, Pozzi had clearly lavished attentions and courtesies on his good friend Montesquiou, whom he addressed as *"cher, grand et noble ami"* (dear, great, and noble friend). Once, when reading Montesquiou's poetry, Pozzi described himself to Montesquiou as *"pénétré de son charme puissant et douloureux,"* (penetrated by its powerful and poignant charm)—an example of the innuendo and flirtation the doctor instinctively practiced on both women and men. Count Robert said of him that *"jamais je n'ai encontré un homme d'une telle seduction, et dont il m'a donné des preuves incomparables"* (I've never encountered a man of such seductiveness, and of which he gave me incomparable proofs). And such beguiling charm wasn't lost on Sargent.

Seduction, in fact, simply radiated from the portrait that Sargent now began to paint. The young artist's full-length, sumptuous portrait of Pozzi, as it emerged, grew ever more arresting and bizarre. Always very particular about the costumes his sitters wore, Sargent dressed the handsome doctor in a striking crimson wool *robe de chambre* (dressing gown). Even Sargent's

choice of color proved startling, his deep crimson pigment suggesting blood and passion. It was an effect that stuck: even four years later, Sargent introduced Pozzi to other friends as "the man in the red gown (not always), a very brilliant creature." *Dr. Pozzi at Home* proved an extraordinary painting, one of Sargent's most daring (see Fig. 10).

Such a boudoir outfit hardly fit the norm for men's portraits of the time. One art historian has recently demonstrated how starkly Sargent's rendition of Pozzi differed from the more formal, public depictions of men typically produced at the time—as shows up in more conventional surviving photographs of Pozzi, in which he wears a top hat and full encumbering Third Republic toggery. In his more conventional rounds as a portraitist, Sargent produced a number of more sober, public portraits of other Parisian men, bust-length images in formal dress, rendered in dark colors and sealed with a smooth, understated conventional finish.

But, focused on the doctor's bedroom attire and dreaming eyes, Sargent's intimate portrayal of Pozzi suggested a vivid boudoir scenario that did more than simply dramatize Pozzi's womanizing reputation. Sargent posed his sitter provocatively with one hand caressing his chest and the other splayed on his hip. The provocative gesture here reappeared—in this case, as one art historian has argued, referencing the homosexual underworld. Another diagnosis of Sargent's composition has it that the "robe's tenuous closure hints at exposure. Pozzi's left hand tugs at his tasseled belt, as if loosening it, while his right appears ready to separate the overlapping lapels, revealing the figure beneath. Like its bloodred hue, the gown's wrinkles and crenellations displace the sensuality of Pozzi's hidden body onto the lush surface that he gently fingers." Another recent view, by the novelist Julian Barnes, focuses on the red tassel that "hangs just below the groin, like a bull's pizzle. Did the painter intend this?"

Whether or not he did, Sargent's painting took a startling perspective for its time. It provoked, but in a complicated way. Recent scholars have asserted that it "function[s] within and between hetero- and homoerotic circuits of desire." Sargent brazenly portrayed Pozzi's erotic availability. Sargent's implanted crypto-messages would unashamedly broadcast joy or disease to his audiences. But the painted Pozzi wasn't just reducible to sex but remained instead a fascinating conundrum over which ink would be spilled for decades, even centuries.

Vernon Lee saw in this painting an "insolent kind of magnificence." Though he kept quiet about his motives, Sargent was aware enough of the

portrait's bold undercurrents that he chose not to show this incendiary piece at the Salon. And when he did exhibit the painting in London and Brussels, it attracted mostly hostile reviews. Shocked audiences recoiled. Baffled critics, unable to pinpoint their discomfort, taunted Sargent for his Parisian modernity, his desire to affront, or his use of too much red. Such a painting aimed for success by means of uproar, one Brussels critic wrote. It stood out as "a complete sample of bad taste dear to certain youths of the French school" ("*un échantillon complet du tape à l'oeil, cher à quelques jeunes de l'école française*"). Such "youths" certainly filled Paris, and Sargent, despite his father's best efforts, had now absorbed some of their decadent tastes. As Montesquiou's protégé, Sargent had embraced the red-velvet atmosphere of dissolute Paris. He'd made a decadent statement, made a splash. But it gave him his first real taste of being spattered back.

But the stakes were running higher, now that Sargent had a name and a reputation to defend. Would he take more risks or swerve back to the greater safety of conventions? The art world in which he was determined to succeed didn't offer much security either way. It regularly inflicted high anxiety, if not serious collateral damage, on all its participants. Paris, teeming with ever more daring avant-garde painters, asserted a mounting pressure on the ambitious, skittish twentysomething painter.

Montesquiou's example wasn't lost on him, either. Provocative women were increasingly becoming the key—had already been for Sargent with Rosina Ferrara, the unnamed woman of *Fumée*, and even bold-eyed Amalia Subercaseaux. But Sargent still hadn't found quite the right recipe for the Salon, never mind the right formula to encompass his warring instincts.

10

Flash Gatherings

Tall, imposing, ginger-haired, and loaded with turquoise jewelry, Henrietta Reubell smoked even more than John Sargent did. Though only in her early thirties in the early 1880s when Sargent began visiting her well-appointed flat, just off the Champs-Élysées in Paris, "Miss Reubell" appeared regal and ironic when poised on her red velvet sofa in an alcove canopied in gold. With her long-handled lorgnette in one hand, she scrutinized her visitors. With the other, she waved a cigarette, invariably enwreathing herself and her guests in smoke.

Sargent, bearded, well-tailored, and now twenty-six, found himself captivated. In the world in which he'd grown up, women weren't supposed to smoke—especially not unmarried ladies who resided on the august avenue Gabriel. Women's smoking betokened disrepute. A cigarette was the standard prop of divorcées, actresses, *grisettes*, and lesbians. As *The New York Times* put it in 1879, "the practice of smoking among ladies seems to be generally regarded as the usual accompaniment of, or prelude to, immorality." Though wealthy and respectable, living in style on the Right Bank in the heart of the American colony, "Etta" Reubell boldly ventured into the Parisian art world, crossing the river to the Left Bank or climbing Montmartre. Her heavy, in-your-face smoking advertised her bohemian edge.

"Her smoking was the least of her freedoms"—as one of her habitués would later remark. As a *salonnière* or salon hostess, she freely invited to her house the often-outrageous rising stars of the French, British, and American art worlds. According to the contemporary understanding of the role, a salon hostess needed to be a "particular lion." Like other women who'd chosen this time-honored, once aristocratic path to women's influence, Reubell combined idiosyncrasy, tolerance, and intelligence with sheer force of

personality. One of her frequent guests, the British painter William Rothenstein, who hated "pseudo-geniuses," praised Reubell as a woman with "a shrewd and original mind." She reminded him of Queen Elizabeth—"if one can imagine an Elizabeth with an American accent and a high, shrill voice like a parrot's."

Half-French, half-American, descended from Revolutionary firebrands and American entrepreneurs, Reubell brought a volatile international mix to Paris high life. She was well positioned to create a distinctive and cosmopolitan salon. She excelled in a *salonnière*'s roles of personal confidante, social networker, and elite arbiter of culture. As Rothenstein summed her up, she was "adept at bringing out the most entertaining qualities of the guests at her table," inviting young artists "to meet people whom she felt [they] would like, or whom she thought might be of use." What's more, Reubell's knack for making introductions especially benefited the queer art underworld of Paris because she welcomed to her house, in addition to more sexually conventional salon regulars like Rothenstein, high-profile, transgressive figures of the Belle Époque such as Edmond de Polignac, Robert de Montesquiou, and Oscar Wilde. As Rothenstein reported, Reubell's salon "permitted anything but dullness and ill manners, delighting in wit and paradox and adventurous conversation."

Sargent left no account of his own experience with Reubell in the avenue Gabriel. But in 1884 or 1885 he painted a watercolor and gouache portrait of his friend (see Fig. 7). Once privately owned and unknown to Sargent scholars until 1988, the painting would remain as obscure as certain details of Sargent's Paris nightlife. But his treatment of Reubell shows that he appreciated this tasteful firebrand's stimulating mix of womanliness and rebellion. This small, private, and perhaps secret piece, the only known image of Reubell, parallels the *salonnière*'s status as an unconventional woman whose role has likewise been forgotten.

Yet in this recovered window into Reubell's salon and Sargent's networking there, the artist portrayed his friend appreciatively and almost impishly. As an intelligent figure leaning eagerly and frankly forward, she looked the very embodiment of an engaging Paris *salonnière*. Reubell's pleasant, sympathetic expression balanced her assertive posture with a certain amount of feminine sweetness. Yet the fiery, dragon-like figures on the Japanese black lacquer screen behind her suggested both an art-world cachet and a vigorous, irreverent genius at odds with her proper lace collar and cuffs and her muted, slate-colored dress. Even without including the hostess's signature

cigarette, Sargent, with the density of the gouache, evoked the dark, smoky atmosphere of Reubell's salon that he loved.

<p style="text-align:center">—+—</p>

In November of 1882, in what was to become her most influential act, Etta Reubell presented her young friend Sargent to the urbane American novelist Henry James.

Rather stout and neatly bearded, James was thirty-nine, thirteen years older than Sargent, and a bachelor. He'd achieved high distinction in Anglo-American letters, having just published his magisterial *Portrait of a Lady* the year before in 1881. Like Sargent, he was a polyglot, with polished French and fluent Italian, scraps of which he also dropped into his English conversation. He was also eerily familiar, Sargent soon found, with the very places the young painter knew, all over the map of Europe. For James's own family had crisscrossed the Continent during his childhood—though until his young manhood, James had mostly lived in the United States.

The James family qualified as even more intellectual and cosmopolitan than the Sargents. Henry James's father, Henry James Sr., was a radical philosopher, his brother William a budding medical psychologist, and his sister Alice a tart feminist diary-keeper. Henry James Jr.'s intellectual cachet and deep cultivation had cowed many a bolder person than the rather bashful Sargent. During his own stint of living in Paris six or seven years before, James had mixed with Ivan Turgenev and Gustave Flaubert. Yet as an inveterate diner-out, the courteous novelist also wielded disarming manners and beguiling charm.

As Sargent soon learned, James's penchant for art matched his own. James simply adored art and artists. In his youth, invading his brother's life study classes in Newport, James had briefly entertained the pipe dream of becoming a painter himself. His first major novel, *Roderick Hudson* (1875), had treated a charged relationship between a cultivated bachelor patron, Rowland Mallet, and a talented young sculptor named Roderick Hudson—a dynamic that he now seemed tempted to try out with this attractive rising star of a painter.

During his years as an upscale journalist in Europe, James had donned the mantle of a self-trained art critic. Between 1868 and the time he met Sargent, writing critiques and appreciations of the so-called Old Masters for the *New-York Tribune*, *The Nation*, and *The Atlantic Monthly*, he'd tried to shape the American taste for European painting according to his own sober,

carefully formed ideas. He'd stodgily specialized in the Old Masters, often waxing abusive about the modern painting to be found in Paris. He'd even declared James McNeill Whistler's pictures "eccentric and imperfect" in 1878 even if he'd admitted they were "extremely amusing" in 1882—though amusing, James allowed, only in the sense of a "buffoon" doing the "comic business" of a "somersault in the ring."

What's more, James was as allergic to scandal as his new young friend was intrigued by it. James blamed both Whistler and Ruskin for a furious dispute over modern painting they'd pursued in a courtroom in 1878: "Few things, I think, have lately done more to vulgarize the public sense of the character of artistic production," James complained. This, like most of James's other opinions, stated with conviction and gravity, carried an almost irresistible weight.

No wonder Sargent started out as nervous, browbeaten by the older man's confidence. But soon he began to adjust to James's strange mix of aggressive intimacy and standoffishness, especially as James soon confessed himself an admirer of Sargent's painting. After all, James knew everyone and, it seemed, everything. That was true even if he also kept almost everyone—would Sargent prove an exception?—at a firm arm's length.

Such a meeting, promoted by his friend Etta Reubell, certainly intrigued James. In his later 1888 novel *The Reverberator*, he'd lay out a map of the complicated interconnecting Parisian worlds through which freshly arrived Americans could break into the city's social life. (Sargent would find his friend's novel "charming, light, comic—a perfect comedy.") Newcomers could meet longer-term expatriate residents of the Champs-Élysées, international artists from the avenue de Villiers, and French aristocrats from the Faubourg St-Germain. This mingling of touristic, artistic, and aristocratic worlds was sometimes understood as promiscuous and dangerous—a rather intimate jostle that James scouted and Sargent privately enjoyed. Likewise, the cosmopolitan Champs-Élysées brashly mixed different classes and nationalities as well as allowing a range of peculiarly French sexual freedoms. Reubell's windows overlooked this congested avenue teeming with hats and umbrellas—not to mention the promenades, cafés, and parks where, according to Parisian scandal sheets, both heterosexual pickups and homosexual encounters not infrequently occurred.

Reubell's front door faced the Théàtre Marigny, a popular panorama during the 1880s and a musical theater after 1894. Sargent patronized such popular venues even if his musical taste was more sophisticated. A couple

of years before, in 1879–80, he'd painted spirited sketches of orchestra rehearsals at the Cirque d'Hiver on another raucous Paris boulevard, where Jules Étienne Pasdeloup intrepidly conducted cutting-edge composers such as Richard Wagner and Gabriel Fauré in cheap and accessible "Concerts Populaires." Even if his father had avoided going to the theater in Europe, Sargent loved doing so—at least going to theatrical concerts.

Even without live music, Reubell's salon likewise opened up exciting possibilities for Sargent. Though the aspiring painter continued to profit from his family's mostly respectable expatriate connections, Reubell's circle, like Paul Helleu's and Robert de Montesquiou's, now offered him fresh and less predictable contacts. What's more, Sargent smoothly blended into such feminine and sometimes feminist venues. After all, his mother, with her artists' parties, had herself been something of a *salonnière*. Reubell's Sunday afternoon gatherings, with their tea and "laden" book table, felt reassuringly familiar to him, even as they offered more liberating possibilities than the Sargent family's decorous milieu.

Sargent no doubt heard Henry James lampoon Reubell's crowd of young and untried artists as a "saloon for gifted infants." James also disapproved of some of her more flamboyant guests, notably Oscar Wilde, whom Reubell frequently entertained in the 1880s and 1890s—and whom incidentally she would loyally defend against James McNeill Whistler's "jibes" even after Wilde's high-profile trial. Yet James clearly hinted at his knowledge of the salon's queer and protofeminist clientele, with their violations of Anglo-Saxon gender and sexual conventions, when he asked Reubell in 1893, "Do the little painters turn up on Sunday afternoons, and the scrappy ladies thirst for more tea?" Sargent well knew that Reubell in fact fostered and encouraged "little painters"—figures James saw as aesthetic poseurs, decadents, dandies, and *l'art pour l'art* aesthetes. She also invited disruptive and assertive "scrappy ladies" to her house.

As Sargent himself appreciated, Reubell qualified as a "scrappy lady" herself. With her close Bostonian friend Louisa ("Isa") Boit, whom James described as having "as much business with daughters as she has with elephants," Reubell fearlessly took on the role of "shepherdess of the studios." The two women made free to insert themselves in young artists' lives and careers, including Sargent's.

Though they weren't painters even if Isa was married to the painter Edward Darley Boit, the pair linked up with bohemians and fearlessly mixed in the erotically tinged Parisian art world. That, in the eyes of some, steered

them toward disrepute. Yet "Iza & Etta," as James called them, paralleled the new waves of women artists, many of them Americans, then being trained in Paris late in the century. Like these female painters, they walked a fine line. To promote artistic culture might be "feminine," but for a woman to paint as a profession or even mix with artists remained fraught. While staying just respectable, Etta and Isa consorted with a Paris set known for its sexual nonconformity. They also brought Sargent into contact with more Paris unconventionality, as Paul Helleu had earlier done. Since, according to James, Sargent saw Isa Boit "constantly," he continually imbibed, along with the ubiquitous tea, the open-minded inclusiveness that "Iza & Etta" so lavishly espoused.

Delighted with Isa, Sargent spent quite a few evenings with her and her artist husband Edward Darley Boit ("Ned") in the nearby 32 avenue de Friedland. There the Boits lived in over-the-top expatriate style. One Boit relative recorded a decade later that the Boits, who were raising four daughters, employed nine servants and traveled with "forty trunks, about 30 boxes and bags, two or three bird cages, two carriages, several cases of silver, linen etc., 1 harp, 1 violoncello." Sargent could relate to such an entourage, having grown up with a similar if somewhat smaller equipage. (The Boits' two huge Japanese Arita vases, which they crated back and forth across the Atlantic and also to dozens of European cities, would figure in Sargent's later pictorial representation of the Boits' household.) He also admired Ned Boit as a "brilliant water-colour painter," according the twenty-year-old ingenue Edith Wharton, who wore a rose-pink Doucet dress to dine in company with James and the Boits about this time. That evening, Sargent unwound by playing with the four daughters, bright children who ranged from ages four to eight. Mary Louisa, Florence, Jane, and Julia could hardly have known that their parents' good-natured friend was about to immortalize them, and in rather a dark and complicated masterwork.

In 1882, by painting the Boits' four daughters on one huge canvas, each wearing their coverall pinafores and each lost in the cavernous darkness of the Boits' big rooms, Sargent created one of his most astonishing canvases and perhaps his greatest masterpiece, *The Daughters of Edward Darley Boit* (see Fig. 12). He was then only twenty-six—as Henry James later pointedly noted. But in his masterful composition he summoned a "superb group" in which he paid tribute to Velázquez's *Las Meninas*, the Spanish painter being the "god of his idolatry." As the art historian Erica Hirshler has observed, Sargent managed to channel *Las Meninas*, that enigmatic group portrait of

the entourage of the Infanta Margaret Theresa, in its "baffling relationships between the figures . . . its shadows and half-lights, and the complex geometry of its space." Like Velázquez, Sargent had created a conundrum of reality and illusion, light and space. He'd set up a troubled, poignant confrontation between the four isolated girls in their playtime pinafores and the viewers of the painting.

Yet, far more than merely striking an homage to the Spanish master, Sargent's portrait of the Boit daughters created its own unsettling and intractable mysteries. It plumbed the paradoxes of childhood and young womanhood. It was psychological in an era when professional psychology was burgeoning. But it laid out its complications by means of Sargent's own deep instincts for psychology as well as his inside knowledge of the bizarrely overcivilized expatriate world, haunted and weighed down by the encrustations of European history, in which he (and James) had been brought up. Though Sargent liked the Boits and understood their milieu, his rendition also gave away the secrets of the Boits and their class—that their splendid world wasn't perhaps as splendid as it looked. Here, as so often, Sargent's deadpan wit illuminated his canvases with subtle satire. But the painting's mysteries also transcended its rarefied social specificity, creating a painting that would fascinate generation after generation.

James nicknamed the picture, which would astound and perturb crowds at the Salon of 1883, as "The Hall with the Four Children." He understood the portrait as alive with virtuosity even in its small details: "When was the pinafore ever painted with that power and made so poetic?" He delighted in Sargent's "light, free security of execution" even though lesser critics, confronted by the painter's raw, incisive ingenuity, found the painting loose, informal, or unfinished.

Even predisposed toward Sargent, however, the more conservative James labored to discern wholesomeness in *The Daughters of Edward Darley Boit* (the children's "instinct and knowledge playing together") when Sargent had in fact rendered the separated figures isolated and rather lost in the great darkness of the room. Here James's inattention was surprising, almost inexplicable. He himself harbored rather dark and complicated impressions of Victorian children's psychology that would later result in works like *What Maisie Knew* (1897) and *The Turn of the Screw* (1898). James hit closer to the mark when he referenced the children's "assimilated secrets."

For the painting conveyed what the art historians Ormond and Kilmurray have brilliantly described as an "Alice in Wonderland quality," and an

"air of mystery and ambiguity." Its painter, James's would-be protégé, would prove much more complicated than James himself yet knew.

—←—

The strange but fated friendship between Sargent and James, tentative at first, strengthened in the hothouse atmosphere of Reubell's salon. The two men gained much from Reubell's intercession, but the particular atmosphere of her crowded, free-spirited, risqué salon also fostered a peculiar connection between them.

That the mistress and her gatherings had a distinctly queer edge emerged, rather surprisingly, in James's later novel *The Ambassadors* (1903), in which James painted Reubell as a tobacco-drenched, elegant iconoclast. For the novel's Miss Barrace, based on Reubell, smoking is definitely "the least of her freedoms." Miss Barrace lives an "irregular life" by bourgeois standards, being "perfectly familiar, freely contradictious." Circulating without a chaperone, Miss Barrace's special métier is the sprawling, sometimes risqué art world, of which she demonstrates proprietary knowledge when she comments to one fastidious American visitor—"Oh, the artist-quarter and that kind of thing"—prompting his immediate conviction of her moral "laxity."

The protagonist of James's novel, Lambert Strether—another of James's fictional old bachelors—becomes obsessed with Miss Barrace's racy "freedoms" and frets about what he considers the "sum of her license." Hearing Miss Barrace gossip about art-world liaisons, Strether reacts with, "Oh no—not *that*!" He recoils from this never-specified eroticism. Yet, also like Miss Reubell, Miss Barrace herself avoids actual indecency. She isn't what one contemporary journalist described as an "adventuress," a divorcée, a demimondaine, or one of a "flock of dusky-fleeced sheep, or of soiled doves" whom some Americans saw, with Fitzwilliam Sargent's kind of primness, as a "moral blot" in the general "evil and dissipation" of Paris. Rather she shines as an observer, interpreter, and facilitator of other people's romances. She doesn't exactly "live all [she] can"—in James's famous phrase. But she applauds those who do.

Miss Barrace's frequent companion in *The Ambassadors* is an under-thirty artist called Little Bilham. This name recalled both the "little painters" James met at Reubell's salon and Little Billee from George du Maurier's *Trilby*. But Little Bilham also shows striking similarities to the youthful Sargent, who, like Bilham, was "not yet thirty" when James met him at Reu-

bell's salon. Though James's later fictional character lacks Sargent's gravitas and talent, Little Bilham's status as "notoriously . . . not from Boston" also recalls how some Parisians mistook Sargent for a Bostonian; the word "notoriously" further contrasted the bohemian Bilham, and by extension Sargent, with Boston's stereotypical prudishness. As an ambiguous cosmopolitan, Bilham becomes Strether's special confidant and guide to Paris, and the "strength of the [erotic] current flowing between Strether and Bilham," as one literary critic has argued, is distinctly queer. Little Bilham, to be sure, figures strongly in what James himself understood as "Strether's theatre of envy and desire"—an insight into James's own complex admiration for Sargent that began in Reubell's salon in 1882. (That Strether was also obsessed with Maria Gostrey in the novel also documented James's and Sargent's complicated alliances with women.) As one Sargent biographer has described the ambiguity of these two gifted men's interactions as they unfolded in the 1880s, James's and Sargent's relation would be "strangely, though not clearly, chaste." Certainly, they were powerfully drawn to one another.

Sargent's friendship with James would burgeon over the next few years. And it was already developing its essential qualities in what James called Reubell's "tobacconized *salon*," laced as it was with exotic indulgence and luxuriousness as with cigarette smoke. Sargent, as a smoker himself, belonged in such a setting. As a friend later reported, the painter had a "smoker's throat which gives him an occasional queer half-cough, and he says 'hmmm—ha—' and draws long breaths as he talks, often leaving as much to be inferred as he actually says." Inference was becoming Sargent's forte, and it was an art he would perfect while circulating in Paris, following the luminous if enigmatic lead of Henry James.

<div align="center">⤙⤙</div>

Increasingly now, Sargent combined hard studio work with restless, tobacco-laced socializing. When in Paris, he dined out, met friends at late-night cafés, and haunted the avenue Gabriel on Sunday afternoons. Henrietta Reubell's salon figured as Sargent's main version of a much more widespread phenomenon in Belle Époque Paris whereby daring and unconventional women received, sheltered, and promoted unconventional artists, and often lost, queer artists.

The better-known salon of Comtesse Élisabeth Greffulhe in the nearby rue d'Astorg also boasted iconoclastic guests, edgily modern, among whom were James McNeill Whistler, Auguste Rodin, and Gabriel Fauré. But this

exquisitely dressed, violet-eyed aristocrat also welcomed homosexual writers and artists, not least her cousin Robert de Montesquiou. He helped render her salon a long-running feature of unconventional Paris (and later even converted the Comtesse to the queer modernist milieu of Sergei Diaghilev's Ballets Russes). Greffuhle achieved lasting fame less through portraits of her painted by Sargent's contemporaries Antonio de la Gándara or Philip de László, or the *Figaro*'s accounts of her dazzling parties, than through her fictionalization in Marcel Proust's *À la Recherche du temps perdu* (*Remembrance of Things Past*, 1913–27), in which, along with other models, Proust transformed the Comtesse into the dazzling Duchesse de Guermantes.

The Jewish *salonnière* Geneviève Halévy Bizet Straus, another model for Proust's Duchesse de Guermantes (as well as his Odette de Crécy), hosted an ambitious "circular" salon that mingled high society, nouveaux riches, and bohemians—in short, "Tout-Paris" (café society or the beautiful people). She coquettishly received her guests reclining in a deep armchair swathed in a sumptuous silk dressing gown. Hostesses sometimes lured their *salonnards* through sexual innuendo as well as domestic hospitality—the "ugly" Henrietta Reubell's version of such frisson being the "adventurous" conversation Rothenstein had noted, and which James labeled "interesting gossipry," distinct from that of Mme Straus but also closely related.

An even more notorious example of a queer-friendly *salonnière* was Baroness Madeleine ("Elsie") Deslandes. This small, determined German novelist, a fanatic for the work of the British artist Edward Burne-Jones (a friend of Henry James's), assembled a circle of artists that rendered her, according to one historian, "the ambassadress of the aesthetic movement in Paris." Dressed in "vaporous tea-gowns," with a "monocle rimmed with opals," the baroness received tributes of lilies from Oscar Wilde and adulation from many beautiful young men—some of them "little painters" of Reubell's favored type—whom she "wafted . . . in the direction of her habitués."

As an American, even a sophisticated Francophone one, Sargent didn't exactly frequent the Paris salon circuit. But Sargent also encountered his friend Robert de Montesquiou at Etta Reubell's Sundays, and the Comte counted as one of the era's most prominent salon habitués. Luckily, the buttoned-up James and the flamboyant Montesquiou never ran into each other at the avenue Gabriel. (When Sargent gave Montesquiou, Edmond de Polignac, and Samuel Jean Pozzi letters of introduction to James in London a

few years later in 1885, James obligingly entertained them—he hoped "successfully"—but, though he found Pozzi "charming," he treated the two covert French homosexuals with only a cordial stiffness that he maintained in two letters he sent merely to "cher monsieur.")

Bold women like these also furnished hesitant men examples of successful and sometimes exhibitionistic eroticism. The Belle Époque was a time of women's self-assertion and self-transformation, and queer male artists, among others, tapped into women's restlessness and dynamism to articulate their own desires. If Sargent had earlier gravitated to Rosina Ferrara—to her personal magnetism as well as the circles of men she gathered around her—he found himself, in a woman-obsessed Paris, drawn to confident, unconventional women for personal, practical, and aesthetic reasons. "There is a great demand for brilliant women," as Henry James had expressed the matter to Reubell, speaking of women's preeminent cultural role in America. But the same could certainly be said of James's and Sargent's Paris.

James, watching his would-be protégé carefully, was already noticing their parallel woman-centered propensities. In 1887, in a glowing evaluation of Sargent's painting in *Harper's Magazine*, James would remark that it was Sargent's "fortune to paint more women than men." In particular, James thought that Sargent knew the "secret of the particular aspect that the contemporary lady (of any period) likes to wear in the eyes of posterity." But Sargent's affinities with women weren't simply accidental or even a matter of the portrait market's frequent focus on women and their lively stylistic preferences. On a deeper level, the "uncanny spectacle" of Sargent's talent, as James phrased it, hinged on women almost completely. Sargent increasingly identified with women and allied himself with their points of view. With great implications for his painting, he built rich and complex connections especially to iconoclasts and divas.

-<+-

*James wrote Etta Reubell regularly, when he couldn't visit her in Paris. His let-*ters (unfortunately only his have survived) echo the chat at her salon that often focused on Sargent's high-profile Salon pieces. James and Reubell were forever canvassing Sargent's latest. Indeed, the young painter fully intended these pieces to precipitate talk, even if he remained rather quiet and laconic himself, except at unguarded moments or in intimate settings. Sargent's paintings fit into the "interesting gossipry" of Reubell's salon especially

because they dramatized his growing predilections for cultivated or exotic women—or rather stylizations of such women—which were increasingly emboldening his paintings.

James didn't attend the Salon of 1882, but he later expressed strong opinions about the paintings of women that Sargent had exhibited there. The novelist was especially attracted to *Lady with a Rose*. This painting depicted a dark-haired young woman in a black dress with a somewhat quizzical expression ("peculiar," James called it), a white rose pinched between the fingers of her left hand. James found the piece "painted with extraordinary breadth and freedom, so that . . . it glows with life, character and distinction" and praised this portrait as "impossible to forget" because of its "simplicity." But simplicity was exactly what this portrait didn't embody, at least on a personal level.

The sitter was a twenty-year-old cosmopolitan named Louise Burckhardt. Dark-eyed, rather solemn-faced, and with a prominent, Cupid's-bow mouth, she was half-Swiss and half-American, a member of Sargent's expatriate circle whom the young man had known for several years. According to his friend Beckwith, who understood Sargent to harbor an amorous interest in Louise, Sargent made some unspecified gestures of courtship at Fontainebleau during the summer of 1881. To encourage this relationship, Louise's American mother, the formidable Mary Tomes Burckhardt, actively plotted idyllic country excursions. The gray-haired, bejeweled matron regarded this budding relation as an engagement and Sargent as her future son-in-law.

The romance never budged, though. Months passed, and no engagement was announced. Vernon Lee saw the resulting painting at the Salon in spring 1882 with John and Emily, but she still dubbed it only the "girl in black." John and his sister didn't claim Louise as any closer relation. A year later, visiting John's new studio in the Boulevard Berthiers, Lee assumed that, John having leased a little house, "Miss Burckhardt is gone off the horizon." It was not until 1884 that Lee met "the girl [John] was supposed to be engaged to"—emphasis on "supposed." Lee found her "very charming, not absolutely pretty." With such faint praise, Lee appeared to rate the "inspiration" less appealing than Sargent's portrait, which she had earlier lionized as "simply superb & like an old master."

The most relevant Old Master was, as so often with Sargent, Diego Velázquez. The art historians Ormond and Kilmurray have suggested

a similarity in Louise Burckhardt's pose to *Buffoon Calabazas*, a painting attributed to Velázquez in Sargent's time. Yet if Sargent had this odd seventeenth-century picture in mind, he'd certainly made a strange choice. Not only did the earlier work portray a young *male* figure but also a Spanish court jester or perhaps even an allegory of madness—an insight into the "peculiar" expression on Louise Burkhardt's face, but not a convincing sign of romantic passion.

Though the "romance" gave birth to an intriguing, rather theatrical Salon portrait, it memorialized a peculiar and distorted passage in Sargent's life. Still, it proved hard to evade anybody in the tight-knit American coteries housed around the Champs-Élysées. Sargent wound up painting a number of Burckhardts, including Louise and her still-hopeful mother in 1885, a commissioned double portrait in which Louise's fashionable red-velvet dress hardly disguised her awkward pose and her rather plain, earnest face.

-+-

James knew that Sargent had traveled in Spain in 1879—Sargent probably told James stories about his travels. But still he was unprepared for Sargent's most dramatic contribution to the Salon of 1882, *El Jaleo* (see Fig. 9).

James thought Sargent's Spanish dancer in *El Jaleo* showed "breadth and boldness." But he worried that it made spectators uneasy and unhappy with its "ugliness" and its "want of serenity." To be sure, James felt less interest in Spain and so-called low life than Sargent did. When he was out walking or dining with the more sedate James, Sargent's tastes appeared flamboyantly bohemian and exotic. But Sargent's magnificent picture, painted from his sojourn with his two woman-focused French friends in Spain, adroitly expressed Sargent's own deep fascination with Spanish music as well as for the dim, risqué, hole-in-the-wall cabaret he evoked in his dark, vast, dramatic picture. *El Jaleo* also marked a further step in Sargent's adulation of diva-figures. For though the dancer remained nameless, she owned the stage.

Sargent's future friend and patron Isabella Stewart Gardner, who adored Spain and its *taberna* nightspots, would fall in love with this piece for all the reasons that James instinctively disliked it—for its dramatization of exultant female erotic force. In a sense, a "want of serenity" was exactly what Sargent was after. It was curious that the otherwise sympathetic James should misunderstand this picture and the motivations behind it when he

described Sargent, with some inside knowledge, as "a young painter less in the dark about his own ideal, more lucid and more responsible from the first about what he desires."

Emily Sargent went through the trouble of returning to Paris from the family's current roost, at Aix-les-Bains, to see her brother's two Salon contenders. "She wanted very much to see John and his pictures at the Salon," her father remarked. Emily traveled not only out of loyalty but also from an interest in her brother's works. After all, she too had seen Roma dancers in Spain and had made her own watercolor sketches in that country. (Emily spent a month in Paris, often seeing her brother and meeting some of his colorful friends.)

Mary too remained interested in her son's painting and his Paris career, but she was more and more dogged by ill health and absorbed in spa treatments. Once these had been excuses for liberation for her; now, increasingly, they were becoming, especially in her son's absence, the main concern of her life. As for *El Jaleo*, Dr. Sargent noted that his son's "dancing scene among the Spanish gypsies" had been "spoken very well of indeed." It also counted, for John's father, that a New York picture dealer was interested in the painting—"who intends taking it to New York to exhibit and sell it if he can."

Sargent's high-spirited companion in Paris and Brittany, Judith Gautier, understood the inspirations of *El Jaleo* far better than either Henry James or Fitzwilliam Sargent. She embraced the exotic ecstasy of this piece and its suggestions of women's sexual allure and prowess. In her review of the painting in *Le Rappel*, she declared Sargent *"le héros du Salon"* (the hero of the Salon) and declared that he had forged a path to unexplored regions (*"s'est frayé sa route vers des coins inexplorés"*). For Gautier, these exotic unexplored regions introduced sensual non-European bodies as well as mystical geographies. She described the central female figure of *El Jaleo* as a *"danseuse d'Andalousie"* so carried away by her own movement as to be poised in an ecstatic instant that the painter had been able to arrest in a composition *"sobre et puissante . . . d'une vérité absolue"* (sober and powerful . . . with absolute truth).

Yet Gautier's fascination, insightfully, also extended to the shadowy male musicians and watchers in the background. She insisted that these obscure *gitano* figures (*"bohémiens, égyptiens, zingaris"*) originated from afar, from so far away in fact that on the way they had forgotten the name of their country (*"même qu'ils ont oublié en route le nom de leur pays"*). Literally, she

referred to European Roma, people living far from their origins in northern India. But figuratively she pinpointed Sargent's orientalizing imagination that had envisioned an underworld sensuality that itself, in overcivilized Europe, qualified as a foreign country. Such an appraisal very much anticipated Proust's later *Sodome et Gomorrhe*, in which, in a similar vein of exoticism, Proust understood homosexuals as exiles from distant and lost homelands, the Biblical Sodom and Gomorrah.

When in Spain, Sargent had made painstaking preparatory studies for his dark, peopled background, including his *Study for Seated Figures, "El Jaleo"* that included a sketch of a male observer whose posture and expression reveal alert sensual subtleties, and *Study for Seated Musicians, "El Jaleo"* that showed intent guitar players and a seated dancer, complete with bloodred accents, a cummerbund, and a cloak, which Sargent omitted in the final painting (see Fig. 8). In such preliminary sketches, Sargent focused on the men's handsome and ecstatic faces. Such figures were genuine points of interest even if they played second fiddle—or rather second guitar—to the female dancer. And though Sargent's figures didn't represent homosexuals per se, they too were bathed in an off-center, obscure eroticism, as Gautier had rightly sensed.

Such a suggestion might have seemed far-fetched to the crowds at the Salon, who focused their attention and admiration on Sargent's prominent, side-lit dancer. But in the couple of years that followed his exhibition of *El Jaleo*, Sargent would privately paint a handsome young male friend in the same kind of Spanish costume as was worn by these half-obscured background figures. And during the autumn after the Salon of 1882, he would go on a hunt for more disturbing low-life figures to rattle and titillate Paris audiences. And, once again, he chose the midnight canals of Venice.

In the Key of Blue

Arriving by gondola at the Palazzo Barbaro on the Grand Canal meant approaching a tall pointed arch and then, once handed onto dry pavement by a gondolier, passing into a columned entrance hall. From there, the excited Sargent climbed staircases lined with potted palms and flowering oleanders, greeted and shown the way, as one visitor remembered, by various courteous Venetian servants and more "bowing gondoliers."

The gondoliers—picturesque in their assorted colorful scarves, sashes, and hats—caught Sargent's attention. Not merely ornamental, they were vital to the hospitality that Daniel Sargent Curtis and his wife Ariana extended to their guests. When Sargent arrived at the palace in August 1882, the Curtises' phalanx of cheerful, obliging gondoliers demonstrated that their dilapidated, once-exquisite palazzo near the Ponte dell'Accademia, part Gothic, part Baroque, had now emerged from decades of neglect. The Curtises were inaugurating in Venice a new era of Belle Époque magnificence. In August 1882, Sargent, though, was venturing on something else, and something even more daring. He was delighted to return Venice; he sensed he had masterpieces to paint.

Amid all this fanfare, Sargent sized up the gondoliers, wondering how they'd fit in. For starters, he loved to go out with them: they provided convenient, ubiquitous, and atmospheric water transport in a city that in the 1880s offered no alternatives except for the crowded public "omnibus steamers" that gave Ariana Curtis the vapors. But these for-hire boatmen also acted as guides for elite travelers and artists, many of whom aspired, like Sargent, to discover the "real" Venice away from increasingly thronged tourist quarters such as the Piazza San Marco, the Rialto, and the Accademia. Such visitors craved inside knowledge—vital to elite "travelers" as opposed to vulgar "tourists."

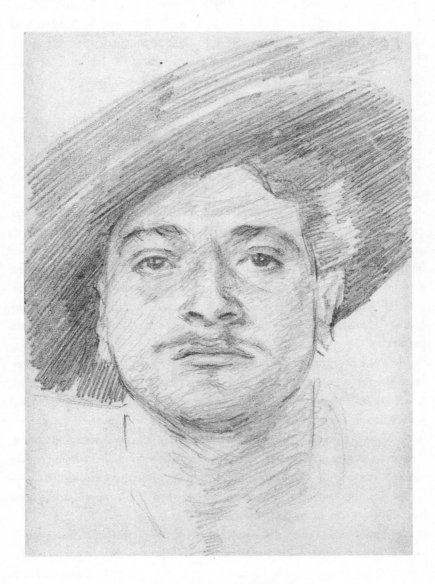

Sargent, *Man in a Hat*, 1880–82

Sargent suspected that such an inside view was most readily available from these genial, willing, and "authentic" working-class Venetians. Gondoliers not only could help him find and clinch the "real" Venice but also physically embodied it, to his delight, in their sunburned, athletic frames, their rough Venetian dialect, and their knowledge of the labyrinth of little canals and streets that made up the ancient, water-laced city.

Reunited with the sights, smells, and sounds of late summer in crowded Venice, Sargent felt the draw and charm of gondoliers and focused at least some of his rebellious energies on them. But as he settled down in the city again, he didn't directly paint many of them. A few pencil sketches of these sinewy boatmen in action survive, as if Sargent like so many visitors was captivated by their lithe movements as they punted him round the old maze of a city in their gondolas. An intense pencil sketch of a handsome mustached man, *Man in a Hat*, may well depict a gondolier Sargent met in Venice.

But more controversy surrounds a surviving oil painting of an even handsomer young man with tousled black hair, a sporty mustache, a square chin, and an inscrutably intense look in his heavily shaded eyes, that was long labeled as a gondolier. *Head of a Male Model*, though it long suggested Venice to Sargent's friends and followers, may or may not have been painted in the city.

Anxious to plunge in, Sargent soon set up shop in a studio at the Palazzo Barbaro. This space he shared with his artist friend Ralph Wormeley Curtis, the Curtises' amiable twenty-eight-year-old son, whom he'd earlier befriended in Paris and with whom he'd once traveled to the Low Countries. Sharing a studio with Ralph attracted Sargent. Two engaging young American painters, Julian Story and Harper Pennington, also worked in this space, lending the studio a convivial if slightly competitive atmosphere.

During the long, hot days, these young men's impromptu studio was haunted by gondoliers. For all moneyed foreigners in Venice, gondoliers made themselves perpetually available, with their cries of "*Comandi Signore?*" (You command, Sir?) at all hours. They provided these young artists dignified symbols of the fallen but still magnificent city-state of Venice. They offered themselves as highly eligible subjects for painting, their colorful and manly qualities widely celebrated among the rich expatriates Sargent knew.

In fact, an "infatuation with gondoliers was a well-recognized characteristic," as one historian has remarked, of genteel Anglo-American circles. The Curtises as well as Sargent's studio buddies also succumbed to a collective infatuation. Another historian has concluded that even "heterosexual men

were permitted to admire gondoliers, and to write publicly about their physical prowess and rugged good looks. Queer men could also participate slyly in this public discourse while carrying things further in private." Sargent's own reaction to gondoliers, though spottily documented in 1882, appears to have been profound, and it would leave an even more profound legacy.

Even in the heat of the day, Sargent felt at home in a gondola and could freely paint on that rocking, bobbing platform. He had a track record, and he already knew his way around the gondoliers' labyrinthine world. But staying with the Curtises, he found, rather complicated the project that soon most grippingly engaged him—of painting gritty street scenes.

Dapper, whimsical Ralph Curtis styled himself as a painter but gravitated to conventional, rather romantic scenes—ladies picnicking beside bridges—rather than Sargent's suggestive streetwalkers. Sargent recognized that his friend wasn't an artistic bomb-thrower. He appreciated Ralph as a cheerful cosmopolitan loafer whose rather pretty, high-colored pieces did nothing to shake the Salon. And Ralph's parents, as John grew increasingly aware, were even more conventional, mannerly, and moneyed. Sargent had strayed into something more like a museum than the carnival of Venice life that he now craved.

Vernon Lee, who ventured into the Curtises' double palaces on the Grand Canal in 1885, found them the "sort of Americans" who shuddered at the gritty realism promoted by writer William Dean Howells and who worshipped Henry James "as a sort of patron saint of cosmopolitan refinement." Daniel Sargent Curtis, whom Lee described as "a nice brisk little man, rather timidly anxious to put in a little piece of information or anecdote or joke here & there," was a rich Bostonian who'd chosen to dwell in exile after an upsetting omnibus altercation in Boston in 1879 that had earned him jail time. Though on that occasion he'd defended Ariana Curtis's honor, he struck visitors to the Palazzo Barbaro, including Sargent, as negligible in comparison to his wife. (Sargent wrote ingratiating letters to Ariana, never to her husband.)

Ariana Curtis, the daughter of an English admiral, had grown up among the courts of Europe ("a rather die-away [faded] English American," Vernon Lee called her). She bristled with impressive cultivation, icy jewels, and strong opinions. Sargent called her *la dogaressa* (the Venetian duchess). She came across to Sargent as formidable and exacting; at least she appeared that way in the portrait Sargent painted of her that autumn as a thank-you for his stay. Here she was sharp-featured, thin-lipped, dressed all in black. Her

old-fashioned lace cap and two strings of pearls captured her arch-Victorian female proprieties. And her attention was focused, hawklike, on her distinguished but potentially wayward guest.

The Curtises were poised to interfere in Sargent's life, for the rooms they provided him to live and paint in. Ariana Curtis and her husband later whispered to Vernon Lee that "it would be most unfortunate were John to marry Miss Burckhardt as her family is extremely vulgar & designing & she has no education." How then did they react to some of the women in Sargent's paintings when they looked in on Sargent's work at his Palazzo Barbaro studio? Some of Sargent's Venetian scenes amounted to what the art historian Fairbrother has called "alley scenes with suggestive exchanges between men and women"—pickups if not prostitution.

In Sargent's *Venetian Street*, a young woman with a long dress and scarf converses in a narrow backstreet with a bearded man in a black cloak. In *Street in Venice*, a similar young woman walks in a similar alley, a red comb conspicuously perched in her hair, with two dark, cloaked figures of men watching her from the side. In yet another painting almost identically titled—again foregrounding the suggestive word "street"—a lone woman stands with a lone man in the doorway of a narrow alley, their keen, disreputable appearance suggesting something very different from the tropes of Victorian "romance" (see Fig. 11).

Some art historians have interpreted these scenes as depicting prostitution. Others see Sargent showcasing independent, confident women in stimulatingly free exchanges with men. *The Sulphur Match* treats a similar encounter indoors, creating a parallel ambiguity of prostitution versus sexual freedom: a darkly handsome young man lights his cigarette beside a young woman in a red scarf tilting back against the wall. "No member of [Sargent's] social circle would publicly lean back in a chair in the uncouth manner practiced by the Venetian woman," Fairbrother remarks. "Her body is totally relaxed, and even her hand touches the wall with extraordinary poise and implied boldness."

When they peered into Sargent's studio, the Curtises no doubt found these canvases outré, perhaps even troubling. But no doubt they were reassured by their son or by Henry James as to Sargent's brilliance. "Art," in the minds of many cultured and otherwise stiff Victorians, granted a certain license not otherwise found in rule-bound patrician life. Henry James wanted to believe as much in 1884, when, contemplating Sargent's increasingly decadent work, he asserted that his friend's "character [was] charmingly naïf

but not his talent." Whether or not Sargent was sexually innocent, however, his work did manifest what James called an "*excess* of cleverness"—code in this case for an ability to portray transgression, and to relish portraying it—in ways that didn't always match his seemingly respectable life.

Of all of the family, Ralph most understood what Sargent was doing, what a delicate tightrope he was walking, with his fresh clutch of Venetian street pictures. Ralph liked John, even or especially his rough edges and his strong, half-articulated hankerings.

With his long days of plein air work and evening wanderings, Sargent labored to make this new round of Venetian genre pieces look spontaneous, as he did with many of his paintings. He imitated, in his sketches, candid moments captured by some roving photographer, like raffish scenes observed by some Parisian flâneur. One fellow painter, witnessing his Venetian methods, marveled at Sargent's "great gift" of deploying a "rapidity of vision by which he could throw his work on the canvas in a very short time, which enabled him to finish his work quickly without losing the freshness of his first impression."

Even so, Sargent was now playing a complicated and rather disingenuous game. He was carefully constructing such images, meticulously dressing and posing models in the studio or incorporating more fleeting sketches taken in streets, alleys, or ateliers. Sargent's sketchbook *Study for a Venetian Scene* depicted local men in rather theatrical costumes; he probably executed it in his studio, with gondoliers dressed up, posed, and given props, rather than sketching the piece hastily in the street.

With such premeditated pieces, the mild-mannered, diffident Sargent was in fact spending less time "slumming" in the seedy quarters of Venice than in imagining such waywardness, and in honing his uncanny ability to reproduce it. The Curtises, pausing at the studio door, peeping at his canvases, knew or sensed as much. For Sargent documented fantasies of backstreet life, not backstreet life itself. And yet these fantasies motivated him more strongly than more genteel options, and more powerfully than the Curtises knew.

What's more, Sargent, making the most of his weeks away from Paris, still pursued more fraught interactions in Venice than the Curtises could monitor. His calm, good-guest exterior disguised bursts of ambition and inventiveness, which carried him out into the city at all hours. As Henry James observed about his friend, Sargent was "intelligent *en diable*"—devilishly intelligent. And actually, he didn't lack exposure to Venetian low life, or low

life of a kind, even if in the early 1880s he'd boarded with his family during his first Venice sabbatical and houseguested with the Curtises during his second.

On hot evenings in Venice, erotic opportunities bloomed like nocturnal flowers. Sargent's Palazzo Barbaro studio-mate Pennington, at least, clearly understood the after-dark Venetian social routine in which visiting artists participated. "Ten o' clock was the hour for formal calls in summer," Pennington remembered. "One dropped in on one's intimates toward midnight, and regained one's gondola somewhere near 2 A.M." Such late-night visiting accommodated sexual or romantic opportunity. But so did the Venetian models, as Pennington described them: "What a place Venice is for models! Stand by your door and beck, or, like characters in the 'Arabian Nights,' just tap on the shoulder of anybody you would like to paint, saying, 'Follow me,' and he follows as a matter of course." Though Pennington described "Men, women, and children" in this same category—"they all appear willing to sit, and seem to understand perfectly what is required of them"—his predilections, to judge from some of his surviving paintings, were for men, as in the "he" used in his example. Pennington himself may have pursued such experiences.

Did Sargent? Two of the most direct allegations from Sargent's contemporaries about his possible homosexuality singled out both Venice generally and gondoliers specifically. A friend from the 1890s, Betty Wertheimer, believed that "Sargent was only interested in Venetian gondoliers." Fellow portraitist Jacques-Émile Blanche allegedly remarked that Sargent was "notorious in Paris and in Venice positively scandalous. He was a frenzied bugger." These reports have rightly been questioned. What remains clear, though, is that Sargent had a genuine fascination, especially during this visit, with Venice, its gondoliers, and its seamier side.

Sargent's strong focus on the city's low life and sexual underside adds weight what historians have recently established about emerging Belle Époque queer subculture in the ancient city. At least since the Renaissance, Venice had nurtured a well-developed culture of sexual exchange, including brothels. The roster of foreign nineteenth- and early twentieth-century writers and artists who pursued affairs with gondoliers includes such figures as August von Platen, A. E. Housman, Jean Cocteau, and Thomas Mann.

At the age of thirty-six, John Sargent had already long been close-lipped about his personal life. He was also still young enough, and still Victorian enough, to be idealistic about love. Vernon Lee reported in 1883 that John

had Dante's *Vita Nuova* "on the brain"—a sonnet cycle about passionate love from afar—and one set in a romantic, historical Italy he so often loved to explore. Yet, especially among Victorians, such idealism was not in fact incompatible with "frenzied buggery." Henry James during the same period illuminated a contradiction in Sargent between a highly Europeanized American "civilized to his fingertips" and a restless young artist "perhaps spoilable."

Sargent encountered ample evidence, all around him, that Venice "spoiled" many men with queer inclinations. The city brazenly offered not only accommodating gondoliers but also male brothels like the one that was exposed in 1908 during a scandal involving opportunistic foreigners. That brothel stood on the Fondamenta Nuove, only a few streets away from the Calle Larga dei Proverbi, one of the backstreets where Sargent staged his provocative Venetian women. What's more, Sargent was increasingly pursuing a brand of elite fascination with working-class life that was in itself, as one historian has argued, one of the prime features of queer Belle Époque Venice. The milieu of gondoliers and backstreet taverns "captured the imaginations of literary homosexual men" and gave "greater freedom of opportunity than in [Anglo-Saxon countries] for sexual relations with other men."

Day after day, Venice provided unconventional opportunities, even though we don't know if Sargent availed himself of them. To a work-hound like Sargent, a gondolier, if he desired one, would have qualified as a dangerous and compromising distraction. Any man's betraying same-sex desire was one of the quickest ways for him to undermine his deeply entrenched privileges.

Descending the Curtises' marble steps to the Grand Canal, Sargent deeply appreciated his own exquisite advantages. Even as he headed out, paint box under his arm, for the rougher parts of Venice, he maintained a taste for the potted palms and many-course dinners the Curtises and their set could provide him. If he wanted more out of Venice, he'd have to think twice before jeopardizing such perks. What's more, even though he now harbored, thanks to Paris, many unconventional and bohemian tastes, he'd also long insistently cultivated a stiff Victorian respectability. On any day out painting in Venice, such contradictions dogged him.

Even at the Palazzo Barbaro Sargent encountered others who harbored contraband knowledge of the Venetian underworld. Horatio Brown, a Scottish writer whom Vernon Lee described as "yelping and friendly," visited the Curtises and lived not far away in a flat in the Palazzo Balbi Valier with

his elderly mother, where he gave Monday at-homes. As his friend Frederick Rolfe remembered these gatherings, Brown's white-haired mother chaperoned his parties "in black satin and diamonds," slicing at visitors with her ebony crutch. Rolfe himself, a penniless English poet who styled himself "Baron Corvo," instigated a number of affairs with Venetian gondoliers.

Brown, too, in spite of his apparent propriety, not to mention his vigilant live-in parent, also pursued outside interests, and partly through his expatriate métier of studying the distinctive local culture. "The gondola is made for solitude or for company—the best company, the company of two," he wrote in his 1884 local-color account of Venice, *Life on the Lagoons*. In this highly respectable and documentary book, Brown argued that anyone "who has become enamoured of the lagoons and lagoon life will find himself obliged to make friends with the gondola." But it was gondoliers themselves whom Brown actually befriended, and he filled his book with details of their lives and pursuits. He dedicated it to "My gondolier Antonio Salin my constant companion." After 1885, the good-looking Salin, though married with a family, joined Brown and his mother in the Ca' Toresella. Salin became inseparable from his employer as a ubiquitous sidekick.

Brown kept almost as discreet as Sargent tended to remain by taste or predilection. Brown's professional passion for "authentic," "low-life" milieus of gondoliers paralleled Sargent's painterly fascination with working-class, backstreet life. And for Brown as well as Sargent, the interest in working-class people was quite genuine even if its motives were sometimes displaced or disguised.

Disguise was something that Brown was good at, that he was obliged to be good at, even in so free-spirited an expatriate wonderland as Venice. But not all the members of his and Sargent's circle easily accepted the restraints of Anglo-Saxon propriety.

◂◂

In spring 1881—near the end of Sargent's first residence in Venice—Horatio Brown accompanied his friend John Addington Symonds to what Symonds later described as "a little backyard to the wineshop of Fighetti at S. Elisabetta on the Lido." Forty-year-old Symonds, a gaunt, nervous Renaissance scholar with a rather full mustache and a triangular beard, hoodedly watched a couple of gondoliers, in this tavern-haunt of that profession, whom he recognized as servants of General William de Horsey. Symonds found one of these gondoliers, with a broad-brimmed black hat on his dark

hair, "strikingly handsome." He had "fiery" gray eyes, brilliant teeth under a blond mustache, bronzed skin, and a well-developed physique. Symonds was smitten with twenty-four-year-old Angelo Fusato. But he was petrified with shyness and didn't dare approach him.

Symonds agonized over the handsome gondolier for months. Though he was strongly drawn and even given encouragement, he remained shocked that "a man of this sort could yield himself to the solicitation of a stranger," not to mention "so vile an act" as Symonds considered prostitution. Symonds himself preferred a somewhat more restrained and ethereal form of interaction, such as he had previously practiced in England and Switzerland, where, racked by Victorian scruples, he had repeatedly held himself back from sex.

But when Symonds eventually initiated erotic relations, the gondolier opened up a whole new world for his patron. Fusato revealed to him that "the gondoliers of Venice are so accustomed to these demands that they think little of gratifying the caprice of ephemeral lovers—within certain limits, accurately fixed according to a conventional but rigid code of honour in such matters. There are certain things to which a self-respecting man will not condescend, and any attempt to overstep the line is met by firm resistance." Though Fusato already kept a mistress by whom he'd fathered two children, Symonds hired him as a servant. Steady employment enabled Fusato to marry, and Maria Fusato also eventually worked for Symonds and his wife.

Thanks to the social hierarchies of the day, this middle-class Englishman generally managed the younger and poorer Italian's life for him in a way that was both patronizing and seemingly mutually agreeable: "He does enjoy his life on the loose with me," Symonds wrote a friend, "much more than his life with wife & babies & bills in Venice." Their relationship lasted some twelve years until Symonds's death in 1893. Symonds believed this intimate alliance, an early attempt to forge a same-sex partnership, created "permanence and freedom." Native Venetians and to some extent their foreign guests appeared to tolerate his arrangement.

Symonds's experience is often cited because it remains the one frank and complete account of such homosexual dealings in Venice. Yet, though his personal life was well-known to a group of so-called Uranians in Venice and England, it was one of this number—Horatio Brown, Symonds's literary executor—who, pressured by Symonds's wife, wound up suppressing or destroying most of the relevant documents in Symonds's papers. The

exception was Symonds's truth-telling autobiography, whose blunt revelations Symonds stipulated not be published for fifty years after his executor's death, and whose confessions became public only in 1984. It took almost a century for an honest treatment of nineteenth-century queer Venice to emerge.

Like Sargent, Symonds belonged to the Palazzo Barbaro circle. Henry James knew enough about Symonds's half-visible life and his clandestine, prohomosexual writings (some of them written for the revolutionary British sexual reformer Havelock Ellis) to declare in 1893 that Symonds was a "candid and consistent creature." As a potential sexual reformer, he was "the Gladstone of the affair." Yet James fretted that Symonds's agonized appeal for homosexual legitimacy amounted to "a queer place to plant the standard of duty"—James himself preferring discretion and, no doubt, conveying this attitude to Sargent. James gossiped that "some of [Symonds's] friends and relations are haunted with a vague malaise."

Like his cautious older friend, Sargent knew a good deal about Symonds. Sargent didn't stand on an intimate footing with Symonds; still, the older man's story is highly relevant to Sargent's negotiation of the ambiguous Venetian underworld. It shows the mix of pent-up desire, guilt, ethnic difference, class, and idealization that characterized that underworld. It also demonstrates the limited and carefully hidden approximation of sexual freedom—or perhaps sexual exploitation—that some men with same-sex desires were able to fabricate.

Symonds's techniques for disguising his relation with Angelo Fusato shed light on Sargent's experiences and artistic choices, whether or not Sargent had quite the same set of motives. In the many sonnets that Symonds wrote about Fusato, he remarked that he "framed [them] to render publication possible." That is, he adapted them to the female sex. In one sonnet from the early 1880s Symonds addressed his beloved as "Seraph, Medusa, Mystery, Sphinx! Oh Thou / That art unattainable!" In another, he pushed this gender shift further, disguising Fusato metaphorically in what he called "her white dress, / Those summer robes she then so lightly wore" even though this composite beauty also had "cheeks bronzed with sunshine"—a strong tan being more likely in a gondolier than in a maiden shrinking under a parasol.

To a modern reader who knows Symonds's story, these poems evince a telltale torment of pronouns as well as an urgency for rendering love figurative, allegorical, and nonspecific. Yet in spite of what one commentator

has called these "mutilations," Symonds insisted that these poems still accurately described "the varying moods, perplexities and conflicts of [his] passion." Even so, such experiences when rendered public were subject to a male-to-female translation or displacement.

Such transformations of the love-object were common in the Victorian underworld. Rather surprisingly, given his medium, Sargent also availed himself of some similar gender-bending—if for a somewhat different set of reasons. Sitters for portraits might seem to be inalterable in the Victorian binary—a man being a man and a woman a woman. But in multiple instances, Sargent consciously or unconsciously imitated his artistic hero Michelangelo and used male models in creating female images. In at least one extremely telling case, as will be seen, a male friend would serve as a model for one of Sargent's most famous portraits of a woman.

Another method of disguise that Symonds adopted also reflects on some the complicated work Sargent was doing in Venice and Paris as well as on Sargent's predilection for nude male figures, which would grow more prominent after this Venetian interlude.

If Symonds could not or chose not to disguise the sex of his love-object, he aestheticized his erotic interest. When Symonds's photographer friend Percival Broadbent took photographs of Angelo Fusato at Davos in Switzerland, Symonds insisted that these images were "magnificent studies of his face" or, when the gondolier was stripped "nude to the waist," "worthy of a place beside the finest chalk drawings of a realistic master." Art justified or exalted images that might otherwise read as erotic or even pornographic—a practice of aestheticization, incidentally, also pursued by even more explicit homoerotic photographers in Italy at the time, such as Wilhelm Plüschow in Naples and Wilhelm von Gloeden in Taormina. In von Gloeden's work, dreamy expressions and classical props—lyres, sofas, pillars—transformed young Sicilian peasants, graphically naked, into homages to Ancient Greek statuary and vase-painting, laced too with Victorian romantic sentiment.

Broadbent's photographs of Angelo Fusato remained strictly private. Symonds circulated them among friends, largely among the "Uranian" underground sympathetic to such homoerotic content. Sargent's work also divided quite sharply between high-profile exhibition pieces and public portraits on the one hand and, on the other, a private and personal opus never intended for general consumption, and one that would ultimately include a large number of male nudes. As he'd already demonstrated, Sargent recognized the difference between a presentable *Fumée d'ambre gris* and a

sketch of naked male Moroccans. Incidentally, Sargent's public opus eventually worked its way into museums' public collections and, associated with his growing fame, became the recognizable body of his work. His private pieces, by contrast—his sketchbooks, watercolors, and pieces given or sold in private and usually unrecorded transactions—remained virtually unknown until long after Sargent's death.

For public consumption, any homoerotic content had to become, in the logic of the time, even more aestheticized—hyper-aestheticized, in fact. Here again Venice furnished a convenient pretext in its dual role as a hub of prostitution and the most painterly of nineteenth-century cities. Symonds resorted to a Venice-specific dynamic of aestheticization that, though it also appears broadly in both nineteenth-century painting and the literature, reaches a fever pitch in an essay called "In the Key of Blue" (1893). In this piece, Symonds used a hyperartistic Venice to disguise his relation with Fusato. He began by swamping any issues of sexuality in Whistler-style aestheticism. In Symonds's dreamy, sensual essay, eroticism in Venice becomes not a matter of lust but an artist's quandary about color palette: "The problem of colour gradations under their most subtle aspect," but (also tellingly) the problem of representing the quality of blue tints among "working people—fishermen, stevedores, porters, boatmen, artizans [sic], facchini."

In a move reminiscent of Sargent's methods with his later male nudes, Symonds in fact imagines himself as an artist in order to justify his focus on male beauty. "And whether the flesh-tints of the man be pale or sun-burned, his complexion dark or fair, blue is equally in sympathy with the model," Symonds writes. "Some men show remarkable taste in the choice and arrangement of the tints combined." He imagines taking a facchino (porter) and "pos[ing] him in a variety of lights with a variety of hues in combination." He then goes on to discuss a number of aspects of his relation with Fusato through this painterly conceit, describing a figure he calls Augusto "sitting gazing dreamily across the Grand Canal." The narrator is "willing to pleasure him" by taking him on tourist excursions and doing painterly "studies" of him in a variety of settings; dining with him at an osteria where the patrons accept the narrator because "they see he has found a mate of their own kindred."

Strikingly, Symonds revealed here what his contemporaries instinctively knew, that the painter-model relation almost exactly correlated to that of the employer-gondolier. Such pairings could channel eroticism due to their unequal power. Under cover of conventions—Sargent was of course more

conversant with painter-model dynamics—eroticism could both be ventured and, especially in the case of male-male pairings, disguised.

Sargent's sketches and paintings of gondoliers, in fact, attracted little notice at the time. His lit-up, startling portrait of an extraordinarily handsome young man, long labeled *Head of a Gondolier*, didn't raise any eyebrows—even though it would eventually find its way into the magnificent collection of early Sargent works owned by Sir Philip Sassoon, the British collector of the next generation whose unconventional sexual tastes were more boldly on display. And paradoxically, this handsome, sensual painting—if the Curtises ever saw it at the Palazzo Barbaro—would have worried them less than Sargent's suggestive working-class women.

Gondoliers after all aroused enthusiasm in almost every Anglo-Saxon expatriate, and Sargent's interests actually connected him to his wider audience. The fastidious Ariana Curtis herself liked gondoliers well enough to keep a number of them ostentatiously in her pay. Incidentally, she also welcomed John Addington Symonds to the splendidly furnished rooms of the palazzo that Vernon Lee described as "a vast & luxurious & exquisite place, full of beautiful furniture and pictures." Everyone knew that Symonds traveled everywhere with his gondolier. He'd even taken Angelo Fusato to England to meet the poet Alfred, Lord Tennyson.

Whether or not Sargent pursued any emotive or sexual encounters in Venice in the early 1880s, once he left there in October 1882, he wouldn't substantially return for sixteen years. And when Sargent did return to the Palazzo Barbaro in 1898, he painted not dark oil studies of shady street life but radiant watercolors of unsuspected Venetian splendors, in the spirit and tradition of his mother's discerning, grand tourist enthusiasms.

Even so, Sargent hadn't finished with gondoliers. He would in fact acquire one of his own—a man one art historian has shrewdly called "Sargent's gondolier." Sargent would discover this man a long way from Venice.

Likewise, it would be in Paris and not Venice that the ambitious young painter would land the provocative masterpiece for which he'd been angling for so long.

12

Diva Trouble

Back in the French capital, Sargent settled, a little uneasily, into a new studio and little house on the boulevard Berthier in a gracious, leafy quarter of northwest Paris. There, in good weather, he entertained guests in the "pretty garden with roses" that Vernon Lee admired, just behind his narrow three-story house at number 41. When he was in the city, Sargent spent long hours in his studio, and in April 1884 he'd been working on a "majestic portrait" of Mrs. Kate Moore, an American socialite, about whom he wrote to Henry James that she was an "ugly woman" who nevertheless struck him as "a great frigate under full sail." Sargent's frustrations with this portrait, though, were nothing in comparison to his anxiety about the fast-approaching Paris Salon.

Near the end of April, Sargent took Ralph Curtis into his confidence during a late dinner in his Plaine Monceau studio. Most likely, the two young men dined on the nineteenth-century equivalent of takeout. Both were bachelors, and Sargent didn't employ a cook. Famously workaholic, Sargent tended to bolt his large meals, often in solitude, in restaurants and clubs. If at best of times Sargent had nothing in the house to offer his guests but seltzer, he'd also been away from home a good deal that spring.

Sargent had spent much of early 1884 in London being escorted, introduced, and shown off by Henry James. Also, as a restless young artist with many friends and eclectic interests—not to mention the wanderlust he'd imbibed from his mother—he often launched out on other junkets. Ralph Curtis had encountered Sargent earlier that warm spring day when "John covered with dust stopped with his trunks at the club." The two young men had then made their supper arrangement, as Curtis had sized up his friend's

mood and fathomed how much was at stake, and how much was in suspense, the evening before the Salon opened.

At least the studio was comfortable, with high ceilings and low upholstered furniture. The room was outfitted with William Morris wallpapers, tapestries, Persian carpets, and paintings copied from Frans Hals and Rembrandt van Rijn—signs of Sargent's continuing aesthetic allegiances. Yet, if occasionally rebellious or perilous, Sargent's assortment of antiques, curiosities, and objets d'art was also reassuring for an establishment painter, advertising to fellow artists, friends, and patrons his taste and success. An upright piano stood against one wall, ready for Sargent to pour out music when he was tired of painting, to charm friends and strangers, as he'd done in Capri or Venice.

After dark, long drapes shut off the high windows with their view of a modern, electric-lit boulevard with its carefully trimmed trees. By day, the northern exposure over the unusually wide thoroughfare dispensed an even, steady light that rendered Sargent's house ideal for a studio, and Sargent in fact had many artist neighbors. By settling here, Sargent had become, in the words of his painter friend Jacques-Émile Blanche, "an artist of the Plaine Monceau"—a fashionable portrait painter wired into Paris society—not *too* bohemian, as he wasn't far from Batignolles, the Parc Monceau, and other bastions of bourgeois respectability. Sargent was walking a fine line, and he was about to render that line even finer.

Sargent and Curtis companionably drank their coffee on an intimate, low corner settle—a rather luxurious space under festoons of tapestry, right next to Sargent's model stand. That stand was the focal point of the room and of Sargent's anxieties that evening. The model for Sargent's Salon entry had recently posed for him there. The room was redolent with the presence of the rather bored, spoiled, and complicated society woman who'd strainingly postured and fidgeted in the studio over weeks and months.

Full of renewed ambitions, Sargent had struck off some thirty studies of this woman in pencil, watercolor, and oil, here and elsewhere (see Fig. 13). And the result of these sittings was bolder, he knew, than anything he'd yet submitted to the Salon. He'd concocted something at least as outré as the portrait of Dr. Pozzi that had baffled and outraged critics in Brussels two or three years before. That was no mere coincidence, as Dr. Pozzi was a ghostly presence in this new painting—perhaps even a factor in Sargent's choice to paint it. For the new work depicted that charismatic sensualist's mistress.

The clandestine liaison between Pozzi and this married woman was one rea-
son why Sargent had blocked out his sitter's name with three asterisks for
its official title in the Salon catalogue. He'd billed the portrait as *Mme* ***, a
precursor of the later well-known title of *Madame X* (see Fig. 14).

To make an avant-garde statement at the rather conventional Salon, Sar-
gent had produced his most ambitious portrait yet of a diva—even if this
one performed on the private and not the public stages of Paris. Virginie
Amélie Avegno Gautreau, a twenty-five-year-old Parisian socialite, hailed
from New Orleans. She was a Francophone white Creole who'd started life
on a Louisiana plantation. Transplanted to Paris as a child of eight, she'd
been educated there and eventually married off to a boring, nouveau riche
merchant banker named Pierre Gautreau. With her striking profile, fashion-
able pallor, and exquisite figure, Amélie Gautreau circulated on the more
daring fringes of Paris society—her hair and eyebrows henna-russet, her
skin moon-glow pale. If she qualified as the it-girl of bohemian circles—
news of her doings often appeared in *L'Illustration*, a splashy society gos-
sip sheet—she shared with Marcel Proust's later courtesan-figure Odette
de Crecy Swann a certain air of disrepute. Even though she'd contracted a
lucrative marriage, respectable women found it tricky to invite her to their
houses.

Rumored to conduct extramarital affairs, a subtle adulteress hidden in
plain sight, Amélie Gautreau struck a delicate balance in Paris. Fashion-
able society tolerated such liaisons as long as they remained discreet, styl-
ish, or in the grand French tradition. Adultery struck Parisians as a sexual
gray area—a gray of many shades. In multiple ways the realm of mistresses
paralleled the half-hidden world of Paris homosexuals, with whom Amélie
Gautreau intersected if only through her lover Dr. Pozzi's friends such as
Robert de Montesquiou. Fascinated by this haunting, somewhat outré fig-
ure, and perhaps also by her parallel world of transgressions and secrets,
Sargent had asked his childhood friend Ben del Castillo—now a Parisian
man-about-town who mixed with Gautreau's set—to persuade this not-so-
innocent ingénue, famous for being infamous, to pose for him.

"I have a great desire to paint her portrait and have reason to think she
would allow it and is waiting for someone to propose this homage to her
beauty," Sargent wrote his friend. "If you are 'bien avec elle' and will see
her in Paris you might tell her that I am a man of *prodigious talent*." A show
of such talent lay at the root of Sargent's intentions. He calculated he could
produce, as he confided in his friend Vernon Lee, a "Portrait of a Great

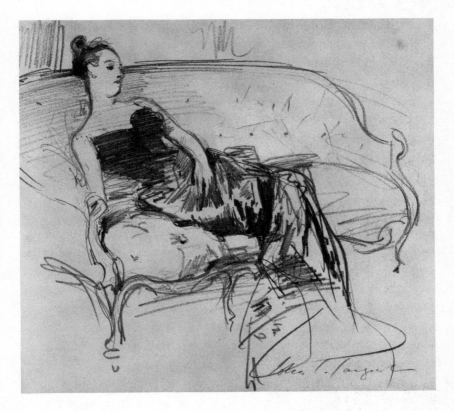

One of many of Sargent's sketches of Amélie Gautreau: *Madame Gautreau (Madame X)*, c. 1883

Beauty," an "'envoi'" to the Salon. As one art historian has put it, Sargent's choice to paint Gautreau was far less personal than "promotional."

Once Gautreau agreed, Sargent threw himself into the work. Gautreau lived down the street from his present studio, in a sumptuous terraced house in the rue Juffroy. Thus the project seemed deceptively convenient. But by February 1883, after the first few sittings, Sargent remarked to Vernon Lee, with growing reservations, that his sitter was one of the "'fardées'" (painted women), tinted "a uniform lavender or blotting-paper colour all over." Though he admitted she had "the most beautiful lines," he found her to be rather overwhelmingly or oppressively a "lavender or chlorate of potash-lozenge colour." To an inventive painter, that curious pallor was "pretty in itself," Sargent thought. But it was also somewhat inhuman and artificial.

Struggling with Amélie's elusive beauty, Sargent drew and painted sketch after sketch of her haughty beauty (see Fig. 13).

Through his multiple images of Gautreau, in fact, Sargent kept his sitter at an ironic, detached distance. For the exhibition portrait he was envisioning was not destined to be one of his empathetic renderings of a woman but rather a stagy and styled one. What's more, he soon bore the full brunt of this prima donna's distracted and luxurious personality. Over months working on the portrait, he grew increasingly weary, he wrote Vernon Lee, of "struggling with the unpaintable beauty and hopeless laziness of Madame Gautreau."

Unable to finish his work in Paris, he'd been obliged to paint Mme Gautreau at her husband's estate at La Chênes at Paramé on the rocky northern coast of Brittany. It took months of effort and ennui for him to produce a likely exhibition portrait. Yet still he felt frustrated. The portrait still didn't feel right, didn't feel finished. "One day I was dissatisfied with it and dashed a tone of light rose over the former gloomy background," Sargent wrote Castillo. "I turned the picture upside down, retired to the other end of the studio and looked at it under my arm. Vast improvement. The *élancée* [slender] figure of the model shows to much greater advantage."

Sargent also made the bold decision to paint Mme Gautreau with the strap of her gown fallen. That move highlighted her illicit sexuality. Yet that was only one facet of his styling her aesthetically. In all his accumulating details, Sargent put a premium on artifice—both Gautreau's and his own. In creating this languorous and insolent elegance, Sargent betrayed his allegiance to decadent writers from Charles Baudelaire to Oscar Wilde, as well as Sargent's queer Paris friends, notably Robert de Montesquiou. (Montesquiou would actually be one of the first observers to see the greatness or at least the panache of Sargent's painting, and he would later describe it as a "sort of masterpiece . . . impressive and unforgettable.")

For Sargent knew he wasn't painting a woman's beauty in any conventional sense. Mme Gautreau's dissipated chic stood "against nature" (as in Joris-Karl Huysmans's famous manifesto of decadence, *À rebours*, from the same year of 1884), crowned by her own artifice—which Sargent had intrepidly rendered through *his*. Vernon Lee noted Sargent's "love for the bizarre" and thought John was trying to capture the "'strange, weird, fantastic, *curious*' beauty of that peacock-woman, Mme. Gautreau." As one art historian has concluded, Amélie Gautreau gave Sargent "the opportunity of depicting a personality that was built on masquerade."

Aware of his own subversions—but also, and paradoxically, oversensitive and self-effacing—Sargent fretted about submitting so edgy, esoteric, and essentially decadent a painting to the annual exhibition. How would the Paris bourgeoisie react? He was racked with doubts. He'd gone so far as to call in help, to consult his old teacher and mentor.

Carolus-Duran visited the studio to view the new work, where it was framed and displayed on a big easel in the center of the room. He sized up the canvas. He looked at it closely and then from far away. Finally made his pronouncement: "*Vous pouvez l'envoyer au Salon avec confiance.*"

Sargent wasn't comforted. He felt Carolus's endorsement to be "encouraging, but false." "I have made up my mind to be refused," he wrote Castillo.

Later, though, the jury accepted the portrait without comment. But still Sargent agonized about having taken his old mentor's recommendation at face value. For Carolus-Duran, having been somewhat eclipsed by his brilliant young student, may well have harbored mixed motives in approving a painting that, from his own scrapes with scandal at the Salon, he suspected might raise hackles. One fellow student understood Sargent's "growing fame" to have caused Carolus-Duran "some anxiety." He felt, too, that "Sargent was aware of this."

As for Ralph Curtis, that fateful evening in the studio, the night before the Salon opened, he saw that John was "very nervous about what he feared." Curtis did his best to reassure him. At the same time, he privately wondered what would happen to his brilliant young friend, whom he'd jocularly nicknamed "Scamps." As Curtis later wrote his parents in their palazzo in Venice, he wondered if the next day would prove "the birthday or funeral of the painter Scamps." For this time Scamps had, in spite of his chronically cautious nature, ventured out on a very fragile limb.

—◂◂—

On Varnishing Day on May 1, 1884, candelabras of white blossom illuminated the great chestnut trees in the Champs-Élysées. Crowds of elegantly dressed people with parasols and top hats, "gesticulating and laughing," as Ralph Curtis observed them, converged on the grand exhibition hall on the south side of the avenue that Curtis dubbed "the Ark of Art."

John Sargent arrived at the grandiose Roman portals of the Palais de l'Industrie hardly less nervous than he'd been the night before. He'd previously experienced the high stress of a Salon opening, of course. He'd gone

through the ritual of the Vernissage, the private preview the day before the exhibition opened its doors to the public, seven times before, ever since he'd submitted his first portrait, of his cousin and would-be love interest Fanny Watts, in spring 1877. He well knew the breathless and superstitious rituals of the day.

Bracing himself for trouble, he threaded the glass-roofed galleries. The *palais* amounted to a great greenhouse of cast iron and glass enclosed in a shell of stone, Napoléon III's answer to the Crystal Palace. The French writer Octave Mirbeau had famously compared the great lumbering build-ing to an ox trampling the rose garden of the Champs-Élysées. In the strained light of the great superstructure, oddly exposing all that was be-neath it, Sargent was used to joining or else avoiding the little crowds of grandees and sightseers admitted to this exclusive by-invitation opening. He'd often witnessed fellow artists in smocks scaling high ladders in order to apply an obsessive varnish to their paintings. He'd felt relieved that his own works had been hung on the line, at eye level, and not at viewers' knees or else vertiginously high on walls completely paved with pictures of every size and description.

As he hailed acquaintances and rivals, he could also reflect that he didn't have the disadvantage, as at the 1880 Salon, of displaying his paintings in the five-room Galerie d'Étrangers (Foreigners' Gallery), among the works of Poles, Italians, and lesser Americans. Since then, he'd always been in-cluded among the French—as were all these *"semi-Français"*—the French committees having returned to their earlier, more ecumenical practice. But acceptance in the Paris art world hadn't come easily for Sargent. Until 1881, the young painter had been incorrectly listed as *"né à Philadelphia"* (born in Philadelphia); he'd only recently been acknowledged as a more cosmopol-itan figure *"né à Florence."* These days he was also accomplished enough to be designated in the Salon guidebooks as "H.C.": *hors concours*. That meant he was out of running to win Salon medals, having already won the maxi-mum number allowed.

Other ambitious artists and their decked-out wives in flower-encrusted hats shot Sargent envying glances at the Vernissage. They recognized a young, dapperly bearded, fêted artist who'd reliably been a darling of the Salon. Sargent's enviable status did little to reduce the stress of exhibiting, though. As a fashionable young portrait painter in Paris, Sargent had a lot to lose or gain from this event, in reputation and commissions. Although by the mid-1880s the Salon was losing the virtual monopoly it had once en-

joyed, thanks to a plethora of rival exhibitions and to the retreat of French state sponsorship, it was still the most important critical and commercial event in the Paris art world. It could justly claim to be the most important art exhibition in the whole world, given the unrivaled artistic preeminence of Paris. The Salon displayed some five thousand paintings, sculptures, prints, and engravings by some of the world's most fashionable and successful artists, on view in the Champs-Élysées over a period of six to eight weeks.

During this time, the exhibition halls were flooded with international visitors as well as Parisians. The cafés and railway stations of Paris were awash with art tourists. In 1884, nearly three hundred thousand people would attend, the equivalent of almost a sixth of the population of Paris, a staggering show of public involvement in and fascination with the visual arts. The Salon, with its ravenous crush of public and critical attention, heaped extraordinary publicity on any painter who could attract and hold public and critical attention.

That was just the problem, though. That was why Sargent had risked an edgy painting. The Salon's most daunting challenge was its very size. In so overwhelming an avalanche of art it was hard for any single painting to stand out. That was especially true if an artist's painting was "skyed"— stuck up at the top of a wall crowded with paintings: the French cartoonist Pif joked that up there a painting couldn't even be seen without a telescope manned by the unfortunate artist. The chockablock pictures stacked from floor to ceiling formed a brick wall that many artists simply couldn't break through. Painters also dreaded the swirling, restless crowd peering through lorgnettes and spectacles. Visitors soon succumbed to exhaustion and scrambled for spots on the few dilapidated sofas set out in the majestic *palais*. Salon fatigue—common, deadly, and inevitable—wrecked the hopes of many a debutant artist.

What's more, Salon entries—unlike the greater originality to be found in the rival Impressionist exhibitions—tended to fall into a familiar range of conventional genres, types, and subjects that rendered the whole exhibition déjà vu. Visitors encountered portraits of august men and soignée women; summery country scenes inhabited by peasants or picnickers; smoky Paris cityscapes; historical and mythological scenes crammed with columns and ethereal, half-dressed figures; pallid nude goddesses; Burgundian cows or African lions; dapper girls with bows on their frocks; and gloomy, melodramatic scenes cribbed from literature. The whole repertoire of nineteenth-century studio painting tended to reduce to a limited and predictable roster

of subjects. These "competent if unimaginative" pieces, as one art historian has described them, deferred to the rules of the École and the bourgeois tastes of buyers.

For decades, in fact, more original paintings had often been spurned by the Salon. In protest against such conservatism, innovative French painters from Gustave Courbet to Édouard Manet to Edgar Degas had staged their paintings in independent exhibitions. (The various Salons des Refusés dated from 1863 and the Impressionist exhibitions began in 1874. Those of the Impressionist group had now almost run their course, the last Impressionist exhibition taking place in 1886.) Sargent had mixed with some of these more obviously rebellious and distinctive artists. He'd met Claude Monet through Paul Helleu in 1876 and would later, rather tardily, adulate and befriend the artist in the 1880s. But, in spite of the inspirations he shared with the Impressionists, and sometimes allied bravura techniques, Sargent's milieu and market differed widely from those of the Impressionist group.

The Salon arranged paintings alphabetically by artist. Sargent's entry was in Salle 31, in the back right-hand recesses of the great greenhouse of art. Anyone who made it through the mazes and many intervening rooms would have encountered a painting that at first hardly even stood out. In a limited color palette of brown and black and sepia and ivory, it depicted an almost-life-size, very pale woman in a dark evening dress. Her hair was pinned up, her head turned to the left in order to display her distinctive profile. Her right hand gripped a little round-topped Louis XVI table whose legs were winged sirens. Her left hand grasped a closed fan. One of the chains or straps that held up her décolletage had slipped down on her powder-white shoulder.

Many of the Salon visitors who made it to Salle 31 would have recognized this woman, in spite of her asterisk-disguised name, as a recognizable, living, breathing Parisian suddenly rendered lurid for everyone to see. Once again, Sargent had discovered then given away his sitter's complicated secrets.

—◄—

"Ah voilà 'la belle!'" "Oh quel horreur!" *In the rising tumult, Sargent was,* when Ralph Curtis found him, "dodging behind doors to avoid friends who looked grave." But John soon latched on to his friend, steering him "by the corridors" to look at his painting. In Salle 31 the two young men encountered a little crowd gathered around Sargent's portrait, where the painter

encountered "shoals of astonished & jibing women." Curtis also overheard a "*blaguer* club man" joke that the painting was a copy. How could it be a copy? his friend innocently asked. Oh, but it is, the man said, with a studied riposte: "*La peinture d'après un autre morceau de peinture s'appelle une copie*" (the painting from another piece of painting is called a copy). This crack insulted Amélie Gautreau as a painted woman.

Inexorably, against his will, Sargent was caught up in a "*grand tapage*" (great uproar). All morning, round the painting, Curtis overheard "one series of bon mots, mauvaise plaisanteries and fierce discussions." "*Détestable! Ennuyeux! Curieux! Monstrueux!*" as another visitor found viewers exclaiming. It seemed the painting had attracted the notice the painter wanted, but not at all the *kind* of notice. Curtis, Sargent's at-hand ally and shield, didn't contribute to the upheaval. But he remained privately uncertain about the painting. Secretly, he was "disappointed in the color."

At least one fellow painter understood the portrait differently, in Curtis's hearing: "Superbe de style," "magnifique d'audace!" A few onlookers, including Sargent's insightful and sympathetic friend Judith Gautier, saw in this painting a goddess, a society beauty of the high caliber of the Napoleonic Madame Juliette Récamier. For Gautier this was "*l'image très exacte d'une femme modern religieusement copiée par un artiste maître de son pinceau*" (the very exact image of a modern woman fervently copied by an artist who is master of his brush).

Many other critics, though, panned the portrait. Henry Houssaye compiled an incendiary list of the painting's defects, both technical and sexual: "*Le profil est pointu, l'oeil microscopique, la bouche imperceptible, le teint blafard, le cou cordé, le bras droit desarticulé; le corsage décolleté ne tient pas au buste et semble fuire le contact de la chair*" (The profile is sharp, the eye microscopic, the mouth imperceptible, the color wan, the neck like a cord, the arm completely dislocated; the bust of the gown doesn't cling to the breast and seems to escape contact with the flesh). The influential Jules Comte lamented the "*amère disillusion*" (bitter disillusion) the portrait had caused him, pronouncing, "*Jamais nous n'avions vue pareille déchéance d'un artiste qui avait semblé donner plus que des esperences*" (Never have we seen a like decline in an artist who had seemed to give nothing but hopes).

Fighting over paintings in Paris was a favorite pastime, almost a blood sport. But the critical and popular uproar over *Madame X*, baffling to many people today, sprang in part from the visceral artistic and moral quarrels that had roiled Paris for decades. The rise of realism and then Impressionism had

also been punctuated by periodic chaotic public scandals, most notoriously that of Édouard Manet's *Olympia* two decades before in the Salon of 1865. As with *Madame X, Olympia*'s outrages were both aesthetic and social. That is, Manet, that bridge between realism and Impressionism, had presented not an ethereal goddess but a gritty, contemporary vision of a nude woman, in a flattened style inspired by Japanese wood blocks, that flew in the face of the classical academic sensibility of the École des Beaux-Arts. But Manet's depiction of a prosperous, shameless Paris courtesan, with her direct and confrontational gaze, inflamed the bourgeoise Salon-goers even more, so that the Salon committee had to post guards on the painting to keep it from being torn apart by outraged visitors.

Brazen displays of women's increasing sexual boldness still titillated and enraged Paris, in spite of its bohemian reputation, and even after two decades of scandals focused on outré women. And Sargent's portrait, with its insolent references to narcissistic shallowness and shame-free adultery, opened old wounds by means of impudently new painting techniques. In short, *Madame X* forced Parisians to confront the deep-dyed decadence in their midst that many preferred not to see or acknowledge. Sargent had succeeded in hitting a very tender nerve.

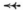

Even without having read the reviews, as yet, Sargent was "navré" *(heart-*broken), Curtis observed. The responses of the crowd galled him. Curtis soon intervened with damage control, sweeping Sargent off to a soothing lunch outside. He marshaled some sympathetic artist friends to bolster the traumatized artist and insulate him from the furor.

A "dozen painters and ladies" joined them at Ledoyens, the premier restaurant near the Salon, with its white-spread tables out in the sunshine of the Champs-Élysées, a privileged artistic space gated with potted palms and hedged in by blooming fuchsia-colored rhododendrons. Ladies with flower-studded hats, food, wine, and partisan friends soon managed to soothe Sargent and bolster his confidence. His companions soon convinced him of what Curtis identified as the positive "turning of the tide" in the Palais de l'Industrie that afternoon.

Yet the diagnosis was premature. Sargent's ordeal was far from over. Later in the day, Curtis conducted Sargent back home to the boulevard Berthier. Exhausted, John off went to gather moral support from his friends Isa and Ned Boit—whose daughters had earned him a wild success at the

Salon in 1883—whilst Curtis remained at the studio. Curtis thus had the misfortune of being in the house when Amélie Gautreau and her mother, Marie Virginie Avegno, arrived. Both of them were "bathed in tears." He managed to send them away, but the distraught mother showed up again after Sargent returned. Promptly, Mme Avegno made a scene: "*Ma fille est perdue—*" she stormed, "*tout Paris se moque d'elle. Mon gen[d]re sera forcé de se battre. Elle mourira de chagrin*" (My daughter is lost—all of Paris mocks her. My son-in-law will be forced to fight [i.e., a duel of honor]. She will die of embarrassment).

More defiant than soothing, Sargent replied that he could hardly withdraw the picture from the exhibition. *That* was against all the rules. Furthermore, he'd painted Mme Gautreau "exactly as she was dressed, that nothing could be said of the canvas worse than had been said in print of her appearance." That was how she presented herself in society, he insisted. Defending himself got Sargent's dander up and, his friend thought, made him feel better.

After Mme Avegno went away, Ralph Curtis stayed with Sargent till one in the morning, canvassing the matter with him in the studio. "I fear he has never had such a blow," Curtis told his parents.

But the full magnitude of the event was lost even on this eyewitness from John's inner circle. For the whole matter was even more complicated than Ralph Curtis understood.

13

Baby Milbank

One of the artist friends who probably lunched with Sargent at Ledoyens—but who evidently didn't come to Sargent's house the night after the Salon opening—knew the private history of Sargent's masterpiece. He'd in fact spent much more time and would spend much more time in the studio than Ralph Curtis. And he had a special reason to know why Sargent's portrait was, in the popular assessment, "*étrangement épatant*" (strangely stunning or shocking). For the painting was mixed up with a different kind of impropriety, one even more scouted in Paris than adultery, and one that had informed Sargent's conception of *Madame X* in both striking and subtle ways. And Sargent had come dangerously close to selecting *him* as the subject of a provocative piece to astonish the Salon.

Albert Milbank was a slender, twenty-year-old Anglo-Belgian with elfin features, dark hair, and a whisper of a mustache. His last name, Milbank, was drawn from a duel-mad British stepfather, later a drug addict. After the age of thirty the young man would adopt his Huguenot birth father's more aristocratic surname and style himself Albert de Belleroche.

Eight years younger than Sargent, Belleroche had also studied with Carolus-Duran. He'd first encountered Sargent two years before, in 1882. Then, at Carolus-Duran's annual dinner for his pupils, this star-struck neophyte, having spent just four days in the studio, was much taken with Sargent, whom he recognized as the painter of *El Jaleo* and a winner of the maximum number of Salon medals.

At some point after that, Belleroche again encountered Sargent—by accident or design?—at a Left-Bank café-restaurant called L'Avenue. There Sargent, something of an in-house celebrity, often made impromptu sketches

of volunteer subjects. Sargent executed these in a large folio kept by "Mademoiselle Fannie" (Belleroche called her the album's "lucky possessor") at her cashier's desk. Though the portfolio contained sketches by other neighborhood artists, it overflowed with Sargent's work. Mademoiselle Fannie called it "*l'album Sargent.*"

When Belleroche encountered him at L'Avenue, Sargent was dashing off a brilliant sketch of his best friend Paul Helleu. Genial and game, Helleu inspired Sargent to sketch with great panache, and the crowd at the café looked on admiringly. Such off-the-cuff, sociable sittings were a regular event at L'Avenue. The next week, Belleroche remembered, "I found myself in the midst of the little group, and also saw one or two portraits of myself by Sargent in Mlle. Fannie's album."

Belleroche's wording here is ambiguous: it isn't clear if he'd somehow agreed to sit for Sargent—or, as is implied by his discovering sketches of himself, Sargent had drawn him by stealth in the café. If so, when were these likenesses made? How could Belleroche not have known he was being sketched? In his later account, Belleroche was all too cagey, as if anything he said might be held against him. In spite of Belleroche's evasions, though, it's clear that Sargent was interested in this good-looking young art student, and, as Belleroche himself later admitted, "this little café had a great attraction" for him. Or rather Sargent did.

These scenes at L'Avenue emerge from a remarkable document, a mini-memoir that Belleroche published after Sargent's death in 1925. Though this short essay ostensibly treated Sargent's few and little-known lithographs (Belleroche himself later became a lithographer and tried to interest Sargent in the craft), Belleroche hesitated to publish it. The editor of the journal reported he'd had "some difficulty in overriding the objections raised by his modesty to this act of authorship, and in obtaining his permission to reproduce as frontispiece to the article an interesting sketch by himself of Sargent in his early Paris days, drawn in 1883." After Sargent's death, a number of friends would honor Sargent's deep-seated sense of privacy by remaining mum. Yet the form and tone of Belleroche's essay, with its reluctance, uneasiness, and intimate materials, stands out. It differed from fulsome accounts of Sargent's life and career published by other friends and acquaintances.

Belleroche may well have been "modest." But his qualms also arose from the intimate quality of his revelations—and sometimes lack of revelations—regarding his relation with Sargent in the early 1880s. The five lithographs

also include two sketches of disrobed men and two of the middle-aged Belleroche, so that the *visual* content of the article almost reads like an unwitting confession of homoeroticism, either Belleroche's or Sargent's.

The drawing Belleroche printed so unwillingly, entitled "Sketch of Sargent Asleep in a Train" shows a tiny, detailed pencil portrait of a handsome, bearded man with his eyes closed, his face couched in his left hand, presumably in the berth of a sleeping-car (see p. 5). But the intensity and the focus of the piece—also the furtive, nighttime occasion when it was taken—lends it the quality of a partner observed asleep. With so intimate a point of view, the sketch adopts what one recent observer describes as "an intensely personal vision of the artist at his most vulnerable and exposed."

How could the tender familiarity of this image have eluded so many observers? In 1883 or even 1926—not that anyone else probably saw this private piece—such a nocturnal close-up could seem quite innocent. Same-sex contexts abounded, and men routinely shared not only train compartments but also bedrooms and even beds. Such a sketch, of course, *could* be innocent. But it was also forced to be so—at the time and on into the twenty-first century—by authoritative presumptions of heterosexuality. Yet in 1926 this sketch was still so powerful and perhaps even so dangerous that Belleroche—who after all was in a position to know more about its backstory—found himself very reluctant to publish it. Also, by the same token, the sketches happening at L'Avenue—and soon to go forward in Sargent's studio—revealed aspects of an intimacy that Sargent himself took pains to keep private.

As for the particular train journey probably depicted, Belleroche recorded that one day when he was dining with Sargent and Helleu at L'Avenue, "Sargent suddenly proposed that we should all go to Haarlem to see the Frans Hals [paintings] together, and by so doing avoid the 14th July in Paris. This little trip to the Netherlands lasted three days, and we came back enchanted." Belleroche dated this journey in 1883—at least in his sketch of Sargent sleeping. But scholars are uncertain whether such a journey would have happened in 1882 or 1883 and have treated such a junket as "unconfirmed," as no second source corroborates it. Yet the singularity of this reference hints less at uncertainty—Sargent highly admired Hals and had gone there with his "two very nice friends" (Emily's phrase) Ralph Curtis and Brooks Chadwick in 1880—and more at Sargent's careful preservation of his privacy. Here was a trip John didn't mention even to Emily, or at least that Emily didn't record. To be sure, Sargent kept his private and pub-

lic lives meticulously compartmentalized—a habit that was endemic to his characteristic caution and desire for "respectability."

When Sargent moved from his studio in the rue Notre-Dame-des-Champs to his new studio in the boulevard Berthier early 1883, Belleroche became a habitué of the new space, perhaps its most frequent visitor and denizen. This was the period of the production of *Madame X*, but Belleroche influenced its progress, partly by giving Sargent a compelling alternate subject. "Amongst the other pictures which Sargent painted in this new studio," Belleroche recorded,

> I will mention a three-quarter life-size portrait of a young man in Florentine costume. This picture which was originally intended to represent an Italian gentleman holding a large double-handed sword, was finally cut down to the bust and the theatrical accoutrements removed. Sargent considered this portrait one of his best studies, for he had it photographed with the intention of allowing it to appear in Mrs. Meynell's work [Alice Meynell's 1903 collection of 62 Sargent photogravures]. With the exception of the portrait of Madame Gautreau, I do not believe that Sargent ever had so many sittings as for this portrait.

Once again, the later Belleroche was being disingenuous. He could "mention" this portrait but didn't "mention" that it depicted *him*. Nor did he admit that, during 1883–84, when Sargent was making his many sketches of Amélie Gautreau, Belleroche modeled for Sargent through some eighty sittings. If Mme Gautreau was the painter's public obsession, Belleroche was Sargent's private one.

<div align="center">⤙⤚</div>

For the particular portrait that Belleroche considered a masterwork—and that Sargent kept in his studio for the rest of his life—the costume wasn't in fact "Florentine" but rather sixteenth century, less reminiscent of the Renaissance and more of Sargent's subversive idol Velázquez. Originally, it had been conceived as a Salon masterwork.

One surviving early sketch for this portrait, a three-quarters-length figure in pencil, shows Belleroche in a skirted costume with a narrow waist striking a highly theatrical pose, in which he holds a body-length sword in front of him.

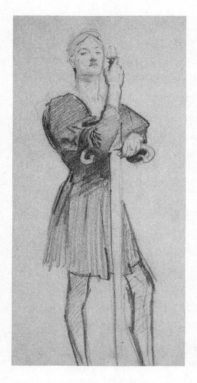

Sargent, *Standing Figure
with a Spear*, 1882–83

Even in this pre-Freudian era, a composition like that suggested rather too much. Such heroic Medieval or Renaissance poses, beloved of Victorian painters and illustrators, often look ludicrously phallic to modern observers. They certainly reinforce male strength, power, and privilege. But Sargent's version departed from these conventions in key ways. Not only was his sitter's slender youthful figure quite delicate, but also Belleroche held the sword very suggestively. His left hand and right elbow rested on the cross guard, and his right hand curled up around the grip. The pommel of the sword stood right next to his handsome face. If Sargent ever imagined an exhibition piece—and that may only have been a pretext, for this composition differed from Sargent's usual public fare—he understood early on that so charged and suggestive a portrait would never do for the Salon.

Yet his final version became even more transgressive, betraying what one art historian has described as its "intense focus on Belleroche's face": "That Sargent cut the portrait down and removed the theatrical prop suggests that he was more interested in portraying Belleroche as he saw him and knew him rather than veiling their unusual friendship with the artifice of costume."

Another dramatic oil study of Belleroche, drenched with Sargent's studio theatricality, showed him in a Spanish costume. The painting happened this way: Belleroche came into Sargent's studio, picked up a hat that Sargent had acquired in Spain, and stuck it on his head. "I must paint you like that," Sargent said. Sargent had earlier used this hat and cloak for one of the suggestive male background figures in his *El Jaleo*. Yet now such a figure came out of the shadows and, in moody underlighting, showed off the young man's delicate features, hooded eyes, and swanlike neck.

Two other surviving oil sketches, now held in private collections, treated Belleroche in contemporary clothes and would appear more traditionally masculine were it not for Sargent's dramatic lighting and his intense focus on Belleroche's fine features—the young man's arching brows, delicate ears, and Cupid's-bow lips. All of these stood out as charged, emotional composition. A moody lyricism also saturates a number of less formal sketches that likewise date from this period of perpetual sittings.

Sargent tore one piece in half—an exquisite and intimate ink drawing. But Belleroche rescued it. Such was the artistic and emotional heat generated by these sittings and by hours spent together in the studio. "As a group," one art historian concludes, "these portraits lack the internal tension for which Sargent became famous and possess, instead, a heightened emotion that reveals his intense friendship and identification with Belleroche." Yet the very intensity of this "friendship," as embodied in these portraits, introduces its own kind of internal tension, especially in an era when same-sex feelings were highly fraught and dangerous.

Two of the oil portraits include the inscription, "to baby Milbank." "Baby" was Sargent's nickname for Albert Milbank (Belleroche's surname in the early 1880s), and it referenced the eight-year difference in the two men's ages. Sargent asserted his seniority and his greater éclat as a painter, often rather imperiously, according to a time-honored master-student model. Yet the one extant letter from Sargent to Belleroche from this early period, written from Paramé in Brittany, where he was painting Mme Gautreau, shows the joking, bluff quality of this sobriquet as well as the playfulness of the interactions between these two men. "Dear Baby, Despite of the ridiculousness of conversing with a child, here I am answering your letter. But please don't write me anymore!"

Such a request, even if ironic, was thorny with complications. Sargent probably didn't intend "baby" as a term of sexual endearment, as it is frequently used today. But such a romantic or erotic usage was already widespread by 1883, having occurred in English as far back as 1694 and being increasingly romanticized in the late nineteenth century, especially among Americans. Sargent's nickname "Baby" pointed to a specific inside joke. But it also hinted at deeper currents that were beginning to leak into Sargent's more public life.

14

The Pact

Meals at L'Avenue, sittings and studio interactions at the boulevard Berthier, a junket to Haarlem, cycling excursions (Sargent was famously bad at riding horses and bicycles, but Belleroche apparently tried to teach him to master the latter), a hunting cap worn by Belleroche (and cartooned by Sargent), a teasing letter from Paramé—such surviving details give only the most fleeting glimpses of a relationship that has otherwise been erased—kept quiet and private by Sargent and Belleroche and barely treated by scholars until very recently.

We don't know if this was fully a love affair, if Belleroche was, as one rather romanticized account has put it, the "love of Sargent's life." Yet the evidence for complex emotions in this relation is both strong and compelling. The art historian Dorothy Moss has noted a "powerful 'homosocial' bond" that is "erotically charged" and concludes that "Sargent's portraits of Belleroche, in their sensuality and intensity of emotion, push the boundaries of what was considered appropriate interaction between men at this period." As distinguished scholar and Sargent grandnephew Richard Ormond also concedes, "Anyone looking for evidence of Sargent's sexual orientation might well find it in these strong and obsessive studies of this beautiful young man."

Yet simply to imagine a hidden homosexual affair is to misunderstand Sargent's era and to miss the intriguing connections between Sargent's sexuality, whatever it was, and his more public art. Sargent's portraits of Belleroche are drenched with imagination, lyricism, and longing because emotive or erotic relations between men in the early 1880s weren't at all simple or straightforward. For one thing, in the peculiar environment of the studio, these portraits didn't just document a relation that was going on somewhere

else. They *were* the relation, the process by which the two men forged their bond. Painting helped Sargent work through his confusion. It masked his desire. The sittings gave Belleroche an excuse to lurk endlessly in Sargent's studio.

Accordingly, the portraits of Belleroche are tinged with something like eroticism—a homoeroticism familiar from Sargent's earlier representations of half-clothed or naked young men in Italy and elsewhere. Yet Belleroche's full if often theatrical dress, as well as his relative social equality, makes his representation quite different from the erotic exposure and subjection of Italian painters' models, both screening the erotic interest in these sketches and intensifying the emotion.

Although the degree to which the Sargent-Belleroche relationship was erotic, emotive, or companionable—and what relationship doesn't contain such complications?—remains ambiguous, there are strong indications that it was all three. We can't be sure of the extent to which any erotic attraction was mutual—or exactly how such a liaison evolved over time, given that Sargent and Belleroche would continue a complicated and episodic private friendship throughout their lives. But we do know how grim the prospects were for anything like sexual unconventionality. Even in relatively tolerant France, where homosexuality wasn't strictly criminal, any hint of same-sex attraction invited disgrace, shame, religious condemnation, medical pathologization, and, perhaps most relevant to Sargent himself, professional suicide. Yet at the same time, and paradoxically, many forms of affection, passion, and even eros between men were heartily if innocently endorsed.

One way of sorting out these contradictions is to understand Sargent and Belleroche as "romantic friends." "Romantic friendship," though sometimes associated with women's same-sex relations, had a long history among men in the eighteenth and nineteenth centuries and allowed various forms of emotionally or erotically tinged male bonding. The male romantic friendships that historians have documented typically took place among young, unmarried white middle- or upper-class men of roughly the same age and social status. Important variants, especially in the United States, also occurred between white and nonwhite men or men of different ages. These male friendships went by such terms as "intimate friendship," "brotherly love," or "manly love" and sometimes, in the male-centered Greek or Platonic tradition, claimed to be a "love surpassing the love of women."

Such intense bonds have been documented in diaries and letters, with various degrees of openness and with varying amounts of sentiment or

eroticism. They also appear prominently in nineteenth-century American fiction, for example, in (interracial) pairings like Ishmael and Queequeg in Herman Melville's *Moby-Dick* (1851) and Huck and Jim in Mark Twain's *Adventures of Huckleberry Finn* (1884). One of the most striking examples of white male romantic friendship in Sargent's lifetime was Bayard Taylor's *Joseph and His Friend* (1870), an overwrought tale of two provincial Pennsylvania men trying to discover the "truth and tenderness of man's love for man, as of man's love for woman." (This book, sometimes considered the "first gay novel," actually raised few eyebrows at the time, so entrenched were the conventions of romantic friendship.)

Another literary example, though, struck Sargent even closer to home. Henry James's early novel *Roderick Hudson* (1875) dramatized a highly charged friendship between a wealthy poetaster called Rowland Mallet and a young sculptor named Roderick Hudson—a model for close male bonding that used art patronage as its chief means and method. This novel, written seven years before James met Sargent in Paris, sheds light on how the older man may have *hoped* his friendship with an attractive young artist would develop. James's entertainment of Sargent in London was, in the words of Stanley Olson, "the closest thing to courtship." Still, the historical James-Sargent friendship seemingly featured less of the intimacy and almost none of the romance of James's earlier, rather strained melodrama.

Along with the overcivilized, hermetically sealed James and the dashing Carolus-Duran, other older men had played important roles in Sargent's life, whether or not these friendships qualified as exactly romantic. One such was Auguste-Alexandre Hirsch, the Jewish-French academic painter Sargent had met in Capri when Hirsch was forty-five and John twenty-two, with whom Sargent had shared a studio space in the rue Notre-Dame des Champs for several years. Almost nothing is known about Sargent's relation with this painter of exotic women and men in mythological or historical settings. But that Hirsch came into possession of more than a dozen early Sargent works suggests a degree of studio camaraderie if not intimacy.

More conspicuously, Sargent had already conducted a romantic friendship with his fellow artist chum Paul Helleu—one charged with artistic or physical attraction and even involving Sargent in queer connections in Paris. It's not impossible that this friendship included an erotic or even sexual component—though no evidence of sexual contact survives (nor would we expect it to). That both Helleu and Belleroche married later in their lives in fact sorts with the perceived nature of romantic friendship in the nineteenth

century. For Victorians like Sargent, such bonds marked a stage of life *before* an inevitable marriage. Such friendships inhabited a different space or set of meanings, sometimes conceived of as loftier and more philosophic ("Platonic" in a more passionate sense than the cliché) than marriage.

In today's terms, either Helleu or Belleroche could have been gay and closeted, bisexual, straight, or even, when they bonded with Sargent in Paris, simply flexible, young, or curious. All of these possibilities were accommodated—simultaneously both screened and enabled—by romantic friendship. In Belleroche's case as in Helleu's, marriage would later lend a stamp of respectability. Belleroche also later took on a quite conspicuous mistress in Paris in the early twentieth century before he married in 1910. Yet Victorian male romantic friendship wasn't incompatible with such outcomes.

Often formal and detached with his friends, often unsentimental, Sargent was, in some ways, an odd candidate for anything whimsical or emotional. But he was raised in a sentimental, romantic era, and his own childhood immersion in romantic culture—for example his love for Hawthorne's *Marble Faun* and the lyrical sentimentality he'd imbibed from his mother—strengthened whatever sentiment came naturally to him. In his youth, before he studied in Paris, he was, he confessed to Lucia Fairchild, "sentimental—oh, maudlin sentimental!" He believed he'd outgrown much of that—that Paris in particular had cured him, as it "was not the place for that kind of thing." Yet as late as 1890, years after the headiest period of the Belleroche relation, he still considered that he "naturally took a sentimental view of things."

How sentiment actually played out in Sargent's Paris friendships, however, proved more complex and contradictory. Terms of endearment such as "baby Milbank" (for Belleroche) and "Leuleu" (for Helleu), which also resembled the lyrical fascination in his portraits of both of them, coincided with bluff, buddy-style male forms of interaction. Such inconsistencies belonged to Sargent's "double nature," as Vernon Lee diagnosed it, if not also to the paradox of romantic friendship or the complexity of human intimacy more generally.

By the early 1880s, too, romantic friendship itself was in decline and under threat. It was being eroded, as historians have noted, by the expansion of men's "cross-sex friendships" with outgoing, liberated women such as Sargent himself cultivated. It was also inhibited by the rise of clinical psychology and the pseudoscientific diagnosis of "homosexuality," which

threw "suspicion on the chastity of intimate, male, same-sex bonds." That Sargent and Belleroche kept their own friendship private suggests that they were worried about being suspected, whether with cause or not.

In another feature of romantic friendship relevant to Sargent, Victorians incorporated various forms of men's culture—sport, outdoor life, education, literature, or even religion—to conduct and promote the friendship's affective or erotic aims. In Sargent's case, the catalyst was art. Sargent's relation with Belleroche belonged to their Parisian context and to conventions of artists' companionship that had defined Sargent's habits for a long time—sketching other young men, for example, as well as going on train-junkets, long walks, gallery visits, or plein air excursions with them.

Sargent's and Belleroche's shared art obsessions shaped their interactions. Art *was* their relation, it defined and enabled it, so much so that many onlookers merely dubbed them painterly colleagues or artist friends. Their unusual friendship was also an essential and foundational element in Sargent's developing work.

-+-

One of the most remarkable documents of Sargent's relation with Belleroche is a sketch in pen and ink sometimes entitled *Head in Profile* from about 1883. At one point, art historians thought this sketch to be a likeness of Amélie Gautreau. Its pose is almost identical with that of the model in *Mme Gautreau Drinking a Toast*, another highly finished canvas that Isabella Stewart Gardner later went to great lengths to obtain in 1919. Only recently did scholars determine, from the details of the sketch "the hairline, the more masculine ear, and the suggestion of a cleft above the upper lip," that the sketch was actually not of Gautreau but of Belleroche.

No one knows the circumstances in which the pen-and-ink sketch was made. Was it preliminary to the oil painting or derived from it? Did Sargent produce it from memory while sketching Amélie at Paramé or did he create it during a sitting with Belleroche in his boulevard Berthier studio? Yet the sketch documents a startling blurring, melding, or transformation of Sargent's two favorite models. In the sketch, as one art historian has pointed out, "the limpness of the head conforms to the alluring and seductive poses generally associated with portraits of women." Especially in a "society that placed a high value on gender differentiation," Sargent had the "experience of seeing a woman in a man and a man in a woman." This key sketch reveals how Sargent fused the two sets of portraits in his mind. As the biographer

Sargent, *Head of a Young Man in Profile*, 1882–83

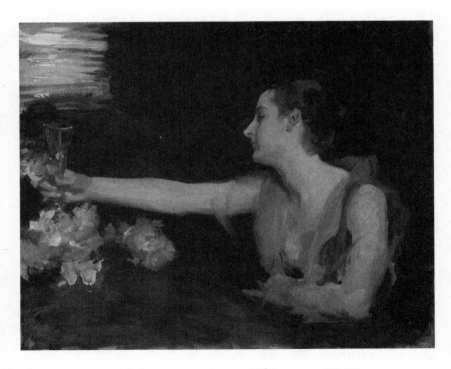

Sargent, *Madame Gautreau Drinking a Toast*, 1882–83

Deborah Davis has put it, "Sargent was in fact thinking about Belleroche when he was painting Amélie."

Was Sargent personally confused, "torn between desires," as Davis has rather romantically phrased it? Or did hidden desire shape this blending of woman and man? Such unconventional longings prompted Sargent to question, probe, and parody his society's rigid if troubled binary definitions of men and women. Such complications saturated many of Sargent's works, not just his intertwined portraits of Amélie and Albert. *Madame X* was "scandalous" in a more complicated way than the critics easily understood. The crowds at the Salon reacted to an unnamed unconventionality that hit them at a gut level. The portrait confronted many of their assumptions, even if they couldn't quite articulate what outraged them.

The same year that Sargent exhibited *Madame X*, a young French symbolist writer named Marguerite Eymery published a scandalous novel called *Monsieur Vénus* under the pseudonym of Rachilde. This novel shockingly portrayed a radical woman character, Raoule de Vénérande, who pursued unconventional sexual satisfaction: women weren't supposed to be sexual, let alone trying out radical sex experiments. Raoule dominated her lover, a florist called Jacques Silvert, and progressively stripped him of his male accoutrements, transforming him into a woman. Here was a gender transformation more melodramatic than Sargent's but hardly more radical. Sargent probably didn't read this novel. Few people read any of the three Belgian printings, as the novel was condemned in a ferocious obscenity trial, with all known copies destroyed. Rachilde was sentenced to fines and two years in prison. (Adroitly, she left Belgium.)

When the book was republished in Paris in 1889, the symbolist writer Maurice Barrès admitted it was "*assez abominable*" and described its central character as a "*jeune fille très singulière*" (a very odd girl). But not only was he not shocked by this book; he also felt its heady content didn't qualify as obscene. Instead, he lauded Rachilde's assertion of female sexual power and independence, as a high-spirited modern woman, and admired her exploration and analysis of "*un des cas les plus curieux d'amour*" (one of the most curious cases of love). Such a complex rewriting of sex and gender belonged to what Barrès described as the "*maladie du siècle*" (literally, sickness of the century), a common journalistic term of the time that referenced the era's transforming gender roles and perceived sexual irregularities, sometimes understood as nervous diseases.

Barrès also understood the book to have a "*charme extreme pour les*

véritables dandys" (an extreme charm for authentic dandies)—linking this book to such artistic barn-burners as Baudelaire, Whistler, or the queer symbolist writer Jean Lorrain. Also implicated were cutting-edge Parisians like those of Sargent's group who appreciated such iconoclastic, "decadent" writers. And such writers, when they muddied the waters of gender, were treating both what we would now think of gay and trans identities— "inverts" (increasingly known as homosexuals) being understood as individuals who not only loved the wrong sex but embodied the wrong sex, male homosexuals being "effeminate" and lesbians being "mannish."

Rachilde's shocking book also shed light on the kind of scandal that Sargent ignited through Amélie Gautreau, who lacked the conventional beauty and the bourgeois morality that the Belle Époque assigned to her sex. *Madame X* may not have obviously treated gender fluidity, but it was likewise a violation of gendered rules, which Sargent himself understood not from a personal experience of adultery but from a different set of "decadent" experiences. And what gave Sargent's art its edge, even or especially his depiction of women, was his own stake in these inflamed questions of gender, his own complexity as rather codedly reflected in his freely painted, exuberant canvases.

For his own reasons Sargent was testing boundaries. And if he'd followed such instincts further—or cast them in different form, perhaps in a Belleroche portrait that had gone to the Salon—he could easily have had on his hands an even deeper and more damaging scandal. As it was, the shock of *Madame X* came from a more profound unconventionality in the painter than most viewers understood. She captured Sargent's personal turmoil in a way that threw Victorian viewers into offended confusion.

A month after the Salon opening, in June 1884, Sargent hosted at his boulevard Berthier studio twenty-nine-year-old Oscar Wilde and his brand-new bride of just ten days. Paul Bourget—the young writer who'd suffered from a brief crush on Robert de Montesquiou—found twenty-five-year-old Constance Lloyd Wilde very alluring: he adored *"cette femme . . . annulée et tendre"* (that washed-out and tender woman). Sargent made no recorded comment on either Constance or her vividly dressed husband—already a provocative proponent of British aestheticism, with all its queer implications, though not yet a scandalous public homosexual. For his part, the retiring, sensitive Sargent felt disinclined to follow Wilde's lead, either to matrimony or notoriety.

In the aftermath of the outcry over *Madame X*, in fact, Sargent was

thoroughly shell-shocked. He repainted the fallen strap. He withdrew the painting from further exhibition and kept it locked up in his studio. In response to Henry James's blandishments and urgings, he began to consider shifting his base of operations from Paris to London. Yet London, in spite of its secure, prosperous, Anglo-Saxon insouciance, didn't always look like a refuge to an oversophisticated Continental refugee.

15

Nadir

In June 1884, Sargent stoically signed into Bailey's Hotel in Gloucester Road in London. This rather chunky, overcarpeted hotel might have comforted him, after his Paris travails, with its heavy drawing rooms and chandeliered staircase. After all, Sargent had spent much of his life in hotels. But London in general struck him as big, smoky, and turgid in its Victorian encrustations, in comparison to the luminous stylishness of Paris. He found London "a sort of glue-pot," as he later conveyed his culture shock to English friends. He missed his family's more customary historical connections to the polyglot Continent. He shared their taste for well-heeled American expatriate neighborhoods afloat in red-roofed French or Italian cities. He'd never before even lived in an English-speaking country. Even more, though, he wondered what his future as a painter would be like, in such a turgid atmosphere.

Henry James, Sargent's chief friend in the city, had given Sargent a London introduction in March and April of that year, a significant promotional push. He'd squired the twenty-eight-year-old on tour of some ten artist's studios, including that of the fifty-one-year-old aesthetic luminary Edward Burne-Jones. With his bent for fanciful and romantic images, Sargent had liked Burne-Jones's latest work, destined for the Grosvenor Gallery's year exhibition, *King Cophetua and the Beggar Maid*, a richly colored dramatization of a legend about love at first sight. Yet it was one thing to admire English writers and artists at a comfortable distance; it was another to nudge in among difficult personalities.

Though Burne-Jones was what James described as "always adorable," though he willingly dined with Sargent, James knew that "the poor dear, lovely, but slightly narrow B.J. suffers from a constitutional incapacity to

enjoy Sargent's [paintings]—finding in them 'such a want of finish.'" Sargent's Paris-trained free brushwork, even by itself, tended to upset Britons and Americans used to conventional renderings and polish. One of James's English friends, the artist and politician George Howard, on viewing Sargent's portrait of the American socialite Margaret White, declared that it must be only James's "patriotism" that had prompted him to sponsor Sargent.

Even before his arrival in Kensington, Sargent had taken a studio from the French artist Paul-Albert Besnard in nearby Ovington Gardens. Comfortingly, Sargent knew Besnard from Paris, where he'd admired his colorful, scintillating virtuosity with paint. Besnard, a *juste milieu* (happy middle) painter, took inspiration from the Impressionists but rooted his work in his elaborate academic training. The year before, Sargent had given this stocky, bearded thirty-four-year-old artist a lively, elegant painting of his bold thirteen-year-old sister Violet reading whilst casually munching on an apple, a delightful modern piece entitled *The Breakfast Table* (see Fig. 15). He'd inscribed it, *à mon ami Besnard*. In 1885, in the rue Guillaume-Tell in Paris, Sargent would paint Besnard, his plump, crimson-clad wife, Charlotte, and his young son Robert, in a splendid domestic genre scene of a birthday party, *Fête Familiale*.

For now, though, Besnard provided Sargent a cautionary tale about moving to London. For though this ultra-French painter had profitably studied Gainsborough and Reynolds during a three-year stint in England, he was now anxious to return to Paris, a city where his complex attention to light and mood would be more understood and appreciated.

Sargent made a game go of London that summer. He did his best to produce his quiet charm at parties to which he began to be invited. At one, he sat with thirty-four-year-old artist Arthur Lemon at the feet of a satin-clad matron, Vernon Lee noticed, "trying to tell her fortune and foretelling a second marriage"—a game the lady enjoyed immensely, flaring up into a "bonne diablesse" (good devil) from the attentions of the young men.

Sargent also decided to throw a tea party at his new studio. He insisted on inviting "no married couples" to his afternoon fête. But he flung open the doors to a garden with apple trees and provided plates of melons, grapes, and strawberries to his handpicked guests. The great prophet of aestheticism, the bald and mustached Walter Pater, limped about with his gout, and his two daughters sported fantastical, fairy-tale apple-green dresses. In his donnish and bourgeois lifestyle, Pater was less outrageous than some

of his aesthetic disciples were beginning to dare to be—for example Oscar Wilde, whom Sargent had recently entertained in Paris, or Vernon Lee, whose idol Pater was. Henry James knew plenty of leading artists and aesthetes, some of them queer, but James's network of exquisite friends lived a more veiled and coded existence than Montesquiou's Paris circle. Pater, for example, larded his aesthetic critiques with idealized Platonisms and was allergic to grittier Paris formulations. "Decadence," rife in Paris in the 1870s, wouldn't fully arrive in London until the 1890s.

Other visitors meandered through the studio, sizing up Sargent's unfinished portrait of the American-born Edith, Lady Playfair, displayed on an easel. Henry James "wrinkl[ed] his forehead as usual with tight boots," Vernon Lee noted. But otherwise the studio rang with the cheerfulness of "artists buzzing about." Sargent played the gracious host—for like his mother he loved throwing art-world parties. But he in fact had plenty of heavy matters on his mind.

Even with a widening acquaintance in London, Sargent increasingly worried that potential British patrons wouldn't appreciate his work. Only a few months before, he'd won his first high-profile commission in England, but that debut commission had been somewhat problematic. He'd portrayed three wealthy young women, the daughters of arms manufacturer Colonel T. E. Vickers. Such an opportunity appeared safe and tame, a sure entrée into a new market.

But in *The Misses Vickers*, painted a few months before the furor of *Madame X*, Sargent demonstrated that even in England, where conventions of painting remained more conservative, he couldn't or wouldn't surrender his unusual perspective and paint according to the decorous conventions of Henry Raeburn or Joshua Reynolds, those classical portraitists of the English elite. Instead Sargent held true to his Paris-trained instincts and created a bold, startling composition in the manner of Diego Velázquez. Cattily, he'd told Vernon Lee that his contracted sitters were "three ugly young women" (and their hometown of Sheffield was a "dingy hole"). But his use of bold contrasts, theatrical poses, and an enveloping dark background rendered Evelyn, Mabel, and Mildred complex, mysterious, and fascinating real-life women.

When Sargent exhibited this portrait back in Paris, one reviewer noticed that these three young ladies were "*un peu bizarre*" (a little strange) and that Sargent had minted "*creatures exquises et bien douées qu'on appelle des paquets de nerfs*" (exquisite and clever creatures that one calls bundles of nerves).

Belle Époque references to nerves often carried connotations of nervous disease—the perceived danger of clever women. In this case, though, Sargent's own nerves came into play, not to mention his boldness and his compulsion to paint edgy, psychological, suspect cases.

Yet if Sargent had actually touched a nerve even in Paris, he tended to offend critics in London still more. The philistine readers of *The Pall Mall Gazette* voted *The Misses Vickers* the worst painting at the Royal Academy exhibition. The *Gazette*'s commentator added the knee-jerk taunt that "it seems a shame that a man should paint young ladies in such a way." His insult implied that Sargent lacked a normal man's gallant or appreciative gaze. Such opinions, though untutored, didn't bode well for Sargent's potential career among moneyed Britons, no matter how much Henry James, who considered him the "only Franco-American product of importance" in Paris, wanted to promote him.

Only a few months before the *Madame X* scandal—when Sargent was in Brittany painting Amélie Gautreau, in fact—his father had summed up all the good things about John's "pleasant life": "He seems to be respected, even admired, and beloved (according to all accounts) for his success as an artist, and for his conduct and character as a man; his work is a pleasurable occupation to him and brings him a very handsome income." Fitzwilliam wasn't exaggerating when he boasted that his son's manners were "good and agreeable": "He is good-looking, plays well, dances well, paints well, converses well etc. etc. etc. In short he has given us, his parents, great satisfaction."

None of these things had since ceased to be true. But of course matters were becoming much more complicated than his parents' pride made them seem, from their genteel distance on the rue Longchamp in Nice. And Sargent's change of countries was making his life more complicated, not less.

—◆—

London, a stone-and-iron snarl of nearly five million people, ranked as the biggest and wealthiest city on the planet. Sargent, of course, keeping to Kensington, to soirées and studios, frequented the privileged side of the metropolis. Still, ever sensitive to his environment, Sargent found his new exposures almost too overwhelming. In any case he was too restless to stay long in London during the warm weather.

That summer and autumn of 1884, he traveled to the countryside to

paint other members of the extended Vickers family, including two beauti-
ful, haunting children among tall staffs of white lilies in *Garden Study of the
Vickers Children*—a premonition of his later masterpiece *Carnation, Lily,
Lily, Rose*. But perhaps his most telling piece was his little-noticed head-
and-shoulders portrait of Edward Vickers, the young women's handsome
twenty-one-year-old cousin. The intense, rather lonely expression com-
bined with a faint mustache and Cupid's-bow lips recalled the sketches Sar-
gent had done in Paris of Albert de Belleroche. Though nothing is known
about the circumstances of this painting, its inscription ("to Mr. Vickers")
suggests a gift or some kind of personal connection. At least it was a vol-
untary painting and not one inspired by the professional need to transform
"ugly young women" into exhibition fodder.

Sargent wasn't sure, though, if he wanted to exhibit at the Salon again.
In 1885, he showed his work in Paris at the Cercle de l'Union Artistique and
at the Galerie Georges Petit, where three of his canvases shared space with
seven of Monet's. That May, he also exhibited his *Misses Vickers* at the Royal
Academy in Burlington House. But there he was savaged by know-nothing
English critics. If he'd been burned by painting temperamental French di-
vas, would he do any better by painting high-strung English ladies?

Under the turgid skies of an English summer, on his frequent furloughs,
Sargent dreamed of Spain, a place where he'd always felt both at home and
inspired. His father learned of a plan of John's "going to Spain later in the
season" to find subjects for pictures.

> Spain affords more such suggestions than any other European
> country . . . and it is less visited than most countries and offers
> more that is novel and picturesque at the same time, baronial-
> looking beggars, weird-looking gypsies and smugglers and
> dancers and peasants, all in their quaint and old time costumes,
> to gather with bull-fights and brigands.

Dr. Sargent's understanding of his son's pictorial motives was crude. But
it affirmed that, even after John's black eye at the Salon, the young painter
hadn't lost his taste for the picturesquely "weird," even if he couldn't in-
dulge those tastes at the moment. As it happened, an outbreak of cholera
in Spain prevented him from traveling there, much as he hankered for its
large-scale, sun-baked vistas.

In London, meanwhile, new commissions and patrons were coming

Sargent's way only glacially. The scandal of *Madame X* had dampened portrait-painting opportunities in Paris, but so far Sargent hadn't acquired much of a professional reputation in Britain. Few knew his work, for all Henry James was doing to trumpet it. In spite of its heady and sometimes decadent art-for-art's-sake aestheticism, the British art world of the 1880s was stodgier and more old-fashioned than that of Paris. Whether Sargent could find "good clientele," as his friend Violet Paget put it, remained a nerve-racking question.

Sargent, *Vernon Lee*, 1881

By now, Vernon Lee, ever besotted by Pater, had written quite a few volumes musing on aesthetic history, bringing to bear her considerable expertise in Italian art history. She'd also published outlandish, fantastical stories, as she was obsessed with fairy tales and ghost stories and did her best to recast them in a provocative, modern mold.

Seeing John occasionally in Paris and London during the 1884–86 transition, Vernon Lee witnessed the aftereffects of the scandal on her childhood playmate. In June 1885, she was shocked to find him "much aged." In September 1885, she still found him old-looking and worn, though "improved." He confided in her that "his picture of Mme Gautherau [*sic*] has had much the same effect in checking his success that *Miss B.*" had had for her. Her novel *Miss Brown*, published in 1885, had also prompted a critical firestorm. Similarly, Lee's novel had attacked the late nineteenth-century gender system by criticizing British Pre-Raphaelite painters' sexualized relations with their female models in what one critic has recently called a "ruthless critique of aestheticism's gender priorities."

Back in 1881, Sargent had painted a masterful portrait of Vernon Lee, in the high, masculine Gladstone collar she'd then favored and round, rimless glasses, capturing the cerebral intensity of her pale elongated face.

But John and Violet didn't always see eye to eye as friends, let alone as fellow nonconforming artists. Though Sargent knew something about his friend's same-sex interests—he would paint her vigorous, outdoorsy companion Clementina ("Kit") Anstruther-Thomson in the late 1880s—the era allowed them very little common ground for discussing such issues. If anything, Sargent disapproved of his old friend's idiosyncratic openness—typical of a period that tolerated women's liaisons because it couldn't fathom them as sexual. Temperamentally mild and intuitive in his own work, he also recoiled from his friend's dogmatic intellectualism, which only grated on him more as they grew older.

Sargent drew back; he didn't confide in Vernon Lee. And she freely criticized what she saw as flaws in his painting that had virtually stripped him of new commissions. (Even Henry James, she noted, thought that Sargent was "in a bad way" since *Madame X*.) Vernon Lee thought that women, Sargent's mainstay, were "afraid of him lest he should make them too eccentric looking." "I fear John is getting rather in the way of painting people too *tense*," she remarked in 1885. "They look as if they were in a state of crispation des nerfs" (nerve clenching or spasms). Here Vernon Lee referred to a time-honored diagnosis in France, going back to medical treatises of the eighteenth century. But the term also evoked late nineteenth-century "modern" nervousness, the "maladie du siècle" of social and sexual change. And Sargent's paintings, coincident with the rise of neurology and clinical psychology (Jean-Martin Charcot in Paris, Sigmund Freud in Vienna), were steeped in psychology, even if Sargent himself eschewed such medical points of view.

In Paris, Sargent had been portraying high-strung, cosmopolitan types. He held to his affinities to the Impressionists—hence his budding friendship with Claude Monet—though his fascination with everyday human beings, particularly women, more resembled the work of Edgar Degas. Like Degas or like Mary Cassatt—whom Sargent scarcely knew—Sargent was an innovator, fascinated with people's psychological complications as well as their physical attributes. It was a rather bold recipe for a portraitist, as neither Degas nor Cassatt was.

Unlike them, and unlike Whistler, who only dabbled in portraiture, Sargent depended on portrait commissions for a living. Yet it was just his live

spontaneity and unconventionality, his deft handling of unconventional people in loose, vivid paint, that defined Sargent's idiosyncratic genius. Unfortunately, not everybody could fathom that. And not everybody, especially in England, would put up with pictures that puzzled or offended them.

-+-

In spite of his painting many members of the Vickers family in Yorkshire or Sussex, Sargent found that his commissions were drying up, and on both sides of the Channel. In a conversation with James's friend the English writer Edmund Gosse, Sargent confided that he was thinking of giving up painting altogether. Gosse reacted with surprise and alarm. As an art critic he was one of Sargent's few English champions and one of the rare fans of *The Misses Vickers*, appreciating the "extreme independence of [Sargent's] eye" and his trenchant Parisian intensity, so different from the "sugar and varnish" of painters like Gérôme.

"'But then . . . whatever will you do?'" Gosse asked, incredulous.

"'I shall go into business.' 'What kind of business?' [Gosse] asked, in bewilderment. 'Oh, I don't know!' with a vague wave of the hand, 'or go in for music, don't you know.'"

This conversation took place in the summer of 1885 in the verdant, sunstruck countryside of Worcestershire. There, away from London, Sargent's daily plein air painting excursions lent him the air of a genteel, insouciant amateur and not necessarily the unemployed professional that he'd in fact become.

But Sargent's increasing involvement with a group of painters and writers in the Cotswolds, though it looked eminently respectable and even soporific (and has sometimes been naïvely treated by scholars as such), was already recapitulating his unconventional associations in Paris. His new friends, in fact, translated his fading Paris alliances into a fresh Anglo-American form. The so-called Broadway Bohemians, who would help Sargent find his feet in Britain and later America—and who'd help fuel Sargent's eventual resurgence—constituted even more of a peculiar community, if possible, than what Sargent had left behind in Paris.

-+-

Sargent began frequenting Broadway—an unspoiled, idyllic village on the western slopes of the Cotswold Hills—due to a swimming accident. During the late summer of 1885, the artist had embarked on a boating tour west

of London with Edwin Austin Abbey. Ned Abbey, Sargent's newest artist buddy, had been escorting him to parties in London and accompanying him everywhere on country junkets.

According to Ned, "Sargent nearly killed himself" at Pangbourne Weir in Oxfordshire in September 1885. Diving off the weir, Sargent struck "a spike with his head, cutting a big gash in the top." Alarmed, Abbey hauled his friend to Broadway to nurse him, making sure the "nasty rap" would have an opportunity to heal. But, even after his head was wrapped up, Sargent clumsily "knocked it a second time and reopened the wound." The workaholic artist, who did nothing but paint all day and seemed otherwise to live in a fog, didn't make a good patient any more than a good swimmer.

Small, bespectacled, and polite, Abbey was a Philadelphian, like Sargent's mother. And like Sargent himself, he was largely self-trained, even if he'd been schooled in New York as an illustrator. By clinching some lucrative book commissions, Abbey had lived and worked mostly in England since 1878. According to Henry James, Abbey's historical and literary set pieces looked "so human, so humorous, and so caught in the act, so buttoned and petticoated and gartered, that [they] might occur around the corner; and so it is; but the corner is the corner of another world." Abbey's illustrations radiated a rather ingenuous and fanciful charm. But if like Sargent Ned Abbey was attracted to the quaint and curious, his retrospective storybook version drastically differed from Sargent's more risqué Paris sophistication.

Sargent had first met Abbey through James, on that ten-studio introduction to London a couple of years before. Especially since one memorably jovial fête that Abbey had thrown for the American Shakespearean actor Lawrence Barrett in his studio, Sargent and Abbey had been growing closer. What did Sargent see in his new companion? Certainly, their difference in style rendered Abbey an innocuous adjunct, no real threat to his more sophisticated companion. ("We differ enough to argue interestedly, and not enough to disagree absolutely," Abbey observed.) Though four years older than Sargent, Abbey also sported a perpetually boyish look, if not a boyish outlook to match, with his big ears, hair parted down the middle, and a pince-nez balanced on his nose. But Sargent also appreciated what one visiting writer at Broadway remembered as Abbey's "quiet, dry humour, his rich drawl and racy American idioms."

Such idioms were almost the only "racy" thing about Ned Abbey, who a few years later would uncomfortably discover Sargent's "earthy" nudes in New York. In spite of a certain waspish and acidic streak, Abbey lacked

Sargent's underlying taste for strangeness, grit, and edge. Abbey bonded with other artists, notably his fellow *Harper's* illustrator, the permanent bachelor Alfred Parsons. Abbey had carried on a spirited social life in England that included many colorful and exquisite art-world figures. He wrote long gossipy letters about them to his mother.

The expatriate American sculptor Augustus Saint-Gaudens addressed Abbey as "DARLING." Something about Abbey, boyish and innocent as he seemed, sparked such spicy, affectionate language in his friends. Sometimes, though, Abbey came off as prudish and rather sexless. He could (naïvely) remark in the mid-1880s, partly under the influence of Sargent, "I am beginning to think I do not pay as much attention to the young chaps as I ought to do—as the older ones used to pay to me long ago." Such paradoxes of innocence and eroticism suited Sargent. And such contradictions were rife among the Broadway men with whom Sargent, bandage on head, now found himself becoming entangled.

16

Broadway Bohemians

After the accident, Abbey brought Sargent to Farnham House in Worcestershire, in the village of Broadway. Here, though he mostly stayed at a local inn, Sargent's hosts were a thirtysomething Massachusetts couple: the painter Francis Davis Millet ("Frank") and his wife Elizabeth Greely Morrill ("Lily"). In the village of Broadway, they'd gathered around them various friends, now including Ned Abbey and Sargent himself. As he convalesced, Sargent marveled at the beautiful bucolic environs of the place, fields and woods climbing gentle slopes. Once his head recovered, he struck out on walks, in fits of euphoric, plein air adventuring that, though the Cotswolds were hardly the Alps, gave him a similar spike of pleasure.

Mingling with the Millets fascinated Sargent, too. In the evenings, thirty-nine-year-old Frank, mustached and prosperously stocky, recounted anecdotes from his handy, do-it-yourself history. He'd been a drummer in the Civil War, a surgeon's helper, and a war correspondent in the Russo-Turkish War, in which he displayed such conspicuous bravery that he won a medal. Inspired partly by this experience, he later translated Tolstoy's *War and Peace*. As for artistic bona fides, he'd helped John La Farge paint the murals at Trinity Church in Boston in 1876. He'd go on in later life to decorate the state capitols of Wisconsin and Minnesota. As a painter, like his friend Abbey—who'd often stayed at his house—he favored the quaint and historical over the contemporary. He executed literary illustrations and painterly genre pieces inspired by seventeenth-century Dutch art. That was a predilection, he found, that allowed him to live in a picturesque backwater. Such tastes did him no disservice in the Anglo-American art world, which hungered for such pieces, competently executed in a rather facile style.

Looking at Millet's paintings, some of them hung at Farnham House,

Sargent could appreciate him as a workmanlike, somewhat conventional Victorian painter, devoted to scenes of cottage and literary life. In his 1884 portrait of his wife, *A Cosey Corner*, Frank had posed Lily Millet in an old-fashioned and sepia-toned cottage kitchen, displaying her in a window-nook where she wore a countrified gown and bonnet, sentimentally perusing a book.

Sargent may or may not have appreciated this painting. But he liked Lily very much. His later portrait of her made her look like an entirely different woman than her husband had painted. In fact, Sargent's portrait blew her husband's version out of the water. Sargent accessorized Lily in a pale lavender shawl and neck-ribbon, and his vigorous treatment looked startlingly alive and engaged. Sargent chose to present Lily as even more beautiful but also, leaning forward, as confronting the viewer with her serious dark eyes. In her, Sargent saw a straightforward, modern, and intelligent woman with a force of her own. Already at Broadway, John and Lily shared interests that granted Sargent inklings about her inner life: Lily was an accomplished musician. Later, after a quarter century in the English countryside, she'd run her own interior decorating business in New York. Sargent liked her confidence and competence: he brought out such qualities in his strong women sitters.

Yet what most attracted Sargent to Broadway was its delightful, garden-like innocence. He especially liked Frank's live-in sister, Lucia, who'd seized on the opportunity of traveling abroad with her brother. It would be in her letters that the neat, quiet details of the Broadway milieu came alive. Only a week after he'd arrived as a casualty on August 17, Sargent was "painting in our garden," Lucia reported. Sargent even enlisted the Millets' five-year-old daughter Kate in a new composition he was contemplating, which Lucia predicted would be "a very charming picture if he does as he has planned."

Such were the beginnings of Sargent's remarkable childhood idyll, *Carnation, Lily, Lily, Rose*. Eventually, he would use two different girls, seven-year-old Dorothy (Dolly) and eleven-year-old Marion Alice (Polly), the children of the English painter Frederick Barnard, a celebrated illustrator of Charles Dickens, with whose family Sargent would bond as much as or more than with the Millets. This particular masterpiece, though, had to await other developments.

<div align="center">—◂┼—</div>

Though entranced by orchards, wheat fields, willow-fringed rivers, poppies, hollyhocks, roses, and little girls, Sargent preferred the larger and grittier

world. At Broadway, indeed, that world often arrived by train from London, in the form of visitors or weekenders like Henry James or the Anglo-Dutch painter Lawrence Alma-Tadema. In November 1885, Sargent himself left Broadway in order to spend time in London and Bournemouth. That fall, too, he toured historical spots in England with Abbey. After that he returned to Farnham House to spend Christmas with the Millets, rather than joining his own family in the South of France.

In April 1886, though, Sargent decided to make his now-annual visit to his family in Nice. His mother, who'd been ailing lately with a knee problem, was only gradually improving. On this junket he also passed through Paris, for he still had friends there, including Helleu and Belleroche.

By this time, however, Sargent had accrued more friends and connections in England. He exhibited his new portrait of Alice Barnard, Dolly and Polly's mother, at the New English Art Club, which he and a group of youngish, like-minded artists had founded in 1885, rather than at the Salon in Paris. That spring, he entered other paintings at the Grosvenor Gallery, the Royal Academy, and the Society for American Artists, even though he did submit his rather dark double portrait of his quondam romantic interest, Louise Burckhardt, and her mother, to the great yearly Paris exhibition. Such a submission was a gesture rather than a coup.

That July, Sargent dutifully traveled to Switzerland to meet up with his family. But he returned to England rather quickly in order to tour beauty spots with his new friend and frequent host in Broadway, Frank Millet. Almost nothing is known about the two men's tour, casually mentioned in a letter by Frank's sister Lucia. But it's likely that both men took advantage of the fine summer weather for plein air painting. They also shared many tastes for art, architecture, history, and music, and they were rapidly growing almost as close, almost as inseparable, as Sargent and Abbey had been the summer before.

In summer 1886, the Broadway group again gathered in and around the Millets' house, though this season, they were headquartered in a different, quaint, semirural property in the Cotswolds. Russell House, a sturdy three-floor country farmhouse surrounded by orchards and gardens that spread such fresh scents and, as Sargent soon found, unpacking his paint box, fresh inspirations. Here he rejoined many friends, among them his perennial sidekick, Abbey, who would be his closest friend among the Broadway group and of whom he would paint a lively, affectionate charcoal portrait some years later.

Sargent, *Portrait of
Edwin Austin Abbey*,
c. 1889

As master of Russell House and informal captain of the Broadway paint-
ers, Frank Millet overflowed with charm and hospitality. That charm, as
Sargent was learning, emanated from good deal of complexity. At this stage
of his career, Frank was a genial, outdoorsy, well-regarded writer as well as
an artist. He was also naturally sociable, easy and comfortable in the role of
host. As he was now gathering English and American friends in the Cots-
wolds, he'd previously annexed fascinating friends in the United States. At
his wedding to Lily seven years before, his friend Mark Twain had stood in
as his best man. He and Lily now had three children, and Frank appeared
to personify all the countrified domestic comforts of Broadway and its old-
fashioned group.

Yet Frank Millet harbored a hidden history. Frank may have confided
some of this backstory to Sargent over late-night Christmas brandy, or else
on their painting tour; then again, he might have kept completely mum. But
eight years before, in 1874, when Millet was twenty-eight, he'd met a man
in an opera box in Venice, who later recalled that they "looked at each other

and were acquainted in a minute. Some people understand one another at sight, and don't have to try, either."

This handsome, curly haired stranger was the American writer Charles Warren Stoddard, then aged thirty-one. Stoddard had spent adventurous years in the South Pacific and California and was now penning travel-pieces for the *San Francisco Chronicle* in the Mediterranean. Millet wasted no time in offering the charming stranger accommodation in the house he'd rented in Venice. ("Where are you going to spend the Winter?" he inquired.) Though this house had oodles of space, the two men wound up sharing an attic room and in fact a bed. They lived and traveled together during the winter of 1874–75, forging a relation in what was clearly, according to Millet's surviving love letters and Stoddard's thinly coded memoirs, a romantic and sexual affair. Millet also employed a young Venetian named Giovanni as a "gondolier, cook, chambermaid, and errand-boy" while painting in Venice in the mid-1870s and during the months that the two men lived together.

Frank Millet had conducted a youthful—well, not *that* youthful—romantic-friendship-with-privileges. Yet Millet also had a genuine if complex bond with his wife and was possibly what we'd now describe as a bisexual—what one historian calls a "fluid" sexuality, such as belonged to an era that had not yet developed strict categories. Yet Millet also carried a long history of romantic friendships and liaisons with other men that suggest some strong same-sex predilections. Much later, back in America, Millet would keep house with a younger man called Archibald Butt instead of his wife (who led her own life in New York), and it was with this longtime companion that he would go down with the *Titanic* in 1912. The sculptor Daniel Chester French's memorial to this pair, the Butt-Millet Fountain, still prominent today in President's Park in Washington, DC, commemorates a couple who at the time were euphemistically understood as close friends and housemates.

Perhaps Millet never confided his personal history to Sargent. Though chummy, he didn't ultimately grow quite as close to Sargent as Abbey became: Sargent never painted Millet, as he did so many of his male friends. Still, Millet's history offered parallels to Sargent's. Millet's romantic and erotic friendship with Stoddard involved a hothouse art world (Venice), shared studio and living space, companionable travel, pet names (Millet called Stoddard "Chummeke"—a Flemish diminutive of "chum"), and, as documented in much coded though charged language, surprisingly earthy sex. Yet if Millet's love letters to Stoddard hadn't arbitrarily or miraculously

survived in Stoddard's papers—Stoddard had no family members or executors to burn his letters as many prominent people did—Millet's family life might have read like a bourgeois storybook.

–<–

Another complicated resident of Broadway—at least a frequent visitor—was Edmund Gosse, the nervous, mustached, thirty-five-year-old English writer to whom Sargent confided his career worries. Gosse was a great friend of Henry James's. Like Millet, Gosse was married (to a Pre-Raphaelite painter named Ellen Epps) and had three children. But, more tormented than Millet partly thanks to a tyrannical father and fundamentalist Christian background he'd worked hard to overcome, Gosse had been pitted in what he regarded as a lifelong struggle against his same-sex desires. Even in serene Broadway, he was palpably a more anguished figure than either Millet or Abbey. Sargent witnessed that. Gosse's intelligent, nervous, and vulnerable qualities showed up in two portraits that Sargent painted of him during 1886. As yet, however, Gosse hadn't confided his secret urges to any of his friends. But he had some exchanges with Sargent that he himself labeled "curious"—Sargent's own onetime favorite word.

One day in August 1885, during Sargent's first Broadway sojourn, Gosse joined Sargent in a whitewashed farmyard in which he was painting. In blazing noon sunshine, Gosse wore no hat. "As I approached him," Gosse reported,

> Sargent looked at me, gave a convulsive plunge in the air with his brush, and said, "Oh! what lovely lilac hair, no one ever saw such beautiful lilac hair!" The blue sky reflected on my sleek dun locks, which no one had ever thought "beautiful" before, had glazed them with colour, and Sargent, grasping another canvas, painted me as I stood laughing, while he ejaculated at intervals, "Oh! what lovely hair!"

The fanciful oddness of this encounter stands out to post-Freudian readers, even if "ejaculation" almost invariably had a nonsexual meaning in 1885.

–<–

Though an astonishing number of these men who summered together harbored same-sex inclinations, the Broadway Bohemians hardly constituted an

explicit or self-identified homosexual group. It's unclear the extent to which these men even knew about one another's proclivities or consciously chose one another's company on that basis. Instead, they found commonalities as painters, American expatriates, or even as friends of Henry James. Yet James, sheltering his own complicated history, though apparently remaining chaste, found or attracted many men with similarly screened homosexual proclivities among the many cultured individuals he knew.

By the same token, Broadway didn't suit certain daring Victorian figures who favored more explicit subject matter. One of these was Henry Scott Tuke, an English painter, very nearly Sargent's contemporary, whom Sargent had known in Paris during the early 1880s. Later in the decade, Tuke painted nude boys and men in a different British rural retreat, in coastal Cornwall. (Tuke, who met Sargent through mutual friends Heath Wilson and Arthur Lemon, admired and even imitated Sargent's painting. He envied Sargent's cosmopolitan life as a painter. "I think I shall like him," Tuke wrote, "but at first I felt he was too polished and suave to become very intimate with, he made me feel I did not know what to do with my hands.") Nor did the Broadway Bohemians imitate Thomas Eakins's Art Students League of Philadelphia, with its studio or countryside experiments with nude models for photography and painting. Such romps resulted in Eakins's famous nude multiple portrait *The Swimming Hole*, dating from 1885—a piece that would have baffled Sargent's Broadway set.

Far from representing "natural" or naked men in the Cotswolds, in fact, the artists among the Broadway Bohemians typically painted rural and historical scenes as well as women and children. Sargent's own best-known work from his Broadway period, *Carnation, Lily, Lily, Rose* (1885–86) was just such an idyllic and innocent painting. It was a fine family piece—though its initial inspiration (the Millets' five-year-old daughter Kate) was based on what we might describe as a queer or at least an unconventional family. If Sargent was sketching any nudes, he certainly wasn't doing so in the Cotswolds. There, among the old-fashioned illustrators, such activities seemed unthinkable. That much came out in Sargent and Abbey's odd conversation about nudes in 1887, in which Abbey admitted he'd never painted anyone naked.

Yet the style of Broadway was also, if less obviously, highly unconventional. These men had gone to a lot of trouble to live in the Cotswolds as opposed to American cities. They'd fled the more rigid and less enlightened land of Comstock Laws. They'd opted for escape. Wittingly or unwittingly,

they took part in a distinct and long-running tradition of queer American expatriates in Europe, even if they'd rather inexplicably chosen the English countryside and not more liberated and painter-friendly France or Italy. In the sleepy Cotswolds, these men's apparent embrace of rural life and domesticity provided a cover and perhaps an antidote to their proscribed inclinations. They could certainly be described as closeted—and indeed, the queer theorist Eve Kosofsky Sedgwick's seminal ideas about the "epistemology of the closet" are largely based on James, one prominent member of the Broadway group.

In the mid-1880s, however, men with same-sex inclinations would have had few alternatives to the secrecy, hiddenness, coding, and dissembling that would later, in more conscious times, constitute "the closet." Even for courageous war heroes like Frank Millet—who'd also written some fairly brazen love letters in his youth—it was suicidal to let anyone know about his predilections. Edmund Gosse didn't formally acknowledge his same-sex desires until 1890, when he was forty years old. On that occasion he wrote to the more intrepid sexual pioneer John Addington Symonds, the British writer who had forged a relationship with a gondolier in Venice,

> I know of all you speak of—the solitude, the rebellion, the despair. Yet I have been happy, too; I hope you also have been happy,—that all with you has not been disappointment & the revulsion of hope? Either way, I entirely deeply sympathize with you. Years ago I wanted to write to you about all this, and withdrew through cowardice. I have had a very fortunate life, but there has been this obstinate twist in it!

It's difficult to know if, for Gosse, the compensatory happiness he mentioned was his marriage (which would last fifty years), his children, or some more secret form of gratification. But the leafy, domestic unreality of Broadway, for at least some of these men, provided much-needed respite and uncomplicated or at least less complicated pleasure. As Gosse would write decades later in *Father and Son*, his reflection on his devout father, he believed it to be "a human being's privilege to fashion his inner life for himself."

For years, Gosse longed to confide in someone. But even in the shadow community of Broadway, he couldn't speak openly about his desires. Similar taboos and inhibitions prevented others from revealing their proclivities even among these people who seemingly shared certain inclinations

and experiences. For if they manifested any sign of same-sex interests, their privileges—very much on display in the blossoming rural leisure of Broadway—would simply vanish. Chiefly, they cultivated comfort. At the moment, Sargent needed that, especially after the uproar in Paris. No doubt he and his friends genuinely liked rural scenes, cottages, women, and children—and conceivably found in such soothing circumstances a relief from forbidden desires. But they were also crushed under the weight of legal, religious, and social codes.

What's more, as bad as circumstances were for homosexuals in the country John Sargent had chosen, their situation was about to grow even worse. From more than a century on we can appreciate that England has had a very long and rich queer history, both hidden and in plain sight. In the 1880s it hosted many queer communities, both in prominent artistic cadres such as the late Pre-Raphaelites and Chelsea aesthetes, as well as among ordinary people. Yet in August 1885, the same month that Sargent stayed at Russell House to heal his head injury, the British parliament passed the so-called Labouchere Amendment, a section of the Criminal Law Amendment Act that for the first time made "gross indecency" a misdemeanor. Sodomy was already a crime in the United Kingdom—had been a capital one until 1867, after which it was punishable by life imprisonment. But sodomy had always been difficult to prove in court and its harsh punishment unfeasible to enforce. But a vague term like "gross indecency," as the sequel would show, made it much easier to prosecute any suspected or even imagined sexual activity between men.

As one historian has put it, this pivotal amendment made illegal "virtually all male homosexual activity or speech whether public or private." Not only did this law lead to a toxic culture of hatred, paranoia, blackmail, and terrified secrecy, but also it would eventually destroy such brilliant figures as Oscar Wilde in 1895 and Alan Turing in 1952, not to mention countless other men whose stories history doesn't similarly commemorate. The cruelty of this law was monumental. It remained on the books until 1967 and wasn't completely abolished until 2003. In the United States, the Comstock Laws of 1873 marked similar attempts (and also long-lived, being weakened in the mid-twentieth century but never officially repealed) to crack down on perceived "indecency" and "vice." But the ubiquitous prejudice in Anglo-Saxon countries that created both draconian laws had already shaped the lives of all the men at Broadway, so that such legislation hardly even surprised them.

—◆—

It was inevitable, though, that Sargent wouldn't stay forever among the slow streams and the black-and-white cottages of Broadway and the Vale of Evesham. As someone still interested in what Vernon Lee described as "the *bizarre* and outlandish," the twenty-nine-year-old painter itched for richer and more sophisticated environments, even London, which he had initially despised. As his father put it (after John's annual visit to his family in Nice in spring 1886), his son was "moving his traps from Paris to London, where he expects to reside instead of Paris, and where he thinks he will find more work to do." "He seems to have a good many friends in London," Dr. Sargent added. "London is a world in itself, with its 4 ½ millions of people."

As a first and tentative move in the metropolis, Sargent was now making a segue from aristocratic Kensington to the more bohemian quarter of Chelsea. Cosmopolitan London gave Sargent an opportunity to reinvent himself—though it was unclear exactly how he would take advantage of the possibilities.

One heartening development for Sargent's career was the founding, in London in 1885, of the New English Art Club, a group of some fifty young artists who described themselves as "more or less united in their art sympathies." Many of them resisted the old-fashioned strictures of the Royal Academy (though some of them, like Sargent, would later become academicians); and many of them, like Sargent, had Paris training or Impressionist predilections. Some of these painters, such as Alfred Parsons, Wilson Steer, and Walter Sickert, were acquaintances or cronies of Sargent's. These young, rather mild firebrands put on their first rival exhibition in 1886, and Sargent contributed his portrait of Alice Barnard from Broadway, an exquisite chiaroscuro of an artist's wife in a muslin gown whose gigot sleeves recalled the style of the 1830s even if the bravura painting of them, white on white, belonged squarely to the 1880s. It was a painterly tour de force that many of the New English set lauded as one of Sargent's best.

—◆—

Sargent also painted a self-portrait in 1886, during this transitional time when he was finding his feet in London. The widow of the Scottish art patron Alexander Macdonald (a man who'd died in 1884) commissioned the piece as part of a collection of artists' self-portraits. Sargent had just turned thirty but was now just famous enough in Britain to be included.

After some struggle, Sargent produced an image of a mild, attentive man with deep-blue eyes, wearing a high collar, blue cravat, and gray suit, his short hair dark, his beard touched with russet. The image, though modest, showed some panache, with Sargent delineating his own features in generous brushstrokes. His loosely painted tannish background overflowed its oval, as if Sargent were committing only to a rough sketch of himself.

Among other things, Sargent's first serious self-portrait illuminated the paradoxes of his gift for psychological exposure. For, though this portrait of the artist was the most sensitive and suggestive of the three main oil self-portraits Sargent would paint in his lifetime—with a hint of vulnerability, of a slightly startled or wary man—it gave away next to nothing.

To be sure, Sargent lacked the instincts of a self-portraitist. But just why was he so deficient in self-revelation? Why did a painter known for his insight into modern "nerves" show so little of his own struggles? In all three of his self-portraits, Sargent suited himself up in his Savile Row coat and tie and styled himself in a rather boring and conventional three-quarters view. In London, his predilection for the "gentlemanly" and "respectable" was strengthening as opposed to weakening. And so it would continue to do. In his 1892 and especially his 1906 self-portraits, he'd grow even stodgier, and even more opaque. In the 1906 portrait, he'd be said to resemble a banker—a banker, incidentally, who wasn't going to grant a loan. These later, even more "respectable" images would coincide with the growth and then the peak of Sargent's reputation as an establishment portraitist. They'd present the studied masculine persona that, as a flourishing society portraitist, Sargent found extremely instrumental.

For someone who was now settling in artistic Chelsea, rife with aesthetic associations and the dandified figures of Whistler and Wilde, Sargent dressed almost too much like a businessman. Even among American painters—a relatively sober lot—he stood out as rather conservative in his dress. In contrast, Sargent's contemporary colleague in New York, the whimsical but solidly heterosexual William Merritt Chase, loved to represent himself flamboyantly in self-portraits, in costumes, with props, and in famous art-historical poses. But Sargent hewed to the blandest possible masculine conventions. In this first self-portrait, Sargent didn't muster even a trace of the theatricality, costume, lighting, posture, or reference to Velázquez with which he'd enlivened many a portrait of a patron or sitter. Rather his pleasant, genteel oval betrayed his mania to exorcise any hint of psychological complexity.

To some extent, the self-portrait simply embodied Sargent's transition to England—and made that transition seem inevitable—by showing deliberate manners and doctored self-images that nowadays we might call "straight-acting." Yet Sargent's series of masks, incomplete or imperfect in 1886, didn't at all interfere with his brilliant portraits of others, into which he channeled the kind of revelation he evaded in himself. Thus Sargent's greatest self-revelations, strangely, emerged in his visions of others. His masterful portraits paradoxically articulated the rich, shadowy complexities he discovered in those sitters but that he rendered according to the desires of an edited self.

<div align="center">⤙⤚</div>

Isabella Stewart Gardner was hell-bent on viewing Madame X *in person when* she arrived at Sargent's new studio in Chelsea in late October 1886. Ever cautious, Henry James visited Tite Street beforehand, in order to "prepare Sargent's mind and Mme Gautreau's body." Gardner, whom Sargent now was meeting for the first time, required careful handling. Imperious, waspwaisted, phenomenally rich, festooned with pearls, Gardner was used to getting her own way. She would gladly have purchased *Madame X,* Sargent's most scandalous piece, if Sargent had offered it for sale. But he preferred to keep it quietly in his own private collection, much to her disappointment.

Forty-six-year-old Gardner identified with *Madame X*. She was drawn to the image of a shapely, outrageous, and transgressive woman and perhaps even to an expressive adulterer, as she herself had conducted a rather highprofile liaison with a globe-trotting young novelist called Francis Marion Crawford only four years before. "Mrs. Jack" now traveled with her longsuffering husband, the gray-whiskered shipping and railroad tycoon John Lowell Gardner, known everywhere as Jack. As Fitzwilliam Sargent had been decades before, Jack Gardner—though a more trenchant personality than Sargent's father—was mostly wise enough to let his free-spirited wife do as she pleased.

Attuned to young men, Belle Gardner loved to collect them—even if in future years she would devote herself just as enthusiastically to amassing rare works of art. Now, in Tite Street, she deemed Sargent worthy of annexation.

Bearded, big-eyed, now slightly portly, Sargent had just turned thirty. He radiated distinction and elegance. Yet Gardner was catching up with him only at the end of one of her hard-driving European tours, during a

visit to London that featured other fashionable painters. Whistler had been prevailed upon to execute a likeness of her. But Sargent wasn't quite ready to take on another diva, especially one so domineering as Gardner. Luckily for him, the Gardners were returning to Boston in a few days, with too little time to persuade him to paint the imperious Belle. But still this magnetic millionaire celebrity was determined to acquire Sargent sooner or later.

Sargent officially made the break from Paris in May of that year; he'd packed up his avenue Berthier studio and shipped his worldly goods to London. But he was still riddled with ambivalence. After the dazzling, stylish modernity of Paris, Sargent continued to regard London as lugubrious. He wasn't the only person who thought so: his friend Henrietta Reubell, with her Parisian prejudices, remained worried about her protégé's move. Earlier in 1886, Henry James wrote Reubell that he didn't "in the smallest degree agree with the idea that Sargent has done an unwise or an unfair thing to come to [London] to live and work." On the contrary, James insisted, Sargent seemed to have "got from Paris all that Paris had to give him": that is, "his technical means." Paris couldn't teach him any more, James insisted. London would provide him not only with "fine models and subjects" but also with "a larger and more various life," including "social opportunities" that would be "good for him, even as an artist." Etta Reubell, though none of her letters have survived, seemingly disagreed.

In England, Sargent now divided his time between Broadway and London. At the time of Gardner's visit, he was "fairly lodged," as Henry James told Reubell, "in a yellow studio (yellowed by its *ci-devant* [onetime] proprietor Whistler)." But the painter wasn't yet "overwhelmed by work—that is, by lucrative orders," James thought. In June 1887, Sargent signed a lease on the Chelsea studio for three years. But, more than usually restless, he hardly felt settled in his new pied-à-terre. He still made trips to Paris to see friends and Nice to see his family.

In summer 1887 Sargent escaped London by heading to nearby Henley-on-Thames for the weeks of hot weather. Here he visited his new friend Robert Harrison at Shiplake Court. He'd painted an elegant, breezy portrait of Harrison's lively wife, twenty-eight-year-old Helen Smith Harrison, the year before, in 1886. In her he found at least some of the "social opportunities" that James had hoped for.

Helen, a flamboyant figure who loved to entertain in Princes Gate or at Wargrave Hill, charmed Sargent and introduced him to more fashionable Londoners. He responded to her lively personality with a daring

composition that involved the dramatic contrast of a white gown with a crimson overdress. His energetic, confident brushwork in the piece recalled Impressionists like Monet whom Sargent was now, rather belatedly, admiring and befriending. Yet Helen's thin, beaked face came out rather preoccupied, her slender hands twisted together in front of her. Sargent hadn't finished, yet, with modern "nerves." Even so, the Harrisons loved the picture, and his relations with them remained affable—he would later meet and befriend Robert's painter cousin Peter Harrison through them. Sargent also shared with the Harrisons a passion for music. Through them, that summer, he also met the Polish Jewish composer George Henschel, of whom he'd paint a charming portrait in 1889.

That summer, thirty-seven-year-old Henschel, nervous, enthusiastic, and shaggily bearded, found Sargent "exceedingly modest" and "inclined . . . to hide his light under a bushel." He also saw to his delight that Sargent had "built himself a little floating studio on a punt on the river." There, thirty-three-year-old Sargent presented "a splendid specimen of manly physique, clad . . . in a white flannel shirt and trousers, a silk scarf around the waist, and a small straw hat with coloured ribbon on his large head." With his costume and punting pole, Sargent played at being a Venetian gondolier, there on the slow-running Thames. Clearly, he qualified as a "Broadway bohemian" even when not boarding with his friends in the Cotswolds. In the country especially, Sargent could loosen up and reclaim his more fanciful and theatrical self, even if that self remained fairly wholesome and not always what Vernon Lee had described as obsessed with the "the *bizarre* and outlandish." Sargent sketched away on the Thames all day—rustic scenes—and then bonded with Henschel over Romantic music in the evenings.

The two men's conversations convinced Henschel of Sargent's "knowledge and understanding," for he found the painter had made a "serious study rather than a pastime" out of music. Still, two years later, sitting for Sargent in the studio, he found the painter quite lyrical and whimsical, for Sargent asked him to "stand on a platform and sing—from *Tristan and Isolde*, by preference."

> It was a great delight to watch him as he was constantly and intently studying my face, talking and painting at the same time. Now and then he would slowly and deliberately recede about a dozen steps from the easel, look at me steadfastly, stop for a mo-

ment and suddenly, the brush lifted ready for action and without ever taking his eyes off me, make a dash for the canvas on which he then recorded his impression, generally accompanying the act by contentedly humming a little tune.

Now Sargent was hitting his stride again—bringing to bear his habitual studio techniques, first learned from Carolus-Duran—even if he wasn't, as often before in Paris, invoking the ghost of Velázquez as he lunged like a swordsman toward the canvas.

Sessions like this resulted in a sensitive if not groundbreaking painting of Henschel. Sargent's portraits of Scots novelist Robert Louis Stevenson in 1885 and 1887 qualified as much edgier male portraits, though. The latter showed the razor-thin Stevenson with legs crossed and a cigarette pinched in his spectral fingers. Then again, Stevenson was a complex, romantic-minded character whose dark, swashbuckling imagination (Stevenson published both *Kidnapped!* and *Strange Case of Dr. Jekyll and Mr. Hyde* during 1886) rather lent itself to Sargent's still-boyish fancy, and perhaps to Sargent's own sense of the bizarre.

At last, Sargent was working his way into English society and winning portrait commissions. (He owed his first Stevenson commission to Ned Abbey.) But he was little inclined to rest at Tite Street or even at the various English country haunts where he could unwind.

At the end of that summer, on September 17, 1887, he took a steamer for Boston, on only his second visit to his parents' native land, and his first in a decade. For he had portraits to paint there—a regal, jolly rendition of his Paris friend Isa Boit in a dinner dress of pink, polka-dotted silk would be one—as well nabobs awaiting him in Newport and New York.

Henry James had always predicted that Sargent could be, and would be, a smash success in America. And by December, Sargent's novelist-patron was able to report to Etta Reubell in Paris that Sargent was beginning, in earnest, to acquire "sitters & triumphs & glory & I hope dollars."

The Cavalier

A schoolboy of fifteen or sixteen, immersed in reading *Ben-Hur*, looked up sharply when he heard a woman's flirtatious scream. Lounging behind rolled-up wrestling mats in the gymnasium of Groton School in rural Massachusetts, Ellery Sedgwick, the future editor of *The Atlantic Monthly*, was simply trying to find some privacy to read his novel. But he wound up witnessing—or so he claimed six decades later—an amorous scene unfolding between Isabella Stewart Gardner and John Singer Sargent.

Gardner entered first, "her modish muslin skirt fluttering behind her as she danced through the open doorway and flew across the floor." Sargent followed, "white-flanneled, black-bearded, panting with laughter and the pace." According to this anecdote, thirty-two-year-old John pursued forty-seven-year-old Belle (who still maintained the "figure of a girl") around the gymnasium running track. It appeared to be an infatuated pursuit whose conclusion the boy didn't witness. In embarrassment, he quickly escaped out a handy open window.

This account has rightly been questioned, as the details of the story suggest a summer encounter (Sargent's white flannels, an open window) when, if it happened "the same year he painted the famous portrait of her," Sargent spent late 1887 and early 1888, freezing winter months, in Gardner's company. It is possible, of course, that some such incident at Groton School might actually have taken place, at some other point. According to another source, however, the pretext of the race around the running track wasn't that Sargent felt passion but that Gardner had "twitted Sargent because he was gaining weight."

More than romance, weight consciousness actually fit both personalities. Mrs. Jack famously "could not stand the sight of a fat man" and Sar-

gent (a little guiltily) loved hearty meals. Still, Belle's hint about Sargent's weight was rather intrusive. More than a year after his first meeting with her in Chelsea, Sargent was becoming involved in a peculiarly personal relation with his would-be patron. That much was customary in an era when portrait painters were often subordinate artisans to whimsical plutocratic employers. But Belle Gardner especially liked the young men she collected to prove themselves not only deferential but also admiring.

Yet even with such a promising romantic setup, this relation wasn't headed toward real intimacy. The unfolding aims of the friendship soon settled into the pragmatic and professional—on both sides. Sargent's bond with one of his most important and influential patrons began as it would go on: useful, cheerful, and businesslike. Yet many contemporaries misread the pair's budding affinities as a romance even though it marked a different kind of alliance in the making.

Rumors erupted that the two were having an affair, that Sargent was Gardner's "cavaliere" or ardent suitor. In 1887, when Sargent alighted in Boston, such gossip was perpetuated by society rags such as *Town Topics*. Later, it was memorialized in any number of family stories, Boston traditions, and highly colored romantic histories. Such legends resulted in an amusing if highly implausible novel published in 1951 by Eleanor Palffy, an eccentric, bookish Bostonian who had married a Hungarian count. Countess Palffy admitted her work was fiction but insisted it was based on "infinite research from a great variety of books, articles, biographies, memoirs, letters, as well as by many personal stories and anecdotes I have heard." Palffy's source legends, in various versions, would have a long life, exposing some persistent distortions of Sargent's life and career. People expected Sargent to be interested in women, for wasn't every man? And onlookers also assumed, given the myths perpetuated by the Belle Époque art world of Paris, that painter-model, painter-patron, and painter-sitter relations were tinged or even saturated with eroticism. At least such erotic involvement was considered inevitable between male painters and female sitters.

Neither Sargent nor Gardner tried to contradict such gossip. The rumors proved useful to both of them. At this time, Gardner had commissioned a portrait from Sargent for $3,000, a formidable sum—the price of a house in Boston. She was ready to extend, too, the full benefits of her patronage. The imagined romance reinforced Gardner's reputation as a forceful, outré art enthusiast who defied conventions—even if her predilection for scandals, weirdly parallel to Sargent's own, sometimes landed her in hot water, and her protégés too.

Sargent had come to Boston at least in part to paint Gardner's portrait. She sat for him at her house on Beacon Street in during the winter of 1887–88. Their sessions pitted a commanding, free-spirited woman patron against a consummate, workaholic male artist. For her part, Gardner came to these meetings with a clear idea of what she wanted. She told her first biographer, Morris Carter, that she expected a portrait to "rival the one of Madame Gautreau." She felt that "her figure, her neck, and her arms"—her finest points—must feature in Sargent's picture. But she would also wear her jewels—her pearls and rubies—as Amélie Gautreau had not. Most of all, she would "look the world straight in the eye, with her head held high, dominant. Attitudes supposedly graceful were not for her though grace was in her every movement; she always sat or stood perfectly straight and square."

Gardner soon imposed her high expectations on her painter-guest. Yet Sargent also brought his quiet perfectionism to Boston, not to mention his previous successes in portraying forceful and vibrant women. It was hardly surprising, then, that the portrait was "done over eight times"—in a room overlooking the dim and muddy estuary of the Charles River, in the limited and uncertain light of a Boston winter. Painting this portrait proved an "ordeal" for Sargent. "Mrs. Gardner *would* look out the window to see what was happening on the river, and more than once Sargent was for giving the whole thing up." But Gardner assured him that, as "nine was Dante's mystic number, they must make the ninth try a success, and they did."

Countess Palffy has her fictional Sargent, gazing on Belle's hourglass figure in the Gardners' upper room, kneel before her and wrap the ropes of pearls around her waist. He breathlessly remarks, "Only Rubens could paint such *volupté*." But actually Sargent didn't much admire Peter Paul Rubens, that painter of florid, full-figured women. He preferred among Dutch painters the more satirical Frans Hals. As for a physical attraction to Gardner, Sargent later told Lucia Fairchild, rather spitefully, that he thought Mrs. Gardner looked like "a lemon with a slit for a mouth." That was hardly a romantic sentiment even if Gardner herself admitted that her rather plain and determined face, under her swirl of rust-colored hair, wasn't her finest point.

As with other women sitters he hadn't found personally compelling, however, Sargent created a breathtaking portrait of his patron (see Fig. 16). Sheathed in a close-fitting black Worth gown, rubies and pearls at her throat and waist, Mrs. Jack stood in a frontal pose with a plunging neckline and white arms clasped, describing an oval that echoed her bodily curves.

Sargent enlarged an elaborate circular pattern on a rust-red Italian textile in the background to create a sort of halo or nimbus behind Gardner's head, with its direct, intense gaze.

The result struck many viewers as quasi-religious or perhaps idolatrous. Edith, Lady Playfair, a Bostonian of whom Sargent had painted a couple of portraits in the mid-1880s, including the one he'd put up at his London tea party, described the portrait to Henry James in just this way. Without having seen the painting himself, James in turn gossiped to Henrietta Reubell that Sargent had rendered "Mrs. Jack a Byzantine Madonna with a halo."

Sargent's Paris friend Paul Bourget also described the portrait as a "*Madone Byzantine.*" But in his otherwise rather overwrought appreciation of this painting, Bourget even more explicitly understood that any worship of this exquisite and stylized female figure was not really erotic or passionate, not a matter of the traditional Italian examples that fascinated romantic Victorians, such as Dante's Beatrice or Da Vinci's *Mona Lisa*. Instead, Bourget mused, this modern woman celebrated American wealth and life force: "This woman can live without being loved. She doesn't need to be loved. What she symbolizes is neither sensuality nor tenderness" ("*Cette femme peut ne pas être aimée. Elle n'a pas besoin d'être aimée. Ce n'est ni la volupté ni la tendresse qu'elle symbolise.*") Once again Sargent had painted a woman who violated the rules of his time—radiating erotic power, self-assertion, and material success. He rendered Gardner, in this image as she was in life, a bold precursor of unfolding women's self-determination.

The portrait attracted some admiration when it was exhibited at Boston's St. Botolph Club in Newbury Street on February 1, 1888. It pleased Gardner's art-set cronies, including one protégé, the pale, cat-mustached, twenty-seven-year-old painter Dennis Miller Bunker, who'd earlier observed some of the sittings and who warmly admired Sargent's panache and skill. Bunker, who was enjoying his own flush of painting Boston portraits—many of them of Boston men to match Sargent's preponderant women—was already spending a lot of time with Sargent, under Gardner's aegis. And the two artists found they had much in common, and soon their friendship would really flourish.

At the exhibition, the Boston hostess Annie Fields and the Maine writer Sarah Orne Jewett, clad in black, sporting ostrich feathers in their hats, served tea. They were intrepid women in their own right, being a secret lesbian couple in a so-called Boston marriage as well as allies of Mrs. Jack and members of her cosmopolitan aesthetic circle.

But the painting prompted negative reactions from less adventurous Bostonians. Gardner had persistently craved a scandal. Now she had one. She tended, in fact, to sow scandals all around her, having grown adept at capitalizing on newspapers and the outrage they fostered to shape her conspicuous public image. Such PR was precocious and ahead of its time: her protégé art connoisseur Bernard Berenson later rather acidly remarked that she had made herself "Boston's pre-cinema star."

Yet in 1888 at least Gardner was knocked off balance by the negative blasts that that Sargent's portrait triggered. Famed for tapping into secrets in his canvases, he'd seemingly given away some of hers. It wasn't even as if the critics didn't like it. Rather, it was a piece that Gardner's fellow Bostonians took badly, thanks to its perceived erotic exposures. Many in Boston dropped highly personal insults on her head.

For some, the portrait's rather bold exposed cleavage reminded them of unguarded acts of flirtation by which Gardner had long defied Boston, in particular her adulterous liaison with young novelist Francis Marion Crawford earlier in the decade. A salacious joke circulated, referring to a well-known piece of New Hampshire geography, "Sargent had painted Mrs. Gardner all the all the way down to Crawford's Notch."

Such an insult bothered even the normally impervious Belle—Sargent did his best to soothe her in his letters. But the innuendo upset the usually long-suffering Jack Gardner even more: he threatened to "horsewhip" anyone who repeated this men's club witticism. Though Gardner told her first biographer she thought "it was the finest portrait Sargent ever painted, and often tried to make him commit himself to the same opinion"—in deference to her husband, she didn't allow the picture to "be exhibited again as long as he lived."

This fresh scandal, though, unlike that of *Madame X*, did little to slow Sargent's rise or injure his growing reputation in the United States. If Gardner and her husband left Boston to weather the uproar in Europe, Sargent was now the toast of the town. At least he found himself in demand among the traveled and cultured northeastern elite. He had so many new clients and commissions, in fact, that an intended two-month visit to his parents' country of origin was now stretching out indefinitely.

FIG. 1: *Man Wearing Laurels*, 1874–80. Sargent's predilection for Mediterranean models began early in his career, and his treatment especially of male studio models often evinced a brooding lyricism. The figure's classical laurel wreath hardly disguises the model's compelling personal immediacy.

FIG. 2: *A Male Model Standing Before a Stove*, 1875–80. Studio modeling could also be an uncomfortable business, and here Sargent portrays its workaday ennui. The posing pouch was probably added later, as models in all-male Paris studios wore such gear only when women were present.

FIG. 3: *Carolus-Duran*, 1879. Sargent's portrait of his Paris teacher is dedicated to a *"cher maître"* (dear master) from an *"élève affectioné"* (affectionate student). Sargent's bold and theatrical rendering of his mentor earned him plaudits at the Paris Salon, but some critics found Carolus's pose and costume "effeminate."

FIG. 4: *Paul Helleu*, C. 1880. Sargent's many informal portraits of his French artist friend showed an appreciation of Helleu's charisma, chicness, and physical presence. Here the cigarette pinched between Helleu's thumb and the first of his splayed fingers suggests ease and intimacy. This pastel is inscribed *"à l'ami Helleu"* (to the friend Helleu), as if he were *the* one important friend.

FIG. 5: *View of Capri*, C. 1878. Sargent painted the Capri model Rosina Ferrara many times, lending her a dignity and self-possession rare in nineteenth-century depictions of peasant women. Here an assertive figure, fists on hips, stands among vertical chimneys to survey a townscape that she seems to own.

FIG. 6: *Fumée d'ambre gris*, 1880–82. This theatrical, highly finished orientalist depiction of an unnamed Moroccan woman standing before an incense brazier beguiled critics and audiences at the Paris Salon. But Sargent remarked that "the only interest of the thing was the color"—the fashionable "white-on-white" of the 1880s.

FIG. 7: *Henrietta Reubell*, C. 1884–85. Sargent's long-lost portrait of this Paris art hostess shows his private debt to assertive and adventurous women. A mutual friend described Reubell's infamous heavy smoking as "the least of her freedoms." In her *"lambris dorés"* (palatial home), Sargent encountered Henry James as well as other aesthetic trendsetters and iconoclasts.

FIG. 8: *Study for Seated Musicians for "El Jaleo,"* C. 1882. An early oil sketch of background musicians for Sargent's flamenco masterpiece outfitted these male musicians and dancers with vivid crimson accoutrements. Though in *El Jaleo* these male figures sank into the background, Sargent's friend Judith Gautier discerned their lyrical and transgressive importance.

FIG. 9: *El Jaleo*, 1882. Depicting a dramatically lit Spanish *taberna*, *El Jaleo* (*The Ruckus*) spotlights a powerful and mesmerizing female dancer. Sargent's patron Isabella Stewart Gardner appreciated the assertive erotic energy of the foreground figure. But Henry James, misunderstanding Sargent's intentions, complained about this diva's "want of serenity."

FIG. 10: *Dr. Pozzi at Home*, 1881. In this unusual boudoir portrait of Samuel Jean Pozzi, a Paris gynecologist and man-about-town, Sargent created a suggestive conversation piece that was too controversial to exhibit at the Salon. With its palette of blood reds and suggestive hand gestures, the painting hazarded what a friend called an "insolent kind of magnificence."

FIG. 11: *A Street in Venice*, C. 1880–82. In the early 1880s, Sargent painted "decadent" backstreet scenes in Venice that suggested erotic encounters between men and women. Did he mean to portray prostitution or instead free-spirited encounters initiated by confident women? In any case, Sargent's own experience in the city focused on gondoliers and artist friends.

FIG. 12: *The Daughters of Edward Darley Boit*, 1882. Four young daughters of American friends allowed Sargent to create a haunting group portrait that recalled Velázquez's masterly *Las Meninas*. Sargent's striking composition, also a masterpiece, hinted at dark sides to Victorian childhood, women's housebound lives, and expatriate privilege.

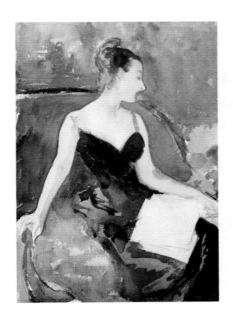

FIG. 13: *Madame Gautreau (Madame X)*, c. 1883. To prepare for his Salon tour de force, Sargent dashed off dozens of sketches of the Louisiana-born Paris society starlet Amélie Gautreau; over many sittings, he wrestled with her "unpaintable beauty and hopeless laziness." To calm and divert himself during this time, he produced almost as many studies of his painter companion Albert de Belleroche.

FIG. 14: *Madame X*, 1883–84. Sargent's notorious succès de scandale almost ended his career, thanks to the outrage the portrait triggered at the Salon of 1884. Sargent later repainted Amélie Gautreau's original fallen strap, but he had already layered into this portrait of an unrepentant contemporary adulterer even more complicated forms of "decadence."

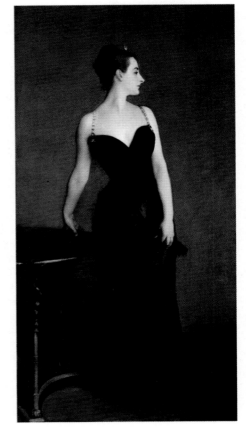

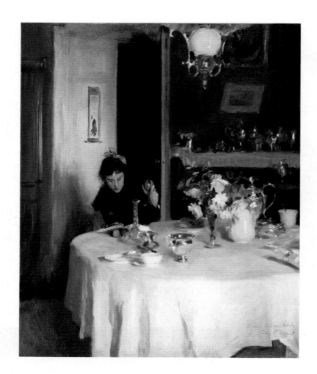

FIG. 15: *The Breakfast Table*, 1883–84. This small, elegant domestic piece featured Sargent's then-thirteen-year-old sister Violet, who became one of his favorite models in the 1880s and 1890s. Sargent repeatedly captured Violet's boldness, beauty, and panache in exuberant, loosely painted modern renderings that resembled those of his Impressionist friends and contemporaries.

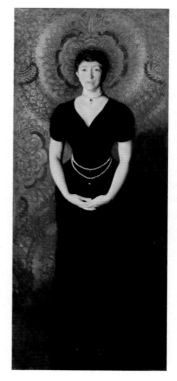

FIG. 16: *Isabella Stewart Gardner*, 1888. One of Sargent's most enthusiastic patrons after *Madame X*, the Boston iconoclast Isabella Stewart Gardner also craved an elegant scandal. In this "idolatrous" portrait that showcased Gardner's hourglass figure, her jewels, and her low-cut gown, Gardner got her wish—and so was unable to exhibit this masterpiece in her Boston museum until after her husband's death.

FIG. 17: *Dennis Miller Bunker Painting at Calcot*, 1888. During the summer of 1888, Sargent pursued plein air painting in the idyllic English countryside with his American artist friend Dennis Bunker. Sargent was taken with Bunker's precocious talent and his slim good looks. In turn, Bunker was beguiled by Sargent's lively sister Violet, here reading serenely beside a river.

FIG. 18: *La Carmencita*, 1890. Sargent's longtime fascination with theatrical and Mediterranean women came to a head in 1890, when he pursued and monopolized the popular Spanish dancer Carmencita in New York. Sargent's stage-door fascination yielded many sketches. In this regal exhibition portrait, the painter glorified Carmencita's fierce, confident persona.

FIG. 19: *Massage in a Bath House*, 1891.
Sargent's journey to Egypt and Turkey
in 1891 inspired him with a biblical
theme, "The Triumph of Religion," for
his Boston Public Library murals. This
oil sketch of the interior of a bath house,
however, hints at Middle Eastern explo-
rations and experiences that were less
official and more transgressive.

FIG. 20: *W. Graham Robertson*, 1894. Am-
bivalently fascinated with aesthetes, Sar-
gent worked hard to coax this London
decorator friend of Oscar Wilde's to
pose for him. Sargent's attitude toward
such over-the-top dandies remained elu-
sive, but this portrait happened to appear
at the Royal Academy just before the
Wilde trials erupted in London.

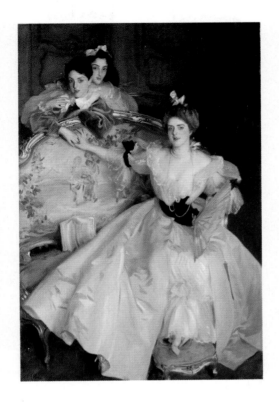

FIG. 21: *Mrs. Carl Meyer and Her Children*, 1896. Sargent's first major portrait of Jewish sitters captured the limelight at the Royal Academy with its playful, elegant use of neoclassical accoutrements and its engaging rendering of this stylish mother and her children. Many critics, however, reacted to this portrayal through the antisemitic prejudices of the time.

FIG. 22: *Asher Wertheimer*, 1898. An intrepid and rising art dealer in London, Asher Wertheimer hired Sargent, then the height of fashion, to execute a stream of portraits of himself and his family at the turn of the twentieth century. Sargent's representation of him skirted various Jewish stereotypes and attempted to portray this sitter's compelling humanity.

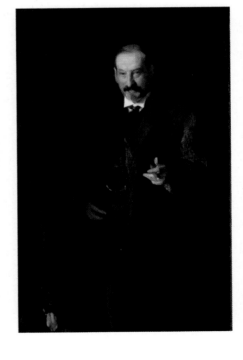

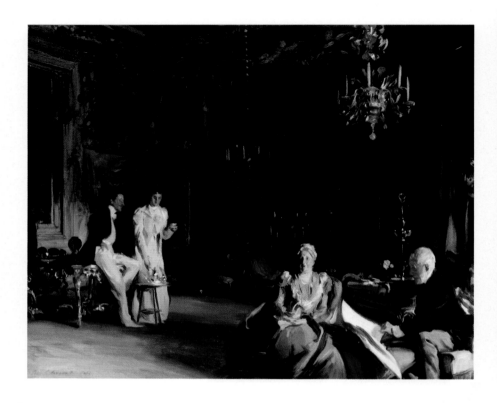

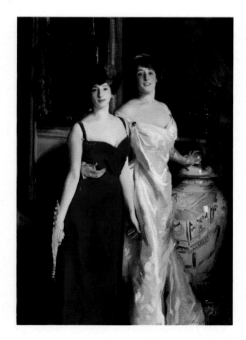

FIG. 23: *An Interior in Venice*, 1899. When in Venice, Sargent often stayed with his wealthy American friends the Curtises at the Palazzo Barbaro on the Grand Canal. As a thank-you for one stay, Sargent painted this candid family piece, which the matron Ariana Curtis (foreground center) resented for its subtle irony and psychological revelation—those signature qualities of many Sargent portraits.

FIG. 24: *Ena and Betty, Daughters of Asher and Mrs. Wertheimer*, 1901. Betty (left) and Ena were children of Sargent's art-dealer friend. Though Sargent especially admired Ena for her free spirit, he rendered both young women sophisticated, sensual, and joyful. Originally, he painted Betty's gown strap as fallen, but he thought better of a bold detail that had caused him grief with *Madame X*.

FIG. 25: *In Switzerland*, C. 1905. In the early twentieth century, Sargent often traveled on the Continent with a familial entourage that included artists friends like Peter Harrison, here pictured in a moment of exhausted abandon in a hotel room. Sargent's swift, spirited private sketches often captured delightful, characteristic, and intimate moments.

FIG. 26: *The Chess Game*, C. 1907. For this exquisite orientalist fantasy, Sargent used as models his valet, the Anglo-Italian immigrant Nicola d'Inverno, and his niece Rose-Marie Ormond. An intricate composition of serpentine forms, articulated by sumptuous fabrics and a sun-dappled Alpine stream, the piece also articulates intimacy and humanity in its romantic protagonists.

FIG. 27: *Man Reading (Nicola d'Inverno)*, 1904–1908. Nicola d'Inverno spent twenty-five years as Sargent's life model, valet, and travel companion. This informal, affectionate piece apparently shows Nicola reading in bed on one of the pair's many junkets—a view that no typical Belle Époque employer would have of a servant.

FIG. 28: *Mountain Stream*, C. 1912–14. Sargent painted this charming, energetic watercolor of an Alpine stream sometime before the outbreak of the First World War. The nude figure, who embodies the innocent liberty of nineteenth-century bathing pictures, was seemingly based on Nicola d'Inverno, Sargent's valet and studio assistant.

FIG. 29: *Tents at Lake O'Hara*, 1915. Sargent's love of mountain adventures began when he was a boy in the Alps but continued through most of his life. While camping and hiking in the Canadian Rockies in 1915, he made this oil study of the light and color of his party's improvised tents. Sargent also renders a sympathetic portrait of a handsome young guide peeling a potato.

FIG. 30: *Tommies Bathing*, 1918. Commissioned to paint an Anglo-American war picture late in the First World War, Sargent roamed the battlefields and army camps of northern France, capturing spontaneous sketches like this watercolor of two British soldiers relaxing after a bathe. Sargent's evocation of innocence and camaraderie contrasts with the dire circumstances of war.

FIG. 31: *The Bathers*, 1917. At Vizcaya on Biscayne Bay in south Florida, Sargent painted Bahamian construction workers during a visit to his friend James Deering. The limpid, luminous atmosphere of the watercolor contrasts with the probable conditions of these workers, showing both Sargent's humanizing of marginalized people and his tendency to exoticize them for his own purposes.

FIG. 32: *Nude Study of Thomas E. McKeller*, c. 1917–20. Sargent's provocative nude rendering of his longtime Bostonian life model Thomas McKeller, though private during Sargent's lifetime, has since become famous, perhaps notorious. Though Sargent had a close working relation with this Black hotel porter, the lit, explicit frontal nudity of this figure, hands behind him, has suggested bondage or erotic exploitation to some viewers.

18

A King's Existence

Sargent was in for a glorious reign in Boston, where he was now being embraced as a long-lost prodigal son. He was also now mingling with the most influential people in the city. The man who'd paid for Sargent's third portrait of Robert Louis Stevenson in 1887 was Charles Fairchild, a fifty-year-old American banker and stockbroker. Though Fairchild had international experience and good manners and would later become a close friend, he thought not like an artist but like the money-man he was; he would later become Sargent's financial advisor. The Stevenson commission had come primarily from his forty-three-year-old wife, Elizabeth Nelson Fairchild, a poet and a scion of Concord, Massachusetts. And though Concord was a long way from London and Paris, Boston was now propelling Sargent's new career, and in surprising ways.

Lily, as she was called, longed like Belle Gardner to annex Sargent. Certain Boston ladies wielded just that kind of ambition. Already, Lily Fairchild was friends with Mark Twain, Walt Whitman, Julia Ward Howe, and Henry James, as well as Robert Louis Stevenson. Stevenson had even written a long narrative poem, *The Battle of Ticonderoga*, in her house at Newport, while recovering from one of his frequent illnesses. Sargent's 1887 head-and-shoulder portrait of Lily showed a dark-haired woman wearing white, her rather beaked face in Sargent's dramatic chiaroscuro generously lit, but showing a pinch of anxiety.

Yet the Fairchilds offered Sargent, who loved his itinerancy but also suffered from it, a home away from home—the hospitality of their vine-covered "cottage" in Newport and their bay-windowed townhouse on Commonwealth Avenue in Boston, as well as a slew of portrait commissions. The couple had six children, four sons and two daughters. Sargent painted a portrait

of the Fairchilds' five-year-old son Gordon, though only his later 1890 portrait of the child has survived. Characteristically, though, he preferred the daughters of the family. Sargent painted Sally Fairchild three times, later and most memorably as the mysterious *Lady with a Blue Veil* in 1890.

Seventeen in 1887, Sally was dark-eyed, long-necked, and widely esteemed a beauty. But she also had intellectual aspirations and, fascinated by the phenomenon of spiritualism, attended William James's lectures on that subject at Harvard. There she became the first woman permitted to attend lectures at the university, even though she was asked to sit behind a screen so as not to distract the male students.

Yet Sargent also liked Lucia, the younger daughter, even if he didn't paint her portrait. Though just fifteen in 1887, Lucia would become increasingly important, in Sargent's mind, as his friendship with her family deepened. Lucia longed to become an artist herself and years later would paint miniature portraits to support her family.

Yet one of her most important achievements would turn out to be a diary she kept beginning a few years later, in which she played Boswell to Sargent's Johnson by recording this table-talk and preserving his unguarded moments. The Fairchilds were so much like family, in fact, that they not only gave Sargent a home-base in the United States but would also later mix with Sargent's family in Europe, Lucia being only two years younger than Violet Sargent, whom she would soon call "Vi," as Sargent himself did.

"When you come & stay in America so long, you must get awfully tired," Lucia said to him, a few years later in England. "We were very worried about you before you went away last fall."

"Worried about *me?*" Sargent said, puzzled. "Why what do you mean? Why worried about me?"

"Well," Lucia replied, "Vi said you talked to yourself all the time."

"I?" Sargent said. "Vi said I talked to myself? Absurd—" Then he laughed. "Did you all think I was going cracked?" Then he added, "But how should Vi have known—"

Lucia said that Violet's room was next to his, and that she said "he muttered & talked to himself all the time."

"But I am sure I never did," he answered. "I suppose I may have talked in my sleep—though I don't think I ever do."

Sargent's sisters knew a lot more about their brother, it seemed, than he was aware; and in this case they would pass on some of their inside knowledge to Lucia Fairchild.

-+-

At the beginning of 1888, Sargent was staying put—or at least making the rounds in Boston and Newport. Meanwhile, Isabella Stewart Gardner had headed off across the Atlantic. The reception of her portrait may have bruised her, but Belle Gardner had a reliable method for recovering from such shocks. She and her husband abandoned Boston for Spain. There— where few but bold travelers braved the bandits, forbidding mountains, and primitive inns—she could forget her troubles in the cathedral of Burgos or the museums of Madrid, be hailed as a noble lady at a bullfight in Seville (though she hated cruelty to animals), and explore her affinities with a glorious historical queen. She hoped, in her way, to surpass the earlier Isabella.

Isabella Stewart Gardner, like Sargent's own intrepid mother and like the painter himself, itched to travel the world. She made herself a first-rate traveler in an era of groundbreaking women's travel. Like her new artist protégé, she effectively translated tourism into a means of personal empowerment and liberation. Without being a millionaire, Sargent harbored similar predilections, and he could relate to Gardner's palpable sense of satisfaction in getting away. That wasn't something everybody understood, and her example reflected strongly on Sargent's own aims in pursuing a radically itinerant life. And as so often happened with Sargent, too, the example actually originated in a woman.

Even before 1888, Gardner had gone abroad to escape troubles and scandals at home. She'd resorted to travel to cure her ills, as did other women of the time—notably bored, restless, or depressed women of means who, as Mary Sargent had done in the 1850s and 1860s, went abroad in an attempt to cure themselves. Cures were often literal, as many of these women sought out sanitariums and cure-baths. Women's focus on health, as opposed to pleasure, provided them one of the few excuses they could easily use, in an era when women were expected to be self-denying, to justify the expense (and freedom) of foreign expeditions.

Unlike many female "invalids" of her time, however—and unlike Mary Sargent, in her middle age—Gardner didn't fall into the trap of perpetual ill-health. She never settled for a life made out of illnesses and failed cures. Remarkably in her circle, she actually benefited from her travels, and dramatically so.

Gardner's first such experience set her pattern of success. In 1867, after two years of depression resulting from the death of her infant son Jackie, a

doctor prescribed European travel. According to later accounts, Belle was taken prostrate from Beacon Street to the Cunard steamer docks in East Boston "in an ambulance and carried up the gangway on a mattress." After travels in Russia, Scandinavia, Austria, and France, however, Gardner returned cheerful, determined, and clad in hip-hugging Worth gowns she'd picked up in Paris. A Bostonian gentleman, accustomed to the period's crinolines and all-enveloping hoopskirts, flung out at her: "Pray, who undressed you!" "Worth," Belle Gardner shot back. "Didn't he do it well?"

In 1874, after the death of her brother David, Mrs. Jack again traveled in order to recover, this time to Egypt and the Middle East. On this intrepid journey, Jack looked after the steamers and letters of credit, and Belle wrote an atmospheric diary and painted watercolors of ruins and sunsets over the Nile. She also assembled scrapbooks, which, though a Victorian women's form, adapted well to the Victorian men's realm of world exploration and discovery. Belle eagerly collected artifacts, photographs, and impressions that would earn her confident worldly knowledge as well as authority for her later art collecting. All in all, travel beautifully stimulated her, as it did Sargent. When at home she was often, as she related to Morris Carter, "groping after some activity that should satisfactorily engage her energies and abilities."

In 1883, after her lover Frank Crawford decamped without so much as a goodbye, Gardner again traveled—and to Asia, a part of the world that Crawford, who had once lived in India, had earlier recommended to her. She went not in a foursome with Crawford, as she originally pipe-dreamed, but in a twosome with her loyal, appreciative, and forbearing husband. Voyaging out, Mrs. Jack scrutinized the port of Yokohama, promenaded on the Great Wall of China, and adventured through the jungles of Southeast Asia, camping out in tents (albeit in high style), in order to see Angkor Wat; she was one of the first Western women to visit this overgrown and ramifying ruined city. She also secured an audience with the two official kings of Cambodia. The First King, Norodom I, was dazzled by her ropes of pearls and coveted her huge yellow diamond, so superior to his own royal treasure. Gardner didn't take the hint and neglected to bestow her diamond on the hopeful monarch.

Such adventurous encounters flooded Gardner with joy, energy, and purpose. "The liberalizing, tranquillizing effect upon Mrs. Gardner of her experiences in the East cannot be estimated," Carter remarked. "She was

an ardent believer in the maintenance of native customs, native costumes, native ceremonies, and native religions." Such intrepid, open-minded appreciations made Gardner a world traveler of the first stamp. She claimed a certain amount of high-handed privilege, as a rich, white Westerner, in this period of intense European colonization. But she also developed a respect for the cultures she encountered, a cosmopolitan outlook that shaped her later world-spanning art collection.

-+-

Would two such ecstatic travelers ever join up? As for Spain in 1888, Belle no doubt invited John to join her there, as he'd shared with her his fascination for the country. Sargent's friend Ralph Curtis *did* join the Gardners in Seville and obligingly sketched Belle wearing a lace mantilla. Mrs. Jack often summoned her friends and protégés to join her in various far-flung countries, and Henry James, Bernard Berenson, and many others had expended much ingenuity on letters outlining the reasons why they couldn't link up with her.

In the case of the cautious novelist, James professed to admire Gardner as a traveler. In 1882, he wrote her, "Your journey to Japan & India is a *coup de genie* [stroke of genius]: won't you take me with you as your special-correspondent—& companion." He quickly added, seemingly recalling Mrs. Jack's adultery (in which a "correspondent" was the home-wrecking guilty party), "I mean your special-companion." Actually, James would never have traveled anywhere so *outré* as Asia himself—being devoted to his sacral, high-cultural vision of France, Italy, and England. No more did he condone Gardner's reputed adultery. When he portrayed a fictional version of her romantic friendship with Francis Marion Crawford in his short story "A New England Winter" (1884), he cast it as innocent and nonsexual.

Privately, James found Gardner's traveler's freedoms unfeminine, chaotic, vulgar, and profoundly disturbing. As he phrased it in his notebook in the 1890s, he associated Isabella Stewart Gardner with what he saw as the major disruptions in the civilized culture of his time. He predicted catastrophe ahead, foreseeing the

> overwhelming, self-defeating chaos or cataclysm toward which the whole thing is drifting . . . the insane movement for movement, the ruin of thought, of life, the negation of work, of literature, the swelling, roaring crowds, the "where are you going?,"

the age of Mrs. Jack, the figure of Mrs. Jack, the American, the nightmare—the individual consciousness—the mad, ghastly climax or denouement . . . The Americans looming up—dim, vast, portentous—in their millions—like gathering waves—the barbarians of the Roman Empire.

Yet when Gardner wrote him from Spain in spring 1888, James merely deflected her with his usual charm: "What a wonderful Mrs. Jack-in-the-Box you are—popping up, with all sorts of graceful effects and surprises, purely your own, in the most unexpected parts of the Universe." "I envy you Spain—& envy Spain you," he went on. He was careful, though, to emphasize the reason he couldn't join her, which was that she had put "so many Pyrenees & things between [herself] & Piccadilly," the "romantic avenue" in London where James firmly intended to spend his spring and summer.

Sargent, though much more open to exotic travel than James, nevertheless had a better excuse not to join Mrs. Jack in Spain. His father had weathered an attack of shingles in 1887 and then had suffered a stroke when John was in Boston in January 1888. John's plans were on hold over the next few months while Mary and Emily decided where Fitzwilliam might best convalesce. In May, sailing back to Europe after his portrait-painting junket in America had extended to six months, Sargent appears to have managed a visit to his ailing father in Florence. Yet this family situation didn't prevent the thirty-two-year-old artist from inviting Dennis Bunker, Gardner's protégé, to join him in Italy for that summer.

❦

The friendship between Sargent and Bunker had prospered since they'd spent time together in Gardner's house. (They may have met before in Paris, as Bunker had studied at the Académie Julian and with Jean-Léon Gérôme.) Clearly, Sargent was attracted by twenty-seven-year-old Bunker's passionate devotion to his painting as well as his nervous, mustached, feline good looks. These Sargent dashed off in an oil sketch that he bestowed on Bunker at Christmas in 1887. In the event, the two young painters would alter their plans in order to spend the summer of 1888 with Sargent's family not in Italy but in Calcot in Berkshire, on the willow-fringed River Kennet. There a romantic old mill, ancient willows, and a rushing stream would renew the kind of rural English peace Sargent had earlier savored at Broadway. And, like Broadway—and in spite of John's frequent attendance on the failing

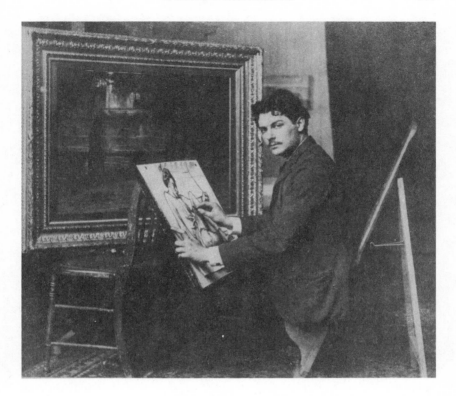

Dennis Miller Bunker in His Studio, 1884–90

Fitzwilliam Sargent—Calcot would offer some stimulating as well as some restful days.

For Sargent's relation with Bunker was now turning into another romantic friendship or painters' alliance that would foster a strong bond between the two men. Sargent's spontaneous portrait of Bunker, in fact, was rumored to be the result of a "rather wild night" at the Tavern Club in Boston. Such sprees with fellow artists were now becoming a conspicuous feature of Sargent's metropolitan pastimes.

In a farewell dinner in New York on April 2, 1888, at a restaurant called Sieghortner's in Lafayette Place, one of the painters later reported that he "tried to escape at midnight but was discovered and pulled back . . . I shall never forget, after leaving the restaurant, hearing the singing and noise for several blocks. Some of the artists were not seen for days." This celebratory dinner involved at least thirty-two young artists, all male.

Sargent's entertaining on this scale was unusual for him—even if, like his

mother, he enjoyed throwing parties. But his drinking heavily and smoking cigars late into the night with chums was not unusual, and Sargent wanted to annex a charming young talent like Bunker. When the young artist joined Sargent in Manhattan a week after the Lafayette Place dinner, ahead of sailing with him to Europe, Bunker wrote Mrs. Jack that he found Sargent prodigious in this Manhattan setting: "*Il mène une existence de roi—c'est un homme étonnant*" (He leads the life of a king—he's an astonishing man).

Gardner's biographer Douglass Shand-Tucci has understood this romantic friendship as a homosexual liaison—one of a number that occurred under Mrs. Jack's aegis. After all, she "remained tolerant of any moral or perhaps immoral code," as Carter described her characteristically open-minded outlook, the nearest American equivalent to a cosmopolitan Paris art hostess like Henrietta Reubell. Gardner's high spirits and her own love for transgression probably made her sympathetic to men with defiant or unconventional bents.

Yet such an interpretation modernizes these dynamics a little too easily, without inquiring how such alliances actually worked in Sargent's milieu. Gardner, like many in her era, might have been shocked by the idea that she ever promoted homosexuality. She may not have had the kind of tolerant protomodern consciousness some have ascribed to her, even if, with the many colorful artists she cultivated, she did deal with many unconventional men whose secrets she seemed willing to keep, or ignore. She was happy to accommodate transgressions as long as they reflected well on her. For whatever reason, as Shand-Tucci points out, Gardner placed Sargent's and Bunker's photographs together in her personal display of her friends.

Although it's possible that this friendship had an erotic or even sexual dimension, Bunker at Calcot also admired John's eighteen-year-old sister Violet Sargent. Violet—vivacious, curvaceous, and blooming—was also staying at the country house and was beginning to become a favorite model for her brother. No paintings or sketches of Violet by Bunker have survived, but a couple of figure studies by Sargent from this summer reveal Bunker. One of these, *Dennis Miller Bunker Painting at Calcot*, renders Bunker's form as handsomely slim. He wears glowing white flannels and a boating cap, and with his hands in his pockets, he comfortably regards his canvas, in this bosky riparian setting, with Violet Sargent, under a straw hat and parasol, sitting not far away (see Fig. 17).

For his part, Bunker wrote Mrs. Jack that Sargent's sister was "awfully

pretty": "What if I should fall in love with her? Dreadful thought, but I'm sure to—I see it coming." (Why was it a "dreadful thought" that Bunker might fall in love with his friend's sister?) Two years later, in 1890, Bunker wed a woman named Eleanor Hardy. Sargent attended the wedding, an honored guest, though he told Lucia Fairchild he thought Bunker looked "pale"—"root-colored,'" as Belle Gardner would have described it. Bunker's pallor might have been his illness. But Sargent thought it was "the moment"—"it must be a terrible ordeal—I suppose it was partly emotion— poor fellow." Bunker was married for only two months before his early death, possibly from spinal meningitis (Bunker's first biographer suspected suicide), that same year.

Still, not only was romantic friendship compatible with marriage in Victorian minds but also Bunker himself qualified as a complicated and "moody" man. According to Gardner's biographer, he was subject to "violent headaches and fits of depression; at such times he would lock himself in his room, go without food and admit no one. Mrs. Gardner alone could persuade him to face the world again." He also wrote his prospective wife in 1890 that she was "marrying a man . . . whose highest ambition is to conceal his identity." Though Bunker may or may not have had homosexual identity in mind, that tendency was one that many men in Sargent's and Bunker's circle took extreme pains to camouflage.

The two men's long, companionable summer together at Calcot left a deep impression on Sargent. Later in his life, he declared that "he could remember no one whom he held in greater affection" than Bunker. Even after Bunker's death, Sargent used an image of this young man—not from his post–Tavern Club oil portrait but from a sketch or sketches that have not otherwise been discovered—for his rendering of Joshua, the young protégé of Moses, in his later Boston Public Library murals.

Along with the prophet Micah in the East Wall and Hosea on the West Wall, this figure that Sargent based on Bunker is one of the few young, engaging men in the frieze. Joshua is also one of the few figures who betrays a corporeal shape beneath a flowing Biblical robe. The young prophet's robes are rose-pink. And in Sargent's rather provocative rendering, the figure raises a brown right arm athwart his body, to draw a sword, revealing on his left side a curve of golden-brown flesh from his underarm to his midthigh, a curiously telling glimpse of nakedness in murals otherwise soberly conservative and meditating on Judeo-Christian themes. Bunker's presence in this

biblical figure gave a depth and passionate engagement that would render the Frieze of Prophets perhaps the most successful panel of Sargent's future megaproject.

The seemingly serious themes proposed by Old Testament prophets would please Sargent's later collective patrons at the Boston Public Library, who were hardly adventurous or avant-garde. Nudes were almost entirely out of the question in Boston especially, and not only because of the antivice crusades of Anthony Comstock and his ilk. Though Sargent would eventually hazard somewhat more risqué if classical depictions of his religious themes at the library, he knew better than to impose anything too experimental.

Except for Americans who'd lived or traveled on the Continent, American artistic taste, though often derived from older European models, tended to be untutored, unimaginative, and unadventurous. Even so, "Old Masters" were beginning to be more fully appreciated, newly opened museums like the Metropolitan in New York or the Museum of Fine Arts in Boston were educating their publics, and more Americans than ever were traveling to Europe and appreciating or collecting European art, both traditional and modern. And, to be sure, Sargent wasn't alone in his project of fostering a more sophisticated, up-to-date taste in the United States.

◄┼

Sargent's farewell-to-America dinner at Sieghortner's in April 1888 convened savvy young American artists who'd studied in Paris and Munich. Collectively they embodied the new art culture that was taking root in New York, sometimes inspired by a new American aestheticism and bohemianism, sometimes fueled by the robber barons and their over-the-top if rather indiscriminate quest for architectural and artistic acquisition.

Sargent's boisterous, hard-drinking party celebrated his spectacularly successful painting-tour of the northeastern United States, which he'd lengthened from two to seven months due to the rush of new commissions. The over-the-top feast he provided his friends included oysters, green turtle soup, *bouchées à la reine* (vols-au-vent), saddle of lamb, *ris de veau*, asparagus, kirsch sorbet, and Nesselrode pudding, wrapping up with *glaces fantaisies*, strawberries, petit fours, and coffee.

Along with Isabella Stewart Gardner, Sargent had now painted many rich and prominent Americans. His new clients featured New York, Newport, and Boston notables and included his first four Vanderbilts: Mrs. El-

An artists' party with John Singer Sargent and others, c. 1890

liott Shepard, Alice Vanderbilt Shepard, Mrs. Benjamin Kissam, and Mrs. William Henry Vanderbilt. Introductions to Vanderbilts had come to him through the prodigious New York architectural firm of McKim, Mead, and White. The brilliant and notorious man-about-town Stanford White also attended John's dinner. (White was a famous womanizer—who would even be fatally shot at the Madison Square Garden roof garden theater in 1906 by a crazed jealous husband. Yet even he, as one recent biographer has acknowledged, also belonged to "the circle of gay life in the New York at the end of the century" and may have been bisexual.)

Sargent now reveled in a flush of success, following the lull in his career precipitated by *Madame X*. He owed his new success to complicated factors. He'd drawn fresh patrons from his personal connections (James, Gardner, the Boits, and other cosmopolitan boosters). But also he could thank his modern, lucid, startling Paris-trained style, now increasingly in vogue on the western shores of the Atlantic.

Henry James's enthusiastic appreciation of Sargent, appearing in *Harper's* in October 1887, had also given the painter a boost. James claimed that "no American painter has hitherto won himself such recognition from the expert" and hinted that Sargent was now finally catching the "attention of the public." Another reviewer noted that this "brilliant young painter" was especially adept at portraying "well-known men and women, leaders in

fashionable society," in that he was "eminently gifted with that wit in paint-
ing that seizes the striking and the characteristic in his sitter and sums it up
in a few happy strokes, emphasizing the point that tells."

Sargent's visual wit did tell. People appreciated his psychological touches
and also noticed his bold use of color, his free brushwork, and his dashing
Paris virtuosity. But in society especially, it was his ability to concoct elegant,
stylish, flattering images that was contributing to a string of public successes
(shows at the St. Botolph Club in Boston and the National Academy of
Design punctuated his American venture) that were gradually transform-
ing him into one of the most in-demand portraitists in the English-speaking
world. That world, in the Gilded Age, was awash with both old and new
money, especially in America.

Wealthy American patrons offered Sargent the prospect of a substantial
and reliable income by which he could help support his mother and sisters.
(Fitzwilliam Sargent died quietly in Bournemouth, England, on April 27,
1889.) Yet to paint plutocrats presented him a quandary. Of course, Sargent
had earlier painted wealthy patrons in London or even Paris: not everyone,
of course, could afford a high-end portrait. Yet well-to-do patrons in Eu-
rope tended to have more schooled, sophisticated tastes than the nouveau
riche nabobs Sargent was beginning to paint in America, and it took all of
the painter's charm and persuasion to keep his new customers happy.

As even one hostile critic phrased it, Sargent had "the gift of imparting
distinction to his subject—makes a dowdy look like a queen, or to a little, in-
significant woman gives the air of the goddess." This same unfriendly critic,
though, failed to appreciate Sargent's limpid, edgy Paris style and accused
him of not only of dashing off portraits but also displeasing his patrons with
a lack of verisimilitude. Such a report was exaggerated—Sargent generally
satisfied his clients. But not all of Sargent's new sitters understood his some-
what Impressionist style, his bravura, or his stagy inspirations. Even though
Sargent also continued to portray friends, fellow artists, or bohemians—or
to produce fluid, flamboyant watercolors for his own enjoyment—his rising
status as a posh society portraitist was beginning insidiously to influence his
mainstream portrait work.

Catering to rich patrons less idiosyncratic and inspired than Gardner
would tarnish Sargent's future reputation by tarring him as a modish or
mercenary opportunist. But that wasn't all. His success would also dampen
the playful, transgressive, and exotic instincts that had previously enlivened
his paintings with raw originality. If Sargent had suffered from a strong

public-private rift in his painting before, that divide would only deepen with his increasing popularity and prosperity. Sargent's old half friend Robert de Montesquiou was not the first or only cosmopolitan in Sargent's circle to feel that the artist was selling out. By 1905, Montesquiou would berate Sargent for abandoning the inspirations of *Madame X* "in favor of brilliant variations and facile effects," for failing to produce work with an "allure of revolt and of defiance."

For now at least, Sargent still showed plenty of defiance. Sargent sailed back to England in May of 1888. Later that year, back in his effervescent London element, he painted a theatrical, richly colored portrait of the English actress Ellen Terry in her role as Lady Macbeth. Here he concocted a figure in spectacular blue-green Celtic robes, with long braided "magenta hair!" (as Sargent described it), posed campily with Macbeth's ill-gotten crown raised exultantly over her head. This "weird and wonderful" picture of a woman who had had two children out of wedlock with her architect-lover E. W. Godwin occasioned not only a public sensation but also another big celebration dinner, this time at the Beefsteak Room at the Lyceum in London.

Such eye-catching paintings were safer, more public manifestations of Sargent's rebellious instincts. For, in spite of his ordeal with *Madame X*, the thirty-four-year-old artist hadn't lost his taste for painting daring and scandalous women—nor lost sight of the publicity value of doing so.

19

The Stage Door

Eager to work, Sargent arrived again in New York Harbor on December 4, 1889, having steamed back across a stormy Atlantic, this time in the company of his nineteen-year-old sister Violet. Plump, lively, auburn-haired, with a radiant pink-and-white complexion, Violet had gamely provided her brother an engaging model at Calcot and elsewhere. She'd furnished Dennis Bunker a distraction. She differed conspicuously from her stiff, dutiful older sister Emily, whom her brother described to Lucia Fairchild as "saintly." Violet spoke multiple languages effortlessly, wielded a ready wit, and instinctively bonded with anyone and everyone, including, when she could manage it, her somewhat standoffish older brother.

While Violet was in a punt or lying on a sofa, Sargent had found her natural and relaxed exuberance compelling. Now, though, her strong-willed liveliness was increasingly frustrating him. Violet had recently met and become infatuated with an inappropriate Swiss man named Louis Francis Ormond. Compact, charismatic, and athletic, Ormond was a cigar-merchant's son. Four years older than Violet, he told her disreputable yarns about running away from his family to Canada or slumming in backwaters of the South Pacific. Yet Violet found his scruffy good looks and iconoclastic energy almost irresistible.

In forming such a preference, Violet was proving as headstrong as her mother had once been. Mary Sargent, though, didn't at all like her youngest daughter's rebellious streak. Now sixty-four and beginning to slow down after a lifetime of locomotion, Mary regarded Violet as a problem her dutiful son could help remedy, now that Dr. Sargent, the nominal paterfamilias, was gone. Thus mother and son had consulted and collaborated. They'd designed Violet's first visit to her native country to help her forget Francis Ormond. They earnestly hoped she'd find someone more solid, trustworthy, and eligi-

ble. As Sargent later expressed the matter to Lucia Fairchild, he didn't believe love was "necessary to getting married": "The chances seem to me much greater for happiness without all that tremendous feeling—You would have to lose your little illusions sometime, & then with all this *Terrific love* & so on, it would be a most awful shock—& there would be nothing left for it but the other extreme—of *Terrific hate*."

Though designated as Violet's chaperone, John parted with his sister once they reached New York. Violet caught a train to Boston to board with Sargent's friends the Charles Fairchilds in Commonwealth Avenue. This well-established family was better-suited than her brother for introducing Violet into good society, especially as Violet would have the scholarly Sally and the sensible Lucia Fairchild for company when she mixed with bright New England men.

Sargent himself embraced the bachelor-privileges of the Clarendon, a comfortable five-story, many-chimneyed hotel built in about 1870, at Fourth Avenue and Eighteenth Street. Here he rolled up his sleeves. He looked forward to a docket of new American portraits, some of them long-arranged, though with new ones coming in all the time. Increasingly, he had his eye on the Millionaire's Mile, on Fifth Avenue uptown, the haunt of New York's wealthiest and most ambitious families. He'd already painted four portraits of Vanderbilts in 1888. He'd soon complete four more Vanderbilt commissions (Benjamin Kissam, Florence Adele Vanderbilt Twombly, Cornelius Vanderbilt II, and George Washington Vanderbilt in 1890). Such high-priced portraits were becoming Sargent's meal ticket. It was a specialized market that his aging colleague Whistler, who circulated among some of the same group of nabobs, would really broach only in the late 1890s, in the last few years of his career.

Each high-profile portrait Sargent painted became an advertisement in itself. And each helped cover his and Violet's expenses in the New World. Yet, even with such set pieces, Sargent could be sensitive to the critical opinions his paintings engendered, especially the idea that he was glib or clever in his society pieces. "Very few writers give me credit for insides so to speak," he wrote to one sympathetic woman friend who had appreciated how much feeling he could put into a portrait like that of five-year-old Beatrice Goelet, which he also painted in New York during this visit—and which presented the child as an intriguing Velázquez infanta.

Sargent's ambition sent him uptown. But his deep restlessness propelled him in the opposite direction, toward downtown and the music halls.

-+-

La Carmencita whirled, twisted like a snake, and whipped back and forth in the dim, steaming footlights lined up at the Tenth Street artists' studios in New York City. That raw spring of 1890, the Spanish dancer was doing her best to heat up Manhattan. Carmencita brought to William Merritt Chase's cold, cavernous studio the fiery stage persona that had recently mesmerized top-hatted New York critics with her "torsal shivers and upheavals." Behind the arching dancer, shadowy figures strumming Spanish guitars filled the room with the intense, pulsating rhythms of flamenco—conjuring up the seedy cabarets of Andalusia in Spain from which this uninhibited woman had drawn her moves—her slashes, lunges, and dramatic poses.

But here in the studio of one of New York's most fashionable artists, Carmencita wasn't dancing for Andalusian peasants. Though she wasn't in fact an ethnic gitana—born Carmen Dauset, she was a French professor's daughter and only half Spanish—she was riding a vogue for gypsy dance created partly by Georges Bizet's opera *Carmen* (1875), which had first swept through New York six years before in 1884. This eponymous Carmencita, though, was entertaining not operagoing crowds but selected upper-crust New Yorkers, cohosted by Belle Gardner—who'd bankrolled the spectacle—and John Sargent—who'd willed it to happen.

Sargent looked on, strangely intent. His stare might have daunted a woman who was less bold than Carmencita. His fascination for the lithe Spanish dancer brought out his brash, daring side. When watching Carmencita, this otherwise mild, bearded, self-effacing workaholic lit up with an inscrutable gratification, visibly relishing the dancer's unexpected moves. Most likely, he'd first discovered this Salome in the overheated carnival atmosphere of the 1889 Paris Exposition Universelle the year before. There she'd become, according to another admirer, "the craze of the Boulevards."

While at the Exposition, with exotic dancers on his mind, Sargent had also painted a number of luxurious maroon-and-gold studies of traditional Javanese women at the Dutch colonial enclosure at the Fair. Such exhibits are today understood as "human zoos" and are seen as highly suspect. But Sargent shared his fascination with such musicians if the time as Claude Debussy and such artists as Auguste Rodin and Henri Toulouse-Lautrec.

The most intimate of these experimental portrayals had come from backstage, a half length of a slender performer applying her makeup using a small oval hand hand mirror. Bare-shouldered, in a blue-green gown,

with the sepia background of the ordinary Fairground (including a French chairback), the unnamed woman claimed some dignity, in Sargent's vision of her. Was Sargent's pushing his way into the dressing room empathetic or invasive? His desire for such close-up experience was becoming almost a mania with him. Violet Sargent was hardly the only member of the family who channeled wayward instincts.

Now, during the winter of 1890, as Carmencita made herself the craze of Manhattan, Sargent tracked her to a saloon and dance hall, Koster, Bial & Co. on Fourteenth Street, in the Tenderloin of Manhattan, accompanied by his old artist chum James Carroll Beckwith. Beckwith fanned Sargent's obsession—perhaps pleased to see his aloof and proper bachelor friend exercised about a woman. At thirty-eight, Beckwith still wore a slightly grizzled form of his old Continental goatee. But the moderately successful artist dressed less flamboyantly now that he was married and trying hard to earn a living among starch-shirted New Yorkers.

In February, Beckwith even went so far as to throw a party in which twelve cigar-smoking men, including Sargent, watched as this "bewilderingly superb creature," as Sargent described her, launched her signature routine.

Harper Pennington, *John Singer Sargent Watching Carmencita Dance at Mrs. Gardner's Home in Boston*, 1890

Lifting "one dainty foot," as one observer recorded, Carmencita threw herself into a series of "crouching and springs, serpentine curves, contortions, gyrations, evolutions, convolutions, whirlings and twirlings, so that the dancer appeared in the height of its delirium on the point of going to pieces." Then she finished, her eyes blazing, by turning a "dazzling but enigmatic smile to the audience."

◄+►

Even more enigmatic, though, was Sargent's bewitchment. After Beckwith's party, at three o'clock in the morning, Sargent volunteered to squire the dancer home. Did he merely ask her to pose for him, or did he want something more? A week later, he again visited her packed, smoky cabaret downtown, once more savoring every detail of her performance. The thirty-four-year-old artist's fascination for this "daughter of Herodias," this "young panther," as another of his friends described her, was conspicuous even in a city besotted with its new stage star.

To Frank and Lily Millet, who were also in New York, Sargent's infatuation with Carmencita bore all the earmarks of a stage-door passion of a type well defined in 1890s Paris and New York. He stalked Carmencita's dance performances. He shadowed her at parties. He coaxed her into posing for him in his studio. Sargent took photographs of Carmencita and dashed off spirited, fluid sketches and oil studies. By one account he even presented her with the many bracelets she wore on her slender arm. Even months later Sargent's young friend Lucia Fairchild reported that the painter still admired the dancer "beyond anything" and "brought down his photographs to show her."

Still, Sargent's interactions with Carmencita often came off as curt and adversarial. In the studio, this "primitive and untutored creature," as Sargent's first biographer described her, showed herself as "wayward, now sullen and subdued, then breaking into tempests of anger and impatience, ready to smash anything that was at hand." A dancer who loved movement, she balked at posing or even sitting still. By this point in his career Sargent had logged a lot of experience with posing difficult sitters—had clashed wills with many a recalcitrant patron or model. But now he was forced to amuse and distract Carmencita by "paint[ing] his nose red to rivet her childish interest upon himself, and when the red nose failed he would fascinate her by eating his cigar." For Isabella Stewart Gardner's Tenth Street party, one observer noted, the dancer "arrived at the studio with her hair frizzled

and her face loaded with powder and paint. Sargent, as her impresario for the occasion, smoothed her hair flat with a wet brush; he even applied a wash rag to her cosmetics."

Sargent was pragmatic and deliberate enough to serve as Carmencita's "impresario," a manager and sponsor as well as an admirer. For ultimately Sargent's odd and combative relation with Carmencita led chiefly to rhapsodic talk and a brilliant exhibition portrait (see Fig. 18). That painting depicted a slender, haughty dancer, proud and poised, her masklike face *à la japonaise*, in an embroidered lemon-yellow dress, striking a pose with arms akimbo. Later in 1890, when Sargent showed off his creation New York, London, and Paris, the portrait won him much attention and generally enthusiastic reviews. In New York, *La Carmencita* crowned him the "hero of this exhibition." In London, the portrait earned him the distinction of having painted "*the* picture of the year."

The chief drawback of the portrait, several critics agreed, was Sargent's very fervor—"*trop d'espirit*" (too much spirit), as one New York critic phrased it. This was a canny remark: Sargent was almost too rapturous. What's more, the Andalusian dancer wasn't of course a one-off but rather a pattern with a long history, that was now intensifying. As the art historians Richard Ormond and Elaine Kilmurray have pointed out, Carmencita embodied Sargent's fascination with Spanish culture as well as his "interest in painting actresses" that was "particularly powerful at this time." Her dark, "exotic" looks amounted to one of Sargent's perennial "favorite pictorial types," represented earlier in his career by such figures as Rosina Ferrara, the unnamed Spanish dancer in *El Jaleo*, and even Madame Gautreau.

Beckwith, surveying Sargent's Carmencita sketches, remarked that his old friend's work was "so stunning that it makes me blue." But, if sometimes envious of his old friend's verve and success—now with Carmencita—he had also helped Sargent find a studio in New York. He arranged for Sargent to borrow a space from his friend Dora Wheeler Keith.

An aspiring portraitist herself, Dora Wheeler had painted a sympathetic, gentle likeness of the white-haired and bearded Walt Whitman a few years before. Her bright and airy studio, with its skylight and two fireplaces for warmth in winter, was one of a pair on the top floor of what the Wheeler family called a "large old-fashioned house" on Twenty-Third Street, owned by Dora's strong-minded mother, Candace Wheeler. The elder Wheeler, a pioneering decorative artist, had once partnered with Louis Comfort Tiffany but in 1883 broke with him to found a women's design firm called

Associated Artists. Once again, Sargent found himself intersecting with strong-minded women.

To interest Belle Gardner—that is, to use her love for Spanish dance to interest her in the images he was painting—he had to stage their cohosted gala party not at the sober and businesslike Wheeler house but rather in William Merritt Chase's big, cluttered, operatically decorated space in the artists' building on Tenth Street. Indeed, Sargent's studio host Candace Wheeler would later dislike the image of Carmencita that Sargent painted in her house, "triumphal" as she admitted its progress around the world would be. "I did not care for the portrait," she wrote, "probably because I did not care for the sort of thing it represented." Paradoxically, Sargent pursued his outré fascination for Carmencita in Wheeler's respectable house. In contrast, though, Candace's daughter Dora found Carmencita's performances "the most wild and primitive thing [she had] ever seen in my life and the most artistic."

Yet both Wheeler's and Keith's appraisals clashed with Sargent's peculiar appreciation of this stage-star—as did the aims and ideas of the entrepreneurial Carmencita herself. Though Sargent relied heavily on women—his career in New York depended on both the genteel and the disreputable—his different, often radically different, sensibility also spawned telling conflicts and ruptures.

Indeed, Carmencita's performance in Chase's studio, Beckwith reported, had "stiffish company" for an audience. It "did not go well." Sargent's patrons were seemingly less bewitched by this interloper than Sargent was himself. Even Isabella Stewart Gardner, normally a fanatic for Iberian dance, balked. She liked Carmencita much less than Sargent had hoped.

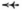

Four years after Sargent painted her, in 1894, the irrepressible Carmencita hit the silver screen. She had the honor of becoming the first woman to appear in a moving picture in the United States. Featuring in William K. L. Dickson's short film at the Edison Black Maria Studios in New Jersey, she reprised a segment of the Koster and Bial's Music Hall performance that Sargent had witnessed. In this rare twenty-second window into the 1890s—now readily accessible on the Internet—the dancer cheerfully kicks, twirls, bobs, bows, and flounces her calf-length embroidered gown.

To twenty-first century audiences, used to more brazen and explicit sexual spectacles, Carmencita's routine may appear free-spirited and

wholesome rather than alluringly sensual. She displays the confidence that attracted Sargent but also a certain physical insouciance, a rather uncomplicated joy in movement. The contemporary *Saturday Review* noticed in 1895 that Carmencita's dance had a "radiant vitality" that was "essentially the spontaneous interpretation of simple sensation. Carmencita's art," the critic concluded, "has not a trace of the modern spirit, nothing of that *maladie du siècle* of which the serpentine dance"—another dance fad of the 1890s— "was a supreme expression." And yet Carmencita's flaunting of her bare arms and stockinged ankles counts as bold for her era. If by 1894 somewhat plump by twenty-first-century Hollywood standards, Carmencita brought to her performance an elastic, full-figured female body that she displayed gracefully and unstintingly, without hesitation or shame.

Of Sargent's surviving sketches of Carmencita—bursting with joy and insight as they are—none focus on her physical body. Several portray her face, its modest or haughty expressions; or her movement, rendered in pencil lines suggesting swishing draperies in motion rather than the explicitly curvy female figure openly on display in the Edison Studio film.

In his finished portrait, in fact, Sargent slimmed away Carmencita's hourglass body and sheathed it in a splendid embroidered yellow satin gown. (Sargent evidently *owned* this gown, as he later loaned it to his friend Sibyl Sassoon to wear to a party.) Sargent gave little indication of hips or breasts, revealing only slender arms planted on her hips and one thin ankle almost obscured by the painting's dramatically dark background.

With her white, masklike face *à la japonaise*, Sargent's Carmencita amounted to a coup of theatrical style, an exquisite vision rather than a more approachable or relatable woman such as appears in the Edison film. The unnamed critic of *The Art Amateur* observed that "in this white-faced, painted, mysterious, evil-looking beauty, with her hands on her hips, her head thrown back and her magnificent yellow dress, [Sargent] has suggested a whole lot of things that Carmencita herself suggests only vaguely, if at all, and omitted a number of more human and attractive ones that she really possesses." The painting was "amazingly clever," the critic concluded, "but it is not Carmencita."

For his own reasons, Sargent had in fact augmented or distorted Carmencita's stage role. He'd concocted not a faithful likeness of the diva but a flamboyant rupture. To Henrietta Reubell back in Paris, James described the painter's erect, haughty Spanish dancer as *"fièrement campée"* (proudly posed). James's use of this French expression called to mind the closely

related French term *se camper*, "to pose in an exaggerated fashion"—a fitting description of Sargent's highly stylized *Carmencita*.

Such French expressions almost certainly gave birth to the English word "camp" that was emerging around the turn of the century, defined in 1909 in J. Redding Ware's slang dictionary as "actions and gestures of exaggerated emphasis." Sargent's Carmencita wasn't "camp" in any simple sense—a term and category that would fully develop only in somewhat different contexts in the coming twentieth century. His painting wasn't exactly tongue-in-cheek or self-consciously ironic or iconoclastic. But Sargent's portrait was defiantly elegant, high style, and painterly in his bold, suggestive Parisian style.

None of Sargent's contemporaries painted Carmencita like this. William Merritt Chase, who'd readily loaned his studio for a performance, also executed a portrait of the dancer in 1890. He chose to portray her in a classic flamenco stance with raised castanets and one leg extended to a pointed toe. Chase simply relied on the conventions of Spanish dance. But Chase—who incidentally produced a number of female nudes as well as eight children with his wife Alice Gerson Chase—also created an image of Carmencita more recognizable from photographs and her Edison Studio film—a curvier, earthier, and more cheerful Carmencita.

In contrast, Sargent posed his Carmencita with an extreme unnatural artificiality—or, alternately, disdain, dignity, and vehemence that hints at brooding erotic power. He rendered her, as one critic described her, "a veritable *Fleur du Mal*, with something of that halo of decay which gives a lurid fascination to the creations of Baudelaire." Sargent's *Carmencita* embodied not only his own idiosyncrasies, otherwise concealed under his "respectable" suit-and-tie exterior. But she also hinted at the specialized tastes of fin-de-siècle aesthetic and decadent movements whose practitioners and works channeled a variety of so-called sexual deviancies including homosexuality. What's more, Sargent posed Carmencita in a regal, dramatic, and impudent posture with arms akimbo. Though sometimes a homosexual symbol in the codes of the time, Carmencita's version suggested a plucky woman's defiance in which Sargent also delighted.

At the same time, Carmencita's pose paralleled Sargent's frequent artistic treatment of men. Among the painter's male models, sitters, and patrons, an arm akimbo was, by 1890, a frequent if not a compulsive feature—drawn self-consciously from Sargent's idol Velázquez, but with strong contemporary resonance in the 1890s. In the next few years, Sargent would paint at

least two art-world bachelors, Oscar Wilde's designer friend W. Graham Robertson and Marcel Proust's pianist friend Léon Delafosse, in this loaded pose, with their fingers splayed on their hips as if to draw attention to this signal gesture.

<div align="center">—◄—</div>

Sargent dashed here and there in New York, always maniacally busy. His friend Dennis Bunker enviously noted that he was "at white heat always, rushing from place to place." When Sargent ventured uptown, of course, his approach differed from his downtown bohemian flair. When during his New York stay Sargent painted the millionaire Cornelius ("Corneil") Vanderbilt II, the grandson of Commodore Cornelius Vanderbilt, he had to deal not only with robber-baron wealth but with a pious, sober philanthropist-businessman who suffered no nonsense.

Sargent's portrait of Vanderbilt has not been exhibited since 1891 and remains mysterious, as the family really didn't like it. Corneil's daughter Gladys, Countess Széchényi, later described it as an "unflattering resemblance." Even if Sargent used a simple formula, imitating old-fashioned American portraiture—a dark background, a dark suit, and a strong, Quakerish light on the face, as he'd done in his portrayal of Vanderbilt relation Benjamin P. Kissam—he seemingly rendered Corneil's features in "very fresh color," according to one reviewer, "and ultra realistic to the verge of vulgarity."

But when Sargent started work with Corneil's youngest brother, George, the sittings went much more smoothly. Here the artist's and sitter's tastes more closely coincided. Twenty-eight-year-old bachelor George Washington Vanderbilt was an arty anomaly in his robber-baron family. Sargent's striking composition emphasized what Vanderbilt's niece Consuelo called his "narrow sensitive face" and hinted at his "artistic and literary tastes." It also capitalized on his "dark hair and eyes," like those of a "Spaniard"—the ethnicity that so fascinated Sargent. Sargent also drew attention to Vanderbilt's crimson lips, as he evoked them with rather thick daubs of paint—creating, as one critic said, "an oriental-looking young gentleman with a very red-edged book held close to his face." He also posed his subject in contrapposto leaning against a table, one arm raised holding the blood-colored book, the other held across his midriff to prop up the other elbow, both hands and wrists palpably delicate. Contrapposto, a counterbalanced bodily position that suggested movement, traced back to the male nudes

of classical Greek sculpture and had been a favorite posture especially of Michelangelo, one of Sargent's longtime artistic heroes.

Sargent's portrait of George Vanderbilt was much more provocative than Whistler's, painted a few years later in 1897, which captured the man's gauntness but very little of the ambiguous sensuality of Sargent's portrait. In an odd way, George Vanderbilt—though in his life quite bookish and shy—had become for Sargent a sort of male *Carmencita*—though ambiguously male—a painted image of him clever, artificial, and loaded with innuendo. Here, as so often happened, Sargent's peculiar taste, imagination, and point of view rendered him, in both cases, a painter of luminous complications. And those complications rose from himself even more than from his sitters.

<div align="center">-+-</div>

Ned Abbey, dropping by Sargent's Twenty-Third Street studio in spring 1890, before his honeymoon journey to Capri, infamously stumbled on "stacks of sketches of nude people." The shy, elfin thirty-eight-year-old illustrator gave them only a "cursory" examination. He judged them all too "earthy." Some writers have associated the nudes Abbey saw with Sargent's later Boston Public Library murals—for which the artist eventually found reason to sketch a large number of male nudes—especially as Abbey mentioned these nudes to the architect Charles Follen McKim in conjunction with this project. But Abbey encountered these sketches *before* Sargent won this commission—and at a point, too, when Sargent was contemplating a series of Spanish historical paintings for the library that would hardly have required nudes.

The mystery runs even deeper, though. How did Sargent find the time to sketch nudes on his grueling, portrait-painting work-junket to the United States? How did he manage them while staying in hotels or friends' houses—not to mention doing his studio work at Wheeler's busy design firm—with very little privacy to be had, even if, in New York, he didn't have Violet in tow? Because Sargent kept few written records, even the admirably meticulous scholarship of recent decades has been unable to account for what the painter did with whole days, weeks, or months, let alone spare evenings.

Still, allowing Sargent idle time or unknown excursions, New York in 1890 was famously destitute of artist's models, especially life models. This dearth owed partly to prudish American attitudes toward nudity exemplified by the Comstock obscenity laws of 1873 or Thomas Eakins's life-drawing scandal at the Pennsylvania Academy of Fine Arts in 1886. In the 1890s Sargent's friend Beckwith sometimes used out-of-work actors as (clothed)

male models in New York, one of whom he found to be an especially "amus-ing fellow." But even the married, rather orthodox Beckwith had resorted to somewhat illicit methods; he once "picked up" a female stranger who at-tracted him with her "fine colouring"—a refreshing way of finding a model, he found, if one that weirdly paralleled street prostitution even if it didn't necessarily include sexual contact. New York had formal or informal pros-titutes even if it lacked artist's models.

In this respect, Sargent's nominal home in London offered better op-portunities. His much-neglected London studio lay in Chelsea, a bohe-mian, free-spirited artists' enclave awash with models of many different ages, types, and specialties, and of both sexes—"a class of people whose sole profession is to pose," as Oscar Wilde, Sargent's Tite Street neighbor, described them in 1889. In Chelsea, according to the writer Arthur Ran-some, male models were less common than female, but they were "nearly all Italians"—Sargent's favorite pictorial type—some of them "good-looking men who have come down in the world." Sargent might have imported his sketches from Europe, though his filling his steamer trunks with nudes begs another question.

If New York supplied few artists' models, it did offer, as the historian George Chauncey has documented, "an immense gay world of overlapping social networks in the city's streets, private apartments, bathhouses, cafete-rias, and saloons." In 1890 this world was centered on the Bowery, only a fifteen-minute walk from the Clarendon, Sargent's hotel at Twentieth Street and Fourth Avenue. While we have no evidence that Sargent frequented the Bowery, we know that Sargent did visit Koster and Bial's, at Twenty-Third Street and Sixth Avenue, in the Tenderloin, a gritty immigrant area also infamous for vaudeville shows, dance halls, and both female and male prostitutes.

According to Chauncey, the 1890s saw a particular rage for top-hatted men to go "slumming" in both the Bowery and Tenderloin, both of which incipient red-light districts provided a whole range of "sexual fantasies," in-cluding homosexual ones, by allowing curious middle-class men "a subor-dinate social world in which they felt fewer constraints on their behavior." Even if we don't know many details of Sargent's own excursions, plentiful evidence has survived of the artist's taste for immoderate partying about this time, some vivid surviving accounts of late dinners and all-night carouses, including that over-the-top dinner in 1888 after which "some of the artists were not seen for days."

The Illustrated American reported in October 1890 that the craze for Spanish dancers such as Carmencita and "La Belle Otero" (an even more scandalous figure of the 1890s) allowed many New Yorkers to feel "their enjoyment of the piquant dancing is increased by the sense that they are doing something naughty in going to a concert-hall [cabaret]. This is true particularly of the female sex and of church members." But when women like Candace Wheeler "did not care for the sort of thing [Carmencita] represented," they were reacting to some really intense displays of sexuality. In "wide open" New York, more was available than what we might imagine as coy, Victorian-style naughtiness. Since the 1870s, the Bowery and Tenderloin had offered saloons such as the infamous Paresis Hall that employed so-called "fairies—powdered, rouged, and sometimes even dressed in women's clothes" as aggressive prostitutes—as well as "live sex shows" including same-sex pairings. Carmencita was just the more respectable tip of this underworld iceberg.

The night Carmencita whirled and pranced at James Carroll Beckwith's party, Sargent and his friends had just come back from seeing W. S. Gilbert and Arthur Sullivan's comic opera *The Gondoliers* (1889)—a lighthearted satire of class distinctions that also highlighted the perceived manly beauty of gondoliers. With their colorful sashes, beribboned hats, and Adriatic tans, Venetian gondoliers qualified as the male sex symbols of the Belle Époque— and in fact often homoerotic ones. New York like Venice hosted an intricate, sprawling homosexual subculture. Eight years before, of course, Sargent had sketched and painted gondoliers in Venice, along with other Italian-looking men in rather intense and moody poses.

That Sargent was somehow able to produce "stacks of sketches of nude people" without anyone's knowing provides one powerful example of just how much of Victorian life, especially sexual life, remained submerged. That Sargent was particularly close-lipped and private—with "inscrutability in all that touched his purely personal life," as one friend described him—reinforces the suggestion of buried complications. Vernon Lee identified in Sargent a "double nature" that she saw as the root of his complex genius: "That double nature of his occasionally self-conflicting, but more often harmoniously blended, as becomes a creature of supreme facility and of restless, indomitable passion for the difficult."

◄◄

Decorating the new Boston Public Library offered Sargent a fresh and compelling prospect for his "passion for the difficult." The possibility had intrigued him since it was first floated shortly after McKim, Mead, and White signed a contract to design the library in March 1887. After all, the project would provide Sargent a high-profile public venue and a chunk of income. It would alleviate his dependence on the scrappy and often maddening business of portrait painting—as prosperous as that occupation was now becoming for him. And it would create the opportunity for a magnum opus that could prove his serious worth as an artist, confirming his deeper and more dignified credentials. For Sargent was concerned by perceptions that, as one contemporary critic put it, he was "more talented than intelligent."

Thanks to his friendships with White and Abbey and his own growing American reputation, Sargent crossed his fingers that he had the inside track for the Boston Public Library commission. Yet he could offer no portfolio of academic or historical painting. He'd in fact done nothing of the kind since he was an art student who'd rather roguishly inserted his friends' faces in Carolus-Duran's Luxembourg Palace mural. For an artist who for more than a decade had been "in possession of a style," as James had observed in 1887, and who, as James claimed, was not at all "in the dark about his own ideal," Sargent seems to have been disastrously unaware of his unfitness for this new work.

Sargent didn't see the potential danger of an undertaking in which his signature modern-spirited iconoclasm would have little scope. The habitual deceptions and displacements that he'd been obliged to practice as a high-end artist added to his vulnerability here. In spite of his off-center tastes, he was accustomed to editing, compromising, and filtering his instincts. If he had a transgressive streak, he was also perennially attracted to "respectability," Bostonian or otherwise. He adopted bourgeois norms and aspired to conventional acclaim and acceptance more often than Isabella Stewart Gardner with her devil-may-care defiance and her millions had ever done.

On May 7, 1890, Sargent dined with White, McKim, Abbey, and the sculptor Augustus Saint-Gaudens at the Players club in Manhattan. A week later a party traveled up to Boston in a private Pullman car in order to visit the library site and dine with the trustees. The trustees talked of granting Sargent the north end of the top-floor Special Libraries Hall. As an overture, Sargent made noises about rendering scenes from Spanish literature—a curious idea to float in Boston, a city whose main vocal Hispanophile was

Isabella Stewart Gardner, even if the Boston Public Library was now the re-
pository for the famous Ticknor Collection of Spanish Literature, acquired
in 1871.

Confirmation of the job lagged for another six months until Sargent had
already returned to Europe after his second prolonged portrait-painting
tour of the Eastern Seaboard. The trustees had taken their time to come to a
decision. Sargent suspected, probably rightly, that in the end Mrs. Jack had
been obliged to "intervene" on his behalf.

Once Sargent signed the contract in 1893, he enjoyed the prospect of
$15,000 and, for the first time in his life, something like job security. ("I am
astonished to see myself the possessor of that respectable thing an income,"
Sargent wrote Charles Fairchild in 1892.) But it remained to be seen whether
this distinguished commission would prove liberating or stultifying.

The Sargent biographer Stanley Olson has summed up a view once
held by many Sargent scholars that by accepting this job Sargent fell vic-
tim to "the idiotic belief that he was embarking on the creation of his
magnum opus." In the end, Olson argues, the Boston Public Library murals
"swamped his powers of imagination, drained his energy, monopolized a
third of his life, and never repaid his huge investment . . . The murals forced
him to overstep the very essence of his art." That essence, in Olson's opin-
ion, amounted to Sargent's "variety of ambition" and the "drama of his life"
he injected into his painting.

Yet Sargent would continue to enrich his work with the "drama of his
life," even if it was a different drama than traditional accounts have mostly
acknowledged. Sargent's complexity transcended his limited and repressive
era, and he would make some intriguing, iconoclastic, and theatrical uses of
his otherwise-sober murals project. In the 1890s, the venture would grant
him a larger and more refreshing scope than fashionable portraiture tended
to do. Sargent would seize on fresh opportunities for masquerade and dis-
placed longing, even if the library project, supervised by a patrician Bosto-
nian committee, also yoked him to an academic, bourgeois respectability. As
Olson himself admits, the commission would even "set his other work free."

For, however this grandiose project would eventually pan out—and
critical opinion about Sargent's Boston Public Library works has shifted
more positively in recent decades—the work would grant Sargent some im-
mediate liberties. And one of these was a hastily bought steamer ticket.

20

Painted Temples

Above his tent, the stars of the Fayum spread extravagantly, undimmed by haze or clouds or city gaslight. Bedding on the hard-baked ground, Sargent lay awake smoking or crouched looking up at the stars. He slept well after a long day's ride: he loved riding even though he sat unsteadily on a horse and tended to pitch right out of the saddle. Mounting a horse, he prized the competence, independence, and self-sufficiency he could find out on his own—and that, for complicated reasons, he could only find while traveling.

Alert and alive, he was hankering to discover something new and world-changing, and something that he could inscribe in that upstairs Boston room as a lasting legacy. He was also looking for something personal: What mysteries or liberties might he find in this new, fierce, radically different place? This new leg of travel was different from anything he'd done before, even from the time he'd spent in Morocco more than ten years before with his French painter friends.

In March 1891 from his base in Cairo, Sargent headed "off with a tent for a week or so in the country," as he'd written to Ralph Curtis. He traveled solo, but with a retinue, as guidebooks advised travelers that a visit to the Fayum required "a tent, a dragoman, and a supply of provisions." A dragoman or guide-translator typically provided everything for a European traveler, and that usually included other Arab servants.

With the library murals strongly on his mind, Sargent was opening up fresh and invigorating vistas for himself. He was tackling multiple objectives. He was tracing the adventurous footsteps of Isabella Stewart Gardner, who'd sung the praises of the Nile's delights. He was giving his still-restless sixty-four-year-old mother a stimulating trip to a country she hadn't yet visited. But mostly, as he told one American friend, he was "cramming hard

for [his] library"—coming up with a conception that would both please his Boston patrons and gratify himself.

The Fayum—that low-lying, crocodile-ridden ancient breadbasket, bordering on the western desert—felt especially free, especially far from the dinner invitations and portrait commissions of New York or London, those exacting projects that were wearing him out and dampening his artistic inspiration. The "land of roses," it overflowed not only with fertility but also new and stimulating things to paint. It featured, at various seasons, "oranges and mandarins, peaches, olives, figs, cactus fruit, pomegranates, and grapes." Bedouins, the Egyptian group who most attracted Sargent pictorially, also concentrated on "the western bank of the Nile," occupying "the whole of this side of the river from the Fayûm as far as Abydos." It may have been here that Sargent produced his *Egyptian Indigo Dyers*, a figure study of three young men each with a roll of cream-colored fabric wound round his head and body, each contrastingly dark face partly concealed. The three picturesque youths were a subject that just begged for paint, for Sargent's signature combinations of dark and bright.

Such a filter for seeing the "Orient"—and his indigo dyers also bore the title *Trois Orientaux* (*Three Orientals*)—belonged to a well-worn formula of Sargent's time. Orientalism, the European mythic casting of non-Western places, was everywhere. Manias for orientalism abounded in France, Britain, and the United States, articulating whole genres of painting and literature, whole schools of archaeology and ethnology. Sargent's Paris training had heavily dosed him with a mythos of this Orient. His passion for the exotic and romantic had rendered him particularly susceptible.

Long before Sargent, his mother, and his sisters had boarded a steamer at Marseille for Egypt, the painter had engaged in characteristic orientalist forms and styles not only in Morocco but also in oil sketches of Javanese dancers at the Paris Universal Exhibition in 1889—a project full of theatricality, myth, and masquerade.

Time and again, Sargent had steeped himself in stereotypes and overheated characterizations—especially those depicting non-Anglo-Saxon women. His *El Jaleo*, his *Carmencita*, and a plethora of other lyrical renditions had dominated his choices for exhibitions as well as his personal fascinations. He'd even chosen to romanticize, mythologize, and exoticize scenes and people in Italy, notably during his stays in Capri and Venice, giving himself over to the pleasures of luxurious paint. Egypt, though, proposed a brand-new set

of intensities, and ones that would help Sargent turn the top floor of a sober Bostonian library into a mythic treasure cave.

━┿━

John, Mary, Emily, and Violet disembarked at Alexandria on Christmas Eve, 1890, ready for anything. They were all together again, really for the first substantial period since Dr. Sargent's death. But they hadn't all embarked at Marseilles for the same reasons, much as they all delighted in ground-breaking travel. Mary still hoped to keep twenty-year-old Violet away from Francis Ormond. Violet, for her part, hadn't lost her preference for this charismatic Swiss rogue. If anything, the unfamiliar country they were now visiting only reminded her of Ormond's own far-flung travels in the South Pacific and the spicy anecdotes he could tell.

Meanwhile, though, the Sargents' first taste of Egypt boded well for everybody. Alexandria, an ancient city founded by Alexander the Great and embellished by the great dynasty of the Greek Ptolemies that ended with Cleopatra, had now fallen under British control. Though the city was hardly modern—British steamships mingled with local fishing craft in the shadow of the ancient lighthouse of Pharos—Alexandria meshed East and West.

It often did so uneasily. The Sargents stayed at a European-grade hotel while taking in the sights of Rhakotis, the old Coptic city along its great east-west central street. They stretched their legs on the Corniche, the promenade running along the Eastern Harbor, enjoying its sweeping view of the low-slung city on the shore of the Delta. Alexandria looked peaceful in the winter sun. It seemed peaceful, too, under the nervous thumb of the British, who worked hard to protect their many investments in the Delta and farther up along the Nile.

By January 11, 1891, the family had alighted in Cairo. They settled into the Hotel du Nil, in the heart of the city. That establishment was reputed to have a "delightful garden" even though it was located among markets and shops just off the great avenue known locally as the Muski. From this family base, Sargent, perhaps escorted by hat-shaded sisters, went restlessly out to visit the Sphinx long enough to paint a rapid, sand-orange watercolor of it. But Sargent was less interested in well-known monuments (he deplored the tourists he saw everywhere) than in the exquisite details he was discovering on his rambles around the city.

Intensifying his artistic ferment, Sargent soon linked up with his old

painter friend Joseph Farquharson, his early instructor in the mountains of Switzerland and now a die-hard practitioner of painterly orientalism. Ten years older than Sargent, the jaunty, mustached, forty-four-year-old Farquharson had lived in Egypt since the mid-1880s, and he was full of an enthusiasm that Sargent would soon catch. He now shared a Nile houseboat or dahabeah with his stepmother, Mary Farquharson. Back in 1881 Sargent had painted a portrait of Farquharson's elder brother Francis, the tenth Laird of Finzean.

Farquharson helped the Sargents arrange a Nile excursion. Such a tour was de rigueur in Egypt. From her own experience in 1873–74, Isabella Stewart Gardner had strenuously recommended that Sargent get out of Cairo and see the rest of the country. "Well-equipped" steamers owned by the British firm Henry Gaze & Sons, embarking from a quay opposite Shepeard's Hotel, plied the Nile as far up as the First Cataract at Aswan, taking twenty-one days for their typical tour. This company guided conglomerate parties of tourists; the Sargents joined a cast of other eager visitors, for "inspect[ing] the principal points of interest" up the river, including Sakkara, the Valley of the Kings, Abydos, Karnak, and Aswan with its bazaars and its torrid rapids breaking through arid yellow hills.

Though laser-focused on his own growing passion for this landscape and its people, Sargent disliked touring with Westerners. "My hatred of my fellow creatures extends to the entire race, or the entire white race," he later reported to a woman friend, "and when I escape from London to a foreign country my principle is to fly from the species. To call on a Caucasian when abroad is a thing I never do." Still, he and the Sargent women enjoyed the Nile, its lazy brown currents and flat banks dotted with villages, "in spite of the steamer & tourists," as Sargent remarked to Charles Fairchild in February.

Sargent and his family took some of the ubiquitous off-river excursions on donkeys and camels, the ladies behatted and thoroughly swathed against the sun. They dined on board the steamer and slept under mosquito nets in their cabins—a familiar feature for the Sargents even from their European travels. They visited Luxor and Philae, and Sargent painted a few sites near Thebes, among them the Hemistyle of Hathor's Temple, with its solemn, earth-cool columns and dark portal, in a work called *The Temple of Denderah*.

On their return, anxious to get back to work, Sargent rented a studio in Cairo. Now that he was thoroughly immersed in Egypt, his painted figures

wore colorful, sumptuous costumes and inhabited sun-drenched landscapes whose painterly qualities Sargent beautifully rendered and celebrated in one rich, lyrical view after another. In comparison to his recent portraits, the freedom of these pieces was palpable, electric. Yet the watercolors and oil sketches that were building up in his portfolios and steamer trunks, in spite of their documentary sophistication and even empathy, adopted the luxurious, privileged view of a seasoned and privileged European traveler. Headdresses, flowing robes, and craggy dark faces all contributed to a mythic perspective saturated with touristic pleasure and sensual self-indulgence. In his Cairo studio, Sargent painted many head-and-shoulder portraits of nameless people ethnically tagged as Arabs or Bedouins—handsome, long-faced women and leathery bearded old men.

This work deeply moved him, though. By spring, inspired by his plunges, he came to a momentous decision, and one that would haunt his studio work for the next twenty-five years. "The consequence of going up the Nile," he wrote Belle Gardner, "is . . . that I must do an Old Testament thing for the Boston Library." It was a startling decision.

Sargent, though not conspicuously pious, was fixing on a project that would come to be called *The Triumph of Religion*. Yet it amounted to a more secular notion than he let on to the devout Episcopalian Gardner, and one that was rife with Sargent's personal fascinations. Yet, Biblical or not, more was brewing in Sargent's sketchbooks than his Boston murals.

-+-

According to Lucia Fairchild, Sargent had actually read the Bible. (To Sargent's astonishment, Lucia had not.) He considered the Bible "tremendous" as a collection "stories of adventure perfectly plainly told, with no reflection." Yet, in spite of his declared quest for Biblical figures, Sargent didn't confront the spectacle of Egypt only through a scriptural perspective, and certainly not through a pious one.

Thanks to his quirky Continental upbringing, Sargent understood Christian history and iconography more loosely than many his contemporaries. Sargent's attitudes have sometimes been paralleled to those of the French orientalist and Semitic scholar Ernest Renan, who had taken a secular view of Biblical history, first in his *Vie de Jésus* (1863), in which he had understood Jesus as a human figure, with humanistic virtues, and later in other progressive and often provocative works on Judeo-Christian history. Such different literati as Edith Wharton, James Joyce, and Marcel Proust

read and treasured Renan, though it's unclear how much Sargent dipped into any of the historian's works. The painter, though he'd try hard to prove his intellectual mettle with his Boston murals, remained largely uninterested in punctilious scholarship, Biblical or otherwise.

Now, along with the Bible, Sargent in fact consulted not intellectual tomes but, characteristically, a favorite childhood storybook.

Mary Sargent, ever romantic and fantastical, had long ago provided her children with a copy of *The Arabian Nights*. Her choice was *Dalziel's Illustrated Arabian Nights' Entertainments*, an 1865 British volume that featured 108 illustrations by notable artists such as John Everett Millais, the Dalziel brothers, and Arthur Boyd Houghton (who'd absorbed his "Orient" in India, where he'd been born). John and Emily had "devoured" this volume, poring over it in Rome, Venice, and Dresden; its piquant but decorous costume melodrama had seeped into their blood.

In later life, Sargent even kept the family's well-worn copy of the *Illustrated Arabian Nights* in "an old valise," as the Boston art dealer Martin Birnbaum noticed. Sargent especially loved Arthur Houghton's lively, theatrical illustrations, some of which he echoed even in later paintings executed in London and the Alps, into which he incorporated elaborate, romantic Middle Eastern fantasies.

Inspirations from *The Arabian Nights* would be crucial to Sargent's eventual achievement. Translations and adaptations of *The Arabian Nights* had long shaped European thought, and versions of this great cycle of folktales had been available in English since 1708. On their travels, Sargent and his friends sometimes read out loud to each other from William Beckford's *Vathek* (1786), a sensational gothic romance set in a faux–*Arabian Nights* world of princesses and djinns. (William Beckford was a celebrated same-sex agitator of the Regency, and Sargent could not have been unaware of his reputation, even if Beckford's notoriety had rather worn down by the late Victorian era.)

Yet a more scholarly and provocative translation of these Middle Eastern folktales had recently stirred even more controversy. Six years before, in 1885, the British polymath explorer Richard Francis Burton had published his ten-volume translation of *The Thousand and One Nights*. Burton boldly included the erotic content of these tales that Victorian versions like *Dalziel's Illustrated Arabian Nights'* omitted or romanticized. He didn't expurgate the taboo homosexual content, either, going as far, in his infamous "Terminal Essay," to argue that homosexuality naturally occurred all over

the so-called Orient, that it wasn't unnatural as Europeans of the time often believed.

Though Sargent read widely, it's unclear if he'd encountered Burton's *Arabian Nights*, even if the bearded, polyglot, sixty-nine-year-old explorer was a well-known if controversial figure in London, much discussed in gentlemen's clubs. Burton would die the same year Sargent visited Egypt. But Burton's more scholarly and uncomfortable version of *The Arabian Nights* would live on, haunting the era and challenging its entrenched conventions. What's more, Burton's racier version of this classic reflected Sargent's own fraught complexities as a painter; after all, Sargent saw the Middle East both as a Victorian travelers' romance and a labyrinth of unconventional eroticism.

Such, too, were the paradoxes of European orientalism itself, for Sargent shared such complicated attitudes with most of his Victorian contemporaries. On one hand, for European imperialists, Middle Eastern people, with their different sexual systems, justified the claims that they craved civilizing and modernizing. Non-Western tolerance of homosexuality or other forms of erotic diversity, for example, needed to be stamped out. At the same time, though, Europeans shamelessly eroticized the non-Western and took advantage of its perceived differences, exploited them both imaginatively and pragmatically. Both Europeans and Americans, in fact, used the Orient as a safety valve for the very kinds of repressive "civilization" they were trying to impose. The Orient into which Sargent had plunged on Christmas Eve wasn't just an involuntary religious mission, economic annex, or political colony. It also amounted to a fantasy playground of a tightly wound Westerners otherwise all too ready to sin at home.

For Sargent, such "sinning" would actually prompt some of his most interesting and inspiring art—and especially in playful pieces that had little to do with the murals. But the sometimes-campy orientalism that lay behind his biblical conceptions for the library would also lend them—especially his Prophets—a liveliness and defiance that otherwise would have been swallowed up in the quasi-religious "decorations" for Boston.

◂✦

In his Cairo studio, Sargent ventured on another painting, a potential exhibition piece, in which he'd explore this more erotic Orient. He now omitted the robes, headdresses, and sunny backgrounds by which he'd mostly depicted the picturesque spectacle of Egypt. He was bent on painting a young Egyptian woman, and painting her naked. Recently he'd been especially obsessed

with nudes. But now he felt a new impetus to startle his audiences in Paris, London, and New York, and startle them with a very public provocation.

Obsessively working on his new picture, Sargent spent long hours in his studio. How he found his model we don't know. Not even the young woman's name has survived, let alone details of the painter's day-to-day interactions with her. But Sargent certainly had disparate power over a colonized Arab woman. In his correspondence to Ralph Curtis, he called her only "the girl." Yet, as he filled out the portrait, he summoned the sensitivity, delicacy, and respect for women's dignity that he'd previously instilled in his portraits of Rosina Ferrara, Carmen Dauset, and others. At the same time, Sargent distanced himself from his subject, subsuming her individual identity into the great European tradition of the nude, effacing her personal and ethnic qualities almost completely. As one recent Arab American historian has seen Sargent's project, "the 'Egyptian girl' was not the subject of [Sargent's] painting, but rather the object upon which he mapped his interpretation of the classical female nude figure." Indeed, Sargent's nude paralleled the many provocative revisions of the nude that had been pioneered by his Impressionist contemporaries in Paris, notably Edgar Degas.

Rather Degas-like in its attempt to fuse innocence and eroticism, Sargent's *Nude Study of an Egyptian Girl* depicts a young woman seen from the back. That her upper body is twisted around to the left in a complicated pose showcases both Sargent's virtuosity and his subject's vulnerability. With delicate attentiveness, Sargent renders the pretty young face and the fingers pulling at a long braid. Though the image is a nude, it remains restrained as opposed to voluptuous.

Etta Reubell, seeing the painting a year later in Paris, insightfully remarked to Henry James that Sargent was "too modest to make her white," Reubell's witticism acknowledging the devious exploitations made by such popular orientalist pieces. James quipped back that Sargent fortunately "wasn't too modest to make her admirable." But modesty as well as admiration fed into what was now becoming a remarkably gentlemanly and classical nude. It stood out as one of very few female nudes Sargent had painted, in Egypt or anywhere else, and the only one he'd exhibit. Though the painting revealed the woman's physical body, Sargent gave this figure less scope, richness, or interest than he had done for Rosina Ferrara or Amélie Gautreau.

If hardly a masterpiece, the painting would be well received. Two years later, Sargent pitched it for the Chicago Columbian Exhibition of 1893. The

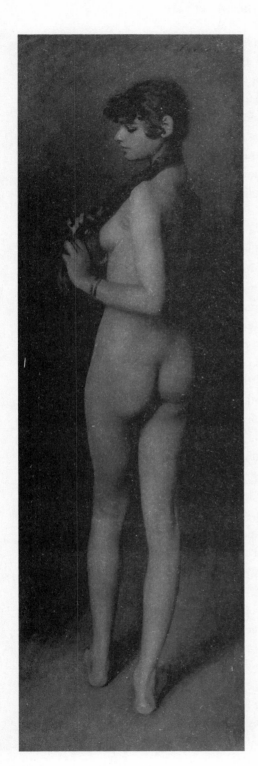

Study of an Egyptian Girl, 1891

so-called White City provided a fitting venue for this somewhat imperialist piece. At the same time, Sargent also consciously or unconsciously inserted a woman of color into the center of an exhibition that otherwise almost exclusively celebrated the achievements of white America. In a similar paradox, Sargent tendered an ostensibly heterosexual piece, catering to Gilded Age men's fantasies, at the same time that he undermined prim American prohibitions against naked bodies. In Anthony Comstock's United States, the public wasn't used to encountering nude images of any kind. As he'd done so often, Sargent channeled brazen unconventionality through his signature modesty.

Still, Sargent had concocted a rather strange painting. One art critic remarked in 1891 that the "Egyptian girl's back is of extraordinary force and solidity. We see the head, with its thick features, twisted violently on the copper-coloured shoulders, pulling a braid of lustrous black hair." Sargent's complicated pose rendered his figure rather awkward and angular, "strained and unsure," as one recent Sargent scholar has observed. As another contemporary reviewer acidly commented, "The thing is as well done as it may be done, but it is passionless and coldly disinterested."

This canvas, indeed, missed the erotic frisson that Sargent was trying to find in Egypt and that he would later blend into his early Boston Public Library decorations. Though appreciative and sensitive in a way, Sargent's nude lacked the allure and delight, the compelling focus of Sargent's *Sketch of a Bedouin Arab* painted at about the same time, in which a handsome young man's brown face looked out intently from a swirl of snowy robes. (Bedouins were plentiful in the Fayum, but this portrait could also have been taken elsewhere. Oddly enough, Burton singled out "the Fayyum, the most ancient delta of the Nile"—as especially subject to homosexual influences.)

Sargent eventually exhibited both pieces. But his female nude finally found its way into the collection of Charles Deering, of the International Harvester Company of Chicago, a philanthropist, patron, and solid family man. The Bedouin portrait wound up with Sargent's later friend Sir Philip Sassoon, a fairly open queer collector of the next generation who had an eye for some of Sargent's most splendid and provocative works.

-<-

In April, having exhausted Egypt for the time being, Sargent accompanied his mother and sisters on a steamer from Alexandria to Greece. Classical Greek

as well as Roman art had underpinned his Italian art training, but so far Sargent hadn't explored his Hellenic predispositions through an on-site visit.

Alighting at Piraeus, the Sargents climbed aboard carriages that jolted them into the sleepy white town of Athens. Greece had been independent from the Ottoman Empire since a British, French, and Russian naval armada had destroyed a Turkish fleet in 1827, but the country still retained certain holdover Ottoman or Eastern habits. These included facilities for tourist guides. Sargent's dragoman or courier, arranged in the city, picked him up at his hotel, for Sargent had no knowledge of Greek, ancient or modern.

Baedeker underscored that a Greek courier paid "all railway, steamboat, or carriage fares," hired "the saddle-horses and packhorses," and catered "all meals (including wine, coffee, etc.)"; "the courier has to provide a mattress and bedding for each member of the party; some couriers supply camp-bedsteads."

Still, a dragoman could be a headache: in Egypt, "energy and baksh-ish" (a tip or bribe), guidebooks advised, could "overcome difficulties"; in Greece it was considered prudent to pay the dragoman only half his fee, the remaining payment designed to "spur to the inborn Oriental indolence of the Greek." Yet many a dragoman was actually enterprising rather than lazy. And some such guides in the Islamic world could be "Oriental" enough to supply travelers even with sexual services, as Carl Jung would find out decades later in North Africa. Sargent, though, probably had simpler adventures in mind when he hired his guide for a tour of the mountains north of Athens as well as the rocky, sea-fringed Peloponnese.

Leaving his mother and sisters in the city, Sargent "set out with a drag-oman for Olympia and Delphi." He apparently rode hard on his courier's horse ("he was in the saddle at 4 a.m., only ending the day's journey when night fell") and worked hard (he "filled up every available corner of canvas and paper" he'd brought with him). Savoring a Mediterranean spring, Sargent reveled in "miles of country carpeted with wildflowers." If Sargent was in quest of "religion," this junket showed just how idiosyncratic that pursuit was for him. Hellenic religion, to which he was instinctively drawn, differed widely from the Judeo-Christian themes he'd self-consciously explored in Egypt.

When the family moved on to Constantinople and encountered an Ottoman city bursting with light, color, and history, Sargent faced off with yet another religion and yet another set of romantic, mythic, and erotic

images. He did so with growing enthusiasm and intrigue. Reveling in Constantinople—he preferred the old Greek name to the Turkish name of Istanbul—Sargent painted at least two oil studies of Hagia Sophia, the ancient Byzantine church-turned-mosque.

Stimulated by this grand old monument—which indeed was filled with rich interior decorations of the kind he was contemplating for Boston— Sargent rose early to visit Hagia Sophia, before the crowds arrived, even "bribing an official" in order to be admitted. The place astonished him. Setting up his easel and working rapidly, he captured the morning light with streaks of gold and ochre paint as it penetrated the great, dim, cavernous space of the mosque. Otherwise, he roved the outskirts of the city, walking "by the shores of the Bosphorus where the Judas trees were in full bloom." In the suburb of Karak, he painted a watercolor in suffused misty blues and grays of domes and minarets seen across the harbor, another early morning picture; he also rendered a superb view of the blue-tiled tomb of Ottoman Sultan Murad II in nearby Bursa.

Determinedly, though, Sargent saw Istanbul as serene—and largely unpeopled—in comparison to the teeming, chaotic Turkey other European travelers encountered. Sargent's Paris friend Judith Gautier had a colleague and future collaborator, Pierre Loti, who envisioned the Ottoman Empire quite differently. Loti, a small, goateed former French naval officer, reveled in the scandalous qualities of the so-called Orient. In 1879, he had published a novel called *Aziyadé* of 1879, a spicy semiautobiographical account focusing on an eighteen-year-old Circassian harem girl of that name.

To capitalize on the book's wild popularity in France, Loti then added a travel narrative on Morocco in 1890 and a short novel, *Fantôme d'orient*, about Constantinople, in 1892. Such oriental semierotica went over well in France, even officially, for the Academie Française would elect Loti as a member in 1892, overlooking the hints that Loti's relation with his Spanish servant Samuel was the actual historical affair that Loti had experienced in the Turkish capital. In the Ottoman Empire, Loti wrote in *Aziyadé*, "the vices of Sodom flourish": "In the old East, anything is possible!" Yet Loti wasn't exactly bedside reading for Sargent.

Having spent half a decade mostly in England and America since 1886, Sargent had edged away from some of the Parisian raciness he'd once savored in friends like Gautier. Yet still, he'd painted, in Cairo, what amounted to his own aspiringly provocative version of *Aziyadé*, in his nude *Egyptian Girl*.

In either Egypt or in Constantinople, though, Sargent crossed another cultural or personal boundary. He boldly ventured into the baths. "A Turkish bath is particularly refreshing after a long journey," Baedeker admonished, "and is an admirable preventative of colds and rheumatism." Early morning arrival also helped tourists avoid the local crowds. All such baths were single-sex, with a cloth hung at the entrance to indicate days when "only women are admitted." The time-honored ritual of a Turkish bath included a cold room, a lukewarm room, and a hot room. In the hot room, a bather perspired, wrapped in a linen cloth. "As soon as the skin is thoroughly moist, he calls for the attendant," Baedeker instructed, for the Egyptian version,

> who pulls and kneads the joints till they crack, a process to which Europeans are not in general subjected. This is followed by the pleasanter operation of shampooing, which is performed by the [attendant], who is requested to do his duty with the word 'Keiyisni' (rub me), and who then rubs the bather with the *kis*, a rough piece of felt. The attendant next thoroughly soaps the bather, and concludes the operations by pouring bowls of warm water over his head.

"Orientals devote a whole morning to the bath," the guidebook remarked, though canny Europeans could get through the business in little more than an hour.

At some point, Sargent experimented with this ritual. At least, he captured similar bath and massage experiences, though in a tepidarium or lukewarm room, in two remarkable paintings evoking the dim, luxurious atmosphere of such establishments. Sargent's *Massage in a Bath House* is particularly evocative. In it, a turbaned, shirtless attendant works on a paler naked man (a Westerner?) laid out on a decorated octagonal platform (see Fig. 19). This oil sketch—seemingly quickly brushed in cool golden and ivory tones—resembles a stolen candid photograph, and Sargent must have painted it rapidly in situ. Clearly, he never intended to display such a piece publicly—though, on the evidence of perforations, art historians believe it was tacked up at some point in his studio, perhaps on display for his more intrepid friends. The unusual piece was rolled up with other canvases when, decades later, after Sargent's death, his sister Violet donated this bundle to the Fogg Museum at Harvard.

The oil sketch still leaves its audience with a conundrum. Victorian baths were both venerable historical institutions associated with health and hygiene and dubious spaces of same-sex interaction. Sargent's vision of such places presents a similar complexity, for Sargent scholars acknowledge that Sargent was both a "sybarite" who "enjoyed Turkish baths and massages" as well as a shy, buttoned-up man obsessed with his own respectability.

<div style="text-align:center">⌁</div>

Respectability, however, wasn't always easy to achieve, especially in matters of the heart. After their momentous sojourn in Constantinople, the four Sargents returned to France by early summer. But though Mary and her son had successfully kept Violet from her paramour for almost a year and a half, and though John was forever proposing alternative matches to his sister in Europe and America, Violet now insisted on seeing Francis Ormond again.

How did her brother react? Did he empathize on some level—at this point he didn't tend to be romantic, especially about marriages—or did he merely shake his head? "I won't be an old maid," Violet declared. John did his best to reason with her. But, in the end, he gave up, with a shrug, in the face of Violet's determined resistance.

In the aftermath, though, Violet's brother was later "very gentle and human" about the whole matter, his friend Lucia Fairchild thought. For he allowed the family to alight in Paris for the middle of the summer, renting a flat in the shadow of the Arc de Triomphe, in the rue de Presbourg. He permitted Violet and Ormond to meet, also allowing Violet to visit the Ormond villa at San Remo, on the Italian Riviera. The rest was only a matter of time. Violet's brother now kept clear of this imbroglio as much as possible, washing his hands of it, and spending time with Vernon Lee in the streets of Paris or with Lucia Fairchild in the Louvre. During one heartfelt conversation, Sargent confided in Lucia that Ormond had now proposed to Violet, that Violet seemed likely to accept, and that wedding plans were already in train.

Lucia knew Violet from the time they'd spent together in Boston, and she liked Violet in spite of temperamental differences between them. Lucia remarked that "Vi" was determined to have Ormond, as she was "was much keener than [Lucia was] on only marrying if she was in love."

Sargent replied that that was "a pity, as she was always so emotional, and might so easily get carried away; and pitch headlong into this very sort of a match, when she would be horribly disappointed in the man." ·

"Well," Lucia replied, "she believe[s] in separating if that happened."

"Believes in it—yes of course," Violet's brother countered, "but practically one can't do that sort of thing."

Feeling his own helplessness—and, as substitute paterfamilias, involved in some of the grating financial negotiations with Ormond's family in San Remo—Sargent was anxious to get back to work. He longed to apply that salve he'd so often used to soothe his troubles and frustrations. He hankered to elaborate on the inspirations he'd found in the Levant.

In Paris, Sargent managed to borrow a studio from Albert de Belleroche, who was then away. There, among his old friend's oil sketches of women, he resumed his painting when he could. Then, on August 17, 1891, at the Episcopal cathedral of Holy Trinity in Paris, twenty-one-year-old Violet married twenty-five-year-old Louis Francis Ormond. It was the respectable society ceremony that both John and Mary had worked very hard to bring about, as a consolation to an untoward match. Violet's brother politely but grimly stood beside his sister in the church.

In September, Mary and Emily returned to London with John. There they signed a lease on a flat at 10 Carlyle Mansions, only a few streets away from Sargent's Tite Street studio. Yet, in typical Sargent-family fashion, mother and daughter chose not to occupy their new home right away. Instead they opted—largely at Mary's instigation—to travel all around the Mediterranean during that winter. Much as they adored John, the two women wouldn't really settle down in Chelsea for several more years. Violet and her husband also chose the inexpensive and insouciant life of the Mediterranean. With their limited means, they tended to live in rather cheaper quarters of it, places like the sleepy Balearic island town of Palma de Mallorca.

For his part, Sargent well understand the lure of the Mediterranean for his mother and sisters. He felt that draw powerfully, himself. To his favorite places in that region of umbrella pines and blue seas he'd now added the Levant—Egypt, Turkey, and Greece—sketches and paintings of which now littered his Tite Street studio. At London dinner parties, he sometimes dropped hints, jokes, or stories. The "Orient" grew ever more powerful in Sargent's mind and imagination, even or especially during a damp, occluded London autumn.

If restless, if in need of the exotic experiences he'd tasted, Sargent could even avail himself of "Turkish baths," right where he was. Long a feature of the Ottoman Middle East, with a colorful history going back to the Roman Empire, such baths were also being enthusiastically imported into Western

cities like London. One establishment called the Hammam in Jermyn Street in the West End, opened in 1862, offered an exotic and orientalized space in which, as one historian has argued, "through peace, calm, and health men could bond without the aggression often associated with the fraternalism of sports."

On his Middle Eastern trip, as well as exploring bathhouses, Sargent had relished the independence and privacy of camping out in tents. He craved this kind of rough, ready, on-the-road companionship. In the early 1890s, Sargent tried to persuade Albert de Belleroche to go back to the Middle East with him. "Write soon if you will come on the trip," Sargent prompted his younger friend during the winter of 1892. "I hope you will. If you won't, I will try to get somebody else—but I should prefer a painter and an old friend. Please let me know soon—for I don't want to go alone . . . Where the devil are you—and why don't you answer my notes and telegrams?"

This attraction to rough travel would prove long-lasting, and it would strongly impact the Boston murals as well as his friendship with Belleroche. Planning a trip to Syria and Palestine fourteen years later in 1905, for more mural work, Sargent again invited his friend to accompany him "as his guest." "We should travel partly on horseback and sleep in tents," Belleroche later reported. Sargent also proposed that, "in case I should have any scruples [about the gift of the trip], he would ask me to paint him a picture."

Initially, Belleroche confessed himself "delighted" by this prospect, ordering art supplies for the expedition and thinking to himself "how our friendship would increase by this long journey." Yet qualms rapidly set in. Belleroche afterward claimed that he "soon realised that a journey like this with Sargent might influence my art and affect my expression, and however tempting it was I could not decide to go." Whether or not Belleroche really feared that Sargent would "influence [his] art and affect [his] expression," he may also have worried about the "increase" of his friendship with Sargent, especially under the loaded conditions of tent-sharing in the desert.

Yet, when Belleroche backed out in 1905, Sargent wouldn't alter his plans. He'd forge ahead and travel to Palestine (tents and all) with another, more willing male companion. He would meet this future travel companion in England, and shortly after his first exhilarating foray to the Middle East.

21

Sargent's Gondolier

At Fairford in Gloucestershire, in the milky light of winter or the honey-colored light of summer, Sargent painted prophets. In the early 1890s, having settled on a history of religion for his Boston Public Library murals, he often stayed in the country with his friend Edwin Austin Abbey. He now shared a studio and living space with Ned at a handsome, long, ivy-covered house called Morgan Hall. Abbey saw this house as "large and roomy," "surrounded by a little park of twenty odd acres." In the warm June of 1892 the two men found it "heavy with the scent of syringa blossoms."

Abbey's companionship now included that of a wife and mother-in-law. Rather late in his life, at the age of almost forty, Abbey had married Gertrude Mead, a vigorous Anglo-American Vassar graduate, a New Woman with whom, according to his first biographer, he was "good comrades" and had a "friendship that lasted as long as Abbey lived."

Though Sargent sometimes protested when his male painter buddies wanted to get married, he now easily bonded with Ned's frank, intelligent wife. Also, Gertrude's sixty-eight-year-old mother, Mary Eliza Mead, "gay, humorous, and kind in manner," soon became "devoted also to Mr. Sargent and he to her," as Abbey's biographer noted. Sargent knew how to bond with women, especially intelligent older women. He later painted several portraits of this gray-haired old lady in her old-fashioned lace cap.

With the Abbeys, at least, Sargent could really relax. The Fairford ménage proved companionable and familial, four bright people making "a happy and contented household, the days filled with the hardest of hard work and the evenings rendered delightful by music, contributed chiefly by Mr. Sargent." The hard work took place in the two men's large shared studio. ("It doesn't look very large with our big canvases in it," Abbey remarked.)

Both artists labored long hours on their Boston library decorations as well as on other projects. Here Sargent could recapture the convivial studio company he'd always relished.

With both men now established in their careers, Fairford soon accumulated apprentices and students. One of these, a stout, rosy young Anglo-German painter named Wilfrid de Glehn, then in his early twenties, immediately latched on to Sargent. He showered Sargent with compliments and imitated every detail of the painter's style with an almost religious enthusiasm. Rapidly and joyously, he took up the role of an acolyte who flattered and idolized the elder painter. Sargent, though cautious, indulged De Glehn's admiration, assigning him tasks around the studio and calling him by the pet name of "Premp."

When, a decade later, the young man decided to marry American-born painter Jane Emmett, Sargent felt the "shock" of the news. "My God! what a trick to play to your sincere well wisher," Sargent wrote his protégé. "I will up and marry in an attempt to be quits."

Eventually Sargent would warm to Jane de Glehn just as he'd grown fond of Gertrude Abbey and his other friends' wives. But before he reached such a state of serenity he always had to pass through "small and discreditable and ill-mannered whimperings," as he wrote to De Glehn. In this case, Sargent found it especially hard to relinquish, even partially, so attentive a protégé.

Still, other friends visited the rambling, vine-covered premises Fairford, among them a straight-backed, athletic neighbor, Major George Conrad Roller. Roller often dropped by and asked Sargent to ride with him. Sargent painted a regal full-length portrait of George's Welsh-born mother, Eva Eyton Roller, gowned in black; the dowager evidently gave him a hunting horse in exchange for the picture. George, almost exactly Sargent's age but a younger-looking thirty-six, had mixed with Sargent and his Paris intimates in earlier years. An amateur artist himself, he helped Sargent frame and preserve his pictures.

In addition to galloping over the fields and along the hedgerows with Sargent—and, it was later rumored, traveling to the Mediterranean with him—George lent himself as a model for one of Sargent's emerging Boston Public Library prophets. Sargent made a studio oil study of his friend in which Roller's square-jawed, handsome face gazed out as a fancy-dress Bedouin version of himself, shadowed by an ivory-colored hood. This hood only became more ample and flowing when Sargent transfigured his riding

companion into the prophet Hosea. Sargent thus reimagined the biblical Hosea, the so-called prophet of doom, as a compelling, pillar-like figure swathed in sumptuous pale-golden robes, his strong, comely face gazing out from just above a dramatically clenched fist. It was one of the successful rewritings of biblical tradition that Sargent was pioneering in his first main panel for the library.

At Fairford, John and Ned also received less-privileged visitors, as it were, at the servants' entrance. Enterprising male models caught the train out from London. One of these, the famous Anglo-Italian model Angelo Colarossi, had previously worked for both painters. At fifty-four, with his gaunt face and still-muscular physique, he readily stood in for various half-draped Old Testament prophets, for he was now rugged and haggard enough to look the part. (Colarossi still modeled nude or seminude; he showed up in Frederic Leighton's painting, *And the Sea Gave Up the Dead Which Were in It*, exhibited in 1892, where his well-built mature body stripped to the waist towered as the central figure.) Yet the ambitious artists at Morgan Hall needed younger inspirations, Sargent especially.

Fresh Italian models materialized at Fairford late in 1892. Two brothers from an immigrant family in Clerkenwell in East London, Luigi and Nicola d'Inverno, ventured out into the unfamiliar Cotswold countryside. The younger, Nicola, had a brush of wiry, abundant dark hair and sported a nascent mustache. He wasn't exactly handsome. Just nineteen years old, he felt a little uncertain, a little excited. He ventured out to Fairford to pose, he later remembered, "as much for a lark as anything else."

Nicola d'Inverno's lark, though, began with a plunge. Sargent, who "came to the door himself," struck the young man as "a big, burly, bearded six-footer." He asked Nicola his name and "directed [him] to step inside and show [his] figure." Though it's unclear if d'Inverno took off his shirt or if he stripped completely, Sargent appreciated what he saw. The painter had originally planned to use Nicola a week later, but he decided to bring him into the studio sooner because, as d'Inverno put it, "I was the 'very man' he wanted."

From the start, this alert, willing, athletic young model stood in awe of the notable international artist. Sargent was not only an imposing "six-footer" but also a paragon of success, cultivation, and celebrity. The d'Inverno brothers may or may not have posed naked at Fairford—as autumn and winter came on the studio was often chilled by drafts, and the household, headed by spruce and vigorous Ned Abbey (though Nicola called it

the "Sargent-Abbey place"), adhered to a certain prim restraint. None of the three friezes of prophets that would eventually appear at the Boston Public Library actually involved nudes—only a few even hinting at the bodies beneath their robes.

Still, nineteenth-century artists' studios were one of the few places—along with brothels, public baths, or backcountry swimming holes—where men or women were allowed to disrobe in front of strangers. Only panels painted after 1903, for example Sargent's *Heaven* and *Hell*, featured numbers of nude figures—tangles of them, in fact—and those were compositions created long after Nicola's debut as a life model in Sargent's studio.

Yet Sargent, a trial-and-error painter who worked from gut instincts, hardly knew yet how his prophets would eventually emerge. What's more, the murals in Boston occupied only a part of his mind and only a sliver of his peripatetic life. Sargent tended to stay with friends all over the map of the North Atlantic, and he hardly spent all of his time at Fairford. In August 1892, for example, he'd hared off to Spain to visit his mother, Emily, and Violet. Violet's first child, Marguerite, had just been born, rendering the thirty-six-year-old John an uncle for the first time.

Three years later, when Abbey's part in the murals was finished, in late 1895, Sargent would take long lease on 12 and 14 The Avenue, Fulham Road, where a roomy studio would enable him to tackle the next stage of his own large-scale mural projects.

But, through all this period, his titular home and workspace was still in Chelsea, that tree-shaded riverside quarter on the banks of the Thames. And, luckily for Sargent and his budding aspirations, Chelsea was the most bohemian and the least prudish district of London.

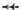

In Tite Street, SW3, Sargent occupied James Abbott McNeill Whistler's former studio in Chelsea's artistic epicenter. Though he'd first signed a lease back in 1886, he only now, as the 1890s unfolded, began really to inhabit these rooms, sometimes to execute English portrait commissions, sometimes to dive into the coruscating social worlds of London. Here, as he lamented to Ned Abbey, he also painted portraits "with anxious relatives hanging on my brush."

With its address at 31 & 33 Tite Street (in a previous system, number 13), Sargent's house and studio stood across the street from Oscar Wilde's house and was almost confusable with it. Wilde's resplendent and highly

decorated "house beautiful" (at Number 34, formerly Number 16), shone out as an aesthetic beacon as well as a gathering place for the feather-hatted ladies and brightly waistcoated men who made up art-loving, unconventional London.

Sargent knew Wilde only rather formally. He'd fallen into awkward misunderstandings in the early 1880s, when, according to Vernon Lee, Wilde had first bestowed on Sargent a volume of his poetry and then publicly criticized Sargent's painting as "vicious and meretricious." Still, Wilde—another friend of the exuberant, cigarette-smoking Henrietta Reubell—had come to lunch and brought his new wife to Sargent's house in the boulevard Berthier in Paris back in 1884. Sargent had once found Wilde "very witty"—in "The Art of Lying." But he'd deemed the recently published *Picture of Dorian Gray*, which advanced a rather racy and decadent vision of artists, "horrid," "dull," "a book that ought to be thrown out the window," as he'd confided to Lucia Fairchild. It was an odd, knee-jerk judgment for a painter whose very sophisticated milieu Wilde was in fact exposing, but perhaps that was the very reason for Sargent's bitter reaction.

In Tite Street, though, Wilde was aware enough of the goings-on in Sargent's studio that he made an enthusiastic assessment of it to a mutual friend after Sargent painted his portrait of actress Ellen Terry in 1889: "The street that on a wet and dreary morning has vouchsafed the vision of Lady Macbeth in full regalia magnificently seated in a four-wheeler can never again be as other streets: it must always be full of wonderful possibilities." And indeed Tite Street would open up new possibilities for Sargent. His metropolitan pied-à-terre, near the Chelsea Embankment, increasingly, like Wilde's house, attracted London's sophisticated and cosmopolitan set, on foot or in their smart carriages, fellow artists and high-profile patrons who would only multiply as Sargent's reputation a flash portraitist grew.

Was it in Fulham Road, the home of his mural projects, that Sargent sketched his life models, including Nicola d'Inverno? There, according to his first biographer, Sargent "could withdraw from the world like a bandit to his fastness, and admit visitors or not as he liked." If he chose to allow observers, they found the artist "in his shirt-sleeves, generally with a cigarette in his mouth." There, too, "scores of pencil studies lay about and vast canvases were in position against the wall."

Or was it in his Tite Street studio, supplied with clotted London daylight from a tall window running up into a slanted skylight, that Sargent more regularly sketched Nicola d'Inverno, as the young Italian became one of

the artist's favorite models? The two studios, in any case, further reinforced Sargent's compartmentalized life, and not just by defining one of his studios for murals, one for portraits. Wherever the nude (and clothed) sketches of d'Inverno were made, at least a few have survived. Most occur in a single volume, seemingly compiled by Sargent himself a decade or two later, though the dates of these striking, sensual, and sometimes quite graphic documents remain uncertain.

This black, cloth-covered album, with a brown-leather spine and marbled endpapers, once snugly closed and tied shut with silk ribbons now tattered and knotted. Its ability to be tied shut may well be material, because the album contains fifty cream-colored pages on which thirty-one images of men, most charcoal drawings, mostly nude or seminude, have been carefully mounted. Mostly Sargent included "manly figures," in the words of one art historian, "who can strike splendid, self-confident poses" and that reflect "the nude as a pleasurable, diverting indulgence."

One of the more thoughtful of these sketches, a handsome, mustached man with a crisp profile and bare shoulders, may well be Nicola d'Inverno. (Only one photograph we can identify as d'Inverno has survived—an undated but presumably late one attached to his *Boston Advertiser* piece in 1926—and we know something of the man's earlier appearance only from a few labeled images Sargent made of him over two decades.) *Reclining Male Nude* may also depict Nicola—a slender though muscular young man with a rather handsome head whose eyes gaze off to the artist's right, as if intent on the corner of the studio that the young man knew well from his additional job of cleaning Sargent's brushes and stacking his canvases.

Some of these undated nudes, as well as Sargent's many surviving watercolors and oils of other unclothed men, probably depict other models that Sargent employed in the late 1890s or in the first fifteen years of the twentieth century. Later, around the turn of the twentieth century, Sargent also employed the Italian brothers Giovanni, Giuseppe, Luigi, Mario, and Vincenzo Mancini. Though one oil study was once entitled *Nicola Resting*, the naked man reclining on a bolster of the sofa at Tite Street—splayed informally on modern furniture as if in a spontaneous, candid view—may be either Luigi Mancini or Nicola d'Inverno. (This canvas is now entitled *A Male Model Resting*.) Likewise, a watercolor of a similar pale, mustached man with a drape over his crotch and with arm up, *Figure Study*, may depict Luigi Mancini rather than Nicola d'Inverno, though it's difficult to be sure.

In an intriguing and for-once-datable foray into such sketches, Sargent

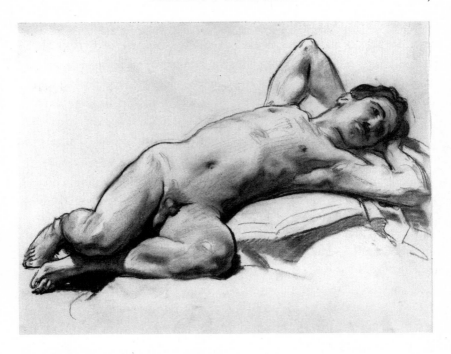

Sargent, *Reclining Male Nude*, c. 1890–1915

also created a clutch of seminude male drawings for an exhibition on lithography at the Galerie Rap in Paris in October 1895. For some of his six lithographs, including *Study of a Young Man, Seated* and *Study of a Young Man in a Robe, Standing*, his model appears to have been Nicola d'Inverno. As lithography was also Albert de Belleroche's favorite medium, these works demonstrate that Sargent's old romantic friend from Paris was still in his orbit. In his later tribute to Sargent's lithography, Belleroche included a study of a seminude young man from 1895 that presumably Sargent gave to him during this time. Belleroche's later article, incidentally, incorporated other intimate lithographs, including another half-clothed young man (*A Young Man Drawing*) and two undated sketches of a middle-aged Belleroche himself.

The dates and circumstances of many of Sargent's nudes remain a "conundrum," in the words of able Sargent scholars. Yet, the sheer number and persistence of such images through Sargent's career create even more of a puzzle for viewers today, who often wonder what such nudes tell us about Sargent's life and work.

To some, these images suggest a private opus of sensual, homoerotic

images. The young men's poses, on Sargent's own sofas as often as on more abstract posing platforms, appear provocative, sensual, and personal. To others these sketches more resemble the familiar or standard academic life studies of Sargent's era, if rather unconventionally and sometimes lyrically rendered. After all, such male nudes were a long-running feature of Western art, deemed to embody the dispassionate or idealized beauty of the *beau idéal*. Likewise, too, Nicola d'Inverno's participation in such images has been a subject for much debate, as has his role in Sargent's life.

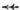

*By 1892–93, in any case, with the Old Testaments prophets for Boston multiply-*ing in his mind, Sargent needed more male life models. Artistic Chelsea luckily supplied a variety of willing candidates—"a class of people whose sole profession is to pose," as Oscar Wilde had described them in his "London Models" of 1889. But Sargent, a creature of habit who disliked putting himself out, and moreover a shy and private man, preferred the familiar. He'd employed d'Inverno at Fairford and, even if he hadn't already reached an understanding with him, soon favored him as a cooperative, admiring young man who was impressed by the splendor of Sargent's studio, with its bibelots and mementos of famous people. Later, d'Inverno listed all the celebrities he met through Sargent. The impressive roster included ballerina Anna Pavlova, politician Lord Rosebery, and monarch George V—not to mention dancer Carmencita and millionaire Isabella Stewart Gardner.

Did Sargent's transactions with d'Inverno, earlier or later, include sex? In the Victorian world, it is possible that even an eroticized relation, especially a dangerous and forbidden same-sex one, wouldn't necessarily have led to a physical consummation. Yet Sargent had a passionate, sensual side, often expressed in paint, often in impulses that had goaded him into the backstreets of Venice or the Tenderloin in New York—no matter how squashed by his mania for respectability. And here was an eligible opportunity, sanctioned or at least screened by his all-important professional work.

What's more, at this point in his career, Sargent knew how to handle models: he'd used many models before, male and female, professional and amateur, nude and clothed. That Abbey saw "stacks" of nude sketches before Nicola d'Inverno even came onto the scene suggests that Sargent had a much longer track record of employing nude models either for professional or personal reasons, or some combination of the two.

Previously—at least since his art training in Paris, in fact—Sargent had treated especially male models with more than the indifferent detachment that was considered respectable for gentlemen artists, even if he hadn't yet betrayed a conspicuous passion or an obsession for a studio model, as Michelangelo had for Gherardo Perini, Whistler for Joanna Hiffernan or Maud Franklin, Manet for Victorine-Louise Meurent, or Modigliani for Jeanne Hébuterne. Oddly, Sargent's most public (though seemingly deferential) obsessions fixed on female models such as Rosina Ferrara or Carmen Dauset. His more private studio involvements, it's true, had once featured Albert de Belleroche, a friend whom he'd chosen to paint repeatedly and intensely.

Nicola d'Inverno brought to Sargent's studio a plain, somewhat delicate face, mug-handled ears, and a mustache sometimes twitched up. But the young Italian lightweight boxer—slender, boyish, and mustached as Albert de Belleroche had been in the mid-1880s—belonged very much to Sargent's preferred physical type, echoing too the young mustached Mediterranean men Sargent had painted repeatedly in the 1870s. Also, d'Inverno, with his unflappability and his willingness to indulge in a "lark," brought that type into Sargent's daily orbit.

Three paintings now generally thought to depict Nicola d'Inverno show versions of a smiling young man wearing nautical clothing, loose shirts and bandanas. (D'Inverno wasn't a sailor even if he would eventually join Sargent on multiple steamer crossings.) The best known of these, *Italian with Rope*, attracted a certain amount of attention during Sargent's lifetime. He published the work in a book of photogravures in 1903 and later hung it in his staircase and passage at Tite Street. The painting captures a jovial young man grasping a golden rope, his white shirt loose, a pale-orange kerchief knotted around his neck. Pale gold suggesting sunshine hangs around him, lavishly, on Sargent's energetically painted surface.

Two other oils, both now called *Head of a Model*, depict a similar young man, couched this time in a darkness that may be a nod to paintings by Frans Hals that Sargent loved, and which these figures recall. These two paintings reveal a male subject with the same glossy red lips, dragoon's mustache, and narrow, wide-set eyes under curving brows as appear in *Italian with Rope*. The figure wears an expression of cheerful utility that also fits with Nicola's known personality. Traditionally, these two paintings have been called *Head of a Gondolier* and *The Gondolier* respectively. Yet, although Sargent began

to visit Venice again by the late 1890s, these are much likelier to be studio pictures of the wiry, shock-haired "gondolier" who increasingly haunted Sargent's land-bound, metropolitan home.

Whatever else Sargent's relation with d'Inverno was becoming, it wasn't merely a visual or voyeuristic fixation with a model. Sargent's increasing domestic involvement with d'Inverno, in fact, matched some rather specialized dynamics of the Chelsea art world well-known to insiders.

As writer Arthur Ransome noted in his *Bohemia in London* (1907), models in Chelsea had come to fill many roles for artists. Female models served as artistic inspiration, filled in as cooks (able to make "*oeufs brouillés*" or scrambled eggs, "the favourite dish of half the studios in the world"), and provided unsolicited commentary, as they possessed from their trade a "very practical knowledge of what makes a painting good or bad."

Humble and helpful, Nicola didn't tender such judgments. Yet he was otherwise idle and available enough to be useful around the studio and, as a domestic employee who at least sometimes prepared Sargent's breakfast (in later years Sargent also employed a cook and a maid at Tite Street), may even have tried his hand at scrambled eggs. For Sargent, who had lived his life out of cafés, restaurants, and men's clubs, was no cook. When based in London, Sargent often took his meals at the Chelsea Art Club, where one catty fellow artist remembered Sargent's "Gargantuan appetite." This big, serious man with a gusto for life could seldom get enough to eat. D'Inverno was later able to report that, though Sargent almost always ate his breakfast at home, after his bath—"never before"—the shy, taciturn, vague, but oddly sociable portraitist dined out all the time: "He was 'wanted' everywhere, and his life, outside of the studio, was a round of dinner engagements." Like his friend Henry James, Sargent almost never had to dine alone, unless he wanted to.

Though notoriously independent, reticent, and private, Sargent scrounged up studio and around-the-house work for his favorite model. In 1893, about a year after Nicola's first interview at Fairford, Sargent hired d'Inverno as a valet. Or, as Nicola later understood his unfolding career, he was employed "first as a model, next as a valet and finally as house manager." D'Inverno not only laid out Sargent's clothes, filled his bath, and brought him his breakfast but also looked after Sargent's brushes, canvases, and paints, ran errands, and nursed the artist when he was sick.

In this rather feminine and wifelike role, d'Inverno paralleled some fe-
male models in Chelsea who likewise found themselves mixed up in art-
ists' lives: "Many an artist owes his life to the Serafina, the Rosie, or the
Brenda who, coming one morning to ask for a sitting, has found him ill
and alone, with nobody to nurse him but an exasperated caretaker," Ran-
some observed. "Many a man has been kept out of the hospital, that dread
of Bohemia, by the simple, kind-hearted model who has given up part of her
working day to cooking his food for him."

In Sargent's case, of course, the caring model in sickness and in health
was a man. Sargent "would never have a doctor in the house," d'Inverno
recollected, with spouse-like inside information. "He had no use whatever
for the medical profession. I thought this a rather queer thing because . . . his
father was a physician." It's significant that d'Inverno intimately understood
this predilection as related to Sargent's father. It's also telling that he saw it as
"queer"—though he didn't use the term in the sexual sense—for Sargent's
phobia probably qualified as such in more than one way. For much more was
going on in Tite Street than just Oscar Wilde's masked ménage with his wife
Constance, across the street.

<p style="text-align:center">⤙⤚</p>

Aside from Sargent's moody, evocative nude sketches of his valet, an article that
Nicola d'Inverno published in a Boston newspaper in 1926, after Sargent's
death, grants the fullest picture of how this unconventional relationship
pushed the boundaries of the time. As a rather tabloid piece, "The REAL
John Singer Sargent" purported to reveal secrets about the artist, though
these turned out to be that Sargent was a nonreligious "freethinker"—even
though he had painted the Prophets of the Boston Public Library—and that,
otherwise clean in his speech, he said "damn" a lot.

More subtly—especially to a rather innocent 1920s audience—the ar-
ticle also disclosed that Sargent received "a good massage" from Nicola
when he was ill, discharged d'Inverno's gambling debts, and paid for his
gym membership. (Significantly for the class dynamic involved in the
Sargent-d'Inverno relation, Nicola worked out at the Quentin or Quintin
Hogg Gymnasium, a charitable "'Palace of Delight' for the downtrodden
of the East End," as one historian has phrased it, "a magnificent building
filled with noble rooms, statues, tapestries, a library, gymnasium, and class-
rooms.") It was in artistic Sargent's interest, of course, for Nicola to keep fit,
but few other artists invested so personally in their models.

As if to quash any compromising speculations, d'Inverno emphasized in his article that "Mr. Sargent" had "nothing of the Bohemian about him," that he kept "regular hours," and that "his life was as orderly as that of a bishop." He even tackled the sensitive question of why Sargent had never married, proffering the contradictory explanations that (1) he, d'Inverno, had "never heard of any romance" Sargent had had with women, and that (2) in his, d'Inverno's, opinion, Sargent "saw too much of women."

In 1898, d'Inverno himself would marry Emily Sarah Askey, a twenty-three-year-old woman born at Middlesbrough in Yorkshire who had been raised by an aunt and uncle in London. We know that this woman, who went by the name of Sallie (for Sarah) or Emily, traveled with her husband and Sargent on the SS *Roumania* to Corfu in September 1909. But little more is known about her. Sargent never mentioned Sallie, and his friends hardly did so. The historical record, relatively ample in its account of Nicola's doings with Sargent, contains few other traces of Sallie. Evidently, the couple had no children. Emily S. Inverno died in Islington, London in 1948, on the opposite side of the Atlantic from her husband's last-known residence. Nicola himself didn't mention her in his memoir of Sargent in 1926. Though sometimes a bit defensive or disingenuous, d'Inverno's account generally took on the deferential tone of a faithful retainer who memorialized Sargent as "the greatest man I have ever known."

When models' embroilment with artists deepened, they sometimes became household fixtures, and not only on the risqué bohemian pattern born in Sargent's art-student Paris. Though Nicola d'Inverno got to know Sargent through the rather intimate and suggestive act of posing naked, he eventually segued into another role, arguably even more intimate and suggestive: that of trusted personal valet. As a "household manager," studio assistant, and personal factotum, d'Inverno filled a time-honored role, with a long history and a slew of job titles and guises, resembling the "private secretaries" that other writers, painters, and aristocrats of Sargent's time had long ambiguously taken on.

Such hierarchical relations were ingrained in aristocratic and even bourgeois European culture and had long been socially ambiguous and confusing even when they didn't cloak sexual predilections. As historians have understood the phenomenon, the inequality of the master-servant relation fostered an uneasy notion that "the usual system of friendship [could] be ignored, and social unequals bound in a service relationship [could] be friends, because the patron would not admit anyone to such a position of proximity

unless he *were* a friend." What's more, these quasi-professional positions took place in an eminently private world. In fact, the word "secretary" itself originally designated a keeper of secrets—and a keeper, incidentally, who was privileged with the intimacy of a master's "closet" or private rooms.

Every day, d'Inverno arrived for quite pragmatic and humdrum work. Like many valets and secretaries—and like many artist's models—he was doing a job, albeit a highly intimate and unusual one, whatever else was going on. A significant number of d'Inverno's contemporaries, of course, were doing something more, including quite a few in Sargent's circle, notably Robert de Montesquiou's Gabriel Yturri, Horatio Brown's Antonio Salin, and John Addington Symonds's Angelo Fusato. (Later in his life, Sargent's pianist friend George Copeland also had a secretary-lover, Horst Frolich.)

That Sargent playfully dubbed Nicola his "gondolier"—though d'Inverno had been born near Rome and was in fact an amateur boxer from Clerkenwell—suggests that, in addition to the Chelsea feature of a model-secretary, he had the Venetian gondolier-sidekick on his mind. Sargent's sailor pictures of Nicola also underscored this association. And this curious alliance, whether or not it was sexual, was exactly what a homosexual affair or partnership between unequals looked like in the 1890s. It couldn't otherwise have found a space or sustained itself for long in a world that frowned on class mixture as well as same-sex love.

If this arrangement sheltered a romantic or erotic involvement, why didn't d'Inverno spill his inside knowledge? As one Sargent biographer has naïvely wondered, why didn't the scrappy and snobbish d'Inverno, in 1926, "try to elevate himself by hinting at some privy knowledge of a famous person"? To begin with, the very stigma of homosexuality tended to keep all parties mum. One toxic effect of the 1885 Labouchere Amendment was to brew a culture of extortion, in which some working-class men bribed middle- and upper-class homosexuals. But the British judicial system still favored elites. For working-class men the cost of bringing accusations could be exorbitant.

D'Inverno, whom Sargent after all incorporated into his home and life, was no extortionist. His discretion belonged to the ethos of the faithful manservant; he piqued himself on his personal loyalty. And like the lover-assistants of Sargent's friends, like Yturri, Salin, or Fusato, who never divulged or even hinted, d'Inverno never gave away any secrets—either because he had none to give or because he would never seriously have entertained the notion of betraying Sargent's private life or his own. What's

more, ordinary working people, in Anglo-Saxon countries as well as in Italy, tolerated homosexuality and other sexual irregularities more often than did the genteel middle-class culture of the time, rather the opposite of today's class dynamic. In turn-of-the-twentieth-century London and well as New York, bars, cabarets, and baths—those foundations of future gay culture— often sprang from working-class neighborhoods and institutions. Workingmen in general were used to inhabiting alternative sexual spaces. They knew better than to divulge their inside knowledge to "respectable" society.

The strongest reason d'Inverno didn't confess, though, may simply have been that his relation with Sargent, whatever it entailed, was largely or entirely voluntary and mutual. Yet we know very little about d'Inverno's motivations, desires, or specific personal experiences. Between 1898 and at least 1909 he apparently lived and even traveled with his wife Sallie, but then other "gondoliers" with some complicated involvement with their employers were also married. In 1926 d'Inverno listed his job as an "artist photographer." Without mentioning his wife, he recollected his time with Sargent as "a precious memory forever." He insisted that the "only priceless thing" he owned, "on the notepaper of the Copley-Plaza Hotel" in Boston in 1918, was the parting letter of recommendation that Sargent wrote for him. The two men spent almost every day together for almost a quarter of a century, and shared inside jokes and pleasures—for example about Whistler. That irascible, witty painter, who sometimes visited Tite Street, slung insults as well as swiping the air with his signature walking stick. John and Nicola agreed he was "a scream."

At Sargent's home in Chelsea, and on the road, the two men were nearly inseparable. Nicola strayed into many a scene and a story, stood behind the camera taking photographs of Sargent and his friends. The two men traveled almost everywhere together—not only on the Syrian junket that Albert de Belleroche had declined but also on tamer trips—for example, to France, where they stayed with Sargent's married sister Violet and where d'Inverno provided Sargent's nieces and nephews avuncular piggyback rides. Nicola's fondest memory would be of when "we went up into the Canadian Rockies and for nearly three months lived in tents." D'Inverno proudly contradicted the well-worn French saying that "No one is a hero to his valet." But then he was no ordinary valet. In short, d'Inverno may really have cared for Sargent in some sense—servantly fealty or same-sex love of whatever form being, contrary to the prejudices of the Belle Époque, not a depraved but an ennobling sentiment.

Nicola also impacted Sargent's art, and not only because the younger man worked in the studio both as a model and a helper. Sargent's relation with d'Inverno, like his associations with previous models, offered opportunities for both insight and exploitation. Which would win out? Sketching d'Inverno or the Mancini brothers naked put Sargent in contact once more with questions of manliness and sex, even if his murals in the 1890s focused on the seemingly loftier subject of Hebrew prophets. Yet this ordinary, quotidian element also helped give the prophets in Sargent's library murals their compelling, earthy, real-life appeal. The working-class inspirations of the prophets balanced the nabobs Sargent painted in his society portraits. Also, Nicola, an immigrant Londoner, represented whole worlds of disadvantaged people with whom Sargent had long been fascinated through his paintings of peasants and non-Western people and from which he was now largely turning away in order to paint aristocrats and millionaires.

Increasingly, Sargent was torn between his longstanding inclinations for transgressive passion on the one hand and frosty respectability on the other, in a household where the familiar, warm, ubiquitous Nicola seemingly addressed his master only as "Mr. Sargent." In his studios, Sargent continued to draw and paint male nudes that were almost uniformly spirited and beautiful, surprisingly free of the sorts of stigma attached to homosexuality in the era. Sargent when he took to his métier, a cigar or cigarette clenched in the corner of his mouth as he confronted any sitter, persistently employed his signature irony. Frequently and sometimes ruthlessly, he revealed others' secrets. But still he could dip into unexpected wells of empathy or passion.

Though more and more a society painter who dressed for sumptuous dinners all over London, Sargent had once been attracted to Venetian backstreets, and he took some interest in Nicola's boxing matches at the Quintin Hogg, which he attended at least once. Even so, he kept aloof from his companion's Clerkenwell world of pugilism, betting, alcoholism, and poverty. Sargent seldom directly represented that rugged, street-smart world in his art—as he had so enthusiastically done a decade before in Venice—unless Nicola's naked body represented it. Sargent never became a painter of boxers, as Thomas Eakins did in the United States.

Yet, through his long involvement with d'Inverno and in the future with other highly embodied, physical men, Sargent kept in touch with instincts and underworlds that had long lent his painting passion and power, even as he simultaneously turned to the gilded salons of the turn of the century for his public materials. His future portrayals of unclothed African Americans

and Tommies would take inspiration and energy from the transgressions he pioneered with Nicola—though, in their half-secret and undefined nature, they would also follow a script of hiddenness and voyeurism.

—✦—

Though his Boston murals, headquartered in Fairford or in the Fulham Road, took up much of his time, Sargent continued to ply at portraits in Tite Street. In the early 1890s, his prices ranged from two hundred guineas for a head to four hundred for a three-quarters length, and five hundred for a full length. These charges fell only slightly short of the premium he'd once charged Isabella Stewart Gardner, that eminently willing millionaire. Sargent now painted (and befriended) quite a few English and American notables, including well-connected, moneyed, and cultured women such as Mrs. Mary Hammersley and Gertrude Lady Agnew of Lochnaw.

Yet Sargent still painted some people for various personal or private reasons, often without commissions. One example was the poet and Pre-Raphaelite éminence grise Coventry Patmore, whom Sargent portrayed at the urging of his friend Edmund Gosse. Patmore was another acquaintance who'd end up in the Boston library's magnificent Frieze of Prophets, in his case as a wizened Ezekiel.

In Gloucestershire in 1893, while foxhunting, Sargent crossed paths with a handsome twenty-four-year-old country gentleman called William Frederick Hewer whom the artist persuaded to sit for at least two portraits even though Hewer wasn't a professional model. As Hewer's wife later told researchers, Sargent even sketched the young man's bare feet. Sargent's murals project facilitated a fascination with human anatomy not quite afforded by patrician portraiture.

In 1894, Sargent contracted a fascination for a moneyed and cultivated young patron whose mother's portrait he had painted, earlier that year. But W. Graham Robertson, a twenty-seven-year-old illustrator, designer, and dandy—a friend of Oscar Wilde's, though he later denied being a follower—didn't receive the proposition directly from the shy painter. Instead Robertson had it from his friend, the daring ash-blonde Irish American actress Ada Rehan.

First Rehan wrote Robertson that she had "something particular to tell [him]" that Sargent had said about him. The young man, "puzzled and intrigued," wondered what "Sargent who so very seldom said anything of anybody" could have remarked.

"Well, he's very anxious to paint you," Rehan told him.

"Me?"

"Yes. He wants you to sit to him."

"Wants *me*? But good gracious, why?"

"I don't know," the actress replied. "He says you are so paintable: that the lines of your long overcoat and—and the dog—and—I can't remember *what* he said, but he was tremendously enthusiastic."

Yes, Sargent was often verbally challenged, hemming and hawing or dissolving into his smoker's cough. But clearly he'd been smitten with a fascination for Robertson's chic long overcoat as well as for his aged poodle. This latter fascination was only pictorial. During earlier sitting with Robertson's mother, Mouton the poodle had ritually if rather toothlessly bitten the painter. One bite per session was all the mild, long-suffering portraitist allowed.

Sargent first posed the young man, Robertson later remembered, "turning as if to walk away, with a general twist of the whole body and all the weight on one foot," Strangely, this pose recalled the stance Sargent's nude Egyptian girl from three years before. Yet, this stance proving too hard for his model to sustain, Sargent adopted a more direct approach and a frontal view. He bent his sitter into a theatrical and exaggerated pose with one of Robertson's hands grasping his jade-handled walking stick, the other arm akimbo, with his fingers fanned on his narrow hip (see Fig. 20).

As the painting gradually came together, Sargent continued to obsess about the coat. He did so in spite of warm summer weather that required the model to shed clothing beneath it. Robertson remembered that "with the sacrifice of most of my wardrobe I became thinner and thinner, much to the satisfaction of the artist, who used to pull and drag the unfortunate coat more and more closely around me until it might have been draping a lamp-post." As Sargent himself declared, "the coat is the picture." The coat, in short, designated the young man as a high-fashion dandy.

Sargent, dashing to Paris for a quick visit in the midst of these sittings, encountered at the Champs de Mars Whistler's just-finished portrait of Robert de Montesquiou, another conspicuous dandy. Whistler had rendered his friend with similar bold theatricality. He'd created a full-length study of a waspishly thin, tailored figure swaggering with a walking stick. "It's just like this!" Sargent confided to Robertson, back in London. "Everyone will say that I've copied it."

Much of the coincidence between these portraits, though, belonged

to the bohemian or homosexual underground of the 1890s as expressed through fin-de-siècle *l'art pour l'art* aestheticism. Effeminate dandies were increasingly linked to homosexuality in the public imagination. This coding was an "open secret," as historians have described it.

Not all dandies were inverts—and earlier nineteenth-century dandies such as Lord Byron and Beau Brummel had remained teasingly ambiguous. By later in the century, British aesthetes, especially Oscar Wilde, rendered dandies conspicuous and outrageous, easily lampooned in Gilbert and Sullivan's hit operetta *Patience* (1881) or glorified in Oscar Wilde's novella *The Picture of Dorian Gray* (1891)—a work immersed in overwrought painters and their hothouse art world, and one that, incidentally, prefigured Sargent's image of Robertson, much as Sargent professed to hate this particular volume. In the 1890s, the case seemed clear: a "modern" icon was dawning. But an icon of what? According to one historian, the fin-de-siècle dandy qualified as "the queer hero of modern life." Sargent's attraction to such a conspicuous and exhibitionistic figure was laced, characteristically, with misgivings.

In the crucial year of 1894, what were Sargent and Whistler trying to say about such conspicuous queers? For Whistler—a highly flamboyant dandy himself although aggressively heterosexual—the portrait of Montesquiou expressed friendship and an appreciation for the Count's high style. Whistler's portrait overlooked Montesquiou's sexual idiosyncrasies rather than endorsing them. For Whistler, in spite of decades spent in the queerest of art worlds, could muster little tolerance for homosexuals. For Sargent, though, the matter was growing even more complex and also more baffling. As Robertson himself expressed it, "Why a very thin boy . . . in a very tight coat should have struck him as a subject of worthy treatment I never discovered."

By 1894 Sargent had a long record of boldly expressing in paint what he evaded or disavowed in personal life—giving away secrets in others whilst withholding his own. In parallel to his student days when he disdained the costume of a bohemian whilst painting a Caprese dancer, Sargent in his thirties continued to dress conventionally and not flashily. Still, he resided in flamboyant Chelsea, stayed late at exquisite parties many nights of the week, and courted colorful actresses and dancers.

Sargent was both intrigued and repelled by the kind of exhibitionistic dandyism Graham Robertson embodied. He harbored deep ambivalences about bohemians, dandies, and other showily unconventional figures at the same time that he was drawn to such figures. Sargent's mixed feelings had many sources, including his lifelong shyness and desire for respectability on

the one hand, and his bold if often voyeuristic attraction to the "curious," as Vernon Lee had long before observed, on the other. But his complex portrayal of this young dandy also sprang from his fascination but deep personal ambivalence toward homosexuality, others' and potentially his own.

Much has been made of Sargent's withholding his portrait of Edmund Gosse from being reproduced in the *Yellow Book*, the signature magazine of British aestheticism and decadence, in 1894. During its three-year run, the quarterly featured works by many of Sargent's artistic and literary cronies, including Walter Sickert, William Rothenstein, and Max Beerbohm. Self-consciously edgy, its very name referenced provocative French novels published under similar yellow covers. Though suggestive as opposed to salacious, and highly distinguished in its dedication to high-end Pater-style idealism, the periodical often hinted at forbidden erotic indiscretions in its highly decorated pages.

"From the artistic point of view I dislike that book too much," Sargent wrote Gosse, "to be seen an habitual contributor." Yet Sargent's friends Gosse, Frederick Lord Leighton, and even the fastidious Henry James voluntarily contributed to the same periodical. Sargent himself appreciated the art of Aubrey Beardsley, "linger[ing] delightedly over [his] illustrations," as Sargent's biographer Charteris himself witnessed.

Sargent's portrait of Robertson went up at Burlington House in spring 1895. Critics did in fact link Sargent's piece with Whistler's, as Sargent had feared. But generally they understood the piece as a satire on dandies. The American critic Agnes Farley Millar saw in Sargent's portrayal "the ideal dandy of the present year of grace." Charteris also described Sargent's portrait as the epitome of the "'Beardsley period,' of the 'Yellow Book,' of the aspiration to startle and the cultivation of disillusioned detachment." To many onlookers, Robertson represented "a period, a type, an attitude of mind" characteristic of the era. For Sargent, in this view, Robertson was a "problem to be solved." But the problem may not have been primarily an intellectual or even an artistic one.

By the time this painting went on display at the Royal Academy that May, the Wilde trials were in full swing. The final court verdict would result, on May 25, 1895, in Wilde's conviction for gross indecency. Sargent's street, almost his home address, was engulfed in the biggest homosexual firestorm of the Victorian period. It was a conflagration that, exploding so near Sargent's daily life, would exert a dark, complicated influence on the artist's entire future work.

22

Cosmopolitans

Sargent turned, now, to another form of provocation. His first high-profile portrait of a Jewish patron—a newly prominent and prosperous group in late nineteenth-century Britain—went up at the Royal Academy in the late spring 1897. True, Sargent had painted George Henschel back in 1889, and he'd often cultivated Jewish friends and colleagues such as Auguste-Alexandre Hirsch, back in his Paris youth. But in his present explosive virtuoso canvas, Sargent radically redefined his vision of European Jews, and he set up his bold and rather liberal statement for all to see.

The main subject of this new eye-catching group portrait, *Mrs. Carl Meyer and Her Children* (see Fig. 21), painted the year before in 1896, was Adèle Levis Meyer. Mrs. Meyer was a colorful thirtysomething art hostess with whom, during his summertime sittings, Sargent had found he had much in common. They shared passions for music, reading, and artistic soirées. Sargent went so far as to stay with the family at their house in Hayward Heath, even though, as a career houseguest, he was now growing pickier. He only stayed over where he felt welcome and understood.

Lady Meyer (her financier husband was created Baronet Shortgrove in 1910) afterward cherished her interactions that summer with Sargent. He in turn appreciated her style, panache, and boldness—so reminiscent of Henrietta Reubell, Isabella Stewart Gardner, and other Paris, London, and Boston hostesses he'd adopted over the years. If Sargent had been fascinated with divas in the past, he'd also had a lifelong fascination for extroverted, charismatic society hostesses.

Mrs. Meyer—handsome, warm-hearted, cosmopolitan, and rich—enabled Sargent to do what he did best—to bring out a luxurious and stimulating exhibition piece that would please critics and thrill exhibition

audiences. It was no accident that he debuted this unconventional portrait just after he'd been elected to full membership in the Royal Academy in May 1897, after his having labored for several years as a mere associate. Though gradually Sargent was swelling into an establishment figure, well-known in the more aesthetic London drawing rooms, he quietly nurtured his old instincts for rebellion. He perpetually hankered to shake up the London art world with a fresh provocation. And that's precisely what his portrait of Adèle Meyer enabled him to do.

When Adèle Meyer arrived at his Tite Street studio in summer 1896, eager to chat and to be charmed, Sargent was ready for her—with a plan in his head. He posed her leaning forward in an exquisite and flamboyant shrimp-pink gown, perched on the edge of a gilt, pictorial Louis XV sofa. He had Mrs. Meyer wield a fan with one hand. With the other, she touched the hand of her young son Frank, clad in dusky-blue velvet, who in turn was clutched from behind by his just-older sister Elsie, the two children posted shyly behind their mother's sofa in the dark background of the painting.

In the painting as Sargent composed it, the cheerful matriarch dominated the foreground, sporting a pink ribbon in her fashionably Augustan gray-touched hair. She displayed a white bosom strung with pearls, and she leaned forward out of the frame with a frank, good-humored gaze whose directness defied, as Sargent so often achieved with seemingly spontaneous touches of paint, the enforced modesty of maidenly or maternal Victorian figures.

Adèle Meyer emerged as a bold fin-de-siècle woman. Her neoclassical trappings conjured up a playful and free-spirited figure with great poise and energy. Sargent's spontaneous yet meticulous mise-en-scène of eighteenth-century French costuming and objects transfigured his sitter, underscoring Mrs. Meyer's and his own fin-de-siècle sophistication and worldliness. The lightness and freedom of such theatricality, illuminated by Sargent's quick, sure brushwork, countered the stodginess of late-Victorian eclecticism. Such cosmopolitan ornaments, as well as the fanned-out book on the sofa, rendered Adèle Meyer an embodiment of intelligence, luxury, and fun.

At its debut in Burlington House, this stage-worthy production delighted London's critics. Still, they noticed that Sargent had somewhat awkwardly foreshortened Mrs. Meyer's craning figure, throwing her skirted lower body quite out of proportion. The rather dizzying composition of the portrait spurred *Punch* to publish a cartoon caricature of the piece in which the Meyer children clutched their mother's arm as if to prevent her from

catapulting out of the picture. *Punch* lampooned Sargent's portrait as "on a sliding scale, a sort of drawing-room tobogganing exercise."

This "sliding scale" played on stereotypes of Jews as financiers and money managers. But more barbed reactions to the painting soon, and more blatantly, channeled the deep-seated anti-Semitism that was ubiquitous in Sargent's dinner circuit. *The Spectator* quipped that even Sargent's skill had "not succeeded in making attractive these over-civilised Orientals." And such opinions were hardly confined to one dyspeptic critic. They were also shared by many members of Sargent's own group, including Henry James. In *Harper's Weekly*, James commented that Mrs. Meyer's "type was markedly Jewish" (with a faint mustache, James cattily hinted, on her upper lip); and that her children's "shy olive faces, Jewish to a quaint orientalism . . . peep out of the lattice or the curtains of [a] closed seraglio or palanquin."

James's remarks betrayed the subtle or blatant anti-Semitism then rampant in the English-speaking world. It came of an entrenched historical bias. But it also reacted to late nineteenth-century Jewish immigration in both Britain and the United States. Some of this immigration was, in the popular mind, conspicuously shabby and Eastern European—tired and poor, as Emma Lazarus famously described it in her poem of 1886 that celebrated the great welcoming symbol of the Statue of Liberty. Such were the impoverished but aspiring shtetl Jews who settled in New York's Lower East Side or in London's Bethnal Green and Mile End. But similar prejudices also targeted wealthy Jewish immigrants like the Meyers who attempted to assimilate or win acceptance in elite London society. Such prosperous newcomers to London increasingly attracted the contempt accorded to all social climbers. But they were also tarred with the broad brush of antisemitic stereotypes, like those Henry James had slathered on Sargent's free-spirited portrait.

In 1897, what's more, the animus against Jews in Europe had badly flared up. The flames were fanned by the Dreyfus Affair that had been raging in France since 1894. A Jewish officer in the French army, Alfred Dreyfus, had been denounced for treason. In 1896, French defenders of Dreyfus (the more liberal faction of Dreyfusards) had finally established the captain's innocence only to be undermined by the discharge of falsified documents from Anti-Dreyfusards, conservative nationalists who abounded in the French army and church. In early 1898—when Sargent was getting ready to exhibit his next high-profile Jewish portrait in London—the novelist Émile Zola would publish his famous open letter, *J'accuse . . . !*, exposing this fraud. For anti-Semitism was unfortunately not limited to the Anglo-Saxon

world, though its manifestations in London or New York—if sometimes less in-your-face than those then raging in Paris—were just as virulent and divisive.

The degree to which Sargent's portrait of Adèle Meyer channels any such prejudice has been much debated. The art historian Kathleen Adler has identified stereotypes of "the Jewess" in this and other Sargent canvases, and she rightly points out that Sargent's fascination with Jewish women belongs to his obsession with exotic types and ethnic others—so thoroughly ingrained in Sargent's sensibility long before 1896. If colorful, appreciative, and lyrical, Sargent's representations of Jewish women often furnished additional examples of his deep-seated taste for an "exotic" East. They showcased his often-problematic fascination with distanced and sometimes exploited others.

Yet Sargent's very attraction to non-Anglo-Saxon people and cultures set him apart from a finicky, ultra-Europeanized figure like James. Sargent had more empathy for outsiders and unconventional people than James generally did. *Mrs. Carl Meyer and Her Children* may have been designed to provoke critics and crowds at the Royal Academy—as with many other specimens of Sargent's iconoclastic women. But Sargent's distinguished, lively figure with her handsome, glowing children also reflected Sargent's fairness and generosity as a portraitist.

It also signaled his growing affinity for Jewish sitters. Sargent told his fellow painter William Rothenstein, himself a Jew, that Jewish people qualified as "at once the most interesting models and the most reliable patrons." And, according to one recent historian, in spite of a "twinge of stereotype," Sargent would grow into an uncommon degree of "affection and trust for his Jewish clients." And that transformation was about to blossom through a different and even more colorful set of Jewish friends.

-+-

In the late 1890s, the small but exquisite gallery at 154 New Bond Street straddled the line between traditionally aristocratic Mayfair and increasingly brash Oxford Street. London was abuzz with money and style, and this small shop, a gallery really, clearly aspired to a loftier clientele than the neighboring businesses. In July 1898, the art dealer Asher Wertheimer added to his inventory the rich Dutch and Flemish art collection of Lord Francis Clinton-Hope, a purchase costing him £121,550—tens of millions of dollars in today's money. This accession linked Wertheimer with the for-

midable Old Master art dealer Otto Gutekunst (whose surname appropri-
ately meant "good art" in German) and the firm of P & D Colnaghi a little
way down New Bond Street, the oldest and most formidable commercial art
dealership in the world.

The Hope collection featured eighty-three paintings, some of them rare
and breathtaking Rembrandts and Vermeers. With his fondness for Dutch
art, Sargent may have visited Asher Wertheimer in 1898 to look over some
of these pictures. But when he'd first ventured into Wertheimer's rather
gilded shop the previous year, he'd done so not to view art but to create it.
The prosperous art dealer had commissioned Sargent to paint portraits of
himself and his wife for their silver wedding anniversary.

For Wertheimer, such patronage showed the same ambitious spirit as
did his Hope acquisition. Sargent now asked a thousand guineas for a full-
length portrait, almost twice the fee he'd charged Isabella Stewart Gardner
a decade before. To order *two* portraits, each of which cost about as much
as a middle-class house in the United States, was no modest outlay. It was
especially bold for a man whose father, Samson Wertheimer, had emigrated
from Germany in 1830, a bronze-worker escaping religious persecution,
who'd then branched into *objets de l'art et de vertù*. Asher Wertheimer wasn't
as rich or prominent as some of Sargent's other patrons—he was an impu-
dent rising star—so his project of commissioning portraits looked all the
more audacious.

Even though Sargent had already exhibited his groundbreaking portrait
of Adèle Meyer, taking on Wertheimer and his wife also counted as a new
and rather bold venture for him. And when he threw himself into painting
their portraits in 1897, not everything went smoothly at first.

Flora's portrait—as Sargent produced it probably in his Chelsea studio,
with an article of Louis XV furniture from Wertheimer's shop for an elegant
prop—gradually revealed a very different being from Mrs. Meyer—a stiff,
faintly smiling matron encased in pale satin and dripping with diamonds,
pearls, and rubies. To be sure, Sargent's grand-manner portrait was respectful
and handsomely executed. He exquisitely rendered complex jewels with mere
dabs and beads of paint. But his elegant production seemingly turned out
rather too stiff to suit this venerated mother of ten whose family understood
her deeper and richer presence. In any case, both Sargent and the Wertheimers
deemed the painting unsatisfactory, though no specific complaints survive.

Everyone preferred the second portrait Sargent painted of Flora six or

seven years later. In it, she is seated in a Louis XV armchair, dressed in black against a pitch-dark background, again crowned with her diamond aigrette. Flora here glows with a pale luminosity that softens her rather stern dignity. *The Spectator*'s critic called it a masterpiece when it was exhibited in the Royal Academy in 1904, a portrait whose paint was "lost in the magic of light." That Sargent got a second crack at painting Flora Wertheimer shows that, even as early as 1897, his friendship with the family had become close and flexible enough to weather disagreements and disappointments.

--+-

*Though Sargent was growing closer to the Wertheimers, other social engage-*ments took up much of his time. In 1897 he was elected as a full member of the Royal Academy—after a long association with its exhibits, and having been an associate member since 1894. He painted one London luminary after another. He also got away from London that winter to do more research on the second stage of his Boston Public Library murals, heading for Sicily, where he painted exquisite honey-colored watercolors of the marble floors and columns of the church of San Cataldo in Palermo. Sargent's increasing immersion in heavily decorated interior spaces, however, would result in figures—for his future Frieze of Angels—less imbued with the passionate individuality that had distinguished his earlier mural work.

Sargent then visited the Vatican, that scene of his childhood infractions, where he was now allowed, through his friend Harry Brewster, to visit the Borgia apartment in order to see Pinturicchio's fifteenth-century decorations, gathering in that exquisite private chamber notions for his Boston work. Such travels, though, would result in less interesting work than Egypt and Turkey had inspired. They also proved lonelier than his Continental rovings had been only a few years before. Sargent most often had Nicola d'Inverno for company, but on this trip, he wasn't able to spend time with his sister Violet in Paris or even with the Curtises in Venice.

Back in London, though, Sargent's social diary tended to fill right up. His latest woman friend, whom he'd met in the mid-1890s during his relentless procession of white-tie dinners out, was Mary Smyth Hunter.

An exuberant spirit, Mrs. Hunter entertained, unusually, not in Mayfair or Kensington but at a house called Hill Hall in Epping, in the far-off and socially unknown reaches of eastern London. Mrs. Hunter became, as Mrs. Meyer had not, a confidante and long-term friend. And such was Sargent's

enthusiasm for her and his continual involvement with her schemes that the unschooled wondered if she'd become the artist's mistress. Such a possibility "seems unlikely," most authorities agree.

But the rumors—akin to those that swirled for years around Sargent and Belle Gardner—didn't faze Sargent. After all, such gossip didn't really harm his reputation as a perpetual bachelor. All through his career he'd bonded with lively, intelligent women—had played piano duets with them, escorted them to dinner, and painted superb portraits of them. But the timbre of his attraction often mystified his friends and well-wishers, not to mention many of the ladies themselves.

A portrait of Mary Hunter that Sargent dashed off in 1898 revealed a woman with a narrow, horselike face and a thin-lipped if pleasant smile, her figure so hung with draperies and furbelows that *Punch* lampooned her as "La Belle Chiffonière." Yet Sargent was delighted to shine at her parties in the full starchy evening dress that *Punch* and Max Beerbohm were now so often lampooning. (In 1909, Beerbohm showed the ample, bespectacled Sargent as "The Great Realist," exhaling from a raised cigarette.) The painter felt calm in Mary's company. And he was always game to help her to decorate her house exquisitely, in the Italian style that he understood to his fingertips.

As a painting, Sargent's portrait of Mary Hunter proved inferior to his *Mrs. Carl Meyer and Her Children*, painted two years before, but his friendship with her would prove more substantial and long-lasting.

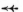

Sargent's portrait of Asher Wertheimer, though, proved even more of a tour de force than *Mrs. Carl Meyer* had been. When Sargent exhibited it at Burlington House in spring 1898, the confident, charming portrayal of the art dealer created a frisson (see Fig. 22). One commentator saw it as the "masterpiece on which all artistic eyes have been fixed since the opening day," and another asserted that Sargent had shown himself peerless: "It would be very hard to name any other modern painter that we could rank with this for sheer power of expression."

Sargent had painted Wertheimer in a dark suit against a dark background, so that the art dealer's wryly humorous face stood out. So too did a gesturing hand pinching a cigar between his two fingers. Since the Renaissance, heads and hands had carried the burden of individuality in portraits, offering insights into sitters' inner lives. In this portrait, Sargent lavishly humanized his friend and patron, rendering him both timeless and topical—

though also leaving him problematic and ambiguous enough to stir much subsequent debate.

To one more recent critic, *Asher Wertheimer* "incorporates many of the elements beloved of antisemitic caricature." These include "the hooded eyes, large nose, and above all, the fleshy lips that are seen to characterize the 'race.'" Even the inclusion of the large poodle Noble—a feature of the Wertheimers' homelife and seemingly only one of several dogs that had the run of the household—proved just as problematic. The "slavering tongue, a shocking pink accent in the foreground," hinted at the stereotypes of Jews as sensual or hypersexual. Likewise, Wertheimer's shrewd expression and gesturing hand referenced Belle Époque stereotypes of Jews as deceptive and shifty dealmakers.

At the Royal Academy, some of Sargent's contemporaries read the painting in just this way. Another of Sargent's sitters, who got an earlier peep at the portrait on an easel in the Chelsea studio, remarked Wertheimer's raised thumb meant that he was "pleasantly engaged in counting golden shekels." Predictably, too, *Punch* produced an immediate spoof that exaggerated all of the features Sargent had more delicately portrayed. It also added a crass antisemitic caption in a stereotypical dialect, referring to the half-visible dog in the portrait: "What only *this* monish for that shplendid dog, ma tear, it is ridiculush." Sargent's knack for clenching salient and telling feature of his sitters—a habit allied to caricature—lent his portrayal to certain negative and racist readings.

Still, Sargent's portrait glowed with Wertheimer's frank and pragmatic dignity. One reviewer declared that the seventeenth-century politician Oliver Cromwell, who preferred to be seen warts and all, "would have loved" such a portrait. "Happy is the man whose portrait has been painted thus," another critic added. Ormond and Kilmurray have rightly identified this painting as a "masterpiece," a "brilliant characterization of a complex character, shrewd, charming and confident . . . The character of the man, caught with such subtle and penetrating force, amused the world without giving offence to its subject." Wertheimer himself reveled in the painting, giving it pride of place in his dining room, which would eventually become a prodigious gallery of Sargent portraits. His own love of Sargent's work affirmed the generosity and rich sense of humor that Sargent had detected in him.

One less noticed feature of the portrait, however, gives an additional clue to Sargent's deft handling of his subject. Ormond and Kilmurray describe a how, "thumb in pocket, [Wertheimer] holds open his overcoat in an

expansive gesture." *Punch* rendered this gesture as almost a hand on the hip, as it also seemed especially in a preliminary pencil sketch Sargent made of Wertheimer, and in the painting itself, though almost obscured by the dark background. Sargent once again brought to bear a variation on his impudent Velázquez pose, here with a different meaning than it had in his portrait of Marcel Proust's pianist friend Léon Delafosse, which he painted at roughly the same period. With Wertheimer, the gesture hinted at confidence, impudence, sensuality, and aristocratic manner, as opposed to underworld coding, as in the portrait of the gracile, angelic, and smoldering Delafosse.

‹‹‹

Connaught Place in Bayswater, the Wertheimer's London home, lay just around the corner from Marble Arch and Speaker's Corner in Hyde Park. A narrow street almost like a mews, hidden near the main thoroughfares of the metropolis, Connaught Place with its white-columned entrances approximated a well-kept secret. In this quiet, private world, Sargent spent ten years painting twelve portraits of the family—a considerable series of commissions, almost the equivalent of his Boston Public Library murals. Asher and Flora Wertheimer would later donate ten of these paintings, in an extravagant and assertive gesture, to the British nation by way of the Tate Gallery. Still, almost all of Wertheimer's papers, including his and his family's correspondence with Sargent, were later destroyed. Almost no documentation survives from either side of Sargent's long relation with the Wertheimer family, of the many family dinners, studio visits, or London outings.

In the late 1890s Sargent wrote his artistic Anglo-German friend Elizabeth Lewis that, with one commission after another from the family, he was in a state of "chronic Wertheimerism." Certainly, in undertaking to paint Asher Wertheimer's six daughters and four sons, individually and in various ensembles, Sargent logged weeks of studio time. But his remark to Lady Lewis implied a frustration he didn't generally feel, for he voluntarily sought out his new patrons' company, joining the family for dinner almost as often as he dined with his mother and sister Emily. Increasingly, he dropped in at the Wertheimer's Bayswater townhouse or ventured out to their country house, Temple, near Henley-on-Thames. He soon took his meals with the family so often that their dining room, where his completed portraits were triumphantly hung one by one, became known as "Sargent's Mess."

Partly, Sargent frequented Connaught Place to revisit this growing gallery of his own works—one of the largest collections of exhibition-grade

Sargents outside his own studio. But increasingly, he came for more: he basked in elegant and cosmopolitan surroundings (Wertheimer, a superb dealer, furnished his home exquisitely), greeted hospitable elders, patted cheerful dogs, mixed with the Wertheimers' friendly sons Edward, Alfred, Conway, and Ferdinand, and especially conversed with their expressive daughters Helena, Betty, Hylda, Essie, Almina, and Ruby. Sargent craved all this warmth.

In autumn 1895, Mary and Emily Sargent had finally settled down more permanently near John in Chelsea, at their long-held flat at 10 Carlyle Mansions. But his mother, now in her sixties, white-haired but hardly fragile in spite of her long career of invalidism, still insisted on frequent junkets, even if these were mostly for medical cures. Violet, in San Remo or various other places on the Continent, shepherded six children under six by 1898. The Wertheimers readily provided Sargent a second family, one perhaps less laced with obligation, and certainly a warm, lively, and openhearted one.

The spirit of Sargent's interactions with the Wertheimers showed especially in the portrait of his favorite Helena ("Ena") and her sister Betty. This double portrait made a stir at the Royal Academy in 1901 (see Fig. 24). Once again, Sargent painted a picture that dazzled the critics with its provocative elegance and also seethed with half-hidden implications.

Using the family's Connaught Place drawing room as a dark background, Sargent posed Ena, six feet tall, in a lustrous, low-cut, ivory-colored gown, one hand placed on the golden knob atop a huge porcelain vase, the other curled around her sister's waist, her rose-pink fingers suggested by flicks of Sargent's paintbrush. Betty in turn wore a bloodred velvet evening dress, her bare, outturned arm flicking a spread fan. Sargent's contrasting use of paint places two illuminated young women in a dark room, as if the uncertain, isolated girls of his *Daughters of Edward Darley Boit* from two decades before had grown up into confident, self-assured women (as the Boit girls did not). Ena and Betty were able to dominate and transcend the huge piece of export porcelain behind them.

In its audacity, warmth, and liveliness, the picture struck one critic as evincing a "vitality hardly matched since Rubens." Another found it drenched with spirit, absolutely "instinct with life." Ena Wertheimer, taller than her sister by half a head, loved the painting. Reveling in Sargent's work, she went on posing for him whenever the moment offered. And in her unfolding friendship with the painter, she actually lived up to the nobility of the painting.

The larger world that Sargent served, though, proved less kind to Sargent's vision of the sisters. The English press singled out the sitters' "race" and social pretentions. Ena's arm around Betty's waist called attention to their physicality. In the words of one recent critic, the two young women are "daringly dressed," as wealthy female Jews were invidiously thought to be. Whether Sargent himself envisioned his lively young friends as hypersexual "Jewesses," he'd once again opted to lionize bold, theatrical women. With Betty and Ena, he longed to bend the rules, as one the recent conservator's discovery reveals. In an earlier rendition on the same canvas, the artist painted one strap of Betty's gown slipping off her shoulder. Evidently, though, he thought better of a gesture that had stirred up so much trouble with *Madame X* seventeen years before. He repainted it (a "pentimento") before he delivered the picture to the public gaze at Burlington House—for the Royal Academy was an even starchier venue than the Salon.

In his forties, Sargent was now backing away from some of his transgressive painterly instincts. But still in his work he was testing the boundaries of sex, as this near-reliving of *Madame X* demonstrated. This painting generously treated glowing faces and sumptuous gowns. If it summoned ghosts of Jewish stereotypes, it didn't reinforce ethnic bias so much as celebrate these unconventional, high-spirited young women with whom Sargent deeply and instinctively identified. He hankered to be as free as Ena and Betty.

William Cushing Loring, a young Massachusetts artist, visited Sargent's studio and saw an early version of the Wertheimer sisters. To him Sargent remarked, "What do you think of it? Isn't it stunning of the taller girl? Don't you think she is handsome?" Sargent savored Ena as a vital, audacious figure. Was he romantically smitten? He sometimes implied as much around other men. He'd logged decades of practice in channeling the gallantry and lasciviousness of the men around him; he had a gift of misdirection and perhaps dissimulation, especially now that, in his forties, he was conscious of his conspicuous and lengthening career as a bachelor—and one who'd lived by himself in the most bohemian, aesthetic, and suspect quarter of London. At the same time, he adored women like Ena—he genuinely did.

Sargent painted Ena again in 1904. He was much struck when she swept into his Chelsea studio in a military fancy-dress costume featuring a dashing velvet Spanish cloak. He captured her entrance in a remarkably playful and theatrical portrait called *A Vele Gonfie* ("Under Full Sail"). He clinched his young friend at her best—as a rakish free spirit, as a boyish cavalier.

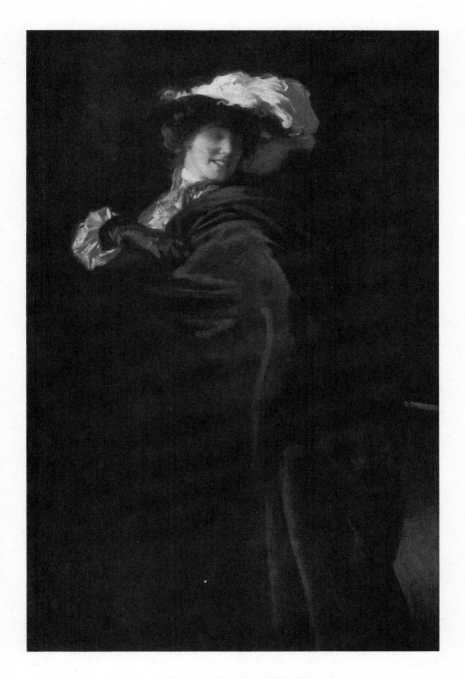

Sargent, *Portrait of Ena Wertheimer: A Vele Gonfie*, 1904

Sargent envied Ena her pluck. The shy painter had often flown in the face of Victorian proprieties even if now, in the tentative first years of the new century, he found such liberties much trickier to perform. It was harder to be playful in his grand-manner, aristocratic pieces, most commissioned by women less willing to participate in his painterly romps than Ena. But in this joyous, fey piece, Sargent rediscovered and reasserted his own instincts as well as paying tribute to Ena's.

Some observers bridled at such liberties. Sargent's frenemy the Bloomsbury critic and painter Roger Fry took exception to this picture. Showing the unexpected impact of so unconventional a painting even on younger artists, he bafflingly misread this portrayal as a "very dry and bitter irony." Yet this joyful canvas was hardly dry and not at all ironic in the way Fry judged; nor was it the "banal" production that Fry dismissed. It was just that Fry, tuned to more recent developments in French avant-garde art, found himself increasingly allergic to Sargent's more out-of-date brand of provocation.

Fry was obsessed at this time with Post-Impressionism, the latest wave of mold-breaking painting from France—with the expressionistic and color-obsessed Fauvists, including rising painters like Henri Matisse. Fry was also influenced by his friends in the just-forming Bloomsbury group, whose aesthetics in painting pitted them against the Royal Academy more generally. What's more, the political and social views of Bloomsbury figures like Fry, Virginia Woolf, and E. M. Forster on feminism, anti-imperialism, and alternative sexuality would clash with Sargent's more old-fashioned milieu and views. To Bloomsbury, Sargent now looked like an old-guard defender. His own type of rebellion, now fading in any case, was redolent of the ateliers of the long-vanished Paris of the 1880s. Then, Sargent had actually dared to paint a strap having slithered off the woman's shoulder. But he now avoided the freer erotic notions, including a more open fascination with homosexuality, that was emerging in the Bloomsbury generation.

-+-

In February 1899, Sargent's second American one-man show opened in Boston. That same month, an announcement of Sargent's death appeared in American press, shocking his many American friends over their breakfast newspapers. "Alive and Kicking," Sargent telegraphed Belle Gardner, to assuage her, as was his custom even with good old friends, in a minimum of words. In Europe, Sargent was very much living and ubiquitous, embroiled in a dizzying self-booked itinerary. In spring 1898, he traveled to Bologna

and Ravenna with his sketchbook to search out inspiration for his *Triumph of Religion* murals in Boston. In summer, he alighted in Paris to hobnob with Whistler and Toulouse-Lautrec and to inspect an exhibition of Monet's paintings. Then, in winter 1899, to cap it all off, he painted the three exquisite Wyndham sisters in Belgrave Square.

The socially prominent Wyndhams measured a high-water mark of Sargent's ever-mounting success in London. For the Honorable Percy Scawen Wyndham and his wife, Madeleine, entertained a circle of aristocratic luminaries self-identified as the Souls. The exquisite couple gathered this privileged group at their pale-golden, arts-and-crafts country estate, Clouds, in Wiltshire. Their three married daughters stood out in London high society as accomplished, assertive, and well-connected beauties.

Wilfrid Scawen Blunt, a bearded, Arabian-horse-loving poet who devoted much of his leisure to the Wyndams, characterized the Souls as "an interesting group of clever men and pretty women" who were "intellectually amusing and least conventional." Yet when Blunt encountered forty-three-year-old Sargent on the doorstep of 44 Belgrave Square, he labeled this stranger as "a rather good looking fellow in a pot hat, whom at my first sight I took to be a superior mechanic." Sargent, as he struggled with a massive, high-profile group portrait, well knew that he *was* a mechanic, in a sense—an employee of his ultra-rich "friends."

The Wyndham Sisters, a wall-size canvas, physically and artistically dominated the colonnaded galleries of the Royal Academy in 1900. Critics acclaimed the work as a masterpiece. Yet this extraordinary piece, half the darkness of a dim green interior, half a glowing cluster of three women in white neo-eighteenth-century gowns seated together on a sofa, cost Sargent a supreme effort. He especially struggled with the delicate, elusive face of Pamela Tennant, the youngest sister, as Blunt and others would vocally notice once the painting was exhibited.

Even so, Sargent was willing to work hard to secure the patronage of the Souls, a group whose taste and money suited him and whose connections augmented his career and reputation at every turn. As a special bonus, the man who'd be Sargent's eventual biographer as well as his good friend, the dapper bachelor Evan Charteris, came as part of this package. Charteris was the brother-in-law of the eldest Wyndam sister, Mary Charteris Douglas, Lady Elcho. Still, the Wyndhams and their fastidious friends demanded all that Sargent could give, and they constituted only one small corner of Sargent's traffic with London's smart, ultra-rich set.

Thus Sargent often turned to his friends the Wertheimers. Their unjudg-mental welcome never failed him. This conversable, warm-hearted family continued to inspire the overcommitted Sargent as the century turned. Sar-gent's favorite, Ena, also a sometime art student, lived on her own, as young women were not supposed to do. She adored Sargent and patterned her life as a daring iconoclast and a careless epicure on him, living with quiet artistic flair rather in Sargent's own style. But the portraitist bonded with the whole family, liking them as elegant, humane outsider figures who chafed against mainstream prejudice and disapproval.

As Sargent's queer painter-friend Jacques-Émile Blanche understood the affiliation, Sargent was attracted to English Jews like the Wertheimers because they "did not intimidate him, they appealed to him because they were more human in their eagerness, their simple confidence in their superiority, and this he made clear in their expressions." Blunt, the man who'd sized up Sargent on the Wyndhams' doorstep, complained that Sargent painted "nothing but Jews and Jewesses now and says he prefers them, as they have more life and movement than our English women." It was true that, once again, Sargent was drawn to exuberant, rule-breaking women. But the relief he found in the Wertheimers also illuminated his own outlaw status, as a mechanic frequent-ing London townhouses, as a purple-loving artist (as Blunt also noticed), as a bachelor conspicuously unattached in the wake of the Wilde trials.

Sargent preferred the Wertheimers for many reasons. He identified with them as lively, confident people; as art-world social climbers; as transgres-sive outsiders. In all these aspects, they mirrored Sargent himself. As the writer Adam Gopnik has observed, Sargent found in this ardent, warm-hearted tribe "an innocent social insolence that matched his own." Yet an affiliation between an unconventional artist and an assimilating Jewish fam-ily channeled deeper affiliations.

Sargent's complex connection with the Wertheimers showed up in the eighteenth-century French objects that had been conspicuous in *Mrs. Carl Meyer and Her Children* and some of the Wertheimer portraits. Asher Wert-heimer furnished his home with objets d'art as well as selling them in his gal-lery. Likewise, Sargent increasingly favored "cosmopolitan" furnishings at Tite Street over the aesthetic bric-a-brac of his own former studio spaces, and (especially with the enthusiastic neoclassical revivals of the 1890s), he used these sophisticated, international pieces in his British and American portraits, formal or playful. In short, both Sargent and the Wertheimers understood themselves as cosmopolitans.

The way Sargent's friends used the term, "cosmopolitan" meant international and sophisticated—and the polyglot, French-trained Sargent definitely fit the bill. In the view of one American art critic in 1903, Sargent counted as "a typical example of the modern cosmopolitan, the man whose habits of thought make him at home everywhere and whose training has been such as to preclude the last touch of chauvinism." Another New York art commentator thought in 1908 that, though he claimed Sargent as an American, "so dazzled has the majority been by [his] cosmopolitanism, that the real racial basis of his nature has been overlooked." Most observers contrasted such cosmopolitanism with the jingoistic nationalism that dominated Europe and America at the turn of the twentieth century.

Still, to be tarred as a "cosmopolitan" wasn't always a compliment in London drawing rooms. It was a complicated and often tinted tag, an outlook, style, and manner that was both admired and scouted. Worryingly, the more negative or accusatory meanings of this term fit Sargent and the Wertheimers even better, because "cosmopolitan" not infrequently correlated with being Jewish or homosexual. Jewish people were often deemed notoriously multinational, not only having emigrated from one country to another but also maintaining supranational outlooks. Sargent's cast of globe-trotting queer friends gravitated to far-flung countries and espoused sophisticated attitudes, their polyglot complexity offering an antidote to the parochialisms of places like Boston and the Cotswolds. Queers and Jews shared similar experiences of exile.

Yet, at the same time, the elegant art-world cosmopolitanism that Sargent and his Jewish patrons feverishly cultivated also self-consciously distanced them from more conspicuous members of their respective communities, the "fairies" of London or New York nightlife, or the Eastern European Jewish immigrants of the ghettos. In this respect, the classical furnishings of Connaught Place and Tite Street served as screens for less palatable identities, and what Sargent and the Wertheimers most shared was a species of strategic disguise. Their elegant artistic choices were calculated to preserve social status and prestige that might otherwise be stripped from them.

How much did these friends understand the anxieties that underlay such elegant masks and screens? Were Sargent and his patrons aware of any common endangerment that caused them to bond, to understand one another, or to confide in each other? Not all queer figures, especially closeted ones, displayed much understanding for Jews, as exemplified by Henry James's rather biased readings of Sargent's paintings. Nor were Jewish immigrants

necessarily empathetic to the homosexuality they found flourishing in cit-
ies like New York or London. Though the evidence remains "fragmentary,"
gay historians have argued that Italian immigrant communities in New York
tended to be more open to homosexual culture—thanks to a greater social
acceptance in southern Italy—than were Eastern European Jews. (Sar-
gent's London immigrant "gondolier" Nicola d'Inverno also illustrated this
dynamic.)

Intellectual Jews were a different matter, of course, as were the prominent
figures of Sargent's era who were both Jewish and queer, such as the French
novelist Marcel Proust, who made his first gestures toward writing about
queer life in his unpublished *Jean Santeuil* (1896–99), or the German sexol-
ogist Magnus Hirschfeld, who in 1897 founded the Scientific-Humanitarian
Committee (Wissenschaftlich-humanitäres Komitee), an early homosexual-
rights organization. Yet it didn't follow that Jewish and queer perspectives
were always mutually supporting, tolerant, or understanding. Quite often
the opposite was true.

Still, "Sargent's Mess" in Connaught Place served as a refuge from some
of the social vigilance that prevailed in Sargent's high-flying professional
orbit. With the Wertheimers, he relaxed more than in other social settings.
That it was Betty Wertheimer who recorded that Sargent "was only inter-
ested in Venetian gondoliers"—though the phrase, as reported, is less than
empathetic—hints at some kind of understanding or openness—openness
in the attenuated sense of that closeted era—that existed between Sargent
and at least some of the Wertheimers.

Did Betty have some kind of inside knowledge, or did she merely echo
the gossip that already circulated about Sargent and his manservant? Yet her
mention of gondoliers may be significant for another reason. For, as it hap-
pens, it was during the height of his friendship with the Wertheimers that
Sargent, after only brief visits to Venice over fifteen years, finally returned
to the Serene Republic, the origin and hometown of gondoliers.

-<+-

In the summer of 1898 Sargent again stayed in high style at the Palazzo Barbaro
on the Grand Canal with his distant cousins the Curtises, this time with his
valet Nicola in tow.

Sargent now witnessed the changed state of that family, after almost two
decades, even in their seemingly changeless historical palace. During this
visit, he captured the family in a rather gloomy portrait later known as *An*

Interior in Venice (see Fig. 23). On one side of a vast, dim room he depicted forty-four-year-old Ralph Curtis with his new wife Lisa de Wolff Colt, a scion of the Colt firearms family. The now-elderly Curtis parents, dwarfed by the grandeur of their own salon, drank tea, Ariana looking on stonily, Daniel Curtis beside her listlessly leafing through a folio.

Sargent intended the piece as a thank-you for his stay. But the formidable Ariana Curtis, now sixty-five years old, objected to her son's rather provocative dandyish pose as well as her own insignificance in the midst of the huge lightless room that Sargent had characteristically conjured up through quantities of dark paint. Not even Henry James's blandishments could make the old lady like the painting, so Sargent later donated it to the Royal Academy as his belated diploma work. For indeed Sargent's rendition of the former bachelor Ralph, knee up, hands on his hips, captured some of the swagger for which Sargent had long been famous. Ralph's pose raised the hackles of his vigilant mother.

The Curtises had aged. Characteristically, Sargent found himself more attracted to the lively new wife Lisa than to the older generation. But Sargent's painterly handling of Venice had changed even more. For all that he told Ariana Curtis that his return to Venice had brought back his youth—and, more flatteringly, how her palazzo qualified as a "fontaine de la Jeunesse" (fountain of youth)—his inspirations had dramatically altered since 1882. He no longer aspired to paint Whistler-style "palaces in rags" or concoct the suggestive street scenes that had formerly dominated his vision of Venice.

Over the next fifteen years, instead, Sargent would paint increasingly lyrical, free, and liquid visions of Venetian splendors—palazzi, churches, quays—mostly though not entirely in the form of brilliant, fluid watercolors, his favorite painterly medium. These views adopted unusual perspectives, focused on little-noticed details, or celebrated colors, shapes, and rhythms, eschewing the more obvious, conventional, or touristic Venice captured by lesser lights in this much-painted city. Many of Sargent's late paintings in Venice were breathtaking, surprising, and eternally fresh. Some of them ranked among his finest works, for the sheer visual pleasure that saturated them.

Between 1898 and 1913, though, Sargent hardly painted human figures in Venice, as if the city—which had in fact had only attracted even more hordes of tourists since the painter's last visit—had been miraculously stripped of its ubiquitous visitors and vocal inhabitants. Sargent objected to

what he saw as "swarms of larky smart Londoners whose goings on fill the *Gazette*." Here he succumbed to a rather Jamesian snobbishness. But the palpable pleasure in his Venice sketches showed Sargent out on a lark—liberated, perhaps self-consciously, from the grind of portraiture. Even if he gave or sold some of these watercolors to Anglo-Saxon patrons, these visions owe little or nothing to the sitters' whims that had long bedeviled Sargent in his Chelsea studio.

Yet, as he grew accustomed to Venice again—opened himself up to it after years of absence—Sargent included one kind of figure in his painterly adventures: gondoliers. At first, in his fresh views of Venice, these figures remained small-scale in comparison to the great churches and palaces, sometimes executed only suggestively with a few flicks of paint. But soon, in other pieces, the gondoliers loomed up in their vibrant, athletic, flesh-and-blood forms. They took on more active roles, for example in Sargent's *Gondoliers' Siesta* from about 1902–1903 or in his *On the Zattere* from 1902–1904, in which the faces, costumes, and dynamic postures of individual gondoliers flared dramatically to life.

For Sargent in his new Venice enthusiasm, the addition of gondoliers counted as straightforward and practical. They embodied the breezy liberation of Venice but also filled Sargent's quotidian life, as he sketched and painted from the passenger seats of gondolas. Still, these handsome young men—and Sargent singled out the fresh and comely in his sketches—illuminated the one kind of human figure that in Venice Sargent now liked most to paint. He saw them repeatedly, in the crowded canals of Venice, or at least included them repeatedly in his watercolors. Their dynamic presence—rowing, hailing, shouting—revealed one fountainhead of the lyric freedom Sargent infused in those very sketches.

In autumn 1902, Sargent again boarded with the Curtises at the Palazzo Barbaro; in autumn 1903, he stayed at the Hotel Luna with his mother and sister Emily. He preferred Venice in September and October for the clarity of the light and the relative out-of-season quiet, and he again returned to the Barbaro along with the de Glehns at this season in 1904. As Sargent plunged still deeper into the splendors of the city on these repeated seasonal visits, some of his watercolors began to buck his Venetian preference for architectural splendors seen from odd angles. These paintings not only included gondoliers but also hinted that, after almost two decades of abstention, Sargent was recovering his old fascination for Venetian low life.

Two fascinating pieces stood out: *A Venetian Trattoria* and *A Venetian*

Interior, both from 1902–1903. The first focused on a little boy in this sim-
ple, working-class restaurant but also included a blurred young gondolier,
in a characteristic sailor-like white tunic bordered with blue. Ormond and
Kilmurray have observed that, with "its sensuous textures and velvety tones,
the water-colour breathes the spirit of Venetian life through its graphic
depiction of a humble interior and the character of the two protagonists."
Sargent was indeed following somewhat belatedly in the footsteps of Hora-
tio Brown and his veiled same-sex interests disguised as studies of gondo-
liers, in his *Life on the Lagoons* from back in 1884. Brown, who belonged
to a somewhat less cautious set of "Uranians" than did Sargent and James,
had grown more daring and published some coded homoerotic poems in a
volume called *Drift* in 1900. For Venice was inspiring increasingly bolder
and more open expressions of same-sex eroticism, with Thomas Mann's no-
torious novella *Death in Venice* (*Der Tod in Venedig*) to be published only a
few years later in 1912.

In his second watercolor, *A Venetian Interior*, Sargent created a rather
startling encounter. He depicted a somewhat rakish older man with his hand
cocked on his hip facing off with a gracile and handsome young gondolier.
The old man's white hair and loose shirt stood out as whorls of bright paint
that set off his craggy, sun-browned face; Sargent articulated the young
gondolier as contrastingly slender and reserved, cool in his blue-black garb.
Sargent focused on the young man's delicate, faintly mustached face, render-
ing it demure, unreadable, and wistful under his dark-brimmed hat. It was
the dreamy look that Sargent had bestowed on young men in his sketches
for decades. Nearby, a little boy strained to pour wine into a white ceramic
cup, adding an odd, sweet touch of innocence and precocity. Sargent's whole
sepia-colored wine shop was hung with pots and bottles, suggested and
quickly brushed in with Sargent's spontaneous, sure watercolor technique,
by which he was also delineating, in other studies, the great marble monu-
ments of Venice. This genre piece captured a social milieu diametrical to the
solemn, museum-like interiors of Anglo-American palazzi where Sargent
slept and dined when not roaming the back canals, *calli*, and *campielli* of the
maritime city.

Oddly, Sargent later presented this watercolor to Asher Wertheimer—
though Wertheimer mislabeled it as a view of Spain and not Italy. Sargent
also bestowed other Venetian pictures on the Wertheimers after his junkets
to Venice. Here was another clue that Betty Wertheimer actually knew
some specifics about Sargent's enthusiasm for Venice and its gondoliers.

The handsome gondolier in this piece rather resembles one of the young boatmen in *Gondoliers' Siesta* and the central figure in *On the Zattere*. But no records identify any specific gondolier, if the model was the same one, let alone indicate how Sargent annexed such a companion or how intimate they became.

We can determine the name of at least one other gondolier Sargent painted in Venice, however. In Sargent's *A Venetian Tavern* from about 1902, he depicts in oils four dark-costumed female figures (one of them perhaps Jane de Glehn masquerading as Venetian tavern haunter) in a similar humble establishment, this one hung with glossy strings of onions also dramatically featuring highlights and shadow, as would befit a slightly shady venue. Though this piece owes to Sargent's earlier treatment of working-class women in Venice, Ormond and Kilmurray describe this rendition as "cast in a different mould—strong and bold where they [were] withdrawn and mysterious."

Yet like Sargent's earlier pictures that feature shadowy brooding masculine figures in the background, this piece includes an indistinct mustached and hatted male figure seated in a back corner of the tavern, raising a wineglass as if in a toast. The man's features, though blurred, strongly resemble those of Sargent's "gondolier," Nicola d'Inverno. Sargent's companionable valet lent himself to an image that appeared innocent and celebratory but also contained at least one unfortunate reference, for d'Inverno battled a drinking problem. Surrounded by Sargent's cheerful female friends, portrayed in sunny paint, he was hardly conspicuous; it would in fact take observers more than a century really to pick him out.

In Sargent's earlier Venetian paintings, male figures hunkering in the background had created brooding, dark presences in plain sight. But the inclusion of d'Inverno in this painting suggested that Sargent's interest in these "background" figures wasn't feigned, even if it also combined, in 1902 as in 1882, with Sargent's genuine delight in costumed, moody, and even provocative female figures. This hunched, half-obscured man at the back seemed almost an afterthought, but in him Sargent had provided at least one key to his fascination with backstreet taverns in the first place.

Still, Sargent didn't linger for long in this particular fanciful taverna. He painted everything else in Venice, churches and palaces, one glorious canal scene after another. And his main professional work—sometimes with Nicola and sometimes without—was still the gilded, exclusive world of high-end portraiture.

23

The President's Coat

Every portrait cost Sargent a struggle, and many became a contest of wills between artist and sitter. Yet Sargent found it especially nerve-racking to sketch the president of the United States standing on a brand-new White House staircase.

It was February 1903, midway through Theodore Roosevelt's first term, and the president and his foreign-seeming painter-guest had toured various White House rooms and arcades in quest of a setting for an official portrait. They'd tried the Blue Room, the East Room, and the South Portico without finding the right backdrop. But when Roosevelt mounted to a landing half-way up the big bare staircase recently installed by Charles Follen McKim as one component of extensive renovations, he swung around to face Sargent, his hand cupped on a big spherical finial, and boomed out, "Don't I?" To this, Sargent replied, "Don't move an inch. You've got it now. Let me sketch you."

Roosevelt froze while Sargent dashed out a quick impression of the president's pose. But the chief executive didn't take kindly to being scrutinized. For a small, mustached, spectacled man—a head shorter than Sargent—forty-four-year-old Roosevelt came off as authoritative if not curt, impatient, and peremptory. Since he'd taken over the presidency after William McKinley's assassination in 1901, Roosevelt had proved a canny, active, and trenchant leader. Among other things, he'd consolidated his formerly weak political position, attacked monopolistic trusts, and overseen the remodeling of the Executive Mansion, as it had previously been known. Roosevelt now insisted on calling his residence by its obscure and seldom-used nickname, "the White House." He had that name boldly imprinted on the official stationery.

Sargent now stayed as a guest of the president and Edith Kermit Carow Roosevelt. He had free use of this stationery as well as presidential linens—some of which he rigged up in the staircase to modulate the amount of light streaming through the windows. But despite the honor of being chosen to paint the president's official portrait—and in fact a considerable and strained honorific correspondence with Roosevelt had prepared the way, initially mediated by the American ambassador in London—Sargent hardly knew how to cope with a hard-edged American of Roosevelt's type.

The Americans Sargent knew in London, Paris, Boston, or New York were different. They were considerably more cultivated and Europhilic if not always more tractable in the matter of portraits. The five-odd short sessions Sargent got with Roosevelt over the course of more than a week—while holding at bay his other commissions, patrons, and engagements—amounted to a decorous, official form of torture.

Once the portrait was finished, Roosevelt liked it, luckily. *President Theodore Roosevelt* presented a dignified vision of a fresh-faced, serious man in a dark suit whose only ornament was a gold watch chain and whose abstracted eyes behind his rimless oval glasses bespoke lofty principles. American historian and political observer Henry Adams thought Sargent had captured "a young intellectual idealist with a taste for athletics, which I take to be Theodore's idea of himself." Yet, much as Adams considered Roosevelt "a terrible bore," he suspected Sargent's portrait aimed at an even darker criticism in "the depth of its malignity towards Theodore. All the worst is there," Adams observed, "paraded and flaunted in one's eyes, but one does not see it." Many other observers didn't catch this hostility—and still don't, as this portrait is a well-regarded public image of the twenty-sixth president. For Sargent, in this instance as in others, channeled subtle, complex, and troubled visions of his sitters that not everyone could fully decipher. At bottom, he didn't like Roosevelt. And, through his painterly legerdemain, he'd had plenty of practice in exposing the perceived secrets of his sitters—in this case hinting at how seriously Roosevelt took himself and how much he forced his dignity on others.

Though Sargent felt uncomfortable with Roosevelt during his stay, his animosity only increased in retrospect. Henry James, who also spent time as a White House guest, made more pointed and verbal criticisms of the president, whom he called "a dangerous and ominous Jingo," "Theodore Rex" (King Theodore), and "Theodore I." (James subsequently admitted that the man had, in person, an "indescribable overwhelming, but really very

attaching personality.") James may well have confided waspish disparagements to his painter friend. But Sargent was still surprised and pleased, years later in 1920, when he read in a just-published volume of James's letters a tirade against Roosevelt that described the former president as "the noisiest figure, or agency of any kind, in the long, dire annals of the human race." Sargent confessed himself relieved to discover that he "was not the only one who had felt like a rabbit in the presence of a boa constrictor."

Roosevelt's effect on Sargent, as on James, had less to do with his being president than with his carefully cultivated hypermasculinity. Once a sickly and asthmatic child, Roosevelt had systematically flogged aggression, confidence, and intimidation into his adult personality. He'd effected this transformation through dude-ranching in the Dakotas in the 1870s, fighting with the Rough Riders in 1898, and prosecuting a sharply rising political career after that. He'd hurled himself into the very athletic and aggressive "Strenuous Life" that he'd advertised in his well-known speech of 1899—a speech that Sargent would hardly have known or cared about, as strenuous as the painter's own itinerant work on two continents had come to be.

If Sargent often appreciated bold, confident women, he recoiled from assertive men. Such reactions owed to his own milder, more agreeable personality, his refined European sensibilities, and his involvement in palatial art worlds that, in comparison to Roosevelt's venues, were nuanced, expressive, and femininized, all carved from mahogany and draped in silk. Yet a part of Sargent's revulsion—perhaps registering in the stark, critical canvas in the black and sepia that Sargent actually painted—was that of a highly cultured artist whose public and private grasp of manhood radically differed from Roosevelt's. No wonder Sargent felt vulnerably leporine in the face of such an aggressively phallic (if diminutive) boa constrictor.

Sargent didn't bring Nicola d'Inverno with him to the White House guest quarters. Other guests brought servants during an era when such attendants were common conveniences for grandees. But, according to his own account, Nicola stayed behind in Boston. He haunted Sargent's empty rooms at the Hotel Vendome, from which, the month before, in January 1903, Sargent had gone forth every morning to mount the second installment of his mural cycle in the Special Collections Hall of the Boston Public Library, just a block away.

There, Sargent had just finished a frieze of angels on the south side of his gallery, to mirror the prophets he'd installed in 1895 on the north. Most critics found Sargent's angels less engaging than his prophets, in which he'd

embedded so many of his friends and obsessions. Still, the more decorative angels, many of them in crimson robes and with gilded haloes, exhibited Sargent's career-long fascination with bold colors and delicate faces, almost as if he'd been trying to create a Burne-Jones stained-glass window on that Boston wall. His semiprivate engagement with the murals—though he still had to please library officials—also felt like a refuge, in comparison to the more skeptical reception he got from portrait commissions, especially from strong antipodal personalities like Roosevelt.

Sargent hated bullies, and he hated officialdom. Still, fourteen years afterward, the painter reluctantly agreed to paint another and rather more refined president—breaking his later determination never to produce another oil portrait. When Sargent worked with Woodrow Wilson in Washington in October 1917, d'Inverno not only "made [his] home" at the splendid Beaux-Arts New Willard Hotel but also "visited the White House twice each day" with his employer. In contrast to Roosevelt, Wilson was "very agreeable to be with," Sargent wrote Isabella Gardner, "and the conditions are perfect as he allows no interruptions and does not hold levees as Roosevelt used to do."

In fact, d'Inverno himself participated in this later portrait. As he later revealed, he "actually posed for Wilson's coat!" By his "posing for the coat part of the portrait the very busy president was enabled to shorten his sittings." So that, perhaps in compensation for the impositions of Roosevelt, the body of *this* president was made up of the narrow physique of Sargent's household intimate.

<div align="center">⤙⤚</div>

In February 1903, Sargent recovered from his transactions with Roosevelt by plunging into the gala opening of Isabella Stewart Gardner's magnificent house-museum of Fenway Court in Boston. Gardner's artistic re-creation of a Venetian courtyard, assembled from architectural pieces of Veneto palaces being dismantled in the 1890s, showcased her genius for creating a Boston facsimile of the Venice that both she and Sargent loved. Both of them had often stayed at the Palazzo Barbaro, as had many others of their set. The idolatrous black-and-gold full-length portrait of her Sargent had executed fifteen years before, which had seen little light since its first scandalous exhibition, now took pride of place in Gardner's sumptuous upstairs Gothic Room. But, partly to shelter this controversial painting, Belle Gardner would keep this room locked and private during the remainder of her lifetime.

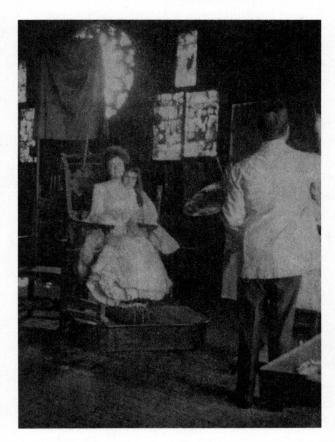

John Templeman
Coolidge, Sargent
painting Mrs.
Fiske Warren
and her daughter,
1903

At Gardner's invitation, Sargent transformed the Gothic Room into a studio and its stock of highly valuable medieval objects into props. Further darkening the already dim room, Sargent prepared to paint a sumptuous mother-daughter double portrait of progressive Bostonian salon-hostess and poet Margaret ("Gretchen") Osgood Warren and her eleven-year-old daughter Rachel.

Sargent, who held distinct ideas about costuming children, insisted on Rachel's wearing pink—as a luminous contrast in his paint to the dim earth colors, picked out with gleams of gold, by which he rendered the great gloomy room and its objects. As the right pink dress eluded them all in Boston, Sargent eventually draped the girl in a length of pink silk fabric by which he counterfeited a gown.

Mrs. Fiske Warren and Her Daughter Rachel would become a favorite in the United States. One Boston critic patronizingly remarked that Sargent had

"grown psychologically" in his portrayal of this mother-daughter relationship, Rachel's chin resting on her mother's shoulder, while pink-cheeked, light-haired Gretchen Warren gazed steadfastly out from her straight-backed Italian Renaissance armchair, a distinctly queenly figure. The painting, though some found it tender, characteristically offered psychological complication rather than easy sentiment. A polychrome sculptural Madonna lurked in the background along with other art-historical references—unusual for Sargent, but after all he was painting in a museum. The painting referenced the Madonna. Yet Sargent previously had painted any number of other mothers and children, if seldom in the modernized Madonna-like mode favored by his near-contemporary Mary Cassatt. He knew about mothers and daughters from his own family, from scenes and dynamics he'd witnessed between Mary Sargent and her two daughters over the decades. His own mother had aspired, rather like Gretchen Warren with her salon, to influence the art world. His dutiful sister Emily had likewise mostly demurred and acquiesced, even if she'd seldom chosen to wear pink, even in her girlhood.

Some less interesting portrait journey-work awaited Sargent in Boston and Philadelphia. In Pennsylvania, Sargent shook hands with the salt-and-pepper-bearded, fifty-eight-year-old Thomas Eakins. Eakins was now painting portraits himself, if less splendid or luxurious pieces than Sargent's. In spite of parallel fascinations with male physicality (Eakins had painted a series of half-naked wrestlers in 1899), the two artists failed to bond. Their sensibilities differed too much. Even their male nudes struck a contrast, Eakins being fascinated with angular, active boxers while Sargent took very little interest even in Nicola d'Inverno's now-past amateur boxing career and preferred more languid and supine male figures.

In May 1903, Sargent could finally take a rest from portraiture and board an Atlantic steamer for Europe with his omnipresent valet. As Sargent's fiftieth birthday approached, he and Nicola continued to live on a diet of travel. Sometimes Sargent ventured off with d'Inverno alone. But more often he engaged companions, some of the troop of family, friends, and hangers-on who seemed only too delighted to be invited along.

Now Sargent was bound for Spain once again. There, the works of Spanish artists such as Velázquez and El Greco, as well as sunny Spanish scenes, refreshed him in Toledo and Santiago de Compostela, after his long hours of painterly and diplomatic toil in American drawing rooms. (He'd spent nearly six months in the United States, having sailed there with his plump protégé Wilfrid de Glehn in January of that year.) After Spain, in map-

crossing peregrinations worthy of his mother's overloaded tourist itineraries, he visited Lisbon, Avignon, Chamonix, and Venice (joining his mother and sister) before at last returning to London that November.

Once back in his Chelsea studio, Sargent returned to a long string of commissions from English swells. But he felt more able to handle the strain of portraiture in Tite Street, even though, in the previous year, he'd hardly inhabited his nominal home and studio.

The foggy winter of 1904 closed in. But Sargent, in his commission to paint British colonial governor Frank Swettenham, compensated for the London miasma. He transformed his studio, lit by the low-pitched revolutions of the winter sun, into a piece of the sun-struck Asian tropics. At least he fabricated a splendid fantasy thereof. Swettenham as a sitter and subject interested Sargent more than Roosevelt had done, and he would produce two exotic, over-the-top portraits of this British colonial administrator.

Though the writer Rebecca West later dubbed Swettenham as a "bounder"—he wasn't an easy subject for Sargent to cope with—the fifty-three-year-old imperial High Commissioner of the Malay States and Governor of the Straits Settlement lent himself to the kind of lavish imperialist stage piece that Sargent could handily produce. Sargent posed him cockily in a snow-white uniform with one hand on his hip and the other hand stroking a magnificent Malaysian brocade draped beside him, the star of his knighthood and the sword of his imperial office standing out, along with his ultra-white uniform, in a crowded, sumptuous composition dominated by luxurious reds and golds and carpeted with leopard-skin.

Clearly, Swettenham shared with Sargent a taste for orientalist trappings: the two men spent "many pleasant hours in [Sargent's] studio." Though Sargent hadn't ventured as far as Singapore in his travels, he knew other parts of the "Orient" extremely well. Swettenham later acquired three works of Sargent's that depicted exoticized versions of Venice, Corfu, and Egypt (this last being *The Temple of Denderah*, painted during Sargent's pivotal journey on the Nile in 1891). Swettenham, an unhappily married man, was rumored to have had affairs with the intrepid traveler Gertrude Bell and also, in 1883, with an Anglo-Indian woman with whom he had an illegitimate child. Though not a homosexual, Swettenham ruled a province deep in Richard Burton's eroticized East and had at least some familiarity with various forms of non-Western sexuality. He demonstrated such knowledge, for example, with his involvement in the 1930s in a question of local royal succession that shut out a homosexual heir to whom the Malays themselves

did not seem to object. If both Roosevelt and Swettenham actually qualified as imperialists, Sargent preferred Swettenham's version, which appeared less naïve and conventional and which lent itself to Sargent's own orientalist staginess.

Sargent recruited the inspirations of his exotic travel—far beyond Avignon or Chamonix—in quite a few others of his late portraits. In 1900, Sargent executed a portrait of the handsome twenty-two-year-old Earl of Dalhousie, whom he was rumored to have met in the sultan's palace in Khartoum. Inevitably, Sargent painted the fair, sunburned young man in a white tropical suit with one arm akimbo, in a contrapposto that owed to Sargent's admiration for Michelangelo and Velázquez, just as his later portrait of Swettenham paid homage to Titian.

Sargent could sometimes inject his sophisticated, easy, sensual impudence into the grand-manner portraits that were now his business. He especially reveled in those sitters he could associate with the Orient, who often sparked the persistence or resurgence of the instincts that had earlier carried Sargent to Rosina Ferrara and Carmencita. Increasingly, though, instead of projecting onto "exotic" women, Sargent's theatricality now spilled over into portraits of men—gondoliers, travelers, tavern-habitués, and aristocrats. Though Sargent perennially painted large numbers of women—and often discovered manifold sympathies with his female sitters—his veneer of pretending to admire entitled or high-strung aristocratic or plutocratic women was increasingly wearing thin. Sargent confided to the publisher Wilfrid Meynell that such ladies "generally bore him so that he is obliged to retire every now and then behind a screen and refresh himself by putting out his tongue at them."

Sargent, at least, could keep his portrait-painting frustrations mostly to himself—one key to his success in the medium. His older colleague Whistler, by contrast, proved much more bearish in the studio. Even the painter William Merritt Chase, who got on with Whistler better than most, complained about how long the artist took to paint his portrait: "He proved to be a veritable tyrant," Chase recalled, "painting every day into the twilight, while my limbs ached with weariness and my head swam dizzily. 'Don't move! Don't move!' he would scream whenever I started to rest." By comparison, Sargent's rapidity was uncanny and his patience angelic.

During his sittings in Chelsea that winter, Frank Swettenham discovered that Sargent "happened to be painting the portraits of a number of [his] friends." He watched with amusement as these other compositions grew

"day by day to completion" around him. Indeed, Sargent had reached the acme of his reputation as a posh Edwardian portraitist. His frequent junkets away from London only added luster to his reputation and increased demand, and the winter season of 1904 soon grew frenzied and congested.

In London as in New York and Philadelphia, Sargent lived at the beck of a dizzying list of moneyed, powerful, and imperious patrons. In England, he not only portrayed a train of earls, countesses, and honorables but also received a request to paint the coronation of Edward VII in 1902. Sargent declined, but in 1904 he found himself re-creating a vignette of that ceremony in a grand-manner portrait of one of the bearers of the regalia for the coronation, Charles Stewart Vane-Tempest-Stewart, Sixth Marquess of Londonderry.

Such commissions paid well and attracted more elite patronage. But they tended to injure Sargent's artistic reputation, as well-known as his name was becoming, as many one-man exhibitions as he had now staged. For one thing, aristocrats themselves were a troubled and senescent commodity in Edwardian England, even before outbreak of the coming war that would shake the old social order to its foundations. As one example, Sargent's painting of the Countess of Essex in 1907 actually portrayed not an old-blood aristocrat but Adele Grant, an American heiress who had married the seventh Earl. Sargent remembered her as "infinitely nicer than the Incroyables [unbelievable people] she flocked with and didn't resemble."

Requests from wealthy patrons kept Sargent on edge. He never knew what magnate would next approach him, and in 1904 he received a summons from Blenheim Palace and the biggest commission of his career. He was to paint the family of Charles Richard John Spencer-Churchill, the Duke of Marlborough—the first cousin, incidentally, of Winston Churchill, at this point a promising thirty-year-old member of Parliament.

The Duke of Marlborough was a case in which American money even more visibly propped up a cash-strapped noble family. The Duchess, whom Sargent went on to depict as swan-necked, elegant, and a little sad, was Consuelo Vanderbilt, the daughter of the American railroad magnate William K. Vanderbilt and his ambitious wife, Alva Erskine Smith Vanderbilt, who'd ruthlessly groomed her daughter for such a marriage.

When Sargent arrived at the sprawling ducal palace near Oxford to begin his work, the Duchess noted that he was "in no wise daunted" when he "was told that he was to paint a pendant [one of a pair] to a picture in which there were eight persons and three dogs." "But," Sargent exclaimed, "how

can I fill a canvas of this size with only four people? I might, of course," he joked, "add a few Blenheim spaniels."

Sargent cracked his bon mot, then he clenched his teeth and painted, for he knew his business. His remark about spaniels wasn't idle, for he included two of the family dogs in his picture. The Marlboroughs could afford a colossal portrait—the largest Sargent ever painted—and pay Sargent's highest commission of 2,500 guineas or about $13,000, the price of a mansion in the United States, mostly because of Consuelo Vanderbilt's millions.

The Vanderbilt fortune had already, from the patronage of other family members, notably George Washington Vanderbilt, provided Sargent with a significant chunk of income. At the turn of the century, most of the money in Sargent's world *was* plutocratic, no matter how assiduously the nouveau riche tried to disguise their origins, building showy palazzi in Renaissance revival styles and commissioning portraits from fashionable painters like Sargent. For a long time now, Sargent had found himself implicated in many such vanity projects. With George W. Vanderbilt, Sargent had become involved with his great white elephant of a mammoth country mansion, Biltmore, a gigantic French Renaissance–style chateau confabulated in the rough mountains of North Carolina and meant to rival his relatives' theatrical showpieces in Newport. The painter had made a rather awkward visit there in 1895, haunting the echoing, half-finished corridors, in order to dash off portraits of Vanderbilt's architect Richard Morris Hunt and his landscape planner Frederick Law Olmsted.

As part of his great parade of turn-of-the-century plutocrats, Sargent painted Jane ("Jessie") Grew Morgan, wife of John Pierpont Morgan, in 1905–1906 and Gladys Vanderbilt, daughter of Cornelius Vanderbilt II, in 1906. But painting the wives and daughters of robber barons hardly garnered Sargent artistic credentials.

Sargent's vogue among the rich and connected made him appear more mercenary and opportunistic than he actually was. If Sargent enjoyed the freedom his hard-won prosperity gave him—though his portrait painting often chained him to London when he yearned to travel—he regarded money as "part of the machinery," according to Evan Charteris, "in which he took very little interest." Sargent painted portraits partly to help support his mother and his unmarried sister Emily, both of whom were otherwise dependent on the remnants of their modest family investments. Violet and her hapless husband, with their growing family of children, also frequently needed help. Yet in 1910 the modern painter Walter Sickert, in an assault on

what he called "Sargentolatry," attacked Sargent's fashionable opportunism, accusing "the whole craven press" of Britain for puffing an artist Sickert saw as merely a "social and commercial success."

In Chelsea or in Boston, earning a living by portraiture meant endless adaptations, concessions, and compromises. In Sargent's grand-manner pieces, the retrospective props and references to Old Masters helped him construct grandiose portraits, each executed with a ration of his painterly virtuosity, that helped authenticate and credential rank arrivistes. Also, though Sargent's classical references once marked his modern, Paris-trained sophistication—his wry, witty homage to historical nonconformist painters like Titian and Velázquez—they now increasingly rendered his elite portraits visibly lofty, old-fashioned, and retrospective, when they emerged at the Royal Academy or appeared in his patron's London mansions and country estates. And all this happened just when new schools of painting, particularly in Sargent's former home of Paris, were rendering portraiture fresh, radical, and raw.

About the time that Sargent depicted the Countess of Essex as a delicate Georgian beauty on an archaic oval canvas, Pablo Picasso, now in what would later be called his "Rose Period," was boldly portraying Gertrude Stein. He did so in warm, aggressive earth colors, rendering the unconventional Paris *salonnière* formidable and monumental. As Stein herself described the new energy of 1907, Picasso had "just finished his portrait of [Stein] which nobody at that time liked except the painter . . . Matisse had just finished his Bonheur de Vivre, his first big composition which gave him the name of fauve or a zoo. It was the moment Max Jacob has since called the heroic age of cubism." Yet even Stein admitted that this was "an art movement of which the outside world at that time knew nothing."

Certainly, Sargent knew little and cared less for avant-garde art we would now identify as Cubism, Fauvism, or Expressionism. On the occasion of an exhibition of "Post-Impressionists" at the Grafton Galleries in London in 1910–11, the critic Roger Fry tried to implicate Sargent as a supporter of this new Parisian painting. Sargent lashed back. In a letter to the editor of *The Nation* indignantly penned on Christmas Eve 1910, he proclaimed that his "sympathies were in the exactly opposite direction as far as the novelties are concerned." He declared himself "absolutely skeptical as to their having any claim whatever to being works of art."

In a subsequent letter to the Scottish painter and critic Dugald Sutherland MacColl, Sargent continued his rant against these interlopers, hinting

at "bad faith on the part of people like Matisse" and asserting that "the sharp picture dealers invented and boomed this new article of commerce." Van Gogh's paintings appeared to Sargent "like imitations made in coral and glass of objects in a vacuum," and Gauguin was admirable to him *only* because of his "rich and rare colour." As Sargent's first biographer would later emphasize, Sargent likewise "regarded the Cubists, their followers and off-shoots with uncompromising disapproval." And, as Sargent told a young art student in the 1920s, he thought Picasso was "ugly bosh, nothing else, ugly, useless, meaningless."

For years, Sargent had harbored a complicated conservative streak. By his early fifties, however, as he grew stouter, more successful, and more often lampooned as a dinner-jacket-wearing socialite, his taste for novelty and provocation had correspondingly dulled. More and more, he resisted new forms of painting by younger artists who had their own visual and philosophical agendas.

In his old-guard traditionalism, however, Sargent didn't stand alone. In such sentiments, he was joined by a bevy of confidently conventional colleagues at the Royal Academy. Even Sargent's less stodgy and more inventive friends, those Broadway Bohemians from an earlier era, tended to discount modern innovations—were often, like Henry James or Edwin Austen Abbey, rankly old-fashioned and old-world. Now decorated and honored, showered with accolades wherever he went, Sargent felt secure in his prejudices and confident of the merits of his own vision of art.

Yet other artists' innovations would soon utterly transform what the art world considered "modern." Sargent's own form of Belle Époque Parisian modernity was already beginning to look as antiquated as the Old Masters he'd long imitated. Sargent's instinctive love of safety, respectability, and tradition was now turning into a paradoxical and deadly trap.

<div align="center">⊷</div>

*No one portrait broke the back of Sargent's patience. But almost every commis-*sion strained him. He suffered from the thorny personalities of some of his sitters—though Sargent was careful not to bad-mouth his patrons—and from his own workaholic perfectionism. In 1904, for example, he painted Lady Helen Vincent, later the Viscountess D'Abernon, at the Palazzo Giustiniani on the Grand Canal in Venice. Sargent spent "spent three weeks," Charteris reported, "painting Lady D'Abernon in a white dress." But then, at what would have been the final sitting, he "suddenly set to work to scrape

out what he had painted. The present portrait in a black dress, was done in three sittings."

It was unclear if Sargent himself disliked the earlier result or if the husband, Sir Edgar Vincent, made some objection. Sargent was usually free of portrait painting when he alighted in Venice with his mother and sister on a time-honored family holiday—he primarily worked his portraits in his home studio in Chelsea or in hired or borrowed spaces in Boston or New York. This infringement on his customary liberty, perhaps blighting these otherwise glorious weeks in Venice, bothered him enough that he subsequently retailed this story to Evan Charteris. Though calm and patient on the surface, Sargent often erupted behind the scenes—for example, covering papers with the stamp reading "Damn!" that Nicola d'Inverno had observed.

Even two years later in 1906, Sargent was sufficiently imprisoned his lucrative business that he agreed to execute a rather conventional portrait of Lady Helen's financier-husband. But when, a couple of years after that, Sir Edgar wanted to commission a portrait of an additional lady, whose identity has been lost, Sargent bridled. "There is nothing I would stick at to bring about your happiness," Sargent wrote his patron from his refuge on the Spanish island of Mallorca, "except painting a portrait, a thing I can no longer do with a pair of tongs." For indeed, after a portrait career now spanning three decades, Sargent had reached his last pinch of tolerance.

"No more paughtraits," Sargent complained Ralph Curtis, using a lock-jawed parody of the word to signal his growing contempt. "I abhor and abjure them and hope never to do another especially of the Upper Classes." More tersely, he began to mutter to all and sundry, "No more mugs." As he confessed to the artist Walter Tittle, "I *hate* to paint portraits! I hope never to paint another portrait in my life." By 1907, Sargent was ripe with such grievances and doing his best to refuse any future commissions. His last burst of grand-manner oil portraits went up at Burlington House in 1908.

To friends who'd followed Sargent's portrait-painting career and who'd eavesdropped on his sittings with patrons—including those where he stuck out his tongue out at them from behind a screen—what was most astonishing wasn't that Sargent virtually ended this career at the age of fifty-one but that he'd endured it for so long. Shy and taciturn, valuing his privacy, Sargent had suffered agonies for years under the enforced, intimate tête-à-têtes that portrait painting required, not to mention the immense work and ingenuity. As he expressed this strain to Jacques-Émile Blanche, "Paint-

ing a portrait would be quite amusing if one were not forced to talk while working. What a nuisance having to entertain the sitter and to look happy when one feels wretched." To Walter Tittle Sargent complained, "Portraiture may be all right for a man in his youth . . . Youth can better stand the exactions of a personal kind that are inseparable from portraiture. I have had enough of it."

Sargent also remarked to the same colleague on the necessary "manual dexterity" and "colour-sense," which age tended to compromise. But the artist's linkage of portrait painting with youth also implied that the energy required—the "exactions of a personal kind"—sprang from an avid interest in human beings, in their emotional and physical makeup, that Sargent had gradually ceased to feel, at least when confronted with stodgy, conventional sitters. He'd always thrived on the undercurrents of his subjects, their subtleties and secrets. But now Sargent yearned to give up formal portraits altogether. He was paralyzed with fatigue. At the same time, he remained fascinated by figure studies and nudes and, as was about to become clear, not only for his perennial mural projects in Boston.

Yet another factor deepened Sargent's weariness. Subtle rebellions had enlivened his earlier public paintings even if he'd often taken refuge in his private work. Now, though a bachelor-aesthete, he'd had to hew to the endless and stifling conventions of the establishment. Again and again, he'd composed facsimiles of power-brokers, marriages, families, and dynasties. Even with his fits of subtle or secret rebellion, small twitches of unruly paint, his patrons bled him dry. Sargent wryly reiterated versions of the phrase, presumably his own, "A portrait is a picture in which there is just a tiny little something not quite right about the mouth." Here he referred to the burden of patrons' expectation of verisimilitude, or perceived verisimilitude. But, especially by focusing on the mouth—that signal feature of emotional and sensual expression, not to mention voice—he hinted at more fleeting yet profound characteristics of human beings that he had long been obliged to mask, translate, or render acceptable.

In his exhaustion, in his disgust, Sargent emotionally pulled back but continued to crank out likenesses, dozens and dozens of canvases every year. In July 1905 in Tite Street, Sargent painted a long-deferred portrait of Joseph Pulitzer, an Americanized Hungarian Jew with a Van Dyck beard. The sixty-eight-year-old Pulitzer behaved with "singular sweetness," his secretary recorded, even though the remodeler of the *New York Evening World* and onetime Congressman had a reputation for an "irascible and im-

patient temper," even after his breakdown from overwork had rendered him debilitated and half-blind. "Sometimes I get a good likeness," Sargent cautioned Pulitzer, "so much the better for both of us. Sometimes I don't—so much the worse for my subject, but I make no attempt to represent anything but what the outward appearance of a man or woman indicates." Sargent wasn't lying; he was reciting his painterly creed of many years. He did paint just what he saw. But his visions surprised and startled others—sometimes, to Sargent's discomfort, bewildering his patrons themselves. For what he saw wasn't what everyone else saw.

In August, leaving his racks of ready canvases behind, Sargent set off with a festive party of friends for the Alps. He longed to escape from London and explore points farther East. He could hardly have anticipated that a happening in Palestine in winter 1906 would enable him to make a clean break with the onerous profession, once and for all.

24

East of Jordan

Seen from the high meadows of Giamein, the Matterhorn was still snow-streaked above the Plateau Rosa glacier, even though warm, clear late-summer weather invited the painting of watercolors in the lush meadows below. By August and September 1905, Sargent's Alpine walks with his father and his early teacher Charles Feodor Welsch lay thirty-five years in the past. But the forty-nine-year-old painter's appetite for the Alps, and for leisurely painting among those crags, streams, and pastures, had hardly slackened. And, as in those now-remote times, Sargent traveled with a family party, even if his working definition of family had changed quite a bit over the years.

At Purtud, in the mountain-lined Aosta Valley of far-northern Italy, Sargent basked in the company of his thirty-five-year-old married sister Violet Ormond and her daughters Rose-Marie and Reine, aged twelve and eight. Brown-haired, brown-eyed Reine, depicted in a pink hair-ribbon and frock with her brother Conrad in an oil portrait of 1907, embodied the freshness that Sargent himself increasingly lacked. Reine and her older sister Rose-Marie cheered and enlivened their uncle. A few years later, he painted them flanking his sister Emily in an intimate composition called *Simplon Pass: The Lesson*. His nieces became frequent subjects for him in the Alps, in idyllic, pastoral figure studies as well as in personalized portraits.

In the Alps especially Sargent could escape from the world of exacting portrait commissions and enjoy himself by painting watercolors—a medium that increasingly delighted him—of anything he fancied. From his many excursions into the Alps and elsewhere he had any number of such productions, though he tended to denigrate them if anybody asked to see them, describing them to one later friend with inventive self-deprecating and satirical titles, including "'Vegetables,' 'Dried Seaweed,' 'Troglodytes

of the Cordilleras,' 'Blokes,' 'Idiots of the Mountains,' and 'Intertwing-les.'" "Intertwingles" was Sargent's nickname for the relatives he liked to portray—his sisters or nieces. Also, his disciple Wilfred de Glehn's wife, Jane, born an Emmet, was a cousin of Henry James's whom the novelist had mirthfully also dubbed an "Intertwingle."

At Purtud Sargent also went on long afternoon painting expeditions with his fair-bearded, fortyish English painter-friend Lawrence Alexander ("Peter") Harrison, whom he'd known since his days at Broadway. Sargent had previously visited the Alps with Harrison, and in 1902 he'd dashed off an oil portrait of him standing booted in a dim Alpine barn. Harrison and his wife lived in Cheyne Walk in Chelsea, and there they mixed freely with Sargent, his sister, and his mother, as did Peter's lithe and ironic brother, nicknamed "Ginx." Sargent was now traveling with Harrison and his family to the Alps almost every year.

About this time Sargent executed several pencil and watercolor sketches of Peter Harrison asleep in daylight among the white linens of beds in Al-pine inns. These affectionate, informal portrayals were prompted by room-sharing. They provided a glimpse of the more intimate arrangements of Sargent's friendships with male companions. Still, in these sketches, Har-rison remained fully dressed, still wearing even his shoes, as if he'd simply collapsed on the bed from fatigue. Wide awake, with a pencil or brush in hand, Sargent paid particular attention to his friend's craggy features. Also, in works like *In Switzerland*, Sargent captured Harrison's long slender legs in khaki trousers, his extended arm, and his limp, open hand (see Fig. 25). Sargent gave at least one of these comradely watercolors to Harrison's wife, "to the Comaniac," with whom he shared musical obsessions; another he inscribed to Harrison himself.

One of the most provocative of these informal pieces, *Peter Harrison Resting*, depicts Sargent's friend spread out on the ground beside an Alpine log wall, one leg stretched out, the other cocked sharply up. The art histo-rian Fairbrother has identified this pose as homoerotic, and indeed several of Sargent's sketches of his friend show a predilection for such languorous or angular postures—reminiscent, too, of Sargent's fascination with Paul Helleu's bony knees a couple of decades earlier. Sargent demonstrated a visual captivation with Harrison that hints at complexities in their close and companionable friendship, especially as it unfolded during their long Al-pine holidays. That Harrison's long, bony body lent itself to the slenderness and delicacy the era associated with "inverts" also shows up in Giovanni

Boldini's portrait of him from 1902, in which the young artist sits jauntily sideways with crossed legs, one slim hand splayed over the arm of his chair.

Sojourning at an inn in Giamein or Breuil-Cervinia, across the high and glaciated massif of Monte Cervino from the Swiss high-altitude resort of Zermatt, Sargent's party later included both Peter Harrison and his brother Ginx, Alma Strettell Harrison, and several respectable, artistic, and well-connected women. As so often happened with his male painter friends, Sargent also liked Peter's wife, Alma, a poet fascinated with Spanish folk music as well as Wagner. During this stay, when the party was sheltering from the high-altitude sun under the trees, Sargent painted a rather free and spontaneous watercolor portrait of Alma, who was thirteen years older than her husband, her brown hat trimmed with pinkish flowers.

For Alma's portrait, Sargent's focused only on the head. Still, during some of these parties during these years, Sargent also painted women lying or sleeping on the grass—outside, not in bedrooms—their intricate, voluminous skirts contorted into fantastic shapes that some critics have also found sexually suggestive, though these potential sexual references may be either unconscious or, on the other hand, satirical.

Sargent's pleasure party in the shadow of the Matterhorn gathered the gracious, lazy, cultivated Alpine tourists among whom he loved to loiter, freed from the tyranny of his Chelsea portraits. Here he was more relaxed than he tended to be in London or Boston. Such insouciant episodes proliferated in an itinerant, travel-heavy set of yearly rituals, rendered with constants and variations, which Sargent increasingly patterned after his mother's and which now also compensated him for his London toils.

In autumn 1905, Sargent also looked forward to more liberating travels farther south and east. More "research" for his Boston murals was now in the offing, now that he had installed his second series of decorations and was working on his third, destined for the vault, in which he would eventually treat holy mysteries—joyful, glorious, and sorrowful—as well as a vision of the Judgment and the Passing of Souls into Heaven. With inchoate schemes as yet, Sargent planned a trip to Syria, where he hoped he could get "new fuel for his decorative work," to find particularly biblical scenes and figures.

For a nonbeliever like Sargent, of course, biblical didn't exactly mean prudish. Though his Boston Public Library murals remained sober and decorous—sometimes to the point of being sententious and uninteresting—

Sargent tended toward more dynamic views of scriptural themes, and the scenes he would eventually concoct would be grandiose and crowded with tangled human figures.

Back in the 1890s, Sargent had contributed several monochrome images for an illustrated Bible being published in London. He'd chosen to depict the passionate friendship in the Old Testament between David and Jonathan. These rather homoerotic pieces were never published in this Bible in 1899, possibly because they were too suggestive, especially in the wake of the Wilde trials. Sargent's *The Parting of Jonathan and David* especially, as Fairbrother describes it, shows that "Sargent could romanticize physical closeness between men. The ardent exchange between prince and soldier . . . echoes the biblical description of their friendship: Jonathan loved David 'as his own soul,' and David lamented Jonathan with the words 'Your love to me was wonderful, passing the love of women.'"

The phrase echoed the formula often used to justify the romantic friendship in which Sargent had long enthusiastically participated. Even in the early twentieth century, he continued to pursue such friendships with male comrades like Peter Harrison.

In the spirit of past romantic friendship, in fact, this journey to the Levant was the very one on which John invited his longstanding if half-estranged friend, Albert de Belleroche. Though Belleroche had continued as an artist—and Sargent had episodically been in touch with him, sometimes seeing him in Paris or borrowing his studio—the younger painter had not achieved anything like Sargent's success. In 1900, Belleroche moved from oil painting to lithography, mostly favoring images of women in rather frowsy dishabille. He pursued a decade-long affair with the artist's model Lili Grenier, who'd earlier worked with French painter and caricaturist Henri de Toulouse-Lautrec. In 1910, Belleroche would marry Julie Visseaux, the daughter of a little-known French sculptor, and he would eventually settle in the green depths of rural England to raise three children and pursue his lithographs.

In his 1905 invitation, in offering to pay Belleroche's way, Sargent lobbied hard for the younger painter to join him. His urgency belied the seeming nonchalance of his earlier Alpine party. And Belleroche came within a hair's breadth of joining Sargent, initially reflecting "how our friendship would increase by this long journey." Belleroche then arrived at the perhaps disingenuous conclusion that "a journey like this with Sargent might influence my art and affect my expression." So, unable to persuade any other

The Parting of Jonathan and David, c. 1895

gentleman—including either his friend Peter Harrison or his protégé Wilfred de Glehn—who with his wife otherwise regularly accompanied Sargent on Italian travels—Sargent determined to travel on alone. "Alone" meant, of course, that he would take the inveterate, built-in Nicola.

It's unclear if in summer 1905 d'Inverno also stayed with Sargent and his party in the Val d'Aosta. It's likely, though, that Nicola was also on hand in the Alps, carrying easels, canvases, and paint boxes for Sargent across meadows and up mountain trails. Yet an intimate portrait of him reading that Sargent painted at about this time—reminiscent of the inn vignettes of Peter Harrison—could have been painted almost anywhere. This small, personal, informal painting, entitled *A Man Reading* or *Nicola Reading*, shows Sargent's thirty-two-year-old valet leaning on his side across a snow-white pillow. His arm, bared to the elbow, props up a handsome, mustached face. He peruses a book folded back on itself, looking comfortable and informal (see Fig. 27).

Is this Nicola reading in bed? Even more than Sargent's images of Harrison, this portrait emanates companionable bedroom intimacy. It adopts a view that no normal master would have of his servant. The very protocols of British domestic service—servants' quarters, separate chambers and passageways, livery, bells for summoning—were designed specifically to avoid informality or intimacy. Even if no other evidence of Sargent's relation with d'Inverno had survived, this curious piece would suggest much. This understated domestic vignette—hidden in plain sight—says almost more about these men's close-quarters relation even than the nudes Sargent sketched in his studio. In the early twentieth century, Sargent also employed the Anglo-Italian family of Mancini—five different brothers—as nude models, but Sargent continued to paint Nicola in the nude until at least 1914.

As for this intimate bedroom glimpse of d'Inverno, the artist's view was purely personal. Sargent wasn't a conspicuous egalitarian—someone who wanted to erase class distinctions on principle. The intimacy, the lapse of conventions otherwise dear to a "gentleman" like Sargent, sprang from a different source. Indeed, this portrait simply recorded an everyday view of Nicola from Sargent's side of the relation.

-<-

In September 1905, Sargent and d'Inverno boarded a steamer together from Brindisi to Port Said in Egypt, sailing from there to an unknown port on

the eastern shore of the Mediterranean. They'd spend that sunny autumn and part of the winter together in Palestine and Syria, and we know about their probable itinerary and sojourns chiefly from almost seventy surviving works, sketches and more finished paintings in watercolor and oils, that Sargent produced during this expedition. "I shall fish here for a while," Sargent wrote Elizabeth Lewis, "and try to bring back some weightier stuff than lots of impossible sketches and perhaps useless studies."

These travel vignettes underpinned Sargent's continuing mural project at the Boston Public Library. They included architectural views and landscapes in and near Jerusalem, Moab, Mar Saba, Bethlehem, Galilee, Tiberias, Baalbek, and points farther afield in Syria. Sargent's deeply ingrained orientalist perspective often dominated these colorful, limpid views of ruins, mosques, and desert landscapes, though for some reason he also produced quite a few sketches of horses and mules in stables and elsewhere. Animals as well as children had fixed Sargent's attention since his adolescent sketchbooks. Sargent eagerly sketched almost everything he saw, but he confided to his friend Lady Lewis that, if he'd secured some new material, it was "different from what I had in view and not abundant."

Sargent's figure studies on this expedition mostly focused on desert Bedouins in flowing robes and headdresses—an obsession with Middle Eastern costume and atmosphere that harkened back to his revelations in Egypt some fourteen years earlier, even if he once again sought biblical models for the murals. Yet, as in Egypt, Sargent's attention often focused on handsome young men, Bedouin men. The most notable of these was his *Bedouin Chief*, a striking portrait of a dark, mustached young man wrapped in a red-and-white woolen cloak, with his brown bared arms, possibly resting on his knees, crossed horizontally in front of him. This man radiated the assertive, brooding quality of young Italian men Sargent had painted since the 1870s and who very much constituted Sargent's preferred type.

Even on the loose in the desert, however, Sargent continued his family entanglements. He worried about his seventy-nine-year-old mother and the most recent stage of her lifelong ill health, actual or imagined. When reports reached him that, staying in Spain with Emily, she had contracted an abscess of the ear, he offered to come home to help look after her. But Mary refused. Ever resolute and independent, she assured her son that she was already getting better. As was her lifelong habit, she was already going out into the world.

Then, abruptly, when he was somewhere east of the Jordan River in late

January 1906, Sargent received a telegram. His mother had died of a heart attack.

Stunned and stricken, Sargent halted right where he was. He immediately made arrangements to head home. In an agony of grief and self-reproach, he waited for a ship at the port of Jaffa. After he and d'Inverno arrived back in wintry London on February 2, he confided in his close friend Mary Hunter, "Just now I seem to feel nothing at all—but I have had bad spells."

Matters continued to unfold at a disconcerting speed: Sargent and his sisters buried their mother in Bournemouth, next to her husband Fitz, on February 5. "Everything is dreadful," Sargent wrote Elizabeth Lewis, "except that her friends were good and that death itself came unsuspected and unrecognized." Yet Mary Newbold Singer Sargent, a traveler to the end, had bequeathed her equally itinerant son a haunting legacy. Letters she'd written before her death would continue to catch up with him, he confided in Mary Hunter, "affectionate and cheerful and telling me she is getting better."

Such letters, however, were the least of Mary Sargent's bequests. Her influence on her son had always been outsized, and it remained profound. Late in her life, though based in Cheyne Walk with her daughter Emily, deliberately fixed near her dutiful son, Mary had continued to travel quite extravagantly—not only her late trip to Spain but also, in a junket strangely parallel to her son's, a tour of Greece and the Middle East in 1904, when she was fully seventy-eight years old. All through her life, even if most influentially in John's childhood, she'd dosed her son with continual tourism, rendering great swaths of both the New World and the Old World, the Middle East in recent years in addition to the Mediterranean, available to her son's restless vision.

John's bereavement, deep and raw, showed up in his letters. He penned them to women confidantes, and he imbued them with more feeling than his telegraphic, matter-of-fact correspondence usually channeled. Yet Mary's deeper impact on him, including her love of bright, colorful, and novel foreign places, continued to pulse through his life. After his mother's death, Sargent would only intensify his lavish affair with a grand, lyrical Europe that his mother had loved and tried to capture through her own paint box. Her passing, if anything, would throw him even deeper into that beloved and chameleonic world.

◄◄

After Mary Sargent's death, John girded himself for a conversation with Emily.
His sister was now on her own, forty-nine and still single, alone in the
world but for a few older women friends. He wasn't about to abandon her.
Gamely, warmly, he took her aside and suggested to her that they keep
house together.

Emily was gratified. She deeply loved her brother, and such a partnership
would cement their natural and lifelong alliance. But Emily hadn't known
her brother inside out for years, for nothing. She sensed, as she later con-
fided to her friend and sometime travel-companion Eliza Wedgwood, that
after "many years as a bachelor," her brother "would find it irksome" to live
at such close quarters with her. If Emily harbored other reasons for turning
down her brother's offer, she didn't enumerate them. But, for one thing,
their mother's death now enabled Emily, for the first time in her life, to stand
on her own instead of in the shadow of her mother. She relished her own
independence.

As for John, Mary's passing lessened his burdens, meant that he had one
fewer person to look after emotionally and financially. John still held his
sisters close, kept even closer track of both "Em" and "Vi"—Emily with
her stiff back and social isolation; Violet with her restless exuberance and
her sometimes-problematic marriage. Violet also came with her train of
rosy, venturesome, growing children, many of them headstrong like herself,
nieces and nephews who would increasingly clamor for Sargent's time and
attention. In 1906, these were Marguerite, Rose-Marie, Jean Louis, Guil-
laume, Reine, and Henri, ranging in age from fourteen to eight. Yet in spite
of these intensifying avuncular involvements, Mary Sargent's death made it
easier for John to announce a momentous and long-deferred decision. He
could now do without the money, and he could certainly do without the
stress and frustration. He pledged to quit portrait painting for good.

Thus released, he fetched a deep breath and took even longer journeys
away from London. As Sargent's first biographer put it, "Every autumn
after his mother's death . . . would see him crossing the Channel, always
with his sister Emily, and either with the de Glehns or Miss Eliza Wedg-
wood [John's old friend who increasingly bonded with Emily], or with the
Misses Barnard [Polly and Dorothy, whom Sargent had known since they
were children at Broadway], or Mrs. Ormond and her children, bound for
some sketching centre in Italy or Corfu, Majorca or Spain, or in the Val
d'Aosta." On these excursions, too, he took Nicola d'Inverno along, with
Sallie d'Inverno or not. Sargent also frequently traveled with married male

artist-friends like Peter Harrison or his perennial copycat painter and hanger-on, the stout and meticulous Wilfrid de Glehn.

These ritual and often seasonal excursions, with their breathtaking Alpine or Mediterranean backdrops, would continue until 1914. In them, Sargent revisited and restaged his family's Continental pleasure-rambles. As these sojourns often involved Sargent's family and old friends, they also radiated the rural and domestic insouciance the painter had relished at Broadway more than two decades before. Yet, as at Broadway, these group excursions also channeled some pretty restless and exotic content. One year, Charteris reported, Sargent "travelled with a stuffed gazelle, bought at Rowland Ward's [a famous London taxidermist in Piccadilly], which was to figure in some landscape." And in 1907, at Peuterey in the Aosta Valley, Sargent painted a series of fantastical orientalist figure studies in the rich, sun-struck grass beside a stream, using his obliging friends and family as fancy-dress models.

One of the most striking of these, *The Chess Game*, portrays a young man and young woman enveloped in luxurious, patterned Turkish-style fabrics lying beside a chessboard and next to a stream (see Fig. 26). The whole canvas is meticulously composed but flamboyantly colored, with rapid, seemingly carefree brushstrokes. The two appear to embody a romantic, heterosexual pairing in an idyllic, Arabian garden drawn straight from Arthur Boyd Houghton's decorous Victorian illustrations in John's dog-eared childhood copy of *Dalziel's Illustrated Arabian Nights' Entertainments*. But less conventional, more Burton-like *Arabian Nights* implications also lurk in this piece. For the models were Sargent's fourteen-year-old niece Rose-Marie Ormond and his thirty-four-year-old valet Nicola d'Inverno.

In this gorgeous orientalist kaleidoscope, a burst of painterly pleasure, the most focused details were the handsome dark features of the man wearing a skullcap. Sargent also focused on the man's pale feet and ankles. These vulnerably protruded from his loose, deep-pink, Turkish-style pantaloons, one foot turned up tenderly against the other ankle.

Sargent had earlier painted bare feet of Bedouins in the Middle East. Now, d'Inverno's naked feet and legs starred in this and at least two other compositions; so did the younger man's rather rugged, handsome features, mustache, and dark hair under the dramaturgical skullcap. Such props were oddly reminiscent of the exotic decorations imposed on sensual fantasies by homoerotic photographers like Wilhelm von Gloeden and Guglielmo Plüschow, working in Italy at this same period, even though Sargent's versions

were oriental-themed as opposed to Greek and at least in this case didn't include nudity.

These pieces were also set in Sargent's wholesome family milieu. Jane de Glehn, a frequent member of Sargent's traveling entourage, described the fifty-three-year-old artist in 1909 as a "funny old dear" whose reaction to an Italian holiday made him "just like a child." But even or especially when not traveling in the East itself, Sargent craved its visual and voyeuristic liberties. And he pursued such visions—as he'd done decades earlier in the Cotswolds—in the midst of the seemingly wholesome domestic environment that otherwise favored familiarity, safety, and comfort.

—◆—

As Sargent entered his fifties, old friends dominated his life. But the semiretired portrait-painter also made new friends. And two or three of the most important of these came to him, paradoxically, through one of his last high-profile exhibition oil portraits, in 1907.

His new patron was Lady Aline Sassoon, a forty-two-year-old society hostess whose fashionable connections included King Edward VII—a close personal friend, so that her children would later hobnob with other royals. She also belonged to the so-called Souls, that group of intellectual and politically progressive aristocrats. Though married to an enormously wealthy Jewish baronet and Liberal Unionist politician, Sir Edward Sassoon, Aline had also been born to the purple. She was a blood Rothschild who'd been exquisitely brought up and educated in Paris.

All in all, Aline personified the brand of cosmopolitan Sargent found most compelling. In his three-quarters portrait of her, he picked out her exquisite qualities. He depicted her in a black opera cloak with black ostrich feathers in her hat, her delicate face taut and pleasant. In light, energetic brushstrokes, he captured both daring and subtle qualities that struck critics as creating "an ensemble of great magnificence" reminiscent of the grand canvases of Rubens.

Yet Sargent's friend Charteris felt that the painting, though noble, portrayed a "highly strung temperament" and gave "an impression bordering on flurry." Aline didn't entirely like Sargent's interpretation of her, either. Not only did she find, inevitably, "a little something wrong about the mouth" but also she didn't much care for Sargent's rather free-spirited rendering of her pearls and her too-long, pink fingers. But such tensions—always present in Sargent's portraits and usually productive—didn't hinder Sargent

from forging a friendship with Lady Sassoon and her family. He courted the Sassoons as he'd cultivated the Wertheimers a decade earlier. And, as with the Wertheimers, Sargent would revel in this Jewish family's culture, intelligence, liveliness, and daring.

In 1907 Aline's daughter Sibyl Sassoon had just turned thirteen, but she would soon become one of Sargent's most important friends and confidantes. Aline Sassoon died from cancer in Paris in 1909, and was much mourned, not least by Sargent himself. In tribute to her, the painter kept up with her two children, rather looking after them as he did his own nieces and nephews. Sargent played piano duets with the adolescent Sibyl and went out on rides with her in the Bois de Boulogne in Paris. (His horsemanship remained shaky.) When in 1913, at the age of nineteen, the motherless Sibyl married the handsome young Earl of Rocksavage, Sargent—who had otherwise foresworn portraits—executed one as a present. The result was a dignified, stylized, introspective picture of the young bride, wrapped in a pale-yellow cashmere shawl.

Though imitating a seventeenth-century portraiture, *The Countess of Rocksavage* amounted to a personal gesture, inscribed "To Sibyl, from her Friend John Sargent." And this tribute came at a difficult moment in Sibyl's life. She'd married a gentile; neither husband nor wife initially converted to the other's religion. At least one contemporary Jewish historian, Cecil Roth, felt that "the pious founders of both families [Sassoons and Cholmondeleys] had turned in their graves." Thereafter, Sibyl and her brother, who later also lost their father, "saw almost nothing of their Rothschild relations" in France, according to another family biographer, till after the Second World War. Sargent, meanwhile, supported Sibyl. He appreciated her defiant, unconventional spirit. It was fitting, too, that he loaned his young friend the yellow satin dress in which, decades earlier, he'd costumed Carmencita. He freely shared with Sibyl that symbol of his own youthful defiance.

Except for her husband, Sibyl maintained her strongest bond with her older brother Philip. Sargent also cultivated this young man, if with less ease or avidity than he accorded the warm and expressive Sibyl.

When Sargent had painted his mother's portrait in 1907, Philip Sassoon had been a slender, rather haunted eighteen-year-old with black wavy hair and heavily lidded dark eyes. Only a few years later, after the premature death of his father, Philip, at the age of twenty-three, inherited his father's title of baronet. He stood for his father's seat in Parliament and won it. And he received a fortune that eventually amounted to over a million pounds

and that transformed him into one of the richest men in Britain. With astute political instincts that would assure him a long and successful career, Philip Sassoon also loved the arts. With a bevy of properties in which to stage parties, benefits, and exhibitions, he turned into a legendary host. He became a male version of the bold, intrepid art hostesses who'd dominated London and Paris during his mother's generation and Sargent's.

Besides remodeling his parents' houses in Park Lane and at Trent Park in Herefordshire, Philip had further architectural aspirations. Beginning in 1912, he built his own fantasy villa near the village of Lympne in Kent. A Dutch Colonial mansion with colonnades, verandas, fountains, and bell-gables, Port Lympne, as the new house was called, displayed an over-the-top style, flamboyant and orientalist, that recalled Philip's family antecedents in Iraq and India. The house also showcased his theatrical and provocative tastes. Sassoon commissioned a lapis-colored dining room with gilded chairs and jade-green cushions, a tribute to the avant-garde, queer style of Sergei Diaghilev's Ballets Russes. He then added wall murals by the Catalan artist and Ballets Russes scene-painter Josep Maria Sert. Sert mixed with Gide, Cocteau, Colette, Proust, and other queer Parisians, and his outlandish tastes outstripped even Sassoon's, for whom he concocted images of elephants and nude Africans.

Such camp was over-the-top even for Sassoon, who had these murals painted over in the 1930s. Sassoon, heavily self-controlled and publicly vigilant, allowed himself such whims only in his private life, and even then, he kept them under some regulation. Even so, his decorative fantasies didn't really match Sargent's more elegant and now increasingly old-fashioned orientalist style. But the painter often stayed over at the villa in the late 1910s and early 1920s, with every indication of enjoyment. Sargent appreciated the freer atmosphere at Port Lympne even if it wasn't quite his cup of tea. He'd leave many a playful, high-spirited sketch in the Port Lympne visitors' book.

As well as hosting parties in sumptuous environments, Philip Sassoon soon made his mark as an art patron and collector. Initially, he acquired works by the young British artist Glyn Philpot, whom Sassoon met at an exhibition in 1913. Sassoon chose Philpot's portrait of Nijinsky in *L'Après-midi-d'un-faune* as one of his first purchases. Philpot, a fresh thirtyish Symbolist-inspired portraitist who chose striking and sometimes radical subjects, would increasingly create homoerotic images of handsome young men. Sassoon pounced on such content. Philpot himself conducted a relationship with the painter Vivian Forbes in the 1920s and 1930s, and his

works eventually grew too bold for his times. His masterwork *The Great Pan* was rejected with great fanfare by the Royal Academy in 1933. (In outrage, Philpot moved to more open-minded Paris.) Rejection was the price of the openness he'd attempted. That danger was something that Sargent, a painter from an earlier generation, had always grasped and assiduously avoided.

Since he was a teenager, Philip Sassoon had known and appreciated Sargent's work. He soon began to acquire it—to fill his house in Park Lane with Sargent's paintings, building his collection on the portrait of his mother he'd inherited. He likewise acquired several Sargents that depicted beautiful and exotic young men, notably Sargent's so-called *Head of a Gondolier* and *Sketch of a Bedouin Arab*. Sassoon's flamboyant tastes and mannerisms, which he was unable or unwilling completely to disguise, amounted to an open secret. It's unclear, however, the extent to which Sassoon understood Sargent as a painter who shared similar erotic proclivities. For although Sassoon belonged to a younger, less inhibited generation, and although he'd achieved early financial independence, he ultimately proved at least as circumspect about his private life as Sargent had been for decades.

Sargent and Sassoon found they had more in common, in fact, than their different personalities suggested. Both disavowed too much openness and evaded the taint of homosexuality. Both were conspicuous lifelong bachelors; both circulated in suspect aristocratic and bohemian circles; and both immersed themselves in queer aestheticism and exoticism. But both also kept an iron grip on their privacy, being careful to eliminate any scrap of incriminating evidence.

Most historians have assumed that Sassoon was homosexual—as did many of his contemporaries. But, according to his most recent biographer, virtually "no evidence of his sexual activities" has survived, and "not surprisingly," given both the elusiveness of such evidence and the grim prohibitions of the time. A couple of personal notes to a fellow British army officer called Jack are highly suggestive. Sassoon may have traveled with this man to Spain in 1920. But Sassoon remained largely enigmatic and silent, eschewing close male friendships even more than Sargent had done. Like Sargent, Sassoon wanted to preserve his social standing. In his case, he had to negotiate rough-and-tumble politics as well as the gossipy art world. He knew that any sexual scandal could devastate him. In some ways more visible and obvious than Sargent, he was also, compensatingly, even more guarded.

Sargent frequented the Sassoon houses, but he and Philip, though mutually attached and professionally allied, failed to forge an intimate friendship. The two men's continued formality—or mutual canniness—shows up in the late portrait Sargent painted of *Sir Philip Sassoon* in 1923. That Sargent even agreed to paint a portrait of his friend and patron at this late stage shows an unusual degree of personal loyalty and commitment. Oddly or tellingly, Sargent also once more used—and perhaps for the last time in a formal portrait—that fraught and characteristic gesture of hand on the hip—though the pose is all but lost, due to the dark background of the portrait and the sitter's black formal dress. Yet the figure's dignity and hauteur, though handsome and sensitive in its way, comes off as forbidding, coldly elegant, and uncommunicative. It's quite different from Sargent's more empathetic and introspective representations of Philip's younger sister.

Sometimes, Sibyl Sassoon Cholmondeley filled in as Sargent's confidante, as Ena Wertheimer had earlier done and sometimes continued to do. By now, Sargent showed an entrenched preference for female intimates, modeled on his old bond with his mother and sisters, especially his sister Emily. But if Sargent told Sibyl about any private matters, she proved the soul of discretion. Indeed, as a loyal sister, she gave away nothing about her brother, either. With Sargent, though, the matter may have been simpler, as he probably confided even less. For a man who'd tailored a life out of extreme privacy, affection rarely led to divulgence. Still, as the last years of his life unfolded, his need for empathy was only increasing.

25

Detonations

When the stout, seventy-year-old Henry James arrived at Sargent's Tite Street studio on the morning of May 18, 1913, he didn't have far to walk. Carlyle Mansions, the block of flats in Cheyne Walk where he stayed when in London, lay just along the Thames, only a few streets away from Sargent's house. Sargent's sister Emily also lived in Carlyle Mansions—had kept at least a nominal lease there since 1891, and until 1906 with her mother. Though James had signed his lease much more recently, and though he still owned a small, neat Georgian mansion called Lamb House in Sussex, he was now Sargent's neighbor and almost, like Emily, a family member. Sargent and James had now known each other for more than thirty years, since they'd met in Paris through Henrietta Reubell in 1882. Even Sargent's pied-à-terre in Chelsea amounted, in a sense, to James's own doing.

Yet, though mutual loyalty, affection, and affiliation welded them together, Sargent and James greeted each other rather stiffly. The present situation, in fact, was rather straining their friendship. By a special arrangement, James was to sit for a portrait. Sargent, who hadn't regularly painted portraits for six or seven years, protested that he'd "lost his nerve" for such work. He "must reserve the faculty of destroying or not delivering the picture," James reported his saying, "if he didn't succeed in pleasing himself."

Besides being allergic to portraiture—recoiling from its head-to-head encounters—Sargent had already suffered from bad luck when trying to portray James. In the 1880s, at Broadway, Sargent had attempted a drawing. But the result had "pleased no one," and Sargent had complained that it was "impossible to do justice to a face that was all covered with beard like a bear." He destroyed the sketch himself.

In recent years, James had given up the obfuscating ursine beard. He was

bare-faced, now, and mostly bald, with a large, solemn, baby-like face. But that wasn't easy to draw, either. The year before, in 1912, Sargent attempted a charcoal sketch of his old mentor and friend. James thought it was a "complete success" and an "admirable drawing." But Edith Wharton, who had instigated the project, didn't care for it. That portrait too had *almost* been destroyed.

The present attempt, also masterminded by Edith Wharton, was supported by 269 subscribing contributors, including Sargent's sister Emily, who wanted to honor the magisterial novelist with a portrait on his seventieth birthday. But even these good intentions introduced thorny problems, as it was awkward for Sargent to paint an old friend to whom he owed so much, for money. Sargent well might have "done the thing *gratis*," as Max Beerbohm quipped, especially as Sargent was "such a devoted friend of H.J." and "the most sensitive and most correct of men." In the end, Sargent received no remuneration. The five hundred pounds subscribed by James's friends went to purchase a reproduction Charles II porringer and dish for the elderly novelist's birthday.

At Tite Street, though, the first sitting went surprisingly well. Sargent "got at it and *placed it*," James thought, "within the first half hour." He tackled it straight on, in "more or less full face." Still, such a showdown wasn't easy—James would eventually sit for Sargent nine times that May and June, though he considered it put "repeated holes" in his "precious mornings," before Sargent felt satisfied.

The painter even urged James to bring somebody else to provide conversation. (Sargent hated making small talk while he worked.) "He *likes* one to have a friend there to talk with and to be talked to by," James remarked, "for animation and the countenance etc., and I didn't have one today and we perhaps a trifle missed it." Accordingly, the novelist invited his handsome thirtysomething protégé, the Irish-born, grouse-hunting Jocelyn Persse, to keep him company in Sargent's studio, though the young man evidently never turned up to alleviate the old friends' tête-à-tête.

When finished, the portrait pleased James immensely. It struck him as "a very fine thing indeed," and "a masterpiece of painting," even if it showed him as "all large and luscious rotundity." Sargent, indeed, represented the novelist's solid, distinguished form in dark clothing that blended with the dark background of the piece. Only his wing-tipped white collar and gray-striped waistcoat, festooned with a watch chain, stood out, aside from his lit pinkish face. Yet Sargent also captured thoughtful subtleties of expression.

Especially James's mouth, the novelist and others thought, looked convincing: "Than which he has never painted a more living, and, as I am told, 'expressive.'" In this case, for once, nothing went maddeningly wrong with the mouth, as in Sargent's timeworn complaint. With James's ringed left hand hooked into the pocket of his striped waistcoat, Sargent, ever bolder pictorially than in his verbal expressions, also granted his old friend a version of a cocked elbow, that telling if ambiguous mannerism. In the dark palette of the painting, it remained an almost invisible pose. Yet that and other touches of restless expression hinted at James's more theatrical and fanciful qualities. And this late gift of friendship subtly acknowledged the two men's shared unconventionality.

For decades, Sargent's intimacy with James had been complex and rather fraught, even though the older man had proved an important and influential mentor. W. Graham Robertson considered the two men "real friends" who "understood each other perfectly and their points of view were in many ways identical." Yet this queer observer of queer men also divined that their friendship channeled an odd *lack* of intimacy: "Renegade Americans both," they were "*plus Anglais que les Anglais* [more English than the English] with an added fastidious, a mental remoteness that was not English."

Paradoxically, James had introduced Sargent to the rich opportunities of his London circles, in Chelsea and at Burlington House, that now dominated his life. Simultaneously he'd set an example of perpetual elusiveness. Sargent, all his life bent on "respectability" and personal privacy, had learned even more about such self-protection from James, whose own private life remained meticulously guarded.

As for the portrait, a strange fate awaited it at the Royal Academy, that scene of so many of Sargent's previous triumphs. At the painting's debut in May 1914, a woman called Mary Wood, a suffragist, paused in front of the canvas. Then, in that era before metal detectors, she brought out a meat cleaver she'd concealed in her purple cloak. She slashed at Sargent's painting three times—"she got at me thrice over," James remarked, in his personal shock about the incident, "before the tomahawk was stayed." The damage was luckily not "past praying for." But the woman's motivation baffled both the painter and the sitter. Though they'd both had long associations with restless and discontented women, they couldn't understand the hostility of this political agitator. Wood, that is, knew little of James or Sargent. She merely wanted to protest women's inequality. Though crude in her methods, she was part of radical changes in English and American

society that would increasingly unsettle Sargent as he approached the age of sixty.

--<--

Sargent was once more painting in the Alps, as he often did in late summer and autumn, and traveling with Nicola d'Inverno and a small party of painters, when war broke out in early August 1914.

His friends and family had warned him against travel in Austria. Tensions were running high after the assassination of Archduke Franz Ferdinand in Sarajevo on June 28, especially as Austria-Hungary had immediately declared war on Serbia. Sargent's sisters felt nervous even at Sotteville-sur-Mer on the English Channel, where they'd gone for a family holiday that also included Sargent's favorite niece Rose-Marie, married the year before to a Frenchman named Robert André-Michel. Sargent loved languid seaside holidays with his family, but, in the spirit of his adolescent Alpine adventures, he was now bent on visiting one mountain, the Seiseralp in the Austrian Tyrol, which he'd seen fleetingly in childhood and whose splendors had long haunted him.

In late July, Sargent and d'Inverno linked up with several painter friends: John's childhood friend Carl Maldoner, his Royal Academy friend Adrian Scott Stokes and his wife, and Colonel Armstrong, an amateur-painter neighbor of Emily Sargent's. John and Nicola carried no passports and hoped that Maldoner would be able to vouch for them in Austrian territory. The party traveled by open car to Campitello, in the high Val di Fassa, from which they rode horses up to the Seiseralpenhaus in the craggy heights.

Everyone was disappointed with the views they'd worked so hard to reach. The mountain wasn't what Sargent remembered. Resignedly, they moved on. Yet they'd chosen a bad place for extemporaneous tourism. On August 4, Britain and France declared war on Germany; on August 10, they added Austria-Hungary.

On August 22, *The New York Times* ran a small item that alarmed the artist's American compatriots: "John Singer Sargent, the painter, is somewhere in Austria, and his friends are worried. He was last heard from on Aug. 4 . . . It is believed that [he has] probably been detained by the military authorities and not permitted to return." In Normandy, hearing such news, Sargent's sisters were beside themselves.

Sargent hadn't been arrested. But he was now trapped in Austria, unable to travel back to England. Yet, in the cloudy peaks of the Tyrol, he

didn't panic. He went right on painting. Stokes, amazed by Sargent's seren-ity or detachment, remarked that the painter "seemed to regard the whole grim affair simply as an example of human folly"; it wasn't "real to him." As his Sargent's friend Charteris more critically understood his attitude, "the war was outside his ken, and so involved with consequences and ques-tions of which he was entirely ignorant, that he seemed merely conscious of being rather isolated. It was as if his imagination had suffered a complete breakdown."

Yet Sargent wasn't exactly insensible; he was able to orchestrate practi-cal affairs in London, including paying Nicola his wages (via d'Inverno's mother). His bankers routed the money he needed to live via Holland. After the party moved to an inn at Kolfuschg or Colfusco, Colonel Armstrong, who'd tried to make his way back to Britain, was arrested on the road and imprisoned by the Austrians. Sargent remained unaware of Armstrong's whereabouts until early October. Then the painter, hearing his friend had been detained, left "no stone unturned in his effort to procure his freedom." That included a trip to the Austrian Adriatic port of Trieste, where Sargent explained to the Austro-Hungarian authorities that the Colonel wasn't on active duty and hence was a noncombatant.

Through a series of tense interactions Sargent remained unflappable and aloof, astonishing his companions. To be sure, at least part of his insouci-ance was put on. Secretly, he was worried about his family; he felt protective of them, as he'd done for years. But, at the same time, he remained rooted in the present: when the weather grew cold in their high Alpine inn during late September, Sargent, d'Inverno, and the Stokeses simply moved down to Carl Maldoner's house in Sankt Lorenzen in the Pustertal, "a jolly old Tirolese house with big rooms and porcelain stoves which it is getting high time to light," where they stayed on in dropping temperatures for the next seven weeks.

During Sargent's enforced mountain stay, he lost himself in his paint-ing. He rendered craggy landscapes gleaming under the late-summer sun or brooding in the onset of autumn, as well as the rustic crosses and dilapi-dated crofts of Tyrolean peasants. In *The Master and His Pupils*, Sargent im-planted Adrian Stokes in a shadowy hollow, seen hatted and from the back, a small figure in an Alpine vignette of tumbled stones and ragged-trunked conifers, teaching three young women in different outfits—all of them based on Marianne Stokes's maid. But, oddly enough, Sargent also chose to paint several male figures fishing in mountain streams, some of these compositions

featuring his model-companion Nicola. Somehow, Sargent needed to create carefree, bucolic images. He needed to compensate for the chaos now unfolding all around him in Europe.

Most memorably, Sargent's *Mountain Stream* depicted a boulder-strewn riverbed and a foamy watercourse, in quick, confident stitches of watercolor (see Fig. 28). Such were the Alpine vignettes he'd always loved. But at the far right of his composition, as if the artist had just noticed him, Sargent added a graceful golden-white, naked, youthful-looking swimmer, seen from behind. For this was not only an idyllic Alpine picture but also another intimate, lyrical view of Nicola. In its innocence that veiled eroticism, this watercolor linked Sargent to a long tradition of homoerotic art, including many nineteenth-century bathing pictures like those of Sargent's contemporaries Thomas Eakins and Henry Scott Tuke. Though unusual in the context of the unfolding European conflagration, these bathing pictures wouldn't be the only ones Sargent would produce during the coming war.

In November, the Austrian police confiscated a stack of Sargent's paintings, his easel, and his paint box. It wasn't until November 21 that he could reclaim his property and travel to Vienna, to the American embassy, to straighten out his passport and Nicola's. Then, finally, the two men could travel, via Switzerland, one of the few nonembattled countries, to Paris.

While in that city, Sargent spent time with his niece Rose-Marie. It was a visit of consolation, for the cheerful young woman Sargent had formerly known was now in deep mourning. That October, Rose-Marie's thirty-year-old French husband had been killed in action at Soissons on the Aisne.

This loss of Robert André-Michel, that idealistic young archivist and historian, couldn't help but move Sargent. It brought the still-new war home to him at last, and forcibly. For he adored his twenty-one-year-old second-eldest niece, who'd long been a favorite.

Two years before, he'd painted a glowing portrait of her, perhaps as an engagement present. He'd posed her wrapped up in an ivory-colored cashmere shawl. But for her uncle, this posture wasn't self-protective or closed. Rose-Marie's crossed arms and expressive hands with their delicate splaying fingers hinted at the sweet liveliness she'd inherited from her mother, Violet. Under her dark-brown hair, Rose-Marie's pink-touched oval face glowed with a gentle openness, a sense of animation and intelligence, that made this family piece eligible for the Royal Academy exhibition in 1913. For the painting demonstrated Sargent's persistent gift, now seldom used. In a single frame, he could capture a sitter's luminous and complex humanity.

-+-

Back in his Fulham studio in February 1916, Sargent encountered a run of bad luck. Though by this time he'd been safe in London for more than a year, he'd kept busy only with such untypical work as the privations of the war allowed him: designing stationery for the Red Cross, selling a few old works for war charities, and even trying his hand (and his painter's eye) at creating camouflage for the War Office—an experiment that went bust, exasperating both Sargent and his supervising generals.

Now, though, the painter was bracing himself to cross the U-boat-infested Atlantic to America. He needed to install the final, or nearly final, panels of his Boston library murals. German submarines, however, posed a serious threat. Infamously, the RMS *Lusitania* had been sunk near the Irish coast in May 1915, killing almost twelve hundred people, including 128 Americans. In total the German *Unterseeboot* would sink more than five thousand big ships, most of them British, during the course of the war.

But as if struggling with such anxieties in himself and his sister Emily wasn't enough, Sargent encountered still more trouble. Supervising the movers, wrestling with the packing, he managed to smash his thumb with a hammer. Then, as the big cases were being loaded into vans in the Fulham Road, one crate tipped over. It knocked the elderly Sargent flat on the ground, crushing his foot. "Don't make much of this," Sargent wrote his friend Charteris, from bed. "I don't want to be kodaked landing in America in splints & crutches."

Their sailing on the *Nieuw Amsterdam* being delayed, Sargent and d'Inverno didn't finally shutter the Tite Street studio and head off together until late March. They expected a long absence. D'Inverno, now in his early forties, welcomed the chance to escape the war zone. As of January 1916, conscription included only unmarried men up to the age of forty, but rumors were rife that a more comprehensive draft was coming. By June of that year, in fact, the marriage exemption would be eliminated and the age-limit raised to fifty-one. (Sargent, now sixty, was out of danger on that score.) Still, both Sargent and his valet-companion were relieved to arrive at Boston Harbor, in the noncombatant United States.

Sargent and d'Inverno settled in. By May, the artist was hard at work with the third and final installation of his Boston Public Library murals, after a quarter-century of labor. To come near to finishing his grand opus brought Sargent relief but also, in a way, a sting of loss. Wrapping up the murals

might have felt even more valedictory if Sargent hadn't been looking ahead to another, similar project. In October 1916, as he was putting the finishing touches on his library galleries, he agreed to decorate the rotunda of the new Boston Museum of Fine Arts. That distinguished museum had first opened in Copley Square in 1876. But an expanded, grander classical building had just been completed and opened in the Fens. The museum stood next door to Isabella Stewart Gardner's Fenway Court, which had been opened to the public as a museum in 1903—all but the Gothic Room, which still contained the secret, scandalous treasure of Sargent's remarkable portrait.

After his long Boston labors, though, Sargent craved a break. Once more, in summer 1916, he looked to the mountains, that long-cherished refuge, for freedom. The Alps being now utterly out of the question, Sargent and d'Inverno set their sights on the Rockies.

Catching trains west, the two men started their mountain adventures in Glacier National Park in Montana. That park had only just been established, in 1910. By 1916, during Sargent's visit, it provided visitors convenient access via train service on the Great Northern Railroad as well as newly built chalets in the Swiss style and horse trails winding up into the gusty, glacial crags.

At their lodge, Sargent and d'Inverno kept company with some Bostonian friends from Jamaica Plain, Harris Livermore and his wife, Mildred Stimson Livermore. Sargent made a lively pencil-sketch in profile of Mildred, in a jaunty small hat, her hair tied up with a ribbon behind. "Mrs. Livermore is perfectly delightful *and plays chess,*" Sargent reported to his cousin Mary Hale. He also noted that the Livermores appreciated the new innovation of air-conditioning, enjoying a "refrigerated dining room" at the Blackstone Hotel in Chicago. Sargent thought air-conditioning had "saved [Mildred's] life" and also his own during a signature Illinois heat wave. "You sit in a perfect temperature over an excellent dinner and watch the crowd dying like flies outside of the window," Sargent recollected. "Nero or Caligula could not have improved on it."

Sargent and Nicola had fewer comforts, though, once they parted with the Livermores and traveled into the wilder country northward in British Columbia. Sargent loved adventuring in tents, but here, he wrote his cousin,

> it was raining and snowing, my tent flooded, mushrooms sprouting in my boots, porcupines taking shelter in my clothes, canned food always fried in a black frying pan getting on my nerves, and

a fine waterfall which was the attraction to the place pounding and thundering all night. I stood it for three weeks and yesterday came away with a repulsive picture. Now the weather has changed for the better and I am off to try the simple life (ach pfui) in tents at the top of another valley, this time with a gridiron instead of a frying pan and a perforated India rubber mat to stand on. It takes time to learn how to be really happy.

In spite of his complaints, Sargent *was* happy. He and Nicola, accompanied by guides and other occasional guests, spent weeks together in the northern ranges of the Rockies (see Fig. 29). This roughing it in the wilderness was d'Inverno's self-declared "happiest experience with the great painter."

Several of Sargent's surviving watercolors from this expedition commemorate his rustic life in tents, amid breathtaking settings. *Camp at Lake O'Hara*, for example, depicts Nicola, as one commentator has described the composition, as a "lone figure . . . in soft focus, possibly obscured by the campfire smoke." Another watercolor, *Shaving in the Open*, portrays Nicola gripping a razor, poised in front of a tiny mirror attached to a conifer tree in order to shave, a rich composition in blues and greens that nevertheless derives its joy from Nicola's pale, slim figure captured in the midst of an intimate ritual.

Sargent's most interesting and telling production, though, was *Inside a Tent in the Canadian Rockies*. Here he provided a view of Nicola lying back and reading on a cot. But, with the painter's Panama hat resting on a shared night-table beside a second and empty cot, the painting suggests that the two men bunked together during this camping trip. A second tent was inhabited by Sargent's local guides, young men whose handsome and rugged profiles also cropped up in some of Sargent's watercolors.

In spite of his complaints to his cousin, camping had long attracted Sargent. Such rugged outdoor settings tended to amplify the virile qualities of his painted figures. In John and Fitzwilliam Sargent's excursion to the Bernese Oberland forty years before, the artist and his father had slept at inns and not in tents (though the young Sargent might have camped on Alpine junkets with his early painting teacher Charles Feodor Welsch). But such manly mountain expeditions remained compelling for the painter during the present war, and even at the age of sixty. He got on "capitally" with one mountain guide, he confided in his friend Thomas Fox, and he was "sorry to part with him." Mountains heightened Sargent's appetite for male companionship.

And, for Nicola at least, this idyll marked the acme of the two men's time-tested intimacy. It recapped the long weeks they had spent together, albeit with the Stokeses and under the stress of Austro-Hungarian regulations, back in the Alps. But it also crowned some two decades of shared mountain visits in which d'Inverno had trailed behind Sargent on the slopes, hauling his easel and canvases.

26

◆

Empire's End

In March 1917, just before the United States finally entered the war, Sargent houseguested with his married friend Charles Deering at Brickell Point near Miami. He spent many hot afternoons and cool evenings with Deering's bachelor half brother James, who was constructing a fantastical Spanish-themed Atlantic-side estate at Vizcaya on Biscayne Bay. (Sargent wrote the Boston architect Thomas A. Fox, his colleague in the MFA Rotunda work, that the Deering brothers had "seduced" him into lingering in the area with various entertainments. Fox, a fellow bachelor who lived at the St. Botolph Club in Boston, would become a sort of confidant and a useful go-between with models.)

At Vizcaya, Sargent also frequented a nearby mangrove-backed beach. There, where Deering's Bahamian garden-construction workers cooled off in the shallows, Sargent painted four watercolor sketches of nude Black men. He depicted one man peering into a pool in the fashion of Narcissus (*Man and Pool, Florida*) and another straddling a log (*Man and Trees, Florida*), the bather's handsome, masklike face and his well-developed upper torso centering the piece.

In a related picture, *The Bathers*, Sargent incorporated three muscular nude Black swimmers (see Fig. 30). He combined the sun-drenched natural setting of South Florida (Deering's estate in the background) with carefree, undressed figures. Without being graphic (Sargent modestly evaded articulating genitals), Sargent's pieces channeled a rather voyeuristic pleasure in an otherwise drowsy backwater. He'd grown especially interested, by this time, in what he called "surf bathing"—that is, the incipient beach culture of the early twentieth century. As he had so often done before, Sargent chose exotic and tastefully suggestive subjects. At this stage of his life, though, he

preferred not colorfully clothed female peasants or dancers but nude male figures in various postures of abandonment.

Yet Sargent's ingrained love of exoticism didn't amount merely to a set of pictorial conventions. It also implied long-established social divisions and hierarchies. It's not known how Sargent persuaded these Black Bahamian immigrant workers to pose, whether he paid them or merely talked them into it, as a privileged white man and friend of their employer. Such transactions weren't immaterial to the visual outcomes of these scenes. The artist's "gaze," though to some degree empathetic, also voyeuristically objectified them. Sargent lay claim to them in a way he'd mostly avoided with his female figures—reading sensual or erotic availability into people whose lives were harder and much more complicated than his carefree depiction suggested. Though these figures weren't quite the "happy slaves" or "noble savages" of earlier racist traditions, Sargent's images drew on a long history of white privilege and Black subordination. Yet, at the same time, Sargent's longstanding interest in marginalized people also empathically envisioned whole categories of people and experiences that many other white artists of his time simply ignored.

One of Sargent's most intimate and erotic male nudes may also have been painted in Florida in winter or spring 1917. It also referenced sea-bathing, if indirectly. *Nude Man Lying on a Bed* captured a handsome sunburned young man sprawled, with his head at the foot of a dark wooden sleigh bed with white sheets, a white area on his chest and trunk showing where his two-strapped bathing-costume had shielded his skin from the sun. Art historian Fairbrother has described this watercolor as the "most warm, intimate, and the least theatrical of Sargent's male nudes"—and indeed the picture appeared to commemorate a spontaneous personal encounter rather than a stylized professional one. In fact, this naked young man, in the relaxed setting of a bedroom and also smoking a cigarette, suggested the aftermath of a sexual encounter. The picture was discovered in Sargent's Boston studio after his death. Clearly, it was an intimate and personal piece never meant to be exhibited.

-◂-

Back in Boston with Nicola, Sargent continued to work on his perpetual library murals. After his 1916 installation, he closed in on the completion of the project—though he would never finish the *Sermon on the Mount*, the crowning piece he'd conceived for the space. Now Sargent tried to "increase the

anticipation" of the Boston Public Library patrons, by "hanging tapestries or heavy curtains" over the shrines that would soon contain the panels he was working on, depicting the *Synagogue* and the *Church*. As one art historian has put it, "The tapestries added an element of theatricality by underscoring the public's expectation that completion would be imminent, dramatic, and climactic." Sargent hadn't lost his taste for the stagy. But now his subject less suited those instincts—being much more sober, grandiose, and historical, in the vein of Ernest Renan's secular rewriting of biblical history.

Yet Sargent's rendering of the Synagogue amounted to a bombshell waiting to explode. It would later cause him unwanted controversy that would in fact injure his reputation and that of his murals. For in spite of his sympathies with Jewish friends and his well-meaning attempt to create a modern, secular vision of religion, Sargent would actually replicate medieval antisemitic prejudices by representing his allegorical figure of the Synagogue as a blindfolded old woman. His love of historical painting—in this case, all those dim, overdecorated chapels at the Vatican and in Sicily—had led him wrong. Such studies had mired him in historical bigotry as opposed to helping him create a tolerant, enlightened modern work.

The controversy would explode very suddenly in autumn 1919. All at once, Sargent complained to Evan Charteris, he was "in hot water with the Jews, who resent my 'Synagogue' and wish it to be removed." For Jewish observers discerned not a *Triumph of Religion* in Sargent's work, but a "triumph of Christianity." The Boston community—having originally arrived as immigrants in the North End in recent decades but now well established in Roxbury and Brookline, and increasingly a civic presence in Boston— had appreciated Sargent's *Frieze of Prophets* as "a beautiful representation of the heroes of Jewish antiquity." But Sargent's *Synagogue* called for a "strong organized protest to the trustees and artist." Among mainstream Boston critics, too, Sargent's uncritical channeling of raw medieval prejudice sorted ill with what they'd hoped would be a tolerant library open to all.

Sargent's misstep, in fact, would also help throw his whole project into disrepute, especially since the obscure, retrospective, and antiquated mode of decoration he had increasingly used in recent years would ripely offend younger art critics like Roger Fry and even Old Master connoisseurs like Bernard Berenson. These and other younger critics would pan Sargent's twenty-five-year project after his death. Though Sargent had labored hard to create his equivalent of a Sistine Chapel—an homage, in a sense, to his lifelong hero, Michelangelo—he'd instead created a gilded and fustian snarl

of obscure scripturalism that would drag down his future reputation even more than his slick society portraits would do.

For decades, critics and audiences alike would take a rather dim view of Sargent's treasure cave. In 2003 and 2004, though, a fifteen-month refurbishment of the murals corrected some distorting mistakes of a 1953 restoration. This improvement stripped off decades of grime and dust, freshening Sargent's bold colors and exposing the subtleties of his faces. The project also prompted a reconsideration of Sargent's murals and some new appreciation for the intricacies of his work. Still, Sargent's would-be magnum opus has continued to be deemed inferior to his best paintings, this old-fashioned project revealing more about the stodgy overeducated ideals of Boston in the early twentieth-century than about Sargent's essential genius.

-+-

Back in 1918, however, Sargent's near-completion of his great project felt more serene and prosperous to him. While the war continued its years-long trench-warfare stalemate in France, Sargent's and d'Inverno's pied-à-terre, when they alighted in Boston, remained the Hotel Vendome.

The Vendome, a Second Empire–style stone building with a steep mansard roof, comforted and sustained Sargent by reminding him of Paris. It was possible to recollect Paris pleasures in the Back Bay of Boston, since Commonwealth Avenue, with its meridian park now sporting young trees, was lined with Beaux-Arts mansions. The Vendome itself, built in 1871, had been designed by the late William Gibbons Preston, who'd studied architecture at the École des Beaux-Arts in the 1860s, a decade before Sargent had joined Carolus-Duran's studio. Through the decades-long vicissitudes of Sargent's Boston Public Library murals project, the Vendome had become Sargent's home away from home, and it was now his base of operations as he started in on his new Museum of Fine Arts decorations. Its reminiscent name (after the well-known and aristocratic Place Vendôme in Paris) subtly added to its familiarity and eligibility.

Just before Easter in 1918, these Parisian associations took on a different cast. On April 3, 1918, Sargent received some horrifying news. The shock came, by a series of telegram communications, from the French capital itself.

The week before, on Good Friday, Sargent's twenty-four-year-old niece Rose-Marie had ventured out to hear church some music. Like her uncle, the widowed Rose-Marie was devoted to music. An excellent choir at the parish church of Saint-Gervais near the Hôtel de Ville tempted her to attend the

Office of Tenebrae that afternoon, especially as the church advertised that the proceeds of the tickets would be given "for the benefit of the wounded being treated in the unsubsidized hospital of Saint Gervais."

The church, with its seventeenth-century rococo façade, harbored a spare sixteenth-century Gothic interior that the Revolution and more recently the War had stripped of much of its ornamentation. Statues had been crated away to safety. The fine stained glass had been replaced by oiled calico. Even with these alterations, though, the church provided a peaceful sanctuary in a city that the War had transformed into a military staging post. The priest had just spoken the words, *"Mon Père, je remets mon espirit entre Vos Mains"* (My Father, I place my spirit into Your hands) when everything changed. A shell, fired from a hundred kilometers away by the latest diabolical German war machine, a long-distance Krupp gun, slammed into the roof of the church. The explosion sent huge blocks of masonry crashing down. The rapid collapse of the nave killed some seventy worshippers and attendees. And Sargent's beloved niece was one of the unlucky ones.

In earlier years, Sargent had frequently coaxed Rose-Marie into being a model for him. He'd always considered her "a person of singular loveliness and charm," and her "youth and high spirits and the beauty of her character had won his devotion." Her sudden and unexpected death deeply affected him.

Now sixty-two, Sargent was already reeling from a series of losses and tectonic changes. The Great War, now in its fourth year, had precipitated many of these. He'd lived through the Civil War (at a distance) and had barely dodged the Italian Risorgimento and the Franco-Prussian War, in his Continental youth. This war, though, had impacted him more directly, beginning with his house arrest in Austria. In 1918, at the time of Rose-Marie's death, Sargent and d'Inverno had spent two solid years in the United States. Yet Sargent continually worried about the many friends and family members he'd left behind in Europe, near the battlefields. He especially fretted about his sister Emily. And even his relatively serene life in Boston hardly insulated him from the momentous destruction of the opulent European world he'd loved and cultivated over the many years of his itinerant and multilingual life.

At her nearby personal palace of art, Belle Gardner had hosted Sargent and supported his projects. Now, in 1918, Gardner, at seventy-eight, had just fulfilled a lifelong dream of acquiring Sargent's youthful tour de force, *El Jaleo*, for her museum. In order to coax the famous painting away from

Thomas Jefferson Coolidge, she'd made special alterations to Fenway Court in 1914; she built the so-called Spanish Cloister to showcase it, as her friend Morris Carter reported, in "an alcove, marked off by a Moorish arch, giving the effect of a stage" and with "a row of electric lights along the floor" as footlights, catching at Sargent's own theatrical inspirations.

Though seemingly possessed of inexhaustible energy, Gardner was also only a year away from a series of debilitating strokes that would lead to her death in 1924. Sargent would paint a final portrait of his longtime patron in 1922. *Mrs. Gardner in White* portrayed in watercolor a ghostly figure seated on a luxurious sofa, her pale, ravaged face peering out as from beneath a turban. Sargent's final pictorial vision of his old friend appeared as a sibylline figure redolent of the mystical, romantic Orient that both he and she had loved and pursued throughout their lives.

By 1918, Henry James was also gone. In summer 1915 James had taken British citizenship to protest American neutrality during the war. "Yes, I daresay many Americans *will* be shocked at my 'step,'" James had written Sargent from Carlyle Mansions—understanding that Sargent himself would probably never have followed suit, and not only because lately America had been claiming much more of his life than before. Six months later, on February 28, 1916, James was dead. Sargent had attended his friend's funeral only a couple of weeks before he and Nicola had boarded their steamer for Boston.

Sargent would miss his old friend and perennial booster. A few years after James's death, he'd be delighted to read through an early edition of the novelist's letters: "Such virtuosity, such beautiful flutters—it is like watching the evolutions of a bird of paradise in a tropical jungle." Sargent's own letters had always been plainer, curter affairs—though not without flashes of wit and fancy. But he knew he couldn't quite imitate what he dubbed James's "miraculous fireworks."

In any case, only one of James's letters to Sargent had survived, inadvertently—the one about the British citizenship. And only one of Sargent's letters to the novelist—a minor one from 1885—would emerge from James's own editing of his papers. Their rest of their mutual "miraculous fireworks," such as they may have been over their thirty-four-year friendship, would remain superlatively private.

<div align="center">ⵢ</div>

At the Hotel Vendome, though, still another piece of Sargent's familiar life was about to be torn away. In April or May of 1918, not long after Sargent had

received the news of his young niece's death, a brawl broke out in the bar of the hotel. The skirmish erupted between a bartender and, of all people, Sargent's forty-five-year-old valet Nicola d'Inverno. The cause of this outbreak is unknown, but d'Inverno was after all a pugilist, trained in amateur boxing. He may also have been drinking, and perhaps heavily. He would also have been vulnerable to insults leveled by a Boston bartender. After all, he conspicuously lodged with an older employer who was known to be Europeanized, artistic, and exquisitely tailored—all markers of queer identity well-established by 1918. Whatever the trigger, fists flew. The resulting melee was disruptive or destructive enough that the hotel management intervened.

Like his departed friend James, Sargent now hated scandal and avoided it at any cost. He hated scandal in his life, that is, even if he'd compulsively created edgy sensations, for years, in his work. At the hotel, he soon reached a bargain with the management. The Vendome would dismiss the bartender if Sargent discharged his valet. Whether Sargent entered into this arrangement reluctantly or with a sense of inevitability or even relief is unclear. Several years later, though, he told a young studio model that his former employee was "inclined to overindulge in alcoholic stimulants at the improper time," a description of Nicola's drinking habits that other sources corroborate. D'Inverno's own account of the incident differed. "What separated us finally was his own America," Nicola wrote in 1926. "Once I saw what life over here was like I got the money fever and wanted—and needed—more than my place with Mr. Sargent was worth. He would not pay the price and we parted, with a little pain on both sides, but with no ill feeling, either."

The lack of clarity in these circumstances are of a piece with d'Inverno's use of the terms "separated" and "parted" as opposed to "dismissed" or "discharged." Nicola screened the circumstances of a bar brawl and the subsequent repercussions to maintain his own dignity. But the break in fact followed on a very complex domestic involvement that had lasted more than twenty-five years.

Once Sargent moved to the Copley Plaza Hotel—he was obliged to change hotels after this fiasco—he wrote a recommendation for d'Inverno on the new hotel's embossed notepaper. Nicola later dubbed this letter, though it seemingly didn't help him find lucrative employment in the United States, the "only priceless thing in [his] possession."

In addition, Sargent reputedly helped d'Inverno financially a few more

times during the following years—as well as receiving news of Nicola at least as late as 1921. Sargent also left his former valet a legacy of £200 in his will—at that time, about a thousand U.S. dollars, enough to cover modest living expenses for a year. It was hardly a grand legacy, but such consideration after the rupture seems characteristic of Sargent's quite generous treatment of others. Still, the painter didn't generally aspire to public philanthropy: he reserved such conduct largely for his inner circle of friends and family. But d'Inverno had belonged to that circle. With people he cared about, Sargent could be courteous and even generous. Such graciousness, in turn, earned him a good deal of loyalty—had done with friends like Paul Helleu and Ned Abbey earlier in his life. It would seemingly help inspire Nicola d'Inverno's subsequent loyalty as well. D'Inverno praised his old companion to the end.

Such liberality was complex, though, as was Sargent's own reaction to the split. He would later rebuff a new candidate for personal intimacy by emphasizing his relief in escaping Nicola's "somewhat overbearing familiarity and eventual indifference to his needs."

<p style="text-align:center">—+—</p>

In June 1918, Sargent returned to London. He didn't tell his sister Emily about his specific sailing for fear of worrying her about his crossing. Even at that stage, German submarines still dangerously patrolled the Atlantic.

Sargent returned to England, in fact, in order to enter the war. He'd enlisted not as a soldier but as a war artist. Or rather some old friends had strong-armed him into signing up. Yet, the sixty-two-year-old painter, otherwise idle and rather adrift, missing his old routine in Boston, found himself "excited and interested" about heading to the front in France. According to his friend Charteris, who may have witnessed some of this excitement firsthand, Sargent "regarded the question of his outfit very seriously." Back in his Tite Street studio, Sargent found that the place "soon became littered with boots, belts[,] and khaki. There was a succession of tryings on, and endless packing and unpacking; buckles suddenly came to play a part in the scheme of things." Sargent had always been attentive to costume, and here he'd found another opportunity. The result was a white-bearded, florid Sargent, who, with his "burly figure," reminded one British soldier of a "'sailor gone wrong.'"

Sargent crossed the Channel, as he'd done so many times, but instead of rushing on to Paris, he halted at Boulogne, reporting to the General Head-

quarters of Field-Marshal Douglas Haig, the straight-backed, mustached commander in chief of the British forces in France. Luckily, Sargent soon felt a little less daunted with this strange new military milieu once he reencountered Sir Philip Sassoon, who was now serving as Haig's private secretary. Sargent found his young friend, dashing and trim in his immaculate uniform, "awfully kind and useful" in preparing him for his work for the Ministry of Information.

Sargent's new task was to create an "epic" painting of British and American forces in the war, to be housed in the Hall of Remembrance then being planned in London. For the United States had entered the conflict in April 1917. By the time of Sargent's involvement at the front in summer 1918, thousands of freshly drafted American soldiers were arriving in France every month. They were also turning the tide of a war and increasing the Allies' optimism. Sargent had been enlisted as an artist partly because the authorities now sensed that the war would soon end, and that it would need memorializing.

By mid-July, Sargent found himself much closer to the front lines, hunkering down in a farming village called Berles-au-Bois near Arras. Here Sargent slept and in what his friend Charteris understood as "one of the iron huts which had been built into a high bank to avoid observation and bombs" or what he himself described as "an iron tube." His main colleague, fifty-six-year-old fellow New English Art Club painter Henry Tonks, suspected Sargent knew very little about war, in spite of his long-running fascination with the campaigns of Napoleon. Tonks thought Sargent failed to understand "how dangerous a shell might be, as he never showed any sign of fear, he was merely annoyed if they burst sufficiently near to shake him." Though he charmed all his companions at General Geoffrey Feilding's mess, throwing himself into discussions of music and painting, Sargent never quite penetrated the intricacies of military hierarchy and wondered aloud to the general, one Sunday when the band was playing, "I suppose there is no fighting on Sundays."

In late July, Sargent and Sassoon enjoyed the test-drive of a tank—a fairly new piece of military technology—taking what Sargent described as "a joy ride . . . up and down slopes, and over trenches and looping the loop generally." Some obsolete and inert tanks at Bermicourt made him "think of the ships before Troy." In spite of the grim dangers around him, Sargent remained charming and often fanciful, at least on the surface. He confessed to one of his messmates that the only line he'd read or remembered

in American writer Frances Marion Crawford's many novels about Rome in the Middle Ages was "the line 'and the silence clashed against the stillness,' when certain lovers met by moonlight in the Pantheon." Lovers' encounters more suited Sargent's romantic sensibilities than the consequences of modern warfare.

Yet Sargent was in for some sobering sights. He was soon haunting the fringes of the battle zone on the chalk plateau of Arras, painting under a big white umbrella that the British tolerated but the Americans eventually made him camouflage. Roving through the boredom and chaos of the battlefields, curiously bent on his own work, Sargent captured a growing range of subjects, figures and landscapes, that showed his keenness as a documentary observer and his ecumenical taste for a range of subjects. In their scope, these wartime works resembled his eclectic youthful sketchbooks, in which he'd been fascinated by people, animals, landscapes, and male classical statuary, all in generous profusion. He now captured such objects with considerably more sophistication and virtuosity, of course.

He was also, in 1918, grimly depicting battle-damaged scenes and not the more tranquil Europe of his youth in the 1860s and 1870s. In his luminous watercolors, Sargent witnessed and documented the gutted cathedral of Arras, ruined houses, factories, fields, camouflage, destroyed tanks, downed planes, camp tents, horses, mules, wagons, and of course the figures of soldiers, usually in small and rather intimate groups.

Figures in landscapes had always attracted Sargent as much or more than the landscapes themselves. So they did even at the front, though he had trouble finding the convergences of British and American soldiers together that he was supposed to memorialize, or the crowds of soldiers deemed suitable for the "epic" painting the authorities wanted. "The nearer to danger the fewer and the more hidden the men," he observed, "the more dramatic the situation the more it becomes an empty landscape." This late in the War, the trenches weren't the death traps they had once been. But Sargent's painting junkets took him through some scenes of graphic suffering: he would see the inside of field hospitals.

Wherever he went, a cigar gripped in his teeth, Sargent extended his ready personal sympathy. He worked better, anyway, with a close-up, serene, personal focus, even or especially in this grim environment. In two watercolors he captured pairs and threesomes of soldiers resting on the ground. *Highlanders Resting at the Front* portrays three kilted British soldiers lying against a haystack, their thin, pale knees hinting at their vulnerability. In

Poperinghe: Two Soldiers, two American doughboys recline on a muddy bank, both of them seeming tranquilly asleep, one of them gripping a rifle wedged between his legs. The Ministry of Information didn't encourage Sargent to paint *individuals*. But Sargent as a portraitist had always been drawn to individuality. Even or especially here, in the battlefield, individuality counted. In his sketches, Sargent viewed these endangered young men as poignant, innocent young figures about to be thrust into the hurly-burly of combat. Such visions took a toll on him, in spite of the luminous and tranquil sketches he managed to produce, almost by way of compensation.

Two of Sargent's most curious and perhaps telling pictures of soldiers depict them washing or resting nude on riverbanks. *Tommies Bathing, France* shows three figures, one partially clothed, one lying naked in the grass with his arm up, one sitting naked in the water, their pallor luminous and dreamlike. Likewise, *Tommies Bathing* pairs two naked figures on a grassy bank, perhaps asleep, their heads resting close together (see Fig. 31). These figures—not at all graphic but pale and blurred, as if seen in a trance—recalled Sargent's many wistful images of clothed male and female friends and family members napping in the grass of the Val d'Aosta and other idyllic tourist spots before the war.

Yet these naked figures were also subtly different, revealing an even more poignant and innocent vulnerability. At the same time, they harkened back to a genre of outdoor male nude studies that conspicuously linked them to nineteenth-century homoerotic art. What's more, the nested heads of two figures suggested emotional intimacy and the raised arm of another embodied sensual abandon—his cocked-up knees, too, recalling Sargent's earlier pictorial studies of close male friends. A seated figure viewed from the back echoed the watercolor Sargent painted of Nicola d'Inverno naked beside an Alpine stream at the beginning of the war. It channeled a similar longing, delicate and distanced.

Such dreamlike scenes of men swimming, bathing, or sunning themselves belonged to a prelapsarian nineteenth-century Whitmanesque vocabulary that both disguised and channeled eroticism, not to mention, in this case, war. But if Sargent had experimented with such nudes as long ago as 1880 in Morocco, he was now in his late maturity all but obsessed with such figures, scenes, and settings. So he'd been, too, more than a year before in Miami, when he'd sketched and painted Black models in south Florida.

Such pictures suggest that unclothed male swimmers still held deep resonance for Sargent—and perhaps a new resonance, thanks to savagery of the

context in which he was now pitted. His watercolors of Tommies bathing, then, were hardly an accidental or adjunct product of his vision in wartime France. Sargent's personal obsession had always crucially informed and underpinned his better-known work, had often informed and shaped that work. And so it did with his battlefield pictures.

The ultimate product of Sargent's months spent near the front would be his huge memorial canvas, *Gassed*. "The word 'gassed' is ugly, which is my own objection to it," Sargent acknowledged, "but I don't feel it to be melodramatic only very prosaic and matter of fact." He'd seen plenty of ugliness, after all. Sargent's monument to Anglo-American involvement in the Great War was a twenty-foot-long mural-like painting that depicted clusters of soldiers, half-blinded by a German mustard-gas attack, shambling toward the Dressing Station on the Doullens-Arras road in August 1918. The piece imitated a classical heroic frieze. At the same time, it channeled horrifying contemporary reality, its juxtaposition of walking sufferers and prostrate wounded memorializing the terrible human costs of war.

In a canvas masterful for many reasons, Sargent brilliantly articulated the subtle points of contact among the nine blinded soldiers. An orderly supported two of them by the arm. The others rested hands on one another's shoulders or held on to one another's backpacks and cords. These pictorially interesting links, these understated indications of the soldiers' dependence on each other, dramatized comfort, camaraderie, and mutual support. These connections between men generated the poignancy and heroism of the piece. For Sargent, these associations constituted the soul of his memorial. For, over months of painstaking work in his Fulham Studios, in his postwar funk, the master painter was able to temper and recast his voyeuristic interest in young soldiers, transforming it into a moving indictment of violence and war.

27

The Contortionist

For all that Sargent's reveries often cropped up on paper or canvas, it's unknown if, in his feverish state in the fall of 1918, he dreamed of the Boston model from which the war had separated him. This man had come to his attention and into his studio two years before but had since lingered in his mind. Sargent had sketched his handsome face in charcoal, his fit brown body, again and again. "I shall want him," Sargent would write; "My soul longs," he'd already written. Such lyrical visions, a whole Atlantic away, beckoned from a happier, headier time that now, for many reasons, seemed improbable.

In September of 1918, near gutted ruins of the French village of Roisel, the painter had suddenly fallen ill. The matter was serious. He had influenza, the Spanish flu—the dread pandemic of that year that would kill tens of millions. Whether or not he relived scenes from his earlier life, he spent a whole week tossing in a hospital-tent bed, wrestling with a high fever and overhearing the "groans of the wounded, and the chokings and coughing of gassed men," as he later wrote to Belle Gardner. He told his old friend that "it always seemed strange on opening one's eyes to see the level cots and the dimly lit long tent looking so calm, when one was dozing in pandemonium."

Even when he returned to Tite Street that October, weak but convalescent, he continued to feel the "queerness" of the war and his own experience in it. The armistice with Germany was signed in a railway carriage at Compiègne north of Paris, on November 11. But one of the most terrible and costly wars in human history would not recede quickly, for anyone. Sargent himself didn't know quite how he was going to recover his customary footing.

Sargent needed fresh blood, a new set of interests, both personal and

painterly. But he found any return to his usual cheerful workaholism elusive in the subdued, exhausted London to which he'd now returned. For one thing, he had no one to come home to at Tite Street, not even Nicola. And now he could look forward to few enough evenings out, except perhaps confabs with his sister Emily down the street. In his thwarted, vulnerable state that winter, he even made the mistake of agreeing to paint some generals for the National Portrait Gallery: "I would gladly do the Army group— gladly is polite," he acknowledged. It was a commission that would in fact "loom before [him], like a nightmare," he observed, sapping his already-reduced powers.

Where could he turn for comfort and inspiration? His studio was full of the sketches of young soldiers, as well as, perhaps, of the lost Boston model. But these figures remained remote. And one of his few at-hand friends brought more sobering complications.

Evan Charteris, fifty-four in 1918, had logged his own wartime experiences as a staff captain. Yet in spite of these shared experiences, Charteris didn't bode well for a comfortable or comforting bachelor friend, for all that he'd seemingly latched on to Sargent. A prickly parliamentary barrister, the arch, aristocratic Charteris was the youngest son of Francis Charteris, the Tenth Earl of Wemyss. He also held court with the "Souls." About town, the long-faced, walrus-mustached, stiff-collared Charteris was best known for his founding in 1886 of the Queen's Club, a private sporting institution that would later host the British Open or Wimbledon tournament.

Sargent felt little interest in tennis. But luckily for the two men's warming relation, Charteris was increasingly bent on art. Also, an enthusiastic bon vivant, correspondent, and keeper of notes, he came as near as Sargent would ever come to a Boswell who would record his wry wit and informal charm. Charteris appreciated the self-deprecating joke titles Sargent gave his paintings, and he wrote them down. Without Charteris's taste for Sargent's wit, even more of the private and idiosyncratic painter's inner life would simply have been lost.

Sargent's other main confidante in London, his old friend Mary Smyth Hunter, matched him in age—was sixty-two in 1918. Mary Hunter had remained inexhaustibly sympathetic for decades now. She'd strategically deployed her coal-baron husband's wealth to immerse herself in culture and art. Her guest-list boasted Henry James, Edith Wharton, Claude Monet, and Auguste Rodin; she would later, though with dwindling resources, add Virginia Woolf to her roster. In 1916, in a watershed of her life, Mary's husband

died. During the last years of the war, she'd unwearyingly welcomed Sargent's observations and complaints.

Sargent admitted to being "most at his ease" with Mrs. Hunter. Rather cut adrift, with few other confidantes, he edged toward Mary's orbit. By the bleak February of 1919, rumors circulated among Sargent's London friends that he was going to marry her. After all, she'd now been widowed for a decent two-year period, and the decorous sixty-two-year-old artist was spending much of his free time with her.

With Sargent itching to return to Boston that spring—hoping to plunge back into work on his MFA decorations—Mary was determined to accompany him on that voyage. For her, an additional chaperone was optional and in fact not desirable. But such colleagues and patrons as got wind of Mary's plan were scandalized. Souls-hostess Mary Charteris, Lady Elcho, whom Sargent had famously painted with her distinguished sisters in 1899, implored her brother-in-law Evan Charteris to put a stop to any such scheme. But Charteris balked, declaring that he "wasn't convinced that the marriage would be a bad thing for Sargent."

In the event, no such scandal, and no marriage, occurred. In fact, Sargent's oldest friends might well have predicted he'd avoid marriage. When similar rumors had flurried around Mary Hunter's proposed travels with Sargent to the Adriatic in 1907, Ralph Curtis had cheerfully observed that his John had simply "started for Dalmatia leaving 'Mrs Tally ho' behind."

Now, in a similar maneuver, Sargent simply boarded a steamer for Boston. He'd fixed his sights on new Boston endeavors. If he'd also thought of his Boston model, he didn't cite that motivation to anyone. As for Mary, Sargent's departure signaled an evasion, not a rupture. Even after he'd disappointed her of an Atlantic voyage, he'd continue to write her regular and faithful letters.

Yet Sargent didn't voyage alone. He took with him his faithful, stiff-backed sister Emily, now sixty-two, and his cheerful twenty-two-year-old niece Reine Ormond. Dark-haired, pink-cheeked Reine, like her now-lost elder sister Rose-Marie, had often posed for her uncle's fanciful painter's compositions—was a top-notch "Intertwingle"—most recently featuring in a watercolor sketch in 1911.

The family party set up house in the plush and paneled Copley Plaza Hotel, on Copley Square in Back Bay. The Beaux-Arts suites of rooms where the Sargents unpacked were convenient to the next-door Boston Public Library, home of Sargent's murals. Their hotel also stood on the site of

the former and original Museum of Fine Arts, for which Copley Square had been named—portraitist John Singleton Copley being a distinguished colonial painter well represented in the museum's seedling collection.

For his part, though, Sargent could muster little enough interest in the remote, colonial Copley. He didn't relate to early American painters, even this metaphorical portraitist-forebear. Still, during his stays in Boston, he visited the historical house in nearby Gloucester that had belonged to his father's eighteenth-century feminist relative Judith Sargent Murray, of whom Copley had in fact painted a fascinating wedding portrait, in which Murray gazed out as a silk-clad, svelte, moody eighteen-year-old. Sargent helped found a museum in her honor. He went as far as to donate some family mementos and pick out some tasteful faux-colonial wallpaper.

While staying at the Copley Plaza, Sargent started work in earnest on decorations for the new museum building a mile away on Huntington Avenue, for which he'd been hired in 1916. Though he'd originally been engaged to paint three lunettes over each doorway of the Rotunda, by October 1917 he'd convinced the trustees to let him undertake more. He wanted to overhaul the entire space, filling it with architectural elements, sculptures, and paintings, in an ambitious classical megacomposition paying homage to all the arts. The project, more Hellenic than his Judeo-Christian Boston Public Library murals, better suited sensibilities formed by Rome and Paris. Here he could recover, in a sense, the charm of the *Marble Faun*.

To tackle this new mural cycle, Sargent rented a studio in the Albert A. Pope Building, on nearby Columbus Avenue in the South End. His new studio space was in a seven-story brick and stone structure, with big Roman-arched windows on the top floor, that until 1914 had been a bicycle factory.

Here Sargent now immersed himself in the familiar and comforting element of his obsessive studio work. Here, in the shifting sunlight of spring and summer, he painted for long hours. His classical subject matter also required him—or allowed him—to paint life studies and nudes. And he did so, as it now happened, by means of one of the most charismatic models he'd ever engaged.

—✦—

The model now on Sargent's mind, now on his studio platforms, had first come to his attention wearing hotel livery. At the turn of the twentieth century, a bellman's uniform typically included a tight-fitting jacket with double or triple rows of brass buttons. In this case, these buttons accentuated an athletic

chest. For, while staying at the Hotel Vendome during his previous stint in Boston, sometime in the cold early spring of 1916, Sargent had encountered a young bellman in an elevator there. According to his Boston architect friend Thomas Fox, he'd noticed that "the operator, a young colored man, was possessed of a physique which he conceived would be of artistic value." Such a body made him eligible to model for naked classical gods.

Before this encounter, the artist and the bellman had perhaps exchanged a few, formal words. But Sargent's proposal no doubt put him out on a limb, no matter how much previous experience the artist had in enlisting immigrants in Europe and Bedouins in the Middle East. His predilection for non-Western, "exotic" subjects may also have come into play. He may even have assumed that the social and financial disadvantages of American Blacks rendered them eligible for his studio needs. But in 1916 Sargent had little firsthand experience with African Americans or with the segregation and racial prejudice that ruled their lives. But the proposition Sargent somehow tendered to this young man—stuttering or brazenly—would soon alter the lives of both men.

Thomas E. McKeller, the twenty-six-year-old bellman, sported a handsome face, a slight Southern drawl, and an engaging manner. He also brought to the studio some harsh life experience. He'd been born in Wilmington, North Carolina, in 1890, a generation after the Civil War, and he'd come of age during a period of brutal oppression for Blacks in the South.

The Wilmington Black community in which McKeller had been raised (he was baptized there in St. Stephen's A.M.E. Church) had accumulated some hard-won achievements. Though the young man would acquire only an eighth-grade education, the careful cursive handwriting of his few surviving letters hints at the successes of Wilmington Black community, many of whom were skilled craftspeople, prosperous business owners, clergy, teachers, and even elected officials. Though the son of a laborer, Tom McKeller had a brother, William ("Willie") who'd bettered himself to became a carpenter and then a shoemaker. Thomas clearly entertained dreams of a more stable life. Wilmington, then the biggest city in North Carolina, with its active Black-owned newspaper, the *Daily Record*, stood out as a relative beacon of Black liberty in the South.

As a child of eight, in 1898, however, McKeller witnessed a horrifying change to the city in which he'd grown up. In November of that year, two thousand white supremacists marched on Wilmington. They wanted to crush a biracial confederation in the local government and vowed to burn

the offices of the *Daily Record* to the ground. On November 10, a mob of white vigilantes killed between sixty and three hundred Black citizens (some with a Gatling gun) and expelled hundreds more, as well as their white sympathizers, from the city. This horrific purge, which also ousted the elected government, has since been called the only coup d'état in American history. But the event was an atrocity as well as a political maneuver. The effect of the Wilmington Massacre on the city's Black citizens, including on young McKeller and his family, was horrendous and devastating.

The Wilmington Massacre no doubt motivated McKeller to leave for the North as soon as he could. By 1913, when McKeller was twenty-three, he was living in Boston. Though the city would have its tangled history of race relations, in the early twentieth century it had a lofty reputation—a leftover from its antebellum abolitionist past and illustrious community of free Blacks who'd settled on Beacon Hill. It was known as a place where African Americans could live in peace and even get ahead. In Massachusetts, civil rights laws first passed in 1865 had been incrementally strengthened over the course of the late nineteenth century—after high-profile cases of discrimination had erupted in barbershops and pool halls. By 1916, when McKeller met Sargent, Boston was not legally segregated, though it was financially and socially balkanized, with fairly distinct Black neighborhoods, especially in the South End and Roxbury.

It was no accident that Sargent and McKeller met at the Hotel Vendome. For Sargent, hotels had frequently served as his adult as well as childhood homes—a studio- and home-space like Tite Street offering only an occasional or episodic pied-à-terre for him. For McKeller, hotel work was one of the few categories of unskilled employment readily available to people of color in Boston. In 1914, according to John Daniels, a social worker, a student of W. E. B. Du Bois, and a contemporary observer of Boston's Black community, "between twenty-five and hotels, restaurants, clubs, and apartment houses" hired African American men as waiters, doormen, or porters. McKeller worked as a "bellman," a post that could include being a porter, doorman, or elevator operator.

McKeller's pay in such a position was roughly equivalent that of waiters, who in the "nine leading hotels" of the city averaged $25 a month, a meager wage that when filled out with tips to amounted to about $11.50 a week or $50 a month. Such a scraped-together income added up to only about $600 a year. Black hotel workers often made "less than the minimum requisite for bare subsistence, in which case resort must be had to the assistance of

friends or to charity" in order to survive. Poorer workers, Daniels observed, were "mostly young unmarried immigrants" from the South and hung on as "lodgers, usually confined to one small room, picking up their meals here and there."

Tom McKeller's situation almost exactly matched this description. In his midtwenties, when Sargent met him, McKeller was trying to improve his lot. But by 1920 the twenty-nine-year-old McKeller still battled hard conditions, living at 44 Appleton Street, in the South End of Boston, in a brick row house boarding establishment run by George Brown, a Black man from Virginia, whose extended family of seven lived in this small residence, along with two other single Black male boarders. The South End was now the main Black neighborhood of Boston, having taken over in the 1890s from both the North Slope of Beacon Hill, where free Blacks had lived since before the Civil War, and the West End, where after the Civil War new Southern migrants had jostled with immigrant Jews from Eastern Europe. In the 1910s and 1920s, McKeller boarded in the South End and the nearby half-Black, half-Jewish suburb of Roxbury, changing address frequently, always on the hunt for an inexpensive or stable situation. McKeller's restlessness gave him an energy, a push, that evidently sparked Sargent's interest.

Sargent's plush world at the Vendome or the Copley Plaza, however, belonged to a whole different realm. So did the painter's financial situation. One wealthy benefactor, Sir Hugh Lane, offered to donate to the Red Cross the sum of £10,000 or $50,000 for Sargent's portrait of President Wilson in 1915. In 1916 Sargent sold two of his oil paintings from his six-week trip Canadian Rockies for $2,500 each as well as other watercolors for lesser sums. In 1917 he sold eleven watercolors from his visit to the Deerings in Florida to the Worcester Art Museum for $2,750. What's more, these amounts merely supplemented Sargent's steadier income of tens of thousand dollars over the years for his Boston Public Library murals and his Museum of Fine Arts Rotunda decorations. (He'd hire McKeller for the latter project.) To be sure, Sargent enjoyed unusual financial success while many other artists, even relatively high-profile ones, scrimped to get by. But the contrast between him and his models remained stark.

To a young man living in marginal conditions, earning a few extra dollars appeared attractive, maybe even essential. McKeller had to be scrappy in order to survive. Sargent paid another model three dollars for a daylong session—the going rate—but, generous by disposition, he sometimes tossed in "several dollars more than the stipulated price" if the session went well.

At a later point in his relation with McKeller, Sargent wrote a twenty-dollar check meant for McKeller to his Boston friend Fox—who often acted as a go-between, especially when Sargent was away from the city—to be "dribble[d] out to him to keep him going" and to prevent his from moving away from Boston. Though this particular check wasn't cashed, McKeller often genuinely needed "ready money," as he later confessed to Fox, being "in quite a little rut."

Yet McKeller's few surviving letters show not only his chronic economic vulnerability but also his larger humanity. Though written to white authority figures and couched in the polite and deferential language that Black people had to adopt during this period, these letters contain a strong and authentic voice, the idiosyncrasies of spelling, punctuation, and grammar adding a sense of McKeller's Southern upbringing and colloquial eloquence. McKeller also showed a wry wit. He tweaked Fox on this very request: "I trust you will have some good luck with the letter in the near future, I [as] well."

For his part, Sargent found himself desperate for life models in Boston. Oscar Wilde's joke about the rarity of models in America—so that painters had to resort to Niagara Falls and millionaires—poked fun at what the playwright considered an impoverished American art world. But the dearth of life models was very real in a country that lacked a sophisticated studio culture and teemed with antivice crusaders. Sargent depended on local art schools for leads, but even these sources often dried up, leaving Sargent casting about for the studio models that his ambitious Rotunda project required.

Sargent may have used McKeller in 1916, but he definitely enlisted the young man for the Museum of Fine Arts mural project in late 1917 or early 1918, and then reengaged him when he returned to Boston in spring 1919. For, once Sargent and his model actually got into working together in the Pope Building, McKeller proved a natural for the job.

According to a fellow model, McKeller also worked as a "part-time contortionist." Contortionists, performers who bent their bodies into bizarre or unnatural positions, were in vogue, Boston newspapers overflowing with ads for contortionist acts. What's more, McKeller's curious hobby linked him both to vaudeville entertainment and to physical fitness. In 1914, according to Daniels, "two of the best private gymnasiums" in Boston were Black-run, though their paying members would have been mostly white, and African Americans tended to get their exercise in more modest or makeshift settings. Though a form of physical ability, contortionism also counted as a scientific

curiosity: the Harvard professor Thomas Dwight delivered a paper on this curious phenomenon to the Boston Society of Natural History in 1889.

More usually, though, contortionism was allied to popular entertainment— to circus acts, vaudeville theaters, street performances, amusement parks, and night clubs. It was a form of show business open to marginalized people during an era when such people were frequently classed as freaks. One contortionist, Major Zamora, a little person from Newfoundland, performed at Barnum-like dime museums, all over the Eastern Seaboard in the 1890s, including appearances in Boston.

As a "part-time" contortionist, McKeller could have picked up a few extra dollars making local appearances as well as accruing a little local celebrity. Possible venues thronged the Black South End. The creation of Back Bay Station in 1897—the tearing down many Black-owned homes in a quiet residential district—created, according to Daniels, "an abode and rendezvous of a nomadic, boisterous, sporting set," the "Negro 'Lower Broadway' of Boston." Social workers like Daniels disapproved of the tendency of working-class Blacks to frequent taverns and "clubs"—such as "the 'Fleur-de-lis,' 'Longworth,' 'Waverly Outing,' and 'Blue Ribbon' clubs"; they scouted the "incessant visiting, going to parties and joining societies." But this very casual, sociable atmosphere rescued McKeller from the stresses of hotel work and boardinghouse living, distracting him from what Daniels called the "daily round of toil and uncertainty" and granting him a liberating showman's persona. Such experiences predisposed him to, or reinforced some existing inclination for, the rather exhibitionistic role of modeling in the nude.

In the Pope Building studio, McKeller was proving a superlative life model. He excelled at an occupation that required not only a comfort with being naked but also an ability to hold difficult poses for a long time. Sargent was now using McKeller extensively for his Museum of Fine Arts Rotunda decorations. Fox later noted that "this young man served as the model for practically all the nude figures, and indeed for some of the others"—that is, for female figures. For, as he'd done before and would do again, Sargent translated his male model into female images. Sargent transformed one sketch entitled *Apollo*, for example, into the female nude depicting Classical Art in the oval mural, *Classic and Romantic Art*.

As for Sargent's male images, a good many of Sargent's nude sketches of McKeller survive. Most of these hewed to the business of Sargent's decorations. But others were free from any such pragmatic purpose. And all of

these sketches radiate an unusual charm and liveliness—these fluid, active, athletic pieces attentively capturing the young man's lithe musculature and handsome features.

McKeller was so compelling as a model that the Utah-born sculptor Cyrus Dallin, visiting the Pope Building around 1920, hired the young man on the spot. He hoped that this "young negro of magnificent figure" would help him clinch a bronze statue he was making of the Pilgrim-era Wampanoag chief Massasoit. "Why not use my model," Sargent said, "in the afternoon, since I use him only in the forenoon?" So, as Dallin later remarked, "The model was Apollo in the forenoon and Massasoit in the afternoon."

Dallin's decision to use a Black man to represent a Native American, if peculiar, fit the times. The choice illustrates the blithe privileges of white artists in the early twentieth century, with their many resulting blind spots. Obtusely, Dallin enlisted McKeller's fit, taut body to lend Massasoit his "savage" nobility, problematically conflating racial others and thus distorting the complicated racial history of the commonwealth to which McKeller belonged for almost all of his adult life. In a similarly complicated move, Sargent himself based white, classical figures on his African American sitter. This move honored McKeller, in a sense, but it also expunged his individual and racial attributes. McKeller's uncommon gifts as a model, paradoxically, made possible his own erasure in both Sargent's and Dallin's art.

Yet McKeller's charisma still strongly impacted Sargent and his art. McKeller's compelling presence as a model may well have influenced Sargent's decision to sketch and paint nude Black men in south Florida in 1917. Such Black men were often invisible to other white Americans of Sargent's time, including painters. Yet Sargent's predilection for representing exotic, physically objectified figures—especially powerless ones, like these Bahamian immigrants and to some extent this Vendome elevator operator— remains a complicated and troubling feature of these nude studies.

McKeller well understood that he was the "main" model for Sargent "while he was here in this country." He would prove Sargent's most regular and most compelling model in Boston, also rivaling the now-departed Nicola d'Inverno in ultimate importance. McKeller understood this importance. But he singled out one figure in particular to which he felt his own contribution was significant: "Atlas, with the world on his sholders [sic], this was my body except my head," he wrote. This casual and straightforward phrase hinted at the somewhat manipulative artistic uses Sargent had

made of his body, but it also memorialized McKeller's own larger-than-life achievement as a model.

-◄-

Perennially the gentleman, for good or ill, Sargent tended to remain so when in his studio. His staid, professional approach showed up in the one surviving letter that the painter wrote to McKeller, in which the artist addressed his model as "Dear Mr. McKeller," and gave him meticulous, almost fussy directions to two studios in Boston where they'd be working together. Such a document hardly resembled a love letter, but it hinted at the strange, often understated dynamics that allowed such a compelling relation to exist.

Sargent's mannered formality showed respect, but it also solidified a power disparity, in which a dressed man gazed continually at an undressed one. Another model of the time would recall how Sargent verbally directed him and physically manipulated his models in the course of his work. That dynamic grew particularly complicated in McKeller's case, given the long history of subjugation and sexual exploitation of African Americans. In other documented moments in the Pope Building, though, Sargent betrayed moments of humor, empathy, or personal interest in his models, and McKeller no doubt also experienced such sides of Sargent. The two men spent uncounted days together in the studio, involved in their intense mutual work.

Such complicated studio interactions raise questions about Sargent and McKeller's relationship. Was it exploitative, or was it intimate, affectionate, or erotic (on one side or both)? Was it that of an artist and his "muse," as some commentators have seen it? Sargent referred to McKeller in a 1919 letter to Fox as "that darkey [*sic*] model"—a jarring example of the artist's knee-jerk participation in the racist language and attitudes of the era. (His father had used the same word to describe the Black skaters in Philadelphia he remembered.) In the same letter, Sargent wrote pointedly how much he'd "want" McKeller when he, Sargent, returned to Boston. "Want" amounted to a demand to use, control, and own. It resounded with Sargent's greater privileges. Yet it also marked something like more personal desire. Sargent's phrase ("I shall want him") echoed, as well, in a letter of 1923, when Sargent feared that McKeller would "take some situation away from Boston."

Sargent's was anxious to keep hold of an especially adept model, to be sure. But McKeller was clearly important to Sargent, someone with whom

he'd developed an unusual rapport. When Sargent wrote his cousin Mary Hale from Washington in October 1917 that "My soul longs for the Pope Building"—the space where he'd spent days and weeks with McKeller—he could conceivably have been yearning for more than just the artistic autonomy of his studio. Sargent's friend Fox—himself a bachelor who lived at the St. Botolph Club and who later became the U.S. executor of Sargent's will—considered that Sargent's friendship with McKeller illustrated his attachment to his "most humble associates." Fox thought Sargent inspired not only "respect and esteem" but also "friendship." Such a friendship between a white man and a Black man was a radical proposition in 1925 whether or not Fox, in his use of the term, hinted at anything more complicated.

In 1934, a decade after his collaboration with Sargent, at the age of forty-four, McKeller married a Black woman of his own age named Noriena Elizabeth (Rena or Reena) Meads, born in Troy, New York. The McKellers evidently had no children. While still modeling for Sargent in early 1923, McKeller exchanged hotel work for a more stable job with the United States Post Office in Boston. He worked for this institution almost without interruption until his retirement in 1956. In 1948, he spoke briefly with Sargent researcher David McKibbin, writing a letter about his work with Sargent. Yet these late reminiscences, though long unavailable to researchers, add only a little to a picture that remains stubbornly obscure.

Was Thomas McKeller a hard worker trying to get ahead or simply a lively, devil-may-care young man out for a lark? He might also have been a striver after culture and self-education. An organization called the Boston Negro Art Club had been organized in 1907: "That its officers are waiters and kitchen-workers," Daniels observed, "shows against what odds the Negroes are striving for some of the finer things." Local Black residents mounted several art exhibitions beginning in 1907 including works by young, self-trained artists. One young Black Bostonian, Robert Hemmings, crossed the Atlantic to become an art student in Paris during this period, even though he didn't attain the fame of Sargent's near-contemporary Henry Ossawa Tanner, who, initially trained in Philadelphia, also studied art in Paris in the 1890s and also exhibited at the Paris Salon. In mid-1920s, the Tennessee-born painter Beaufort Delaney likewise studied art in Boston, joining the Copley Society of Art, before moving to New York in 1929 to bolster the transformational artistic project of the Harlem Renaissance.

What did McKeller derive from this relationship? Did he ever go to the Museum of Fine Arts Rotunda to crane his head up at the classical gods and

goddesses that had been based on his own body? McKeller could well have visited the museum, if he'd wanted to. In Boston, according to Daniels, "all public institutions, not only libraries and museums, but homes, baths, parks, playgrounds, and the rest, are in law as fully accessible to Negroes"—although, "owing to the prevailing attitude toward this race, more or less discrimination enters into the actual administration of these institutions." Still, Daniels reported seeing, every time he visited the Boston Public Library, another of Sargent's artistic venues, "at least one Negro—and usually several—intently reading and taking notes." In the Museum of Fine Arts, Daniels witnessed Black visitors "studying paintings" with great avidity.

Yet Sargent's most vivid painting of McKeller, *Nude Study of Thomas E. McKeller*, wouldn't be exhibited at the museum during the model's lifetime, and for good reason. Sargent's estate—apparently without any consultation with McKeller—would later loan the piece to the museum between 1929 and 1932, though not with any expectation of exhibiting so unthinkable a painting. After that, the work would be kept by William James Jr., Henry James's nephew, who was a teacher at the Museum of Fine Arts School. Later on, this remarkable and complicated piece would also be owned by the art historian David McKibbin, the man who'd interviewed McKeller in 1948, before the Museum of Fine Arts finally purchased the painting outright in 1986. Because of its association with the Rotunda decorations, this piece has long remained in the orbit of the museum. But it has always qualified as a complex and somewhat troubling stepchild.

Sargent's striking *Nude Study of Thomas McKeller* has since become famous, almost notorious (see Fig. 32). In a palette of golds and browns, the canvas depicts a naked man, his arms propped behind his torso, his face raised and turned aspiringly toward the source of the golden light that is falling on him. His raised face is thoughtful and reflective, his dark eyes catch the light, and the brown background references the paraphernalia of the Pope Building studio in a blurred, brushed background. This background includes a panel of the mural project that depicts some angelic figure, just behind the model. Closely aligned to this painted figure, the naked man appears to wear a pair of sketchy feathered wings. Yet the lit, explicit frontal nudity of the man, the splayed legs of his half-kneeling posture, the hands hidden behind him, also suggest intense scrutiny to some observers, and even bondage.

For Sargent's emotive, theatrical vision of his nude model remained provocative. The painting suggested both oppression and liberation, both

deep humanity and voyeuristic objectification. The mute canvas raised agitating questions about race and homoeroticism that, for decades, few wanted to acknowledge or confront.

–←–

In late June 1921, the urban resort of the L Street Baths, facing Dorchester Bay, offered a "body of clear unpolished water," as one habitué remembered, next door to Boston Harbor. A student at the Massachusetts Normal Art School, unleashed for the summer and unemployed, surveyed the crowds of half-dressed men sunning themselves or plunging into the "invigorating salty brine." Boston Harbor remained famously cold, even in summer. Yet twenty-two-year-old Anton Kamp found himself noticing "the variety of male bodies in and out of the water" and evaluating especially those with "a fine physical showing" who might actually qualify as artists' models.

Were such places, baths and beaches, recruiting grounds for artists like Sargent in need of men to pose nude? Certainly, baths were some of the few places where men's physiques were on view, and Sargent had visited Turkish baths and American beaches, ostensibly with an eye to the studio uses of the men who also frequented such venues. But according to Kamp, in an account delivered to a Sargent researcher half a century later—the most detailed account of Sargent's dealings with any model—the young man himself hatched the notion of posing for Sargent. Without being recruited, he made up his mind to present himself at the Pope Building.

A "tall, ruddy-complexioned man, heavily bearded in white and gray," opened the door, a cigar in his mouth and brushes in his hand. Sixty-five-year-old Sargent wore no artist's smock. He was working in his shirtsleeves (ever industrious, the painter would often roll up his sleeves); his salt-and-pepper beard was stained on the right side from where a smoking cigar was almost permanently lodged in his lips. Kamp later learned that, though Sargent had long been a prolific smoker, he "failed to inhale"—an abstention that amused the artist's friends. He thereby denied himself, Kamp thought, "the true purpose of 'Princess Nicotine.'"

The world-famous artist looked the unknown young man "up and down" even before Kamp could explain himself. Cowed, the young man falteringly offered his services. "Have you posed professionally?" Sargent wanted to know. When the Kamp said yes—he'd posed for several local painters and would later model for the Massachusetts-born illustrator N. C. Wyeth—Sargent invited him into the studio. Here, instead of the "neatly

appointed atelier" Kamp expected, he found a "room with a twelve foot ceiling, cluttered to capacity with stretchers, large canvases, several pieces of workshop furniture, boxes and crates along with two tables."

"Do you pose in the nude?" Sargent asked.

"Yes, if and when requested," the young man replied.

"Would you mind disrobing for a moment so that I might see your figure?"

Once Kamp had taken off his clothes and draped them over a chair, Sargent looked him over carefully, prompted him to turn around, and then remarked, "Oh, you've been swimming, you are sunburned."

"Yes," Kamp replied, "I've just come from there."

This stripping-down was only a preview of days and weeks Kamp would spend at the Pope Building working in the nude. In Kamp's first few days of work "in the presence of a great man," as Kamp described it, Sargent remained mostly silent and businesslike. He studied Kamp's figure and sometimes manipulated his body, "moving [him] about to the position he had in mind." For most of his work, Kamp climbed an elevated platform to give the perspective Sargent needed for the overhead interior of the museum's rotunda. Sargent's quickness and fluency astounded his model, as the artist sketched the young man's body in charcoal, sometimes pausing to use bits of French bread as erasers.

Sargent gazed at his model, his pencil or brush busy. But the model also looked back. Kamp noticed that Sargent possessed a "regal stature." But he also felt "a spirit of the non-conformist showed clearly." Though the artist carried himself "as erect as a Greek column," Kamp suspected that inside "seethed the life of the universe."

A sensual as well as a characterological appreciation ran through Kamp's metaphors, suggesting an erotic current between artist and model. Initially, though, Sargent kept what Kamp called a "reserved attitude" except for two small incidents. Once, Kamp walked over, naked, to stretch his legs and to look at the drawing. Sargent turned halfway around, "with a twinkle in his eye," and said, referring to the classical Greek sculptor known for his graceful male nudes, "I believe Phidias would have enjoyed you being about his workshop." On the second occasion, Kamp saw Sargent smile when he noticed that "the imprint of an upholstered cushion [he] had squatted upon was deeply impressed in [his] buttocks."

Yet Sargent was working toward his goal. For a lunette representing Music, he had Kamp grip a violin. In the final version, though Sargent be-

Sargent, *Study for Perseus*, c. 1921–25

stowed "a head of golden locks," to Kamp's consternation, on what otherwise seemed to the model a faithful image.

The two continued to work alone together during the summer of 1921. As they grew more comfortable with each other, they talked about "art, books, people." They developed a "warmer rapport" even if Sargent still remained cagey. The young man tried hard to make himself useful around the studio: his mother ironed the too-wrinkled sheet he wore at one point as a toga, and then, when asked, he tried his best to help Sargent locate a female model.

Kamp knew of only one possibility, but she'd gone to New Hampshire for the summer. Sargent was "dismayed over the difficulty in finding a good specimen." He told Kamp he "did have one, a very attractive girl, but she informed me that her posing for me was somewhat risky since she was not supposed to do it." The two men racked their brains for other candidates, to no avail. (In a later period, for a different project, Sargent would give

Kamp taped-on, wadded-cheesecloth breasts under a drapery, to allow him to substitute for a female model.) In the meantime, Sargent playfully drew a cartoon for Kamp of the kind of woman he'd sometimes had to reject: "An angular, scrawny figure one might associate with an old emaciated courtesan."

Once, after a particular vigorous session, Sargent complained of a pain in his arm and shoulder that had bothered him on and off for two weeks. Kamp "volunteered to massage or rub the affected part, but was turned down." After more weeks of work, Kamp, straining to make himself useful, also asked Sargent if "he ever took someone with him on his tours, such as when he traveled to the Continent, one who would attend to the menial chores, the cleaning of brushes, or whatever odd jobs might come up."

The young man was seemingly angling for what had once been Nicola d'Inverno's job. Sargent, however, flatly said no. He explained to Kamp that he'd once engaged "an Italian lad whose somewhat overbearing familiarity and indifference to his needs became a nuisance, necessitating his discharge and dispensing with such help thereafter." Though Sargent never mentioned a name, Kamp knew the artist meant Nicola d'Inverno. As for Sargent, his rejection of Kamp's further services, whatever these might entail, had several possible motives, including those he expressed to Kamp. Sargent was genuinely tired of the complication and interference of a young live-in assistant and travel companion, especially because those were potentially much more loaded than either artist or model could easily acknowledge. Sargent meticulously maintained a threshold of privacy. He didn't allow Kamp to cross, sometimes turning him unceremoniously away from the studio if the young man arrived at what he regarded as an inconvenient or "improper moment." "I do not need you today," Sargent would say, shutting the studio door almost in his face.

As their collaboration unfolded, Kamp saw Sargent's vulnerabilities as well as his greatness. Once when a "brilliant ray suddenly hit him in such a way that his entire head was sharply silhouetted," Kamp noticed that Sargent had slightly "protrusive" eyes as well as a beard that covered a distinctly receding chin. This "physiognomy" startled him. He afterward wondered if Sargent had grown that beard, that "symbol of the late nineteenth century," in order to "disguise this weak area of his otherwise strong features." Sargent maintained his calculated masks and correctives. His nineteenth-century accoutrements of beard and formal clothing now looked, to young people of Kamp's generation, old-fashioned and stilted.

Meanwhile, spoiling unsuccessfully to "barter his services" for watercolors, Kamp managed to arouse Sargent's generosity. The young man had his eye on a couple of figure studies the artist had made of him. He asked for copies. Instead, Sargent fished one of the originals out of a portfolio and signed it, "To Mr. Kamp . . . John S. Sargent." "He looked at me with a warm smile on his ruddy face," Kamp remembered, "his blue eyes pleasantly directed at mine saying—'I want you to have this, you deserve it.'" It is unknown if this particular nude has survived—many seem not to have done, and others have stayed immersed in museum basements or private collections. But this moment had the status of an important culmination for the model, the "climactic close to a most thrilling adventurous summer." In spite of the formal dedication the artist had made to "Mr. Kamp," the nude figure forged a strangely compelling and intimate bond between artist and model.

Sargent sometimes executed nude figure studies like this one in peculiar and heady circumstances, as Kamp recognized. At such a moment, the artist gazed at him "intently"; "Please remain as you are while I get some paper," he remarked. The resulting drawing, Kamp recounted, "had no special purpose in mind concerning the [museum] decorations." It was instead an "inspirational diversion." The young model understood that these pieces arose from the "same spirit" that "some months before" had produced a very striking oil painting that hung in Sargent's studio and that Kamp had noted from the first. This was a large canvas depicting "a negro figure," a man with "superbly developed" musculature. This was Sargent's *Nude Study of Thomas E. McKeller*.

At least once, Kamp met the model who'd inspired this "impressive study." Sometime after 1921 Kamp was introduced, perhaps accidentally, to Tom McKeller (Kamp spelled the name McKellar, but McKeller himself spelled it with an *e*). Kamp noted him as "a postal employee and part-time contortionist." But at this point McKeller was a much longer-serving model, now over thirty, who'd worked with Sargent for years. Their long-running relation had created, as a sort of culmination, this provocative masterwork, that hung in the studio but would not become public knowledge for more than half a century.

-+-

In spite of his tasteful classical decorations in the museum, the public still didn't understand Sargent as a painter of nudes. Rather, 1922 became the year of war pictures for him.

At Burlington House that May, however, Sargent also exhibited one picture that wasn't war-oriented—*The Countess of Rocksavage*, his second portrait of his friend Sibyl Sassoon. He presented her in a Worth gown that imitated a late sixteenth-century court dress, with an embroidered gold panel down the front and a gold-lined train trailing from her shoulders. It was a theatrical, retrospective piece—harkening back to the splendid women he'd painted over many years, and back in the Belle Époque.

Such a woman's portrait was still much more to Sargent's taste than his other offering at the Royal Academy exhibition, *Some General Officers of the Great War*. This complicated commission had first been broached in 1918, and, though Evan Charteris had encouraged Sargent to undertake it, the artist had long resisted the project. This huge group portrait, a canvas two meters high and more than five wide, had cost Sargent a leviathan effort and involved him in multiple sittings for the twenty-two men, mostly generals, that it depicted: "Putting them all in one canvas," his sister Emily remarked in 1920, "is what hangs like a weight on his mind!" Sargent feared failure, and indeed the result was deemed historically relevant but artistically uninteresting. The London *Times* noted the patched-together quality of this monster of a group portrait, complaining that "these generals never were so gathered together . . . they ought to be divided from each other and framed separately."

Sixty-six-year-old Sargent, though, wasn't on hand in London to monitor the reception of his generals. He'd once again sailed back to Boston that March. Recent years had witnessed many crossings of the Atlantic, with or without enemy submarines. Sargent had voyaged by himself or had squired one or both of his sisters, occasionally adding his convivial niece Reine to his retinue. Thanks to these voyages—and to Sargent's multiple projects in the city—Boston had become a sort of second home for him. Sometimes it even felt like a primary one, in spite of his temporary, rented premises at the Copley Plaza Hotel.

For Sargent's attachment to Boston wasn't entirely a matter of his many murals-projects there, though august Massachusetts institutions continued to commission him. He'd finished his rotunda decorations for the Museum of Fine Arts in October 1921, but he'd also been hired for additional decorations to be placed in the adjoining museum staircase. And in November 1921, he'd contracted to paint two Roman-arched panels for Widener Memorial Library at Harvard University. The two resulting compositions, *Soldiers of the Nation Marching to War* and *The Conflict Between Death and Victory*, would be unveiled at the university in November 1922.

Both of these paintings struck viewers as a bit odd. One Harvard fine-arts professor, G. H. Edgell, rather wrestled with the compositions. He noted that the former panel, "the coming of the Americans," relieved the drab colors of the caps and khaki of the column of rather faceless soldiers by means of a "Phrygian cap" worn by a blonde woman wearing red, white, and blue, and by the splash of an American flag at the top of the composition. These additions "enliven[ed] the color scheme." The critic had no way of knowing, though, that Sargent's main model for these white soldiers was Thomas McKeller. Sargent's favorite model was highly qualified to pose, having been drafted as a soldier himself. Between September and December 1918, for three months, McKeller had been inducted into the Army's Pioneer Brigade and stationed at Camp Devens, Massachusetts. Now Sargent posed McKeller and one other model in uniforms borrowed from a local army base. Just when Sargent was celebrating the achievements American doughboys through his African American model, however, Harvard president Abbott Lawrence Lowell barred Black students from the freshman dormitory at the college.

Incidentally, Sargent would also paint Lowell in late 1923—after, as was now usual with him, strenuously resisting the commission. Yet in this three-quarters-length portrait, he would give Lowell the dignity of an academic gown, a scroll gripped in his hand, and a blue-eyed, gray-mustached face hinting at institutional capability. For whatever dealings Sargent had had with McKeller and a string of other marginalized models over the years, the artist had long been, solidly, an establishment figure.

Sargent had painted earls, duchesses, and presidents. He'd won dozens of awards. By one reckoning, he'd acquired whole rooms full of accolades at Tite Street: five honorary degrees, sixteen exhibition prizes, and many memberships in arts institutions. He'd won a Legion d'Honneur from France, a membership in the Royal Academy, and had other decorations from the United States, Britain, Italy, France, Belgium, and Germany. Most recently, in 1921, he'd accepted the chairmanship of the British School in Rome. Though he continued to stutter, in his signature style, or to keep a cryptic silence, he appeared unassailable when he gathered at Burlington House with old friends and colleagues. He looked as solid as the Royal Academy itself. If in his private life he was more complicated or vulnerable, he kept that secret well-screened behind the sober suits and sleek dinner-jackets that contained his heavy, ponderous body. Behind the cigar smoke and port glasses of celebratory dinners, his florid face remained pleasantly unreadable.

Yet in the turbulent, inventive transatlantic worlds of the 1920s Sargent

was rapidly being deemed a painter not of the present establishment but of a defunct one. Back in London in July 1923, he would (reluctantly) deliver an address at the Royal Academy on the bicentenary of the birth of Sir Joshua Reynolds, that elegant portraitist of the eighteenth-century gentry and aristocracy. Indeed, Sargent, a fellow "grand manner" portraitist, amounted to a kind of Reynolds himself. He was now increasingly pigeonholed as the portraitist-of-record for the turn-of-the-twentieth-century elite. And, as these once-brilliant constellations began to dim, Sargent's star, too, was starting to fade. This diminishing, if not always perceptible, was unstoppable. It was as inexorable as the gathering of dust in all the once-new museums that Sargent had seen founded in his lifetime. It was as relentless as the aging that his dear sisters were too polite to notice or mention.

In 1923, too, when nine of Sargent's brilliant Wertheimer portraits were at last delivered to the National Gallery, per Asher Wertheimer's will, Sargent's modern-minded nemesis Roger Fry slammed them. He remarked that Sargent's work was aesthetically negligible, that his values were "never aesthetic values"; that his works, if they had "profound historical interest," offered nothing else. Sargent had long understood that "no one is sacred, not even the vengeful critic," as he'd put it to his Scottish artist-friend Dugald Sutherland MacColl decades before.

Still, modernist gadflies meant nothing to Sargent. He waved them away with a sweep of his hand, and he went back to work on his staircase decorations, an unlit cigar still clenched in his teeth.

28

Miss Sargent's Party

In the mid-1920s, a stout, dignified, gray-haired woman in her late sixties was sometimes seen on the Chelsea Embankment, walking stiffly in the morning sun or hunched on one of the park benches that faced the Thames, her walking stick planted resolutely in front of her. Though sometimes she wasn't seen for months, she'd always reappear sooner or later. And always she returned in versions of the same dark-colored, nunlike costumes.

Though her brother didn't paint her in old age, Emily Sargent continued to look much as she had when John executed several images of her on the island of Majorca decades before in 1908. In several watercolors and one oil, sometimes paired with her friend Eliza Wedgwood, Emily had then appeared as a somewhat stout woman who favored black. She wore rather elaborate black gowns with lace and draperies. She also chose complicated confections of black hats. (Her mother had died in 1906, but perhaps Emily had extended her sartorial mourning past the conventional Victorian period of one year.) Though such fashions had gone out of style by the 1920s, Emily changed her ways very little. She still wore her gray hair up in a chignon, still set her thin lips in a firm line that showed unswerving loyalty and determination. She still bore the marks, too, of the childhood injuries that had given her a stoop and a twisted spine.

At times, yes—as her brother had depicted her on Majorca in *Miss Eliza Wedgwood and Miss Sargent Sketching*—Emily clenched a paintbrush in her lips. A horizontal bar across her mouth, that paintbrush symbolized this woman's long silence as much as her self-expression. In another of her brother's images, *Simplon Pass: The Lesson*, Emily wore the same kind of black frock and had the same brush clenched in her mouth in Switzerland in 1911, even when pleasantly flanked by her nieces Rose-Marie and Reine.

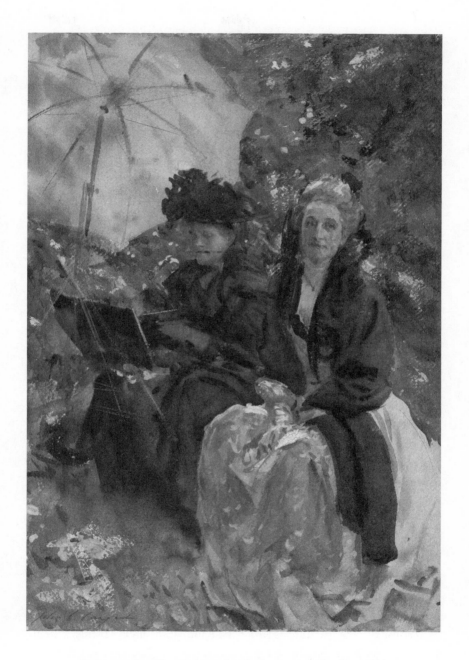

Sargent, *Miss Eliza Wedgwood and Miss Sargent Sketching*, 1908

As it had been then, in the Mediterranean or in the Alps, so it continued to be. For Emily Sargent hadn't stopped painting watercolors on her travels. Her brother honored this passion in his earlier images of her, giving credit to her for plying doggedly at her work, perhaps with little praise from anyone now that their mother was gone. Like their mother, Emily continued to paint, with little encouragement from anybody else. As a female amateur with no training and a rather rigid, old-fashioned style, Emily had no prospect of an artistic career.

Like Mary Sargent, too, Emily could sometimes throw parties. And, though she enjoyed pomp and society less than her more exuberant mother had done, sixty-eight-year-old Emily arranged for a dinner in her flat at 10 Carlyle Mansions on the evening of April 14, 1925. It was a sort of going-away party for her brother. John, now sixty-nine, stout and almost white-bearded, had booked tickets for April 18 on the RMS *Baltic*. He was headed back to Boston to supervise the installation of further decorations he'd made for the rotunda-adjacent staircase at the Museum of Fine Arts.

In recent years John had taken Emily with him to Boston, where he'd reserved a room at the Copley Plaza Hotel for her and sometimes for other family members. John remained, as he'd been since his childhood, devoted to his sisters—though in quite a complicated way—and they to him. Whether or not Sargent could be said to understand women, his close, considerate, and respectful relation to his sisters showed that he understood *them*. He actively included "Em" and "Vi" in his life on both sides of the Atlantic. At the same time, conspicuously, he lived on his own in grand isolation, and his sisters respected his privacy.

In preparation for this latest journey, in fact, Sargent had been much in his own house and studio at nearby Tite Street. He'd been furiously packing portfolios, trunks, and crates, a rather strenuous process that recapitulated what he, in his itinerant and art-saddled life, had so often done—the grand tradition of packing he'd mastered over his long life. For all the Sargents, really, packing for a journey felt almost more homelike than any kind of settled household.

That spring evening, Emily gave the dinner at her own flat in Carlyle Mansions. But, as usual, her more social and charismatic brother actually acted as host. He welcomed the guests and headed the table. He offered, in his half-bashful, half-stammering, yet winning way, a few odd and rather unexpected anecdotes. John was in "high spirits" that evening, as his friend Charteris later reported.

As for the dinner guests, the first and foremost of these was John's fifty-five-year-old sister Violet—Mrs. Ormond—still handsome, high-colored, and cheerful in spite of the vicissitudes of her rather unsatisfactory marriage. She was a full-figured incarnation of the more joyful side of the old Sargent family party, akin to the enthusiastic Mary—while Emily echoed the more sober and perhaps more disappointed side, the dutiful gloominess of the long-departed Fitzwilliam.

Other women filled up five of the party of ten, as a balance of sexes was de rigueur. Men and women processed into dinner together. Their seating at a formal table followed the pleasant though inflexible pattern of gentleman, lady, gentleman, lady. Tiny, lively Lady Fanny Prothero, a year older than Violet, an old friend of Henry James's, never failed to entertain her dinner partner, if not the whole table. She told anecdotes with the ghost of a Missouri accent whilst keeping a hawk's eye on the servants she scrutinized for any sign of negligence, as Sargent's old friend James, now dead nine years, had once humorously noted.

The two fortysomething Misses Barnard, Polly and Dorothy, filled out the female contingent. These two were old family friends who'd contributed to many a genteel picnic and Alpine excursion over the years. They'd offered themselves as gracious models in white muslins during those long-passed days and contributed to resounding two-piano quartets during those long-ago evenings. When they were nimble young girls in the mid-1880s, in the Cotswolds, Sargent had bribed them with sweets to stand still for *Carnation, Lily, Lily, Rose*—his own chaste version of what Marcel Proust had called *l'ombre des jeune filles en fleurs* (the shadow of girls in flower). In his will Sargent would leave Polly and Dorothy's widowed mother, Alice Barnard, the rather surprising sum of £5,000, twenty times the two hundred pounds he would quietly bequeath to Nicola d'Inverno. But Nicola of course had also attended many of those same picnics and also appeared in Sargent's watercolors and oil sketches, his open snow-white collar brilliant in the sunshine in contrast to his sunburned throat.

Among Emily's and John's male guests, one was Nelson Ward, Sargent's friend and solicitor. The rest of them, though—in the grand tradition of Mary Sargent's ready invitations to artists of all descriptions—were well-known London painters. All three of the men in this artistic category counted as old friends of the family, though none now appeared particularly gifted or successful. Wilson Steer had once caused a stir with his colorful, Parisian-inspired portrayals of his model-girlfriend, Rose Pettigrew; he'd

also produced misty landscapes and seascapes in a rather Impressionist style. But his works now looked old-fashioned, and he was better known as a teacher at the Slade School. Henry Tonks, who'd traveled with Sargent to wartime France, also featured as a well-worn professor there, bringing a trenchant and sarcastic manner to his podium. But his students, if initially cowed, tended sooner or later to outdo him. And Peter Harrison, who'd once daubed portraits and landscapes with some flair, now spent much of his time with Steer and Tonks or other members of the New English Art Club. Once this group had qualified as renegades—if only rather mild ones. Though hardly a rebel now, Harrison was still lanky and effervescent. He'd grown older and stiffer since he'd inspired Sargent's inn-bedroom pictures and Alpine idylls two decades before. Yet he remained, in some slightly faded way, John's warm and jovial companion.

The dinner broke up, as per Sargent's habit, at ten thirty. John started down Cheyne Walk for home. Which one of the guests was it who reputedly confided to Emily, as they lingered at the door and watched Sargent recede, "Do you know, I am still a little terrified of your brother"? And then, with a laugh and a witty allusion to the famous phrase from the Gospel of John, "This is not a case of perfect love casting out fear."

Whether or not anyone actually said such a thing, the party, its warmth and camaraderie, suffered from just this deferential or intimidated limitation. In old age, John grew increasingly ceremonious as well as firmly entrenched in his habits. Even though in 1925 the world was rapidly changing—had changed radically already, as in America women could vote, Black art was the rage in Harlem, and Hollywood was producing provocative silent films—this dinner followed the same Victorian formal conventions to which Sargent had adhered for decades in his London life.

Yet, even more profoundly, all through John's life—as far back as his student days in Paris—his friends had admired him rather at their peril. In many or most cases, they didn't quite understand why they felt browbeaten, held at arm's length, or shut out. As Sargent's old friend James Carroll Beckwith had expressed the paradox decades before, he'd "never known an unpleasant thought" from John; they were "old chums." But still John had systematically "distanced" himself. Even Sargent's sisters had sometimes been daunted by John or even a little frightened, as Violet had been intimidated by her much-older brother in her youth. Closeness in the Sargent family involved discretion and respectful distance.

At home in Tite Street, John got himself ready for bed by eleven

o'clock. His choice of reading that evening was Voltaire's *Dictionnaire Philosophique*—that great compendium of the Enlightenment that criticized many forms of traditional and conventional authority. These days John often fell asleep while reading, and after a while he pushed his glasses up on his forehead and laid this rather heavy volume aside.

Later that night, he died in his sleep. He died from a heart attack, as his mother had done, and seemingly quite peacefully. At least he seemed merely to be sleeping when the maid, not receiving an answer to her knock, discovered him there the next morning.

❧

Once more, if she'd ever ceased to do so, Emily Sargent could dress in black. On April 16, 1925, Emily and Violet buried their brother. They didn't inter him with their parents in Bournemouth. Instead, they laid him to rest in the vast complex of Brookwood Cemetery, the so-called London Necropolis, founded in 1849, in nearby Surrey. Brookwood was in bloom that spring with wisteria and lilac, and the season of hope and renewal both underlined and mitigated their loss. Their brother's grave, marked *John S. Sargent*, would also have inscribed on it the motto from St. Benedict, *Laborare est orare* (To labor is to pray), a fitting epitaph for a man who had spent decades utterly consumed by his work. Emily would eventually be buried there next to her brother. Her mourning for him was already conspicuous, if superlatively private. How could she not be devastated by the death of the most important person in her life? She would never really recover from the loss.

A memorial service took place on April 24 at Westminster Abbey. Emily and Violet huddled together in the front pews. The solemn religious service—though Sargent had been, as Nicola d'Inverno had well known, a "free-thinker"—packed the Abbey with the painter's friends, colleagues, patrons, and well-wishers. Sargent had boasted a wide acquaintance in London and many supporters from Burlington House, and his wealthy constituency—including some former aristocratic patrons, now quite faded—knew how to dress for a society memorial. As d'Inverno put it, "The lords, dukes and marquises I have politely showed away from 33 Tite Street, Chelsea, would make an imposing list." And now that list at least partly showed up in the flesh, almost like a whole gallery of Sargent portraits—aged versions thereof—assembling in the Abbey.

And yet, humbler, less noticed tributes would also appear. In Boston, on the day of Sargent's death, Thomas Fox received a visit from Thomas

McKeller at his office. The architect was not in, but the young man returned the next morning. "'I just came to pay my respects, sir,'" McKeller said. "We shook hands," Fox recollected, "and he went quietly away." Such a moment suggests a connection, perhaps even a strong and heartfelt connection, between model and artist. Anton Kamp, then working as a journalist in Boston, was also shocked to hear of Sargent's death. He couldn't find an outlet for expressing his sadness, even though he felt that "he and I experienced a rapport" that others might not have "realized to the same degree." Then, in February 1926 Nicola d'Inverno published his warm, somewhat cocky tribute to Sargent in a Boston tabloid. That same month, Albert de Belleroche reluctantly shared his own account of his onetime friendship with Sargent, revealing intimate sketches from the 1880s and afterward that previously no one had known existed, though he did so in an obscure quarterly for print collectors that almost no one read.

Such modest and unassuming voices, seemingly tangential, tended to get lost in the torrent of memoirs and reminiscences that followed Sargent's death. Some accounts were written by people who'd scarcely known the famous artist. In that category was a piece published in two different periodicals by the sometime painter Hamilton Minchin. He'd known Sargent only slightly and only for a year, five decades before in Paris. But he felt that his memories—much embroidered by irrelevant flourishes of erudition—were "perhaps worth recording at a time when even trifles about a great man are welcome." Many other people more qualified to comment on Sargent's life chose not to do so. Many friends held their tongues and stilled their pens, respecting the artist's closely guarded privacy.

Sargent's friend and designated biographer Evan Charteris wasted little time in compiling his life of Sargent, and he published this volume in 1927. This biography remains a significant source of documentation for the painter's life. Charteris includes extensive quotations from letters that have otherwise not survived. Still, this work is flawed and limited in many respects, not least by Charteris's decorous, almost worshipful treatment of his distinguished friend. The extent to which Charteris may have edited, selectively transcribed, or even destroyed letters and other papers is unknown.

But at the end of his rather stately volume, Charteris boldly included Vernon Lee's "J.S.S., In Memoriam," a lively and complicated recollection of a shared childhood. Though Violet Paget had largely lost contact with Sargent since the 1880s (though she had something like a reunion with his

sisters after John's death), Vernon Lee's would prove one of the most illuminating accounts of the painter, and at least partly because of Lee's (undeclared) perspective as a queer writer, which illuminates many overlooked aspects of Sargent's youth and young manhood.

The art world also celebrated Sargent's life through memorial exhibitions. Between November 1925 and March 1926, a number of extensive presentations of Sargent's collected works honored the power, breadth, and diversity of his painting, at the Museum of Fine Arts in Boston (where Sargent's final decorations had been unveiled), the Metropolitan Museum of Art in New York, and the Royal Academy in London. Such powerful retrospectives, at museums and art institutions strongly associated with Sargent during his life, attested to the official acceptance of Sargent as a major Anglo-American artist. At the same time his work, increasingly judged as old-fashioned, hardly sorted with the modernist and avant-garde art then being produced in London and New York, Paris and Berlin.

A more selective and personal retrospective, however, came from Sargent's unconventional favorite Ena Wertheimer Mathias, who in July 1925 displayed twenty Sargent watercolors in her Claridge Gallery. Ena showed a rare collection of rather lyrical, intimate paintings—watercolors being Sargent's most beloved medium. But Ena left no reminiscences in print of her avuncular friend.

—◂┾▸—

That same month—on July 24 and 27, 1925—Emily Sargent found herself in the uncomfortable predicament of having to part with 237 of her brother's oils and watercolors through an auction at Christie's. The sheer volume of Sargent's possessions made the sale necessary. Also on the block were almost a hundred paintings in Sargent's collection by other artists, including works by Tiepolo, Corot, and Monet, but also works by Sargent's close friends Edwin Austin Abbey (who'd died in 1911) and Paul Helleu (who would die in 1927). The sale realized £176,366, tens of millions of dollars in today's money, and a third more than Asher Wertheimer had paid for the distinguished Hope Collection more than two decades before. Violet's husband, Francis Ormond, had proved right that the market for Sargents stood at a high-water mark just after his death—even though, after a long hiatus in the artist's reputation, Sargents would fetch even more in the late twentieth century. Ormond himself was shut out from any direct profits, though.

Sargent had split his estate between his sisters but had made sure to set up a trust so that Violet and her children, not Violet's rather unscrupulous husband, would benefit from his bequest.

Even with this massive sale, Emily Sargent and Violet Ormond still had to cope with most of the contents of Sargent's home and multiple studios—sketchbooks, letters, notes, photographs, all manner of artistic productions including drawings, watercolors, and oil sketches. Emily's flat at Carlyle Mansions as well as her sister's house in Cheyne Walk were crammed to the ceilings with their brother's papers, artworks, and belongings. With such an archive on her hands, Emily Sargent became the chief curator of Sargent's legacy. She took on the role partly because she was devoted to her brother, partly because she had more time and attention to spare than Violet, who—though the youngest of her six children was twenty-seven in 1925—had more pressing family involvements. More than almost anyone else, indeed, Emily would exert a strong influence on how her brother would be understood and remembered.

Did Emily edit, cull, or destroy documents or images in her possession? It's difficult to know, as Emily and Violet had almost total control over their brother's works and documents. Certainly, the Victorian era was often policed by editors, censors, and letter-burners, mostly family members, who expunged from the record anything they felt was awkward or incriminating. In Sargent's own circle, John Addington Symonds's queer confessions had barely survived culls by his widow, in spite of his explicit instruction to his executor Horace Brown. Frank Millet's love letters to Charles Warren Stoddard endured only by a fluke, and partly because Stoddard had no surviving family members to expurgate his papers. Sargent himself, of course, though famously careless about his work, may have destroyed drawings or documents himself, before his death.

Yet Emily and Violet appear to have been faithful preservationists. Most probably, it is to them to whom we are indebted for the richness of Sargent's legacy. Far from eliminating materials, the sisters worked hard to ensure that their brother's work survived. After John's death, Emily and Violet launched lifelong campaigns to place their brother's minor and incidental works in any museums that would take them. They "gave lavishly," in the words of one Sargent biographer: "Few legatees have cared so little for their pockets and so ardently for the deceased's memory." Emily Sargent continued doggedly to donate Sargent's productions until her death, which happened as the result of a freak bicycle accident in Zurich, in spring 1936.

Violet Ormond continued the effort, and often in Emily's name, until her own death in 1955.

What's more, almost all of Sargent's surviving male nudes passed through Emily's and Violet's hands, either directly or indirectly, via agents like Thomas Fox in Boston. Sargent's nude upper-body sketch of his favorite model Spinelli from the late 1870s, with one nipple in profile, went to the Rhode Island School of Design through Fox, as did another early male nude. Likewise, quite graphic undated male nudes, certainly lacking fig leaves, went to Yale and the Wadsworth Atheneum in Hartford, Connecticut, as joint gifts by the sisters. Quite a few nude male sketches ended up at the Philadelphia Museum of Art, the Museum of Fine Arts in Boston, the Corcoran Museum in Washington, and the Fogg Museum at Harvard, under the sisters' individual or joint auspices. A few significant nudes were donated by Violet Ormond alone, as late as 1950, for example John's odd sketch of naked men from Morocco, *Nude Bathers on a Wharf*. Yet it's hard to know if such images were deliberately held back by Emily or Violet, or if they simply emerged from the jumble later, or if—another important factor—they were simply harder to place with museums.

American museums from the 1920s to the 1950s weren't particularly interested in most of Sargent's private productions, and especially not in the faint or open homoeroticism they suggested. Most of the great American museums had actually been founded during Sargent's lifetime (Boston's Museum of Fine Arts and New York's Metropolitan had both been officially established in 1870, when Sargent was twenty-four), and they embodied the aspirational ethos of a high culture that lauded the perceived aesthetic and moral values of canonical European art. Ruled by patrician trustees and middle-class subscribers, they embodied the conventional values of this group of elites at this period. Those conventions allowed little or no latitude for unconventionalities, especially gender or sexual difference.

Boston's Museum of Fine Arts, the institution with which Sargent became most closely associated by the end of his life, embodied complicated views toward nudes. The museum opened its doors in 1876 with all of its male classical casts—over half of its original contents—completely masked in fig leaves. In the late nineteenth century, the museum was reputed to be "too solemn, too pedagogical, too given to the unprovoked doing of artistic and intellectual good," as one historian has phrased it, to tolerate anything perceived as degraded or licentious. Isabella Stewart Gardner might have adored Sargent's *El Jaleo* in 1882, but many other Bostonians found "the

subject of a Spanish gypsy dancer, however admirably painted" was highly "unsuitable." In 1903, the Museum of Fine Arts declined to purchase an archaic grave stele of a nude youth from Thebes because curators felt it could not be publicly displayed in Boston "without mutilation."

Especially because the early museum's mission was largely pedagogical, administrators were sensitive to anything that might be seen to corrupt or even distract youths—anything, certainly, antivice crusaders might turn into a newspaper scandal. And especially in the early twentieth century, in the wake of the Wilde trials and with the widespread pathologization of homosexuality in the press, male nudes—in spite of their importance to classical art and their venerable role in training artists of previous generations—increasingly stood at the forefront of such public crusades and expurgations.

By 1930, the Museum of Fine Arts had acquired at least a few nudes without fig leaves, to judge from an official handbook from the time. Among these were Sargent's own rotunda decorations—which, though delicate, classical, idealized, distant, and "very ladylike" (some thought)—included a few bared breasts and penises, relics of Sargent's boldness earlier in his life. But American museums were still far from approving the kind of transgression embodied in some of Sargent's edgier public works, let alone his private production of male nudes. These included the many sketches he'd made of Thomas McKeller, which his sisters had since inherited. (Isabella Stewart Gardner also received a batch of these beautiful, spirited nudes, and these have been the center of a magnificent recent exhibition focusing on Thomas McKeller.) The lofty and sacralized conceptions of high art that shaped American museums in the late nineteenth and early twentieth centuries tended to denigrate art's social underpinnings, especially those connected to the low life (ethnic, racial, or sexual) to which Sargent had often been attracted. And although the art world on both sides of the Atlantic had always sheltered many queer figures—artists, curators, scholars, enthusiasts—for that very reason museums tended to downplay any such connections in an era when the taint of homosexuality remained career-breaking if not downright criminal.

If intellectual and potentially sophisticated foundations such as museums and universities offered little tolerance, conventional middle-class society provided even less. Throughout the period of Emily's and Violet's lives, most Americans wouldn't have cared if the ambiguous legacy of Sargent's art *had* been eliminated. Some would have preferred that it had been lost or erased. Nor would the Sargents' adopted society in England have proved

much more broad-minded, in spite of London's vaunted cosmopolitanism. Yet it is a striking and moving dynamic of this evidence that, though some suggestive items emerged from private collections much later, after Emily's and Violet's eventual deaths, the greater share of this important body of Sargent's work was carefully and lovingly preserved, placed, and archived by Sargent's sisters.

Were Emily and Violet naïve—didn't they see the implications of the images they were conserving? That's certainly possible. Before the sexual revolutions of the mid- to late twentieth century—and in fact even after—homosexuality and other forms of sexual irregularity were so forbidden and unthinkable in many circles, especially in genteel middle- and upper-class milieus such as those of the Sargent sisters—that avoidance and denial often predominated.

What's more, middle-class women in the Victorian era (Emily was born in 1857 and Violet in 1870) were as much as possible kept innocent of sex and sexuality—were believed, in fact, to lack erotic desires. Such imposed ignorance or innocence might appear to apply to an unmarried and presumably celibate woman such as Emily Sargent, even if it's harder to imagine in a lively, rather defiant figure such as Violet Ormond. Neither sister alluded to the possibility of her brother's sexual nonconformity. At any rate, such powerful dynamics of the time shouldn't be discounted: Emily and Violet may not have known, or may not have believed in the possibility. Yet such repression and denial might be thought to eliminate sexual evidence as opposed to preserving it.

It seems more probable, in fact, that Emily and Violet, from decades of exposure to their brother and his circle, knew just about everything there was to know about him. Although John had kept his personal life private even or especially from his family, his sisters over the years would have met Albert de Belleroche, Paul Helleu, Edwin Austin Abbey, Frank Millet, Dennis Bunker, Peter Harrison, and most of John's other artist chums, companions, sitters, and romantic friends. Even if they didn't encounter models like Thomas McKeller—and perhaps Emily did, in that shared hotel residence in Boston or at her brother's Pope Building studio—they'd have received a pretty full exposure over twenty-five years to the ubiquitous Nicola d'Inverno.

Are we to think of them as blind and unobservant, when they possessed, themselves, the Sargent family genius—were daughters of their unconventional mother and also thoroughly immersed, over whole lifetimes, in the kaleidoscopic sophistication of Europe? When Emily declined to keep house

with John after her mother's death, such knowledge may well have been part of what she meant when she remarked on her brother's having been "many years a bachelor" and finding an invasion of his private life "irksome."

Yes, it seems likely that Emily and Violet knew their brother thoroughly, in all his many complications, and accepted him thoroughly—enough, certainly, to grasp the implications of their brother's male nudes. They loved his other works and personal qualities, and the nudes, after all, gave only one small glimpse into the multifarious affair, with all its twists and turns, that was his life. But they loved their brother too much to allow any fragment of his rich and impassioned immersion in life to die with him.

Notes

Abbreviations Used in the Notes

AAA: Archives of American Art, Smithsonian Institution

BA: Archives of the Boston Athenaeum, Boston

ES: Emily Sargent

FM: Fogg Museum, Harvard University, Cambridge, Massachusetts

FWS: Fitzwilliam Sargent

ISG: Isabella Stewart Gardner

ISGM: Isabella Stewart Gardner Museum, Boston

ISGMA: Isabella Stewart Gardner Museum Archives, Boston

JSS: John Singer Sargent

MFA: Museum of Fine Arts, Boston

MMA: Metropolitan Museum of Art, New York

Tate: Tate Britain Gallery, London

VL: Vernon Lee (Violet Paget)

A Note on Sargent's Artworks

Sargent's paintings, drawings, sketches, and other visual material that are mentioned or discussed in this book are briefly cited in the following endnotes (by title, year, medium, and institution). More in-depth notes accompany the black-and-white and color illustrations in this book, as listed in the illustration credits. John Singer Sargent, as embedded in his world, is best explored through his remarkable artistic productions. Many of Sargent's works mentioned in this book but not pictured in this volume are available through a variety of online sources. Most of Sargent's works are in the public domain, and they are available for study and appreciation via various open-access policies and via such online clearinghouses as the Creative Commons (creativecommons.org). A compendious and enthusiastic "Virtual Gallery" of Sargent artworks, with useful notes and discussions, can be found at jssgallery.org, with its mission to "further the knowledge and appreciation of Sargent's work and life." And, finally, a full and annotated survey of Sargent's known works is available in the nine-volume series of the *Complete Paintings*, edited by Richard Ormond

and Elaine Kilmurray and published by Yale University Press. This catalogue raisonné is the definitive source for Sargent's works and scholarly information about them.

Prologue: The Prince of the Glass Palace

4 *smoking a cigarette and lounging in Sargent's studio*: See JSS, *Paul Helleu*, c. 1880, pastel on paper, FM, Harvard University; *Paul Helleu*, c. 1882–85, watercolor on paper, private collection.

4 *"habitual good humour"; "surprises and* imprévu*"*: Albert de Belleroche, "The Lithographs of Sargent," *The Print Collector's Quarterly* 13 (February 1926): p. 42.

4 calcaire grossier: John Lichfield, "The Stones of Paris," *Independent*, September 22, 2007, https://www.independent.co.uk/news/world/europe/the-stones-of-paris-403115.html.

4 *Sargent's Paris glowed with such visual style*: According to the historian Patrice Higonnet, nineteenth-century Paris considered itself the "capital of the world," and in a number of respects. "For one thing," Higonnet writes, "it was more 'multifunctional' than its peers. Some cities, such as Rome, Florence, and Venice, are art and history incarnate. Others, such as New York, London, and Berlin, are embodiments of modern finance and government. Only Paris was in the truest sense all these things at once. Paris was simultaneously a capital of the arts, politics, religion, finance, administration, and science." See Patrice Higonnet, *Paris: Capital of the World*, trans. Arthur Goldhammer (Cambridge, MA: Harvard University Press, 2002), p. 235.

4 *his little railway junket*: The only source for this trip to Holland is Albert de Belleroche's "Lithographs of Sargent," published after Sargent's death. Sargent's 1880 trip to Haarlem is corroborated by the guest book at the Frans Hals Museum, but no signatures appear for 1883. See Richard Ormond and Elaine Kilmurray, *John Singer Sargent: Figures and Landscapes, 1874–1882* (New Haven, CT: Yale University Press, 2006), pp. 199–200.

4 *"Leuleu"*: Stanley Olson, *John Singer Sargent: His Portrait* (New York: St. Martin's Press, 1986), p. 63.

4 *"Baby Milbank"*: Sargent inscribed some of his portraits of Belleroche "To baby Milbank."

5 *risked a sketch of his drowsing friend*: Printed in 1926 in Belleroche, "Lithographs of Sargent," p. 20. This sketch, dated 1883, may have been captured on the train to Haarlem or on another train taken by Sargent and Belleroche. Even if it memorializes the trip to Holland, that trip may have or may not have been taken in 1883.

7 *"With the exception of Madame Gautreau"*: Belleroche, "Lithographs of Sargent," p. 34.

8 *"stacks of sketches of nude people"; "cursory observations"; "a bit earthy"*: E. V. Lucas, *Edward Austin Abbey, Royal Academician: The Record of His Life and Work*, vol. 1 (London: Methuen, 1921), p. 231.

9 *It isn't known if the specific sketches Abbey observed*: See Trevor Fairbrother, *John Singer Sargent: The Sensualist* (New Haven, CT: Yale University Press, 2000), p. 104.

9 *raised thorny questions about Sargent's life and career*: Many Sargent scholars now acknowledge that Sargent was "queer"—a figure engaging in unconventional

modes of gender and sexuality. But a number of different theories about Sargent's sexuality have been proposed and debated.

Trevor Fairbrother was the primary scholar to "out" Sargent between 1981, when he published an essay on Sargent's male nudes, and 2000, when through a landmark exhibition he extensively explored Sargent's complex homoerotic "sensuality." See Trevor Fairbrother, "A Private Album: John Singer Sargent's Drawings of Nude Male Models," *Arts Magazine* 56, no. 4 (December 1981): pp. 70–79, and his *John Singer Sargent: The Sensualist* (Seattle: Seattle Art Museum; New Haven, CT: Yale University Press, 2000). In a career of meticulous archival scholarship and careful art-historical analysis, Fairbrother has made an increasingly compelling case for Sargent's presenting a complex "repressed sexuality" and "conflicted socio-sexual identity" as well as for interpreting much of Sargent's work through dynamics of homoeroticism, disguise, and impersonation: Fairbrother, *John Singer Sargent* (New York: Abrams, 1994), pp. 8, 83.

Many other art historians have also documented the nonnormative complexities of gender and sexuality in Sargent's life and work. As long ago as 1986, Albert Boime noted the "powerful influence" on Sargent in the 1880s and 1890s of Wilde, Montesquiou, and other "Bohemians" and "Aesthetes" now understood as queer. Examining fictionalized versions of Sargent in such works as Wilde's *The Picture of Dorian Gray* (1890–91), Boime argues, "The society in which Sargent moves is sharply exposed": see Boime, "Sargent in Paris and London: A Portrait of the Artist as Dorian Gray" in Patricia Hills, ed., *John Singer Sargent* (New York: Whitney Museum/Abrams, 1986), pp. 75, 77. More recently, Dorothy Moss has seen compellingly complex androgyny and "gender bending" in the creation of Sargent's *Madame X* (1884), springing from an intimacy with fellow painter Albert de Belleroche that, in its "sensuality and intensity of emotions, push[ed] the boundaries of what was considered appropriate interaction between men at this period": Moss, "Sargent, Madame X, and Baby Millbank [*sic*]," *Burlington Magazine* 143 (May 2001): p. 274. In many new studies, a focus has been placed on Sargent's many sketches of male nudes, which, as Donna Hassler argues, were "more than just an academic pursuit" and, "created for [Sargent's] own personal study and enjoyment," copiously documented Sargent's "strong preference for portraying the masculine form throughout his career": Hassler's preface in John Esten, *John Singer Sargent: The Male Nudes* (New York: Universe, 1999), p. 11.

A new generation of biographical and historical scholars has found resonance in Sargent's complex erotic life and has rightly understood him as belonging to queer social contexts related to the Paris arts world of the 1880s, Isabella Stewart Gardner's circle in Boston, or the Palazzo Barbaro group in Venice: see Deborah Davis, *Strapless: John Singer Sargent and the Fall of Madame X* (New York: Penguin, 2003), pp. 113, 120–21; Douglass Shand-Tucci, *The Art of Scandal: The Life and Times of Isabella Stewart Gardner* (New York: HarperCollins, 1997), p. 89; Alan Chong, "Artistic Life in Venice" in Elizabeth Anne McCauley et al., eds., *Gondola Days: Isabella Stewart Gardner and the Palazzo Barbaro Circle* (Boston: Isabella Stewart Gardner Museum, 2004), pp. 87–128.

Recent art historians have found what the art historian Sarah Burns has described as a welcome and revealing antidote to an older view of Sargent as a "slick, superficial antimodernist society painter" through revisiting his homoerotic and queer

associations, thereby achieving a "more complex and challenging image of the art-
ist": quoted in Patricia Failing, "The Hidden Sargent," *Art News* 100, no. 5 (May
2001): pp. 170–71. Recent anthologies, exhibitions, and catalogues have located
Sargent's work in a tradition of American queer and homoerotic art: see Jonathan
Weinberg, *Male Desire: The Homoerotic in American Art* (New York: Abrams, 2004),
pp. 42–45; and Jonathan D. Katz and David C. Ward, *Hide/Seek: Difference and De-
sire in American Portraiture* (Washington, DC: Smithsonian, 2010). Alison Syme in
her *A Touch of Blossom: John Singer Sargent and the Queer Flora of Fin-de-Siècle Art*
(University Park, PA: Pennsylvania State University Press, 2010) interprets queer
content in Sargent's work through nineteenth-century botany, gynecology, and ho-
mosexual subculture.

This present work will build on this scholarship, offering new applications of it,
as well as integrating the consideration of Sargent's sexuality into a larger vision of
his life and work.

9 *Yet the labels that have been attached to Sargent*: Sargent's sexual complexities, as
manifested in his life and work, have often been marginalized, dismissed, or ig-
nored. This book attempts to address this neglect. The so-called presumption of
heterosexuality that undergirds mainstream society (and often scholarship) is ex-
tremely powerful. As the social theorist Michael Warner has asserted, "much of het-
erosexual privilege lies in heterosexual culture's exclusive ability to interpret itself
as society. Even when coupled with a toleration of minority sexualities, heteronor-
mativity has a totalizing tendency that can only be overcome by actively imagining
a necessarily and desirably queer world." See Michael Warner, "Introduction: Fear
of a Queer Planet," *Social Text* 29 (1994): p. 8.

This book, however, does not make a claim that Sargent was "gay," in the pres-
ent understanding of the word. As the historian of sexuality Jonathan Ned Katz
has argued, "We may refer to . . . nineteenth-century men's acts or desires as gay
or straight, homosexual, heterosexual, or bisexual, but that places their behaviors
and lusts within our sexual system, not the system of their time." Historical con-
text is crucial; it is important to locate figures like Sargent within what Katz calls
the "erotic and emotional institutions of their own time." See Jonathan Ned Katz,
Love Stories: Sex Between Men Before Homosexuality (Chicago: University of Chi-
cago Press, 1999) pp. 9, 11. For this and other reasons, this book often uses recent
concepts of queer theory—"queer" in this case covering a range of illicit or non-
normative sexualities that need not be classified according to rigid late nineteenth-
century pathological categories ("invert," "homosexual") or late twentieth-century
political ones ("gay"). At the same time, without presuming an "identity" as we
now understand it, this biography will explore the range of Sargent's affective or
erotic experiences with men (and his complex relation with women), linking them
to important aspects of his works.

10 *"diva"*: *Oxford English Dictionary*, "diva" (n.). John Singer Sargent's affinity for
"divas" will be a strong theme of this book. For a contrast between Sargent's and
Henry James's attitudes toward strong theatrical women, see Paul Fisher, "'Want of
Serenity': James, Sargent, and the Queer Problem of Divas," *Henry James Review*
41, no. 3 (fall 2020): pp. 252–58.

10 *His choice of such exuberant models tapped into*: This predilection hinted at a more
profound if complicated identification with women, theatricality, and exoticism.

Even at twenty-seven, Sargent understood the complex interpersonal relations associated with both portraiture and figure drawing.

This book will accordingly have a lot to say about Sargent's relation with his models, both named and unnamed. Scholarly interest in turn-of-the-twentieth-century artists' models has increased in recent years, and there are now some interesting studies, including Sarah R. Phillips, *Modeling Life: Art Models Speak About Nudity, Sexuality, and the Creative Process* (Albany: State University of New York Press, 2006); Heather Dawkins, *The Nude in French Art and Culture, 1870–1910* (Cambridge: Cambridge University Pres, 2002); Jane Desmarais, Martin Postle, and William Vaugh, eds., *Model and Supermodel: The Artist's Model in British Art and Culture* (Manchester, UK: Manchester University Press, 2006); Marie Lathers, *Bodies of Art: French Literary Realism and the Artist's Model* (Lincoln: University of Nebraska Press, 2001); and Susan Waller, *The Invention of the Model: Artists and Models in Paris, 1830–1870* (Aldershot, UK: Ashgate, 2006). One of the most interesting recent studies of Black models is Denise Murrell, *Posing Black Modernity: The Black Model from Manet and Matisse to Today* (New Haven, CT: Yale University Press, 2018), the catalogue for a recent exhibition at the Wallach Art Gallery at Columbia University. For a recent reconsideration of Sargent's relation to one specific model, Thomas McKeller, see Nathaniel Silver, ed., *Boston's Apollo: Thomas McKeller and John Singer Sargent* (Boston: Isabella Stewart Gardner Museum, 2020).

10 *"'uncanny' spectacle"*: James, "John S. Sargent," in John L. Sweeney, ed., *The Painter's Eye: Notes and Essays on the Pictorial Arts by Henry James* (London: Rupert Hart-Davis, 1956), p. 218.

10 *Thomas McKeller*: See note on models and their importance to recent scholarship, above. My own contribution in Silver, *Boston's Apollo*, "'Atlas, with the World on His Shoulders, This Was My Body': Thomas McKeller and His Work with John Singer Sargent" (pp. 41–61), which discusses McKeller's biography in more depth, has informed some of my discussion of McKeller in Chapter 27.

10 *"queer"*: In the twenty-first century, "queer," once a slur used against gay people, has been rehabilitated to describe a range of LGBTQ+ identities. In this book, the term "queer" will encompass a range of illicit formulations of gender and sexuality.

11 *a vision of a fuller and richer, a more unpredictable*: Richard Ormond's and Elaine Kilmurray's excellent nine-volume catalogue raisonné of Sargent's works, recently completed, has done much to make the larger and more complete scope of his work visible, especially with its exhaustive documentation and careful commentary. See Richard Ormond and Elaine Kilmurray, *Complete Paintings*, 9 vols. (New Haven, CT: Yale University Press, 1998–2016). Any study of Sargent would be beholden to this thorough and scholarly compendium, and this present work gratefully acknowledges this debt. This biography, however, though it attempts a full and inclusive narrative of Sargent's life, investigates the "fuller and richer," the "more unpredictable Sargent," largely in terms of gender and sexuality in Sargent's life and historical context, a vision of the painter and his art worlds that has been made possible by feminist and queer scholarship in recent decades.

11 *slick, elite, or meretricious artist*: For example, the critic David Gervais saw Sargent as an appealing but rather superficial painter, arguing that the pleasure he gives viewers "is not the kind that dawns gradually on us so that we see more in him each

time we go back to him: what we see is what we get" (p. 101) and that a painting like *Madame X* shows only a "lazy freedom." But even he, resisting Sargent's enduring popularity, acknowledges Sargent's brilliance as a painter and concedes that "as a case, he is more of a paradox." See David Gervais, "Sargent and the Fate of Portrait Painting," *Cambridge Quarterly* 29, no. 2 (2000): pp. 101, 112. This book will argue that Sargent's deeper personal paradoxes in fact render his painting much more interesting and relevant than critics such as Gervais have allowed.

1. Mrs. Sargent's Party

13 vetture di rimessa: Vernon Lee, "J.S.S.: *In Memoriam*" in Evan Charteris, *John Sargent*, p. 243.

13 *"bubbling with sympathies"; "unquenchable youthfulness"*: Lee, "J.S.S.," p. 237.

14 *"locomotive disposition"*: Charteris, *John Sargent*, p. 10.

14 *"born of innumerable stay-at-home generations"*: Vernon Lee, *The Sentimental Traveller: Notes on Places* (London: John Lane, 1908), p. 6.

14 *"break for freedom"; "revolt against security"*: Ida Tarbell, *All in a Day's Work: An Autobiography*, 1939 (Boston: G. K. Hall, 1985), p. 114.

14 *Wills Hospital in Philadelphia;* On Bandaging: Olson, *John Singer Sargent*, pp. 3, 10; Charteris, *John Sargent*, p. 1.

14 *"the humbug variety of Americans"*: FWS to George Bemis, August 20, 1865, Massachusetts Historical Society, Boston.

14 *dirtier than before; the American chapel*: FWS to Emily Haskell Sargent, December 11, 1868, AAA.

15 *"gods or sibyls or stray martyrdoms"*: Lee, "J.S.S.," p. 243.

15 *fifty thousand Americans had steamed across the Atlantic*: Alison Lockwood, *Passionate Pilgrims: The American Traveler in Great Britain, 1800–1914* (Rutherford, NJ: Fairleigh Dickinson University Press, 1981), p. 283.

15 *Sargents could read*: Paul R. Baker, *The Fortunate Pilgrims: Americans in Italy, 1800–1860* (Cambridge, MA: Harvard University Press, 1964), p. 20.

15 *"a good many of our old acquaintance"*: FWS to Emily Haskell Sargent, December 11, 1868, AAA.

15 *"a household that quivered on the brink of doom"*: Olson, *John Singer Sargent*, p. 6.

15 *porphyry and cipollino with the tips of their umbrellas*: Lee, "J.S.S.," p. 242.

16 *"Rome seems quite like home"*: FWS to Emily Haskell Sargent, December 11, 1868, AAA.

16–17 *"kept a white-capped chef"; "enfants mal élevés"; "skippery boy"; "grave and docile"; "pepper-and-salt Eton jacket"*: Lee, "J.S.S.," pp. 241–42, 245.

17 *"a slender American-looking lad"*: Edwin Howland Blashfield, "John Singer Sargent," 1925, reprinted in *Commemorative Tributes of the American Academy of Arts and Letters: 1905–1941* (New York: American Academy of Arts and Letters, 1942), p. 185.

18 *"remarkably quick and correct eye"*: Mary Sargent to Emily Haskell Sargent, October 20, 1867, AAA.

18 *"boyish priggishness"*: Lee, "J.S.S.," p. 241.

19 Libyan Sibyl: William Wetmore Story, modeled 1861, carved 1868, marble, Smithsonian American Art Museum, Washington, DC.

19 Cleopatra: William Wetmore Story, *Cleopatra*, 1858; carving of 1869, marble, MMA.

19 *"fierce, voluptuous, passionate"*: Nathaniel Hawthorne, *The Marble Faun, or the Romance of Monte Beni* (1860; reprint Boston: Houghton Mifflin, 1889), pp. 152–53. Hawthorne had also noticed the exotic, racially freighted addition of "Nubian lips" as well as the "the magnificence of her charms," able to "kindle a tropic fire in the cold eyes of Octavius." Clearly, Hawthorne's sometimes-cold eye had had also been fired up by this Cleopatra.

19 *"every stage of wet-sheeted clay"*: Lee, "J.S.S.," p. 243.

19 Nydia, the Blind Flower Girl of Pompeii: Randolph Rogers, 1853–54, marble, MMA. The statue was based on Edward Bulwer-Lytton's popular novel *The Last Days of Pompeii* (1834). Rogers started out in Rome as a struggling artist who made rather more conventional busts of visiting American tourists and their offspring. With the particular sculptural recipe of *Nydia*, however, Rogers eventually sold seventy-seven marble replicas of his best-known piece. See Susan James-Gadzinski and Marry Mullen Cunningham, "Randolph Rogers," in *American Sculpture in the Museum of American Art of the Pennsylvania Academy of Fine Arts* (Philadelphia: Pennsylvania Academy of Fine Arts, 1997), pp. 58–61.

19 *Harriet Hosmer*: Harriet Hosmer represented the surprisingly populous world of female American sculptors in Rome. In 1903 the novelist Henry James would notoriously describe these women, in a term prompted by Nathaniel Hawthorne's romance, as "the white marmorean flock." Yet these bold women sculptors made marble their catalyst and glory. Many of them were displaced Massachusetts women, many lesbians, and their group included Anne Whitney, Emma Stebbins, Margaret Foley, Louisa Lander, Vinnie Ream Hoxie, and Edmonia Lewis. This last sculptor Henry James pejoratively identified as "one of that sisterhood" of assertive female sculptors. But Lewis's background was in some ways atypical: her Massachusetts heritage was African, Ojibwe (Chippewa), and Haitian. See Henry James, *William Wetmore Story and His Friends: From Letters, Diaries, and Recollections*, vol. 1 (1903; reprint New York: Grove, 1957), pp. 257–58.

19 *Zenobia*: Harriet Hosmer, *Zenobia, Queen of Palmyra*, 1857; *Zenobia in Chains*, c. 1859, St. Louis Art Museum, St. Louis.

19 *her own marble fauns*: Harriet Hosmer, *A Waking Faun*, marble, c. 1868, Lafayette Park, St. Louis; *The Sleeping Faun*, c. 1870, marble, Cleveland Museum of Art, Cleveland.

19 *"erotics of purity"*: See Walter T. Herbert, "The Erotics of Purity: *The Marble Faun* and the Victorian Construction of Sexuality," *Representations* 36 (fall 1991): pp. 114–32.

20 *"emancipate[d] the eccentric life"*: Elizabeth Barrett Browning to Mrs. M.R. Mitford, May 10, 1854, in *Letters of Elizabeth Barrett Browning*, vol. 2 (New York: Macmillan, 1897), p. 166.

20 *"faithful worshipper of Celibacy"*: Hosmer to Wayman Crow, August 1854: quoted in Cornelia Crow Carr, ed., *Harriet Hosmer: Letters and Memories* (New York: Moffat, Yard, 1912), p. 35.

21 *"void left in our family circles"*: FWS to Emily Haskell Sargent, June 23, 1864, AAA.

21 *"admit[ted] no argument"; "The sick have a right"*: Julia Ward Howe, *From the Oak and The Olive*, 1868; quoted in Mary Suzanne Schriber, *Telling Travels: Selected Writings by Nineteenth-Century American Women Abroad* (DeKalb: Northern Illinois University Press, 1995), p. 160.

21 *"Fitz"*: Mary Sargent to Emily Haskell Sargent, October 20, 1867, AAA.

22 *"Altho' my words are not skillfully chosen"; "[I] express all the love"*: Mary Sargent to Winthrop Sargent, April 25, 1871, AAA.

22 *"never been to a Theatre in Europe"*: FWS to Winthrop Sargent, July 10, 1873. AAA.

22 *January 12, 1856*: For the dispute about the actual date of John Singer Sargent's birth, see Olson, *John Singer Sargent*, p. 2.

22 *"Fra Giovanni"*: Mary Newbold Singer to her sister, February 1856, AAA.

23 *$10,000; $45,000*: For an in-depth evaluation of the Sargent family finances, see Olson, *John Singer Sargent*, p. 4.

24 *"the happiest moment in life"*: Lee, *Sentimental Traveller*, p. 11.

24 *"this nomadic sort of life"; "pack up our duds"*: FWS to Emily Haskell Sargent, October 10, 1870, AAA.

24 *"Children are a source"*: FWS to Thomas Parsons Sargent, August 29, 1865, AAA.

24 *her nurse had dropped her*: As told to Stanley Olson; in Olson, *John Singer Sargent*, p. 6.

25 *"Poor little Minnie"; "Emily and I bought"*: JSS to Ben del Castillo, April 16, 1865, quoted in Charteris, *John Sargent*, p. 6.

25 *"the sooner he goes to heaven the better"*: FWS to Winthrop Sargent, March 7, 1867, AAA.

25 *"When I first began to practice medicine"*: FWS to Winthrop Sargent, March 1, 1870, AAA.

25 *"sham domestic life"*: Olson, *John Singer Sargent*, p. 16.

25 *unusually mobile domesticity*: In the family's European exile, did Dr. Sargent, cut off from his profession, lead what his great-grandson Richard Ormond called a "rather purposeless existence"? No, it was rather that, as an "exemplary husband," Fitzwilliam "shouldered many of the household chores"—as Ormond has also observed. Richard L. Ormond, "The Letters of Dr. Fitzwilliam Sargent: The Youth of John Singer Sargent," *Archives of American Art Journal* 14, no. 1 (1974), pp. 16–18, 17. "The doings of my daily life are composed of little things," Dr. Sargent confided to his father in 1860, "which are necessary enough and keep me tolerably busy, but yet they are so small in themselves that they might almost pass for nothing" (FWS to Winthrop Sargent, December 18, 1860, AAA). As late as 1868, Fitzwilliam could divulge to his father that "so far as I am concerned, solely, my desire is to go home to America to work there, and to let Johnny grow up there where he will someday live" (FWS to Winthrop Sargent, February 16, 1868, AAA). And yet Fitzwilliam actually found much purpose and gratification in his European life.

25 *"smile and 'coo'"*: FWS to Emily Haskell Sargent, April 7, 1870, AAA.

26 *"dear, eloquent, rubicund"; "the doubtful world of marble fauns"*: Lee, "J.S.S.," p. 243.

2. The Fig Leaf

27 *Four of Sargent's earliest efforts*: Sargent House Museum, Gloucester, MA.

28 *"it tries his little soul wonderfully"*: FWS to Emily Haskell Sargent, November 28, 1864, AAA.

28 *"tolerably advanced in ignorance"*: FWS to Anna Maria Low or Emily Pleasants, May 10, 1869, continued September 20, AAA.

28 *"impertinence"*: Fitzwilliam Sargent (FWS) to Winthrop Sargent, December 18, 1860: "While I was engaged in writing you, John has had the impertinence to take my portrait, which I enclose, thinking you will prize it."

28 *Maison Virello; pepper trees*: Lee, "J.S.S.," p. 237.

29 *"There were illustrated books and papers"*: Lee, "J.S.S.," p. 239.

29 *"delicate, taciturn, austere"; "puritan, reserved, and rather sternly dissatisfied"*: Lee, "J.S.S.," pp. 240, 249.

30 *"John S. Sargent"*: Miriam Stewart and Kerry Schauber, "Catalogue of Sketchbooks and Albums by John Singer Sargent at the Fogg Art Museum," *Harvard University Art Museums Bulletin* 7, no. 1 (autumn 1999–winter 2000): pp. 17–18.

30 *"Johnnie is growing"*: Mary Sargent to Emily Haskell Sargent, October 20, 1867, AAA.

30 *"still in course of formation"; "several admirable works"*: Karl Baedeker, ed. *Italy: Handbook for Travellers, First Part: Northern Italy and Corsica* (Coblenz: Karl Baedeker, 1870), p. 302.

30 *"working his way through Geometry"*: FWS to Winthrop Sargent, March 1, 1870, AAA.

30 *But so far she's been given little credit*: Previous biographers, especially those unaffected by feminist scholarship, have criticized Mary, essentially, for being an assertive and dominant woman. Stanley Olson labeled Mary as "willful," "spoiled," "accustomed to having her own way," "driven by a strange abstract dissatisfaction," and "petrified by any notion of what people expected as her duty" (Olson, *John Singer Sargent*, p. 5). Even Mary's great-grandson Richard Ormond has understood her, inside such a traditional framework, as a "domineering wife." But Ormond perhaps came closer to the mark when he described Mary Sargent as relentlessly "exuberant" and (for example in her letters) habitually "more spirited" than her husband (Ormond, "Letters of Dr. FitzWilliam Sargent," p. 17). As Sargent's first biographer and friend Evan Charteris phrased it, Mary Sargent was, at least as her son preferred to remember her, preeminently "a woman of culture . . . vivacious and restless in disposition, quickly acquiring ascendancy in any circle in which she was placed. In her family she was a dominating influence. She was one of the first to recognize the genius of her son, and in a large measure responsible for his dedication to art" (Charteris, *John Sargent*, p. 3).

31 *"As a girl [Mary] had travelled"*: Charteris, *John Sargent*, p. 3.

31 *Pennsylvania Academy of Fine Arts*: For a history of women at this institution, see *The Pennsylvania Academy and Its Women, 1850–1920: May 3–June 16, 1974 Pennsylvania Academy of the Fine Arts, Philadelphia, Pennsylvania* (Philadelphia: Pennsylvania Academy of the Fine Arts, 1974), pp. 12, 17, 19; Stephen May, "An Enduring Legacy: The Pennsylvania Academy of Fine Arts, 1805–2005," in Mark Hain et al., *Pennsylvania Academy of Fine Arts, 1805–2005: 200 Years of Excellence* (Philadelphia: Pennsylvania Academy of the Fine Arts, 2005), p. 16.

31 *"disruptive sexual figure"; "Of all the arts in the nineteenth century"*: Christine Stansell, "Women Artists and the Problems of Metropolitan Culture: New York and Chicago, 1890–1910," in Wanda Corn, ed., *Cultural Leadership in America: Art Patronage and Matronage* (Boston: Gardner Museum, 1997): p. 26, 32.

32 *"painting, painting away"*: Lee, "J.S.S.," p. 235.

32 *"The crude drawing style"*: Stephen D. Rubin, *John Singer Sargent's Alpine Sketch-books: A Young Artist's Perspective* (New York: Metropolitan Museum of Art, 1991), p. 12.

32 *Sargent's two sisters*: Lee, "J.S.S.," p. 235.

32 *"models of precision and clarity"*: Olson, *John Singer Sargent*, p. 10.

32 *"deep-seated character"; "strength"; "smelted and tempered [his] talent into genius"*: Lee, "J.S.S.," p. 235.

32 *"far exceeded his mother's meager accomplishments"; "could not have served long as his teacher"*: Rubin, *Alpine Sketchbooks*, p. 12.

33 *"the enchanting, indomitable, incomparable Mrs. S."*: Lee, *Sentimental Traveller*, p. 11. Vernon Lee's sometimes hyperbolic praise of Mary Sargent has caused some Sargent biographers to dismiss such representations as "a nice combination of genius-heroine-goddess. Any warm memories Violet would keep of her childhood were the work of Mrs. Sargent, and part of the elaborate revenge on her mother" (Olson, p. 15). In *Vernon Lee: A Literary Biography* (Charlottesville: University of Virginia Press, 2003), Vineta Colby acknowledges that Lee adopted a "series of surrogate mothers" of which "Mrs. Sargent was the first" (pp. 7, 14). Others, certainly, including Mary Sargent's own children, gave her somewhat more moderate praise. Yet biographers have sometimes dismissed Lee's vision of Mary Sargent by psychologizing Lee's obsession with mother figures, in a rather old-fashioned and stereotypical view of Lee's lesbianism. Lee's admiration for this warm, dynamic woman was certainly motivated in part by the contrasting cold sternness of her own mother. But, even more profoundly, Lee's deep appreciation of Mary Sargent accurately identified a key contribution that Mary made to her son's sensibility, with her gift for passionate, art-centered tourism.

33 *"months of strealing [sic] after"; "I heard of rides in the Campagna"; "And beyond this Rome"*: Lee, *Sentimental Traveller*, pp. 13–14.

33 *It qualified, itself, as an art form*: That travel *was* an art belonged to Victorian sensibilities. In 1854 the British polymath Francis Galton had published a work called *The Art of Travel: Or, Shifts and Contrivances Available in Wild Countries*—inspired by his own experiences with the Royal Geographical Society in southwest Africa in the early 1850s—a landmark of practical advice for European imperialism that became a perennial bestseller. In his title, though, Galton merely tapped into the already-commonplace Victorian idea that travel was an art—that is, a set of practices and methods (Galton's book was stocked with practicalities for explorers: fishing, bedding, rifles, etc.) that could be learned. Yet for a large group of nineteenth-century literary and artistic travelers in Europe, from the romantic pioneer Johann Wolfgang von Goethe to the young Henry James—who in the late 1860s was beginning his career by writing travel sketches—travel was beginning to be an art in a more sophisticated and intriguing sense.

34 *"growing to appreciate the beauties of nature and art"; "quick and correct eye"; "never had any instruction"*: Mary Sargent to Emily Haskell Sargent, October 20, 1867, AAA.

34 *"insatiable love of travel"*: Charteris, *John Sargent*, p. 10.

34 *artist of travel, or just a tourist*: The terms "traveler" and "tourist" didn't have equal footing in the Victorian world. Prejudices against tourism were rife in genteel

Anglo-American culture. Even Violet Paget had "been brought up to despise persons who travelled in order to 'sight-see'" (Lee, *Sentimental Traveller*, p. 7). For middle-class people with a work ethic, the term "traveler" was often reserved for practiced, educated, and discriminating males circulating in the older, originally aristocratic tradition of the Grand Tour. A "tourist"—a traveler for pleasure and often a social climber, a woman, an uneducated person, or an outsider—was regarded as an upstart with no taste, method, or application. The masses of tourists with whom the Sargents jostled—with whom they competed for space at various monuments—were widely considered to be vulgar interlopers. Increasingly, crowds of Americans, English people, and Germans patronized the railroads and grand hotels of Italy, propelled by tourist guidebooks such as *Murray's*, *Cook's*, and *Baedeker's*. But Mary, with her "lavish" appreciation of Italy and France, with her traveling dress and guidebook, also looked like a "tourist" much of the time. To many an old-blood traveler, she amounted to a rhapsodic, untutored female. See, for example, the distinctions of "tourism" and "antitourism" developed by James Buzard in *The Beaten Track: European Tourism, Literature, and the Ways to Culture, 1800–1918* (Oxford: Clarendon Press, 1993): pp. 1–17.

34 *"a generation of the wondrous priestesses of the Genius Loci"; "the sacred fury of travel"; "the high priestess of them all"; "the most favoured and inspired votary of the Spirit of Localities"; "most genially imperious, this most wittily courteous, this most wisely fantastic of Wandering Ladies"*: Lee, *Sentimental Traveller*, pp. 9–10.

34 *"Missionaries and novelists, archaeologists and journalists"*: Mary Suzanne Schriber, *Telling Travels: Nineteenth-Century American Women Abroad* (DeKalb: Northern Illinois University Press, 1995), p. xi.

35 *"serious interest in antiquities"*: Stephanie L. Herdrich and H. Barbara Weinberg, *American Drawings and Watercolors in the Metropolitan Museum of Art: John Singer Sargent*, with an essay by Marjorie Shelley (New York: Metropolitan Museum of Art, 2000, p. 48.

35–36 *"some beautiful statues"; "Mamma and Pappa"*: JSS to Ben del Castillo, May 23, 1869, quoted in Charteris, *John Sargent*, pp. 12–13.

36 *"to him paints were not for the telling of stories"*: Lee, "J.S.S.," p. 239.

36 *"long icicles"; "the figures of Tritons"*: FWS to Henry Sargent, January 25, 1869, AAA.

36 *"after the antique"; "Indeed, the antique had so strong a hold"*: Carl Goldstein, *Teaching Art: Academies and Schools from Vasari to Albers* (Cambridge: Cambridge University Press, 1996), pp. 159, 172.

37 *"gray-headed"; "feeble"; "amiable and benignant look"; "His character is said"*: FWS to Emily Haskell Sargent, December 11, 1869, AAA.

37 *"'the Pope's Bull against a Comet'"*: FWS to Winthrop Sargent, March 1, 1870, AAA. The reference is to Pope Callixtus III (1455–1458), Alfonso de Borgia, who was reputed to have excommunicated the appearance of Halley's Comet to forward a Crusade. Lincoln echoed this history during one of his less fine moments, in a letter of 1862, when he fretted about issuing an Emancipation Proclamation that he feared no one would heed.

38 *without complaint*: Victoria and Albert Museum papers, 1903. See "David's Fig Leaf": http://www.vam.ac.uk/content/articles/d/davids-fig-leaf/.

38 *"every obscene, lewd, lascivious, filthy or vile article"*: Act for the Suppression of Trade
 in, and Circulation of, Obscene Literature and Articles of Immoral Use, 1873, ch. 71,
 Section 1461.

38 *Roland Knoedler; "virtually every New York city newspaper"*: Nicola Beisel, "Morals
 Versus Art: Censorship, the Politics of Interpretation, and the Victorian Nude,"
 American Sociological Review 58, no. 2 (April 1993): pp. 145–46.

38 *American art galleries and museums*: See Louise L. Stevenson, *The Victorian Home-
 front: American Thought and Culture, 1860–1880* (New York: Twayne Publishers,
 1991), p. 68.

38–39 *Henry Jacob Bigelow; blacked out the phalloi of satyrs*: Walter Muir Whitehill,
 Museum of Fine Arts, Boston: A Centennial History (Cambridge, MA: Harvard Uni-
 versity Press, 1970), pp. 30, 674.

39 *"The plain truth is"*: S., "A Plea or the Fig-Leaf: With Contrasting Pictures Pro and
 Con," *Brush and Pencil* 16, no. 4 (October 1905): p. 128.

39 *merely signal Victorian prudery*: Nor does a fig leaf necessarily confirm the so-called
 repressive hypothesis of Victorian middle-class morality. Following the theories
 of Michel Foucault, the art historian Kenneth Colburn has asserted that in fact
 this very "act of censorship must be viewed as a complex process whereby what ap-
 pears to be denied or negated, on one level, is in fact affirmed and given prominence
 on a deeper level." That is, by covering the genitals of a statue like the *David*—
 and what's more with an object that approximates the shape—the fig leaf not only
 called attention to the taboo it was supposed to hide but also heightened its inter-
 est and also rendered sexuality the single most powerful element of the nude. So
 that, "while the fig leaf ostensibly acts to conceal David's sex, it can do so only by
 its affirmation of the body's sexual power." See Kenneth Colburn Jr., "Desire and
 Discourse in Foucault: The Sign of the Fig Leaf in Michelangelo's *David*," *Human
 Studies* 10 (1987): pp. 61, 66.

39 *"icy miles of Vatican galleries"; "scamperings, barely restrained by responsible elders";
 "hurried forbidden sketches of statues"*: Lee, "J.S.S.," pp. 242–43.

39 permesso *from the papal* maggiordomo: Karl Baedeker, *Italy: Handbook for Travel-
 lers*, vol. 2, *Central Italy and Rome* (Coblenz and London: Karl Baedeker,1867), pp.
 270, 102.

40 *"secret vice"*: See Alyssa Picard, "'To Popularize the Nude in Art': Comstockery
 Reconsidered," *The Journal of the Gilded Age and Progressive Era* 1, no. 3 (July
 2002): pp. 200–201; Richard Sennett, *The Conscience of the Eye: The Design and So-
 cial Life of Cities* (New York: Knopf, 1990), p. 21.

40 *early link between art and forbidden sexuality*: An essay that Vernon Lee wrote ten
 years after her expeditions with John in Roman museums underscores this point. It
 beautifully illuminates the complex effects of antique statuary on susceptible chil-
 dren and adolescents. In "The Child in the Vatican," Lee's young observer starts
 out daunted by "a dreary labyrinth of brick and mortar, a sort of over-ground cat-
 acomb of stones, constructed in our art-studying" and finds the bone-white, dead-
 seeming classical statues repugnant: their "naked, or half-naked limbs are things
 which the child has never seen, at least, never observed." But gradually, in a slightly
 sinister fairy-tale transformation, the "demons" of the old statues fix on a particular
 child (Lee herself, it seems), slyly administering a mysterious love philter. Through
 the statues' insidious spell, "the child was in love; it was in love with what it had

hated; in love intensely, passionately, with Rome." Vernon Lee, "The Child in the Vatican," in *Belcaro: Being Essays on Sundry Aesthetical Questions*, 1882 (London: T. Fisher Unwin, 1887), pp. 17, 20, 26. Lee conceives of this love as aesthetic, not sensual (hence the love for Rome in general), and the antique figure that fascinates her child is *Niobe*—characteristically for Lee, a complex mother figure. To judge from his sketchbooks, young John preferred male statuary, but his transfiguration had strong parallels. When he read this essay and others in Lee's *Belcaro* in 1882, he told Lee that her "view of art is the only true one": "To me the conclusions you come to, or the feeling you start from, are altogether natural and self evident, and need no debating": JSS to VL, March 24, 1882, quoted in Charteris, *John Sargent*, p. 56.

3. Mountain Men

41 *"stupendous mountain wall"; "No earthly object I have seen"*: Leslie Stephen, *The Playground of Europe* (1871; reprint London: Longmans, 1894), p. 67.

42 *sketched the peaks from Thun*: JSS's two alpine sketchbooks are in the collections of the Metropolitan Museum of Art in New York. See Rubin, *Alpine Sketchbooks*, p. 7.

42 *"My boy John seems to have a strong desire"*: FWS to Emily Haskell Sargent, October 10, 1870, AAA.

42 *"incubating"*: FWS to George Bemis, [October] 1870, AAA.

42 *John's enthusiasm showed in a lively sketch*: *Mountain Climbers*, 1869, graphite on paper, MMA.

44 *"summer campaigns"; "as brisk as a bee"*: FWS to Winthrop Sargent, September 15, 1869, AAA.

44 *Amelia B. Edwards; Lucy Walker*: See Nicholas Shoumatoff and Nina Shoumatoff, *The Alps: Europe's Mountain Heart* (Ann Arbor: University of Michigan Press, 2001), p. 216.

44 *majestic, unspoiled nature*: Romantic poets such as Byron had called the Alps "palaces of Nature": See George Gordon, Lord Byron, *Childe Harold's Pilgrimage* III.62–64: "palaces of Nature, whose vast walls / are pinnacled in clouds their snowy scalps, / And throned Eternity in icy halls of cold sublimity."

44 *"playground of Europe"*: One popular destination on the Sargents' route in the Bernese Oberland, the vista of the Wengernalp, stood out as a vivid example. There Stephen had noted with disgust "turf strewn with sandwich-papers and empty bottles, even in the presence of hideous peasant-women singing 'Stand-er auf' for five centimes"—the cheap folk songs and litter of a tourist scrum that still didn't blunt for him the "imperishable majesty" of the high Alps (Stephen, *Playground of Europe*, p. 313). Staying in similar Oberland hostelries to the Sargents, Mark Twain would remark in his *A Tramp Abroad* (1880), "What a change has come over Switzerland this century. Now everybody goes everywhere, and Switzerland, and many other regions which were unvisited and unknown remotenesses a hundred years ago, are in our days a buzzing hive of restless strangers every summer": Mark Twain, *A Tramp Abroad*, vol. 2 (1880; reprint New York: Harper, 1907), p. 32.

45 *highland adventure*: To negotiate the mountains, Fitz carried a *Murray* guide given him by his lawyer friend George Bemis. He may also have read the British alpinist Hereford Brooke George's *The Oberland and Its Glaciers, Explored and Illustrated with Ice-Axe and Camera* (1866), published a few years earlier, as this account covered

a trek almost identical to Fitzwilliam's own itinerary. Even though the Sargents didn't plan to scale any peaks, the two would traverse several high passes and cross several hazardous glaciers.

Contemplating such prospects, the novice mountaineers knew about the experiences of Edward Whymper's climbing party—a disturbing incident from five years before in July 1865—when the British alpinist had succeeded in reaching the summit of the Matterhorn for the first time in recorded history only to encounter, on the way down, a hair-raising accident. An untested climber slipped, skidded against a Swiss guide and dislodged him, then dragged both of them as well as two other climbers over a cliff. The recovered remains of the four, stripped and mutilated, were detailed in the newspapers of the era, stoking both a ghoulish fascination and a (temporary) backlash against mountaineering. Such stories underlined the imaginative frisson as well as the genuine danger of Alpine treks, in which freak snowstorms or accidental falls could claim the lives of the unwary or the unlucky.

45 *"effect . . . upon the imagination . . . so great"; "the beginning and end of all natural scenery"*: John Ruskin, *The Works of John Ruskin*, vol. 6 (London: G. Allen, 1904), pp. 287, 418.

45–46 *"the age of twelve or fourteen"; "Sketching from Nature"; "rounded and simple masses, like stones"*: John Ruskin, *The Elements of Drawing* (1857; reprint London: George Allen, 1904), pp. ix, 116.

46 *labeled by his mother with the title* Splendid Mountain Watercolours: Olson (*John Singer Sargent*, p. 24) attributes this label to Mary Sargent; Herdrich assigns it to ES: Herdrich and Weinberg, *American Drawings and Watercolors*, p. 66.

46–47 *"to Loëch in a mixture of snow & rain"; "This was the only bad weather we had"*: FWS to George Bemis, August 8, [1870,] Massachusetts Historical Society.

47 *"Accuracy"; "the first and last thing"; "being clever"; "only for what costs it self-denial, namely attention and hard work"*: Ruskin, *Elements of Drawing*, p. xi.

47 *John's most dramatic and ambitious sketches to date*: These sketches are so impressive, in fact, that some of this sketchbook juvenilia, rediscovered in museum archives in 1988, featured in an exhibition at the Metropolitan Museum in 1992 and a full documentary catalogue in 2000. See Rubin, *Alpine Sketches*, and Herdrich and Weinberg, *American Drawings and Watercolors*. The Metropolitan Museum exhibition paired Sargent's image from the Eggishorn with a foldout panorama from a *Baedeker's* guidebook in order to suggest, as well as the Sargents' connection to Alpine tourism, the admirable accuracy of the young artist's rendering. Likewise, John's sketch of the Wellhorn and Wetterhorn in the eastern Oberland, coupled with a contemporary photograph, was intended to establish "the young artist's ability to transcribe the details of a landscape setting with great accuracy and clarity." See Rubin, *Alpine Sketchbooks*, pp. 26–27, 40–41.

47 *the monstrous Aletsch Glacier*: Sargent labeled each peak in the approved manner of nineteenth-century tourist guides. Likewise, his careful depiction of the Rosenlaui revealed Ruskin's influence and his father's prejudices; it was a sober image in comparison to more romantic nineteenth-century renderings of this popular tourist scene, for example one richly colored and stylized view, patently Romantic, of the Weimar painter Friedrich Preller the Elder. Yet, as Preller had also done in his version of *Wellhorn und Wetterhorn*, the young Sargent also steepened and exaggerated

the height of the crags in question as well as intensified the atmosphere through dramatic contrasts of dark forests below and gleaming glaciers above. See John Singer Sargent, *Wellhorn and Wetherhorn*, 1870, watercolor on paper, Metropolitan Museum, New York; Friedrich Preller the Elder, *Wellhorn und Wetterhorn*, n.d., oil on cardboard, private collection.

47 *the magnificent Rhône Glacier*: This morass of ice has dwindled since the nineteenth century, but in 1870 the young artist confronted a vast cape of ice flung across a massif of high peaks. Such a "sublime" vista acted as the end point for the long journey John had made to visit it; it was a pilgrimage destination equivalent to cathedrals, ruins, and museums in the Sargents' lowland wanderings. Such outlooks, laborious to reach and dazzling to view, furnished John both exaltation and exultation as payoffs for Alpine travel.

47 *the Grimsel Pass and the deep Aar valley*: FWS to George Bemis, [October] 1870, AAA.

48 *"Regardez moi ça"*: JSS Alpine Sketchbook, MMA.

48 *"on Emily's account"*: FWS to Winthrop Sargent, June 21, 1870, AAA.

48 *"primitive"*: John Addington Symonds, *The Memoirs of John Addington Symonds*, ed. Phyllis Grosskurth (New York: Random House, 1984), p. 137.

48 *"as thick as blackberries"; "from which avalanches roll and thunder daily"*: FWS to Emily Haskell Sargent, August 15, 1870, AAA.

49 *Charles Feodor Welsch*: Often referred to in early Sargent sources as "Carl Welsch," Charles Feodor Welsch (1828–1904), also known as Carl Friedrich Christian Welsch and Theodore Charles Welsch, was son of the German landscape painter Johann Friedrich Welsch (1796–1871). Resident in Rome from 1866 to 1874, Welsch could well have instructed the thirteen-year-old Sargent in the winter of 1869–70, as Charteris claims (Charteris, *John Sargent*, p. 10). He may also have instructed the young Sargent in Florence. But Charteris's information, though drawn in part from Emily Sargent, is prone to errors; and Rubin rightly cautions that such lessons "are not mentioned by Vernon Lee, who described that winter in Rome in great detail, nor by Dr. Sargent [during the family's Rome residence], who wrote numerous letters during the same period" (Rubin, *Alpine Landscapes*, p. 13). For more information about Welsch, see Olson, *John Singer Sargent*, pp. 21–22n; Sue Rainey and Roger B. Stein, *John Douglas Woodward: Shaping the Landscape Image, 1865–1910* (Charlottesville, VA: Bayly Art Museum, 1997), p. 21 and n.; Friedrich von Boetticher, *Malerwerke des neunzehnten Jahrhunderts*, vol. 2 (Dresden: Beitrag zur Kunstgeschichte, 1898), p. 995.

49 *"took an interest in the boy"; "come and work in his studio"*: Charteris, *John Sargent*, p. 10.

49 *Joseph Farquharson*: Charteris records that the Sargents encountered Farquharson at Mürren in 1868 (Charteris, *John Sargent*, p. 10), but the Sargents first stayed in the village in 1870, and Rubin is no doubt correct that it was in the summer of 1870 that the young Sargent took lessons from him (Rubin, *Alpine Landscapes*, p. 13).

49 *"impressed by the boy's talent"*: Charteris, *John Sargent*, p. 10.

49 *"gave [John] his first lessons in drawing a head"*: Charteris, *John Sargent*, p. 10. A page including sensitive sketches of hands and a head may also belong to Sargent's "lessons": Though some sketches are inscribed with dates, the chronology of the sketchbooks is sometimes difficult to establish. On the basis of a "graphic style that

is inconsistent with Sargent's work of about 1870," Herdrich and Weinberg propose that Sargent "may have returned to this sketchbook at a different date": Herdrich and Weinberg, *American Drawings and Watercolors*, p. 69.

50 *"Germanico-American Artist"*: FWS to Winthrop Sargent, May 20, 1871, AAA. For additional details and sources, see the note on Welsch above.

50 *John Douglas Woodward as a teenage student in Cincinnati*: Rainey and Stein, *John Douglas Woodward*, p. 29.

51 *"sketch together, fish, &c."; "It is an excellent opportunity"; "keep near him"*: FWS to Winthrop Sargent, May 20, 1871, AAA.

51 *"very pleasant six days walk"; "[his] son John"*: FWS to Thomas Parsons Sargent, August 3, 1871, AAA.

51 J.S. Sargent/F.C. Welsch: Stewart and Schauber, "Catalogue of Sketchbooks and Albums," p. 20.

51 *"amusing themselves trout-fishing"; "eight fine trout"*: FWS to Winthrop Sargent, August 11, 1871, AAA.

51–52 *"Alpine inns are favourable places"*: Symonds, *Memoirs*, p. 138.

52 *"painting tour"; "powders"; "I wish to put my boy at school"*: FWS to Thomas Parsons Sargent, August 3, 1871, AAA.

4. The School of Michelangelo

54 *"dusky-looking town"*: FWS to Winthrop Sargent, November 11, 1871, AAA.

54 *Dresden Museum*: Though several previous studies state that the young artist sketched casts at the Albertinum—e.g., Olson, *John Singer Sargent*, p. 29—that Renaissance-style showcase for the King of Saxony's Skulpturensammlung, or sculpture collection, wasn't completed until 1887.

54 *Museum of Antiquities in the Grosser Garten*: See Karl Baedeker, *Northern Germany: Handbook for Travellers* (Leipzig: Baedeker, 1881), p. 282, 287.

55 *"Saline-Alcaline [sic] waters"*: FWS to Emily Sargent Pleasants, May 30, 1872, AAA.

55 *"little Donkey cart by a circuitous route"*: FWS to Winthrop Sargent, May 30, 1872, AAA.

55 *"was not so unwell"*: FWS to Gorham Sargent, June 17, 1872, AAA.

55–56 *"fancy all sorts of horrors"; "This gentleman replied"; "This relieved our uneasiness"; "Whether he fell into a crevasse"*: FWS to Thomas Parsons Sargent, August 25, 1873, AAA.

56 *"half-baked polyglot scribbler of sixteen"; "a tall, slack, growing youth"; "grey plaid shawl"; "stooping shoulders"; "the exotic, far-fetched quality"; "that imaginative quality of his mind"; "priggish historical sensibilities"; "words 'strange, weird, fantastic'"*: Lee, "J.S.S. In Memoriam," pp. 248–49.

57 *"a big-eyed, sentimental, charming boy"*: Mrs. Hugh Fraser, *A Diplomat's Wife in Many Lands*, I, p. 143; Charteris, *John Sargent*, p. 16.

57 *"brisk and decided"*: Charteris, *John Sargent*, p. 16.

57 *"to use [his] right foot"*: JSS to Elizabeth Austin, April 25, 1874, quoted in Charteris, *John Sargent*, p. 19.

57 *"leaping down stairs"; "contrary to my oft-repeated warning"*: FWS to Winthrop Sargent, April 25, 1874, AAA.

57 *"This boy of ours is on our minds"*: FWS to George Bemis, April 23, 1874, AAA.

57 *"This unhappy Accademia"*; *"students of the cast"*; *"without a Master, while the former Professor vacillated"*: JSS to Elizabeth Austin, April 25, 1874, quoted in Charteris, *John Sargent*, p. 19.

58 The Dancing Faun, After the Antique: 1873–74, black chalk and charcoal on paper, FM (see illustration credits).

58 *"extraordinary artistic value"*; *"executed with a remarkable knowledge of anatomy"*: Catalogue of the Royal Uffizi Gallery in Florence (Florence: Galleria degli Uffizi, 1890), p. 59.

59 *"to admire Tintoretto immensely"*: JSS to Elizabeth Austin, March 22, 1874, quoted in Charteris, *John Sargent*, p. 18.

59 Michelangelo's rather muscular Night: After Michelangelo Buonarroti, Italian, 1475–1564, c. 1872–74, graphite on paper, MMA.

59 *"a very handsome Neapolitan model"*: JSS to Elizabeth Austin, April 25, 1874, quoted in Charteris, *John Sargent*, p. 19.

61 *"Greek statues of Athletes"*; *"the full fullness of muscular development"*; *"full of energy and movement"*: Charles Heath Wilson, *Life and Works of Michelangelo Buonarroti* (1875; reprint London: John Murray, 1881), p. 17.

61 *"unique artistic training"*; *"We hear that the French artists"*; *"sufficiently advanced to enter a studio"*: JSS to Elizabeth Austin, April 25, quoted in Charteris, *John Sargent*, p. 19.

5. "Rather Too Sinister a Charm"

62 *"comfortably and cheaply"*: FWS to Winthrop Sargent, May 19, 1874, AAA.

62 *"gigantic heap of smouldering ruins"*; *"The ruins are not accessible to the public"*; *"fiendish proceedings of the Communists"*: Karl Baedeker, *Paris and Its Environs: Handbook for Travellers* (Leipzig: Karl Baedeker, 1878), pp. 171, 173.

62 *"war . . . going on between France and Germany"*: FWS to Winthrop Sargent, November 21, 1870, AAA.

62 *"heaps of combustibles steeped in petroleum"*; *"barrels of gunpowder"*: Baedeker, *Paris and Its Environs*, pp. v–vi.

63 *"abundant and large"*; *"escaped injury"*: FWS to Winthrop Sargent, May 19, 1874, AAA.

63–65 *"no fewer than twenty-two important public buildings"*; *"for the teaching of painting, sculpture, engraving"*; *"upwards of 500 pupils of different nationalities"*; *"prominent political agitator"*; *"the chief modern votary of the coarsest realism"*: Baedeker, *Paris and Its Environs*, pp. 257, xxxviii.

63 *"hard customer"*; *"sell or otherwise dispose of our flesh and blood"*; *"biggest toad in [the] family puddle"*; *"thousands of carriages"*; *"'good Americans when they die go to Paris'"*; *"congregate about the Champs Élysées"*: FWS to Winthrop Sargent, May 30, 1874, AAA. This notion was later recapped and made more famous by Oscar Wilde.

65 *"shouts and howls"*; *"shower of apples, wads of paper, small coins, and eggs"*: As described by Phillip Hotchkiss Walsh, "Viollet-le-Duc and Taine at the École des Beaux-Arts: On the First Professorship of Art History in France," in Elizabeth Mansfield, ed., *Art History and Its Institutions* (New York: Routledge, 2002), p. 85.

65 *liberate them from state control*: See Robert Tombs, *The Paris Commune 1871* (New York: Routledge, 2014), p. 100.

65 *"une médiocrité implacable"*: Quoted in *Le Palais de l'industrie, 1855–1875: Petites annales du palais, exposition universelle, expositions diverses et concours, les salons, fêtes et cérémonies, le palais pendant la guerre et la Commune* (Paris: Au Palais de l'Industrie, 1875), p. 37.

66 *"Some of the French painters"*: FWS to Winthrop Sargent, April 25, 1874, AAA.

67 *"so smoothly painted, and with such softened edges"; "more interest in each of his pupils"; "one of the greatest French artists"*: JSS to Heath Wilson, May 23, 1874, quoted in H. Barbara Weinberg, "Sargent and Carolus-Duran," in Marc Simpson, Richard Ormond, and H. Barbara Weinberg, *Uncanny Spectacle: The Public Career of the Young John Singer Sargent* (New Haven, CT: Yale University Press, 1997), p. 7.

67 *"eager for sensations"*: James Carroll Beckwith, "Carolus-Duran," in John C. Van Dyke, ed., *Modern French Masters: A Series of Biographical and Critical Reviews by American Artists* (1896; reprint New York: Garland, 1976), p. 76.

67 *"gleaming with the luster of black satin"; "intense expression of life"; "sugared mediocrities"; "created a sensation"; "hotly disputed by the critics"*: Beckwith, "Carolus-Duran," pp. 77, 74.

68 *"tall and athletic frame"; "ought to be draped in a Spanish mantle"*: "Carolus Duran in His Studio," *New York Times*, July 10, 1885.

68 *"impressionable, artistic temperament"; "harboring the fire and intense enthusiasm"; "rolled through the modest iron paling"*: Beckwith, "Carolus-Duran," pp. 74–75, 78.

68–69 *"finely lighted"; "several palettes covered with a rainbow of tones"; "painter à la mode"*: "Carolus Duran in His Studio," *New York Times*, July 10, 1885.

69 *"out-of-the-way place"*: Beckwith, "Carolus-Duran," p. 73.

69 *"great roll of canvases and papers"; "almost bashfully"; "sketches and studies in various mediums"; "the work of many years"; "amazement to the class"; "You desire to enter the atelier as a pupil of mine?"; "I shall be very glad to have you do so"*: Will H. Low, "The Primrose Way," typescript, "revised and edited from the original MS by Mary Fairchild Low, with the collaboration of Berthe Helen MacMonnies," 1935, Albany [New York] Institute of History and Art, pp. 55–56; quoted in H. Barbara Weinberg, "Sargent and Carolus-Duran" in Simpson, *Uncanny Spectacle*, p. 5.

69 *"His observations were brief"*: Charteris, *John Sargent*, p. 26.

70 *"fifteen or twenty pupils"*: FWS to Winthrop Sargent, May 30, 1874, AAA.

70 *"newcomer is treated in the most brutal way"; "You may imagine that I would not relish"*: JSS to Heath Wilson, May 23, 1874, quoted in Olson, *John Singer Sargent*, p. 40.

70 *"maudlin sentimental"; "Paris was not the place for that kind of thing"*: Lucia Fairchild, diary, October 2, 1890, in Lucia Miller, "John Singer Sargent in the Diaries of Lucia Fairchild, 1890 and 1891," *Archives of American Art Journal*, 26, no. 4 (1986): p. 5.

70 *twenty francs or four dollars a month*: FWS to Winthrop Sargents, May 30, 1874, AAA.

70 *"two nasty little fat Frenchmen"; "gentlemanly, nice fellows"*: JSS to Heath Wilson, June 12, 1874, quoted in Weinberg, "Sargent and Carolus-Duran," p. 7.

70 *subject to a vote of the pupils beforehand*: *"Le choix des modèles . . . sont soumis préalablement au vote des élèves"*: "Atelier des Elèves de Mr. Carolus Duran Règlement,"

n.d., James Carroll Beckwith Scrapbooks, v. 1 (To 1892), New-York Historical Society, New York.

71 *"the face must be laid directly"; "conventional bounding of eyes and features with lines"*: R. A. M. Stevenson, *Velazquez* (London: Bell & Sons, 1899), pp. 107–108.

71 "Cherchez le demi-teinte"; *"You must* classify *the values"*: Charteris, *John Sargent*, pp. 28–29.

71–72 *"painter of painters"*: Quoted in David T. Gies, "Velázquez, or Social Climbing as Art," *Virginia Quarterly Review* 63, no. 1 (winter 1987): p. 158.

72 *"shade of Velasquez"; "retreat a few steps from the canvas"; "habit of stepping backwards"; "He, too, when in difficulties"*: Charteris, *John Sargent*, pp. 28–29.

72 *"must make a finished drawing"; "Heaven only knows if I shall get through"*: JSS to Ben del Castillo, October 4, 1874, quoted in Charteris, *John Sargent*, p. 22.

72 *Only two members: Procès-verbaux originaux des jugements des concours des sections de peinture et du sculpture, 23 octotre-22-octobre 1883* (AJ52: 78), Archives de l'École national supérieur des beaux-arts, Archives Nationales, Paris.

72 *"We all watched his growth"*: Edwin H. Blashfield, "John Singer Sargent—Recollections," *North American Revue* 221 (June 1925): p. 642.

73 *"one of the most talented fellows"; "Such men wake one up"*: J. Alden Weir to his mother, October 4, 1874, quoted in Dorothy Weir Young, *The Life and Letters of J. Alden Weir* (1960; reprint New York: Kennedy Graphics and DaCapo, 1971), p. 50.

6. The *Rapins*

74 *"too distracting for the students and insufficiently elevating"*: Anthea Callen, "Doubles and Desire: Anatomies of Masculinity in the Later Nineteenth Century," *Art History* 26, no. 5 (November 2003): p. 680.

74 *the* beau idéal *of such* académies *had been gradually revised over the course of the century*: See Susan S. Waller, *The Invention of the Model: Artists and Models in Paris, 1830–1870* (Farnham, England: Ashgate, 2006): pp. 1–36.

74 *light fell from a high window on a nude model: Life Study Class* (c. 1874–76), Metropolitan Museum of Art. See Herdrich and Weinberg, *American Drawings and Watercolors*, p. 133; Elaine Kilmurry and Richard Ormond, eds., *John Singer Sargent* (Princeton, NJ: Princeton University Press, 1998), p. 24.

75 "beau morceau de nu": Quoted in Callen, "Doubles and Desire," p. 688.

75 *"troubled commodity"*: Callen, "Doubles and Desire," p. 680.

75 *"is the most beautiful thing there is"*: Thomas Eakins to his father, May 9, 1867, in William Innes Homer, *The Paris Letters of Thomas Eakins* (Princeton, NJ: Princeton University Press, 2009), p. 210.

76 *Eakins's philosophy*: For an accessible collection of Eakins's male-oriented photography and painting, see John Esten, *Thomas Eakins: The Absolute Male* (New York: Universe, 2002).

76 The Swimming Hole: Thomas Eakins, *The Swimming Hole*, c. 1883, oil on canvas, Amon Carter Museum, Fort Worth, TX.

76 In the Studio: c. 1874, untraced, from a negative by Peter A. Juley, c. 1928. Peter A. Juley & Son Collection, PPJ-22531, Smithsonian American Art Museum, Washington, DC. See Richard Ormond and Elaine Kilmurray, *John Singer Sargent: Figures and Landscapes, 1874–1882* (New Haven, CT, Yale University Press, 2006), p. 32.

76 A Male Model Standing Before a Stove: c. 1875–80, oil on canvas, MMA (see illustration credits).

76 *The posing pouch may be a later addition*: Ormond and Kilmurray, *Figures and Landscapes, 1874–1882*, p. 37.

76–77 *the huge influx of Italian immigrants; "sometimes conflicting concerns"; "classicism, primitivism, and authenticity"*: Waller, *Invention of the Model*, pp. 107–8, 89–90.

77 Man Wearing Laurels: 1874–80, oil on canvas, Los Angeles County Museum of Art (see illustration credits).

77 *"a classical attribute for a man"*: Fairbrother, *The Sensualist*, p. 68.

77 *"cruelty, he was sometimes inclined to say"*: Lucia Fairchild, diary, 1891, in Miller, "Diaries of Lucia Fairchild," p. 11.

78 *"strong sympathy for the Pre-Raphaelite painters"*: Charteris, *John Sargent*, p. 57.

78 *"passionate in their art"*: Quoted in Charteris, *John Sargent*, p. 87.

78 Bacchus: Simeon Solomon, *Bacchus*, 1867, oil on paper laid on canvas, Birmingham Museums and Art Gallery, Birmingham.

78–80 *"wild to go out into the country and sketch"; "cleared the studio of easels and canvasses"; "illuminated it with Venetian or coloured paper lanterns"; "quite surpass[ed] anything I have ever seen"; "out all night in the wildest festivity"; "a very good example of a Quartier Latin ball."; "'The devil of a spree'"; "I enjoyed our spree enormously"*: JSS to Ben del Castillo, March 6, 1875, quoted in Charteris, *John Sargent*,p. 37.

79 *the École didn't admit women until 1897*: Weinberg, "Sargent and Carolus-Duran," p. 9.

79 *Such female students*: "The Paris Latin Quarter. Models in a Studio for Ladies," *New York Times*, March 18, 1877.

79 blanchisseuses; *"bien ornés"*: *Le Petit Journal*, March 6, 1875.

79 "le plus bohème": James Carroll Beckwith diary (March 16, 1875), AAA.

80 *"neither exists nor can exist anywhere but in Paris"*: Henri Murger, *The Bohemians of the Latin Quarter*, trans. Ellen Marriage and John Selwyn (1851; translation 1901; reprint Philadelphia: University of Pennsylvania Press, 2004), p. xxiv.

80 *One of his favorite books was Honoré de Balzac's* Un prince de la Bohème: Lucia Fairchild, diary, October 2, 1890, in Miller, "Diaries of Lucia Fairchild," p. 11.

81 *"romantic devotion"*: Charteris, *John Sargent*, p. 36.

81 *"entirely taken up"*: Charteris, *John Sargent*, p. 41.

81 *an artist friend from Paris*: This friend remains unidentified; see Herdrich and Weinberg, *American Drawings and Watercolors*, p. 366.

81 *"a good model"*: Oscar Wilde, "London Models," *The English Illustrated Magazine* 64 (1888–89):p. 13.

82–83 *"'l'existence debraillée des rapins'"; "unreasonably long difficult and terrible"; "absorbed in his work to a point of fanaticism"; "a little shy and awkward in manner"; "formed no part of his . . . career"*: Charteris, *John Sargent*, pp. 36–37, 22.

82–83 *"'Respectable' is one of his highest terms of praise"*: Lucia Fairchild, diary, October 2, 1890, in Miller, "Diaries of Lucia Fairchild," p. 9.

83 *"All the menacing sensations of youth"; "maturity and talent dazzled onlookers"; "awe, not intimacy"*: Olson, *John Singer Sargent*, pp. 44–45.

83 *"is screamed about by the Bohèmes"*: VL to her mother, June 25, [1883,] *Vernon Lee Letters* (London: privately printed, 1937), p. 118.

83–84 *"the baggy corduroy trousers"*: Charteris, *John Sargent*, p. 36.

84 *"his flowing locks[,] wide-brimmed hat"*: Seaton Carew, "Our Paris Letter," *The Art Record* 1 (March 2, 1901): p. 22.

84 *"exotic, far-fetched quality"; "imaginative quality of mind"; "strange"; "weird"; "fantastic"; "curious"*: Lee, "J.S.S.," pp. 248–49.

84 *"dominant adjective"; "pronounced with a sort of lingering undefinable aspirate"*: Vernon Lee, *For Maurice: Five Unlikely Stories* (London: Jay Lane, 1927), p. xxx–xxxi.

84 *"favorite expression . . . was 'La la!'"; "gay, fantastic things"*: Lucia Miller, diary, October 2, 1890, in Miller, "Diaries of Lucia Fairchild," pp. 5, 10.

84 *"iconoclastic and revolutionary, 'glancing like a meteor'"*: Charteris, *John Sargent*, p. 26.

84–85 *"Really my impression"*: JSS to Dugald Sutherland MacColl, undated letter [November 1916], quoted in Charteris, *John Sargent*, p. 27.

85 *"the most highly educated and agreeable people"*: Julian Alden Weir to his mother, May 1, 1875, AAA.

85 *"I have never met such a woman"*: Albert Gustaf Edelfelt to his mother, January 10, 1877, in Albert Edelfelt, *Drottning Blanca och Hertig Carl*, samt Nagra Andra Tavlor (Helsingfors, 1917) p. 12.

85 *"couple of his friends"; "gay for them with holly and mistletoe"; "mince-pie, plum-pudding, and turkey"*: FWS to Winthrop Sargent, January 9, 1876, AAA.

85 *"my (fat!) arms"*: Mary Sargent to Anna Maria Low, December 13, 1875, AAA.

86 *Marshal Patrice de MacMahon*: William A. Penniston, "Pederasts, Prostitutes, and Pickpockets in Paris of the 1870s," in Jeffrey Merrick and Michael Sibalis, eds., *Homosexuality in French History and Culture* (New York: Harrington Park Press, 2001), p. 169.

86 *Comte de Germiny*: Michael L. Wilson, "*Drames d'amour des pédérastes*: Male Same-Sex Sexuality in Belle Epoque Print Culture," *Homosexuality in French History and Culture*, pp. 193–94.

7. Little Billee

87 *a thousand francs, about two hundred dollars; "My talented young friend Sargent"*: James Carroll Beckwith, [unpaginated] diary, 1874–78, September 23, 1874; October 13, 1874, AAA.

87 *"real Art life began"*: James Carroll Beckwith, *Souvenirs and Reminiscences: A Book of Remembrance*, unpublished ms, 1917, AAA.

88 *"brotherhood"; "association fraternelle"*: Murger, *Bohemians of the Latin Quarter*, p. 1.

88–89 *"She would have made a singularly handsome boy"; "and one felt instinctively"; "love"; "for his lively and caressing ways"; "as fond of the boy as they could be"*: George du Maurier, *Trilby* (New York: Harper & Brothers Publishers, 1894), pp. 18, 9.

89 *Du Maurier did his level best to recast bohemia's homosexual connotations*: See Jonathan H. Grossman, "The Mythic Svengali: Anti-Aestheticism in *Trilby*," *Studies in the Novel* 28, no. 4 (winter 1996): pp. 525–42.

89 *"unpleasant little anthropoids"; "little misshapen troglodytes"*: George du Maurier, *The Martian* (1897; London, Harper, 1898), p. 390. See also Dennis Denisoff, "'Men of My Own Sex': Genius, Sexuality, and George Du Maurier's Artists," in Richard Dellamora, ed., *Sexual Dissidence* (Chicago: University of Chicago Press, 1999), pp. 163–64.

89 *"charming Little Billee"*; *"such depths of demoralization"*; *"They realized . . . how keen and penetrating and unintermittent"*: Du Maurier, *Trilby*, pp. 222–25.

89 *based Little Billee on the painter and illustrator Edward Walker*: Richard Kelley, *George Du Maurier* (Boston: Twayne, 1983), p. 113.

89–90 *"almost girlish purity of mind"*; *"a quickness, a keenness, a delicacy of perception"*: Du Maurier, *Trilby*, pp. 9, 10.

90 *"temporal space"*: Judit Minczinger, "A Mass-Produced Muse: Gender and Late-Victorian Urban Developments in George Du Maurier's *Trilby*," *Gender Forum* 42 (2013): p. 2.

90 *"sweet Alice"*; *"much to interest him"*; *"manly British pluck"*: Du Maurier, *Trilby*, pp. 236–38.

90 *some lively sketches that he and his friend Beckwith made during the mid-1870s*: See Roberta J. M. Olson, "John Singer Sargent and James Carroll Beckwith, Two Americans in Paris: A Trove of Their Unpublished Drawings," *Master Drawings* 43, no. 4 (winter 2005): pp. 415–39.

91 *"talking the whole time"*: VL to her mother, June 25, 1881, *Letters*, p. 65.

91 *"intertwined"*; *"Sargent's personal panache"*: Olson, "Two Americans in Paris," p. 418.

92 *"the handsomest Italian in Paris"*: Quoted in Pepi Marchetti Franchi and Bruce Weber, *Intimate Revelations: The Art of Carroll Beckwith* (New York: Berry-Hill Galleries, 1999), p. 20.

92 The Falconer: James Carroll Beckwith, *The Falconer*, 1878, oil on canvas, Pennsylvania Academy of the Fine Arts, Philadelphia.

92 *two half-length sketches of the youth*: *Two Half-Length Sketches of a Youth*, c. 1878, graphite on paper, Rhode Island School of Design, Providence (see illustration credits).

92 *"allowed him to draw a nipple in profile"*; *"admiration for olive- or brown-skinned, dark-haired people of Mediterranean origin"*; *"exotic allure"*: Fairbrother, *The Sensualist*, p. 100.

93–94 *"Charming, charming"*; *"He would be proud if Sargent would accept it"*; *"I should never enjoy this pastel"*; *"less fortunate competitors"*; *"the turning point of his career"*; *"vigorous, robust, full of humour"*; *"warmed the company with his laughter"*: Charteris, *John Sargent*, pp. 45–46.

94 *"Leuleu"*: Olson, *John Singer Sargent*, p. 63.

94 *"wiry and physical angularity"*; *"bony male knees"*: Richard Ormond and Elaine Kilmurray, *The Early Portraits* (New Haven, CT: Yale University Press, 1998), p. 93.

94 *"irresistible"*: JSS to VL, August 16, [1881,] Ormond Family Archive, MFA; quoted in Ormond and Kilmurray, *Early Portraits*, p. 28.

94 *Artists modeled for one another for free*: Olson, "Two Americans in Paris," p. 419.

94 *a portrait of family friend Fanny Watts*: *Fanny Watts*, 1877, oil on canvas, Philadelphia Museum of Art.

94 *Mary was reputed*: According to correspondence in the Ormond papers; see Ormond and Kilmurray, *Early Portraits*, p. 42.

95 *"very creditable performance"*: FWS to George Bemis, March 24, 1877, Massachusetts Historical Society, Boston.

95 *each canvas amounting*: As the sociologist Howard S. Becker has argued, any work of art—any one of Sargent's portraits—"always shows signs of this cooperation." All artworks have complex social origins, but portraits in particular are, as Sar-

gent's career in the early 1880s shows, complex negotiations among painters, sitters, patrons, models, buyers, and public audiences, both historical and contemporary. Becker's idea of a networked and cooperative "art world" provides a useful framework for understanding "how people produce and consume works of art," and how, as a result—and in this case largely hinging on women and their changing roles in Sargent's world—"the essential character of the society expresses itself, especially in great works of genius." See Howard S. Becker, *Art Worlds* (Berkeley: University of California Press, 1982), pp. 1, x–xi.

96 *secured public if anonymous cameos by painting each other's likenesses*: According to Barbara Weinberg; see Weinberg, "Sargent and Carolus-Duran," p. 26. Sargent's image appears twice in this composition, and at least one likeness, according to ES, was painted by Carolus-Duran himself: See Ormond and Kilmurray, *Early Portraits*, p. 43.

96 *"he told John he would sit for his portrait"*: ES to VL, July 24, 1878, Ormond Family Archive, MFA. See also Ormond and Kilmurray, *Early Portraits*, p. 43.

96 *"was the envy of the whole studio"; "had, however, to admire generously"*: Blashfield, "John Singer Sargent," p. 641.

96 *"The friendship existing between this young artist and his instructor"; "love[d] to have his young American disciple in company"*: *Art Amateur* 2 (May 1880): p. 118.

96 *"took one of their vacant beds in my room"*: JSS to Ben del Castillo, March 6, 1875, quoted in Charteris, *John Sargent*, p. 37.

97 *"à mon cher maître M. Carolus Duran son élève affectioné"*: *Carolus Duran*, oil on canvas, 1879, Clark Art Institute, Williamstown, MA (see illustration credits).

97 *"Oui mais Papa était là"*: quoted in Charteris, *John Sargent*, p. 49.

97 *"a somewhat effeminate effect to 'dear Master Carolus'"*: "The American Artists. Close of the Exhibition," *New York Times*, April 16, 1880, p. 8; see also Simpson, *Uncanny Spectacle*, p. 85.

97 *"épatant"*: Charles Du Bois to Julian Alden Weir, May 14, 1879, AAA.

8. Rosina's Spell

98 *"fellows"; "I am inclined to think that companionship a great object"*: JSS to Ben del Castillo [August 10, 1878], quoted in Charteris, *John Sargent*, p. 47.

99 *"brilliant Prix de Rome men"*: Frank Hyde, "The Island of the Sirens," *International Studio* 51, no. 204 (February 1914): p. 285.

99 *its large central courtyard*: Charles Montague Bakewell, *The Story of the Red Cross in Italy* (New York: Macmillan, 1920), pp. 134–35.

99 *He soon painted both exterior and interior staircases*: *Staircase at Capri*, 1878, oil on canvas, private collection; and *Staircase*, c. 1878, oil on canvas, Clark Art Institute. See Margaret C. Conrads, *American Paintings and Sculpture at the Sterling and Francine Clark Art Institute* (New York: Hudson Hills Press, 1990), pp. 158–60.

99–100 *"one of the charmingly picturesque houses of the* contadini*"; "under a vine-covered pergola"; "the tobacco shops, hidden away under the Moorish arches"; "discussed affairs of State, heard the latest scandal"*: Hyde, "Island of the Sirens," pp. 285–86.

101 *a few drawings now preserved at the Biblioteca del Centro Caprense*: Hotel Pagano Albums, Biblioteca del Centro Caprense Ignacio Cerio, Capri. See Ormond and Kilmurray, *Figures and Landscapes, 1874–1882*, pp. 141–43.

101 *"close personal friend"; "the record is silent"*: Ormond and Kilmurray, *Figures and Landscapes, 1874–1882*, p. 387.

101 *"Salto di Tiberio"*: JSS to Ben del Castillo, May 23, 1869, quoted in Charteris, *John Sargent*, p. 12.

102 *"under the influence of his demon,"; "sacrificed to the sun"; "the beautiful Antinous"*: Ferdinand Gregorovius, *The Island of Capri*, trans. Lilian Clarke (Boston: Lee and Shepard, 1879), p. 63.

102 *"gladly do good turns"*: Jean-Jacques Bouchard, quoted in James Money, *Capri, Island of Pleasure* (London: Hamish Hamilton, 1986), p. 11.

102 *Duchesse de La Vallière*: Primi Visconti, *Mémoires sur la cour de Louis XIV, 1673–1681*, ed. Jean-François Solnon (Paris: Perrin, 1988), p. 81.

102 *caused, some thought, by a torrid climate; "the Italian vice"*: see Chiara Beccalossi, "The 'Italian Vice': Male Homosexuality and British Tourism in Southern Italy," in Valeria Babini, Chiara Beccalossi, and Lucy Riall, eds., *Italian Sexualities Uncovered, 1789–1914* (London: Palgrave Macmillan, 2015), pp. 187–88.

102 *The German poet August von Platen-Hallermünde; Hans Christian Andersen, etc.*: Robert Aldrich, *The Seduction of the Mediterranean: Writing, Art, and Homosexual Fantasy* (London: Routledge, 1993), p. 126–28.

103 *"Great Pan is not dead"*: Hyde, "Island of the Sirens," p. 288.

103 Young Man in Reverie: 1878, oil on canvas, private collection. Though the painting is inscribed with the date 1876, the curators of a Whitney Museum exhibition in 1986–87 determined this painting to be from 1878. See Patricia Hills, ed., *John Singer Sargent* (New York: Whitney Museum of American Art, 1986), pp. 31, 41. Ormond and Kilmurray, who prefer the title *Study of a Male Model*, note that there is "insufficient evidence to identify the setting" and cite the "Hispano-Moresque" ceramics to suggest the possibility that the picture was painted during Sargent's travels in Spain or Morocco in 1879–80. That this sketch belonged to Auguste-Alexandre Hirsch, however, may lend additional weight to the idea that the painting was done in Capri, where Hirsch and Sargent met and seemingly spent time together: Ormond and Kilmurray, *Figures and Landscapes, 1874–1882*, p. 44.

Another painting of similar relevance is *Head of a Male Model* (1878), oil on canvas, private collection. For a larger discussion of Sargent's figure studies of striking Mediterranean men from the late 1870s, see Ormond and Kilmurray, *Figures and Landscapes, 1874–1882*, pp. 39–44.

Sargent's extant works from his stay on the island—though few of these little-studied images can be definitively linked with Capri—include sketches of lounging sailors as well as several striking Mediterranean men. (See Herdrich and Weinberg, *American Drawings and Watercolors*, pp. 157–58.) Nothing is known about Sargent's interactions with these unnamed Italians. And there may be other such images that have not survived since, as the Sargent scholar Elaine Kilmurray has observed, "Sargent was notoriously casual about his work" and did not always keep or preserve it: Ormond and Kilmurray, *Figures and Landscapes, 1874–1882*, p. 148. But, strongly attracted to Mediterranean types, Sargent no doubt found the local men appealing, artistically or personally. Even Gregorovius, who like many visitors to Capri in the 1870s singled out the young Capri women, appreciated the local fishermen as "powerful men, often very handsome, of herculean proportions, with muscular limbs and a dark-brown complexion, and faces full of energy, looking

very bold and striking under the Phrygian cap which they wear": Gregorovius, *Island of Capri*, p. 27.

103 *"the Oriental colouring and Saracenic features"*: Hyde, "Island of the Sirens," p. 286.

103 *"features often show signs"; "something of an Oriental character"*: Gregorovius, *Island of Capri*, p. 32.

104 *"tawney-skinned, panther-eyed, elf-like Rosina"*: "American Art in the Paris Salon," *Art Amateur* 7, no. 3 (August 1882): p. 46.

104 *"simple"; "primitive"; "They made excellent wives"*: Hyde, "Island of the Sirens," p. 287.

104 *"unperverted"*: Gregorovius, *Island of Capri*, p. 32.

104 *women and children gathering oysters on a Breton beach*: *Oyster Gatherers of Cancale*, 1878, oil on canvas, Corcoran Gallery of Art, Washington, DC.

104 Dans les Oliviers: *Dans les Oliviers, à Capri*, 1878, oil on canvas, private collection. Sargent painted three versions of this painting, the most definitive and finished of which is *A Capriote*, 1878, oil on canvas, MFA. See Warren Adelson, ed., *Sargent's Women* (New York: Adelson Galleries, 2003), p. 50.

105 *he inscribed many of his sketches of Rosina to his fellow artists*: See Ormond and Kilmurray, *Figures and Landscapes, 1874–1882*, pp. 164–70.

105 *Hyde painted Rosina*: *Capri*, c. 1880, oil on canvas, private collection.

105 *"self-contained, distant, and detached"; "independent creatures—sultry, sensual, and self-possessed"*: Elaine Kilmurray, "Sargent's Women: Models, Dancers, Exotics" in Adelson et al., eds. *Sargent's Women*, p. 27.

106 Rosina: 1878, oil on canvas, private collection.

106 View of Capri: c. 1878, oil on academy board, Yale University Art Gallery, New Haven (see illustration credits).

106 Capri Girl on a Rooftop: 1878, oil on canvas, Westervelt-Warner Museum, Tuscaloosa, AL.

106 *"imported a breath of the Latin Quarter"*: Charteris, *John Sargent*, p. 48.

107 *"with what delight we watched"*: Hyde, "Island of Sirens," pp. 285–86.

9. Travels in the Dark

108 *The two artists shared*: See Hamilton Minchin, "Some Early Recollections of Sargent," *Contemporary Review* 27 (June 1925): pp. 735–43.

108 Calliope Teaching Orpheus: Auguste-Alexandre Hirsch, *Calliope Teaching Orpheus*, 1865, oil on canvas, Périgord Museum of Art and Archaeology, Périgueux, France.

109 *"second-class"*: Karl Baedeker, ed., *Paris, and Its Environs* (Leipzig: Baedeker, 1878), p. 7.

109 *portrait he painted of the celebrated poet-playwright*: *Édouard Pailleron*, 1879, oil on canvas, Musée d'Orsay, Paris.

109 *"en veston de travail"; "infraction aux règles"*: Marie-Louise Pailleron, *Le Paradis perdu* (Paris: A. Michel, 1947), p. 150.

109 *a critic compared it, favorably, to Pailleron's amusing romp*: Unsigned review of *The Importance of Being Earnest*, *Truth* 27 (February 21, 1895), pp. 464–65.

109 *"a somewhat effeminate effect"*: "The American Artists. Close of the Exhibition," *New York Times*, April 16, 1880, p. 8.

110 *As historians have documented, it was a loaded gesture*: In a discussion of this pose in England, Thomas A. King has argued that, in representations of men, an arm akimbo had an aristocratic cachet in the mannerist and Baroque portraits of the seventeenth century but that "by the mid-eighteenth century, the bourgeois strategy of specifying an affected bodily style as sodomy . . . had produced a reading of this gesture as characteristic of the effeminate sodomite." That is, the emerging middle class reinterpreted "the aristocratic gesture of the arm set akimbo as signaling both the pride (narcissism) and lack (castration) 'characteristic' of sodomites." By the late nineteenth century, a middle-class reading of such postures in England as well as America had become only more entrenched. Even if the "molly houses" and punitive sodomy trials of the eighteenth century lay far in the past, the word "molly" was still in active circulation in 1890 along with many newer terms ("fairy," "invert," "Uranian," etc.) that attempted to describe an even more visible sexual minority often identifying through coded gestures and postures, among which an aristocratic or theatrical arm akimbo still held pride of place. See Thomas A. King, "Performing 'Akimbo': Queer Pride and Epistemological Prejudice" in Moe Meyer, ed., *The Politics and Poetics of Camp* (London: Routledge, 1994), pp. 30–31.

110 *"excellence"; "the proof of the pudding"*: FWS to Thomas Parsons Sargent, August 15, 1879, AAA.

111 *"lady's portrait"*: ES to VL, September 3, 1879, Colby College, Waterville, ME.

112 *Sargent's unconventional portrait*: *Madame Édouard Pailleron*, 1879, oil on canvas, Corcoran Gallery of Art, Washington, DC.

112 *"éclatant"*: Quoted in Ormond and Kilmurray, *Early Portraits*, p. 47.

112 *portrait of the Pailleron children*: *The Pailleron Children*, 1881, oil on canvas, Des Moines Art Center.

112 *one slim male Spanish performer*: *Spanish Dancer*, 1879–80, graphite on off-white wove paper, MMA.

112 Spanish Male Dancer Before Nine Seated Figures: 1879, ink and ink wash, FM (see illustration credits).

113 *Armand-Eugène Bach, about whom almost nothing is known*: In some previous literature this figure was thought to be Ferdinand Bach or Bac, a French artist, cartoonist, and writer, son of an illegitimate nephew of Napoleon. See Olson, *John Singer Sargent*, p. 70n; Fairbrother, *The Sensualist*, p. 115.

113 Woman Playing with Doves: Charles-Edmond Daux, *Woman Playing with Doves* (*Femme jouant avec des colombes*), 1880, oil on canvas, Musée d'Orsay, Paris.

115 *"half-naked Arabs"; "The Arabs [are] often magnificent"*: JSS to Ben del Castillo, January 4, 1880, quoted in Charteris, *John Sargent*, p. 50.

115 *an oil sketch of two naked men on a quay*: *Two Nude Bathers Standing on a Wharf*, c. 1879–80, oil on panel, MMA (see illustration credits). See John Esten, *John Singer Sargent: The Male Nudes* (New York: Universe, 1999), p. 6; Ormond and Kilmurray, *Figures and Landscapes, 1874–1882*, p. 128. Ormond and Kilmurray insist this sketch doesn't portray bathers, as others have assumed, but it's difficult to know what else two naked figures are supposed to be doing on a wharf; indeed, even if bathing seems a bit unlikely in this setting, one argument that the painting portrays Morocco is this very nakedness, something that would happen less in European Mediterranean ports.

115 Fumée d'ambre gris: 1880, oil on canvas, Clark Art Institute, Williamstown, MA (see illustration credits).

115 *"stately Mahometan"; "mysterious domestic or religious rite"; "radiant effect of white upon white"*: James, "John S. Sargent," p. 222.

116 *"The only interest of the thing . . . was the color"*: JSS to VL, July 9, 1880, quoted in Kimurray and Ormond, *John Singer Sargent*, p. 88.

116 *Here the delicate, daring beauty of the portrait: Madame Ramón Subercaseaux*, c. 1880–81, oil on canvas, private collection.

116 *"male gaze"*: See Laura Mulvey, "Visual Pleasure and Narrative Cinema," *Screen* 16, no. 3 (1975): pp. 6–18.

117 *Louis Moreau Gottschalk; "a very attractive gentleman"; "very poor and bohemian"*: Amalia Subercaseaux, diary, quoted in Ormond and Kilmurray, *Early Portraits*, p. 57.

117 *"siphon"*: VL to her mother, June 23, 1883, *Vernon Lee Letters*, p. 117.

117 *"great swell"*: JSS to Ben del Castillo, [June 1881,] quoted in Charteris, *John Sargent*, p. 55.

118 *The portrait Sargent painted of him: Francis Brooks Chadwick*, 1880, oil on panel, Adelson Galleries, New York.

119 *a portrait of Curtis as a small, dapper man: Ralph Wormeley Curtis*, 1880, oil on panel, High Museum of Art, Atlanta.

119 *of whom Sargent also produced a handsome portrait: George Hickock*, c. 1880, watercolor on paper, private collection.

119 *"two very nice friends"; "enjoyed the pictures immensely"*: ES to VL, August 25, 1880, Colby College, Waterville, ME. .

120 *"omnibus-boats"; "not recommended"; "patronized by Germans"*: Karl Baedeker, *Italy, Handbook for Travelers*, vol. 1(Leipzig: Baedeker, 1883), p. 231.

120 *Venetian Women in the Palazzo Rezzonico*: c. 1880, oil on canvas, private collection.

121 *"barrack for artists"*: Charteris, *John Sargent*, p. 53.

121 *"coffee, rolls, and butter on old republic silver"; "palette appeared to be set with varied shades of mud"; "stupidity of [their] garish efforts"*: Harper Pennington, "Artist Life in Venice," *Century Illustrated Magazine*, 64, no. 6 (October 1892): pp. 836–37.

121 *"a Venice in Venice that others seem never to have perceived"*: Quoted in Hugh Honour and John Fleming, *The Venetian Hours of Henry James, Whistler, and Sargent* (Boston: Little, Brown, 1991), p. 37.

121 *"unpicturesque subjects, absence of color"*: Martin Brimmer to Sarah Wyman Whitman, October 26, 1882, AAA.

121 *"palaces in rags"*: See James McNeill Whistler, *The Palace in Rags*, 1879–80, pastel, private collection; Chong, "Artistic Life in Venice," pp. 94–97.

122 *"the inevitable study of bead-stringers"*: Pennington, "Artist Life in Venice," p. 838.

122 *"There were no slums more slummy"*: Pemble, *Venice Rediscovered*, p. 2.

122 *"moods that are strained, disturbed, sinister, and erotic"*: Richard Ormond, "In Sargent's Footsteps, 1900–1914," in Bruce Robertson et al., eds., *Sargent and Italy* (Los Angeles: Los Angeles County Museum of Art, 2003), p. 71.

122–23 *"great maker of theories"; "art for art's sake"; "quite emancipated from all religious ideas"*: VL to her mother, June 20, 1881, *Vernon Lee Letters*, p. 63.

124 *"the unique extra-human Montesquoiu"*: JSS to Henry James, June 25, 1885, Hough-ton Library, Harvard University, b MS Am 1904 [396]; See also Leon Edel, *Henry James: The Middle Years, 1882–1895* (Philadelphia: Lippincott, 1962), pp. 149–53.

124 *"exerted a powerful influence on Sargent"*: Boime, "Sargent in Paris and London," p. 75.

124 *"mon cher Yturri"*: Robert de Montesquiou, *Les Pas Effacés, Mémoires*, vol. 2 of 3 (Paris: Paul-Louis Couchoud, 1923), pp. 168–169, 210.

125 *"a far greater role in the life of this man"; "But he has so much taste!"; Montesquiou squired stunning and bejeweled women*: Philippe Jullian, *Prince of Aesthetes: Count Robert de Montesquiou, 1855–1921*, trans. John Haylock and Francis King (New York: Viking, 1968), pp. 36–37, 34.

126 *he was once induced—to his distaste*: Jullian, *Prince of Aesthetes*, p. 60.

126 *"handsome, still youthful head"*: James, "John S. Sargent," p. 225.

126 *"cher, grand et noble ami"; "pénétré de son charme puissant"; "jamais je n'ai en-contré"*: Montesquiou, *Les Pas effaces*, vol. 2, pp. 198, 195.

127 *"the man in the red gown"*: JSS to Henry James, June 25, 1885, Houghton Library, MS Am 1094 (396).

127 Dr. Pozzi at Home: Or *Dr. Pozzi* (1881), oil on canvas, UCLA at the Armand Ham-mer Museum of Art and Cultural Center, Los Angeles (see illustration credits).

127 *referencing the homosexual underworld*: See Syme, *Queer Flora of Fin-de-Siècle Art*, pp. 216–17.

127 *"robe's tenuous closure hints at exposure"*: Juliet Bellow, "The Doctor Is In: John Singer Sargent's *Dr. Pozzi at Home*," *American Art* 26, no. 2 (summer 2012): pp. 44–45, p. 56.

127 *"hangs just below the groin"*: Julian Barnes, *The Man in the Red Coat* (New York: Knopf, 2019), p. 6.

127 *"function[s] within and between"*: Bellow, "The Doctor Is In," p. 48.

127 *"insolent kind of magnificence"*: VL to her mother, June 16, 1881, *Vernon Lee Letters*, p. 61.

128 "un échantillon complet du tape à l'oeil": *Echo de Bruxelles* (February 11, 1884).

10. Flash Gatherings

129 *her well-appointed flat*: James called it her "lambris dorés," a phrase difficult to trans-late but meaning something like "palatial home": Henry James to Henrietta Reu-bell, October 13, [1883,] Correspondence and Journals of Henry James J. (MS am 1094), Houghton Library, Harvard University, 1053.

129 *Women's smoking betokened disrepute*: See Cassandra Tate, *Cigarette Wars: The Triumph of the Little White Slaver* (New York: Oxford University Press, 1999), p. 24; Dolores Mitchell, "The 'New Woman' as Prometheus: Women Artists Depict Women Smoking," *Women's Art Journal* 12 (spring–summer 1994): p. 3.

129 *"the practice of smoking among ladies"*: "Women and Smoking," *New York Times*, September 1, 1879, p. 2.

129 *Her heavy, in-your-face smoking*: I first worked out some of my ideas about Henri-etta Reubell and her Paris artistic circles in three previous articles. See Paul Fisher, "'Her Smoking Was the Least of Her Freedoms': Henrietta Reubell, Miss Barrace, and the Queer Milieu of Henry James's Paris," *Henry James Review* 33, no. 3 (fall 2012): pp. 247–54; Paul Fisher, "'The Dear Little Tobacconized *Salon*': Henrietta

Reubell as Queer *Salonnière* in Henry James's Paris," in Donatella Izzo, Anna De Biasio, and Anna Despotopoulou, eds., *Transforming Henry James* (Newcastle-on-Tyne: Cambridge Scholars Press, 2013), pp. 271–286; and Paul Fisher, "The Lost Ambassador: Henrietta Reubell and Transnational Queer Spaces in the Paris Arts World, 1876–1903," in Karen L. Carter and Susan Waller, eds., *Strangers in Paradise: Foreign Artists and Communities in Modern Paris, 1870–1914* (Basingstoke, UK: Ashford, 2015), pp. 199–212.

129 *"Her smoking was the least of her freedoms"*: Henry James, *The Ambassadors* (1903; reprint New York: Oxford University Press, 1985), p. 81.

129 *"particular lion"*: Muriel Harris, "Salons Old and New," *North American Review* 213 (June 3, 1921): pp. 830.

130 *"pseudo-geniuses"; "a shrewd and original mind"; "if one can imagine"; "adept at bringing"; "to meet people"; "permitted anything"*: William Rothenstein, *Men and Memories*, vol. 1 of 2 (New York: Coward-McCann, 1931–32), p. 81.

130 *But in 1884 or 1885 he painted a watercolor: Henrietta Reubell*, watercolor and gouache on paper, c. 1884–85, MMA (see illustration credits).

131 *In November of 1882*: Sargent's first encounter with Henry James was long thought to have taken place in 1884, but the art historian Erica Hirshler recently discovered that James knew Sargent earlier. Hirshler convincingly suggests that Sargent met James at Reubell's salon in November 1882: See Erica E. Hirshler, *Sargent's Daughters: The Biography of a Painting* (Boston: MFA Publications, 2009), pp. 72–73. In 1882, James dispatched a greeting to Reubell's whole circle of artists, her *"jeune monde"* (young world), adding "in special, something as friendly as possible for me to Sargent." (Henry James to Henrietta Reubell, December 5, 1882, Houghton Library, Ms am 1094: 1051.) Though Sargent could have met James through his and Reubell's mutual friends the Edward Darley Boits, who lived nearby in the avenue de Friedland, it is most probable that Sargent met James at Reubell's salon in November 1882, Reubell's salon being a place in which artists like Sargent met fellow painters, critics, patrons, and others vital to their lives and careers.

132 *"eccentric and imperfect"; "Few things"*: Henry James, "On Whistler and Ruskin," in *Painter's Eye*, pp. 173–74.

132 *"extremely amusing"; "buffoon," "comic business"; "somersault in the ring"*: Henry James, "London Pictures," in *Painter's Eye*, pp. 208–209.

132 *"charming, light, comic"*: Lucia Fairchild, diary, October 2, 1890, in Miller, "Diaries of Lucia Fairchild," p. 8.

133 *orchestra rehearsals at the at the Cirque d'Hiver: Rehearsal of the Pasdeloup Orchestra*, 1879–80, oil on canvas, MFA.

133 *"laden"*: Henry James to Henrietta Reubell, December 29, 1893, Houghton Library, Ms am 1094: 1122.

133 *"saloon for gifted infants"*: Henry James to Jonathan Sturges, October 19, [1893,] in Leon Edel, ed., *The Complete Letters of Henry James*, vol. 3 of 4 (Cambridge, MA: Harvard University Press, 1974–1984), p. 435.

133 *"jibes"*: Rothenstein, *Men and Memories*, vol. 1, p. 81.

133 *"Do the little painters"*: Henry James to Henrietta Reubell, December 29, 1893, Houghton Library, Ms am 1094: 1122.

133 *"as much business with daughters"*: Henry James to Henrietta Reubell, September 10, [1893,] Houghton Library, Ms am 1094: 1119.

133 *"shepherdess of the studios"*: Hirshler, *Sargent's Daughters*, p. 72; Edel, *The Middle Years*, p. 107.

134 *"constantly"*: Henry James to Elizabeth Boott, October 14, 1883, Edel, *Henry James Letters*, vol. 3, p. 9.

134 *"forty trunks"*: John Boit to Robert Boit, quoted in Robert Apthorp Boit Diaries (November 29, 1891), vol. 2, p. 275, quoted in Hirshler, *Sargent's Daughters*, p. 66.

134 *"brilliant water-colour painter"*: Edith Wharton, *A Backward Glance* (London: D. Appleton-Century, 1934), pp. 171–72.

134 *In 1882, by painting the Boits' four daughters*: *The Daughters of Edward D. Boit*, 1882, oil on canvas, MFA. For a masterful account of this painting in all its dimensions, see Hirshler, *Sargent's Daughters*.

134 *"superb group"; "god of his idolatry"*: James, "John S. Sargent," pp. 218, 220.

135 *"baffling relationships between the figures"*: Hirshler, *Sargent's Daughters*, p. 87.

135 *"The Hall with the Four Children"; "When was the pinafore"; "light, free security of execution"; "instinct and knowledge"; "assimilated secrets"*: James, "John S. Sargent," pp. 218, 220, 222–23.

135–36 *"Alice in Wonderland quality"; "air of mystery and ambiguity"*: Ormond and Kilmurray, *Early Portraits*, p. 88.

136–37 *"irregular life"; "perfectly familiar"; "Oh, the artist-quarter"; "laxity"; "sum of her licence'; "Oh no—not that!"; "not yet thirty"; "notoriously . . . not from Boston"*: James, *Ambassadors*, pp. 79, 81, 143, 82, 74.

136 *"adventuress"; "flock of dusky-fleeced sheep"; "evil and dissipation"*: Lucy H. Hooper, "The American Colony in Paris," *Appleton's Magazine* (June 20, 1874): p. 780.

137 *"strength of the [erotic] current"*: Eric Haralson, *Henry James and Queer Modernity* (New York: Cambridge University Press, 2003), pp. 125–26.

137 *"Strether's theatre of envy and desire"*: Henry James, *The Notebooks of Henry James*, eds. F. O. Matthiessen and Kenneth B. Murdock (New York: Cambridge University Press, 1947), p. 393.

137 *"strangely, though not clearly, chaste"*: Olson, *John Singer Sargent*, p. 107.

137 *"tobacconized salon"*: Henry James to Henrietta Reubell, December 5, [1885,] Hougthton Library, Ms am 1094: 1062.

137 *"smoker's throat"*: Lucia Fairchild, diary, October 2, 1890, in Miller, "Diaries of Lucia Fairchild," p. 5.

138 *Proust transformed the Comtesse*: See Laure Hillerin, *La Comtesse Greffulhe, l'Ombre des Guermantes* (Paris: Flammarion, 2014).

138 *Geneviève Halévy Bizet Straus; "circular" salon; "Tout-Paris"; coquettishly received her guests*: Jullian, *Prince of Aesthetes*, pp. 72–73.

138 *"ugly"; "adventurous"*: Rothenstein, *Men and Memories*, vol. 1, p. 81.

138 *"interesting gossipry"*: Henry James to Henrietta Reubell, May 26, 1900, Houghton Library, Ms am 1094: 1141.

138 *"vaporous tea-gowns"; "monocle rimmed with opals"; "wafted . . . in the direction of her habitués"*: Jullian, *Prince of Aesthetes*, pp. 67, 104.

139 *"successfully"; "charming"*: Henry James to Henrietta Reubell, [July 5, 1885,] Edel, *Henry James Letters*, vol. 3, p. 93.

139 *"cher monsieur"*: Henry James to Robert de Montesquiou, Edel, *Henry James Letters*, vol. 3, pp. 91, 96.

139 *"There is a great demand for brilliant women"*: Henry James to Henrietta Reubell, January 9, 1882, Houghton Library, Ms am 1094: 1046.

139 *"fortune to paint"; "secret of the particular aspect"*: James, "John S. Sargent," p. 218.

140 Lady with a Rose: Or *Louise Burckhardt*, 1882, oil on canvas, MMA.

140 *"peculiar"; "painted with extraordinary breadth and freedom"; "simplicity"*: James, "John S. Sargent," p. 219.

140 *According to his friend Beckwith*: Beckwith, diary, July 5–13, 1881, AAA; see also Olson's discussion in *John Singer Sargent*, pp. 88–89.

140 *"girl in black"*: VL to her mother, June 8, 1882, Lee, *Letters*, p. 84.

140 *"Miss Burkhardt is gone off the horizon"*: VL to her mother, June 23, 1883, Lee, *Letters*, p. 116.

140 *"the girl [John] was supposed to be engaged to"; "very charming, not absolutely pretty"*: VL to her mother, September 5, 1885, Lee, *Letters*, p. 199.

140 *"simply superb & like an old master"*: Vernon Lee to her mother, June 8, 1882, Lee, *Letters*, p. 84.

140–41 *Ormond and Kilmurray have suggested a similarity in Louise Burkhardt's pose*: See Ormond and Kilmurray, *Early Portraits*, p. 65.

141 Buffoon Calabazas: Diego Velázquez [?], *Buffoon Calabazas*, c. 1628–29, oil on canvas, Cleveland Museum of Art, Cleveland.

141 *a commissioned double portrait*: Mrs. Edward Burkhardt and her Daughter Louise, 1885, oil on canvas, private collection.

141 El Jaleo: 1882, oil on canvas, ISGMA (see illustration credits).

141–42 *"breadth and boldness"; "ugliness"; "want of serenity"; "a young painter less in the dark about his own ideal"*: James, "John S. Sargent," pp. 221, 217. I discuss James's reaction to *El Jaleo* in more depth in Fisher, "'Want of Serenity,'" pp. 252–58.

142 *"She wanted very much to see"; "dancing scene among the gypsies"; "spoken very well of indeed"; "who intends taking it"*: FWS to Thomas Parsons Sargent, May 5, 1882, AAA.

142 "le héros du Salon"; "s'est frayé sa route vers des coins inexplorés"; "danseuse d'Andalousie"; "sobre et puissante . . . d'une vérité absolue"; "bohémiens, égyptiens, zingaris"; "même qu'ils ont oublié en route le nom de leur pays": Judith Gautier, "Le Salon IV / Sargent," *Le Rappel* (May 12, 1882), p. 3.

143 Study for Seated Figures, "El Jaleo": 1880–82, oil on canvas, FM.

143 Study for Seated Musicians, "El Jaleo": 1880–82, oil on canvas, FM (see illustration credits).

143 *the same kind of Spanish costume*: See Moss, "John Singer Sargent, 'Madame X,' and 'Baby Milbank,'" p. 274; Mary Crawford Volk et al., *John Singer Sargent's* El Jaleo (Washington, DC: National Gallery of Art, 1992), p. 188.

11. In the Key of Blue

144 *"bowing gondoliers"*: Julia Cartwright, *A Bright Remembrance: The Diaries of Julia Cartwright, 1851–1924*, ed. Angela Emanuel (London: Weidenfeld and Nicholson, 1989), p. 288.

144 *"omnibus steamers"*: VL to her mother, September 11, 1885, Lee, *Letters*, p. 202.

144 *But these for-hire boatmen also acted as guides*: See Chong, "Artistic Life in Venice," pp. 109–110.

146 *A few pencil sketches of these sinewy boatmen*: e.g., *Gondoliers*, graphite on paper, 1880–82; and *Gondolier*, graphite on paper, c. 1882, MMA.

146 Man in a Hat: Graphite on paper, 1880–82, MMA (see illustration credits).

146 *long labeled as a gondolier*: *Head of a Gondolier* or *Head of a Male Model*, c. 1878–80, oil on canvas, private collection. Though this work was long known as the *Head of a Gondolier*, Sargent scholars Ormond and Kilmurray have claimed that "there is nothing . . . to indicate that the young man is a gondolier" and that the style of the piece dates it to about 1878, before Sargent's primary stays in Venice. Still, they concede that it is "just possible" that this and another similarly handsome painting, *Head of a Young Man*, were painted in Venice. In that case, it may be that several of Sargent's early portraits of Italian men document interactions with models in Venice, gondoliers or not, about whom little else is known. See Chong, "Artistic Life in Venice," p. 114, Kilmurray and Ormond, *Figures and Landscapes, 1874–1882*, pp. 41–42.

146 "Comandi Signore? ": A common cry of gondoliers to get work; specifically overheard in the "hoarse voice of Angelo [Fusato]" by John Addington Symonds (see below), in John Addinton Symonds to Mary Robinson, March [15,] 1886, Herbert M. Schueller and Robert L. Peters, eds., *The Letters of John Addington Symonds*, vol. 3 (Detroit: Wayne State University Press, 1967–69), p. 124.

146 *"infatuation with gondoliers was a well-recognized characteristic"*: Pemble, *Venice Rediscovered*, p. 48.

146–47 *"heterosexual men were permitted to admire gondoliers"*: Chong, "Artistic Life in Venice," p. 110.

147 *"sort of Americans"; "as a sort of patron saint of cosmopolitan refinement"; "a nice brisk little man, rather timidly anxious"; "a rather die-away [faded] English American"*: VL to her mother, September 11, 1885, Lee, *Letters*, p. 202.

147 *an upsetting omnibus altercation in Boston*: See Olson, *John Singer Sargent*, pp. 85–86; Pemble, *Venice Revisited*, p. 45.

147 la dogaressa: Ormond and Kilmurray, *Early Portraits*, p. 62.

147 *the portrait Sargent painted of her that autumn*: *Mrs. Daniel Sargent Curtis*, 1882, oil on canvas, Spencer Museum of Art, University of Kansas, Lawrence, KS.

148 *"it would be most unfortunate were John to marry Miss Burkhardt"*: VL to her mother, September 11, [1885,] Lee, *Letters*, p. 202.

148 *"alley scenes with suggestive exchanges between men and women"*: Trevor Fairbrother, "Sargent's Genre Paintings and the Issues of Suppression and Privacy," in Doreen Bolger and Nicolai Cikovsky Jr., eds, *American Art Around 1900: Lectures in Memory of Daniel Fraad* (Washington, DC: National Gallery of Art, 1990), p. 32.

148 Venetian Street: 1880–82, oil on canvas, private collection.

148 Street in Venice: 1882, oil on canvas, National Gallery of Art, Washington, DC.

148 *In yet another painting almost identically titled*: *A Street in Venice*, 1880–82, oil on canvas, Clark Institute of Art, Williamstown, MA (see illustration credits).

148 *Some art historians have interpreted these scenes as depicting prostitution*: See Warren Adelson, "Sargent's Life: Routes to Venice," in Warren Adelson et al., eds., *Sargent's Venice*, eds. Warren Adelson et al. (New Haven, CT: Yale University Press, 2006), p. 54.

148 The Sulphur Match: 1882, oil on canvas, private collection.

148 *"No member of [Sargent's] social circle would publicly lean back in a chair"*: Fairbrother, "Sargent's Genre Paintings," p. 33.

148–49 *"character [was] charmingly naïf but not his talent"*; *"excess of cleverness"*; *"intelligent* en diable"*: Henry James to Elizabeth Boott, [June 2,] 1884, Edel, *Henry James Letters*, vol. 3, p. 43.

149 *"great gift"*; *"rapidity of vision"*: Belleroche, "The Lithographs of Sargent," p. 42.

149 Study for a Venetian Scene: 1880–82, ink on paper, private collection.

150 *"Ten o' clock was the hour for formal calls in summer"*; *"What a place Venice is for models!"*; *"Men, women, and children"*; *"they all appear willing to sit"*: Pennington, "Artist Life in Venice," p. 838.

150 *Pennington himself may have pursued such experiences*: Though Pennington subsequently married and had two daughters, he also produced some suggestive and homoerotic paintings that have recently resurfaced in art auctions, for example the shirtless *A Baker's Assistant Mixing Dough* (1894) and the naked *Portrait of a Young Man, Nude* that he produced for the decorator Ogden Codman in 1903. Pennington also befriended Oscar Wilde, of whom he painted a portrait in 1884 and for whom he illustrated an essay—about artists' models in London, as it happens—in 1889. Even if, in his retrospective account, Pennington scarcely mentioned gondoliers at all, he himself may have had more complicated experiences. See Harper Pennington, *A Baker's Assistant Mixing Dough*, 1894, oil on canvas, private collection; Pennington, *Portrait of a Young Man, Nude*, 1903, oil on canvas, private collection; Pennington, *Oscar Wilde*, Clark Library, UCLA, Los Angeles; Oscar Wilde, "London Models," illus. Harper Pennington, *The English Illustrated Magazine* 6, no. 64 (January 1889): pp. 313–19.

150 *"Sargent was only interested in Venetian gondoliers"*: See Trevor Fairbrother, "The Complications of Being Sargent," in *John Singer Sargent: Portraits of the Wertheimer Family* (New York: Jewish Museum, 1999), p. 39; Fairbrother, *The Sensualist*, p. 155; Chong, "Artist Life in Venice," p. 115; among others.

150 *"notorious in Paris and in Venice positively scandalous"*: Clive Bell to Mary Hutchinson, July 31, 1927, H. Ransom Center, University of Texas at Austin; see Fairbrother, *The Sensualist*, p. 155; Fairbrother, "The Complications of Being Sargent," p. 39; Chong, "Artist Life in Venice," p. 115; among others. Blanche's comment was heard secondhand, and from a man who was a well-known liar.

150 *the roster of foreign nineteenth- and early twentieth-century writers and artists who pursued affairs with gondoliers*: See Aldrich, *Seduction of the Mediterranean*, pp. 10–11, 35, 66, 78–79, 84–85, 92–93, 122, 123.

151 *"on the brain"*: VL to her mother, June 25, 1883, Lee, *Letters*, p. 118.

151 *"civilized to his fingertips"*; *"perhaps spoilable"*: Henry James to Grace Norton, February 23, 1884, Edel, *Henry James Letters*, vol. 3, p. 33.

151 *exposed in 1908 during a scandal involving opportunistic foreigners; the Fondamenta Nuove*: Pemble, *Venice Revisited*, p. 49.

151 *Calle Larga dei Proverbi*: Adelson, "Sargent's Life: Routes to Venice," p. 53.

151 *"captured the imaginations of literary homosexual men"*; *"greater freedom of opportunity"*: Sean Brady, "John Addington Symonds, Horatio Brown, and Venice: Friendship, Gondoliers, and Homosexuality," in Valeria Babini, Chiara Beccalossi, and Lucy Riall, eds., *Italian Sexualities Uncovered, 1789–1914* (London: Palgrave Macmillan, 2015), p. 207.

151 *"yelping and friendly"*: VL to her mother, June 25, 1881, Lee, *Letters*, p. 65.

152 *"in black satin and diamonds"*: Frederick Rolfe, *The Desire and Pursuit of the Whole: A Romance of Modern Poets* (London: Cassell, 1934), p. 231.

152 *"The gondola is made for solitude or for company"; "who has become enamoured of the lagoons and lagoon life"; "My gondolier Antonio Salin my constant companion"*: Horatio F. Brown, *Life on the Lagoons* (1884; reprint New York, Macmillan, 1894), pp. 60–61, frontispiece.

152–53 *"a little backyard to the wineshop of Fighetti"; "fiery"; "a man of this sort could yield himself to the solicitation of a stranger"; "so vile an act"; "the gondoliers of Venice are so accustomed to these demands"*: Symonds, *Memoirs*, pp. 271, 274, 277.

153 *"He does enjoy his life on the loose with me"*: John Addington Symonds to Janet Ross, November 13, 1891, Symonds, *Letters*, vol. 3, p. 625.

153 *"permanence and freedom"*: Symonds, *Memoirs*, p. 277.

154 *"candid and consistent creature"; "the Gladstone of the affair"; "a queer place to plant the standard of duty"; "some of [Symonds's] friends and relations are haunted with a vague malaise"*: Henry James to Edmund Gosse, January 7, [1893,] Henry James, *Letters*, vol. 3, p. 398.

154–55 *"framed [them] to render publication possible"; "the varying moods, perplexities and conflicts of [his] passion"*: Symonds, *Memoirs*, p. 272.

154 *"Seraph, Medusa, Mystery, Sphinx!"*: John Addington Symonds, "L'Amour de l'Impossible," in *Animi Figura* (London: Smith, Elder, & Co, 1882), p. 41.

154 *"her white dress"; "cheeks bronzed with sunshine"*: John Addington Symonds, "Stella Maris XXXV," in *Vagabunduli Libellus* (London: Kegan Paul, Trench, & Co., 1884), p. 45.

155 *"mutilations"*: Phyllis Grosskurth's term: See Symonds, *Memoirs*, p. 272n.

155 *"magnificent studies of his face"*: John Addington Symonds to Mary Robinson, February 27, 1886, Symonds, *Letters*, vol. 3, p. 120.

155 *"nude to the waist"; "worthy of a place"*: John Addington Symonds to Henry Graham Dakyns, March 22, 1886, Symonds, *Letters*, vol. 3, p. 124.

156 *"The problem of colour gradations under their most subtle aspect"; "working people— fishermen, stevedores, porters, boatmen, artizans [sic], facchini"; "pos[ing] him in a variety of lights with a variety of hues in combination"; "willing to pleasure him"; "they see he has found a mate of their own kindred"*: John Addington Symonds, "In the Key of Blue," in *In the Key of Blue and Other Prose Essays* (London: Elkin Mathews, 1908), pp. 3–4, 7–8, 16.

157 *"a vast & luxurious & exquisite place"*: VL to her mother, September 11, [1885,] Lee, *Letters*, p. 202.

157 *"Sargent's gondolier"*: See Chong, "Artistic Life in Venice," p. 113.

12. Diva Trouble

158 *"pretty garden with roses"*: VL to her mother, June 23, 1883, Lee, *Letters*, pp. 116–17.

158 *"majestic portrait"; "ugly woman"; "a great frigate"*: JSS to Henry James, [May 25, 1884,] Houghton Library, Harvard University, b MS Am 1094 [395].

158 *"John covered with dust"*: Ralph Curtis to his parents, May 2, 1884, quoted in Charteris, *John Sargent*, p. 61.

159 *an even, steady light*: See John Milner, *The Studios of Paris: The Capital of Art in the Late Nineteenth Century* (New Haven, CT: Yale University Press, 1988), p. 181.

159 *"an artist of the Plaine Monceau"*: Jacques-Émile Blanche, *Portraits of a Lifetime*, trans. Edward Clement (London: Coward McCann, 1937), p. 153.

160 *three asterisks;* Mme ***: F. G. Dumas, *1884: Catalogue Illustré du Salon* (Paris: Librairie d'art L. Baschet, 1884), p. xlvi. The entry reads: "Sargent (J.-S.). H.C. Portrait de Mme ***."

160 *a precursor of the later well-known title*: Madame X, 1884, oil on canvas, MMA (see illustration credits).

160 *"I have a great desire to paint her portrait"*: JSS to Ben del Castillo, undated, quoted in Charteris, *John Sargent*, p. 59.

160–61 *"Portrait of a Great Beauty"; "'envoi'"; "'fardées'"; "a uniform lavender"; "the most beautiful lines"; "lavender or chlorate"; "pretty in itself"*: JSS to VL, February 10, [1883,] quoted in Charteris, *John Sargent*, p. 59.

161 *"promotional"*: Moss, "John Singer Sargent, 'Madame X,' and 'Baby Milbank,'" p. 270.

162 *"struggling with the unpaintable beauty"*: JSS to VL, undated, quoted in Charteris, *John Sargent*, p. 59.

162–63 *"One day I was dissatisfied"; "Vous pouvez l'envoyer"; "encouraging, but false"; "I have made up my mind"*: JSS to Ben del Castillo, undated, quoted in Charteris, *John Sargent*, pp. 59–60.

162 *Montesquiou would actually be one of the first observers*: Jullian, *Prince of Aesthetes*, p. 70.

162 *"sort of masterpiece"*: Robert de Montesquiou, "Le Pavé rouge: Quelques reflections sur 'l'Oeuvre' de M. Sargent," *Les Arts de la Vie* (1905); translated by and quoted in Edgar Munhall, *Whistler and Montesquiou: The Butterfly and the Bat* (New York: Frick Collection, 1995), p. 138.

162 *"love for the bizarre"; "'strange, weird, fantastic'"*: Lee, "J.S.S.," pp. 252, 250.

162 *"the opportunity of depicting a personality"*: Moss, "John Singer Sargent, 'Madame X,' and 'Baby Milbank,'" p. 270.

163 *"growing fame"; "some anxiety"; "Sargent was aware of this"*: Belleroche, "Lithographs of Sargent," p. 35.

163 *"very nervous"; "the birthday or funeral"; "gesticulating and laughing"; "Ark of Art"*: Ralph Curtis to his parents, [May 2,] 1884, quoted in Charteris, *John Sargent*, p. 61.

164 *Galerie d'Étrangers;* "semi-Français" ; "né à Philadelphia"; "né à Florence": Lois Marie Fink, *American Art at Nineteenth-Century Paris Salons* (Washington, DC: National Museum of American Art/Smithsonian Institution, 1990), pp. 117–19, 388.

164 *"H.C."*: F. G. Dumas, *1884: Catalogue Illustré du Salon* (Paris: Librairie d'Art L. Baschet, 1884), p. xlvi.

165 *In 1884, nearly three hundred thousand people*: Milner, *Studios of Paris*, p. 51.

165 *"skyed"*: Milner, *Studios of Paris*, p. 51.

165 *the French cartoonist Pif joked*: Pif (Henri Maigrot), *Croquis* in *Le Charivari*, May 23, 1880. Reprinted in Patricia Mainardi, *The End of the Salon: Art and State in the Early Third Republic* (Cambridge: Cambridge University Press, 1993), p. 76.

166 *"Ah voilà 'la belle!' "; "Oh quel horreur!"; "dodging behind doors to avoid friends who looked grave"; "by the corridors"*: Ralph Curtis to his parents, May 2, 1884, quoted in Charteris, *John Sargent*, p. 61.

167 *"shoals of astonished & jibing women"*: VL to her mother, London, June 8, 1884, Lee, *Letters*, p. 143.

167 "blaguer *club man"; "*la peinture d'après un autre morceau*"; "*grand tapage*"; "*one series of bon mots"; "disappointed in the color"*: Ralph Curtis to his parents, May 2, 1884, quoted in Charteris, *John Sargent*, p. 61.

167 "Détestable! Ennuyeux! Curieux!": Overheard by the otherwise sympathetic Louis de Fourcauld and recorded in the *Gazette des beaux arts* (May 1, 1884); quoted in Charteris, *John Sargent*, p. 63.

167 "l'image très exacte d'une femme": Judith Gautier, *Le Rappel* (May 1, 1884).

167 "Le profil est pointu": Henry Houssaye, *Revue des deux mondes* (May 1, 1884).

167 "amère disillusion"; "Jamais nous n'avions vue pareille déchéance": Jules Compte, *L'Illustration* (May 1, 1884).

168 "navré"; *"dozen painters and ladies"; "turning of the tide"*: Ralph Curtis to his parents, May 2, 1884, quoted in Charteris, *John Sargent*, pp. 61.

168 *Ledoyens*: For an image of the festive crowd at this restaurant in 1885, see James Tissot, *The Painters and Their Wives*, c. 1885, oil on canvas, Chrysler Museum, Norfolk, VA.

169 *"bathed in tears"*; "Ma fille est perdue"; *"exactly as she was dressed"; "I fear he has never had such a blow"*: Ralph Curtis to his parents, May 2, 1884, quoted in Charteris, *John Sargent*, pp. 61–62.

13. Baby Milbank

170 "étrangement épatant": Ralph Curtis to his parents, May 2, 1884, quoted in Charteris, *John Sargent*, pp. 61.

170 *much taken; encountered Sargent . . . at a . . . café-restaurant*: Belleroche, "Lithographs of Sargent," p. 32.

170 *a Left-Bank café-restaurant called l'Avenue*: This restaurant, which would have been near Sargent's rue Notre-Dame-des-Champs, may well have been the "Lavenue" listed at 1 rue du Départ, near the Gare Montparnasse, in Karl Baedeker, ed., *Paris and Environs, with Routes from London to Paris: Handbook for Travellers* (Leipzig: Karl Baedeker, 1900), p. 19.

171 *"Mademoiselle Fannie"; "lucky possessor"; "*l'album Sargent*"; "I found myself in the midst"; "this little café"*: Belleroche, "Lithographs of Sargent," pp. 32–33.

171 *"some difficulty in overriding"*: Campbell Dodgson, editor's preface, in Belleroche, "Lithographs of Sargent," p. 31.

172 *"Sketch of Sargent Asleep in a Train"*: 1883?, pencil on paper, private collection, published in Belleroche, "Lithographs of Sargent," p. 30 (see illustration credits).

172 *"an intensely personal vision"*: Davis, *Strapless*, p. 134.

172 *1882 or 1883; "unconfirmed"*: Ormond and Kilmurray, *Early Portraits*, p. xiv.

172 *"two very nice friends"*: ES to VL, August 25, [1880,] Colby College, Waterville, ME.

173 *"Amongst the other pictures"*: Belleroche, "Lithographs of Sargent," p. 34.

173 *Alice Meynell's 1903 collection*: Alice Meynell, *The Work of John S. Sargent, R.A., with an Introduction by Mrs. Meynell* (London: Heinemann, 1903). It seems significant that Sargent ultimately did not include in this first major published overview of his work a freighted intimate portrayal of Albert de Belleroche.

173 *some eighty sittings*: Charles Merrill Mount, *John Singer Sargent* (London: Cresset

Press, 1957), p. 78. For the particular portrait of Belleroche in "Florentine" dress, the catalogue raisonné suggests twenty sittings (Ormond and Kilmurray, *Early Portraits*, p. 100), but the many sittings Belleroche remembered and that Mount tallied no doubt encompassed other sketches and portraits.

173 *sixteenth century; Velázquez*: See Ormond and Kilmurray, *Early Portraits*, p. 100.

173 *a three-quarters-length figure in pencil*: *Albert de Belleroche*, pencil on paper, c. 1882, Yale University Art Gallery, New Haven (see illustration credits).

174 *"intense focus on Belleroche's face"; "That Sargent cut"*: Moss, "John Singer Sargent, 'Madame X,' and 'Baby Milbank,'" p. 275.

174 *Another dramatic oil study of Belleroche*: *Albert de Belleroche*, oil on canvas, c. 1882, Colorado Springs Fine Arts Center.

174 *"I must paint you like that"*: Information apparently from Belleroche's son, F. S. Bartlett to David McKibbin, October 6, 1967, quoted in Ormond and Kilmurray, *Early Portraits*, p. 99.

175 *Two other surviving oil sketches*: Both entitled *Albert de Belleroche*, oil on canvas, in private collections. See Ormond and Kilmurray, *Early Portraits*, pp. 98–99.

175 *Sargent tore one piece in half*: *Albert de Belleroche*, sepia ink and wash on paper, c. 1883, private collection; see Ormond and Kilmurray, *Early Portraits*, p. 99.

175 *"As a group"*: Moss, "John Singer Sargent, 'Madame X,' and 'Baby Milbank,'" p. 273.

175 *"Dear Baby"*: JSS to Albert de Belleroche, September 7, 1883, private collection.

175 *occurred in English as far back as 1694*: See *OED*; see also Alice Robb, "Why Do Adult Romantic Partners Call Each Other Baby?" *New Republic* (May 25, 2014).

14. The Pact

176 *cycling excursions; a hunting cap worn by Belleroche*: according to sketches held in private collections but published in Moss, "John Singer Sargent, 'Madame X,' and 'Baby Milbank,'" p. 273.

176 *"love of Sargent's life"*: Davis, *Strapless*, p. 4.

176 *"powerful 'homosocial' bond"; "erotically charged"; "Sargent's portraits of Belleroche"*: Moss, "John Singer Sargent, 'Madame X,' and 'Baby Milbank,'" p. 274.

176 *"Anyone looking for evidence"*: Ormond and Kilmurray, *Early Portraits*, p. 88.

176 *Yet simply to imagine*: Ormond and Kilmurray, for example, note the "powerful enigmatic quality" of these sketches and remark that it is "easy to read into them evidence of sexual attraction, but the story of Sargent's life resists such simple explanations": *Early Portraits*, p. 98. I would disagree, for there is definitely evidence for sexual attraction. At the same time, the complexities of Sargent's life are worth considering, especially in order to establish the connection of such sexual impulses to his art.

177 *The male romantic friendships that historians have documented*: The historian Axel Nissen has defined romantic friendship as "noninstitutionalized, socially sanctioned, (often) temporarily limited and premarital, (ostensibly) platonic, nonexclusive yet primary emotional relationships, (usually) between young, coeval, coequal white men of the middle and upper classes," in Axel Nissen, *The Romantic Friendship Reader: Love Stories Between Men in Victorian America* (Boston: Northeastern University Press, 2003), p. 4. Nissen draws his definition from an extensive scholarly literature on this subject by such historians as John W. Crowley, John D'Emilo

and Estelle B. Freedman, Karen V. Hansen, Jonathan Ned Katz, Robert K. Martin, Jeffrey Richards, J. A. Mangan and James Walvin, and E. Anthony Rotundo.

178 *"truth and tenderness"*: Bayard Taylor, *Joseph and His Friend: A Story of Pennsylvania* (New York: Putnam and Sons, 1870), Foreword, n.p. Some critics see this as the first gay novel in the United States; others find it an essay in male platonic idealism.

178 *"the closest thing to courtship"*: Olson, *John Singer Sargent*, p. 107.

178 *Hirsch came into possession*: "How he came to acquire [these works] is not clear," Ormond and Kilmurray comment, "it has been suggested that they were works left behind by Sargent in the studio." See *Early Portraits*, p. 33. Although Sargent could be careless about his work, especially unfinished sketches, it is hard to believe that he would simply leave behind this number of quality works. It was also common practice for artists to present works to each other, with or without emotional tribute, as part of studio camaraderie.

179 *"double nature"*: Lee, "J.S.S.," p. 246.

179–80 *"cross-sex friendships"*; *"homosexuality"*; *"suspicion on the chastity"*: Nissen, *Romantic Friendship Reader*, p.10.

180 Head in Profile: Also known as *Head in Profile of a Young Man (Albert de Belleroche)*, pen and ink, c. 1883, Yale University Art Gallery, New Haven (see illustration credits).

180 Mme Gautreau Drinking a Toast: c. 1883, oil on canvas, ISGMA (see illustration credits).

180 *"the hairline, the more masculine ear"*: Ormond and Kilmurray, *Early Portraits*, p. 98.

180 *"the limpness of the head"*; *"society that placed"*; *"experience of seeing"*: Moss, "John Singer Sargent, 'Madame X,' and 'Baby Millbank,'" p. 269.

182 *"Sargent was in fact thinking"*; *"torn between desires"*: Davis, *Strapless*, p. 136.

182–83 *"assez abominable"*; *"jeune fille très singulière"*; *"un des cas"*; *"maladie du siècle"*; *"charme extreme pour les véritables dandys"*: Maurice Barrès, "Complications d'Amour" (Préface) in Rachilde, *Monsieur Venus* (Paris: Félix Brossier, 1889), n.p.

183 *"cette femme . . . annulée et tendre"*: VL to her mother, June 8, 1884 in *Vernon Lee Letters*, p. 143.

15. Nadir

185 *"a sort of glue-pot"*: Charteris, *John Sargent*, p. 73.

185–86 *"always adorable"*; *"the poor dear, lovely"*; *"patriotism"*: Henry James to Elizabeth Boott, June 2, 1884, Edel, *Henry James Letters*, p. 43.

186 *portrait of the American socialite Margaret White*: *Mrs. Henry White*, 1883, oil on canvas, Corcoran Gallery of Art, Washington, DC.

186 The Breakfast Table: 1883, oil on canvas, FM (see illustration credits).

186 Fête Familiale: also known as *The Birthday Party*, 1885?, oil on canvas, Minneapolis Institute of Arts.

186 *"trying to tell her fortune"*; *"bonne diablesse"*: VL to Eugene Paget, June 26, [1884,] Lee, *Letters*, p. 150.

186 *"no married couples"*: VL to Eugene Paget, July 4, [1884], Lee, *Letters*, p. 150.

187 *Sargent's unfinished portrait of the American-born Edith, Lady Playfair*: *Lady Playfair*, 1884, oil on canvas, MFA.

187 *"wrinkl[ed] his forehead"*; *"artists buzzing about"*: VL to Eugene Paget, July 4, [1884] Lee, *Letters*, p. 150.

187 The Misses Vickers: 1884, oil on canvas, Sheffield City Art Galleries.

187 *"three ugly young women"; "dingy hole"*: JSS to VL, [early 1884,] Colby College, Waterville, ME.

187 *"un peu bizarre"; "creatures exquises"*: *Gil Blas*, May 1, 1885, n.p.

188 *"it seems a shame"*: *Pall Mall Gazette* (August 4, 1886), p. 4.

188 *"only Franco-American product"*: Henry James to Grace Norton, February 23, 1884, Edel, *Henry James Letters*, vol. 3, p. 32.

188 *"pleasant life"; "he seems to be respected"; "good and agreeable"; "he is good-looking"*: FWS to Thomas Parsons Sargent, November 16, 1883, AAA.

189 Garden Study of the Vickers Children: c. 1884, oil on canvas, Flint Institute of Arts, Michigan.

189 *"to Mr. Vickers"*: *Edward Vickers*, c. 1884, oil on canvas, private collection.

189 *"going to Spain later in the season"; "Spain affords more such suggestions"*: FWS to Thomas Parsons, June 17, 1884, AAA.

190 *"good clientèle"*: VL to her mother, June 24, 1884, in *Vernon Lee Letters*, p. 149.

190 *"much aged"*: VL to her mother, June 25, 1885, in *Vernon Lee Letters*, p. 171.

190 *"improved"; "his picture of Mme Gautherau"*: VL to her mother, September 5, 1885, in *Vernon Lee Letters*, p. 199.

190 *"ruthless critique"*: Angela Dunstan, "'An Interesting Failure': Pre-Raphaelite Celebrity and the Sexual Politics of Aestheticism in Vernon Lee's *Miss Brown*," in Peter Marks, ed., *Literature and Politics: Pushing the World in Certain Directions* (Newcastle-on-Tyne: Cambridge Scholars Publishing, 2012), p. 23.

191 *masterful portrait of Vernon Lee*: *Vernon Lee*, oil on canvas, 1881, Tate (see illustration credits).

191 *Clementina ("Kit") Anstruther-Thomson*: *Clementina Anstruther Thomson*, 1889, oil on canvas, private collection.

191 *"in a bad way"; "afraid of him"*: VL to her mother, July 27, 1885, in *Vernon Lee Letters*, p. 177.

191 *"I fear John"*: VL to her mother, June 25, 1885, in *Vernon Lee Letters*, p. 171.

191 *medical treatises of the eighteenth century*: See for example Jean-Baptiste Pressavin, *Nouveau traité des vapeurs, ou Traité des maladies des nerfs* (Paris: Chez V. Reguilliat, 1771), p. 189.

192 *"extreme independence"; "sugar and varnish"; "'But then'"; "'I shall go'"*: Edmund Gosse quoted in Charteris, *John Sargent*, p. 76.

193 *"Sargent nearly killed himself"; "a spike with his head"; "nasty rap"; "knocked it a second time"*: Edwin Austin Abbey to Charles Parsons, September 28, 1885, quoted in Lucas, *Edwin Austin Abbey*, p. 151.

193 *"so human"*: Quoted in Lucas, *Edwin Austin Abbey*, vol. 1, p. 150.

193 *"We differ enough"*: Quoted in Lucas, *Edwin Austin Abbey*, vol. 1, p. 210.

193 *"quiet, dry humour"*: Anstey Guthrie, quoted in Lucas, *Edwin Austin Abbey*, vol. 1, p. 151.

194 *"DARLING"*: Letter quoted in Lucas, *Edwin Austin Abbey*, vol. 1, p. 228.

194 *"I am beginning"*: Quoted in Lucas, *Edwin Austin Abbey*, vol. 1, p. 210.

16. Broadway Bohemians

196 A Cosey Corner: Francis David Millet, *A Cosey Corner*, 1884, oil on canvas, MMA.

196 *His later portrait of her*: Mrs. Frank Millet, 1885–86, oil on canvas, private collection.

196 *"painting in our garden"; "a very charming picture"*: Lucia Millet to her parents, August 24, 1885, Francis Davis Millet and Millet family papers, AAA.

196 Carnation, Lily, Lily, Rose: 1885–86, oil on canvas, Tate.

197 *his new portrait of Alice Barnard*: Mrs. Frederick Barnard, 1885, oil on canvas, Tate.

197 *mentioned in a letter by Frank's sister Lucia*: Lucia Millet to her family, July 19, 1886, AAA.

198–99 *"looked at each other"; "Where are you"*: Charles Warren Stoddard, "A Modern Monte Cristo," *National Magazine* 24 (August 1906): pp. 463–64.

199 *"gondolier, cook, chambermaid"*: Stoddard, "A Modern Monte Cristo," p. 464. For documentation of the Millet-Stoddard affair, see Katz, *Love Stories*, pp. 203–219.

199 *"fluid"*: Katz, *Love Stories*, p. 205.

199 *Millet's romantic and erotic relationship*: The historian Jonathan Ned Katz, who has made a study of this relationship, concludes that "Stoddard's earlier and later sexual liaisons with men, his written essays and memoirs, and Millet's letters to Stoddard, all strongly suggest that their intimacy found active affectionate and erotic expression." See Katz, *Love Stories*, p. 203.

199 *"Chummeke"*: Katz, *Love Stories*, p. 207.

200 *two portraits that Sargent painted of him during 1886*: Edmund Gosse, 1886, oil on canvas, Brotherton Library, University of Leeds; *Edmund Gosse*, c. 1886, oil on canvas, National Portrait Gallery, London.

200 *"curious"; "As I approached him"*: Quoted in Charteris, *John Sargent*, p. 78.

201 *whom Sargent had known in Paris*: See Catherine Wallace, *Catching the Light: The Art and Life of Henry Scott Tuke*, 1858–1929 (London: Atelier Books, 2008), pp. 26–29.

201 *"I think I shall like him"*: Quoted in Maria Tuke Sainsbury, *H.S. Tuke, A Memoir* (London: Secker, 1933), p. 59.

201 *Thomas Eakins's Art Students League of Philadelphia*: See Esten, *Thomas Eakins*, pp. 16, 18, 75.

201 The Swimming Hole: Thomas Eakins, *The Swimming Hole*, 1885, oil on canvas, Amon Carter Museum, Fort Worth, TX.

201 *odd conversation about nudes*: Lucas, *Edwin Austin Abbey*, p. 210.

202 *"I know of all you speak of"*: Edmund Gosse to John Addington Symonds, quoted in Grosskurth, *John Addington Symonds: A Biography* (London: Longmans, 1964), pp. 280–81.

202 *"a human being's privilege"*: Edmund Gosse, *Father and Son: A Study in Two Temperaments* (New York: Scribner, 1907), p. 374.

203 *"virtually all male homosexual activity"*: Richard Dellamora, *Masculine Desire: The Sexual Politics of Victorian Aestheticism* (Chapel Hill: University of North Carolina Press, 1990), p. 200.

204 *"the* bizarre *and outlandish"*: Vernon Lee, "J.S.S." p. 252.

204 *"moving his traps"; "He seems to have"; "London is a world"*: FWS to Thomas Parsons Sargent, May 13, 1886, AAA.

204 *"more or less united in their art sympathies"*: From the first New English Art Club exhibition pamphlet, quoted in Charteris, *John Sargent*, p. 90.

204 *his portrait of Alice Barnard*: Mrs. Frederick Barnard: 1885, oil on canvas, Tate.

204 *Sargent also painted a self-portrait*: Self-Portrait, 1886, oil on canvas, Aberdeen Art Gallery.

205 *In his 1892 and especially his 1906 self-portraits*: Self-Portrait, 1892, oil on canvas,

National Academy, New York; *Self-Portrait*, 1906, oil on canvas, Galleria degli Uffizi, Collezione degli Autoritratti, Florence.

206 *"prepare Sargent's mind"*: Henry James to ISG, October 26, [1886,] ISGMA.

207 *"in the smallest degree"; "got from Paris"; "his technical means"; "fine models and subjects"; "a larger and more various life"; "social opportunities"; "good for him"*: Henry James to Henrietta Reubell, March 11, 1886, Edel, *Henry James Letters*, vol. 3, pp. 117–19.

207 *"fairly lodged"; "in a yellow studio"; "overwhelmed by work"*: Henry James to Henrietta Reubell, November 12, [1886,] Houghton Library, Harvard University, b Ms AM 1094 [1068].

207 *an elegant, breezy portrait of Harrison's lively wife*: Mrs. Robert Harrison, 1886, oil on canvas, Tate.

208 *"exceedingly modest"; "inclined . . . to hide"; "built himself a little floating studio"; "a splendid specimen"*: George Henschel, *Musings and Memories of a Musician* (London: Macmillan, 1918), pp. 331–32.

208 *"the bizarre and outlandish"*: Vernon Lee, "J.S.S.," p. 252.

208 *"knowledge and understanding"; "serious study rather than a pastime"; "stand on a platform and sing"; "It was a great delight"*: Henschel, *Musings and Memories*, pp. 332–33.

209 *a sensitive if not groundbreaking painting*: Sir George Henschel, 1889, oil on canvas, private collection.

209 *portraits of Scots novelist Robert Louis Stevenson*: Robert Louis Stevenson and His Wife, 1885, oil on canvas, Mrs. John Hay Whitney; Robert Louis Stevenson, 1887, oil on canvas, Taft Museum, Cincinnati.

209 *Isa Boit*: Mrs. Edward Darley Boit, 1888, oil on canvas, MFA.

209 *"sitters & triumphs"*: Henry James to Henrietta Reubell, December 19, [1886,] Houghton Library, Harvard University, b MS AM 1094 [1072].

17. The Cavalier

210 *"her modish muslin skirt"; "white-flanneled, black-bearded"; "figure of a girl"; "the same year he painted"*: Ellery Sedgwick, *The Happy Profession* (Boston: Atlantic Monthly Press, 1946), pp. 60–61.

210 *"twitted Sargent because he was gaining weight"; "could not stand the sight of a fat man"*: Louise Hall Tharp, *Mrs. Jack* (Boston: Little, Brown, 1965), pp. 132, 81.

211 *"infinite research from a great variety of books"*: Eleanor Palffy, *The Lady and the Painter: An Extravaganza* (New York: Coward-McCann, 1951), p. vii.

212 *"rival the one of Madame Gautreau"; "her figure, her neck, and her arms"; "look the world straight in the eye"; "done over eight times"; "ordeal"; "Mrs. Gardner would look out the window"; "nine was Dante's mystic number"*: Morris Carter, *Isabella Stewart Gardner and Fenway Court* (Boston: Gardner Museum, 1925), p. 104.

212 *"Only Rubens could paint"*: Palffy, *The Lady and the Painter*, p. 23.

212 *"a lemon with a slit for a mouth"*: Lucia Fairchild, diary, October 2, 1890, in "Diaries of Lucia Fairchild," p. 6.

213 *"Mrs. Jack a Byzantine Madonna"*: Henry James to Henrietta Reubell, February 22, [1888,] Houghton Library, Harvard, b MS Am 1094 [1074].

213 *"Madone Byzantine"; "Cette femme peut"*: Paul Bourget, *Outre-Mer (Notes sur l'Amerique)*, vol. 1 (Paris: Alphonse Lemerre, 1895), vol. 1, p. 149.

213 *Boston hostess Annie Fields*: See Tharp, *Mrs. Jack*, pp. 133–34.

214 *"Boston's pre-cinema star"*: Bernard Berenson, *Rumor and Reflection* (New York: Simon & Shuster, 1952), p. 14.

214 *"Sargent had painted"; "horsewhip"*: Louise Hall Tharp claims that "*Town Topics* printed [this remark] but in terms too vulgar even for a scandal sheet, but the reference has not been verified." See Tharp, *Mrs. Jack*, pp. 134–35.

214 *"it was the finest"*: Carter, *Isabella Stewart Gardner*, p. 105.

18. A King's Existence

215 *Sargent's 1887 head-and-shoulder portrait*: Mrs. Charles Fairchild, 1887, oil on canvas, Bowdoin College Museum of Art, Brunswick, ME.

216 *only his later 1890 portrait of the child*: Gordon Fairchild, 1890, oil on canvas, private collection.

216 *Sargent painted Sally Fairchild three times*: Sally Fairchild, c. 1885–87, oil on canvas, private collection; *Sally Fairchild*, 1887, oil on canvas, private collection; *Lady with the Blue Veil (Sally Fairchild)*, 1890, oil on canvas, private collection.

216 *a diary she kept beginning a few years later; "When you come & stay"; "Well"; "Vi [Sargent's sister Violet] said"; "I?"; "Vi said I talked"; "Did you all think"; "But how should Vi"; "he muttered & talked"; "But I am sure"; "I suppose I may have talked"*: Miller, diary, 1891, in "Diaries of Lucia Fairchild," : p. 15.

218 *"in an ambulance"*: Carter, *Isabella Stewart Gardner*, p. 28. The following account of Isabella Stewart Gardner as a traveler owes to ideas first worked out in Paul Fisher, "Isabella Stewart Gardner's 'Barbarous Barbaro': Fenway Court as Exilic Map ad Liberation," in Karen Bishop, ed., *Cartographies of Exile: A New Spatial Literacy* (New York: Routledge, 2016), pp. 133–52.

218 *"Pray, who undressed you!"; "Worth"; "Didn't he do it well?"*: Tharp, *Mrs. Jack*, p. 43.

218 *"groping after some activity"*: Carter, *Isabella Stewart Gardner*, p. 43.

218 *"The liberalizing, tranquillizing effect"*: Carter, *Isabella Stewart Gardner*, p. 89.

219 *"Your journey to Japan"; "I mean your special-companion"*: Henry James to ISG, September 3, [1882,] ISGMA.

219 *"overwhelming, self-defeating chaos"*: Henry James, *The Complete Notebooks of Henry James*, ed. Leon Edel and Lyall H. Powers (New York: Oxford University Press, 1987), p. 126.

220 *"What a wonderful"; "I envy you Spain"; "romantic avenue"*: Henry James to Isabella Stewart Gardner, March 18, 1888, ISGMA.

220 *an oil sketch he bestowed on Bunker*: Dennis Miller Bunker, c. 1887, oil on canvas, private collection. See Ormond and Kilmurray, *Early Portraits*, pp. 206–207.

221 *"rather wild night"*: Shand-Tucci, *The Art of Scandal*, p. 89.

221 *In a farewell dinner in New York*: See Trevor J. Fairbrother, "John Singer Sargent in New York, 1888–1890," *Archives of American Art Journal* 22, no. 4: pp. 27–32.

221 *"tried to escape at midnight"*: Gorham Bacon, *Recollections: Gorham Bacon*, ed. Ruth Bacon Cheney (Boston: privately printed, 1971), p. 54.

222 *"Il mène un existence"*: Dennis Bunker to ISG, April 9, 1888, ISGMA.

222 *"remained tolerant"*: Carter, *Isabella Stewart Gardner*, p. 89.

222 Dennis Miller Bunker Painting at Calcot: 1888, oil on canvas, Terra Foundation for American Art, Chicago (see illustration credits).

222–23 *"awfully pretty"; "What if I"*: Dennis Bunker to ISG, June 25, 1888, ISGMA.

223 *"pale"; "root-colored, '"; "the moment"; "it must be"*: Miller, "John Singer Sargent in the Diaries of Lucia Fairchild," pp. 4–5.

223 *"moody"; "violent headaches"*: Carter, *Isabella Stewart Gardner*, p. 103.

223 *"marrying a man"*: Quoted in Erica Hirshler, *Dennis Miller Bunker: An American Impressionist* (Boston: Museum of Fine Arts, 1994), p. 26.

223 *"he could remember"*: R. H. Ives Gammell, *Dennis Miller Bunker* (New York: Coward-McCann, 1953), p. 26.

224 *oysters, green turtle soup*: According to a menu preserved by James Carroll Beckwith and now in his papers. See Fairbrother, "Sargent in New York," p. 27.

225 *"the circle of gay life"*: Mosette Broderick, *Triumvirate: McKim, Mead & White: Art, Architecture, Scandal, and Class in America's Gilded Age* (New York: Knopf, 2010), p. xvii. Broderick admits to a "current running through the office [of McKim, Mead, and White] in the 1880s and 1890s" and that one earlier researcher "came to the conclusion that White was homosexual." "It seems clear that White was bisexual," Broderick concludes, but she also asserts, more problematically, that "the sexual orientation of White and the circle he favored is of no importance to the work he did."

225 *"no American painter"; "attention of the public"*: James, "John S. Sargent," p. 216.

225–26 *"brilliant young painter"; "well-known men"; "eminently gifted with that wit"*: *Art Amateur* 19, no. 1 (June 1888), p. 5.

226 *"the gift of imparting"*: *Art Amateur* 19, no. 1 (June 1888), p. 4.

227 *"in favor of brilliant variations and facile effects"; "allure of revolt and of defiance"*: Montesquiou, "Le Pavé rouge," p. 138.

227 *theatrical, richly colored portrait*: *Ellen Terry as Lady Macbeth*, 1889, oil on canvas, Tate.

227 *"magenta hair!"*: John Singer Sargent to ISG, January 1, 1889, ISGMA.

19. The Stage Door

228–29 *"saintly"; "necessary to getting married"; "The chances seem to me"*: Miller, "Diaries of Lucia Fairchild," pp. 15, 12–13.

229 *"Very few writers"*: JSS to Mariana Griswold Van Rensselaer, December 15, [no year,] quoted in Charteris, *John Sargent*, p. 110.

229 *a portrait like that of five-year-old Beatrice Goelet*: *Beatrice Goelet*, 1890, oil on canvas, private collection.

230 *"torsal shivers and upheavals"*: *Town Topics*, April 3, 1890, p. 2.

230 *"the craze of the Boulevards"*: James Ramirez, *Carmencita, The Pearl of Seville* (New York: Law and Trade, 1890), p. 42.

230 *"human zoos"*: Ethnological expositions, often a part of World's Fairs and *Expositions Universelles*, have long been considered problematic by historians, though the term "human zoos" has only recently come into popular currency, largely thanks to the French historian Pascal Blanchard. See Pascal Blanchard et al., *Human Zoos: Science and Spectacle in the Age of Colonial Empires*, trans. Teresa Bridgeman (Liverpool: Liverpool University Press, 2008); and Pascal Blanchard, Gilles Boëtsch, and Nanette Jacomijn Snoep, *Human Zoos: The Invention of the Savage*, trans. Deke Dusinberre et al. (Paris: Musée du Quai Branly, 2011).

230 *a half length of a slender performer*: *A Javanese Girl at Her Toilet*, 1889, oil on canvas, private collection.

231 *"bewilderingly superb creature"*: JSS to ISG, [undated,] ISGMA; see also Richard Ormond and Elaine Kilmurray, *John Singer Sargent: Portraits of the 1890s* (New Haven, CT: Yale University Press, 2002), p. 21.

232 *"one dainty foot"; "crouching and springs"; "dazzling but enigmatic smile"*: Ramirez, *Carmencita*, p. 18.

232 *Did he merely ask her to pose for him*: This is the art historian Elizabeth Boone's theory. See M. Elizabeth Boone, *Vistas de España: American View of Art and Life in Spain, 1860–1914* (New Haven, CT: Yale University Press, 2007), p. 140.

232 *"daughter of Herodias"; "young panther"*: John Jay Chapman to Helen Dunham, February 28, 1890, in M. A. De Wolfe Howe, *John Jay Chapman and His Letters* (Boston: Houghton Mifflin, 1937), p. 83.

232 *bore all the earmarks of a stage-door passion*: Also, the public understood relations between painters and their models to be fraught with sexual meaning: See Phillips, *Modeling Life*, pp. 3, 7; Waller, *The Invention of the Model*, pp. 49–56.

232 *By one account*: When Wilfrid de Glehn offered Sargent £600 for his portrait of Carmencita, Sargent remarked that the painting had cost him more than that "in bracelets and things": Evan Charteris, *John Sargent* (New York: Scribners, 1927), p. 113. Yet Sargent's friend Sally Fairchild remembered that, at one of the parties, ladies threw bracelets and other jewelry at Carmencita's feet, which later the artist had to buy back for them: See Ormond and Kilmurray, *Portraits of the 1890s*, p. 21.

232 *"beyond anything"; "brought down his photographs"*: Lucia Fairchild, diary, October 2, 1890, in Miller, "Diaries of Lucia Fairchild," p. 8.

232 *"primitive and untutored creature"; "wayward, now sullen and subdued"*: Charteris, *John Sargent*, p. 111.

232 *"paint[ing] his nose red"; "arrived at the studio"*: Henry Brock quoted in Charteris, *John Sargent*, pp. 111–12.

233 La Carmencita: 1890, oil on canvas, Musée d'Orsay, Paris (see illustration credits).

233 *"hero of this exhibition"*; "trop d'espirit": *Art Amateur* 23, no. 1 (June 1890): p. 3

233 *"the picture of the year"*: Claude Phillips, "The Summer Exhibitions at Home and Abroad," *Art Journal* (July 1891): p. 198.

233 *"interest in painting actresses"; "particularly powerful at this time"; "favorite pictorial types"*: Ormond and Kilmurray, *Portraits of the 1890s*, p. 21.

233 *"so stunning"*: Beckwith, diary, March 16, 1890, AAA.

233 *"large old-fashioned house"*: Candace Wheeler, *Yesterdays of a Busy Life* (New York: Harper Brothers, 1918), p. 237.

233 *The elder Wheeler*: As one art historian has asserted, Wheeler "ambitiously promoted art and design as paying careers for women rather than hobbies" and was "one of the first American women to produce designs for American manufacturers and paved the way for thousands of female designers who followed." Amelia Peck, "Candace Wheeler: A Life in Art and Business," in Amelia Peck and Carol Irish, *Candace Wheeler: The Art and Enterprise of American Design, 1875–1900* (New Haven, CT: Yale University Press, 2001), p. 3.

Wheeler was ambitious enough that, in the art studios at the top floor of her house, she entertained other high-profile women of the 1880s and 1890s, including the globe-trotting Queen Kapiolani of Hawaii and the sexually daring actresses Lillie

Langtry and Ellen Terry—the latter being of course the actress Sargent had captured in a lush, theatrical portrait of her as Lady Macbeth just before he'd voyaged to New York. Wheeler had also hosted Oscar Wilde, who'd also rather disconcertingly dropped in during the 1880s, and who, fascinated by Candace's sumptuous textile designs, had "bestow[ed] an hour of twilight loiter upon [them], filled with speculative conversation." Wheeler, *Yesterdays*, pp. 255, 253; Liliuokalani, *Hawaii's Story by Hawaii's Queen* (Boston: Lee and Shepard, 1898), pp. 128–35. Deeply connected to an artists' community that included both bold women and sexually unconventional men like Wilde, Wheeler also generously loaned a studio to several "distinguished painters from abroad." She now repeated the favor for Sargent.

234 *"triumphal"; "I did not care for the portrait"*: Wheeler, *Yesterdays*, p. 261.

234 *"the most wild and primitive thing"*: Interview with Dora Wheeler Keith, January 24, 1927. Lockman Papers, AAA, quoted in Boone, *Vistas de España*, p. 140.

234 *"stiffish company"; "did not go well"*: James Carroll Beckwith, diary, April 1, 1890, AAA.

234 *the first woman to appear in a moving picture in the United States*: Charles Musser, *Edison Motion Pictures, 1890–1900: An Annotated Filmography* (Washington, DC: Smithsonian Institution Press, 1997), pp. 34–35.

234 *In this rare twenty-second window*: William K. L. Dickson, *Carmencita*, Edison's Black Maria Studio, March 10–16, 1894, Smithsonian Institution, Washington, DC.

235 *"radiant vitality"; "essentially the spontaneous interpretation"*: "Carmencita," *Saturday Review* 79 (April 6, 1895): p. 441.

235 *Of Sargent's surviving sketches of Carmencita*: See Ormond and Kilmurray, *Portraits of the 1890s*, pp. 20–24.

235 *loaned it to his friend Sibyl Sassoon*: See Ormond and Kilmurray, *Portraits of the 1890s*, p. 23.

235 *"in this white-faced, painted, mysterious, evil-looking beauty"; "amazingly clever"*: *Art Amateur* 23, no. 1 (June 1890): p. 3.

235 *"fièrement campée"*: Henry James to Ariana Curtis, December 18, 1890, quoted in Philip Horne, ed., *Henry James: A Life in Letters* (London: Penguin, 1999), p. 234.

236 *"camp"; "actions and gestures of exaggerated emphasis"*: J. Redding Ware, *Passing English* (London: 1909), p. 61. The term "camp" would eventually come to mean "ostentatious, exaggerated, affected, theatrical; effeminate or homosexual; pertaining to or characteristic of homosexuals" (*OED*). But already in the early twentieth century camp was associated with homosexuality (Ware's "persons of exceptional want of character"). "Homosexuality" itself was a pseudoscientific category fabricated in the late nineteenth century. In any case, camp's essential connection to posing—both in the sense of bodily expression and social masquerade—was firmly rooted in Sargent's Belle Époque. The historian Moe Meyer has argued in his "archaeology of posing" that exaggerated and theatrical codes, gestures, and postures played a central role in the emerging homosexual subcultures of the 1880s and 1890s, most obviously in the figure of Sargent's contemporary and Chelsea neighbor Oscar Wilde—whose trial in 1895 would cement public perceptions of homosexuality. See Moe Meyer, "Under the Sign of Wilde: An Archaeology of Posing," in Moe Meyer, ed., *The Politics and Poetics of Camp* (London: Routledge, 1994), p. 77. Meyer uses the Foucauldian sense of "archaeology"—"not as a search for origins, but an investigation of ideas that can provide a descriptive foundation for establishing Camp as

a discourse." Michel Foucault, *The Archaeology of Knowledge and the Discourse on Language*, trans. A. M. Sheridan (New York: Pantheon, 1972), p. 140.

236 *Sargent's Carmencita wasn't "camp"*: Still, the signal attributes of camp, as identified by the film historian Jack Babuscio, include irony, aestheticism, and theatricality, and Sargent's *Carmencita* definitely incorporates two if not all three of these aspects. Even more importantly, the world of Belle Époque "posing"—the gestural language and codes of emerging homosexual subculture as well as the content of fin-de-siècle art movements that carried veiled homosexual content—helps us to understand this and other Sargent works in fresh and intriguing ways. See Jack Babuscio, "Camp and the Gay Sensibility," in David Bergman, ed., *Camp Grounds: Style and Homosexuality* (Amherst: University of Massachusetts Press), pp. 20–24.

236 *also executed a portrait of the dancer*: William Merritt Chase, *Carmencita*, 1890, oil on canvas, MMA.

236 *"a veritable* Fleur du Mal*"*: Claude Phillips, "The Summer Exhibitions," p. 198.

236 *so-called sexual deviancies including homosexuality*: By sometimes treating this complicated phenomenon as a single homosexual subculture, I follow the historian George Chauncey, who writes that this phenomenon/development "actually consisted of multiple social worlds, or social networks, many of them overlapping but some quite distinct and segregated form others along lines of race, ethnicity, class, gay culture style, and/or sexual practices. I have nonetheless referred to the making of 'a' gay world because almost all of the men in those networks conceived of themselves as linked to the others in their common 'queerness' and their membership in a single gay world, no matter how much they regretted it." George Chauncey, *Gay New York: Gender, Urban Culture, and the Making of the Gay Male World, 1890–1940* (New York: Basic Books, 1994), p. 3n.

236 *an arm akimbo*: See King, "Performing 'Akimbo,'" pp. 30–31.

237 *"at white heat"*: Dennis Bunker to Eleanor Hardy, n.d. [early 1880], quoted in Hirshler, *Dennis Miller Bunker*, p. 73.

237 *"unflattering resemblance"*: Lewis Auchincloss, *The Vanderbilt Era* (New York: Scribners, 1989), p. 38.

237 *"very fresh color"*: *Art Amateur* (May 1891), p. 142.

237 *"narrow sensitive face"; "artistic and literary tastes"; "dark hair and eyes"; "Spaniard"*: Consuelo Vanderbilt Balsan, *The Glitter and the Gold* (New York: Harper Brothers, 1952), p. 4.

237 *"an oriental-looking young gentleman"*: *Art Interchange* (May 24, 1890): p. 176.

238 *Sargent's portrait of George Vanderbilt*: *George W. Vanderbilt*: 1890, oil on canvas, Biltmore Estate.

238 *loaded with innuendo*: Both Sargent's portraits of Carmencita and George Vanderbilt were "queer" in the twenty-first century sense of channeling off-center and nonnormative (and nonbinary) versions of gender and sexuality. Both paintings, to say the least, tapped vividly into the "gender crisis" of the Belle Époque.

As Sargent's friend Vernon Lee understood him, Sargent had an "instinct for the esoteric" and a taste for anything with an "exotic, far-fetched quality" (Vernon Lee, *For Maurice*, pp. xxx–xxxi; Vernon Lee, "J.S.S.," p. 249). The art historian Trevor Fairbrother has noted that Sargent often sought "a release from the primness of his Anglo-Saxon Protestant cultural heritage through esoterically coded sensualism"

(Trevor Fairbrother, *John Singer Sargent* [New York: Abrams, 1994], p. 21.) Yet such sensualism was not merely "esoteric" in general but, in Sargent's historical context, specifically and transgressively gender-bending or homosexual.

238 *"stacks of sketches of nude people"; "cursory"; "earthy"*: Lucas, *Edward Austin Abbey*, vol. 1, p. 231.

238 *Thomas Eakins's life-drawing scandal*: Eakins's particular infraction was presenting a nude male model to *women* art students, though there was also a questionable instance where Eakins himself stripped for a female student. See William Innes Homer, *Thomas Eakins: His Life and Art* (New York: Abbeville Press, 1992), p. 166.

239 *"amusing fellow"; "picked up"; "fine colouring"*: James Carroll Beckwith, diary, June 5, 1895; October 2, 1895, New-York Historical Society, New York.

239 *"a class of people whose sole profession is to pose"*: Oscar Wilde, "London Models," p. 13.

239 *"nearly all Italians"; "good-looking men"*: Arthur Ransome, *Bohemia in London* (New York: Dodd, Mead & Company, 1907), p. 77.

239 *"an immense gay world"; "slumming"; "sexual fantasies"; "a subordinate social world"*: Chauncey, *Gay New York*, pp. 2, 36.

239 *"some of the artists were not seen for days"*: Gorham Bacon, *Recollections: Gorham Bacon*, ed. Ruth Bacon Cheney (Boston: privately printed, 1971), p. 54.

240 *"La Belle Otero"*: The *Chicago Tribune* (August 23, 1890, p. 16) described Carolina Otero, "Carmencita's rival" as "well educated, accomplished, and refined," "the daughter of the Spanish general Otero." But, born in poverty in Galicia as Augustina Iglesias, though not a Roma or gypsy as her stage persona suggested, Otero was likewise a self-made diva. If anything, Otero became more notorious than Carmencita, as she later joined the Folies-Bergère and pursued infamous love affairs with European noblemen. See Carmen Posadas, *La Bella Otero* (Barcelona: Planeta, 2001). That Sargent didn't intersect with Otero may be an accident of timing or a quirk of personal attraction, but Otero engaged in sexual affairs as a courtesan, whereas Carmencita remained more aloof, inspiring tributes and fantasies but not cementing a scandalous sexual reputation—another indication of the particular uses Sargent found for this Spanish dancer.

240 *"their enjoyment of the piquant dancing"*: "Otero: The Spanish Dancer," *Illustrated American* 4, no. 35 (September 18, 1890), p. 167.

240 *"wide open"; "fairies"; "live sex shows"*: Chauncey, *Gay New York*, p. 37.

240 *"inscrutability in all that touched his purely personal life"*: Percy Grainger, quoted in Charteris, *John Sargent*, p. 151.

240 *"double nature"; "That double nature of his"*: Lee, "J.S.S.," p. 249.

241 *"more talented than intelligent"*: Forbes Watson, "John Singer Sargent," *Arts* 7, no. 5 (May 1925): p. 245.

241 *"in possession of a style"; "in the dark"*: James, "John S. Sargent," pp. 216–17.

242 *"intervene"*: John Singer Sargent to Ralph Curtis, November 18, [1890,] BA. Trevor Fairbrother remarks that Gardner's intervention "may be assumed, although there seem to be no documentary records to confirm it." Trevor J. Fairbrother, *John Singer Sargent in America* (New York: Garland, 1986), p. 268 (n. 15).

242 *"I am astonished"*: JSS to Charles Fairchild, March 6, 1892, John Singer Sargent Papers, BA.

242 *"the idiotic belief"; "swamped his powers"; "variety of ambition"; "drama of his life";* *"set his other work free"*: Olson, *John Singer Sargent*, p. 155.

20. Painted Temples

243 *"off with a tent"*: JSS to Ralph Curtis, March 19, [1891,] Curtis Papers, BA.

243 *"a tent, a dragoman"*: Karl Baedeker, ed., *Egypt: Handbook for Travelers* (Leipzig: Baedeker, 1898), p. 147.

243–44 *"cramming hard for [his] library"*: JSS to Charles Fairchild, February 1, [1891,] Fairchild Papers, BA.

244 *"land of roses"; "oranges and mandarins" "the western bank of the Nile"; "the whole of this side"*: Baedeker, *Egypt*, p. 148, p. lv.

244 Egyptian Indigo Dyers: *Egyptian Indigo Dyers—A Sketch*, 1891, oil on canvas, H. W. Mesdag Museum, The Hague. Ormond and Kilmurray suggest that this picture was "possibly painted during Sargent's visit to El Fayûm, which was a centre for the production of dark blue indigo dye," though dye shops existed in "Cairo, Luxor, and other Egyptian cities." See Richard Ormond and Elaine Kilmurray, *John Singer Sargent: Figures and Landscapes, 1883–1899* (New Haven, CT: Yale University Press, 2010), p. 238.

244 *Orientalism*: The theorist Edward Said has succinctly defined orientalism, applied to the Middle East as well as many other non-Western places, as a "Western style for dominating, restructuring, and having authority over the Orient": Edward Said, *Orientalism* (New York: Random House, 1978), p. 3.

245 *Hotel du Nil; "delightful garden"*: The Sargents probably stayed in this hotel, as Sargent wrote his friend Ralph Curtis that they intended to stay there, though it's also possible the family stayed on a Nile houseboat: JSS to Ralph Curtis, n.d. [November or December 1890?], Curtis Papers, BA.

245 *a rapid, sand-orange watercolor: The Sphinx*, 1891, watercolor on paper, private collection.

246 *"Well-equipped"; "inspect[ing] the principal"*: Baedeker, *Egypt*, pp. xxiv, xviii. Little is known about the exact itinerary of the Sargents' excursion; they may have taken trains as well as Nile steamers in order to tour the Nile Valley.

246 *"My hatred of my fellow creatures"*: JSS to Miss Popert, April 7, 1908, quoted in Fairbrother, *The Sensualist*, p. 119.

246 *"in spite of the steamer & tourists"*: JSS to Charles Fairchild, February 1, 1891, Fairchild Papers, BA.

246 The Temple of Denderah: 1891, oil on canvas, private collection.

247 *"The consequence of going up the Nile"*: JSS to ISG, [April 14?, 1891,] ISGMA.

247 *"tremendous"; "stories of adventure perfectly plainly told"*: Miller, "Diaries of Lucia Fairchild," p. 14.

248 *"devoured"*: JSS to Ralph Curtis, December 23, [1903,] Curtis Papers, BA.

248 *"an old valise"*: Martin Birnbaum, *John Sargent: A Conversation Piece* (New York: William E. Rudge's Sons, 1941), p. 22.

248 *in later paintings executed in London and the Alps*: These paintings are *Almina, Daughter of Asher Wertheimer* (1908) and the *Chess Game* (1907), according to Fairbrother. See Fairbrother, *The Sensualist*, p. 111.

248 *read out loud to each other*: Richard Ormond, "In the Alps," in Warren Adelson, ed., *Sargent Abroad: Figures and Landscapes* (New York: Abbeville Press, 1997), p. 110.

248 *"Terminal Essay"*: In the fourth section of this essay, Burton openly surveyed the taboo subject of non-Western homosexuality. Deviant sexuality of various kinds was already widely associated with the "Orient." But Burton ethnographically documented it, outlining what he described as a "Sotadic Zone" where homosexuality widely occurred. Burton's "Sotadic Zone" was weirdly precise, stretching from 43 degrees north latitude to 30 degrees south, incorporating Mediterranean countries both north and south of the sea that were Sargent's favorites, including Italy, Spain, southern France, Greece, Turkey, and Egypt. "Within the Sotadic Zone the Vice is popular and endemic," Burton wrote, "held at the worst to be a mere peccadillo, whilst the races to the North and South of the limits here defined practice it only sporadically." Though Burton declared his zone was not racial, his rather confusing argument that sexual irregularity was either climactic or temperamental suffered from contradictions and limitations. Still, his was one of the first surveys of world sexualities—and one that provocatively registered the scope of homosexual acceptance in non-Western societies. For, in spite of describing homosexuality as a "vice" practiced by the "excrabilis familia pathicorum" (accursed family of pathics), Burton wrote about such customs with a tolerance born from a scientific or pseudoscientific objectivity as well as probable personal experience. Richard Burton, "Terminal Essay,"in *The Thousand Nights and One Night*, vol. 10 (London: Burton Club, 1885), pp. 207, 205.

For Burton, as the historian Robert Aldrich has phrased it, homosexuality was "a natural occurrence rather than willfully sinful behaviour." Aldrich has also described how, in the nineteenth century, "a widespread belief circulated in Europe that homosexuality (and other sexual deviance) was endemic in the non-European world." Such a perception, both in queer subculture and in the mainstream culture that condemned it, understood such exotic places as "a homosexual playground"— even if historical reality would have offered such opportunities only "to a limited extent." Queer "travelers and expatriates," Aldrich has written, "assumed that almost any foreign man was available to a passing European, and money could buy sex, if not love. Relations of power permeated colonial sexual culture." Yet, as so often happened in Sargent's era, even this environment, problematic as it was, offered a rare facsimile of sociosexual freedom much less available in London or even in Paris. For this and many other reasons, queer people of the era often tapped the liberation of travel and expatriatism. As Aldrich has described this prominent dynamic, "Itinerancy has remained a prime trait of modern homosexuals, migrating form countryside to city, leaving the provinces for *fin de siècle* Paris or Weimar Berlin, journeying to Capri, Taormina[,] and other mythic Mediterranean sites." See Robert Aldrich, *Colonialism and Homosexuality* (New York: Routledge, 2003), pp. 31, 9, 5.

250 *"the girl"*: John Singer Sargent to Ralph Curtis, March 19, [1891,] Curtis Papers, BA.

250 *the great European tradition of the nude*: As one Arab American historian has seen the matter, "the 'Egyptian girl' was not the subject of [Sargent's] painting, but rather the object upon which he mapped his interpretation of the classical female nude figure." See Amira Jarmakani, *Imagining Arab Womanhood: The Cultural Mythology of*

Veils, Harems, and Belly Dancers in the U.S. (New York: Palgrave Macmillan, 2008), p. 55.

250 Nude Study of an Egyptian Girl: 1891, oil on canvas, Art Institute of Chicago (see illustration credits).

250 *"too modest to make her white"; "wasn't too modest to make her admirable"*: Henry James to Henrietta Reubell, June 21, [1892,] Houghton Library, Harvard, b MS Am 1094 [1108]. As Jarmakani has similarly put it, the "figure's ethnicity, the fact that she was Egyptian, was enough to assuage public discomfort at the thought of seeing a nude woman": Jarmakani, *Imagining Arab Womanhood*, p. 55.

252 *a rather strange painting*: Critical opinion on this painting is divided, and some art historians have even seen this figure as "a calculated gambit to allay questions about his bachelor status": See Fairbrother, *The Sensualist*, p. 156.

252 *"Egyptian girl's back"*: *Saturday Review* 72 (December 26, 1891): p. 721.

252 *"strained and unsure"*: Fairbrother, *The Sensualist*, p. 156.

252 *"The thing is as well done"*: Unsigned [Roger Fry], "Sargents at the Carfax Gallery," *The Athenaeum* (April 1, 1905): p. 408.

252 Sketch of a Bedouin Arab: 1891, oil on canvas, Gregory Callimanopoulos Collection.

252 *"the Fayyum, the most ancient delta of the Nile"*: Richard Burton, "Terminal Essay," p. 225.

253 *"all railway"; "the saddle-horses"; "all meals"; "the courier has to provide"*: Karl Baedeker, ed. *Greece, Handbook for Travellers* (Leipzig: Baedeker, 1909), p. xiv.

253 *"energy and bakshish"*: Baedeker, *Egypt*, p. 355.

253 *Carl Jung would find out*: When the psychologist Carl Jung toured North Africa in 1920, he encountered a common dynamic that some other travelers had kept quiet. "My dragoman confirmed my impression of the prevalence of homosexuality," Jung wrote, "and of its being taken for granted, and promptly made me offers"—though it's unclear here if this dragoman made the heterosexual but scientifically broad-minded Jung direct sexual proposals or if he volunteered to procure sex from others. See Carl Jung, *Memories, Dreams, Reflections*, ed. Aniela Jaffé, trans. Richard and Clara Winston (New York: Pantheon, 1973), p. 239.

253 *"set out with a dragoman"; "he was in the saddle"; "filled up every available corner"; "miles of country"*: Charteris, *John Sargent*, p. 115.

254 *at least two oil studies of Hagia Sophia*: Sketch of Santa Sophia, 1891, oil on canvas, Speed Art Museum, Louisville, KY; Sketch of Santa Sophia, 1891, MMA.

254 *"bribing an official"; "by the shores of the Bosphorus"*: Charteris, *John Sargent*, p. 115.

254 *a watercolor in suffused misty blues and grays*: Constantinople, 1891, watercolor on paper, private collection.

254 *view of the blue-tiled tomb of Ottoman Sultan Murad II*: Two Architectural Views, 1891, oil on canvas, MFA.

254 *"the vices of Sodom"; "In the old East"*: Pierre Loti, *Aziyadé*, trans. Marjorie Laurie (New York: Routledge, 1989), pp. 10, 14. See Richard M. Berrong, "Portraying Male Same-Sex Desire in Nineteenth-Century French Literature: Pierre Loti's *Aziyadé*," *College Literature* 25, no. 3 (fall 1998): pp. 91–108.

255 *"A Turkish bath"; "only women are admitted"; "As soon as the skin"; "who pulls and kneads"; "Orientals devote"*: Baedeker, *Egypt*, xxxviii–xl.

255 Massage in a Bath House: 1891, oil on canvas, FM (see illustration credits).

256 *"sybarite"; "enjoyed Turkish baths and massages"*: Ormond and Kilmurray, *Figures and Landscapes, 1883–1899*, pp. 218, 236.

256 *"I won't be an old maid"*: Quoted in Karen Corsano and Daniel Williman, *John Singer Sargent and His Muse: Painting Love and Loss* (Lanham, MD: Rowman and Littlefield, 2014), p. 22.

256–57 *"very gentle and human"; "Vi"; "was much keener"; "a pity, as she was always so emotional"; "Well"; "she believe[s] in separating"; "Believes in it"*: Miller, "Diaries of Lucia Fairchild," pp. 12–13.

258 *"through peace, calm, and health"*: John Potvin, "Vapour and Steam: The Victorian Turkish Bath, Homosocial Health, and Male Bodies on Display," *Journal of Design History* 18, no. 4 (winter 2005): pp. 327, 319. Ostensibly intended as a club for elite men, the Hammam quickly accommodated a queer clientele who could "experience safely—at the levels of the visual and the corporeal—homoerotic desire" (Potvin, "Vapour and Steam," p. 319). Similarly, bathhouses in New York, San Francisco, and other U.S. cities proliferated at the turn of the twentieth century. These institutions, soon familiar features, started out looking quite respectable, hygienic, and innocent. They evolved "not by themselves," as one historian has written, "but in the context of the slowly developing sexual landscape in the nation's cities. Men—both heterosexual and homosexual—chose to meet each other in bathhouses as alternatives to other places, usually for reasons of safety and privacy." See Allan Bérubé, "The History of Gay Bathhouses," *Journal of Homosexuality* 44: p. 36.

258 *"Write soon if you will come"*: John Singer Sargent to Albert Belleroche, February 15, 1892, private collection; quoted in Moss, "John Singer Sargent, 'Madame X,' and 'Baby Millbank,'" p. 273.

258 *"as his guest"; "We should travel"; "in case I should"; "delighted"; "how our friendship would increase"; "soon realised"*: Belleroche, "Lithographs of Sargent," pp. 35, 38.

21. Sargent's Gondolier

259 *"large and roomy"; "surrounded by a little park"; "heavy with the scent"*: Edwin Austin Abbey to Charles Parsons, June 1892, quoted in Lucas, *Edwin Austen Abbey*, vol. 1, p. 255.

259 *"good comrades"; "friendship"*: Lucas, *Edwin Austin Abbey*, vol. 1, p. 183.

259 *"gay, humorous, and kind"; "devoted also to Mr. Sargent"; "a happy and contented household"*: Lucas, *Edwin Austen Abbey*, vol. 1, pp. 246–47.

259 *"It doesn't look"*: Edwin Austen Abbey to Charles Parsons, June 1892, quoted in Lucas, *Edwin Austen Abbey*, vol. 1, p. 355.

260 *"Premp"; "shock";"My God!"; "I will up and marry"; "small and discreditable"*: JSS to Wilfred de Glehn, September 20, [1903,] quoted in Charteris, *John Sargent*, p. 230.

260 *Eva Eyton Roller*: Mrs. Frederick Roller, 1895, oil on canvas, Charles and Emma Frye Art Museum, Seattle.

260 *gave him a hunting horse*: G. P. Jacomb-Hood, "John Sargent," *Cornhill Magazine* 59 (September 1925): p. 284.

260 *traveling to the Mediterranean with him*: See "Major George Roller—a Tadley Hero,"

Tadley District Historical Society Project News 8 (June 2005), reprinted at https://www.jssgallery.org/Paintings/Portrait_of_Major_George_Conrad_Roller.htm.

260 *a studio oil study*: *Portrait of Major George Conrad Roller*, c. 1892, oil on canvas, private collection.

261 *he showed up*: Frederic Leighton, *And the Sea Gave Up the Dead Which Were in It*, 1892, Tate.

261–62 *"as much for a lark"; "came to the door"; "a big, burly, bearded six-footer"; "directed [him] to step inside"; "I was the 'very man'"; "Sargent-Abbey place"*: Nicola d'Inverno, "The Real John Singer Sargent, as his Valet Saw Him," *Boston Sunday Advertiser*, February 7, 1926, p. 3.

262 *"with anxious relatives hanging on my brush"*: Quoted in Charteris, *John Sargent*, p. 137.

263 *"vicious and meretricious"*: Quoted in Olson, *John Singer Sargent*, p. 108n.

263 *"very witty"; "horrid"; "dull"; "a book that"*: Miller, "Diaries of Lucia Fairchild," p. 8.

263 *"The street that on a wet and dreary morning"*: W. Graham Robertson, *Life Was Worth Living: The Reminiscences of W. Graham Robertson* (New York: Harper and Brothers, 1931), p. 233.

263 *"could withdraw from the world"; "in his shirt-sleeves"; "scores of pencil studies"*: Charteris, *John Sargent*, p. 155.

264 *This black, cloth-covered album*: Sargent sketchbooks and albums collection, c. 1890–1915, FM, Gift of Mrs Francis Ormond (1937.9). See Stewart and Schauber, "Catalogue of Sketchbooks and Albums," pp. 34–36.

264 *"manly figures"; "who can strike"; "the nude as a pleasurable"*: Fairbrother, *The Sensualist*, pp. 109, 106. Fairbrother is the main scholar who has written about this album and its contents, both in Fairbrother, "A Private Album," pp. 70–79, and in Fairbrother, *The Sensualist*, in which he reproduces all these sketches, pp. 180–211.

264 *a handsome, mustached man*: *Male Head in Profile*, charcoal on paper, c. 1890–1915, FM.

264 Reclining Male Nude: *Reclining Male Nude with Hands Clasped behind Head*: charcoal on paper, c. 1890–1915, FM.

264 A Male Model Resting: c. 1904, oil on canvas, private collection.

264 Figure Study: c. 1904, watercolor on paper, National Museum of Wales, Cardiff.

265 Study of a Young Man, Seated: 1895, lithograph, MMA.

265 Study of a Young Man in a Robe, Standing: 1895, lithograph, MMA.

265 A Young Man Drawing: 1895, lithograph, published in Belleroche, "Lithographs of Sargent," p. 36.

265 *"conundrum"*: Ormond and Kilmurray, *John Singer Sargent: Figures and Landscapes, 1900–1907* (New Haven, CT: Yale University Press, 2012), p. 36.

266 *"a class of people whose sole profession is to pose"*: Wilde, "London Models," p. 13.

267 Italian with Rope: Also called *Italian Sailor*, *Italian Bell Ringer*, *Italian Sailor with Rope*, c. 1900, oil on canvas, private collection.

267 Head of a Model: c. 1900, oil on canvas, Manchester City Art Galleries, Manchester; *Head of a Model*, c. 1900, oil on canvas, Spanierman Gallery, New York.

267 Head of a Gondolier *and* The Gondolier: See discussion in Ormond and Kilmurray, *Figures and Landscapes, 1900–1907*, p. 39.

268 *"oeufs brouillés"; "the favourite dish of half the studios in the world"; "very practical knowledge of what makes a painting good or bad"; "Many an artist owes his life to the Serafina"*: Ransome, *Bohemia in London*, pp. 72, 75, 76.

268 *"Gargantuan appetite"*: Rothenstein, *Men and Memories*, vol. 1, p. 244.

268–69 *"never before"; "He was 'wanted' everywhere"; "would never have"*: D'Inverno, "The Real John Singer Sargent," p. 3. It is tempting to draw a parallel between d'Inverno's increasing domestic embroilment with Sargent and nineteenth-century versions of dating, courtship, and marriage.

269 *"a good massage"*: D'Inverno, "The Real John Singer Sargent," p. 3.

269 *"'Palace of Delight' for the downtrodden"*: Joseph F. Kett, *The Pursuit of Knowledge Under Difficulties: From Self-Improvement to Adult Education in America, 1750–1990* (Stanford, CA: Stanford University Press, 1884), p. 191.

270 *Emily Sarah Askey*: Marriage record: "England and Wales Marriage Registration Index, 1837–2005," Niccola Inverno, 1897, *FamilySearch*; from "England & Wales Marriages, 1837–2005," 1897, quarter 4, vol. 1B, p. 324, Pancras, London, England, General Register Office, Southport, England, *findmypast*; census record: "England and Wales Census, 1881," Emily Sarah Askey in household of William Hayden, Middlesbrough, Yorkshire, Yorkshire North Riding, *FamilySearch*; from 1881 England, Scotland and Wales Census, *findmypast*; citing p. 18, Piece/Folio 4853/70, The National Archives, Kew, Surrey; FHL microfilm 101,775,350; death record: "England and Wales Death Registration Index 1837–2007," Emily S Inverno, 1948, *Family Search*; from "England & Wales Deaths, 1837–2006,"; citing Death, Islington, London, England, General Register Office, Southport, England, *findmypast*.

270 *traveled with her husband and Sargent*: According to Eliza Wedgwood's diary from 1909. See Richard Ormond and Elaine Kilmurray, *John Singer Sargent: Venetian Figures and Landscapes, 1898–1913* (New Haven, CT: Yale University Press, 2009), p. 45.

270 *"the greatest man"*: D'Inverno, "The Real John Singer Sargent," p. 3.

271 *"secretary"; "closet"*: See Alan Stewart, "The Early Modern Closet Discovered," *Representations* 50 (spring 1995): pp. 83–87, 86; Gero Bauer, *Houses, Secrets, and the Closet: Locating Masculinities from the Gothic Novel to Henry James* (Bielefeld, Germany: Transcript, 2016), pp. 36–37.

271 *"try to elevate himself"*: Olson, *John Singer Sargent*, p. 183.

272 *"artist photographer"; "a precious memory"; "only priceless thing"; "a scream"; "we went up"; "No one is a hero"*: D'Inverno, "The Real John Singer Sargent," p. 3.

274 *two hundred guineas for a head*: Sargent stated this price scale in at least two letters in the early 1890s: See Ormond and Kilmurray, *Portraits of the 1890s*, pp. 63, 86.

274 *whom the artist persuaded to sit for at least two portraits*: One is *William Frederick Hewer*, 1893, oil on canvas, private collection. See Ormond and Kilmurray, *Portraits of the 1890s*, pp. 75–76.

274–76 *"something particular to tell"; "puzzled and intrigued"; "Sargent who so very seldom said"; "Well, he's very anxious"; "Me?"; "Yes"; "Wants me?"; "I don't know"; the actress replied. "He says you are"; "turning as if to walk away"; "with the sacrifice"; "the coat is the picture"; "It's just like this!"; "Everyone will say"; "Why a very thin boy"*: Robertson, *Life Was Worth Living*, pp. 235–38.

275 *As the painting gradually came together*: W. Graham Robertson, 1894, oil on canvas, Tate (see illustration credits).

276 *"open secret"; "the queer hero of modern life"*: See Eliza Glick, *Materializing Queer Desire: Oscar Wilde to Andy Warhol* (New York: State University of New York Press, 2009), pp. 3, 7.

277 *"From the artistic"*: John Singer Sargent to Edmund Gosse, 1894, quoted in Charteris, *John S. Sargent*, p. 142.

277 *"linger[ing] delightedly over Beardsley's illustrations"*: Charteris, *John S. Sargent*, p. 142.

277 *"the ideal dandy of the present year of grace"*: Agnes Farley Millar, *Independent*, July 9, 1896, p. 931.

277 *"'Beardsley period,' of the 'Yellow Book'"*; *"a period, a type, an attitude of mind"*; *"problem to be solved"*: Charteris, *John Sargent*, p. 154.

22. Cosmopolitans

278 Mrs. Carl Meyer and Her Children: 1896, oil on canvas, Tate (see illustration credits).

279–80 *cartoon caricature; "on a sliding scale"*: *Punch* 112, May 8, 1897, p. 227.

280 *"not succeeded in making attractive"*: Quoted in William Howe Downes, *John Singer Sargent: His Life and Work* (Boston: Little Brown, 1925), p. 49.

280 *"type was markedly Jewish"*; *"shy olive faces"*: Henry James, "London," *Harper's Weekly* (June 5, 1897); quoted in Sweeney, *The Painter's Eye*, p. 257.

281 *"the Jewess"*: Kathleen Adler, Kathleen Adler, "John Singer Sargent's Portraits of the Wertheimer Family," in *Portraits of the Wertheimer Family*, p. 27.

281 *"at once the most interesting models"*: Rothenstein, *Men and Memories*, vol. 2, p. 142.

281 *"twinge of stereotype"*; *"affection and trust"*: Norman L. Kleeblatt, "Sargent's Wertheimers / Wertheimer's Sargents," in *Portraits of the Wertheimer Family*, p. 17.

281 *Dutch and Flemish art collection Lord Francis Clinton-Hope, etc.*: Adler, "Portraits of the Wertheimer Family," p. 22; Michelle Lapine, "Mixing Business with Pleasure: Asher Wertheimer as Art Dealer and Patron," in *Portraits of the Wertheimer Family*, p. 46.

282 *Flora's portrait*: Mrs. Asher Wertheimer, c. 1898, oil on canvas, New Orleans Museum of Art.

282–83 *Flora six or seven years later*: Mrs. Asher Wertheimer, 1904, oil on canvas, Tate.

283 *"lost in the magic of light"*: *Spectator*, May 17, 1904, p. 730.

284 *"seems unlikely"*: Ormond and Kilmurray, *Portraits of the 1890s*, p. 150.

284 *A portrait of Mary Hunter*: Mrs. Charles Hunter, 1898, oil on canvas, Tate.

284 *"La Belle Chiffonière"*: *Punch*, May 3, 1899, p. 556.

284 *"The Great Realist"*: Max Beerbohm, "John Singer Sargent ('Men of the Day, No. 1160, "A Great Realist")," *Vanity Fair*, February 24, 1909.

284 *Sargent's portrait of Asher Wertheimer*: Asher Wertheimer, 1897–98, oil on canvas, Tate.

284 *"masterpiece on which all artistic eyes"*: *Athenaeum*, June 11, 1998, p. 762.

284 *"It would be very hard"*: *Times* (London), April 30, 1898, p. 14.

285 *"incorporates many of the elements"*; *"the hooded eyes"*; *"slavering tongue"*: Adler, "Portraits of the Wertheimer Family," p. 26.

285 *"pleasantly engaged in counting"*: Isaac Phelps Stokes, *Random Recollections of a Happy Life* (1923; reprint New York: privately printed, 1923), p. 118.

285 *"What only this monish"*: *Punch*, May 7, 1898, p. 132.

285 *"would have loved"*: *Times* (London), April 30, 1898, p. 14.

285 *"Happy is the man"*: *Athenaeum*, June 11, 1898, p. 762.

285 "masterpiece"; "brilliant characterization"; "thumb in pocket": Ormond and Kilmur-
ray, Portraits of the 1890s, pp. 132–33.

286 a preliminary pencil sketch Sargent made of Wertheimer: Asher Wertheimer, pencil on
paper, FM.

286 portrait of Marcel Proust's pianist friend Léon Delafosse: Léon Delafosse, c. 1895–98,
oil on canvas, Seattle Art Museum.

286 "chronic Wertheimerism": Quoted in Charteris, John Sargent, p. 164.

286 "Sargent's Mess": Olson, John Singer Sargent, p. 208.

287 portrait of his favorite Helena ("Ena") and her sister Betty: Ena and Betty, Daughters
of Asher and Mrs. Wertheimer, 1901, oil on canvas, Tate (see illustration credits).

287 "vitality hardly matched since Rubens": D. S. MacColl, Saturday Review, May 18,
1901, p. 532.

287 "instinct with life": Times (London), May 4, 1901, p. 13.

288 "daringly dressed"; "Jewesses"; one strap of Betty's gown: Adler, "Portraits of the
Wertheimer Family," p. 27.

288 "What do you think of it?": William C. Loring to his mother (February 10, 1901),
quoted in William C. Loring Jr., "An American Art Student in London," Archives
of American Art Journal, 24, no. 2 (1984): p. 18.

288 He'd logged decades of practice: Trevor Fairbrother has written about Sargent's
"need to 'pass' as a heterosexual bachelor": Fairbrother, "The Complications of
Being Sargent," in Portraits of the Wertheimer Family, p. 36.

288 A Vele Gonfie: Also known as Portrait of Ena Wertheimer, 1904, oil on canvas, Tate
(see illustration credits).

290 "very dry and bitter irony"; "banal": Athenaeum, May 6, 1905, p. 567.

290 "Alive and Kicking": JSS to John Singer Sargent, [February 1899,] ISGMA.

291 "an interesting group"; "intellectually amusing": Wilfred Scawen Blunt, My Diaries:
Being a Personal Narrative of Events, 1888–1914, vol. 1 (New York: Knopf, 1923),
p. 53.

291 "a rather good looking fellow": Blunt, My Diaries, vol. 1, pp. 314–15.

291 The Wyndham Sisters: Or Lady Elcho, Mrs Adeane, and Mrs Tennant, 1899, oil on
canvas, MMA.

292 "did not intimidate him": Blanche, Portraits of a Lifetime, p. 158.

292 "nothing but Jews and Jewesses": Wilfred Scawen Blunt, My Diaries, vol. 2, p.171.

292 a bachelor conspicuously unattached: Such evidence has motivated the art historian
Trevor Fairbrother to conclude that Sargent strongly identified with Jews like
the Wertheimers at least partly because of his own experience as an outsider, as
a parallel "complicated, exuberant individual" but with "a homosexual identity":
Fairbrother, "The Complications of Being Sargent," p. 35.

292 "an innocent social insolence": Adam Gopnik, "Sargent's Pearls," New Yorker, Feb-
ruary 15, 1999, p. 64.

293 "cosmopolitan": According to the OED, the word meant "belonging to all parts of
the world; not restricted to any one country or its inhabitants," a meaning that dates
primarily from the mid-nineteenth century.

293 "a typical example of the modern cosmopolitan": Evan Mills, "A Personal Sketch of
Mr. Sargent," World's Work (November 1903): p. 4116.

293 "so dazzled has the majority been": Christian Brinton, Modern Artists (New York:
Baker & Taylor, 1908), p. 157.

294 *"fragmentary"*: Chauncey, *Gay New York*, p. 72. Chauncey observers for example that "at a time when the numbers of Italians and Jews in New York were roughly equal, almost twice as many Italians were arrested on homosexual charges."

294–95 An Interior in Venice: 1898, oil on canvas, Royal Academy of Arts, London (see illustration credits).

295 *"fontaine de la Jeunesse"*: JSS to Ariana Curtis, [May 27, 1898,] Curtis Papers, BA.

296 *"swarms of larky smart Londoners"*: Quoted in Charteris, *John Sargent*, pp. 171–72.

296 Gondoliers' Siesta: Also known as *The Grand Canal, Venice; Venetian Street Scene; Gondoliers Resting; Gondoliers*, c. 1902–1903, watercolor on paper, private collection.

296 On the Zattere: Also known as *Man in a Gondola, Venice*, c. 1902–1904, watercolor on paper, private collection.

296 A Venetian Trattoria: Also known as *Venetian Interior, Venetian Wine Shop*, c. 1902–1903, watercolor on paper, Philadelphia Museum of Art.

296–97 A Venetian Interior: Also known as *A Spanish Interior; Wineshop*, c. 1902–1903, private collection.

297 *"its sensuous textures"*: Ormond and Kilmurray, *Venetian Figures and Landscapes*, p. 67.

298 A Venetian Tavern: Also known as *Trattoria; A Venetian Wine Shop*, c. 1902, oil on canvas, collection of James and Fran McGlothlin.

298 *"cast in a different mould"*: Ormond and Kilmurray, *Venetian Figures and Landscapes*, p. 65.

23. The President's Coat

299 *"Don't I?"; "Don't move an inch"*: As reported by Nicholas Murray Butler, *Across the Busy Years*, vol. 2 (New York: Scribner's Sons, 1940), p. 329.

300 President Theodore Roosevelt: 1904, oil on canvas, The White House, Washington, DC.

300 *"a young intellectual idealist"*: Henry Adams to Elizabeth Cameron, March 10, 1903 in J. C. Levenson, Ernest Samuels, Charles Vandersee, and Viola Hopkins Winner, eds. *The Letters of Henry Adams*, vol. 5 (Cambridge, MA: Harvard University Press, 1988), p. 472.

300 *"a terrible bore"; "the depth of its malignity"*: Henry Adams to Elizabeth Cameron, April 5, 1903, in Levenson et al., *Letters of Henry Adams*, vol. 5, p. 480.

300 *"a dangerous and ominous Jingo"*: Henry James to Jessie Allen (September 19, 1901), *Henry James Letters*, vol. 4, p. 202.

300 *"Theodore Rex"*: Henry James to Mary Cadwalader Jones (January 13, 1905), Edel, *Henry James Letters*, vol. 4, p. 337.

300 *"Theodore I"*: Henry James to Edith Wharton (January 16, 1905), Edel, *Henry James Letters*, vol. 4, p. 341.

300 *"indescribable overwhelming"*: Henry James to Jessie Allen (January 16, 1905), Edel, *Henry James Letters*, vol. 4, p. 339.

301 *"the noisiest figure"*: Henry James to Dr. J. William White (November 14, 1912) in Percy Lubbock, ed. *The Letters of Henry James*, vol. 2 (London: Macmillan, 1920), p. 283.

301 *"was not the only one"*: JSS to James Ford Rhodes (April 19, [1920]), Massachusetts Historical Society, Boston.

302 *"made [his] home"; "visited the White House twice each day"*: D'Inverno, "The Real John Singer Sargent," p. 3.

302 *"very agreeable to be with"*: JSS to ISG, [October 28, 1917,] ISGMA.

302 *"actually posed for Wilson's coat!"; "posing for the coat"*: D'Inverno, "The Real John Singer Sargent," p. 3.

303 Mrs. Fiske Warren and Her Daughter Rachel: 1903, oil on canvas, MFA.

304 *"grown psychologically"*: Boston Transcript (June 12, 1903), n.p.

305 *produce two exotic, over-the-top portraits of this British colonial administrator*: The most notable is *Sir Frank Swettenham*, 1904, oil on canvas, Singapore History Museum.

305 *"bounder"*: Rebecca West, *1900* (New York: Viking, 1982), p. 111.

305 *"many pleasant hours in [Sargent's] studio"*: Frank Swettenham, *Footprints in Malaya* (London: Hutchison and Company, 1942), p. 141.

305 The Temple of Denderah: 1891, oil on canvas, private collection.

305 *rumored to have had affairs*: See Henry S. Barlow, *Swettenham* (Kuala Lumpur: Southdene, 1995), p. 721; Stephanie Williams, *Running the Show: The Extraordinary Stories of the Men Who Governed the British Empire* (London: Penguin, 2011), p. 254.

305 *a question of local royal succession*: See Aldrich, *Colonialism and Homosexuality*, p. 196.

306 *a portrait of the . . . Earl of Dalhousie*: The Earl of Dalhousie, 1900, oil on canvas, private collection.

306 *"generally bore him"*: as Meynell related to Wilfrid Scawen Blunt; see Blunt, *My Diaries*, p. 585.

306 *"He proved to be a veritable tyrant"*: Quoted in Ronald Anderson and Anne Koval, *James McNeill Whistler: Beyond the Myth* (London: John Murray, 1994), p. 275.

306–307 *"happened to be painting the portraits"; "day by day to completion"*: Swettenham, *Footprints in Malaya*, p. 141.

307 Sixth Marquess of Londonderry: *Charles Stewart, Sixth Marquess of Londonderry, Carrying the Great Sword of State at the Coronation of King Edward VII, August 1902, and Mr. W.C. Beaumant, his Page on that Occasion*, 1904, oil on canvas, MFA.

307 *"infinitely nicer than the Incroyables"*: JSS to Evan Charteris (October 8, [1922]), private collection, quoted in Richard Ormond and Elaine Kilmurray, *John Singer Sargent: The Later Portraits* (New Haven, CT: Yale University Press, 2003), p. 192.

307 The Duke of Marlborough: *The Marlborough Family*, 1904–1905, oil on canvas, Blenheim Palace, Oxfordshire.

307–308 *"in no wise daunted"; "was told that he was to paint"; "But . . . how can I"*: Conseuelo Vanderbilt Balsan, *The Glitter and the Gold* (New York: Harper, 1952), p. 146.

308 *"part of the machinery"*: Charteris, *John Sargent*, p. 177.

309 *"Sargentolatry"; "the whole craven press"; "social and commercial success"*: Walter Sickert, "Sargentolatry," *The New Age* 7 (May 19, 1910): pp. 56–57.

309 Countess of Essex: *The Countess of Essex*, 1907, oil on canvas, private collection.

309 *Pablo Picasso . . . was boldly portraying Gertrude Stein*: Pablo Picasso, *Gertrude Stein*, 1906, oil on canvas, MMA.

309 *"just finished his portrait"; "an art movement"*: Gertrude Stein, *The Autobiography of Alice B. Toklas* (1933; reprint New York: Vintage, 1990), pp. 6, 28.

309 *"sympathies were in the exactly opposite"; "absolutely skeptical"*: Nation, January 7, 1911, p. 610.

310 *"bad faith on the part of people like Matisse"; "the sharp picture dealers"; "like imitations made in coral and glass"; "rich and rare colour"*: JSS to Dugald Sutherland MacColl,

[January 21, 1912,] Glasgow University Library; quoted in Charteris, *John Sargent*, pp. 192–93.

310 *"regarded the Cubists"*: Charteris, *John Sargent*, p. 193.

310 *"ugly bosh, nothing else"*: Anton Kamp, "John Singer Sargent as I Remember Him," Typescript of Tape Recording, February 23, 1973, p. 24. AAA, Gift of Anton Kamp via Barbara Bluff, 1983.

310 *painted Lady Helen Vincent: Lady Helen Vincent*, 1905, oil on canvas, Birmingham Museum of Art, Birmingham, AL.

310 *"spent three weeks"; "painting Lady D'Abernon"; "suddenly set to work"*: Charteris, *John Sargent*, pp. 184–85.

311 *"Damn!"*: D'Inverno, "The Real John Singer Sargent," p. 3.

311 *Lady Helen's financier-husband*: *Sir Edgar Vincent*, 1906, oil on canvas, private collection.

311 *"There is nothing"*: JSS to Edgar Vincent, November 15, [1908?,] British Library Add. MS 48933 f.45.

311 *"No more paughtraits"; "I abhor and abjure them"*: JSS to Ralph Curtis, undated, quoted in Charteris, *John Sargent*, p. 155.

311 *"No more mugs"*: Olson, *John Singer Sargent*, p. 228.

311 *"I hate to paint portraits!"*: Walter Tittle, "My Memories of John Sargent," *Illustrated London News* 166 (1925), p. 724.

311 *"Painting a portrait"*: Blanche, *Portraits of a Lifetime*, p. 158.

312 *"Portraiture may be all right"; "manual dexterity"; "colour-sense"*: Tittle, "My Memories of John Sargent," p. 724.

312 *"A portrait is a picture"*: *L'Oeuvre de John S. Sargent*, introduction by Alice Meynell (Paris: Hachette, 1905), flyleaf.

312–13 *"singular sweetness"; "irascible and impatient temper"; "Sometimes I get a good likeness"*: Norman G. Thwaites, *Velvet and Vinegar* (London: Grayson and Grayson, 1932), pp. 55–57.

24. East of Jordan

314 *Brown-haired, brown-eyed Reine*: *Conrad and Reine Ormond*, 1906, oil on canvas, private collection.

314 Simplon Pass: The Lesson: c. 1911, watercolor on paper, MFA.

314–15 *"'Vegetables,' 'Dried Seaweed,' 'Troglodytes of the Cordilleras,' 'Blokes,' 'Idiots of the Mountains,' and 'Intertwingles'"*: As remembered by Evan Charteris in Charteris, *John Sargent*, p. 178.

315 *oil portrait of him standing booted in a dim Alpine barn*: Peter Harrison, c. 1902, oil on canvas, Wake Forest University, Winston-Salem, NC.

315 In Switzerland: c. 1905, graphite and watercolor, Brooklyn Museum (see illustration credits).

315 *"to the Comaniac"*: Ormond and Kilmurray, *Later Portraits*, p. 91. That the "Comaniac" to whom Sargent inscribed some sketches of Harrison was Alma Strettell Harrison is indicated by letters addressed to her in 1886, when the two shared a passion for Wagner. See Charteris, *John Sargent*, p. 94.

315 Peter Harrison Resting: c. 1905, watercolor on paper, private collection.

315 *Fairbrother has identified this pose*: See Trevor Fairbrother, "Sargent's Genre Paint-

ings and the Issues of Suppression and Privacy," in Doreen Bolger and Nicolai Cikovsky Jr., eds., *American Art around 1900: Lectures in Memory of Daniel Fraad* (National Gallery: Washington, DC, 1990), pp. 41–42.

315–16 *Giovanni Boldini's portrait*: Giovanni Boldini, *Portrait of the Artist: Lawrence Alexander "Peter" Harrison*, 1902, oil on canvas, private collection.

316 *free and spontaneous watercolor portrait of Alma*: *Mrs. Peter Harrison (Alma Strettell)*, 1905, watercolor on paper, private collection.

316 *some critics have also found sexually suggestive*: See Fairbrother, *The Sensualist*, p.174.

316 *"new fuel"*: JSS to Elizabeth Lewis, undated, quoted in Charteris, *John Sargent*, p. 172.

317 The Parting of Jonathan and David: c. 1895, charcoal on paper, FM (see illustration credits).

317 *"Sargent could romanticize"*: Fairbrother, *The Sensualist*, p. 161.

317 *"how our friendship would increase"; "a journey like this with Sargent"*: Belleroche, "The Lithographs of Sargent," p. 38.

319 *It's unclear if in summer 1905*: Sargent's correspondence yields surprisingly scant documentation, and vital details of Sargent's personal arrangements are often revealed only in the letters or reminiscences of his companions.

319 A Man Reading: Also known as *Nicola Reading* or *Man Reading (Nicola d'Inverno)*, c. 1904–1907, oil on canvas, Reading Public Museum, Reading, Pennsylvania (see illustration credits).

319 *Anglo-Italian family of Mancini*: The brothers were Giovanni, Giuseppe, Luigi, Mario, and Vincenzo; see Ormond and Kilmurray, *Figures and Landscapes, 1900–1907*, pp. 44–45.

320 *"I shall fish here"*: JSS to Elizabeth Lewis, undated, quoted in Charteris, *John Sargent*, p. 172.

320 *"different from what"*: JSS to Elizabeth Lewis, undated, quoted in Charteris, *John Sargent*, p. 172.

320 Bedouin Chief: Also known as *Portrait of a Bedouin Chief*, c. 1905–1906?, oil on canvas, private collection.

320 *Sargent's preferred type:* Whether this type stayed merely visual and voyeuristic or whether such desires played out more concretely remains unknown. But Sargent's anonymity and his Western privilege in the Sotadic Zone, often mediated by dragomen, offered him more or easier sexual opportunities than he would have found in London or New York. How did d'Inverno react to any such opportunities? That additional complication can only be speculative, but it is abundantly clear that Nicola proved himself a trusted figure who never commented on any of the content of this expedition—any more than other similarly ambiguous "gondoliers" or "secretaries" of this time hinted at their partner's forbidden activities with them or any others.

321 *"Just now I seem"*: JSS to Mary Smyth Hunter, [February 3, 1906,] AAA.

321 *"Everything is dreadful"*: JSS to Elizabeth Lewis, undated, quoted in Charteris, *John Sargent*, p. 172.

321 *"affectionate and cheerful"*: JSS to Mary Smyth Hunter, January 24, [1906,] AAA.

322 *"many years as a bachelor"; "would find it irksome"*: Eliza Wedgwood to Evan Charteris, November 22, 1925, quoted in Olson, *John Singer Sargent*, p. 231.

322–23 *"Every autumn after"; "travelled with a stuffed gazelle"*: Charteris, *John Sargent*, p. 170.

323 The Chess Game: 1907, oil on canvas, Allen Family Collection (see illustration credits).

324 *"funny old dear"; "just like a child"*: Jane de Glehn to Roger Quilter (September 5, 1909), Quilter Papers, British Library, London, [Add] MS 70597.

324 *one of his last high-profile exhibition oil portraits*: *Lady Sassoon*, 1907, oil on canvas, private collection.

324 *"an ensemble of great magnificence"*: *Athenaeum*, May 4, 1907, p. 547.

324 *"highly strung temperament"; "an impression bordering on flurry"*: Charteris, *John Sargent*, p. 175.

324 *"a little something wrong"; pearls; too-long, pink fingers*: Mount, *John Singer Sargent*, p. 225.

325 *a dignified, stylized, introspective picture of the young bride*: *The Countess of Rocksavage*, 1913, oil on canvas, private collection.

325 *"the pious founders"*: Cecil Roth, *The Sassoon Dynasty* (London: Hale, 1941), p. 231.

325 *"saw almost nothing"*: Peter Stansky, *Sassoon: The Worlds of Philip and Sybil* (New Haven: Yale University Press, 2003), p. 35.

326 *He'd leave many a playful, high-spirited sketch*: Stanksy, *Sassoon*, p. 157.

327 *"no evidence of his sexual activities"; "not surprisingly"*: Stansky, *Sassoon*, p. 171.

327 *a fellow British army officer called Jack*: see Stansky, *Sassoon*, pp. 81–82.

328 Sir Philip Sassoon, 1923, oil on canvas, Tale Britain Gallery, London.

25. Detonations

329 *"lost his nerve"; "must reserve the faculty"*: Henry James to William James III, May 13, 1913, Edel, *Henry James Letters*, vol. 4, p. 675.

329 *"pleased no one"; "impossible to do justice"*: Charteris, *John Sargent*, p. 79.

330 *"done the thing* gratis*"; "such a devoted friend"; "the most sensitive"*: Max Beerbohm to Reggie Turner, March 11, 1913, *The Letters of Henry James*, ed. Percy Lubbock, vol. 2 (New York: Scribner, 1920), p. 222.

330 *"got at it and* placed it*"; "more or less full face"*: Henry James to William James III, May 13, 1913, Edel, *Henry James Letters*, vol. 4, p. 675.

330 *"repeated holes"; "precious mornings"*: Henry James to Rhoda Broughton, June 25, 1913, Percy Lubbock, ed. *The Letters of Henry James*, vol. 2, p. 330.

330 *"He likes* one*"; "for animation and the countenance"*: Henry James to Jocelyn Perrse, May 18, 1913, Edel, *Henry James Letters*, vol. 4, pp. 671–72.

330 *When finished, the portrait*: *Henry James*, 1913, oil on canvas, National Portrait Gallery, London.

330 *"a very fine thing indeed"; "a masterpiece of painting"; "all large and luscious rotundity"*: Henry James to Rhoda Broughton, June 25, 1913, Lubbock, *Letters of Henry James*, vol. 2, p. 330.

331 *"Than which he has never"*: Henry James to William James III, June 18, 1913, Lubbock, *Letters of Henry James*, vol. 2, p. 329.

331 *"real friends"; "understood each other"; "Renegade Americans both"; "plus Anglais que les Anglais"*: Robertson, *Life Was Worth Living*, p. 240.

331 *"she got at me"; "before the tomahawk"; "past praying for"*: Henry James to Jessie Allen, May 6, 1914, Edel, *Henry James Letters*, vol. 4, p. 712.

332 *"John Singer Sargent, the painter"*: "Special Cable," *New York Times*, August 22, 1914.

333 *"seemed to regard"; "real to him"*: Adrian Stokes, "John Singer Sargent, R.A., R.W.S.," in Randal Davies, ed., *The Old Water-Colour Society's Club 1925–1926*, vol. 3 (London: The Club, 1926), pp. 58–59.

333 *"the war was outside"*: Charteris, *John Sargent*, p. 203.

333 *"no stone unturned"*: Stokes, "John Singer Sargent," p. 57.

333 *"a jolly old Tirolese house"*: JSS to ES, October 7, [1914,] John Singer Sargent Archive, MFA.

333 The Master and His Pupils: 1914, oil on canvas, MFA.

333 *male figures fishing in mountain streams*: Some of the candidates are *Trout Stream in the Tyrol*, 1914, oil on canvas, Fine Arts Museums of San Francisco; *Man Fishing*, 1914, watercolor on paper, private collection; and *Man Seated by a Stream*, c. 1914, watercolor on paper, private collection.

334 Mountain Stream: 1912–14, watercolor on paper, MMA (see illustration credits).

334 *painted a glowing portrait of her*: Rose-Marie Ormond, 1912, oil on canvas, private collection.

335 *"Don't make much"; "I don't want"*: JSS to Evan Charteris, [February 6,] 1916, private collection, quoted in Olson, *John Singer Sargent*, p. 249.

336 *Bostonian friends from Jamaica Plain*: *Social Register, Boston, 1911* (New York: Social Register Association, 1910), p. 94.

336 *Sargent made a lively pencil-sketch*: *Portrait of Mildred Stimson Livermore, Wife of Colonel Livermore*, 1916, pencil on paper, private collection. According to the *Social Register, Boston, 1911*, Mildred Livermore was wife of Harris Livermore and daughter-in-law of Colonel Thomas Livermore.

336 *"Mrs. Livermore is perfectly delightful"; "You sit in a perfect temperature"; "it was raining and snowing"*: JSS to Mary Hale, August 30, 1916, quoted in Charteris, *John Sargent*, pp. 204–205.

337 *"happiest experience with the great painter"*: D'Inverno, "The Real John Singer Sargent," p. 3.

337 Camp at Lake O'Hara: 1916, watercolor and graphite on paper, MMA.

337 *"lone figure . . . in soft focus"*: Herdrich and Weinberg, *American Drawings and Watercolors*, p. 350.

337 Shaving in the Open: 1916, watercolor on paper, private collection.

337 Inside a Tent in the Canadian Rockies: 1916, oil on canvas, private collection. Ormond and Kilmurray identify the figure in this painting as one of the guides, but the Sargent scholar David McKibbin believed this man was Nicola d'Inverno. See Ormond and Kilmurray, *John Singer Sargent: Figures and Landscapes, 1914–1925* (New Haven, CT: Yale University Press, 2016), p. 155.

337 *"capitally"; "sorry to part with him"*: JSS to Thomas Fox, August 2, [1916,] Thomas A. Fox–John Singer Sargent Papers, BA.

26. Empire's End

339 *"seduced"*: JSS to Thomas Fox, April 10, [1917,] Thomas A. Fox–John Singer Sargent Papers, BA.

339 Man and Pool, Florida: 1917, watercolor on paper, MMA; *Man and Trees, Florida*, 1917, watercolor on paper, MMA.

339 The Bathers: 1917, watercolor and body color on paper, Worcester Art Museum, Worcester, MA (see illustration credits).

339 *"surf bathing"*: JSS to Thomas Fox, March 5, [1917,] Thomas A. Fox–John Singer Sargent Papers, BA. Sargent said of Ormond Beach, Florida, that "surf bathing is the best of this place." JSS to Thomas Fox, March 11, [1917,] Thomas A. Fox–John Singer Sargent Papers, BA.

340 Nude Man Lying on a Bed: 1917, watercolor on paper, private collection.

340 *"most warm, intimate"*: Fairbrother, "A Private Album," p. 75.

341 *"hanging tapestries or heavy curtains"*; *"The tapestries added"*: Salley M. Promey, "Sargent's Truncated Triumph: Art and Religion at the Boston Public Library, 1890–1925," *The Art Bulletin* 79, no. 2 (June 1997): p. 231.

341 *"in hot water with the Jews"*: Charteris, *John Sargent*, p. 209.

341 *"triumph of Christianity"*; *"a beautiful representation"*; *"strong organized protest"*: "Real Interpretation of 'The Synagogue' Missing in John Singer Sargent's Explanation," *Jewish Advocate*, October 23, 1919, p. 1.

343 *"for the benefit"*: Le Temps, March 5, 1918, translated and quoted in Karen Corsano and Daniel Williman, *John Singer Sargent and His Muse: Painting Love and Loss* (London: Rowman & Littlefield, 2014), p. 160.

343 "Mon Père, je remets"; *"a person of singular"*; *"youth and high spirits"*: Charteris, *John Sargent*, p. 210.

344 *"an alcove, marked off by a Moorish arch"*; *"a row of electric lights"*: Carter, *Isabella Stewart Gardner and Fenway Court*, p. 241.

344 Mrs. Gardner in White: 1922, watercolor on paper, ISGM.

344 *"Yes, I daresay"*: Henry James to JSS, July 30, 1915, Edel, *Henry James Letters*, vol. 4, p. 774.

344 *"Such virtuosity, such beautiful flutters"*; *"miraculous fireworks"*: JSS to Evan Charteris, May 12, 1920, in Charteris, *John Sargent*, p. 218.

345 *"inclined to overindulge"*: Anton Kamp, "John Singer Sargent as I Remember Him," p. 26. Charles Merrill Mount's account of this dismissal, otherwise dubious and unsourced, references alcoholic bouts of absence and a particularly long one in 1918 that caused Sargent to leave instructions "with his Boston attorney that, if Nicola eventually did appear, he was to be paid, and discharged": Mount, *John Singer Sargent*, p. 289.

345 *"What separated us"*: D'Inverno, "The Real John Singer Sargent," p. 3.

345 *"only priceless thing"*: D'Inverno, "The Real John Singer Sargent," p. 3.

346 *as late as 1921*: For example, Sargent referred to some sort of debacle with Nicola in a letter to Fox (January 30, 1921), Thomas A. Fox–John Singer Sargent Papers, BA.

346 *"somewhat overbearing familiarity"*: Kamp, "John Singer Sargent as I Remember Him," p. 26.

346 *"excited and interested"*; *"regarded the question"*; *"soon became littered"*; *"burly figure"*; *"'sailor gone wrong'"*: Charteris, *John Sargent*, p. 210.

347 *"awfully kind and useful"*; *"epic"*: JSS to Evan Charteris, September 11, 1918, quoted in Charteris, John Sargent, p. 214.

347 *"one of the iron huts"*: Charteris, *John Sargent*, p. 211.

347 *"an iron tube"*: JSS to Evan Charteris, July 24, 1918, quoted in Charteris, *John Sargent*, p. 212.

347 *"how dangerous a shell might be"; "I suppose there is no fighting"*: Quoted in Charteris, *John Sargent*, p. 211.

347–48 *"a joy ride"; "think of the ships before Troy"; "the line 'and the silence clashed'"*: JSS to Evan Charteris, July 24, 1918, quoted in Charteris, *John Sargent*, p. 212.

348 *"epic"; "The nearer to danger"*: JSS to Evan Charteris, September 11, 1918, quoted in Charteris, *John Sargent*, p. 214.

348 Highlanders Resting at the Front: 1918, watercolor on paper, Fitzwilliam Museum, Cambridge.

349 Poperinghe: Two Soldiers: 1918, watercolor on paper, MFA.

349 Tommies Bathing, France: 1918, watercolor on paper, MMA.

349 Tommies Bathing: 1918, watercolor on paper, MMA (see illustration credits).

350 *his huge memorial canvas*: Gassed: The Dressing Station at Bac-du-Sud, on the Doullens-Arras Road, August 1918, 1918, oil on canvas, Imperial War Museum, London.

350 *"The word 'gassed' is ugly"*: Quoted in Charteris, *John Sargent*, p. 215.

27. The Contortionist

351 *"I shall want him"*: JSS to Thomas Fox, August 22, 1923, Thomas A. Fox–John Singer Sargent Papers, BA.

351 *"My soul longs"*: JSS to Mary Hale, October 20, 1917, quoted in Charteris, *John Sargent*, p. 162.

351–52 *"groans of the wounded"; "it always seemed strange"; "queerness"; "I would gladly do"*: Quoted in Charteris, *John Sargent*, pp. 216–17.

352 *"loom before [him], like a nightmare"*: JSS to Evan Charteris, May 12, 1920, quoted in Charteris, *John Sargent*, p. 217.

353 *"most at his ease"*: Charteris, *John Sargent*, p. 169.

353 *"wasn't convinced that"*: Cynthia Asquith, diary, February 20, 1919, quoted in Olson, *John Singer Sargent*, p. 214.

353 *"started for Dalmatia"*: Ralph Curtis to ISG, August 4, [1907,] ISGMA.

353 *most recently featuring in a watercolor sketch*: Reine Ormond, c. 1910–11, watercolor on paper, private collection.

354 *of whom Copley had in fact painted a . . . portrait*: John Singleton Copley, Portrait of Mrs. John Stevens (Judith Sargent, later Mrs. John Murray), 1770–72, oil on canvas, Terra Foundation for American Art.

355 *"the operator"*: Thomas A. Fox, "As Sargent Goes to Rest," *Boston Evening Transcript*, April 24, 1925, p. 12.

355 *Thomas E. McKeller*: Very little research was done on McKeller and his association with Sargent until the preparations for "Boston's Apollo" exhibition at the Gardner Museum in Boston in winter and spring 2020. My essay in this catalogue, which informs this discussion, gives a more in-depth account of McKeller and Sargent's relation along with a biographical sketch of McKeller. See Fisher, "Atlas, with the World on His Shoulders," in *Boston's Apollo*, pp. 41–61.

355 *baptized there in St. Stephen's*: Letter from L. A. Moyer, United States Civil Service Commission, to First Assistant Postmaster, February 27, 1940, Privacy and Records Management Office, United States Postal Service.

356 *Wilmington Massacre*: See Leon H. Prather Sr., "We Have Taken a City: A Centennial Essay," in David Cecelski and Timothy B. Tyson, ed., *Democracy Betrayed: The Wilmington Race Riot of 1898 and Its Legacy* (Chapel Hill: University of North Carolina Press, 1998), pp. 15–41.

356 *By 1913 . . . he was in Boston*: Boston City Directory, 1913, p. 1224.

356 *"between twenty-five"; "nine leading hotels"*: John Daniels, *In Freedom's Birthplace: A Study of the Boston Negroes* (Boston: Houghton Mifflin, 1914), p. 336.

356 *"bellman"*: 1920 U.S. Census, Massachusetts Suffolk, Boston Ward 7, District 0202.

356–57 *"less than the minimum"; "mostly young unmarried"; "lodgers, usually confined"*: Daniels, *In Freedom's Birthplace*, p. 174.

357 *But by 1920 the twenty-nine-year-old McKeller*: 1920 U.S. Census, Massachusetts Suffolk, Boston Ward 7, District 0202.

357 *In the 1910s and 1920s*: In 1913, McKeller boarded in Ruggles Street in Roxbury; in 1917, in West Canton Street in the South End; and in 1922, in Rutland Square, in the South End: Boston Directory, 1913, p. 1224; Boston Directory, 1917, p. 1008; Boston Directory, 1922, p. 1131.

357 *So did the painter's financial situation*: See Ormond and Kilmurray, *The Later Portraits*, pp. 243–45; Richard Ormond and Elaine Kilmurray, *John Singer Sargent: Figures and Landscapes, 1914–1925* (New Haven, CT: Yale University Press, 2016), p. 20.

357 *Sargent paid another model; "several dollars more"*: Kamp, "John Singer Sargent as I Remember Him," pp. 6, 14.

358 *"dribble[d] out to him to keep him going"*: JSS to Thomas Fox, August 22, 1923, Thomas A. Fox–John Singer Sargent Papers, BA.

358 *"ready money"; "in quite a little rut"; "I trust you will"*: Thomas E. McKeller to Thomas A. Fox, May 2, 1927, John Singer Sargent Archive, MFA.

358 *"part-time contortionist"*: Kamp, "John Singer Sargent as I Remember Him," p. 6.

358 *"two of the best"*: Daniels, *In Freedom's Birthplace*, pp. 82–83.

359 *Harvard professor Thomas Dwight*: Dwight's paper was "Joints and Muscles of Contortionists." See *Proceedings of the Boston Society of Natural History* 24 (1889): pp. 355–57.

359 *"an abode and rendezvous"; "Negro 'Lower Broadway'"; "clubs"; "incessant visiting"; "daily round of toil"*: Daniels, *In Freedom's Birthplace*, pp. 149, 199, 176.

359 *"this young man"*: Fox, "As Sargent Goes to Rest," p. 12.

359 Apollo: c. 1921–25, charcoal on paper, MFA; *Classic and Romantic Art*, 1916–21, oil on canvas, MFA. For a side-by-side comparison, see Esten, *The Male Nudes*, pp. 74–75.

360 *"young negro of magnificent figure"; "Why not use"; "in the afternoon"; "The model was Apollo"*: M. J. Curl, "Boston Artists and Sculptors in Intimate Talks," *Boston Herald*, December 12, 1920.

360 *"main"; "while he was here"; "Atlas, with the world"*: Thomas E. McKeller to David McKibbin, July 29, 1948, John Singer Sargent Archive, MFA. McKeller spelled the word model as "modle." The spellings of "modle" and "sholders" are richly idiosyncratic and, like other McKeller phrases in the surviving letters, provide valuable examples of McKeller's distinctive voice. McKeller's rendering of a word like

"modle" should not be misconstrued as ignorance, when it was simply a word he'd had no occasion to see in print and that he spelled phonetically. McKeller was an intelligent man who worked for the U.S. Post Office for much of his adult life. For Blacks after the Civil War, literacy and education were hard-won, especially in the South where McKeller grew up, and McKeller's letters are graceful, dignified, and eloquent.

361 *"Dear Mr. McKeller"*: JSS to Thomas McKeller, December 7, [n.y.], David McKibbin Collection on John Singer Sargent, BA.

361 *Another model of the time would recall; In other documented moments*: See observations by Anton Kamp, below.

361 *"that darkey [sic] model"; "want"*: JSS to Thomas Fox, March 24, 1919, Thomas A. Fox–John Singer Sargent Papers, BA.

361 *"I shall want him"; "take some situation"*: JSS to Thomas Fox, August 22, 1923, Thomas A. Fox–John Singer Sargent Papers, BA.

362 *"My soul longs"*: JSS to Mary Hale, October 20, 1917, quoted in Charteris, *John Sargent*, p. 162.

362 *"most humble associates"; "respect and esteem"; "friendship"*: Fox, "As Sargent Goes to Rest," p. 12.

362 *Noriena Elizabeth (Rena or Reena) Meads*: Index to Marriages in Massachusetts, 1931–1935, vol. 16, p. 470; Request for a Report on Loyalty Data, Federal Bureau of Investigation, Privacy Records Management Office, United States Postal Service. The FBI report listed Rena's maiden name as "Meask," not Meads as it was in the Census and Marriage Records.

362 *he spoke briefly to Sargent researcher David McKibbin*: McKibbin's interview with Thomas McKeller (August 20, 1948); Thomas McKeller to David McKibbin, July 29, 1948; John Singer Sargent Archive, MFA.

362–63 *"That its officers"; "all public institutions"; "owing to the prevailing"; "more or less"; "at least one Negro"; "studying paintings"*: Daniels, *In Freedom's Birthplace*, pp. 174, 97, 189.

363 Nude Study of Thomas B. McKeller: c. 1917–20, oil on canvas, MFA (see illustration credits).

363 *between 1929 and 1932; William James Jr.; David McKibbin*: See Ormond and Kilmurray, *Figures and Landscapes, 1914–1925*, p. 138.

364 *"body of clear"; "invigorating salty brine"; "the variety of male bodies"; "a fine physical showing"; "tall, ruddy-complexioned man"; "the true purpose"; "up and down"; "Have you posed"*: Kamp, "John Singer Sargent As I Remember Him," pp. 1–3, p. 18.

364 *would later model for . . . N. C. Wyeth*: Richard S. Monkman, *Just Before Dark* (New York: Xlibris, 2012), p. 164.

365–68 *"in the presence"; "moving [him] about"; "regal stature"; "a spirit of the non-conformist"; "as erect as"; "seethed the life"; "reserved attitude"; "with a twinkle in his eye"; "I believe Phidias"; "the imprint of"; "a head of"; "art, books, people"; "warmer rapport"; "dismayed over the difficulty"; "did have one"; "an angular, scrawny"; "volunteered to massage"; "he ever took"; "an Italian lad"; "improper moment"; "I do not need"; "brilliant ray"; "protrusive"; "physiognomy"; "symbol of the late nineteenth century"; "disguise this weak area"; "barter his services"; "To Mr. Kamp"; "He looked at me"; "climactic close to a most thrilling"; "intently"; "Please remain as you are"; "had no special"; "inspirational diversion"; "same spirit"; "some months before"; "a*

negro figure"; "superbly developed"; "impressive study": Kamp, "John Singer Sargent as I Remember Him," pp. 6–7, 14–15, 18–19, 23–26, 28–29.

369 The Countess of Rocksavage: 1922, oil on canvas, private collection.

369 Some General Officers of the Great War: Now entitled *General Officers of World War I*, 1920–22, oil on canvas, National Portrait Gallery, London.

369 *"Putting them all"*: ES to ISG (November 3, 1920), ISGMA.

369 *"these generals never"*: *Times* (London), April 29, 1922, p. 13.

369 Soldiers of the Nation Marching to War: Also known as *Coming of the Americans*, 1922, oil on canvas, Widener Library, Harvard University.

369 The Conflict Between Death and Victory: 1922, oil on canvas, Widener Library, Harvard University.

370 *"the coming of the Americans"; "Phrygian cap"; "enliven[ed] the color scheme"*: G. H. Edgell, "Death and Victory—By John Singer Sargent," *Harvard Alumni Review*, November 9, 1922, https://www.thecrimson.com/article/1929/6/8/sargent-murals-well-received-at-first/

370 *having been drafted a soldier himself*: Service record for Thomas Eugene McKeller, General Services Administration; Report on Separation or Transfer, December 31, 1956, Privacy and Records Management Office, United States Postal Service.

370 *posed McKeller and one other model*: For more detail, see Jane Dini, "The Art of Selling War: Sargent's World War I Murals for Harvard University," *Harvard University Art Museums Bulletin* 7, no. 1 (autumn 1999–winter 2000): pp. 67–84.

370 *barred Black students*: Dini, "The Art of Selling War," p. 84, n. 33.

370 *Sargent would also paint Lowell*: *Abbott Lawrence Lowell*, 1923, oil on canvas, Harvard University Portrait Collection, Harvard University.

370 *five honorary degrees*: Olson, *John Singer Sargent*, p. 237.

371 *"never aesthetic values"; "profound historical interest"*: Roger Fry, "The Wertheimer Portraits," *New Statesman*, January 15, 1923, pp. 429–30.

371 *"no one is sacred"*: JSS to D. S. MacColl, n.d., Glasgow University Library.

28. Miss Sargent's Party

372 *In several watercolors and one oil*: The oil painting is *Mosquito Nets*, 1908, oil on canvas, Detroit Institute of Arts. The best-known watercolors are *Miss Eliza Wedgwood and Miss Sargent Sketching*, 1908, watercolor on paper, Tate (see illustration credits); and *Simplon Pass: The Lesson*, c. 1911, watercolor on paper, MFA.

374 *Emily gave the dinner at her flat; "high spirits"*: Charteris, *John Sargent*, pp. 231–32.

376 *"Do you know"; "This is not a case"*: Quoted in Mount, *John Singer Sargent*, p. 333. Mount, who does not cite his sources, is not always reliable. Charteris reported that "after lingering a little with his sister, he drove away": Charteris, *John Sargent*, p. 232.

376 *"never known an unpleasant thought"; "old chums," "distanced"*: James Carroll Beckwith, diary, April 13, 1895, New-York Historical Society, New York.

377 *Voltaire's* Dictionnaire Philosophique: Charteris, *John Sargent*, p. 232.

377 *"free-thinker"; "The lords, dukes and marquises"*: D'Inverno, "The Real John Singer Sargent," p. 3.

378 *"I just came"; "We shook hands"*: Thomas Fox, *Collections and Recollections*, Thomas A. Fox–John Singer Papers, BA.

378 *"he and I experienced"; "realized to the same degree"*: Kamp, "John Singer Sargent as I Remember Him," p. 30.

378 *"perhaps worth recording"*: Hamilton Minchin, "Some Early Recollections of Sargent," *Living Age*, August 1, 1925, p. 234.

379 *£176,366*: See Olson, *John Singer Sargent*, p. 270; Ormond and Kilmurray, *Figures and Landscapes, 1914–1925*, p. 23.

380 *"gave lavishly"; "Few legatees"*: Olson, *John Singer Sargent*, p. 271.

381 *Sargent's nude upper-body sketch*: *Two Half-Length Sketches of a Youth*, n.d., pencil on paper; and *Study of a Male Nude*, n.d., pencil on paper, Rhode Island School of Design, Providence. See Esten, *The Male Nudes*, pp. 10, 13.

381 *quite graphic undated male nudes*: *Male Nude Reclining*, n.d., charcoal on paper, Yale University Art Gallery, New Haven; *Reclining Nude Figure*, n.d., charcoal on paper, Wadsworth Atheneum, Hartford.

381 Nude Bathers on a Wharf: c. 1880, oil on wood, MMA (see illustration credits).

381–82 *"too solemn, too pedagogical"; "the subject of a Spanish gypsy dancer"; "unsuitable"; "without mutilation"*: Whitehill, *Museum of Fine Arts, Boston*, pp. 128, 674.

382 *an official handbook from the time*: *Museum of Fine Arts Boston Illustrated Handbook* (Boston: Museum of Fine Arts, 1930). Besides Sargent's murals, the nudes included at least one Greek marble relief (p. 39) and William Blake's *Creation of Eve* (p. 157).

382 *"very ladylike"*: Whitehill, *Museum of Fine Arts, Boston*, p. 353.

384 *"many years a bachelor"; "irksome"*: Eliza Wedgwood to Evan Charteris, November 22, 1925, quoted in Olson, *John Singer Sargent*, p. 231.

Acknowledgments

This long-running research project has accrued many debts over the years, and I'm grateful to all the colleagues, collaborators, and editors who have helped me with various aspects of this book since I began working on Sargent.

I owe special thanks to Erica Hirshler at the Museum of Fine Arts, Boston, whose kind collegiality and friendship have opened many doors and whose brilliant scholarship on American art has never ceased to inspire me. I'd also like to thank Nat Silver and Elizabeth Reluga at the Isabella Stewart Gardner Museum in Boston for their remarkable work on the exhibition and catalogue for *Boston's Apollo*, where much of my research on Sargent's model Thomas McKeller first saw the light.

I would also like to extend special gratitude to Richard Ormond and Elaine Kilmurray, whose nine-volume catalogue raisonné is such a paragon of scholarship, for their professional example and personal kindness. I'd also like to thank Stephanie Herdrich, Trevor Fairbrother, Dominic Green, Caroline Corbeau-Parsons, and Pam Parmal for useful conversations, practical assistance, and unfailing inspiration in person and in their distinguished works. Also for kindness, collegial support, and editorial savvy, in Henry James's world and outside of it, I'd like to recognize Greg Zacharias, Donatella Izzo, Susan Gunter, Rosella Mamoli Zorzi, Colm Tóibín, Philip Horne, Michael Gorra, and Kevin Hayes. I'm also grateful to eminent fellow biographers and history writers for wisdom, insight, and support, notably Carla Kaplan, Megan Marshall, and Christina Thompson. For collaboration and editorial wisdom on various other projects connected to this research, I'd like to thank Susan Waller, Karen Carter, and Karen Bishop. I'd also like to thank the Newhouse Humanities Center at Wellesley, the Biography and Life-Story Group at the Northeastern University Humanities Center, and the New England Biography Seminar at the Massachusetts Historical

Society for providing stimulating forums and inspiring discussions related to this work.

I am grateful to the curators and staff of the physical archives, digital archives, and museums where I have done research over many years, including the Archives of American Art at the Smithsonian, the Boston Athenaeum, the Isabella Stewart Gardner Museum, the Harvard University Art Museums, Houghton Library at Harvard, the Museum of Fine Arts in Boston, the Tate Britain Museum, the New-York Historical Society, and the Metropolitan Museum in New York.

I would also like to thank many colleagues at Wellesley College who have provided me advice, encouragement, and support over the years. These include Elena Creef, Yoon Sun Lee, Vinni Datta, Jonathan Imber, Bill Cain, Lee Cuba, Wini Wood, Andy Shennan, Michael Jeffries, Becky Bedell, Martha McNamara, Peggy Levitt, Alice Friedman, Larry Rosenwald, Cappy Lynch, Jay Turner, David Lindauer, Lisa Rodensky, Vernon Shetley, Dan Chiasson, Marilyn Sides, Margaret Cezaire-Thompson, Kathleen Brogan, Ryan Quintana, Kate Grandjean, Petra Rivera-Rideau, Genevieve Clutario, Jeanne Hicks, and many others.

For invaluable help with this book, I would like to thank my superlative agent, Brettne Bloom, who has done wonders for me as well as facilitating this project patiently over the years. I would also like to extend special thanks to my editors at Farrar, Straus and Giroux: Jonathan Galassi for insightful readings and suggestions; Alex Star for his unerring perspicacity and rich perceptions; and Ian Van Wye, Logan Hill, and Janine Barlow for much practical assistance.

I'm also grateful to my partner, Jeff Taliaferro, and to friends and family members who have helped, informed, cheered, and inspired me over the years, including Charlotte Gordon, Tim and Sibella Makower, Susan Lyddon, Gab Watling, Sibyl Johnston, Karen Sontag, Phil Kelly, Sarah Wykes, Emily Gordon, Scott Fisher, Ian Sweedler, Cari and Paul Updike, Heidi and Todd Macfarlane, Randall Fisher, Christina Schroder, Ryan Warner, Camille Serchuk, Larry Civale, Mie Inouye, and Brooks Richon.

Index

Page numbers in *italics* refer to illustrations.

ILLUSTRATION CREDITS

In Text

p. 5: "Sketch of Sargent Asleep in a Train, 1883, size of the original pencil drawing 4 ½ x 5 ½ inches," published in Albert de Belleroche, "The Lithographs of Sargent," *The Print Collector's Quarterly* 13 (February 1926): p. 30.

p. 6: John Singer Sargent in his studio, c. 1884. Photographs of artists in their Paris studios, 1880–90. Archives of American Art, Smithsonian Institution.

p. 17: Portrait of John Singer Sargent as a boy, 1864. Benjamin F. Curtis papers. Archives of American Art, Smithsonian Institution.

p. 35: John Singer Sargent, *Dancing Faun and Narcissus, after the Antique*; Verso: Cave Canem, after a Pompeiian mosaic, 1869, Harvard Art Museums / Fogg Museum, Gift of Mrs. Francis Ormond, Photo © President and Fellows of Harvard College, 1937.7.2.49.

p. 43: Sargent, John Singer (1856–1925). *Mountain Climbers* (from Switzerland 1869 Sketchbook), 1869. Graphite on off-white wove paper. 7 ¾ x 11 ¾ in. (19.7 x 29.8 cm). Gift of Mrs. Francis Ormond, 1950 (50.130.146ss). The Museum of Modern Art, New York, NY, U.S.A. Image copyright © The Metropolitan Museum of Art. Image source: Art Resource, NY.

p. 58: John Singer Sargent, *Dancing Faun, After the Antique*, 1873–74, black chalk and charcoal on off-white laid paper, 76.6 x 49.9 cm, Harvard Art Museums / Fogg Museum, Gift of Mrs. Francis Ormond, Photo © President and Fellows of Harvard College, 1937.8.16.

p. 91: James Carroll Beckwith, *The Reading Club: John Singer Sargent, Seated with Another Man and Reading Shakespeare*, c. 1875, graphite on ivory paper, formerly mounted on a page of Album 2, 9.5 x 14.8 cm. Gift of the National Academy of Design. 1935.85.2.151. New-York Historical Society.

p. 92: John Singer Sargent, *Two Half-Length Sketches of a Youth*, c. 1878. Graphite on paper. 19.5 x 27 cm (7 ¹¹⁄₁₆ x 10 ⅝ inches). Gift of Emily Sargent and Mrs. Francis Ormond. 31.015. Courtesy of the RISD Museum, Providence, RI.

p. 100: John Singer Sargent, c. 1880. R. L. Ormand material relating to John Singer Sargent, 1851–1979. Archives of American Art, Smithsonian Institution.

p. 113: John Singer Sargent, *Spanish Male Dancer Before Nine Seated Figures*, 1879, brown ink and brown wash on off-white wove paper, 13.3 x 207 cm (5 ¼ x

8 ⅛ in.), Harvard Art Museums / Fogg Museum, Gift of Mrs. Francis Ormond, Photo © President and Fellows of Harvard College, 1937.8.2.

p. 114: Sargent, John Singer (1856–1925). *Two Nude Bathers Standing on a Wharf*, 1879–80. Oil on wood. 13 ¾ x 10 ½ in. (34.9 x 26.7 cm). Gift of Mrs. Francis Ormond, 1950 (50.130.10b). The Museum of Modern Art, New York, NY, U.S.A. Image copyright © The Metropolitan Museum of Art. Image source: Art Resource, NY.

p. 145: Sargent, John Singer (1856–1925). *Man in a Hat*, 1880–82. Graphite on off-white wove paper. 6 ¼ x 3 ¹⁵⁄₁₆ in. (15.9 x 10 cm). Gift of Mrs. Francis Ormond, 1950 (50.130.88). The Museum of Modern Art. NY, U.S.A. Image copyright © The Metropolitan Museum of Art. Image source: Art Resource, NY.

p. 161: John Singer Sargent, *Madame Gautreau (Madame X)*, c. 1883, graphite on off-white wove paper, 24.6 x 26.6 cm., Harvard Art Museums / Fogg Museum, Bequest of Grenville L. Winthrop, Photo © President and Fellows of Harvard College, 1943.319.

p. 174: John Singer Sargent, *Standing Figure with a Spear*, n.d., graphite, 24.3 x 22.9 cm, Gift of Miss Emily Sargent and Mrs. Francis Ormond (through Thomas A. Fox), 1931.24, Yale University Art Gallery. Photo credit: Yale University Art Gallery.

p. 181: John Singer Sargent, *Head of a Young Man in Profile*, n.d., pen and ink, 24.4 x 33 cm, Gift of Miss Emily Sargent and Mrs. Francis Ormond (through Thomas A. Fox), 1931.26, Yale University Art Gallery. Photo credit: Yale University Art Gallery.

p. 181: John Singer Sargent, *Madame Gautreau Drinking a Toast*, 1882–83, oil on panel, 32 x 41 cm (12 ⅝ x 16 ⅛ in.) Isabella Stewart Gardner Museum, Boston (P3w41).

p. 190: *Vernon Lee*, 1881, John Singer Sargent. Bequeathed by Miss Vernon Lee through Miss Cooper Willis 1935. Photo: Tate.

p. 198: John Singer Sargent, *Portrait of Edwin Austin Abbey*, c. 1889, black chalk / charcoal, 35.6 x 25.6 cm, Edwin Austin Abbey Memorial Collection, 1937.4157, Yale University Art Gallery. Photo credit: Yale University Art Gallery.

p. 221: *Dennis Miller Bunker in His Studio*, between 1884 and 1890. Dennis Miller Bunker Collection, 1882–1943, Archives of American Art, Smithsonian Institution.

p. 225: Artists' party with John Singer Sargent and others (detail), c. 1890. Otto Bacher papers, 1873–1938. Archives of American Art, Smithsonian Institution.

p. 231: Harper Pennington, *John Singer Sargent Watching Carmencita Dance at Mrs. Gardner's Home in Boston*, 1890. Ink wash and gouache on paper, 35.6 x 55.9cm. Gift of Daphne Peabody Murray, 82.289.62. Courtesy of the RISD Museum, Providence, RI.

p. 251: Sargent, John Singer (1856–1924). *Life Study (Study of an Egyptian Girl)*, 1891. Oil on canvas. 190.5 x 61 cm. Anonymous loan. 82.1972. The Art Institute of Chicago. Photo Credit: The Art Institute of Chicago / Art Resource, NY.

p. 265: John Singer Sargent, *Reclining Male Nude (Nicola D'Inverno?)*, c. 1890–1915. Charcoal on off-white laid paper. 47.6 x 62.4 cm. Harvard Art Museums / Fogg Museum, Gift of Mrs. Francis Ormond. Photo © President and Fellows of Harvard College, 1937.9.28.

p. 289: *Portrait of Ena Wertheimer: A Vele Gonfie*, 1904, John Singer Sargent. Bequeathed by Robert Mathias, 1996. Photo: Tate.

p. 303: John Templeman Coolidge (American, 1856–1945), John Singer Sargent painting Mrs. Fiske Warren (Gretchen Osgood) and her daughter Rachel in the Gothic Room, 1903. Platinum print. Isabella Stewart Gardner Museum, Boston (P27w19.3).

p. 318: John Singer Sargent, *The Parting of Jonathan and David*, c. 1895, charcoal on off-white laid paper, 60 x 45.3 cm (23 ⅝ x 17 ¹³⁄₁₆ in.), Harvard Art Museums / Fogg Museum, Gift of Mrs. Francis Ormond. Photo © President and Fellows of Harvard College, 1937.8.163.

p. 366: John Singer Sargent, *Study of Perseus for Perseus on Pegasus Slaying Medusa*, mural, Stairway, Museum of Fine Arts, Boston, c. 1921–25, black chalk/charcoal, 63 x 47.5 cm, Gift of Miss Emily Sargent and Mrs. Francis Ormond 1929.286, Yale University Art Gallery. Photo credit: Yale University Art Gallery.

p. 373: *Miss Eliza Wedgwood and Miss Sargent Sketching*, 1908, John Singer Sargent. Bequeathed by William Newall 1922. Photo: Tate.

Color Plates

Fig. 1: John Singer Sargent, *Man Wearing Laurels*, 1874–80, oil on canvas. Mary D. Keeler Bequest (40. 12. 10). Los Angeles County Museum of Art.

Fig. 2: John Singer Sargent, *A Male Model Standing Before a Stove*, c. 1875–80. Oil on canvas. 28 x 22 in. (71.1 x 55.9 cm). Gift of the Marquis John De Amodio, O.B.E., 1972 (1972.32). Image copyright © The Metropolitan Museum of Art. Image source: Art Resource, NY.

Fig. 3: John Singer Sargent, *Carolus-Duran*, 1879, oil on canvas, 46 x 37 ¹³⁄₁₆ in. (116.8 x 96cm). Image courtesy Clark Art Institute, 1955.14. clarkart.edu.

Fig. 4: John Singer Sargent, *Paul Helleu (1859–1927)*, c. 1880, pastel on brown wove paper, 49 x 43.9cm (19 ⁵⁄₁₆ x 17 ⅝ in.), Harvard Art Museums / Fogg Museum, Bequest of Annie Swan Coburn, Photo © President and Fellows of Harvard College, 1933.18.

Fig. 5: John Singer Sargent, *View of Capri*, c. 1878, oil on academy board, 10 ¼ x 13 ⅜ in. (26 x 33.9 cm), Edwin Austin Abbey Memorial Collection, 1937.2595, Yale University Art Gallery. Photo credit: Yale University Art Gallery.

Fig. 6: John Singer Sargent, *Fumée d'ambre gris*, c. 1880–82, oil on canvas, 29 ⁹⁄₁₆ x 20 ⅝ in. (75.1 x 52.4 cm). Image courtesy Clark Art Institute, 1955.15. clarkart.edu.

Fig. 7: John Singer Sargent, *Henrietta Reubell*, c. 1884–85. Watercolor and graphite on paper. 14 x 10 in. (35.6 x 25.4 cm). The Metropolitan Museum of Art. Marguerite and Frank A. Cosgrove Jr. Fund, 2018 (2018.384).

Fig. 8: John Singer Sargent, *Study for Seated Musicians for "El Jaleo,"* c. 1882, oil on canvas, 61.3 x 81.1 cm (24 ⅛ x 31 ¹⁵⁄₁₆ in.), Harvard Art Museums / Fogg Museum, Bequest of Grenville L. Winthrop, Photo © President and Fellows of Harvard College, 1943.153.

Fig. 9: John Singer Sargent, *El Jaleo*, 1882, oil on canvas, 232 x 348 cm (91 ⅝ x 137 in.), Isabella Stewart Gardner Museum, Boston (P7s1).

Fig. 10: John Singer Sargent, *Dr. Pozzi at Home*, 1881. Oil on canvas. 79 ⅜ x 40 ¼ in. (201.6 x 102.2 cm). The Armond Hammer Collection, Gift of the Armond Hammer Foundation. Hammer Museum, Los Angeles.

Fig. 11: John Singer Sargent, *A Street in Venice*, c. 1880–82, oil on canvas, 29 %16 x 20 ⅝ in. (75.1 x 52.4 cm). Image courtesy Clark Art Institute, 1955.575. clarkart.edu.

Fig. 12: John Singer Sargent, *The Daughters of Edward Darley Boit*, 1882. Oil on canvas. 221.93 x222.57 cm (87 ⅜ x 87 ⅜ in) Museum of Fine Arts, Boston. Gift of Mary Louisa Boit, Julia Overing Boit, Jane Hubbard Boit, and Florence D. Boit in memory of their father, Edward Darley Boit. 19.124.

Fig. 13: John Singer Sargent, *Madame Gautreau (Madame X)*, c. 1883, watercolor and graphite on white wove paper, 35.5 x 25.2 cm (14 x 9 ¹⁵⁄16 in), Harvard Art Museums / Fogg Museum, Bequest of Grenville L. Winthrop. Photo © President and Fellows of Harvard College, 1943.316.

Fig. 14: John Singer Sargent, *Madame X (Madame Pierre Gautreau)*, 1883–84. Oil on canvas, 82 ⅛ x 43 ¼ in. (208.6 x 109.9 cm). Arthur Hoppock Hearn Fund, 1916 (16.53). Image copyright © The Metropolitan Museum of Art. Image source: Art Resource, NY.

Fig. 15: John Singer Sargent, *The Breakfast Table*, 1883–84, oil on canvas, 54 x 45 cm (21 ¼ x 17 ¹¹⁄16 in.), Harvard Art Museums / Fogg Museum, Bequest of Grenville L. Winthrop. Photo © President and Fellows of Harvard College, 1943.150.

Fig. 16: John Singer Sargent, *Isabella Stewart Gardner*, 1888. Oil on canvas, 190 x 80 cm (74 ¹³⁄16 x 31 ½ in), Isabella Stewart Gardner Museum, Boston (P30w1).

Fig. 17: Sargent, John Singer, *Dennis Miller Bunker Painting at Calcot*, 1888. Oil on canvas mounted on Masonite, 27 x 25 ¼ in. Daniel J. Terra Collection, 1999.130. Photo credit: Terra Foundation for American Art, Chicago / Art Resource, NY.

Fig. 18: John Singer Sargent, *La Carmencita*, 1890. Oil on canvas, 232 x 142 cm. RF746. Photo: Gerard Blot. © RMN-Grand Palais / Art Resource, NY.

Fig. 19: John Singer Sargent, *Massage in a Bath House*, 1891, oil on canvas, 65.4 x 83.8 cm (25 ¾ x 33 in.), Harvard Art Museums / Fogg Museum, Gift of Mrs. Francis Ormond. Photo © President and Fellows of Harvard College, 1937.204.

Fig. 20: John Singer Sargent, *W. Graham Robertson*, 1894, oil on canvas. Presented by W. Graham Robertson, 1949. Photo: Tate.

Fig. 21: John Singer Sargent, *Mrs. Carl Meyer and Her Children*, 1896, oil on canvas. Bequeathed by Adèle, Lady Meyer 1930, with a life interest for her son and grandson and presented in 2005 in celebration of the lives of Sir Anthony and Lady Barbadee Meyer, accessioned 2009. Photo: Tate.

Fig. 22: John Singer Sargent, *Asher Wertheimer*, 1898, oil on canvas. Presented by the widow and family of Asher Wertheimer in accordance with his wishes, 1922. Photo: Tate.

Fig. 23: John Singer Sargent, *An Interior in Venice*, 1899. Oil on canvas, 64 x 84 cm. Photo credit: © Royal Academy of Arts, London; photographer: Prudence Cuming Associates Limited.

Fig. 24: John Singer Sargent, *Ena and Betty, Daughters of Asher and Mrs. Wertheimer*, 1901, oil on canvas. Presented by the widow and family of Asher Wertheimer in accordance with his wishes, 1922. Photo: Tate.

Fig. 25: John Singer Sargent, *In Switzerland*, c. 1905. Translucent watercolor and graphite and touches of opaque watercolor, 9 ¹¹⁄16 x 13 ¹⁄16 in. (24.6 x 33.2 cm). Brooklyn Museum, Purchased by Special Subscription, 09.827.

Fig. 26: John Singer Sargent, *The Chess Game*, c. 1907. Oil on canvas: 27 ¹¹⁄16 x 21 ¹⁵⁄16 in (70.3 x 55.7 cm). Allen Family Collection.

Fig. 27: John Singer Sargent, *Man Reading (Nicola d'Inverno)*, 1904–1908, oil on canvas, 25 ¼ x 22 ¼ inches, Museum Purchase. Reading Public Museum, Reading, Pennsylvania.

Fig. 28: John Singer Sargent, *Mountain Stream*, c. 1912–14. Watercolor and graphite on off-white wove paper, 13 ¾ x 21 in. (34.9 x 53.3 cm). Purchase, Joseph Pulitzer Bequest, 1915 (15.14.2). Image copyright © The Metropolitan Museum of Art. Image source: Art Resource, NY.

Fig. 29: John Singer Sargent, *Tents at Lake O'Hara*, 1915. Oil on canvas, 22 x 28 ⅛ in. (55.9 x 71.4 cm), Wadsworth Atheneum Museum of Art, Hartford, CT. The Ella Gallup Sumner and Mary Catlin Sumner Collection Fund, 1944.57. Photo: Allen Phillips / Wadsworth Atheneum.

Fig. 30: John Singer Sargent, *Tommies Bathing*, 1918. Watercolor and graphite on white wove paper, 15 ⁵⁄₁₆ x 20 ¾ in. (38.9 x 52.7 cm). Gift of Mrs. Francis Ormond, 1950 (50.130.48), Metropolitan Museum. Image copyright © The Metropolitan Museum of Art. Image source: Art Resource, NY.

Fig. 31: John Singer Sargent, *The Bathers*, 1917, watercolor and graphite on wove paper, 40.1 x 53 cm. Credit: Worcester Art Museum, Massachusetts, USA © Worcester Art Museum / Bridgeman Images.

Fig. 32: John Singer Sargent, *Nude Study of Thomas E. McKeller*, c. 1917–20. Oil on canvas. 125/73 x 84.45 cm (49 ½ x 33 ¼ in.) Museum of Fine Arts, Boston. Henry H. and Zoe Oliver Sherman Fund. 1986.60.

A NOTE ABOUT THE AUTHOR

Paul Fisher is a professor of American studies at Wellesley College and the author of *House of Wits: An Intimate Portrait of the James Family* and *Artful Itineraries: European Art and American Careers in High Culture, 1865–1920*. He helped organize the Isabella Stewart Gardner Museum's pathbreaking 2020 exhibit *Boston's Apollo: Thomas McKeller and John Singer Sargent*, and contributed to the exhibition catalogue, which won the 2020 George Wittenborn Memorial Book Award for an outstanding publication in the visual arts and architecture.